Enchanted Ground

Enchanted Ground

André Breton, Modernism and the Surrealist Appraisal of Fin-de-Siècle Painting

Gavin Parkinson

BLOOMSBURY VISUAL ARTS
NEW YORK • LONDON • OXFORD • NEW DELHI • SYDNEY

BLOOMSBURY VISUAL ARTS
Bloomsbury Publishing Inc
1385 Broadway, New York, NY 10018, USA
50 Bedford Square, London, WC1B 3DP, UK
29 Earlsfort Terrace, Dublin 2, Ireland

BLOOMSBURY, BLOOMSBURY VISUAL ARTS and the Diana logo are trademarks
of Bloomsbury Publishing Plc

First published in the United States of America 2018
Paperback edition published 2021

Cover design: Irene Martinez Costa
Cover image © Charles Filiger, *Pouldu Landscape* (c. 1890–93).
Oil on canvas / Musée des Beaux-Arts, Quimper.

A catalog record for this book is available from the Library of Congress.

ISBN: HB: 978-1-5013-3725-3
 PB: 978-1-5013-7564-4
 ePub: 978-1-5013-3727-7
 ePDF: 978-1-5013-3726-0

Typeset by RefineCatch Limited, Bungay, Suffolk
Printed and bound in the United States of America

To find out more about our authors and books visit www.bloomsbury.com
and sign up for our newsletters.

The fate of our times is characterized by rationalization and intellectualization and, above all, by the 'disenchantment of the world.' Precisely the ultimate and most sublime values have retreated from public life either into the transcendental realm of mystic life or into the brotherliness of direct and personal human relations. It is not accidental that our greatest art is intimate and not monumental, nor is it accidental that today only within the smallest and intimate circles, in personal human situations, in pianissimo, that something is pulsating that corresponds to the prophetic pneuma, which in former times swept through the great communities like a firebrand, welding them together. If we attempt to force and to 'invent' a monumental style in art, such miserable monstrosities are produced as the many monuments of the last twenty years. If one tries intellectually to construe new religions without a new and genuine prophecy, then, in an inner sense, something similar will result, but with still worse effects. And academic prophecy, finally, will create only fanatical sects but never a genuine community.

Max Weber
'Science as a Vocation' (1919)

Contents

List of Illustrations

List of Plates

List of Figures

Introduction

Chapter 1

Chapter 2

Chapter 3

Chapter 6

Chapter 7

Epilogue

Acknowledgements

The subject matter of this book is much closer to the specifics of my graduate teaching than usual so while working on it I recalled and benefitted from many happy, stimulating classes with students on my course 'Modernism After Postmodernism' at The Courtauld Institute of Art and I would like to thank all those who have participated in it since 2009. I am particularly grateful to my current and former students Will Atkin, Hannah Barton, Charlotte Broker, James Day, Catherine Howe, Kylie King, Kristina Rapacki, Sam Reilly, Eira Rojas, Tessa Stevenson, Grazina Subelyte and Sophie Yaniw who all steered my thinking and reading at various stages of the project. Also helpful when it came to monographic queries concerning Antonin Artaud, Paul Gauguin and Georges Seurat were another former student Lucy Bradnock and my near contemporaries at The Courtauld, Linda Goddard and Nancy Ireson; yet another former student Vicky Clouston, a good friend Michael Richardson and recent interlocutors Tessel Bauduin, Kristoffer Noheden and Dan Zamani taught me a lot about Surrealism, Celticism, medievalism and magic. Holly Clayson was tactful and informative about details of the social history of Paris for the fourth chapter, and discussions with Sandy Isenstadt and Hélène Valance proved incredibly informative about urban lighting. I am deeply indebted to my colleagues at The Courtauld, Giovanni Verri and Kate Edmondson, for taking the time to observe at close hand and discuss with me a drawing by Seurat. Another colleague Satish Padiyar initiated the whole project in a way, by inviting me to write on Cézanne and Surrealism for the collection of essays he edited, *Modernist Games: Cézanne and His Card Players* (2013). For help with translations, I am grateful to Hélène Valance; Karin Kyburz was as effective as ever in her role as picture researcher and Celeste Pfahler was helpful and supportive through various tasks relevant to this book in her time as Assistant to the Modern and Contemporary Section at The Courtauld in 2014–15. More than ever for this book, I found the Courtauld Library an extraordinary resource and its staff unfailingly accommodating; Vicky Kontou, Diana Palmer and Lauren Dolman were particularly cooperative in obtaining material through inter-library loan and acquisitions. My thanks, as well, to Margaret Michniewicz at Bloomsbury who showed such confidence in my book and its humble author, to Paul King and Merv Honeywood for their speedy but scrupulous editorial work and proofing, and to Kerry Taylor for compiling an excellent index.

Beyond these debts I owe a special one to Sam Rose who read the whole manuscript at a late stage and whose remarks were typically generous, perceptive and thought provoking. The same is true of the anonymous peer reviewers of the manuscript who I hope will recognize the value of their observations and criticism in the final book.

Finally, for their advice, friendship, support and love, thanks always to my family, Alessandra, Gabriel and Greta, and the now-familiar litany: Lesley Bell, the Brooks family, Barnaby Dicker, Zavier Ellis, Christopher Green, Jane and Faruque Hussain, Gill and Mick Keber, die Kiso Familie, la famiglia Mazzoli, Dominic Shepherd, Marquard Smith, Michael Taylor and Rita Zuccari.

Colle del Marchese
August 2017

Introduction: Art after Impressionism
after Surrealism

Readers of this book may well be familiar with the sections on artist 'precursors' that are found in the many histories, dictionaries, encyclopaedias and beginners' guides devoted to Surrealism and its art. In those surveys, certain mid- and late nineteenth-century artists, particularly Gustave Moreau and Odilon Redon as well as a few other regulars such as Arnold Böcklin (figures I.1 and I.2), Alfred Kubin, and even Fernand Khnopff, Edvard Munch, Félix Vallotton and J. J. Grandville, invariably and justifiably come in for comparison with Surrealist artists on formal, stylistic, thematic or iconographic grounds. Discussion of these commonalities is valuable and informative about both Surrealism and Symbolism and much more could be made of the suggestive resemblances between these two broad bodies of work and the fragments of text written within and about Surrealism that have been devoted to such artists and others who were earlier recognized by Symbolist writers.[1]

[1] See José Pierre, *André Breton et la peinture*, Lausanne: L'Age d'Homme, 1987, 20–3. Redon's work left its trace in that of Marcel Duchamp (the paintings of 1910–11), André Masson and Yves Tanguy, yet André Breton's attraction to Moreau is much better known and more often explained than his resistance to Redon, which José Pierre failed to break: Pierre, *André Breton et la peinture*, 23. For Surrealists, it seems that the resemblance between Redon's work and Surrealist painting was superficial, like the comparison with Grandville's, and, worse, 'aestheticist', decorative and a mere fabrication of mysteries and dreams, complaints that were documented most comprehensively soon after the Redon exhibition held at what was then the Orangerie des Tuileries from October 1956 till January 1957 (and made in contrast with the art of Moreau, Kubin and Munch) by the Surrealist Jean-Louis Bédouin, 'Trop d'honneur', *Le Surréalisme, même*, no. 2, spring 1957, 100–4. Years later, Redon came out second best to Moreau on mainly formal grounds in a survey of pre-Surrealist art by José Pierre, *L'Univers surréaliste*, Paris: Somogy, 1983, 56–7. Also see the alternative (meaning more favourable) discussion of Redon and Grandville by Stefanie Heraeus, 'Artists and the Dream in Nineteenth-Century Paris: Towards a Prehistory of Surrealism', trans. Deborah Laurie Cohen, *History Workshop Journal*, no. 48, autumn 1999, 151–68.
 Obviously, Symbolist poetry and theory are important to this book but they are diverted to its aims, which are to rethink early modernist art after Surrealism; so in my fourth and fifth chapters, for instance, I construe the 'surrealist' qualities of the work of Georges Seurat and Paul Gauguin partly by recourse to an essay by Breton devoted to Symbolist poetry that assessed its relevance in the twentieth century according to how far it adhered to the Surrealist marvellous as against the manufactured 'mystery' of Symbolism (which the dated work of the 'bourgeois' 'pseudo voyant' Redon fell foul of in Bédouin's analysis): André Breton, 'Marvellous versus Mystery' [1936], *Free Rein* [1953], trans Michel Parmentier and Jacqueline d'Amboise, Lincoln and London: University of Nebraska Press, 1995, 1–6.

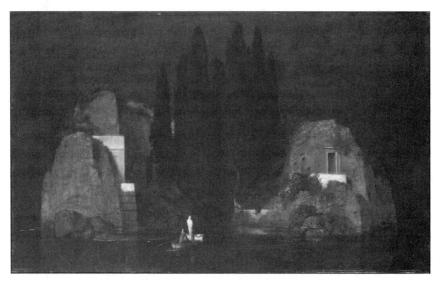

Figure I.1 Arnold Böcklin, *The Isle of the Dead* (1890). Oil on wood, 73.7 × 121.9 cm. The Metropolitan Museum of Art New York. www.metmuseum.org.

However, the attention given in the pages that follow to the painters that came to prominence in the late nineteenth century is extended only incidentally to those artists, to Symbolist painters generally, to Nabis such as Charles Filiger and Paul Sérusier, and to one-offs like Henri Rousseau, an artist who held a particular appeal for the Surrealists. My book collects and analyses, instead, the Surrealist commentary on the painters who became the canonical figures of early French modernism. This is an approach to the period that remains entirely novel at the moment of writing. Combining historiography and Surrealist theory to both review and extend the readings of that art by Surrealist writers and artists, this book submits such interpretation as an alternative to the treatments by 'old' and 'new' art histories, broadly meaning 'formalist-modernist', on the one hand, and the more contextual, political and theoretical approaches that enhanced the discipline from the late 1960s, on the other. The Surrealist writings revived and expanded upon here were and still are meant to compete with the former and have been suppressed by both. If they have been marginal, overlooked, ignored or derided, they were also belated, occasional, minor and ambivalent. In bringing them together and drawing out their ramifications and repercussions, I indicate significant gaps in the art historical record. My goal is to identify a Surrealist position on the foundational canon of late nineteenth-century French painting, a canon that emerged in modernist art criticism, art history and curatorship at the beginning of the twentieth century and was consolidated from then up to the mid-1950s.[2] Across that era, we can track the

[2] The nearest to a joined up discussion are the passages given over mainly to Gauguin in Pierre, *André Breton et la peinture*, 26–8, 31–2. Also see the equally brief material on Seurat and mainly Gauguin in Pierre, *L'Univers surréaliste*, 57–61.

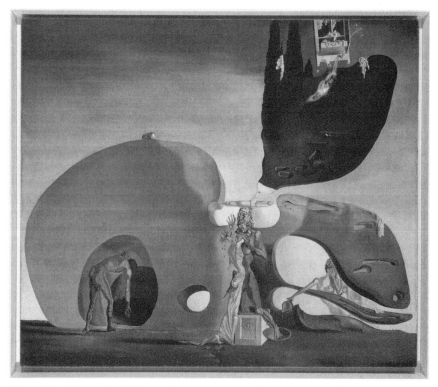

Figure I.2 Salvador Dalí, *The Birth of Liquid Desires* (1932). Oil and collage on canvas, 96.1 × 112.3 cm. The Solomon R. Guggenheim Foundation Peggy Guggenheim Collection, Venice. © Peggy Guggenheim Collection, Venezia (Solomon R. Guggenheim Foundation, New York). © Salvador Dali, Fundació Gala-Salvador Dalí, DACS 2018.

fervent arc of historical Parisian Surrealism itself and it therefore acts as the period frame for the 'appraisal' of my title.

The idea of making a swerve from the customary artists of the late nineteenth century who are seen to predate Surrealist painting, such as Moreau, Redon and Rousseau, had a strong, counter-intuitive appeal for me. But I also found while researching and writing this book that an alternatively finessed canon to the modernist one was developed in patches in Surrealism. I believe that is worth collating and unifying for the study of modernism and for academic art history and will offer a new contribution to scholarship on Surrealism. I choose my words carefully here because Surrealism did not tender an entirely dissimilar range of artists to those privileged in modernist art criticism and art history, as I will show; rather, it filtered those who had long and not-so-long ago achieved eminence in the 1920s such as Paul Cézanne and Pierre-Auguste Renoir, those who had not (at the time) such as Georges Seurat and those well on their way to doing so such as Paul Gauguin and Vincent van Gogh, through its own theoretical or thematic proclivities by which their reputations within

the movement stood or fell. This *qualitative* reassessment by Surrealism is more than has been managed by contemporary art history, which tends to uphold the same canon in spite of its abjuration of the very formalist and modernist modes of writing that were instrumental in creating it.[3] In this sense, my book sometimes proposes Surrealist writings on those artists as alternatives to the ones of academic art history.

These Surrealist tendencies against which earlier artists were judged did not merely differ from the accents placed by modernists, they represented an entirely different system of values for interpreting and evaluating art. There is much complexity and nuance on both sides and their edges even touch at certain points. However, a way of broaching this divergence in a manner easy to understand is to say that the well-known prominence given in the first two-thirds of the twentieth century by formalist and modernist critics and writers, art historians and curators to the formal, aesthetic and stylistic elements of works of art (qualitative judgements on colour, line, shading, volume, space, composition and other perceptual material-based aspects of art) at the expense of consideration of recognizable, representational content was almost entirely reversed by Surrealism's devotion from its beginnings in the early 1920s to a poetics of art, and increasingly from the late 1930s to how that poetics incubated eroticism, occultism and magic.[4] For this reason, I chose a term from an 1889 letter from van Gogh that I quote from in this introduction and will return to a few times in my book, meant by that artist to affirm his practice as a mode of realism and not fantasy, giving me a way of thinking about this alternative Surrealist reception and also providing me with my accidentally surrealist and perhaps Magrittean title *Enchanted Ground*.[5]

Impressionism and After

Although I will have something to say about the (no doubt unexpected) 'surrealism' of the pioneers of modernist painting – Gustave Courbet, Édouard Manet and the early Cézanne – I take the art that followed in France immediately after Impressionism,

[3] See, for instance, the monographic chapters that uncritically assess van Gogh, Seurat, Cézanne and Gauguin along contextual lines (scientific, political, ideological and occultist) while leaving the canon secure in Albert Boime, *Revelation of Modernism: Responses to Cultural Crises in Fin de Siècle Painting*, Columbia and London: University of Missouri Press, 2008.

[4] For a more detailed account than is possible or necessary here of the history, intricacies and fate of 'formalism', mainly in the writings of Clement Greenberg, see Caroline A. Jones, *Eyesight Alone: Clement Greenberg's Modernism and the Bureaucratization of the Senses*, Chicago and London: The University of Chicago Press, 2005, 60–95.

[5] I am thinking primarily of the major exhibition, both historical and contemporary, organized by the movement and titled *Surrealist Intrusion in the Enchanters' Domain* held at the D'Arcy Galleries on Madison Avenue in New York from 28 November 1960 till 14 January 1961; also the influential article questioning any possibility of a Surrealist painting based on technique by Max Morise, 'Enchanted Eyes' ['Les Yeux enchantés'] [1924], Mary Ann Caws (ed.), *Manifesto: A Century of Isms*, Lincoln and London: University of Nebraska Press, 2001, 478–81; and even René Magritte's major commission executed for the casino at Knocke-le-Zoute in Brussels in 1953 consisting of reheated Magrittean iconography and titled *The Enchanted Realm* or *Domain* (*Le Domaine enchanté*). There was also the major exhibition and catalogue that partly revived Surrealism in Britain: *The Enchanted Domain*, Exeter: Exe Gallery, 1967.

repudiating that movement to a greater or lesser extent, as that which the Surrealists came to see in terms of their own ends, as the most relevant of the second half of the nineteenth century. What form did that complaint against Impressionism take and how was it processed in Surrealism?

By the early 1890s, Impressionism was being challenged by alternative forms of modern art that saw painting as the vehicle for other kinds of knowledge, and by Symbolist supporters such as writer-critics Félix Fénéon and Gustave Kahn, anxious to dissociate the generation of Neo-impressionists from it.[6] Of the cohort of painters critical of the Paris Salon who came to prominence after the Impressionists, Gauguin was the one who came to reject their attitudes most violently in the wake of Symbolism. This was carried out with an ideological fervour in the widely quoted passage with which 'the Surrealists would have agreed without hesitation', according to José Pierre[7]:

> They studied color, and color alone, as a decorative effect, but they did so without freedom, remaining bound by the shackles of verisimilitude. For them there is no such thing as a landscape that has been dreamed, created from nothing. They looked, and they saw, harmoniously, but without any goal: they did not build their edifice on any sturdy foundation of reasoning as to why feelings are perceived through color.
>
> They focused their efforts around the eye, not in the mysterious center of thought, and from there they slipped into scientific reasons. . . . Intellect and sweet mystery were neither the pretext nor the conclusions; what they painted was the nightingale's song. . . . Dazzled by their first triumph, their vanity made them believe it was the be-all and the end-all. It is they who will be the official painters of tomorrow, far more dangerous than yesterday's.[8]

Although Gauguin recognized some of the initial achievements of the Impressionists, especially those of Claude Monet, his conclusions were unsparing: '[w]hen they talk about their art, what exactly are they talking about? An entirely superficial art, nothing but affectation and materialism; the intellect has no place in it.'[9]

These lines would eventually appear in *Diverses Choses* written in 1896–8 around the time Gauguin painted *Te Rerioa (The Dream)*, *Nevermore* and *Where*

[6] See the remarks on Fénéon and Kahn made by Sven Lövgren, *The Genesis of Modernism: Seurat, Gauguin, van Gogh and French Symbolism in the 1880s*, trans. Albert Read, Stockholm: Almqvist & Wiksell, 1959, 63, 66. For the significance of the year 1891 in this and the role of Camille Pissarro, see T. J. Clark, *Farewell to an Idea: Episodes from a History of Modernism*, New Haven and London: Yale University Press, 1999, 71–7.

[7] 'les surréalistes auraient souscrit sans hésiter', Pierre, *L'Univers surréaliste*, 57.

[8] Paul Gauguin, *The Writings of a Savage* [1974], ed. Daniel Guérin, trans. Eleanor Levieux, New York: The Viking Press, 1978, 140–1. Further discussion and approval within Surrealism, beyond Pierre's remark, of Gauguin's rejection of Impressionism can be found in Gérard Legrand, *Gauguin*, Paris: Club d'Art Bordas, 1966, 43–4. For a full study of Gauguin's six years as an Impressionist up to 1885, see Richard R. Brettell and Anne-Birgitte Fonsmark, *Gauguin and Impressionism*, New Haven and London: Yale University Press, 2005.

[9] Gauguin, *Writings of a Savage*, 141.

Do We Come From? What Are We? Where Are We Going? (which the Surrealists would come to revere).[10] It has been argued that they are implicitly evoked in André Breton's attempt as early as 1923 in the essay 'Distance' to prioritize the art of Gauguin and Seurat over that of Cézanne at the origins of twentieth-century art.[11] In any case, they make an evidently neat fit with Breton's founding statement, first uttered in 1925, about the demand made by Surrealism on the visual arts, which forms the most important, theoretical opening part of *Surrealism and Painting* (1928). Appealing there for recourse to 'a *purely internal model*', at a time when, he said, philosophy and science were making 'the external world ... increasingly suspect', Breton asserted: 'to make the magic power of figuration with which certain people are endowed serve the purpose of preserving and reinforcing what would exist without them anyway, is to make wretched use of that power.'[12] No wonder Breton would quote Gauguin's 'mysterious centre of thought' in years to come in support of this opinion.

Even at this early stage in Breton's thinking about the visual arts, then, for him as for Gauguin, 'magic' in art was meant to bring forth the invisible not represent the visible. In spite of the period and cultural contexts (and the different vocations of poet and painter) that separated them, it was a shared position that articulates starkly their remoteness not just from Impressionism, but also from some artists who came after the Impressionists and equally painted from nature. This brings me to the famous letter by van Gogh the realist who wrote to Émile Bernard in November 1889 using the term 'abstraction' to denote and critically defame the limitative intrusion of the imagination in painting along these paradoxical lines: '[w]hen Gauguin was in Arles, I once or twice allowed myself to be led into abstraction, as you know ... and at that time abstraction seemed an attractive route to me. But that's enchanted ground [terrain enchanté], – my good fellow – and one soon finds oneself up against a wall.'[13] Van Gogh's judgement on the recourse to imagination in painting as alluring but inevitably constrained throws into relief the shared ground of Breton and Gauguin.

[10] Gauguin's statement about the Impressionist artists were first put into circulation in 1906 when quoted in the very early monograph on the artist by Jean de Rotonchamp, *Paul Gauguin, 1848–1903*, Paris: Édouard Druet et Cⁱᵉ, 1906, 210. For the Surrealists' reverence for the great tableau as 'une des plus grandes peintures de tous les temps', see Legrand, *Gauguin*, 31.

[11] See the editor's remarks in André Breton, *Oeuvres complètes*, vol. 1, Paris: Gallimard, 1988, 1317, 1320.

[12] André Breton, 'Surrealism and Painting' [1925–8], *Surrealism and Painting* [1965], trans. Simon Watson Taylor, New York: Harper & Row, 1972, 1–48, 4.

[13] Letter to Émile Bernard of about 26 November 1889 in Vincent van Gogh, *The Letters: The Complete Illustrated and Annotated Edition, Vol. 5: Saint-Rémy-Auvers 1889–1890*, eds Leo Jansen, Hans Luijten and Nienke Bakker, London and New York: Thames & Hudson, 2009, letter 822, 146–53, 148. This approach to art lamented by van Gogh was characteristic of Gauguin: before going to meet van Gogh in Arles, he had offered the following patronizing advice in a letter to his friend Émile Schuffenecker on 14 August the previous year: 'A hint – don't paint too much direct from nature. Art is an abstraction! study [*sic*] nature then brood on it and treasure the creation which will result, which is the only way to ascend towards God – to create like our Divine Master', Paul Gauguin, *Letters to his Wife and Friends* [1946], ed. Maurice Malingue, trans. Henry J. Stenning, Boston: Museum of Fine Arts, 2003, 100–1, 100. Evidence that Gauguin's position as spelt out here was known to the Surrealists can be found in Legrand, *Gauguin*, 11.

It is the firm but fantastic terrain that underlies the polemic of the former in the *Manifesto of Surrealism* (1924) against the contraction of the imagination from childhood on by the social utilitarianism entailed by capitalism, and the one that bears Gauguin's abrupt shelving of the 'exactitude' insisted upon by realism in an earlier letter to Bernard of November 1888.[14]

Yet in spite of a common outlook held between Breton and Gauguin on the task of painting, it would be a long time before Gauguin received any concerted attention in Surrealism. At first, Breton saw the late nineteenth-century precursors of the movement as poets not painters: the Comte de Lautréamont (Isidore Ducasse), Arthur Rimbaud and Stéphane Mallarmé.[15] Then in his subsequent writing of the 1920s and for some time after, it was the Cubist-era Pablo Picasso who acted as his chronological point of departure for the important and up-and-coming art of that decade. At that point, already in conflict with the emerging formalism, art was seen by Breton to be less about experiments with form than with an 'inwardly' directed examination that indicates a 'future' or beyond shared with poetry and even the 'literature' usually derided by the Surrealists:

> We leave behind us the great grey beige 'scaffoldings' of 1912, the most perfect example of which is undoubtedly the fabulously elegant *Man with a Clarinet* [figure I.3, 1911–12], whose 'parallel' existence must remain a subject for endless meditation. ... The *Man with a Clarinet* remains as a tangible proof of our unwavering proposition that the mind talks stubbornly to us of a future continent, and that everyone has the power to accompany an ever more beautiful Alice in Wonderland.[16]

Breton would continue to hold Cubism and especially the *Man with a Clarinet* in very high esteem up to his last major word on art in *L'Art magique* (1957). By then, however, it was Gauguin's imagining of an alternative to plain reality in pursuit of a personal myth that would draw the greater attention of Surrealism, even though mythic themes took on an entirely different appearance in Gauguin's art to Picasso's and even the Surrealists'.

For that reason, Breton quoted from the closing part of Gauguin's refutation of Impressionist opticality – about superficiality, affectation and materialism – in one of the lectures he gave on his pedagogical visit to Port-au-Prince in Haiti in 1945–6, taking it as a general denunciation of the 'occidental' art of Gauguin's day.[17] Earlier in

[14] 'Threat is piled upon threat, one yields, abandons a portion of the terrain to be conquered. This imagination which knows no bounds is henceforth allowed to be exercised only in strict accordance with the laws of an arbitrary utility', André Breton, 'Manifesto of Surrealism' [1924], *Manifestoes of Surrealism*, trans Richard Seaver and Helen R. Lane, Ann Arbor: University of Michigan Press, 1972, 1–47, 4; Victor Merlhès, *Correspondance de Paul Gauguin: Documents, témoignages*, Paris: Fondation Singer-Polignac, 1984, 275.
[15] Breton, *Surrealism and Painting*, 4.
[16] Breton, *Surrealism and Painting*, 6.
[17] André Breton, 'Conférences d'Haïti, III' [1946], André Breton, *Oeuvres complètes*, vol. 3, Paris: Gallimard, 1999, 233–51, 237.

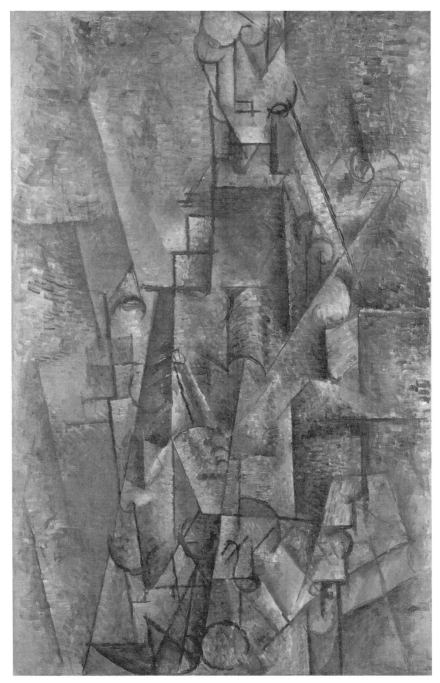

Figure I.3 Pablo Picasso, *Man with a Clarinet* (1911–12). Oil on canvas, 106 × 69 cm.
Museo Thyssen-Bornemisza, Madrid. © Museo Thyssen-Bornemisza/Scala, Florence.
© Succession Picasso/DACS, London 2018.

that lecture, which was given over entirely to the art of the second half of the nineteenth century but remained unpublished in his lifetime (and will be discussed at length in my second and, especially, third chapters), Breton made his own most extensive comments to date on Impressionism. Crediting Eugène Delacroix with the invention of the modern spirit in painting as that had culminated in Surrealism, while acclaiming Courbet as the inventor of an oneiric atmosphere in painting that would be inherited by the equally mediumistic though stylistically entirely dissimilar canvases of Giorgio de Chirico, Breton turned briefly and with reservations towards the Monet–Renoir wing of Impressionism:

> Impressionism, as a movement in reaction against those that had preceded it, repudiated, in fact, the Romantic imagination and all that which painters named with ill-will *literature*. Indifferent to philosophy and poetry, the Impressionist painters claim to paint only what they see and as they see it, focussing above all on water, the sky and mists, or in other words on everything that time makes and unmakes indefinitely. The unsolicited find [trouvaille], fruit of simple chance as almost always, which gave flight to Impressionism, seems to have been the initially vague and completely involuntary observation of the reflection of a landscape on the water of a river.[18]

This was a well-worn take on Impressionism that had its source in Symbolist circles in the early 1890s, but was redeemed at least a little in Breton's rendering by his refusal to lump every non-Symbolist from Courbet and Manet through to Seurat with Impressionist 'materialism' or 'positivism'. Beyond this, however, he gave his attentive Haitian audience hungry for culture only an abbreviated introduction to the Impressionists as artists preoccupied with temporality and light and too tied to the surfaces of objects to create anything more decisive than a 'visual revolution'.[19]

No doubt Breton had always thought of Impressionism in this way. But it is significant that he stated only in the mid-1940s that it was a kind of aberration in the recent history of art, in reaction to that which had come before it and in poor contrast especially to what came after it, an opinion that had been consolidated through

[18] 'L'impressionnisme, comme mouvement de réaction contre ceux qui l'ont précédé, répudie en effet l'imagination romantique et tout ce que les peintres nomment en mauvaise part la *littérature*. Indifférents à la philosophie comme à la poésie, les peintres impressionnistes prétendent ne peindre que ce qu'ils voient et comme ils le voient, en s'attachant surtout à l'eau, au ciel et aux brumes, autrement dit à tout ce que le temps fait et défait indéfiniment. La trouvaille, fruit du simple hasard comme presque toujours, qui a donné essor à l'impressionnisme semble bien avoir été l'observation d'abord distraite et tout involontaire du reflet d'un paysage dans l'eau d'une rivière', Breton, *Oeuvres complètes*, vol. 3, 235–6. Breton was referring at the end of this passage to the studies of water carried out by Monet and Renoir at the floating restaurant and bathing place La Grenouillère late in 1869: John Rewald, *The History of Impressionism* [1946], New York: The Museum of Modern Art, 1973, 226–32.
[19] 'révolution visuelle', Breton, *Oeuvres complètes*, vol. 3, 236.

conversations with Marcel Duchamp in New York during the Second World War.[20] In a
similar fashion, and not coincidentally, Clement Greenberg had pronounced Magrittean
and Dalinian 'academic' Surrealism a deviation from the historical logic of avant-garde
painting a little over a year earlier.[21] Breton and Greenberg would continue to devise
competing lineages of the most important modern art during the Cold War, through
the 1950s driven by a mutual detestation of socialist realism, and into the 1960s. In the
Surrealist account, Impressionist opticality made no sense to the validation of a
metaphorical and increasingly magical content in art, while in the modernist narrative,
much Surrealist art was excused from a canon formed in the wake of Impressionist
truth-to-materials as 'academic', 'kitsch' or, yes, 'literary'.

Breton would protest again the 'literary' label given by some to any art that was
neither realist nor merely for visual delectation on the occasion of *Dessins Symbolistes*,
the 1958 exhibition he curated with the collector and gallery owner Mira Jacob at the
Bateau-Lavoir gallery, which had opened three years earlier specializing in works on
paper from the late nineteenth century onwards.[22] After a dip in its critical fortunes in
the 1920s and 1930s, Monet's painting had been thoroughly revived by then, largely
thanks to the success of abstract expressionism. This trend had been helped along by
the recent opinion given prominently by the former Surrealist André Masson in which
Monet was viewed as a revolutionary who created a '[n]ew way to see, to feel and to
love nature', with an illustrious phrase from Breton's *Manifesto* cheekily dropped in to
make the case: 'here the imagination regains its rights'.[23] Breton used his essay in the

[20] See the letter of 27 October 1945 sent to Victor Brauner in which Breton writes of himself and
 Duchamp leafing through *Cahiers d'Art* before concluding 'all works of art which make the slightest
 concession to the physical, to the physical aspect of things, to models nude or dressed, landscapes,
 still-lives, etc. . . . and whatever distortion to which they may give rise, must be *pitilessly* shunned. All
 of that smacks of the vainest sort of Impressionism. Today, this must be the sole measure of
 judgement', quoted in Didier Semin, 'Victor Brauner and the Surrealist Movement', The Menil
 Collection (ed.), *Victor Brauner: Surrealist Hieroglyphs*, Hatje Cantz: Ostfildern-Ruit, 2001, 23–41,
 34 (translation slightly modified).
[21] Clement Greenberg, 'Surrealist Painting' [1944], *The Collected Essays and Criticism, vol. 1,
 Perceptions and Judgements, 1939–1944*, ed. John O'Brian, Chicago and London: The University
 of Chicago Press, 1986, 225–31. For Greenberg's measured 'banishment' of Surrealism in the
 1940s, in which '[f]ormalist innovation trumps Surrealist malingering', see Jones, *Eyesight Alone*,
 67–9.
[22] André Breton, 'Concerning Symbolism' [1958], *Surrealism and Painting*, 357–62, 357.
[23] 'Nouvelle manière de voir, de sentir, d'aimer la nature', 'ici l'imagination reprend ses droits',
 André Masson, 'Monet le fondateur', *Verve*, vol. 7, nos. 27/28, December 1952, 68. 'The imagination
 is perhaps on the point of reclaiming its rights', Breton, *Manifestoes*, 10 (translation modified).
 His editor has expressed the view that Masson's enthusiasm for Impressionism was affected by
 renewed debates about automatism in France due to the advent of 'lyrical abstraction' (to be
 surveyed in my fifth chapter): André Masson, *Le rebelle du surréalisme: écrits*, ed. Françoise
 Will-Levaillant, Paris: Hermann, 1976, 195 n. 127. Masson was quoted a few years later in the
 formalist account of Monet as one of 'the great precursors who put forth the premises which
 culminated in abstract painting' and viewed '[t]he optical qualities of Impressionism' as 'integral
 to the abstract painting of the forties and fifties', William Seitz, 'Monet and Abstract Painting',
 College Art Journal, vol. 16, no. 1, Autumn 1956, 34–46, 45, 34, 35. Seitz was probably prompted by
 the 'late' Monet exhibition at Knoedler in New York as was another champion of abstract
 expressionism who also mentioned Masson's text and viewed the vogue for Monet as a change
 of heart by formalist criticism brought about by the success of American abstraction: Thomas B.

catalogue of *Dessins Symbolistes* to try to tip the historical record back in favour of Symbolism and Surrealism. However, he must have had the modernist defence of US abstraction in mind as much as Impressionism when he complained that Symbolist art 'appeared for a long time to have been swept away entirely by the tide of Impressionism', quoting again for support from the conclusion of Gauguin's dismissive remarks about that movement.[24] In that text, Breton also roped in the equally disparaging observations made by the chronicler of Gauguin and Symbolism, Charles Chassé, and the one by Redon whose quip about not embarking on the Impressionist boat, 'because I found the ceiling too low', had been repeatedly cited by Sérusier to Chassé.[25] Breton had never

Hess, 'Monet: Tithonus at Giverny', *Art News*, vol. 55, no. 6, October 1956, 42. See the text that dates the origin of the Monet revival in America to 1955 and its culmination in exhibitions in 1957 and the major Monet show of 1960 at MOMA in New York that went to the Los Angeles County Museum of Art: Michael Leja, 'The Monet Revival and New York School Abstraction', London: Royal Academy of Arts, *Monet in the 20th Century*, 1998, 98–108 and 291–3, 103. For the critical reception of Impressionism before and after abstract expressionism, see Mary Tompkins Lewis, 'Introduction: The Critical History of Impressionism: An Overview', Mary Tompkins Lewis (ed.), *Critical Readings in Impressionism and Post-Impressionism: An Anthology*, Berkeley, Los Angeles, London: University of California Press, 2007, 1–19, 10–14. Greenberg's main contribution to the reconsideration of Monet and Impressionism can be found in Clement Greenberg, '"American-Type" Painting' [1955], *The Collected Essays and Criticism, vol. 3, Affirmations and Refusals, 1950–1956*, ed. John O'Brian, Chicago and London: The University of Chicago Press, 1993, 217–36, 228, 229–32.

[24] Breton, *Surrealism and Painting*, 360. The deep roots of the advancement of Gauguin ahead of Impressionism, as Breton must have been aware as a reader of the *Mercure de France*, lie in the article by Albert Aurier, 'Le Symbolisme en peinture: Paul Gauguin', *Mercure de France*, tome 2, March 1891, 155–65.

[25] Impressionism, Breton wrote, 'shares with naturalism the characteristic of attempting to achieve a position of subservience in relation to positivism: "It is a question of painting humbly, stupidly, the plays of light which pass before the artist's eyes,"' Breton, *Surrealism and Painting*, 360. Breton was quoting here from the passage in which Impressionism was viewed as 'une des phases du mouvement positiviste' and the Impressionist painter said to paint 'humblement, bêtement' the play of light: Charles Chassé, *Le Mouvement symboliste dans l'art du XIXe siècle*, Paris: Librairie Floury, 1947, 19. For a rejection of the crudeness of such pronouncements as Chassé's (made by some as early as the 1890s), channelled through Camille Pissarro, along with the counter-intuitive suggestion that 'Monet's art is driven not so much by a version of positivism as by a cult of art as immolation' that is flavoured by the mood evoked by the likes of (Surrealist hero) Gérard de Nerval, see Clark, *Farewell to an Idea*, 71, 129, 12; and for a longer discussion of positivism, Impressionism and Symbolism embedded in a larger argument stating that '*Symbolism and Impressionism, as understood around 1890, were not antithetical*', see Richard Shiff, *Cézanne and the End of Impressionism: A Study of the Theory, Technique, and Critical Evaluation of Modern Art*, Chicago and London: The University of Chicago Press, 1984, 7, 11, 23–6. Breton quoted Odilon Redon from the book he owned by Chassé, *Le Mouvement symboliste*, 48; Chassé repeated it a few years later in another book Breton owned (signed by the author), *Les Nabis et leur temps* (1960): 'Paul Sérusier several times repeated to me this sentence of Redon's: "I refused to embark on the Impressionist boat because I found the ceiling too low"', Charles Chassé, *The Nabis & their Period* [1960], trans. Michael Bullock, London: Lund Humphries, 1969, 26; Redon's quotation showed its durability by appearing yet again in the survey of pre-Surrealist art by Pierre, *L'Univers surréaliste*, 57. In 1913, Redon held forth on the artists of his generation as follows: 'True parasites of the object, they cultivated art on a uniquely visual field, and in a certain way, closed it off from that which goes beyond it, and which might bring the light of spirituality into the most modest trials', Odilon Redon, *To Myself: Notes on Life, Art and Artists* [1979], trans Mira Jacob and Jeanne L. Wasserman, New York: George Braziller, Inc., 1986, 110. Redon can be found debating the point with the Nabis led by Sérusier at the Galerie Vollard in Maurice Denis's 1900 painting *Homage to Cézanne*, in which canvases by Renoir and Gauguin also

had much time for the Fauves who had failed to live up to the example set by Moreau, the one-time teacher of several of them, referred to in *Dessins Symbolistes* as the 'great visionary and magician'.[26] More unexpectedly, his old confidence in the capacity of Cubism to transport its audience to another world had gone by that time and it had been brought equally low as Impressionism in his estimation (caused partly by Picasso's all-too-real conversion in this world to Soviet communism). Breton now saw both Fauvism and Cubism as mere 'off-shoots' of Impressionism, 'limit[ing] themselves strictly to an external view and insist[ing] on wasting our time with trivial objects physically within reach'.[27]

Surrealism, Modernism, Formalism and 'Post-Impressionism'

When considered alongside the title of Breton's catalogue essay, 'Préface-Manifeste', the 1958 exhibition *Dessins Symbolistes* points to a wish to counter both the modernist canon and the formalist means by which it was validated by the dominant modernist criticism and writing. The continued vigour of the latter could be viewed in that very year where the supposed proto-modernism of Seurat was restated by Robert L. Herbert, at the time of the slightly early 'centenary' exhibition held for the artist in Chicago, which ended on the day *Dessins Symbolistes* began.[28] In conjunction with the attention they gave to Symbolist art, the Surrealists' make-over of Gauguin had been underway for nearly a decade by then and the stronger case they made for the Surrealist Seurat for much longer in the face of the modernist account that had increasingly shaped the institutional narrative of modern art history. Breton would have become more aware of that orthodoxy while in New York during the Second World War. He could have witnessed since then the growing interest shown in, and bigger exhibitions given to the work of Cézanne, Gauguin, Seurat and van Gogh by modernist critics, art historians and curators. Accordingly, he attempted to appropriate Gauguin and Seurat in *Dessins*

appear (it was painted in the midst of Denis's attempt to accommodate theoretically the early moderns to classicism: Maurice Denis, *Théories, 1890–1910: Du symbolisme et de Gauguin vers un nouvel ordre classique* [1912], Paris: L. Rouart et J. Watelin, 1920). Redon was considered as equally parasitical as the Impressionists by Bédouin who aimed to demonstrate this by contrast with Gauguin and with reference to that artist's letter of August 1901 sent to Daniel de Monfreid in which Gauguin avowed: 'il y a en somme en peinture plus à chercher la suggestion que la description, comme le fait d'ailleurs la musique' (oddly, Bédouin omitted Gauguin's joke about Redon being senile and possessed of a depleted, one-note imagination that led up to this famous, Symbolism-inspired passage): Bédouin, 'Trop d'honneur', 101–2; Paul Gauguin, *Lettres de Gauguin à Daniel de Monfreid*, Paris and Zurich: Éditions Georges Crès et Cᵢᵉ, 1918, 321–8, 325–6.

26 Breton, *Surrealism and Painting*, 361.
27 Breton, *Surrealism and Painting*, 360.
28 'Seurat's planar and often geometric forms encourage us to stress his importance as a forebear of modern abstract art', Robert L. Herbert, 'Seurat's Drawings', Chicago: The Art Institute of Chicago, *Seurat: Paintings and Drawings*, 1958, 22–5, 24. I note in my third chapter the important scholarship on Seurat and Jules Chéret by Herbert who was by no means a passive formalist, as underlined by Paul Smith, 'Introduction', Paul Smith (ed.), *Seurat Re-Viewed*, University Park PA: The Pennsylvania State University Press, 2009, 1–13, 5–6.

Symbolistes, stating that 'the whole exhibition hinges upon this deliberate juxtaposition of the work of these two masters'.[29] In this way, he returned them to Symbolism and therefore to a history that was relevant to Surrealism even as Breton and the Surrealists modified the canon through their elimination of Cézanne and resistance to van Gogh.

Given this leaning, it is mildly ironic that the status of those four artists as the patriarchs of modern painting was achieved partly by writers dear to Breton, long before the advent of formalist modernism, as he knew. In the article he wrote for the weekly cultural newspaper *Arts* in November 1951, 'Alfred Jarry as Precursor and Initiator', which responded to the recent publication of the *Oeuvres complètes* of Jarry by surveying what was, till then, the little-known range of his writing, Breton gave prominence to the exceptional foresight of Jarry's understanding of art, since he was the first to predict the largely post-Impressionist litany of Cézanne, Renoir, Manet, Gauguin, van Gogh and Rousseau in the 1890s.[30] Much earlier and more important than this, it must have been through Guillaume Apollinaire by whom he was mentored as a poet from late 1915 to 1918 that Breton became comprehensively apprised of that emerging canon in his pre-Surrealist years for, remarkably, as early as 1907, Apollinaire's hit-and-miss art criticism had lined up and isolated the four pioneering early modernists in a single sentence at a time when only Cézanne's reputation was secure.[31]

By then, the modernist canon was already bound to an early variety of formalism, helped along by the writings of Maurice Denis on the Impressionists, Symbolists, Cézanne, Gauguin, van Gogh and others, fronted by the artist-theorist's declaration of 1890, which became a sort of axiom: 'Remember that a picture – before being a horse in wartime, a nude or some anecdote or other – is essentially a plane surface covered with colours assembled in a certain order.'[32] Breton's interest in Denis as an artist would remain minor due mainly to his 'eventual surrender to religious stereotype', as Breton put it; he would harbour a similar reservation about Bernard who also played a significant role in the standardization of the early modernist canon (and was powerfully

[29] Breton, *Surrealism and Painting*, 361.
[30] André Breton, 'Alfred Jarry as Precursor and Initiator' [1951], *Free Rein*, 247–56, 252–3. Jarry had met Gauguin with the poet Léon-Paul Fargue in 1893 and devoted three poems to paintings by Gauguin that year: Alastair Brotchie, *Alfred Jarry: A Pataphysical Life*, Cambridge, Mass. and London: MIT, 2011, 41. His esteem for the artist is declared in chapter 17 of Alfred Jarry, *Exploits & Opinions of Doctor Faustroll, Pataphysician* [pub. 1911], trans. Simon Watson Taylor, Boston: Exact Change, 1996, 43–4 (Denis and Bernard are also noted in passing or among the many dedicatees in the book). It should be added that critics such as André Fontainas and Jules Antoine also isolated the same four artists among a few others in the 1890s as recorded by Nathalie Heinich, *The Glory of Van Gogh: An Anthropology of Admiration*, trans. Paul Leduc Browne, Princeton NJ: Princeton University Press, 1996, 15, 23.
[31] Guillaume Apollinaire, 'Bernheim-Wagram' [1907], *Apollinaire on Art: Essays and Reviews 1902–1918* [1960], ed. Leroy C. Breunig, trans. Susan Suleiman, Boston, Mass: MFA, 2001, 17–18, 18. For the importance of Apollinaire as an art critic to Breton, see Pierre, *André Breton et la peinture*, 36–50.
[32] 'Se rappeler qu'un tableau – avant d'être un cheval de bataille, une femme nue, ou une quelconque anecdote – est essentiellement une surface plane recouverte de couleurs en un certain ordre assemblées', Maurice Denis, 'Définition du néo-traditionnisme' [1890], *Théories*, 1–13, 1.

present in the *Dessins Symbolistes* project through the twenty-four-run limited edition
of the catalogue, twelve of which each contained an original drawing by him).[33] His
opinion on Denis had remained firm in the face of the efforts of the critic Charles
Estienne in the late 1940s to turn the famous quotation towards ends favourable to a
Surrealist reading, by means of a triangulation of Denis's 'subjective conception' and
Wassily Kandinsky's 'inner need' with Breton's 'purely internal model'.[34] In the end,
Denis's writings received a wholly different emphasis to their nascent formalist one
from the Surrealists, who seem to have overlooked the equal invitations to enchantment
they offer. An example of this can be found in the conclusion of the same introduction
to *Théories 1890–1910* (1912), for instance, where Denis saved his formalism from
mere materialism by speaking of great art from the ancients to the moderns as 'the
disguise of natural objects, with their vulgar sensations, as icons that are sacred,
hermetic and commanding'.[35] Instead of capitalizing on such remarks, the Surrealists
gave prominence to Denis's commentary on the spiritual qualities of Gauguin's teaching
and leadership, as I detail in the fifth chapter of this book.

Perhaps the key early event in the history of the creation of the genetic modernist
canon was the curatorial primacy given Cézanne, Gauguin and van Gogh in the
exhibition of 1910 *Manet and the Post-Impressionists*, organized by Roger Fry and held
at the Grafton Galleries in London. That is because the event drew the three artists
together under a theory that placed the accent on the formal concerns of their art
through a standardized, bureaucratic language. This lay in the 'simplification of planes',
'design', 'architectural effect', 'geometrical simplicity', 'fundamental laws of abstract form',
'rhythm' and 'abstract harmony of line' (even as that other modernist preoccupation with
what Fry called the 'principle of expression' was shared by the Surrealists who sought the
source of it in the unconscious).[36] It was a means of understanding the importance of
Cézanne, Gauguin and van Gogh that Fry would extend to Seurat in the 1920s.

[33] Breton, *Surrealism and Painting*, 362.
[34] Charles Estienne, 'De Sérusier le nordique à Kandinsky l'oriental', *Combat*, no. 880, 7 May 1947, 2.
 The legendary quotation was mobilized by a former Surrealist in the 1970s to assert what Breton
 claimed, more or less, in *Dessins Symbolistes*, that formalism since Denis 'tends to regard [Symbolism/
 Surrealism] with extreme disdain even to the point of trying to eliminate [them] historically', José
 Pierre, *Symbolism*, [1976], trans. Désirée Moorhead, London: Eyre Methuen, 1979, n.p.
[35] 'le travestissement des sensations vulgaires – des objets naturels, – en icons sacrées, hermétiques,
 imposantes', Denis, *Théories*, 12.
[36] Roger Fry, 'The Post-Impressionists', London: Grafton Galleries, *Manet and the Post-Impressionists*,
 1910, 7–13, 10, 11. Its sequel of 1912, the *Second Post-Impressionist Exhibition*, was subtitled *British,
 French and Russian Artists* and gave equal coverage and pre-eminence to Cézanne but not the
 others (van Gogh has only one work listed in the catalogue and there are none by Gauguin), since
 the intention was to display the 'moderns' not the 'masters'. Nevertheless, the essays on those
 moderns by Clive Bell and Fry revelled in the victory of 'simplification and plastic design', 'logical
 structure' and 'closely-knit unity of texture' over content (though not the one on Russian art by the
 mosaicist Boris von Anrep, which included some cultural context for the Russian works on show
 and gave notice of the importance of the imagination in their creation) to the point that Bell's
 bathetic coal-scuttle has no symbolism for artists let alone 'magic' worth reporting and its
 significance for them lies only in its form and what that can 'express' of 'the toes of the family circle
 and the paws of the watchdog', Clive Bell, 'The English Group' and Roger Fry 'The French Group',
 London: Grafton Galleries, *Second Post-Impressionist Exhibition*, 1912, 21–4, 22; 25–9, 26. For some
 contrast, see the remarks made the following year on the chimney flue as '"the most strange, the

The endeavours of the essential artists privileged by Fry and Bell were buried deep among the 1,300 works shown at the massive Armory Show held in New York in 1913: Cézanne was represented by sixteen, Gauguin by fourteen ('one' of which was a set of lithographs), van Gogh by eighteen and Seurat by a paltry two. Their appearance came as a surprise to Americans still hooked on Impressionism, according to Meyer Schapiro, who wrote in the early 1950s once their pre-eminence was secure: 'we had ignored the art of van Gogh, Gauguin, Seurat, and the later Cézanne'.[37] That situation soon changed, aided by the fundamental approach taken by Fry and Bell into the 1920s and beyond, which undermined Impressionist 'objectivity', a strategy plausibly and ironically linked by Mary Tompkins Lewis to the rise of Surrealism.[38] It was confirmed, consolidated and amplified in the English-speaking world in 1929 by the earliest activities of the Museum of Modern Art (MOMA) in New York, which opened its curatorial programme with an exhibition of those artists that would be the highest attended show in the first ten years of the museum. Through that event, a recently triumphant German Expressionism rather than a yet-to-be-validated Surrealism was viewed by Alfred H. Barr, Jr. as the historical outcome of the work of Gauguin and van Gogh. This was argued in a hyperbolic catalogue essay that had not yet fully succumbed to formalism but did bear evidence of Barr's admiration for the way of writing about art popularized by Fry (whom Barr had met two years earlier).[39]

The remarkable success of that exhibition of 1929 gives some credence to Isabelle Cahn's assertion that Cézanne, Gauguin and van Gogh had been the key figures for modernist writers since the 1930s.[40] The concerted revival of classicism in modern art in Europe around the beginning of the First World War had not checked this; that style and ideology demanded only that the inconvenient van Gogh should be replaced in the

most bizarre subject"' to the painter of 'two realities', as stated by Rodolphe Bresdin in 1864 and recalled by his student Redon, *To Myself*, 109, 110. Van Gogh and Gauguin were the two main artists treated as 'post-impressionists' by Albert Barnes in 1927; Barnes gave Cézanne a section of his own with some reservations while Seurat is alluded to only briefly and it is Courbet, Manet, Monet and Pissarro who are said to be the initiators of modern art through this phrase: '[t]he chief point of difference between the old and the new may be said to be that the moderns exhibit greater interest in relatively pure design', after which the typically formalist language of 'plastic elements', 'structural values', 'organic wholes' and so on ensues: Albert C. Barnes, *The Art in Painting*, London: Jonathan Cape, 1927, 239.

[37] Meyer Schapiro, 'The Introduction of Modern Art in America: The Armory Show' [1952], *Modern Art, 19th and 20th Centuries: Selected Papers*, vol. 2, London: Chatto & Windus, 1978, 135–78, 160.

[38] Lewis (ed.), *Critical Readings in Impressionism and Post-Impressionism*, 12.

[39] Alfred H. Barr, Jr., *The Museum of Modern Art First Loan Exhibition, New York, November 1929: Cézanne, Gauguin, Seurat, van Gogh*, New York: Museum of Modern Art, 1929. Describing the exhibition and accompanying book, one writer states: 'Barr's formal analysis was pervasive in all his writings and translated itself into the organisational structures of the Museum', Sybil Gordon Kantor, *Alfred H. Barr, Jr. and the Intellectual Origins of the Museum of Modern Art*, Cambridge, Mass. and London: MIT, 2002, 218. For the way in which Barr 'made the history of modern art a narrative of the developing codes of formalism' at MOMA and for the relation of his writing to Fry's at the time of the exhibition *Cubism and Abstract Art* (1936), which immediately preceded *Fantastic Art, Dada, Surrealism* (1936–7) at the museum, see Johanna Drucker, *Theorizing Modernism: Visual Art and the Critical Tradition*, New York: Columbia University Press, 1994, 82.

[40] Isabelle Cahn, 'Belated Recognition: Gauguin and France in the Twentieth Century, 1903–1949', Boston: Museum of Fine Arts, *Gauguin Tahiti*, 2004, 285–301, 299.

narrative by Seurat on certain occasions. The 'classicism' of Seurat, as it was recognized from the 1920s by conservative critics and writers such as Robert Rey, did nothing to prevent the beginnings of his surrealization in the same period, as I show in my third and fourth chapters.[41]

Following the relative hiatus in publishing and exhibiting caused by the Second World War, the canon was consolidated through the attention given those artists by American critics, collectors and curators. Initially, in a review of the Gauguin exhibition held at the Wildenstein Gallery in New York in April 1946, Greenberg suggested a decline in that artist's repute in the preceding years.[42] This could not have been much more than a wartime blip because the historical record shows a slow and steady escalation in the visibility of Gauguin's paintings. This was about to accelerate, as I show in my fifth chapter, partly due to the efforts of Breton who returned to France from New York later in April that year at the end of his wartime stay in America soon after viewing the same Wildenstein exhibition.[43] The reassessment was piloted in France by the 1949 'centenary' exhibition *Gauguin*, held at the then Orangerie des Tuileries, at which time the curator and art historian René Huyghe had Cézanne, Gauguin, Seurat and van Gogh down with Henri de Toulouse-Lautrec as the most important artists after Impressionism.[44] By the 1950s, this hierarchy was so beyond dispute in Europe and America that Robert Goldwater could lead out his 1957 monograph on Gauguin with the apparently incontestable declaration that the artist was one of '[t]he four fathers of modern painting'.[45] In a now-familiar teleology, he went on to assert that Cubism and abstraction in the twentieth century were the whole point of late nineteenth-century art: '[t]here is an intimate connection between Gauguin's strong reaction against Impressionism and his subsequent influence. The analytic approach of Cézanne and Seurat bore its fruit in Cubism and geometric abstraction.'[46]

Barr ceased to be director of MOMA in 1943 but stayed on at the museum till 1968. In the period between, Goldwater, Greenberg, John Rewald and Herbert were chief among those art historians and critics in the US who helped seal through formalist means the reputations of Cézanne, Gauguin, Seurat and van Gogh. Breton had plenty

[41] See Robert Rey, *La Renaissance du sentiment classique: Degas, Renoir, Gauguin, Cézanne, Seurat*, Paris: Beaux-Arts, 1931.

[42] Clement Greenberg, 'Review of Exhibitions of Paul Gauguin and Arshile Gorky' [1946], *The Collected Essays and Criticism, vol. 2, Arrogant Purpose, 1945–1949*, ed. John O'Brian, Chicago and London: The University of Chicago Press, 1986, 76–80.

[43] See Breton's catalogue of the show at: http://www.andrebreton.fr/fr/item/?GCOI=56600100610741 (accessed 10 June 2014).

[44] René Huyghe, 'Gauguin, créateur de la peinture moderne', Paris: Orangerie des Tuileries, *Gauguin: Exposition du centenaire*, 1949, vii.

[45] Robert Goldwater, *Gauguin*, New York: Harry N. Abrams, Inc., 1957, 9.

[46] Goldwater, *Gauguin*, 36. This book appeared in the same coffee table series 'The Library of Great Painters' in which Schapiro had published monographs on van Gogh (1951) and Cézanne (1952). Sven Lövgren broke with the formalist orthodoxy at the end of that decade by situating the artists of the 1880s in their Symbolist milieu while remaining within the canonical one, emphasized by the necessity to explain away the absence from his book of Cézanne, 'the fourth great pioneer of the art of the 1880s', Lövgren, *Genesis of Modernism*, xiv.

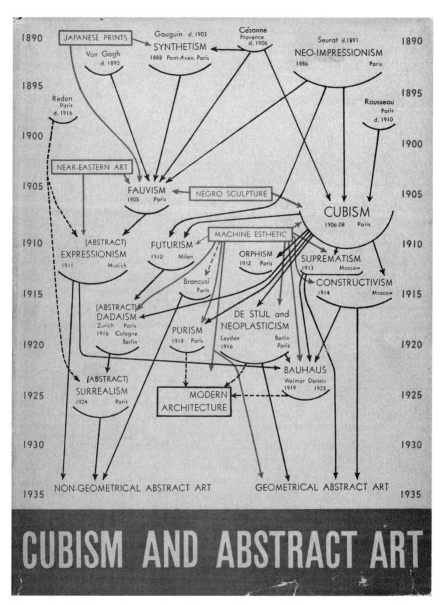

Figure I.4 Alfred Barr diagram for exhibition *Cubism and Abstract Art*, Museum of Modern Art, New York, 1936. © Digital image, The Museum of Modern Art, New York/ Scala, Florence.

of dealings (most of them fractious) with Barr during the organization of the 1936–7 MOMA-organized travelling exhibition *Fantastic Art, Dada, Surrealism* so he must have known about formalism before the Second World War.[47] This is especially the case since the museum's modernist ideology was aggressively on display in the event that preceded it, *Cubism and Abstract Art*, for which Barr's diagram (figure I.4), in which all of twentieth-century art tumbles mainly out of the achievements of the four artists from '1890', provided Goldwater with his cue about their paternity. However, that bias was not evident in the Surrealism show or reflected in the booklet by Barr that went with it and was referred to only by contrast with the (unspecified) 'fantastic', 'irrational', 'spontaneous', 'marvellous', 'enigmatic' and 'dreamlike' content of Surrealist art in the pamphlet distributed as a guide at the exhibition.[48]

Breton must have come into contact directly or through their writings with art historians or critics in New York during the war. He could earlier have met Goldwater who was in Paris in 1937–8 as a student researching what would become his best-known book *Primitivism and Modern Painting* (1938), containing a section on Dada and (mainly) Surrealism. In that period, Goldwater met his future wife Louise Bourgeois who had lived in the same building that housed Breton's Galerie Gradiva for a little over a year from the beginning of 1937, so there were opportunities to meet.[49] In New York Breton got to know very well personally the French-speaking Schapiro who was so close to Goldwater that the prefatory note in *Primitivism and Modern Painting* could state that he had 'followed the work from its beginning'.[50] Others available for discussion on trends in criticism and historiography at the time included artists, critics and writers in the vicinity of Surrealism such as Lionel Abel, David Hare, Gerome Kamrowski, Robert Motherwell and Harold Rosenberg, as well as the collector, writer on contemporary art and future dealer Sidney Janis. From these and other sources, Breton knew at first hand despite his limited English about the formalist justification of the modern canon.

[47] For the difficult negotiations that surrounded the staging of *Fantastic Art, Dada, Surrealism*, see Lewis Kachur, *Displaying the Marvelous: Marcel Duchamp, Salvador Dalí, and the Surrealist Exhibition Installations*, Cambridge, Mass. and London: MIT, 2001, 10–19.

[48] 'These qualities have always been present in the metaphors and similes of poetry but they have been less frequent in painting, which in the past was largely concerned with reproducing external reality, with decoration, or, as in some of the more advanced movements of recent years, with the composition of color and line into formal design', Alfred H. Barr, Jr., 'A Brief Guide to the Exhibition of Fantastic Art, Dada, Surrealism' [1936], *Defining Modern Art: Selected Writings of Alfred H. Barr, Jr.*, eds Irving Sandler and Amy Newman, New York: Harry N. Abrams, 1986, 93–7, 93.

[49] Mignon Nixon, *Fantastic Reality: Louise Bourgeois and a Story of Modern Art*, Cambridge, Mass. and London: MIT, 2005, 15.

[50] Robert J. Goldwater, *Primitivism in Modern Painting*, New York and London: Harper & Brothers Publishing, 1938, vii. In a letter of 8 October 1938 meant to impress her friend the artist Colette Richarme, which turned out to be speculative about its cast of characters, Bourgeois wrote: 'Fortunately in New York I shall be joining artistic circles. Othon Friesz is there at the moment, so is Fernand Léger. Chirico and Salvador Dalí are Robert's friends and will be in our house regularly. Picasso and André Breton will also be there', Louise Bourgeois, *Destruction of the Father, Reconstruction of the Father: Writings and Interviews 1923–1997*, eds Marie-Laure Berndac and Hans-Ulrich Obrist, London: Violette Editions, 1998, 31–2, 32; Nixon, *Fantastic Reality*, 15.

As I already noted and will show in detail in this book, Surrealism had its own ideas about those artists, refusing to endorse the same canon. However, it should be conceded that Breton could be moved under certain circumstances, such as those created by Soviet cultural policy, to toe the line of modernist institutional convention. One example of his compliance can be found in this typically calculated roll call from the early 1950s given in a statement in *Arts* about 'the concept of a *living art*, in the sense of a passionate quest for a new vital link between man and things', as opposed to the deadness he thought to be innate to socialist realism:

> All those who have some notion of what this art is about understand that what is at stake is a spiritual adventure that simply cannot be interrupted at any price. They know that it is along that royal road that are inscribed in modern times the names of [William] Blake, Delacroix, Géricault, [Henry] Fuseli, Courbet, Manet, Cézanne, Gauguin, van Gogh, Seurat and that it extends magnificently all the way to us.[51]

This 'royal road' (voie royale) (with Impressionism-shaped breach, but rare inclusion of Cézanne and van Gogh as stones upon it) bears in its terminology the prioritization that is always given in Surrealism of the 'interiority' of the subject as opposed to formal concerns.[52] This had been sought in dreams before the war, which had been important to its painting and pivotal to the Surrealist object, while the route to the self would be signposted by the languages of esotericism in the postwar period. The Surrealist assessment of the canon instituted by modernism – unusually proffered without demurral in the names tacked onto the lineage in that declaration – has never been cogently given, with the exception, perhaps, of certain passages in Breton's own *L'Art magique*, which was commissioned the year after those remarks appeared. That book can be viewed as Breton's own fullest attempt to counter formalism, which by then was well and truly prevailing.

Such can be verified through Herbert's apologetically stated avowal made while writing on Seurat in 1962 in a formalist manner only fringed by the barest contextualism, at the very moment modernist art and criticism were finally coming into question, that the twentieth century had been 'dominated by formalistic considerations.... We delight in investigating the abstract components of art, and too often give a secondary place to the artist's ties with the tangible world.'[53] The

51 André Breton, 'Why Is Contemporary Russian Painting Kept Hidden from Us?' [1952], *Free Rein*, 257–64, 263. Breton had further availed himself of the essential four-cornered canon in 1947 to contrast it with the caution that he felt dogged contemporary artists: André Breton, 'Surrealist Comet' [1947], *Free Rein*, 88–97, 89, 90.
52 '*The interpretation of dreams is the* via regia *to a knowledge of the unconscious activities of the mind*', Sigmund Freud, *The Interpretation of Dreams* [1899], ed. Angela Richards, trans. James Strachey, Harmondsworth: Penguin, 1978, 769 (rendering of translation slightly modified).
53 Robert L. Herbert, *Seurat's Drawings* [1962], London: Studio Vista, 1965, 95–6. Clark's recollection is unusually colourless: 'The history of modernism constructed by its apologists in the 1950s and 1960s – I shall call them "the modernist critics" from now on, but always with the proviso that their

elevation of Seurat's reputation among critics from Fry's late discovery of the artist, probably towards the end of the First World War or shortly thereafter, up to the moment Herbert was writing, was, of course, more down to the rise and rise of varieties of formalism than of the 1920s classicism that had initially bolstered it. This was carried out most blatantly in the numerous analyses of Seurat's work using diagrams, schematic drawings and grids as though to distract from or obscure the actual content of the paintings. These ranged from the comparison of the 'straight line organisation' of *A Sunday on La Grande Jatte – 1884* (1884–6) with its 'curved line organisation' by Daniel Catton Rich in the mid-1930s, through Germain Seligman's investigation of Seurat's drawings with bespoke linear illustrations in the mid-1940s and Henri Dorra's grids at the end of the 1950s, up to Niels Luning Prak's use of Gestalt figures in his consideration of the *Grande Jatte* and other paintings at the beginning of the 1970s.[54]

By the 1950s, the retrospective term 'post-impressionism', which had been introduced reluctantly by Fry in 1910 almost simultaneously with his announcement of the essential quality of the form of works of art and taken up in Britain and America and more rarely in France, was equally well established.[55] Although Rewald also demonstrated hesitancy and caution when writing of it in 1956 as 'not a very precise term', he concluded that it is 'certainly a very convenient one' in the still useful though much maligned study *Post-Impressionism: From Van Gogh to Gauguin* in which the key artists are three of the four (minus Cézanne because of his slightly later prominence among artists and dealers).[56] In spite of Rewald's monumental effort, it was asserted by Alan Bowness in 1979 that 'no serious comprehensive history of post-impressionism

modernism was local and in a sense terminal – does not seem to me to have worn well. Even at the time it was chilling to see Greenberg's views become an orthodoxy. What was deadly, above all, was the picture of artistic continuity and self-sufficiency built into so much modernist writing: the idea that modern art could be studied as a passing-on of the same old artistic flame ... from Manet to Monet to Seurat to Matisse to Miró. . .', Clark, *Farewell to an Idea*, 175.

[54] Daniel Catton Rich, *Seurat and the Evolution of La Grande Jatte*, Chicago: The University of Chicago Press, 1935, 27, 29; Germain Seligman, *The Drawings of Georges Seurat*, New York: Curt Valentin, 1947, 30–2; Henri Dorra, 'The Evolution of Seurat's Style', Henri Dorra and John Rewald, *Seurat: L'Oeuvre peint, biographie et catalogue critique*, Paris: Les Beaux-Arts, 1959, 79–107; Niels Luning Prak, 'Seurat's Surface Pattern and Subject Matter', *The Art Bulletin*, vol. 53, no. 3, September 1971, 367–78. For early resistance to the trend given 'in criticism of the purely formalistic view of Seurat' that was essentially a review of Rich's book, see Meyer Schapiro, 'Seurat and *La Grande Jatte*', *The Columbia Review*, no. 17, November 1935, 9–16, 11. Cézanne's work received the same treatment during this period from Erle Loran, *Cézanne's Composition: Analysis of His Form with Diagrams and Photographs of His Motifs* [1943], Berkeley, Los Angeles, London: University of California Press, 2006.

[55] I am referring to the initiating essay by Fry, which led out with a quotation remarkably close to Denis's about a plane surface with colours in a certain order (though it was actually by the Royal Academician John Collier), but went on to elaborate by stipulating the six 'emotional elements of design', namely, rhythm, mass, space, light and shade, colour and (perhaps) 'the inclination to the eye of a plane', Roger Fry, 'An Essay in Aesthetics' [1909], *Vision and Design* [1920], Harmondsworth: Penguin, 1961, 22–39, 22, 36. I am very grateful to Sam Rose for informing me of the source of Fry's quotation.

[56] John Rewald, *Post-Impressionism: From Van Gogh to Gauguin*, New York: The Museum of Modern Art, 1956, 9.

has been written, and perhaps none can be written because the unity of an artistic movement is quite simply lacking', while Bowness himself made an attempt to begin a history of the term.[57] Soon after those words appeared, Rewald and Bowness received a thorough going-over from Fred Orton and Griselda Pollock for being joint contrivers of the simplifying-by-chronologizing habits of modernist art history.[58] I assess critically their important article at some length in the sixth chapter of this book then return to it in my last chapter under the shadow of a folk Surrealism I infer as shared by Breton and Gauguin.

My assessment through Surrealism of Pollock and Orton's interpretation of Gauguin's Brittany entails no retrieval of the old art history or the term 'post-impressionism', which was used only rarely by Breton and the other Surrealists.[59] I have avoided exercising it here mainly because of its historical suggestion of some kind of agreement among artists (stylistic, methodical, critical, generally intentional or other) when that was only available here and there. However, I have kept to the key figures of the modernist canon it demarcates since the whole point of this book is to highlight and evaluate critical responses to those artist and contributions to their reputations from the perspective of the Surrealists. For them, art was meant to aspire to the condition of poetry. Increasingly, during and after the war, this was a poetry found less through dreams and the unconscious than by recourse to magic.

[57] Alan Bowness, 'Introduction', London: Royal Academy of Arts, *Post-Impressionism: Cross-Currents in European Painting*, 1979, 9–12, 11.

[58] Fred Orton and Griselda Pollock, 'Les Données Bretonnantes: La Prairie de Représentation' [1980], *Avant-Gardes and Partisans Reviewed*, Manchester and New York: Manchester University Press, 1996, 53–88. In spite of the influential rejection of the artificial, retrospective term 'post-impressionism' by Orton and Pollock, it still has currency in the more popular forms of art writing, while some art historians have offered more conciliatory reappraisals, criticizing the term for implying a unity on art after Impressionism that did not exist while maintaining the value of its signposting usage: see Belinda Thomson, *Post-Impressionism*, London, Tate Gallery Publishing, 1998. Its tenacity and perhaps continued serviceability can be witnessed in its appearance in the title of the respected 2007 volume I referenced earlier by Mary Tompkins Lewis (ed.), *Critical Readings in Impressionism and Post-Impressionism* (where Orton and Pollock are absent even from any kind of critical discussion) and its equally uncritical indulgence in the more recent exhibition held in Canberra: National Gallery of Australia, *Masterpieces from Paris: Van Gogh, Gauguin, Cézanne & Beyond, Post-Impressionism from the Musée d'Orsay*, 2012. It comes as a surprise to find 'postimpressionism' used unproblematically in the otherwise meticulous and reflexive volume by Hal Foster, Rosalind Krauss, Yve-Alain Bois, Benjamin H. D. Buchloh and David Joselit, *Art Since 1900: Modernism, Antimodernism, Postmodernism* [2004], London: Thames & Hudson, 2016.

[59] See the complaint about the 'réalisme primaire' of 'post-impressionnisme après Seurat, l'école de Pont-Aven sans Gauguin', and the reference to the continuation in art of the sensorial up to Giorgio de Chirico, 'du post-impressionnisme au cubisme', in André Breton, *L'Art magique* [1957], Paris: Éditions Phébus, 1991, 73, 83. The English translation of Breton's *Le Surréalisme et la peinture* has him salvaging 'post-impressionism' and certain 'post-impressionists' at the time of the 1958 exhibition of Symbolist drawings: Breton, *Surrealism and Painting*, 362; however, this is a mistranslation of 'néo-impressionnisme' and 'néo-impressionniste' in the original, which shows the preference for the former term in English at least up to the 1970s: André Breton, *Le Surréalisme et la peinture* [1965], Paris: Gallimard, 1979, 362.

Enchanted Ground, or Modernist Positivism and
Surrealist Enchantment

By these two terms 'poetry' and 'magic', I mean to refer initially to the responsibility heaped on metaphor in Surrealism, as determined unequivocally by Breton in 'Surrealist Situation of the Object' (1935):

> The poet, whose role it is to express himself in a more and more highly evolved social state, must recapture the concrete vitality that logical habits of thought are about to cause him to lose. To this end he must dig the trench that separated poetry from prose even deeper; he has for that purpose one tool, and one tool only, capable of boring deeper and deeper, and that is the *image*, and among all type of images, *metaphor*.[60]

Along what path did poetry/metaphor meet magic in Surrealism? Odd, local events of action-at-a-distance that evaded contemporary rationalist causality had been identified and circulated in the 1920s among Surrealists as an effect of the unconscious, like the turbulent metaphorical imagery obtained by automatism (the best known can be found in Breton's *Nadja* of 1928). These could already be situated in a framework of esoteric knowledge given by their contemporary reading of J. G. Frazer (whose vast repository *The Golden Bough* of 1890/1906–15 was translated into French in 1911–15) and Sigmund Freud's *Totem and Taboo* (1913, French translation 1923, where Frazer is an important source), as well as Éliphas Lévi, Lucien Lévy-Bruhl and perhaps Marcel Mauss, who were also read by former friends and enemies of Surrealism.[61]

By 1930, Louis Aragon could write of the re-enchantment of the world brought about by the modern marvellous, of which collage was one of the chief exemplars, 'recall[ing] more the procedures of magic than those of painting.'[62] Aragon's promotion of collage was meant to counter what it lamented as the 'success of Cézannism' for the visual arts and is saturated with references to magic and enchantment.[63] It asserts that beginning with Duchamp and Francis Picabia, these 'new magicians have reinvented incantation', and collage itself had replaced painting by 'restoring its true meaning to

[60] André Breton, 'Surrealist Situation of the Object: Situation of the Surrealist Object' [1935], *Manifestoes*, 255–78, 268.
[61] For more on Frazer, Freud and Lévy-Bruhl and Surrealism's attraction to magic and occultism generally as early as 1923, and the Romanticist and Symbolist avenues along which the occult arrived in the movement, see Tessel M. Bauduin, *Surrealism and the Occult: Occultism and Western Esotericism in the Work and Movement of André Breton*, Amsterdam: Amsterdam University Press, 2014, 16–17, 120–2. For the same reading of Michel Leiris and, less so, Georges Bataille and Carl Einstein in anthropological and psychoanalytic interpretations of magic from 1924 up to the end of the decade, and their relevance for our understanding of Masson, Joan Miró and Picasso as 'artist-magicians' in the pages of *Documents*, see Christopher Green, *Picasso: Architecture and Vertigo*, New Haven and London: Yale University Press, 2005, 189–223.
[62] Louis Aragon, 'The Challenge to Painting' [1930], Pontus Hulten (ed.), *The Surrealists Look at Art*, trans Michael Palmer and Norma Cole, Venice CA: The Lapis Press, 1990, 47–72, 52.
[63] Aragon in Hulten (ed.), *Surrealists Look at Art*, 57.

the ancient pictorial act', leading the artist 'back to magical practices, origin and justification of that plastic representation forbidden by many religions'.[64] In fact, as Mauss had argued, '[m]agic includes ... a whole group of practices which we seem to compare with those of religion'.[65] The entire panoply of the activities of the modern shaman and medieval magician that he gathers under his theory of magic – rites and ceremonies, incantations and spells, shape shifting, totemism, the varieties of mediumism, astrological prediction and other divination, sympathetic contiguity, the creation of magical recipes and talismans – would be carried out, engaged in, theorized, considered or represented in some way by Surrealists.[66] As demonstrated by Aragon's essay, however, there is no evidence in Surrealism's trajectory up to 1930 of any serious reading in, or understanding and application of magic. Rather, Aragon seems to have been sharing in and contributing to an emerging language within the Paris group that made the movement's growing interest in alchemy and magic more visible and positioned Surrealism as the palpable heir to occultism (or hermeticism) as traditionally understood and practiced. This is particularly marked in a text that was exactly contemporary with Aragon's, namely Breton's *Second Manifesto of Surrealism* (1930).[67]

Alchemy, clairvoyance and magic had been important to understanding creativity and practice for artists such as Victor Brauner, Max Ernst and Masson in the 1920s and 1930s.[68] However it was only from the later 1930s, following their unhealable rift with organized communism, that the Surrealists' own and others' writing, art and experiences were consistently theorized by members of the group in a detailed manner. This took place through their increasing knowledge of pre-modern belief systems and greater understanding of the ways alchemy, the occult and magic had informed modern poetry, especially that of Victor Hugo, Charles Baudelaire, Mallarmé and Rimbaud. Ultimately, this would happen through recourse to Surrealist texts that identified and could potentially comprehend such phenomena (initially, unexplainable action-at-a-distance, second sight or precognition) through alternative causalities that were the domain of magic. As Mauss had pointed out with reference to Frazer: 'magic gives every outward appearance of being a gigantic variation on the theme of the principle of causality'.[69] Freud understood that, too, allowing the Surrealists to root coincidences in art and life

[64] Aragon in Hulten (ed.), *Surrealists Look at Art*, 60, 60–1. Aragon had even referred to Max Ernst as 'notre magicien' in an unpublished manuscript reputed to date from 1923, in which Ernst's paintings of the early 1920s are viewed as a contemporary updating of Edgar Degas and Gauguin: Louis Aragon, 'Max Ernst, peintre des illusions' [1923], *Les collages* [1965], Paris: Hermann, 1980, 27–34, 30, 31.

[65] Marcel Mauss, *A General Theory of Magic* [1902], trans. Robert Brain, London and New York: Routledge, 1972, 11.

[66] Mauss, *General Theory of Magic*, 42, 44, 45, 47, 57, 59, 61, 79.

[67] For Breton's still-debated references to 'hermeticism' and specifically 'occultation' in the *Second Manifesto*, see Bauduin, *Surrealism and the Occult*, 104–5.

[68] A survey of Surrealism's engagement with alchemy extending as far back as its origins in the early 1920s can be found in Leon Marvell, 'Take Two Emerald Tablets in the Morning', Aaron Cheak (ed.), *Alchemical Traditions: From Antiquity to the Avant-Garde*, Melbourne: Numen Books, 2013, 518–35.

[69] Mauss, *General Theory of Magic*, 78. For more in that volume on magical causality, see the comments on Frazer's laws of 'sympathetic magic', Mauss, *General Theory of Magic*, 15.

in their own early exploration of the unconscious through automatic writing and drawing, and accordingly perceive them as forms of clairvoyance close to mediumism.[70]

In the absence of just about any feature of Cézanne's art that could be latched onto positively by Surrealism, 'magic' in this sense became an inferential tool by which it could be assessed in the second half of the 1930s. I look at this subtext of Surrealist interpretation in my first chapter. The apparently unassailable 'father' of early twentieth-century art according to painters of that period and modernist critics who came after is well and truly berated there by Surrealists while functioning momentarily as an initial, revisionist test case for reimagining the nineteenth-century canonical artist as seer by none other than Breton himself in his *Mad Love* (1937).[71] By then, the word 'myth' was virtually interchangeable with 'metaphor' in the movement due to those important writings by Breton from 1935 on myth, poetry, art and predestination, to be discussed in my second chapter, on René Magritte and Renoir.[72]

The outbreak of war forced consideration along the lines of esotericism of the epistemic failure of European civilization as it had during and after the First World War. The creation of a card pack following Breton's research into the tarot at the time of the Surrealists' passage through Marseille between 1939 and 1942, and Breton's re-encounters with black writers soon after in Martinique, would ultimately lead to efforts to bridge the European and non-European traditions of magic. This endeavour was carried out by anti-colonial Surrealists who, at the time, perceived individuals of Afro-Caribbean descent, such as Wifredo Lam and Aimé Césaire, to be ancestrally close to magic. Breton's text titled 'De la survivance de certains mythes et de quelques autres mythes en croissance ou en formation'/'On the Survival of Certain Myths and on Some Other Myths in Growth or Formation', inserted into the catalogue of the exhibition *First Papers of Surrealism* mounted in 1942 in New York, introduced brief consideration of the Philosopher's Stone, the Androgyne and tarot in connection with the poetry of Rimbaud and Gérard de Nerval, as well as the occultist apparition of the 'new myth' of the 'Great Invisibles', all of which would receive theoretical elaboration later.[73]

However, it was really the poet Benjamin Péret who extended Surrealist poetic theory fully from prophecy to non-modern magic specifically. This took place in his loosely written 1943 volume *La Parole est à Péret*, translated in an abridged form in the

[70] In *Totem and Taboo* we read: 'as in so many … instances of the workings of magic, the element of distance is disregarded; in other words, telepathy is taken for granted', Sigmund Freud, 'Totem and Taboo' [1913], *The Origins of Religion*, ed. Albert Dickson, trans. James Strachey, Harmondsworth: Penguin, 1985, 43–224, 138.

[71] I view *Mad Love* as a key book in Surrealism's path towards magic because of its more forthright use of a language for the events it records, associable with a tradition of esotericism, which, nevertheless, is anticipated in the preceding years, as I noted, and most recently at the close of Breton's *Communicating Vessels* (1932) in the statement that 'the objective consciousness of realities and their interior development' was a relationship that 'contains something magical for the time being', André Breton, *Communicating Vessels* [1932], trans Mary Ann Caws and Geoffrey T. Harris, Lincoln and London: University of Nebraska Press, 1990, 147.

[72] See André Breton, 'Political Position of Today's Art' [1935], *Manifestoes*, 212–33; André Breton, 'Nonnational Boundaries of Surrealism' [1936–7], *Free Rein*, 7–18.

[73] André Breton (ed.), *First Papers of Surrealism*, New York: Coordinating Council of French Relief Societies, Inc., 1942, n.p.

New York poets' magazine *View* as 'Magic: The Flesh and Blood of Poetry'.[74] Composed in Mexico and meant as an introduction to a collection of myths, legends and folktales from Latin America, it presents an instance of Péret's own purported precognition alongside the claim that '[t]he common denominator of the sorcerer, the poet and the madman cannot be anything else but magic', in which the sorcerer is both the tribal shaman and medieval magician, as he had been for Mauss.[75] 'Primitive myths are largely made up of the residue of poetic illuminations, intuitions or omens', Péret insisted, 'confirmed in such a brilliant manner that they instantaneously penetrated to the depths of these peoples' consciousness'.[76] Heavily informed by Péret's reading since at least 1931 of *The Golden Bough, Totem and Taboo* and probably Lévy-Bruhl, this publication was prefaced by a statement of solidarity that declared agreement with Péret's conclusions, signed by seventeen Surrealists in nine countries in their absence and by Breton, Duchamp, Charles Duits, Ernst, Matta and Yves Tanguy in New York.[77]

The paradigm apparently established by Péret here was immediately taken up by *View*. In fact, that publication had affirmed in the leader of its previous number that the 'artist should be understood as a contemporary magician', ending with the declaration: '[s]eers, we are for the magic view of life', presumably influenced by Péret's recent text, which was advertised as forthcoming in the review on the back of that issue.[78] It was explored further in Surrealism's wartime periodical in America *VVV* (four issues, 1942–4). Meanwhile Breton's book *Arcane 17* took a major step towards formulating the movement's shift towards esotericism by reinforcing in 1944 the charges made by the *Manifesto of Surrealism* twenty years earlier against 'the realistic attitude, inspired by positivism',[79] through denunciation of the 'monopolistic and intolerant character' of the 'positivist interpretation of myths',[80] declaring that, by contrast:

> Esotericism, with all due reservations about its basic principle, at least has the immense advantage of maintaining in a dynamic state the system of comparison, boundless in scope, available to man, which allows him to make connections linking objects that appear to be farthest apart and partially unveils to him the mechanism of universal symbolism.[81]

[74] Benjamin Péret, *La Parole est à Péret*, New York: Éditions Surréalistes, 1943.
[75] Benjamin Péret, 'Magic: The Flesh and Blood of Poetry', *View*, series 3, no. 2, June 1943, 44–6 and 63 and 66, 46.
[76] Péret, 'Magic: The Flesh and Blood of Poetry', 46. As noted above, Breton had recorded similar incidents from his own life in *Nadja* and again in *Mad Love*; by the time of the latter, he was using the term 'magic' sparingly, then from the war more frequently following his reading of Péret and greater knowledge of Victor Hugo's occultist interests presented in Auguste Viatte's *Victor Hugo et les illuminés de son temps* (1942): Bauduin, *Surrealism and the Occult*, 17–18.
[77] Richard Spiteri, 'Péret, Freud et Frazer', *Mélusine*, no. 16 (Cultures – Contre-cultures), ed. Henri Béhar, Paris: L'Age d'homme, 1997, 125–31; Péret, *La Parole est à Péret*, 7.
[78] Anonymous, 'The Point of *View*', *View*, series 3, no. 1, April 1943, 5.
[79] Breton, *Manifestoes*, 6.
[80] André Breton, *Arcanum 17* [1944], trans. Zack Rogow, Toronto: Coach House Press, 1994, 87, 86.
[81] Breton, *Arcanum 17*, 87.

Here Breton meant to place under the care of esotericism not only the longstanding complaint first made in the *Manifesto* against positivism, soon developed to encompass art in *Surrealism and Painting*,[82] but also the definition of the image established in that document (after Pierre Reverdy) as '*a juxtaposition of two more or less distant realities*'.[83] Following this intervention, the movement's concerted shift towards magic, superstition and occultism or esotericism generally reached a wider public in the form of the International Exhibition of Surrealism or *Le Surréalisme en 1947* held in Paris. Indeed, occultism specifically became a means of comprehending the totality of Surrealism in the writing of Michael Carrouges from that year.[84]

Let us remind ourselves that this culmination took place in the very year that Greenberg came to see as the one in which an American school of abstract artists was established.[85] At the time, a few months after the closure of *Le Surréalisme en 1947*, he wrote as follows in an important statement that aspired towards what is now to us a familiar formulation of the logical extension of the French avant-garde into the contemporary American vanguard, along with an attempt to identify the predicament of the latter:

> The Impressionists and those who came after them in France put themselves in accord with the situation [created by 'bourgeois industrialism'] by implicitly accepting its materialism – the fact, that is, that modern life can be radically confronted, understood and dealt with only in material terms.... From now on you had nothing to go on but your states of mind and your naked sensations, of which structural, but not religious, metaphysical or historico-philosophical, interpretations were alone permissible. It is its materialism, or positivism ... that made painting the most advanced and *hopeful* art in the West between 1860 and 1914 ... The School of Paris rested on a sufficient acceptance of the world as it must be, and it delighted in the world's very disenchantment, seeing it as evidence of man's triumph over it. We, confronted more immediately by the paraphernalia of industrialism, see the situation as too overwhelming to come to terms with, and look for an escape in transcendent exceptions and aberrated states. True, it was a Frenchman who eminently taught the modern world this way out – but one suspects that one of the reasons for which Rimbaud abandoned his own path was

[82] See the rejection of the theory of subliminal memory, 'that vengeful hypothesis through which the positivists, neo-Kantians and even psychoanalysts have attempted to burden Tanguy with the weight of his childhood impressions', Breton, 'Surrealism and Painting', *Surrealism and Painting*, 43.

[83] Breton, *Manifestoes*, 20.

[84] See Michel Carrouges, 'Surréalisme et Occultisme', *Les Cahiers d'Hermès*, no. 2, Paris: Éditions du Vieux Colombier, 1947, 194–218. This reappeared amended as the first, long analytical chapter of the highly regarded Michel Carrouges, *André Breton et les données fondamentales du Surréalisme*, Paris: Gallimard, 1950, 19–85; Michel Carrouges, *André Breton and the Basic Concepts of Surrealism* [1950], trans. Maura Prendergast, Alabama: University of Alabama Press, 1974, 10–66.

[85] See the remarks made by Greenberg in interview over forty years later to Florence Rubenfeld, *Clement Greenberg: A Life*, New York: Scribner, 1997, 106–7; Jones, *Eyesight Alone*, 89.

the realization that it was an evasion, not a solution, and already on the point of becoming, in the profoundest sense, academic.[86]

Given the dominant themes of Surrealism's Paris show and Breton's standard references in his introductory catalogue essay to Rimbaud in his inventory of pre-Surrealist 'visionaries', this could almost be read as a direct rebuttal of Surrealism's esotericism in 1947 if Surrealism had still mattered to Greenberg by that year.[87] In fact, Greenberg had started to use the term 'positivism' to characterize modernism in 1944 at the time he launched his landmark attack on Surrealism.[88] Although he was capable of acknowledging the importance of Surrealist painting to Jackson Pollock when it suited him, here in 1947 Pollock's work was cordoned off as 'positivist, concrete' in spite of its quasi-Surrealist debt to 'intuition'.[89]

A few months earlier, Greenberg had even managed to extend the opinion given here, that 'in all great periods of art, scepticism and matter-of-factness take charge of everything in the end', to a favourable but very strange review of the recent *oeuvre* of Victor Brauner.[90] Shown at the Julien Levy Gallery in New York from 15 April till 1 May 1947, signature works on display were all from the previous two years and inspired by Brauner's interest in mediumism and magic since 1939. However, this went entirely unmentioned by Greenberg in favour of their 'flatter and tighter handling' afforded by their main material, wax, and the 'flat-patterned, ornamental, emblematic kind of painting' on view, 'that clings as closely to the picture surface as inlay work', even as it is Paul Klee's influence that takes up virtually all of the review.[91] The suppression of their content by Greenberg extended to the text by Breton that was included in the catalogue for this first solo show of Brauner's in America. It was ignored by Greenberg no doubt for its equally objectionable, reverie-like style and comparison of poets and artists with 'mages, heretics [and] "initiates" of all sects', and more so for Breton's claim that the wax in Brauner's pictures possessed the power of exorcism.[92] Those were views entirely aligned with the current direction of Surrealism and supported by the artist's own esoteric musings in the same catalogue.

[86] Clement Greenberg, 'The Present Prospects of American Painting and Sculpture' [1947], *Collected Essays and Criticism, vol. 2*, 160–70, 164–5.
[87] André Breton, 'Before the Curtain' [1947], *Free Rein*, 80–7, 85, 87.
[88] See the remarks by Nancy Jachec, 'Modernism, Enlightenment Values, and Clement Greenberg', *Oxford Art Journal*, vol. 21, no. 2, 1998, 121–32, 126–8.
[89] Greenberg, *Collected Essays and Criticism, vol. 2*, 166.
[90] Greenberg, *Collected Essays and Criticism, vol. 2*, 166.
[91] Clement Greenberg, 'Review of an Exhibition of Victor Brauner' [1947], *Collected Essays and Criticism, vol. 2*, 147–50, 148. For a full list of the twelve works shown at the exhibit, see Camille Morando and Sylvie Patry (eds), *Victor Brauner: Écrits et correspondances 1938–1948*, Paris: Centre Pompidou, 2006, 316 n. 57.
[92] André Breton, 'Victor Brauner: Entre chien et loup' [1946], *Surrealism and Painting*, 123–7, 124, 126. The essay first appeared in *Cahiers d'Art* in 1946 to coincide with Brauner's solo show at the Galerie Pierre in Paris: André Breton, *Oeuvres complètes*, vol. 4, Paris: Gallimard, 2008, 1288; Morando and Patry (eds), *Victor Brauner*, 386, 401.

In spite of the fragmentation of the Surrealist group during the war over the period of that recent work, the activities of Brauner had confirmed the new bearing of the movement. In the 'altar' he created for *Le Surréalisme en 1947* he would construct (on Breton's suggestion) a three-dimensional version of the 'wolf-table' that had appeared in two earlier paintings, called 'neo-academic' by Greenberg but thought divinatory by Breton.[93] The same important role in Surrealism was played by the presence in America in the 1940s of the Swiss artist Kurt Seligmann. His wide-ranging knowledge of the history, theory and practice of magic accrued since the 1930s is confirmed in Seligmann's articles in *View* and *VVV* from 1942, foreshadowing his major though often criticized study *The Mirror of Magic* (1948).[94] They secured a central if temporary place for him in the movement in this transitional period, while he went completely uncited in Greenberg's writings.

Seligmann's disappearance from the history of art was confirmed by his omission from Breton's *L'Art magique*. That absence would be baffling were it not for the disagreement between the artist and Breton early in 1943 over an interpretation of the tarot and Seligmann's subsequent ejection from the Surrealist group, just as it was turning resolutely towards magic. Revising the Western canon and, more specifically, the modernist one, *L'Art magique* relocated both on the high altar of magic and it stands as the main statement on the subject within Surrealism. Breton's introduction to the book leans heavily initially on Paracelsus and especially Novalis to trace a path for occultism and magic through the reading of Lévi in the modern period by poets Baudelaire, Mallarmé and Rimbaud, and the reception of the same ideas by Hugo, Nerval and Lautréamont.[95] Breton opposed the functionalism, positivism and objectivism of Frazer, Mauss, Durkheim and even Freud by drawing upon the writings of those who were immersed in magic such as Lévi and Louis Chochod.[96] This familiar difference between the academic study and rationalization of a subject area, on the one hand, and a purported practice by or experience of writers, artists and initiates, on the other, was also played out in the enquiry that accompanied the book. The difficulties Breton acknowledged in defining magic art in his introduction to *L'Art magique* are plain for all to see in his efforts to adapt to the theme a voluminous

[93] Greenberg, *Collected Essays and Criticism, vol. 2*, 148; Breton, *Surrealism and Painting*, 126. For Breton's suggestion, see Breton, *Oeuvres complètes*, vol. 4, 1289. The three-dimensional version was regarded as a typically Surrealist expression of 'sceptical negativity' by Jean-Paul Sartre, 'Situation of the Writer in 1947' [1947–8], *What is Literature?* trans. Bernard Frechtman, London: Methuen & Co., 1967, 123–231, 223.

[94] Kurt Seligmann, *The Mirror of Magic: A History of Magic in the Western World*, New York: Pantheon, 1948. Breton recorded a series of events under the rubric of 'magic' in the 1950s when Surrealism was deepening its immersion in esotericism: André Breton, 'Magie quotidienne', *La Tour Saint-Jacques*, no. 1, November–December 1955, 19–31; also see Jean Bruno, 'André Breton et la magie quotidienne', *Revue Métapsychique*, no. 27, January–February 1954, 97–121; and my discussion of these writings in the context of parapsychology in France in that decade: Gavin Parkinson, *Futures of Surrealism: Myth, Science Fiction and Fantastic Art in France 1936–1969*, New Haven and London: Yale University Press, 2015, 104–12.

[95] Breton, *L'Art magique*, 23, 34–6.

[96] Breton, *L'Art magique*, 37, 46–7, 55, 70.

quantity of objects from across the world from prehistory to modernity, ending, of course, with Surrealism where magic is 'rediscovered'. This along with Breton's conclusion could have been predicted by anyone who had read his previous writings: magic in art was to be found in the same place as magic in poetry, in 'the magico-biological character of metaphors'.[97]

Throughout Surrealism from the mid-1940s, then, culminating in *L'Art magique*, magic and (poetic) enchantment as traditionally understood, but substantiated often with reference to psychoanalysis, became the ground upon which Surrealist art criticism and art history could contest what the movement perceived broadly to be the 'positivism' of naturalism, Impressionism, classicism and socialist realism, and especially modernist formalism.[98] By these alternative means, it reassessed and even claimed to return the unease to the art of some of those painters already domesticated by modernism. It is modernity we have to thank for those too-expansive categories as much as modernism as a critical paradigm itself. And because of that it was modernist positivism and modernity conceived as 'the disenchantment of the world' in Max Weber's well-worn phrase – meaning secularization and the decline of magic with the escalation and intensification of capitalist utilitarianism, intellectualization and scientific, bureaucratic, legal and political rationalism under the banner of 'progress' – that Surrealism aimed to combat in its take up of magic and the occult and its location of a future for the human race in the past.

Surrealism's first historian Walter Benjamin read Weber closely and one other sympathizer of the movement recently evoked this central critique of Weber's to set up his defence of Surrealism as a 'precise instrument' for escape from the 'rigid and narrow-minded confines of use value'.[99] However, there is no evidence that Breton,

[97] 'le caractère magico-biologique des métaphores', Breton, *L'Art magique*, 43.

[98] I cited some key sources for positivism and Impressionism above in footnote 25, but also see Lewis (ed.), *Critical Readings in Impressionism and Post-Impressionism*, 1; James H. Rubin, *Impressionism*, London: Phaidon, 1999, 36–9, 45–8; and especially its treatment as a central epistemological concern by Norma Broude, *Impressionism, A Feminist Reading: The Gendering of Art, Science, and Nature in the Nineteenth Century*, New York: Rizzoli, 1991, 110–23, 137, 143, 144, 153–4, 165–7, 170, 173. It is still debated how useful the term 'positivism' is to our own understanding of Impressionism, to the analysis of artists who came after such as Denis and Toulouse-Lautrec (who can seem superficially attractive to Surrealism yet were rejected by the movement) and to the other categories I list here; however, I have already demonstrated Greenberg's fondness for it and its relevance to his repudiation of Surrealism in the mid-1940s, while a convincing case for the decisive importance of positivism to Greenberg's modernism is made by Jones, *Eyesight Alone*, 97–119. For Denis's reading in and recourse to positivism in his theoretical writings, see Allison Morehead, 'Defending Deformation: Maurice Denis's Positivist Modernism', *Art History*, vol. 38, no. 5, November 2015, 890–915. A more substantial argument measuring the philosophical and political gulf between Impressionist painters and Surrealists could be made available by tracing the conduct of the former 'during a period of conservative political backlash' in the 1870s, when Impressionists 'still link[ed] their activities to the positivism and materialism of modern life expressed in Third Republic science, entrepreneurialism and colonialism', Albert Boime, *Art and the French Commune: Imagining Paris After War and Revolution*, Princeton NJ: Princeton University Press, 1995, 45.

[99] Michel Löwy, *Morning Star: Surrealism, Marxism, Anarchism, Situationism, Utopia* [2000], trans Jen Besemer and Marie Stuart, Austin TX: University of Texas Press, 2009, 2, 37.

Aragon or any other first generation Surrealist knew of Weber's assertion of the dissolution of 'mysterious incalculable forces' with 'increasing intellectualization and rationalization' in what he called 'Occidental culture', entailing a society and civilization in which 'one can, in principle, master all things by calculation'.[100] Yet, like Surrealism itself, it was a contention determined by the mechanized catastrophe of the First World War. Made at the very moment Surrealism was being born, Weber's interpretation of modernity diagnosed the movement's future theoretical orientation, which would in turn determine a unique and still-obscure critical history of fin-de-siècle painting fashioned from poetry, psychoanalysis, dialectics and ultimately, and most significantly, a range of esoteric theories. Its reconstruction in the pages that follow is shaped by the diverse tools made available by art history, literary theory and social and intellectual history, mainly, and is meant to acknowledge and engage with contemporary scholarship in those fields, as well, more specifically, as with the histories and theories of Surrealism, modernism and studies of enchantment, magic and occultism.

[100] Max Weber, 'Science as a Vocation' [1919], *From Max Weber: Essays in Sociology*, eds and trans H. H. Gerth and C. Wright Mills, London and New York: Routledge, 2009, 129–56, 139. For further discussion of this core idea, see Max Weber, 'The Social Psychology of the World Religions' [1922–3], *From Max Weber*, 267–301. One historian of modernism has even viewed it from the 'inside', so to speak (not from the outside of modernism as interpreted by the 'seers' of Surrealism), as a stand against the disenchantment observed by Weber: Clark, *Farewell to an Idea*, 9, 12.

1

Greengrocer, Bricklayer or Seer?
Psychoanalysing Paul Cézanne

Unfortunately for the topic of this book, on first sight, the Surrealists' ambiguous enthusiasm for Symbolist art, thought and writing, and their lesser-known favourable disposal towards the art of those who came after Impressionism, such as Paul Gauguin, Georges Seurat, Vincent van Gogh and even the later Pierre-Auguste Renoir – all of whom receive an auspicious outing within Surrealism at some point – were not extended to the painting of Paul Cézanne. Why this was the case among Surrealist artists and writers is probably obvious to anyone who knows anything about the movement but should be gone into briefly here for those who do not and for the historical record. More interesting is the single exception to the rule: the passage written by André Breton in 1936 for his book *Mad Love* (1937), which has hardly ever been commented upon. Breton attempted there to corral a number of Cézanne's paintings including one of the two-figure compositions titled *The Card Players* (1892–3) into a Surrealist paradigm. In this first chapter, I will be examining the latencies of Breton's interpretation in the context of Surrealism's theoretical orientation in the mid-1930s. But I will also be setting a pattern for my other chapters by looking beyond the boundaries of the movement at the larger reception of the artist by modernist critics and others in the twentieth century to ask the unexpected question: why Cézanne for Surrealism in 1936?

Cézanne and Surrealism in France

Surrealism's disdain for the Master of Aix is demonstrated loudly and clearly at two points in its long trajectory. In an essay on his friend André Derain, published in the periodical *Littérature* (thirty-three issues, 1919–24) early in 1921 while Dada was still functioning in Paris, Breton channelled the artist's own words to refer cautiously and sceptically (and optimistically, as it turned out) to Cézanne's glowing reputation as perhaps about to dim, and to his art as 'flattering like make up [la poudre de riz]'.[1] 'This

[1] André Breton, 'Ideas of a Painter' [1921], *The Lost Steps* [1924], trans. Mark Polizzotti, Lincoln and London: University of Nebraska Press, 1996, 62–6, 64 (translation slightly modified). Whether Cézanne's 'reputation' dimmed or not depends on whether we take Breton to mean by this his fame or his influence, for as late as 1946 he could speak of the artist as 'le mieux connu de tous les peintres modernes', while reporting 'l'influence de Cézanne a été très largement prépondérante en France de 1906 à 1918', André Breton, 'Conférences d'Haïti, III' [1946], André Breton, *Oeuvres complètes*, vol. 3, Paris: Gallimard, 1999, 233–51, 237, 238.

man,' he continued, 'who has captured the world's attention, was perhaps completely mistaken.'[2] A pretty, quasi-Impressionist superficiality can be read into that remark: Breton was still in the process of detaching himself from art-loving mentors like Paul Valéry on whose walls he later recalled seeing '[b]eautiful Impressionist canvases,'[3] while articulating at the time a Dada stance that conceived of 'art only as a means of despairing.'[4] In this passage, however, it sounds like Cézanne's mistake was to rely too heavily on the senses, whereas 'Derain is not a subjectivist.'[5]

Breton's negative take on Cézanne had been hardened by his on/off acquaintance in the first half of the 1920s with Francis Picabia. They were close at the time of the fabrication of Picabia's ultra-Dada statement: the iconoclastic, numerously insulting *Still Lives* (figure 1.1, 1920), which Breton apparently had a surprising role in deradicalizing.[6] This long-gone Dada masterpiece was first shown on stage at the Dada Manifestation of 27 March at the Maison de l'Oeuvre and was probably sparked quite specifically by Renoir's recent death. That event is celebrated in the title and by the cheerfully wanking, merrily waving stuffed monkey attached to cardboard, along with the presumed or hoped for death of genre, particularly those of the portrait, still life, nude and landscape.[7] A precedent can be found in February 1919 on the cover of the eighth number of Picabia's review *391*, which carried the legend 'I have a horror of the painting/of Cézanne/it bores me' ('j'ai horreur de la peinture/de Cézanne/elle m'embête') in tiny script over the editor's name.[8] A few years later in 1922, Breton puckishly reported Picabia's remark, conveyed by the artist supposedly from its original source in 'a member of the high Persian nobility' (one Surkhai Sardar), who thought Cézanne's apples, pears and lemons gave evidence of the 'mind of a greengrocer.'[9]

Also that year, in his state-of-play lecture introducing Picabia's exhibition at the Dalmau Gallery in Barcelona in November, Breton opened a parenthesis to announce that the most important contemporary art – of Pablo Picasso, Picabia, Marcel Duchamp, Giorgio de Chirico, Man Ray and Max Ernst, which then stood between Cézanne and a not-quite evolved Surrealism – owed nothing to Cézanne himself (not even Picasso's work, apparently):

[2] Breton, *Lost Steps*, 64.
[3] André Breton, *Conversations: The Autobiography of Surrealism* [1952], trans. Mark Polizzotti, New York: Paragon House, 1993, 10.
[4] Breton, *Lost Steps*, 64.
[5] Breton, *Lost Steps*, 64.
[6] See the brief account of its errant fabrication in André Breton, 'Artistic Genesis and Perspective of Surrealism' (1941), *Surealism and Painting* [1965], trans. Simon Watson Taylor, New York: Harper & Row, 1972, 49–82, 60 n.1.
[7] For a lengthy interpretation, see George Baker, *The Artwork Caught by the Tail: Francis Picabia and Dada in Paris*, Cambridge, Mass. and London: MIT, 2007, 99–118.
[8] The sentiment was shared by all Dadas judging from Max Ernst's sarcastic remarks broadcast from Cologne the same year in *Bulletin D*: '"That paaynting! Ooo that paaynting!" Je m'en fous de Cézanne', Max Ernst, 'On Cézanne' [1919], Lucy R. Lippard (ed.), *Dadas on Art: Tzara, Arp, Duchamp and Others* [1971], Mineola NY: Dover, 2007, 125.
[9] Breton, 'Francis Picabia' [1922], *Lost Steps*, 96–9, 97. Breton was quoting from a letter of 15 October 1922 that he received from Picabia, which was eventually reproduced in Michel Sanouillet, *Dada in Paris* [1965], trans. Sharmila Ganguly, Cambridge, Mass. and London: MIT, 2009, 444.

Figure 1.1 Francis Picabia, *Still Lives* (1920). Mixed media, dimensions unknown. Reproduced in *Cannibale*, no. 1, 25 April 1920. Current whereabouts unknown. Image © University of Iowa Libraries. © ADAGP, Paris and DACS, London 2018.

(it would be absurd to speak in their regard of Cézanne, about whom I personally could not care less and whose human attitudes [l'attitude humaine] and artistic ambitions, despite what his flatterers say, I have always considered imbecilic – almost as imbecilic as the current need to praise him to the skies)....[10]

Breton went on to supplant the ubiquitous Cézanne, the painter's painter and arty technical master – beloved of or at least respected by the likes of Édouard Manet, Edgar Degas, Renoir and Camille Pissarro (and most perceptively analysed early on, too, by the painters Émile Bernard and Maurice Denis) – with the artist's obscure nineteenth-century contemporary the Comte de Lautréamont. Picasso and the others had not even read Lautréamont's *Chants de Maldoror* (1869) at this stage. Yet to that long-dead, little-known writer fell 'perhaps the greatest responsibility for the current state of affairs in poetry', according to Breton, who then made a case for a visual art not of the senses but of the imagination as extrapolated from his avid reading of Lautréamont.[11] This imagination was one of 'hallucinations and sensory disturbances in the shadows',[12] and the Truth it sought to uncover went beyond the usual dualistic morality, displayed in an end product that 'no longer has a right or wrong side: good so nicely brings out evil'.[13]

As opposed to the art of rational construction (figure 1.2), against which the success of Cézanne's work was endlessly gauged by its admirers and which was and is the indissociable outcome of an artistic practice borne by conscious awareness (whatever the debate that has raged since Bernard through and beyond Joachim Gasquet over whether the primary sensible substance of his practice was one of 'spontaneous finding or of controlled making'), Breton was at this stage advocating an art in which the emphasis was laid upon content at the expense of technique.[14] Automatism had still not been introduced into the visual arts in 1922, and at that time the work of de Chirico was thought of by the soon-to-be Surrealists as the main source of illumination for painting, as could be seen in Ernst's contemporary work. What Breton sought to inject into the visual arts as characteristic of the 'modern evolution' were those elements of modern writing that, like Lautréamont's and those of Charles Baudelaire and Arthur Rimbaud, would 'convey that debauchery was still the rule most applicable to the mind'.[15] Cézanne's mature canvases, of course, did nothing of the kind, but there is a

[10] Breton, 'Characteristics of the Modern Evolution and What it Consists Of' [1922–4], *Lost Steps*, 107–25, 117 (translation modified). Breton's exasperation was recapitulated by Aragon at the end of the decade in the important essay that I mentioned in my Introduction complaining about the 'success of Cézannism' and viewing collage as the means by which the pictorial tradition exemplified by Cézanne would be overturned: Louis Aragon, 'The Challenge to Painting' [1930], Pontus Hulten (ed.), *The Surrealists Look at Art*, trans Michael Palmer and Norma Cole, Venice CA: Lapis Press, 1990, 47–72, 55.
[11] Breton, 'Characteristics', *Lost Steps*, 117.
[12] Breton, 'Characteristics', *Lost Steps*, 117.
[13] Breton, 'Characteristics', *Lost Steps*, 117–18.
[14] Richard Shiff, *Cézanne and the End of Impressionism: A Study of the Theory, Technique, and Critical Evaluation of Modern Art*, Chicago and London: The University of Chicago Press, 1984, 132.
[15] Breton, 'Characteristics', *Lost Steps*, 118.

Figure 1.2 Paul Cézanne, *Houses at L'Estaque* (1880). Oil on canvas, 80.2 × 100.6 cm. Art Institute of Chicago. © The Art Institute of Chicago/Art Resource, NY/Scala, Florence.

first hint here of the latent material that Breton would later view in Surrealist painting and subsequently dig hard to discover layered through Cézanne's *oeuvre*.[16]

Preceding the foundational *Manifesto of Surrealism* of 1924, Breton's early criticism was not honed by a fully elaborated Surrealist theory, and even after Surrealism took wing from that moment, '[t]he continued scandals of Cézannism, of neo-academicism, or of machinism,' as Breton put it in 'Surrealism and Painting' in 1926, were assumed rather than fully argued in this initial phase.[17] However, the limitation such art writing already placed on the outwardly familiar pictorial language of Cézanne's landscapes, still-lives and nudes made a sufficiently significant prejudicial contribution to the collective idea of that artist in Surrealism that he could subsequently be dismissed by those in Surrealist circles with little more than an eye-rolling groan, which would, moreover, be immediately understood by all.

[16] The former Surrealist Nicolas Calas must have been thinking of this text when he recalled at the time of Breton's death: '[i]n the twenties he had upset Cézanne's apple cart' by means of the prioritization he gave dialectical poetics over traditional aesthetics: Nicolas Calas, 'The Point of the Mind: André Breton' [1966], *Art in the Age of Risk*, New York: E. P. Dutton & Co., Inc., 1968, 100–3, 100.

[17] André Breton, 'Surrealism and Painting' [1925–8], *Surrealism and Painting*, 1–48, 9.

That attitude can be visited over thirty years later in the 'precursor' game 'Ouvrez-vous?' where Cézanne received such a reception on the threshold of Surrealism. Introduced in 1953 in the first number of their journal _Médium: Communication surréaliste_ (four issues, 1953–5), 'Ouvrez-vous?' asks participants if and why they would open the door when visited in a dream by various long-dead 'illustrious individuals' (figure 1.3).[18] Cézanne was poised as a potential guest among a party of thirty-four, leaning towards writers, artists and revolutionaries more or less established in the pre-Surrealist canon such as Baudelaire, Sigmund Freud, Gauguin, Goethe, Lenin, Friedrich Nietzsche, Edgar Allan Poe, Maximilien Robespierre, Seurat and van Gogh. The odds already looked stacked against him and not surprisingly the eminent artist was left standing on the doorstep more often than any other figure (receiving fifteen 'Nons' and only two reluctant 'Ouis', even fewer than Honoré de Balzac, bottom with Paul Verlaine).[19] As corollaries in a game demanding speed and brevity (and, because of that, pith), the Surrealists' reasons for cold-shouldering Cézanne are often casually and amusingly reprehensible (Jean Schuster: 'No, because I hate apples'; Anne Seghers: 'No, because I like apples'), demonstrating an ingrained predisposition fortified over the previous thirty years as much as anything else.[20]

This longstanding bias was only confirmed in the pages of the major survey _L'Art magique_ on which Breton was beginning preparation at the time, though it would only be completed in 1957. While that book fully heralded the arrival of Gauguin into the pantheon of pre-Surrealists, as I will show, Cézanne is mentioned only in passing alongside a restatement of the dismissive 1922 'greengrocer' phrase.[21] In this way, Surrealism's attitude in this later stage is doubled back onto that held in its earliest days, leaving no room for the Master of Aix in the fold.

As perhaps shown in Breton's dismissal of the artist in the 1920s, which is robust yet lightly shaded with a youthful hesitation, Cézanne had long since reached a pre-eminent position among painters and writers on art by the time Surrealism started to bud in the period after the First World War. This was for reasons that would in no way correspond with the movement's own idea of what painting should aspire towards. The young Surrealists' impatience would have been compounded by the fact that Cézanne's reputation seemed set in stone to their generation. Breton himself was born a few weeks after Cézanne achieved major recognition with his first solo exhibition at Ambroise Vollard's in 1895 at the age of fifty-six. Surrealism's future leader would have suffered into early adulthood the prodigious reverberations of Bernard's 1904 article on Cézanne's artistic methods and technical procedures, especially celebrated after it

[18] 'illustres personnages', The Surrealist Group, 'Ouvrez-vous?' _Médium: Communication surréaliste_, no. 1, November 1953, 1 and 11–13, 1.
[19] Breton's response sounds bored: 'Non, rien à se dire', Surrealist Group, 'Ouvrez-vous?' 11.
[20] 'Non, par haine des pommes (J. S.). – Non, parce que j'aime les pommes (A. S.)', Surrealist Group, 'Ouvrez-vous?' 11. As in other Surrealist games, the speed of response was meant to undercut too much conscious deliberation: see Penelope Rosemont, 'Time-Travelers' Potlatch', _Surrealist Experiences: 1001 Dawns, 221 Midnights_, Chicago: Black Swan Press, 2000, 109–15.
[21] André Breton, _L'Art magique_ [1957], Paris: Éditions Phébus, 1991, 237.

OUVREZ-VOUS ?

Puisqu'il advient que nous soyons visités en rêve par d'illustres personnages depuis longtemps disparus et qu'aussi bien une fiction persistante veut qu'un petit nombre d'autres — tels Isaac Laquedem, Nicolas Flamel, le comte de Saint-Germain — s'obstinent si bien à vivre qu'ils se montrent, par intervalles, au grand jour, ce n'est pas beaucoup forcer la pente du plausible d'imaginer que, par l'entrebâillement d'une porte, à la suite d'une sonnerie ou de coups frappés, nous nous trouvions en présence de tel « noble visiteur » (comme on dit « noble voyageur ») issu de notre imagerie. L'intérêt d'une telle spéculation est, abstraction faite de la stupeur où nous plongerait cette brusque reconnaissance — que nous identifiions d'emblée l'arrivant ou qu'il lui faille se nommer — de précipiter en nous, à la seconde, les sentiments assez souvent complexes que nous pouvons lui porter. Les seules ressources sont, en effet, de faire entrer (avec plus ou moins d'enthousiasme) ou d'éconduire (avec plus ou moins de ménagements). Comme nous l'avons vérifié en commun, s'interroger à cet égard (pour avoir, il va sans dire, à se répondre sur-le-champ) introduit une nouvelle dimension dans les rapports que nous pouvons entretenir avec les figures du passé. On s'aperçoit très vite que des considérants d'ordre inhabituel tendent ici à primer tous les autres : c'est ainsi que les êtres dont la vie ne saurait être séparée de l'œuvre jouissent, sous le rapport de l'attraction, d'une manifeste supériorité sur les autres. Des remarques complémentaires s'imposeront à ceux qui tenteront l'expérience par eux-mêmes (il serait prématuré de les formuler après une confrontation jusqu'ici trop limitée et aussi trop sommaire : il eût fallu, au moins dans certains cas, préciser l'âge du visiteur au moment où il se présente, les conditions de solitude ou non-solitude qu'il se trouve affronter, l'heure du jour ou de la nuit qu'il a choisie, etc...). — A. B.

BALZAC : Oui, comme à un voisin (J.-L. B.). — Oui, eu égard à *Melmoth* (R.B.). — Non (chaos) (A.B.). — Non, assez de la vie de tous les jours (E.B.). — Non, le temps m'est trop mesuré... Je regrette (A.D.). — Oui, par ébahissement (G.G.). — Non, il n'a rien à ajouter (J.G.). — Oui, Paris et la Touraine (G.L.). — Oui, pour parler de certaines rues de Paris (W.P.). — Oui, Monseigneur (J.P.). — Oui, mais un peu à contre-cœur (B.P.). — Non, par manque d'intérêt (B.R.). — Non, en le regrettant un peu (J.S.). — Oui, avec une grande timidité (A.S.). — Oui (Parisien) (T.). — Non, je préfère ma rêverie (M.Z.).

BARBEY D'AUREVILLY : Non, pour répondre à son défi (J-L. B.). — Oui, par curiosité (R.B.). — Oui, mais parce que difficile de faire autrement (A.B.). — Non (embarrassant) (E.B.). — Oui, pour sortir un peu de cette époque d'épiciers (A.D.). — Oui, par libéralité (G.G.). — Non, trop volumineux dans un couloir (J.G.). — Non, par provocation (G.L.). — Oui, pour le prier de lire les *Diaboliques* à haute voix (W.P.). — Non, à cause du choix entre la bouche du pistolet et le pied de la croix (B.P.). — Oui, mais l'épée au poing (J.P.). — Oui, sans joie (B.R.). — Oui (le scabreux) (J.S.). — Non, il me cacherait Hauteclaire (A.S.). — Oui, les *Diaboliques* (T.). — Oui, sans grande curiosité (M.Z.).

BAUDELAIRE : Oui, avec passion (J.-L. B.). — Oui, non sans quelque trac (R.B.). — Oui, ému aux larmes (A.B.). — Oui, et de tout cœur ! (A.D.). — Oui, bouleversé (E.B.). — Oui, en vénération (G.G.). — Oui, sans hésitation (J.G.). — Oui, avec une immense attente inépuisée (G.L.). — Oui, pour l'examiner de près (S.H.). — Oui, en le saluant profondément (W.P.). — Oui, avec une intense satisfaction (B.P.). — Oui, que la porte vole en éclats ! (J.P.). — Oui, au delà de l'émotion (B.R.). — Oui, en essayant de dissimuler mon émotion (J.S.). — Oui, tout à fait ébloui (A.S.). — Oui, avec affection (T.). — Oui, que je voie enfin le prisme de toutes les passions ! (M.Z.).

BETTINA : Oui, par faiblesse (J.-L. B.). — Non, la barbe ! (R.B.). — Non (crampon) (A.B.). — Non, trop habile pour moi (E.B.). — Oui, avec grand plaisir (A.D.). — Non (bel esprit) (G.G.). — Oui, avec enthousiasme (J.G.). — Oui, pour la corriger (G.L.). — Non, je crains qu'elle ne laisse rien à deviner (W.P.). — Non, bas-bleu (B.P.). — Non, merci (J.P.). — Oui (la femme-enfant) (J.S.). — Oui, c'est une curiosité (A.S.).

BRISSET : Oui, m'attendant au pire (J.-L. B.). — Oui,

(Suite page 11.)

SIMON HANTAI

A mi-chemin entre le fossile sorti de sa gangue et l'oiseau de feu qu'il poursuit, Simon Hantaï a retracé, pour sa propre édification, toute la démarche surréaliste en art. Avec lui, les matériaux les plus indignes (un os, une arête de poisson, un fragment de journal) acquièrent un éclat qui les révèlent à eux-mêmes et à nos yeux. La métamorphose s'opère soudain sur chaque élément et dans ses parties les plus infimes. Un os devient une aile battante, un fragment de journal un œil qui interroge ou vous menace : « Que viens-tu faire ici ? Es-tu des miens ? Un ami ? Sinon, passe ton chemin avant que, des couleurs qui te composent, je peigne sur ton os iliaque la vie que tu aurais dû mener. »

Simon Hantaï est né en 1922, à Bia (Hongrie). Il a suivi pendant six ans les cours de l'école des Beaux-Arts de Budapest. Arrivé à Paris en 1949, il a exposé pour la première fois à **L'Etoile scellée**, en février 1953.

HASARD ET TRADITION

Il y a, au Musée Carnavalet, un portrait de René Crevel. Si l'on prend un certain recul et que l'on gravit les quelques marches de l'escalier qui lui fait face, le coup d'œil embrasse à la fois le tableau et les deux bustes de l'étage supérieur situés à égale distance de part et d'autre, l'un de Lepelletier de Saint-Fargeau, l'autre de Marat.

— 1 —

LES LOUPS ENTRE EUX

Engagez-vous, rengagez-vous dans l'objection de conscience. C'est ce à quoi nous invite l'éditorialiste anonyme du Figaro (30 septembre). Le sous-entendu menaçant de cette proposition est à peine dissimulé : si l'adhésion à une secte de crétinisés du genre « témoins de Jéhovah » n'est pas tout à fait obligatoire, il va de soi qu'aux termes du statut qui devrait «assouplir» l'actuelle législation militaire, l'objecteur de conscience figurera dans un service civil aussi long et aussi dangereux que l'autre. « Infirmier-parachutiste » en cas de conflit, il aura la satisfaction de mourir entre les feux croisés, l'âme sans tache, et les curés pacifistes des armées adverses béniront du même goupillon son cadavre d'imbécile, roulé dans les plis confondus des torchons nationaux. — G. L.

Figure 1.3 'Ouvrez-vous' in *Médium: Communication surréaliste*, November 1953, 1. Author's collection.

was revised and extended in 1907 for the *Mercure de France* (where Breton's mentor in poetry and, to an extent, art criticism Guillaume Apollinaire also published).[22] It appeared in the month following the publication of Denis's equally laudatory piece in *L'Occident*.[23] Breton would have known of the artist's further rise to unquestioned greatness with the two Cézanne retrospectives at the Salon d'Automne in those years. By the time Breton began to look at art with a critical eye in 1913, Cézanne must have seemed as colossal and enduring as Mont Sainte Victoire itself, with the publication of the memoirs of Bernard and Vollard on either side of that year doing their best to bring the deceased artist back to life.[24]

Cézanne had by then taken posthumous paternal ownership of the keys of painting to the generation of Picasso, Georges Braque and Henri Matisse that preceded Surrealism. Yet his attitude towards his craft as 'painting for its own sake' (as Bernard had understood it in his earliest reflections on the artist) would never find any advocates among the Surrealists.[25] As Breton had set it out in his 1920 essay on Lautréamont's *Maldoror*, they believed painting could no more be reduced to a frisson that ended at the senses than poetry, but 'must lead somewhere', preferably all the way down to the unconscious:

> It would . . . be a mistake to consider art an end in itself. The doctrine of 'art for art's sake' is as reasonable as a doctrine of 'life for art's sake' is, to my mind, insane. We now know that poetry must lead somewhere. On this certainty rests, for example, our passionate interest in Rimbaud.[26]

In spite of its temporary, emphatic, more commercial and populist turn towards the visual arts in the 1930s and 1940s – with its big international art exhibitions, Breton's Galerie Gradiva and the high quality periodical *Minotaure* – Surrealism held to this idea of art's purpose as a means of sounding the self and its others in the 1950s at the time that Roger Fry's and Clive Bell's straitlaced 1920s formalist interpretations of Cézanne as reducer and designer were extending into Clement Greenberg's 1950s reading of the artist. As is well known, Cézanne was combatively confirmed by Greenberg at the beginning of that decade as the artist of 'sensation', 'surface pattern' and 'two-dimensional solidity', '[c]ommitted . . . to the motif in nature in all its givenness' and said to have 'cover[ed] his

[22] See Émile Bernard, 'Souvenirs sur Paul Cézanne et Lettres inédites (I–III)', *Mercure de France*, no. 247, vol. 69, 1 October 1907, 385–404; Émile Bernard, 'Souvenirs sur Paul Cézanne et Lettres inédites (IV–V, fin)', *Mercure de France*, no. 248, vol. 69, 16 October 1907, 606–27.

[23] Denis's 1907 essay was republished in Maurice Denis, *Théories, 1890–1910: Du symbolisme et de Gauguin vers un nouvel ordre classique* [1912], Paris: L. Rouart et J. Watelin, 1920, 245–61.

[24] Émile Bernard, *Souvenirs sur Paul Cézanne*, Paris: Société des Trente, 1912; Ambroise Vollard, *Paul Cézanne*, Paris: Galerie A. Vollard, 1914. Breton, who would use the second of these as a reference source, marked his own maturity at 1913 at the beginning of Breton, *Conversations*, 3. Also see his remarks about his 'first encounter with Picasso's work' in 1913: Breton, *Surrealism and Painting*, 116.

[25] 'la peinture pour elle-même', Émile Bernard, 'Paul Cézanne', *Les Hommes d'aujourd'hui*, vol. 8, no. 387, 1891, n.p.

[26] André Breton, 'Les Chants de Maldoror by the Comte de Lautréamont' [1920], *Lost Steps*, 47–50, 47 (translation slightly modified).

canvases with a mosaic of brushstrokes whose net effect was to call attention to the physical picture plane' from the late 1870s, as though he were already laying the paving stones of the flat and even path leading to abstract expressionism (figure 1.4).[27]

It has been stated that the Surrealists scorned Cézanne as a wealthy, Catholic, conservative bourgeois, which could be true.[28] Furthermore, it might be argued that Cézanne's frequently touted 'classicism' would also have turned them off and even turned them against him. Such seems to have been the case for Ernst whose cartoon depiction of the solemn, trussed up artist painting with the aid of an absurd contraption while being nearly fellated by Rosa Bonheur in the eighth chapter of his collage novel *The Hundred Headless Woman* (1929) is akin to Picabia's self-

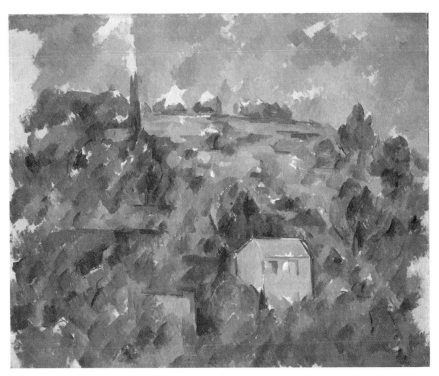

Figure 1.4 Paul Cézanne, *House on the Hill* (1904–6). Oil on canvas, 65.7 × 81 cm. National Gallery of Art, Washington D.C., White House Collection. Image courtesy of the Board of Trustees, National Gallery of Art, Washington.

[27] Clement Greenberg, 'Cézanne and the Unity of Modern Art' [1951], *The Collected Essays and Criticism, vol. 3, Affirmations and Refusals, 1950-1956*, ed. John O'Brian, Chicago and London: The University of Chicago Press, 1993, 82–91, 87, 86, 87, 84, 85.

[28] This view of the Surrealists (which sounds perfectly plausible and compares with their prejudice against Henri Bergson) is stated without evidence by Françoise Cachin, 'A Century of Cézanne Criticism 1: From 1865 to 1906', London: Tate Gallery, *Cézanne*, 1996, 24–43, 43.

consciously adolescent jibe earlier in the decade (figure 1.5).[29] Yet they had their pick of many versions of the artist towards which they would have been more conducive. There was the 'romantic' early Cézanne, almost as enigmatic as Lautréamont; the Symbolist Cézanne of the 'sickly retinas' admired briefly and presciently by the exemplary pre-Surrealist Joris-Karl Huysmans, whose word they revered on Gustave Moreau;[30] the asocial outsider subject to 'mystic revelation', as Richard Shiff put

Figure 1.5 Max Ernst, 'Cézanne et Rosa Bonheur', collage from *The Hundred Headless Woman* (1929). Private collection. © ADAGP, Paris and DACS, London 2018.

29 Also see Breton's foreword to this volume in which Ernst is credited with the repudiation of form, 'in regard to which all compliance leads to chanting the idiotic hymn of the "three apples" perpetrated, in the final analysis, all the more grotesquely for their manners, by Cézanne and Renoir', André Breton, 'Foreword' in Max Ernst, *The Hundred Headless Woman* [1929], trans. Dorothea Tanning, New York: George Braziller, 1981, 7–11, 10.
30 'rétines maladies', Joris-Karl Huysmans, 'Cézanne', *Certains* [1889], Paris: Tresse & Stock, 1894, 41–3, 43.

it, listing Bernard, Félix Fénéon, Gauguin and André Mellerio as followers of that creed;[31] the rustic regionalist or Baudelairean 'primitive' described by Julius Meier-Graefe as drawing with 'the hands of a child';[32] the Cézanne who imitated Giotto in the fabrics of his card players, as advised by Apollinaire;[33] or the Cézanne in possession of 'the ardent and naïve soul of the artists of the Middle Ages', proposed by Georges Rivière at the very time Breton was holding forth on the artist's 'overestimation' and not long before the stereotypes of medievalism began to exert their sway on the Surrealists.[34]

However, it was, firstly, the emphasis laid by the artist on his *motif* out in nature and, secondly, that further stress placed by his admirers and critics on what Greenberg in his other essay on the artist called Cézanne's 'need to enhance the unity and decorative force of the surface design [so] that he let himself sacrifice the realism of the illusion to it', or, in other words, the denial of content, that caused them to reject his art in these two periods.[35] The first was interpreted by Maurice Merleau-Ponty as a debt to the Impressionists and especially to Pissarro, thanks to whom Cézanne abandoned the 'painted fantasies' of his work up to about 1870 and later 'conceived painting not as the incarnation of imagined scenes, the projection of dreams outward, but as the exact study of appearances: less a work of the studio than a working from nature', a characterization of his later work that could now be challenged in the wake of T. J. Clark's reading of the late *Bathers* paintings as 'reach[ing] back to images and directions that had been abandoned long ago, in the 1870s and even the 1860s, as if only now the means were available to complete the dream-work then begun'.[36] As for the second, content was crucial to Surrealism while it was denied

[31] Shiff, *Cézanne and the End of Impressionism*, 164.

[32] Julius Meier-Graefe, *Cézanne*, trans. J. Holroyd-Reece, London: Ernest Benn Limited, 1927, 59.

[33] Guillaume Apollinaire, 'The Cézanne Exhibition: Bernheim Gallery' [1910], *Apollinaire on Art: Essays and Reviews 1902–1918* [1960], ed. Leroy C. Breunig, trans. Susan Suleiman, Boston, Mass: MFA, 2001, 57–8, 57.

[34] 'l'âme ardente et naïve des artistes du Moyen Age', Georges Rivière, *Le Maitre Paul Cézanne*, Paris: Henri Floury, 1923, 130. For medievalism, see especially André Breton, 'Introduction to the Discourse on the Paucity of Reality' [1924], *Break of Day* [1934], trans Mark Polizzotti and Mary Ann Caws, Lincoln and London: University of Nebraska Press, 1999, 3–20.

[35] Clement Greenberg, 'Cézanne: Gateway to Contemporary Painting' [1952], *Collected Essays and Criticism, vol. 3*, 113–18, 118.

[36] Maurice Merleau-Ponty, 'Cézanne's Doubt' [1945], *Sense and Non-Sense* [1948], trans Hubert L. Dreyfus and Patricia Allen Dreyfus, Evanston IL: Northwestern University Press, 1964, 9–25, 11; T. J. Clark, *Farewell to an Idea: Episodes from a History of Modernism*, New Haven and London: Yale University Press, 1999, 140. An alternative and very strange interpretation of the latencies of Cézanne's painting that was made through the discovery of 'cryptomorphs' or hidden faces and rebuses among their unconscious symbolism, which might not have been possible without the art historical scholarship on Salvador Dalí and Ernst, was given by Sidney Geist, *Interpreting Cézanne*, Cambridge, Mass. and London: Harvard University Press, 1988; a sceptical rehearsal of one of Geist's 'almost Surrealist' readings of Cézanne's paintings can be found in James Elkins, *Why Are Our Pictures Puzzles? On the Modern Origins of Pictorial Complexity*, New York and London: Routledge, 1999, 213–15. Another book that has similar claims about a whole roster of late nineteenth- and twentieth-century artists makes available another means of approaching the relationship between Surrealism and fin-de-siècle art: Dario Gamboni, *Potential Images: Ambiguity and Indeterminacy in Modern Art*, trans. Mark Treharne, London: Reaktion, 2002.

in Cézanne's painting by generations of commentary on the artist from Denis onwards. Even when it was passingly noted, as in Greenberg's 'sacrifice' of 'realism', the results were never seen to open out into anything like the surreal world that I will show Seurat led towards in my third and fourth chapters. Since the 1980s it has been routine to comment upon content in Cézanne, in the surreal-sounding 'mysterious, meditative mood', for instance, the 'inwardness and mystery' of a 'ceremony or ritual' presiding over the series of card player paintings.[37] Yet it was only as Greenberg lauded Cézanne and as modernist criticism and historiography reached its position of dominance in the early 1950s, while the Surrealists closed the door on him one more time, that the first murmurings could be heard of what would be, in the next decade, the full-blown psychoanalytic art writing of Meyer Schapiro, perceiving in Cézanne's art 'the burden of repressed emotion in this shy and anguished, powerful spirit'.[38]

Physical unease: Psychoanalysis, Cézanne and Dalí in 1936

In 1936, at the midway point of this thirty-year gap between Breton's youthful vilification of Cézanne and the confirmation it received from the participants of 'Ouvrez-vous?' in 1953, a flurry of Cézanne-based activity took place within Surrealism. This can be explained partly by the movement's greater closeness to the world of art museums and exhibitions in that decade, which I touched on above, and partly because this thirtieth anniversary of his death coincided with an important period of research and curatorship on Cézanne. In that year, the Cézanne industry moved up a notch with the publication of Lionello Venturi's catalogue raisonné, *Cézanne: son art – son oeuvre*, the most thorough study to date of the artist's paintings and the first sustained attempt to rationalize the development of his art using the language of art history.[39] To accompany this, Venturi contributed an article in October on Cézanne's last years to *Minotaure*, the review more or less requisitioned by the Surrealists.[40] Since Vollard's 'Souvenirs sur Cézanne' had appeared in *Minotaure* in the previous year, we can assume that these essays were accepted by the review over the complaints of most of the Surrealists on the editorial board, or that their

[37] Theodore Reff, 'Cézanne's *Card Players* and their Sources', *Arts Magazine*, vol. 55, no. 3, November 1980, 104–17, 105.

[38] Meyer Schapiro, *Cézanne*, London: Thames and Hudson, 1952, 2. For his later view, that 'one may suppose that in Cézanne's habitual representation of the apples as a theme by itself there is a latent erotic sense, an unconscious symbolizing of a repressed desire', see Meyer Schapiro, 'The Apples of Cézanne: An Essay on the Meaning of Still-Life' [1968], *Modern Art, 19th and 20th Centuries: Selected Papers*, vol. 2, London: Chatto & Windus, 1978, 1–38, 12.

[39] Lionello Venturi, *Cézanne: son art – son oeuvre*, two vols., Paris: Paul Rosenberg, 1936.

[40] Lionello Venturi, 'Sur les dernières années de Cézanne', *Minotaure*, no. 9, October 1936, 33–9.

attitude towards the artist was undergoing a temporary thaw.[41] This was also the year of the first of John Rewald's many contributions to the scholarship on Cézanne, which would have a transformative effect on the understanding of the artist. Rewald himself wrote around that time that Venturi's book would inaugurate 'a new era of Cézannean research' and would be 'at the foundation of all publications on Cézanne'.[42] So the middle 1930s must be regarded as a watershed moment for scholarship on Cézanne, which helps account for the cluster of responses to the artist around Surrealism.

In 1935, the recently disaffected Surrealist Roger Caillois had attempted to delineate two recent traditions in painting, one of which ran from Cézanne to Picasso, which he thought was a 'transformative effort on a given object', while the other went from Moreau to Salvador Dalí, viewed by Caillois as 'realist painting of an imagined subject'.[43] In saying this, Caillois ignored the Surrealist lineage long since specified for Picasso by Breton while acknowledging the by-then well-established importance given the imagination by Surrealism, its claim to a tradition and the main exponent of Surrealist 'realism', Dalí. In the following year, Herbert Read offered an alternative, making a half-hearted attempt to draw Cézanne into a broad Surrealist paradigm by acknowledging 'the imaginative range of his genius' while complaining that 'such an art is deceptive if it does not extend our sensibility on more than a sensational level. Cézanne himself seemed to realize this,' he continued, 'and was not satisfied with his apples'.[44]

If Read went easy on Cézanne, merely patronizing him on the basis that he got the wrong balance between the senses and the imagination, other Surrealists saw no saving grace in his work. Dalí had written of the 'great inimitable masterworks' of Impressionism and 'the marvellous Renoir, Monet, Pissarro, Seurat, Cézanne, etc.' in the monthly magazine *La Nova Revista* in 1927 before he left Spain to join the Paris Surrealists.[45] However, his involvement with the group turned his head, somewhat, about the modernist canon. Indeed, Dalí had pitched in on Cézanne before Read, suggesting in a 1933 letter to Breton the idea of a catalogue preface to his forthcoming exhibition that began with a question in the spirit of Picabia: '[d]o you remember a very filthy painter who called himself Cézanne?'[46]

[41] Ambroise Vollard, 'Souvenirs sur Cézanne', *Minotaure*, no. 6, winter 1935, 13–16. For the limited powers of the Surrealists to veto contributions to *Minotaure*, see Brassaï, *Conversations with Picasso* [1964], trans. Jane Marie Todd, Chicago and London: The University of Chicago Press, 1999, 32.

[42] John Rewald, *Cézanne et Zola*, Paris: Éditions A. Sedrowski, 1936; 'une nouvelle ère des récherches cézanniennes', 'à la base de toutes les publications sur Cézanne', John Rewald, 'A propos du catalogue raisonné de l'oeuvre de Paul Cézanne et de la chronologie de cette oeuvre', *La Renaissance*, vol. 20, no. 3/4, March–April 1937, 53–6, 53.

[43] 'effort de transformation d'un objet donné', 'peinture réaliste d'un sujet imagine', Roger Caillois, *Procès intellectuel de l'art*, Marseille: Les Cahiers du Sud, 1935, 22 n. 1.

[44] Herbert Read (ed.), *Surrealism*, London: Faber and Faber, 1936, 62.

[45] Salvador Dalí, 'Current Topics: Right and Left' [1927], *The Collected Writings of Salvador Dalí*, ed. and trans. Haim Finkelstein, Cambridge: Cambridge University Press, 1998, 49–50, 50.

[46] Dalí quoted in Marcel Jean with Arpad Mezei, *The History of Surrealist Painting* [1959], trans. Simon Watson Taylor, New York: Grove Press, 1960, 219.

As part of an increasingly active programme to extend Surrealism historically and geographically beyond the boundaries of the Paris group, Dalí returned to the theme in 1936. In the course of an article on the women of Pre-Raphaelite art, carried by the previous number of *Minotaure* to the one in which Venturi's appeared, Dalí ridiculed Cézanne's contemplative 'Platonic' apple.[47] Arguing for the superiority of the harder-edged 'realist' art of Dante Gabriel Rossetti and his friends over the so-called 'distortion' of Cézanne's art, lauded by Bell the previous decade, the crab-like, analogical movement of Dalí's essay travels back and forth between the two artists. It gathers in a polemic that transforms Cézanne from a greengrocer into a builder:

> If we succinctly consider Pre-Raphaelitism from the viewpoint of 'general morphology,' taking into account Édouard Monod-Herzen's amazing study, we will see that its aspirations are diametrically opposed to those of Cézanne.... From the morphological viewpoint, Cézanne appears to us as a kind of Platonic bricklayer who is satisfied with a programme consisting of the straight line, circle, and regular forms in general, and who disregards the geodesic curve, which, as we know, constitutes in some respects the shortest distance from one point to another. Cézanne's apple tends to have the same fundamental structure as that of the skeleton of siliceous sponges, which on the whole is none other than the rectilinear and orthogonal scaffolding of our bricklayers, in which one discovers with amazement numerous spicules that materially realize the 'trirectangular dihedron' that is so familiar to geometricians. I am saying that Cézanne's apple *tends* to the orthogonal structure, because in reality, in the case of the apple, this structure is dented, deformed and denatured by the kind of 'impatience' that led Cézanne to so many unhappy results.[48]

Dalí's paranoiac-critical mode of interpretation demanded the annexation of spontaneous irrational associations experienced by the viewer into the reading of the phenomena under observation – here, Cézanne's apples. By means of this method, his sideways recollection of an image that accompanied the discussion by the decorator and librarian Édouard Monod-Herzen in his *Principes de Morphologie Générale* (1927) of the internal structure of sponges and amoeboid protozoa (figures 1.6 and 1.7), where they are compared by that author to 'the scaffolding of our builders, rectilinear and orthogonal', was allowed space in Dalí's appraisal of Cézanne.[49] The same is true of Monod-Herzen's text, which he decanted more or less completely into his own.

[47] Salvador Dalí, 'Le Surréalisme spectrale de l'Éternel Féminin préraphaélite', *Minotaure*, no. 8, June 1936, 46–9.
[48] Salvador Dalí, 'The Spectral Surrealism of the Pre-Raphaelite Eternal Feminine' [1936], *Collected Writings*, 310–14, 312 (translation slightly modified).
[49] 'un échafaudage de nos maçons, rectiligne et orthogonale', Édouard Monod-Herzen, *Principes de Morphologie Générale*, two vols., Paris: Gautier-Villars et Cie., 1927, vol. 1, 2–3.

3

FORMES DÉFINIES.

La disposition trirectangle, ou cubique, associée ou non avec une sphère, se retrouve dans le squelette de quantité de *Radiolaires* (¹). Dans la figure 2 (*Nassellaria*), nous avons une sphère à trois grands cercles orthogonaux; dans la figure 3 (*Spumellaria*), une sphère à

Fig. 2. — Squelette de radiolaire (*Trissocyclus sphaeridium*) (Haeckel).

Fig. 3. — Squelette de radiolaire (*Hexastylus triaxonius*) (Haeckel).

trois axes rectangulaires; et dans la figure 4 (*Phaeodaria*), un octaèdre régulier, avec ses axes : 8 faces égales, triangles équilatéraux.

Ce dernier *Phaeodarié* appartient à la famille des *Circoporidas*, dont le corps principal, c'est-à-dire moins les prolongements axiaux, est un *polyèdre* inscriptible dans une sphère.

Ce polyèdre peut être *régulier*, circonstance intéressante, car elle ne se présente pas souvent dans la nature.

Sont rares surtout : le *dodécaèdre régulier*, 12 faces égales, pentagones réguliers; et l'*icosaèdre régulier*, 20 faces égales, triangles équilatéraux. Le premier est donné par la *Circorrhegma dodecahedra* (fig. 5); et le second par la *Circogonia icosahedra* (fig. 6).

(¹) *Cf.* les beaux travaux de HAECKEL : *Monographie der Radiolarien* : *Gonerilla Morphologie*, etc.

Figure 1.7 Page from Édouard Monod-Herzen, *Principes de Morphologie Générale* (1927). Author's collection.

SCIENCE ET ESTHÉTIQUE

Édouard MONOD-HERZEN
Licencié ès sciences, Artiste décorateur
Bibliothécaire de l'École nationale
supérieure des Arts décoratifs

Principes
de
Morphologie
générale

TOME I
Formes définies. Forme et Fonctionnement.
Des Cristaux à la Matière vivante.

GAUTHIER-VILLARS ET Cⁱᵉ, ÉDITEURS — PARIS

1927

Figure 1.6 Cover of Édouard Monod-Herzen, *Principes de Morphologie Générale*, vol. 1 (1927). Author's collection.

In doing this, Dalí's article aligned with the earlier language of some of Cézanne's admirers, such as that of Théodore Duret thirty years before (recently retold by Shiff), which reluctantly used the same metaphor: '[o]ne could go so far as to say that, in certain cases, he renders his tableau with concrete.'[50] Meanwhile, the double metaphor allowed by the mosaic appearance of Cézanne's pictures, on the one hand, and the thick paint applied to the canvas (like cement trowelled onto bricks), on the other, led to the assessment in Julius Meier-Graefe's equally favourable publication, celebrating the artist as a 'barbaric mason', whose paintings 'looked like walls rather than pictures'.[51] As recently shown by Anthea Callen, such terms were used for Gustave Courbet in the mid-nineteenth century, 'frequently recurring' for those like Cézanne who came after him, 'in criticism of the flat, opaque, masonry-like surfaces of modern painting'.[52] They were recycled here by Dalí with the aim of associating their surfaces with building and labour and through that with coarseness and even ineptitude.

But it was not only the painterly pattern-making of Cézanne's cerebral geometricity that bothered Dalí (though like a clumsy, overworked bricklayer, the artist even messed that up) and which the Surrealist contrasted with the sharply contoured, smoothly painted (more 'Dalinian', in short) art of the Pre-Raphaelites, redolent, for him, of the geodesic curve described by Monod-Herzen's book.[53] No, he also objected to the lack of volume in his painting, dictated by Cézanne's 'accidental' ambition, in the later words of Greenberg, to 'give the picture surface its due as a physical entity'.[54] Dalí drew a distinction between that and the corporeal presence and sensuous heft of the massy, tightly clothed Pre-Raphaelite women, appreciating them beyond any mere narrative. He spoke of them thrillingly as 'terrifying', situating an erotics on 'the Adam's apples of Rossetti's luminous beauties' as in *Beata Beatrix* (c. 1864–70, figure 1.8), which Dalí reproduced with his text and which had years earlier provided the inspiration for *The Great Masturbator* (1929).[55] Dalí's article lends itself to any number of psychoanalytic readings, predictive as it is of the heavy, consoling maternal bodies that René Magritte would muster in his art from 1943 in a Brussels under

[50] '[o]n peut aller jusqu'à dire que, dans certain cas, il maçonnait son tableau', Théodore Duret, *Histoire des peintres impressionnistes*, Paris: H. Floury, 1906, 178. See the remarks by Richard Shiff, 'He Painted', London: Courtauld Institute of Art, *Cézanne's Card Players*, 2010, 73–91, 73.

[51] Meier-Graefe, *Cézanne*, 21, 21–2. Also see the extended metaphor in which Cézanne is described painting 'with the blows of a stonemason' and that of him building 'like a child with cubes and bricks', Meier-Graefe, *Cézanne*, 40, 59. An article on Seurat by another artist that was almost exactly contemporary with Dalí's in *Minotaure* asserts: 'Cézanne is a mason, masoning, touch by touch, with no plans, only sketches. Great mason, certainly, and great sketches', Jean Hélion, 'Seurat as a Predecessor', *The Burlington Magazine for Connoisseurs*, vol. 69, no. 44, July 1936, 4 and 8–11 and 13–14, 10.

[52] Anthea Callen, *The Work of Art: Plein-Air Painting and Artistic Identity in Nineteenth-Century France*, London: Reaktion, 2015, 120.

[53] Monod-Herzen, *Principes de Morphologie Générale*, vol. 1, 89–99.

[54] Greenberg, 'Cézanne and the Unity of Modern Art', *Collected Essays and Criticism, vol. 3*, 86.

[55] Dalí, *Collected Writings*, 312.

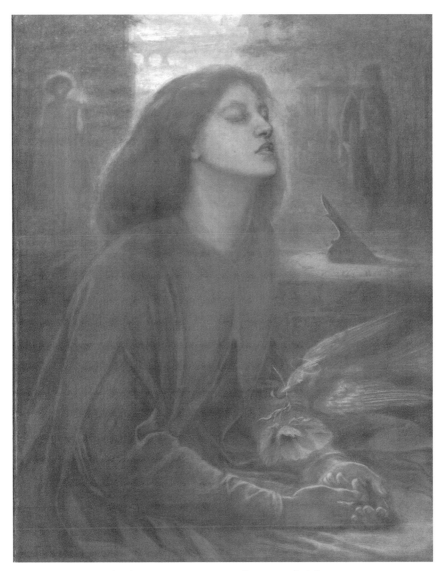

Figure 1.8 Dante Gabriel Rossetti, *Beata Beatrix* (*c.* 1864–70). Oil on canvas, 86.4 × 66 cm. Tate Gallery, London. © Tate, London 2018.

occupation, and of the later interpretations that art historians would devise of Renoir's large nudes, both of which I turn to in my next chapter.

The mid-1930s was the period of Surrealism's and, specifically, Dalí's most intense attack on abstract art. Once pointed out, that historical context reveals that Dalí's and Greenberg's remarks emerge from competing attitudes towards abstraction, but a

shared understanding of the causal role played in its rise by Cézanne.[56] And even if we go only some way (not all the way) along with Greenberg's later observation that '[l]oyalty to his sensations' led Cézanne into 'disregarding the texture, the smoothness and roughness, hardness and softness, the tactile feel of objects and seeing colour exclusively as a determinant of spatial position',[57] we can still easily comprehend Dalí's 'hypermaterialist' contrast of that artist's 'inedible' apples with the too-real 'carnal concretions of excessively ideal women, these feverish and panting materializations', producing 'the same effect of terror and unequivocal alluring repugnance [*sic*] as that of the soft belly of a butterfly seen between the luminescences of its wings'.[58] We can also take in just how opposed in its preference such psychoanalytically inflected, Surrealist pictorial analysis was to the high modernism to come and why Greenberg, perfectly aware of Dalí's one-of-a-kind contributions to art criticism, would himself make a comparison between Pre-Raphaelitism and Surrealism in which neither came out well, in the hypnotically repudiatory essay written a few years later that consigned most of Surrealism to 'academic' status and refused to take Dalí seriously.[59] Fascinated by the often curvaceous structures of art nouveau, Dalí had already declared himself the first artist of the *époque de mou* in *Minotaure* in 1934, so what he saw as the erasure of the supple erotic body at the expense of the physicality of medium in Cézanne's painting did little to recommend itself to his innovative interpretations, which were as heavily directed by psychoanalytic theory in their form as in their content.[60] Indeed, the point is that here are two different methods of writing on art – not two different kinds of art – that turn on interpretation by means of the psychoanalytic body, on the one hand, and visual sensation, on the other. Therefore, the question Dalí inadvertently raised was: might the interpretation of Cézanne, too, be turned from visual sensation and go all the way down to the unconscious?

56 Friction between Surrealism and the Association Abstraction-Création, set up in 1931, is most evident in the attack upon the 'modèle de débilité mentale qui s'appelle art abstrait, abstraction-création, art non-figuratif, etc.' made under the subheading 'Abjection et Misère de l'Abstraction-Création' in Salvador Dalí, *La Conquête de l'irrationnel*, Paris: Éditions Surréalistes, 1935, 19.
57 Greenberg, *Collected Essays and Criticism, vol. 3*, 386–7.
58 Dalí, *Collected Writings*, 310, 312.
59 Clement Greenberg, 'Surrealist Painting' [1944], *The Collected Essays and Criticism, vol. 1, Perceptions and Judgements, 1939–1944*, ed. John O'Brian, Chicago and London: The University of Chicago Press, 1986, 225–31.
60 Salvador Dalí, 'Aerodynamic Apparitions of "Beings-Objects,"' *Collected Writings*, 207–11, 209; Salvador Dalí, 'Apparitions aérodynamique des "Être-Objets,"' *Minotaure*, no. 6, Winter 1934–5, 33–4, 34. For a discussion of the scientific and psychoanalytic components of this text, see my *Surrealism, Art and Modern Science: Relativity, Quantum Mechanics, Epistemology*, New Haven and London: Yale University Press, 2008, 185–7. There is an alternative view of modernist writing on Cézanne that inserts it into 'traditional criticism of Cézanne's art, with its awkward mix of metaphors of touch and vision', which means 'his painting never accommodated a straightforward "visual" interpretation', but this argument reduces Greenberg to a footnote and has nothing to say about Fry or Bell: see Richard Shiff, 'Cézanne's Physicality: The Politics of Touch', Salim Kemal and Ivan Gaskel (eds), *The Language of Art History*, Cambridge: Cambridge University Press, 1991, 129–80, 166.

Metaphysical unease: Psychoanalysis, Cézanne and Breton in 1936

Still in the year 1936, Breton was pulling together the texts that would soon be published as his third (non-anthologized) major book *Mad Love*. The main purpose of this poetic, theoretical tract was to give a Surrealist account of the ways in which love, as the most powerful concrete representative of unconscious desire, can be the luminous guide by which people can comprehend the partly conscious and partly unconscious motivations that lie behind everyday events, relationships, behaviour, acts, decisions and coincidences. It maintains that this is love rooted in eroticism, exceeding the common, sentimental, socially and psychologically delimited version of love. If the signposts it creates are followed, it can give the same remarkable access to ways of understanding the world and the mind as dreams and magic.

The two most repeated anecdotes in *Mad Love* are meant to illustrate this and can be sketched briefly. In the third section of the book, Breton detailed a visit he made with Alberto Giacometti to the flea market at Saint-Ouen to the north of Paris, where both men buy objects to which they are powerfully attracted: a large wooden spoon with a small shoe at the end of the handle for Breton; a metal, slatted mask for the eyes and nose for Giacometti (figures 1.9 and 1.10). Breton interprets them in the way Freud had treated dreams, as condensed, manifest material, the latencies of which bespoke, in both cases, inner erotic necessity. The discovery of the two objects was determined, he maintained, by unconscious wishes on the part of the poet and the sculptor to address and overcome obstacles related to love.[61]

The second, equally well-known episode appears in the fourth section of *Mad Love* and is that of Breton's first encounter and euphoric nocturnal stroll in Paris with

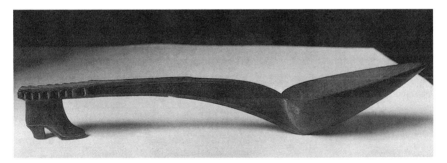

Figure 1.9 Man Ray, photograph of 'slipper spoon', 1937 (published in André Breton, *L'amour fou*, 1937). © Man Ray Trust/ADAGP-DACS/Telimage 2018.

[61] André Breton, *Mad Love* [1937], trans. Mary Ann Caws, Lincoln and London: University of Nebraska Press, 1987, 25–38.

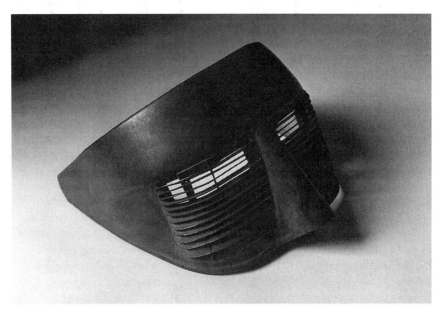

Figure 1.10 Man Ray, photograph of mask, 1937 (published in André Breton, *L'amour fou*, 1937). Collection Man Ray Trust. © Man Ray Trust/ADAGP-DACS/Telimage 2018.

his future wife Jacqueline Lamba on 29 May 1934, followed a few days later by his rediscovery of his 1923 poem 'Sunflower', which he re-read as a point-by-point precognitive account of the events of that evening.[62] Breton drew attention to these two incidents in *Mad Love* to argue that the strength of feeling associated with love heightens the events, relationships, objects and so on that surround it, making them perfect analytical material for fathoming the capricious orbits of the mind. Like much of Breton's work, the whole book is an attempt to salvage predestination as a material possibility that can be understood as the province of poetry and not as mere superstition or a fantasy of magic, corroborated through events heightened by love by means of methods and a language developed from psychoanalysis.

Brought together from a set of essays written (and some of them published) over a four-year period, *Mad Love* was some way into the publication process when Breton decided to add as section six a further anecdote relating a recent event, which has been barely discussed in the scholarship on Surrealism.[63] Concerned with temporary discord in love, 'a banal theme of popular songs' as Breton put it, this section of *Mad Love* is situated in Lorient on the southern coast of Brittany where his parents lived,

[62] Breton, *Mad Love*, 39–67.
[63] For more details on the publication of the book, see André Breton, *Oeuvres complètes*, vol. 2, Paris: Gallimard, 1992, 1693.

and where he was holidaying as usual in the summer of 1936.[64] On the afternoon of 20 July, a bus sets him and Lamba down at the beach location of Le Fort-Bloqué, about seven miles west of Lorient. The weather is poor, the landscape uninteresting and the married pair bored. When they set off walking in search of some signs of life they are directed towards Le Pouldu, ten miles away, made famous by Gauguin's time there with Charles Filiger and others in the late 1880s (but not enough by the 1930s for Breton to mention it). As they skirt the monotonous shoreline, Breton's boredom turns to irritation and he begins uncharacteristically pelting seagulls with stones. The stilted conversation of the fed up couple turns to sullen silence as they approach a building:

> Would this day never end! The presence of an apparently uninhabited house a hundred metres along on the right added to the absurd and unjustifiable nature of our walking along in a setting like this. This house, recently built, had nothing to compensate the watching eye for its isolation. It opened out on a rather large enclosure stretching down to the sea and bordered, it seemed to me, by a metallic trellis, which, given the prodigious avarice of the land in such a place, had a lugubrious effect on me, without my stopping to analyze it.[65]

Some minor squabbling with Lamba takes place as their grim promenade progresses. It is all so dissimilar to the euphoric stroll of the 'Night of the Sunflower' recorded in the earlier section of *Mad Love*, which it is meant to meet dialectically as the abrasive, hidden underside of the harmonious aspect of love. Breton feels a '*panicked* desire to turn back on my steps' as he crosses a stream in that terrain, believing it is getting too late to reach their destination, then the holiday reaches its nadir as the unhappy couple separate to walk around either side of a small fort, also abandoned.[66] Soon after, the barren, deserted landscape recedes, they reach an attractive area of beach, and good contact is resumed. Refusing to accept anything so commonplace as ordinary discord between individuals, Breton insists of those moments, 'we could only have been under the sway of some delirium'.[67]

That hypothesis was verified as far as Breton was concerned when he recounted the last few miserable hours to his parents back at their house, at which point his father intervened to remind him that the empty house they passed had been that of Michel Henriot, which lay at the centre of the notorious '*drame du loch*' (figure 1.11).[68] Breton instantly recalled that banal yet spectacular rural incident and its vivid narrative because the trial had been headline or front page news in the local, national, international and specialist press the previous summer (figure 1.12):

[64] Breton, *Mad Love*, 99.
[65] Breton, *Mad Love*, 102–3.
[66] Breton, *Mad Love*, 103.
[67] Breton, *Mad Love*, 104.
[68] See the note on the manuscript in Breton, *Oeuvres complètes*, vol. 2, 1732.

LE DRAME DU LOCH

Michel Henriot
l'assassin de sa femme devant les Assises

MICHEL HENRIOT, DEBOUT, ÉCOUTE L'ACTE D'ACCUSATION
Devant lui ses avocats : à gauche, Me Beneix ; à droite, Me Legrand.

(Photo-cliché « L'Ouest-Éclair ».)

VANNES, 27 juin (de notre envoyé spécial). — Michel Henriot, l'assassin du Loch, n'a guère changé depuis le jour où, cour la première fois, je le rencontrai dans sa villa isolée du Loch, en Guidel, pleurant à côté du cercueil dans lequel reposait, atrocement mutilée, celle qui avait été sa femme, la petite Georgette Deglave qui, à moins de 19 ans, avait été assassinée en plein jour, par un rôdeur, affirmait le mari, en cet après-midi du 8 mai 1934.

Je l'ai vu tout à l'heure à son arrivée au palais de justice où il est entré par une porte dérobée ouvrant sur la rue de la salle d'asile. Peut-être même a-t-il quelque peu engraissé. Il est moins pâle et ses joues bien remplies ont la couleur d'une peau de pêche. Il s'avance encadré d'un groupe de gendarmes, les mains lourdement enchaînées. Il s'arrête un instant, surpris par le déclic des appareils photographiques, mais il reprend vite son assurance et il s'esquive à pas rapide vers la salle réservée aux accusés avant leur introduction dans la salle des Assises.

Le voici assis dans le box des accusés gardé par deux gendarmes, ayant devant lui ses défenseurs Me Étienne Legrand, de Lorient, et Me Beneix, de Paris, qu'assiste le secrétaire Me Odette Lazard.

Vêtu d'un complet noir, il baisse la tête comme il la baissait au cours de cet après-midi de l'Ascension 1934 alors qu'il suivait, les yeux gonflés et rougis par les larmes, le convoi funèbre de celle qui avait été sa compagne et qu'il avait assassinée sauvagement.

Les moustaches blondes qu'il a laissé pousser assez longues dissimulent presque complètement le bas de son visage. Mais il a conservé cette physionomie sournoise dans laquelle les yeux apparaissent mobiles et incapables de fixer leur attention sur le même objet.

Il semble se soucier bien peu de la foule qui s'est précipitée vers le palais de justice, mais qu'un service d'ordre rigoureux et parfaitement organisé a filtré minutieusement. Il n'a d'yeux que pour les magistrats qui composent la Cour. M. le conseiller Papin Beaufond, de la Cour de Rennes ; MM. Huc, président du Tribunal civil de Vannes et Trousselou, juge au Tribunal ; M. Guihière, juge au siège, a été désigné comme juge supplémentaire.

C'est à peine s'il paraîtra prêter attention à la lecture de l'acte d'accusation que fait d'une voix monotone M. Guennec, commis greffier. Il ne manifestera pas plus d'émotion lorsqu'il appelle son huissier audiencier, les témoins, parmi lesquels nombreux sont ses proches et ses anciens amis, défilent devant lui.

Mais voici un résumé de l'acte d'accusation.

LA SCÈNE DU CRIME

Le 8 mai 1934, vers 13 heures, René-Michel Henriot, éleveur de renards argentés, à Kerbennec en Guidel, qui, selon son habitude s'était rendu à Lorient en automobile pour acheter du poisson pour ses bêtes, rentra à son domicile où sa femme l'aida à décharger les provisions. Une heure plus tard une dispute éclata entre les époux qui étaient seuls chez eux. Commencée dans la cuisine, cette querelle se continua dans une chambre voisine. À un moment donné Henriot recourut à la cuisine où il s'empara d'un tisonnier et revint en courant vers sa femme qui se tenait dans le vestibule. Devant l'aspect menaçant de son mari, Mme Henriot voulut s'enfermer dans les cabinets d'aisance, mais celui-ci ayant réussi à pénétrer à sa suite dans cette pièce, lui asséna sur la tête un coup si violent, que le sang gicla sur les murs et sur les vêtements mêmes de l'agresseur.

Malgré ses souffrances, Mme Henriot réussit pourtant à s'échapper de cette pièce et se réfugia dans un bureau contigu où se trouvait le téléphone. Elle décrocha l'écouteur et tenta d'appeler au secours. Prise de frayeur et sous le coup de la douleur, elle ne put que pousser des cris perçants et inarticulés semblables à des hurlements, comme déclara plus tard le téléphoniste qui s'était mis à l'écoute aussitôt après le déclenchement de la sonnerie ; il était à ce moment 16 h. 25.

En présence des appels de sa femme, Henriot s'empara de la carabine déposée à l'entrée d'une chambre faisant face au bureau et qui, selon les dires de l'accusé, était toujours chargée. Dans le vestibule, il commença en marchant, à tirer une première fois sur sa femme puis sans arrêt quatre autres fois alors que cette dernière était déjà tombée sur le plancher. Mme Henriot fut atteinte de cinq coups de feu, deux à la face, un au cou et deux autres à l'épaule gauche.

Henriot saisit aussitôt sa victime par les pieds et la traîna jusqu'à son lit où il l'étendit. Celle-ci succomba quelques minutes après à l'hémorragie considérable consécutive à ses blessures.

Très maître de lui et porteur de son fusil pour laisser croire qu'il revenait de chasser, Henriot sortit alors, et ayant rencontré un cultivateur du village voisin, M. Bouger, qui revenait dans un champ, il lui cria : « Bouger, viens voir, ma femme est tuée. »

Accompagné de plusieurs autres voisins, celui-ci se rendit sur les lieux où déjà l'avait précédé Henriot ; un autre paysan, M. Le Crom, qui avait suivi M. Bouger, vit Henriot sortir d'une chambre tuée en face du bureau, sa carabine à la main et déposer celle-ci en biais sur le plancher du couloir.

Aux témoins aussitôt accourus comme aux premiers enquêteurs, Henriot déclara que sa derrière était, déjà pour chasser sur la falaise, il avait trouvé à son retour sa femme assassinée sans doute par un rôdeur ou par un mendiant venu demander un peu d'aumône.

Durant ces deux jours qui suivirent ces faits, Henriot tenta d'accréditer la version du crime commis par un vagabond et assista même avec beaucoup

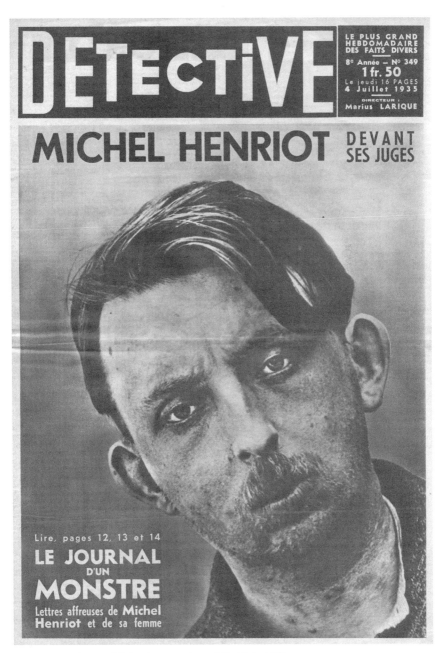

Figure 1.12 Cover of *Détective*, year 8, no. 349, 4 July 1935.

the whole criminal case reconstituted itself under my eyes, one of the most singular, the most picturesque cases imaginable. It had indeed in its time occasioned much discussion. ... the exterior appearance of this house, even with the *halo* I had found myself attributing to it, is so everyday that you could not possibly recognize it from the pictures published in the papers.[69]

Henriot was the son of the *procureur de la République* or local public prosecutor of Lorient (figure 1.13). Initially, he suggested to the police that the murder of his wife, Georgette Deglave, on 8 May 1934 by shots from a hunting rifle, had been carried out in his absence by a homeless drifter. Suspicion soon fell upon Henriot when it was discovered that he had taken out a life insurance policy on her to the tune of 800,000 francs should she die before him. Following his peremptory confession under questioning on 11 May (in which he claimed the motivation for the murder was not greed but his wife refusing him sex), Henriot's parents made pathetic appeals on his behalf at the brief trial of 27 June–1 July 1935. Over the course of those days, it was heard that the marriage of Michel and Georgette was not founded on love but was the outcome of their parents' desire to bring together two fortunes. Deeply distressed letters sent more or less daily by the unfortunate Deglave to her sister Marie from October 1933 until two days before her fatal shooting were read out in court. Several times they predicted her murder at the hands of Henriot, linked to the insurance policy, by detailing his death threats, physical abuse and neglect of her in favour of the silver foxes he reared.[70] This correspondence had no effect whatsoever on her relatives and failed to save Deglave's life: '[a] lovely testimony in honour of the bourgeois family', concluded Breton.[71]

All of this set up Breton's argument that the temporary disenchantment between himself and Lamba was caused by the geographical locale in which these events took place. Henriot's habit of shooting at seagulls for the pleasure of seeing them die slowly, as reported in the press, was revisited in Breton's own impatient behaviour of that day. Deglave's funeral procession led by the sobbing Henriot and attended by most of the townspeople of Lorient (figure 1.14) had initially followed the same lugubrious path as that taken by Breton and Lamba where they first fell into frustrated silence. The acrimonious, blighted liaison in that isolated house built by Henriot after his marriage degraded Breton and Lamba's loving relationship when they drew near to it. Finally, the ground between the 'villa of the Loch' and the small fort, where it was reported that the Henriots had set up temporary home until building on the villa was completed, was for Breton 'that afternoon such an exceptional place of disgrace'.[72]

Although Breton reserved judgement as to whether the bleak atmosphere of the area was determined by the murder carried out by Henriot or whether that fatal

[69] Breton, *Mad Love*, 104 (translation slightly modified).
[70] Extracts from Deglave's letters along with Henriot's written confession are reprinted in Henri Danjou, 'Journal d'un monstre', *Détective*, year 8, no. 349, 4 July 1935, 12–14.
[71] Breton, *Mad Love*, 108.
[72] Breton, *Mad Love*, 109.

Figure 1.13 *Dans la région*, report of 'the affair of the loch', 29 June 1935.

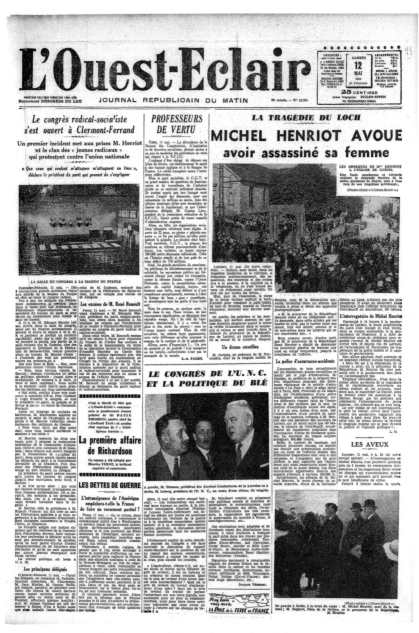

Figure 1.14 *L'Ouest-Éclair*, report of the confession of Michel Henriot and funeral of Georgette Deglave, 12 May 1934.

incident was itself the outcome of a locale previously saturated for some reason and in some way with malevolence, he was in no doubt that the disturbance that entered into the love between himself and his wife was caused by a malicious frequency generated by the history of that part of Brittany. The couple had merely tuned into it innocently and accidentally that unhappy day, no matter, he writes, 'how medieval such a way of seeing, in the eyes of certain positivistic minds, may seem.'[73]

Now, in between Breton's first mention of the Henriot affair in *Mad Love* and his subsequent detailed report of the crime and its aftermath in the book, comes a sudden and perplexing digression. This is given over to a sympathetic assessment of the painting of Cézanne, an artist usually thought of as reviled by the Surrealists for reasons to do with craft, as we have seen, to which Breton alludes at the outset of his aside:

> Here I open a parenthesis to declare that contrary to the current interpretation, I think Cézanne is not above all a painter of apples, but the painter of *The House of the Hanged Man* [*La Maison du pendu*]. I insist that the technical preoccupations, which everyone starts to talk about as soon as it is a question of Cézanne, make us too systematically forget the concern he showed, on several occasions, to treat those subjects having a *halo* [ces subjets à *halo*] from *Murder* of 1870, which bears witness to this concern with evidence, up to the [*Card*] *Players* of 1892, around which there floats a half-tragic, half-guignolesque menace in every point resembling the one pictured in the card game of Chaplin's film *A Dog's Life*, without forgetting the *Young Man before a Skull* of 1890, in its apparent conception of an ultra-conventional romanticism, but in its execution extending far beyond this romanticism: the metaphysical unease falls on the painting *through the pleats of the curtain*.[74]

[73] Breton, *Mad Love*, 110. As well as providing the cover stories for French crime magazines *Police Magazine* in May 1934 soon after Henriot's confession, and *Détective* in July 1935 after the trial, the case was reported the year after the publication of Breton's book with photographs of Henriot at Deglave's funeral and on trial as well as extracts from Deglave's diary, along with the crime of the Papin sisters (to which the Surrealists had also responded), under the editorship of the psychoanalyst René Allendy who had treated Antonin Artaud and René Crevel, in a special issue of *Crapouillot* ('Les Crime et les perversions instinctives'), May 1938, 35–8. For more details of Henriot's background, life and trial (narrated, again coincidentally, immediately after the cases of Surrealist anti-heroines the Papin sisters and Violette Nozières), see Maurice Garçon, *Histoire de la Justice sous la III République*, vol. 3, Paris: Librairie Arthème Fayard, 1957, 87–93. In the only full account in English, which draws on *Détective* and *Crapouillot*, Henriot is said to have died in 1945; apparently from tuberculosis after he had been drafted by the Nazis to help with the Atlantic Wall fortifications: Alister Kershaw, *Murder in France*, London: Constable & Company Limited, 1955, 118–31. His personality and Georgette's funeral are recalled by 'Margaët' who was born in Lorient in 1913 and testified to the renown of the crime when she said of the villa: '[t]out le monde allait voir le lieu du drame, on venait même de loin pour ça', Guillaume Moingeon (ed.), *Paroles de bretonnes*, Turquant: L'Àpart Éditions, 2011, 149.
[74] Breton, *Mad Love*, 106 (translation slightly modified). His abrupt turnaround on Cézanne begun in this passage gains added force through comparison with his defence of the politics of avant-garde and Surrealist art the previous year where Breton had contended implicitly that the apple-painting Cézanne was not even an avant-garde artist: André Breton, 'Political Position of Today's Art' [1935], *Manifestoes of Surrealism*, trans Richard Seaver and Helen R. Lane, Ann Arbor: University of Michigan Press, 1972, 212–33, 215.

Breton joined the exactly contemporary reinterpretation of Cézanne close to the Surrealist group here. Although he did not mention it, he must have had in mind Dalí's recent broadside against Cézanne's architectural apples because it had appeared only two months earlier in *Minotaure*. Still active in Surrealism, Dalí had been pushed to the outer circle of the group over the preceding two years due to his fascination with Adolph Hitler and somewhat ill-judged rendering of Lenin in his paintings (as far as Breton and his friends were concerned), all of which no doubt helped spur Breton's alternative reading in this digression. By reminding him of the painting by Cézanne in which another death had seemingly taken place, what Breton saw as the 'halo' surrounding the former home of Michel Henriot and his wife and the source of his recent tense and uncanny experience, filtered through reflections on violence and chance in a rural setting, nudged him further into rethinking Cézanne within the larger concerns of the Surrealists.[75] That is why he inserted these thoughts self-consciously into his book in the most abrupt manner as a kind of textual *aperçu*. But in Breton's compressed reading (covering only just over a page) these are implied rather than stated outright, so for clarification I will draw them out here in relation to the main concerns of *Mad Love* and view them in the ways in which they connect to the experience near Lorient that he describes.

In fact, as Marguerite Bonnet pointed out, the painting by Cézanne that Breton reproduced in *Mad Love* is not commonly known under the title *The House of the Hanged Man* but as the less evocative (though not much less relevant to his anecdote) *The Abandoned House* (*La Maison abandonée*, 1878–9) (figure 1.15 and plate 1a).[76] Although it is not one of Cézanne's best known paintings, it is certain that *The Abandoned House*, reproduced in all subsequent editions of *Mad Love*, is the painting Breton had in mind, because this is the tableau he describes slightly further along:

> *The House of the Hanged Man*, in particular, has always seemed to me very singularly placed on the canvas of 1885 [*sic*], placed so as to render an account of something else entirely than its exterior aspect as a house, at least to present it under its most

[75] In her translation, Mary Ann Caws renders *halo* as 'aura', which perhaps gives an English-speaking audience a stronger sense of Breton's meaning and also helps to distance the term from any religious connotation unintended by Breton, but I am preferring the correct dictionary translation 'halo' here to avoid any confusion with Benjaminian readings of Surrealism through that term, which is clearly used in a different manner in the well-known essay: Walter Benjamin, 'Surrealism: The Last Snapshot of the European Intelligentsia' [1929], *One Way Street and Other Writings*, trans Edmund Jephcott and Kingsley Shorter, London and New York: Verso, 1997, 225–39. It is worth pointing out that Breton used in italics the same word '*halo*' after the war, when Surrealism had become fully immersed in magic and the occult, to designate the powers of the beings honoured in the 'altars' of the comeback exhibition *Le Surréalisme en 1947* and also a little later for the equally revered artefacts of the South Sea Islands: André Breton, 'Surrealist Comet' [1947] and 'Oceania' [1948], *Free Rein* [1953], trans Michel Parmentier and Jacqueline d'Amboise, Lincoln and London: University of Nebraska Press, 1995, 88–97, 95 and 170–4, 174. However, around the same time he used the French word '*aura*', also in italics, to designate both pre-Columbian objects and the writings of poets such as Rimbaud, showing some interchangeability between the two words: André Breton, 'Caught in the Act' [1949], *Free Rein*, 125–69, 128.

[76] Breton, *Oeuvres complètes*, vol. 2, 1732.

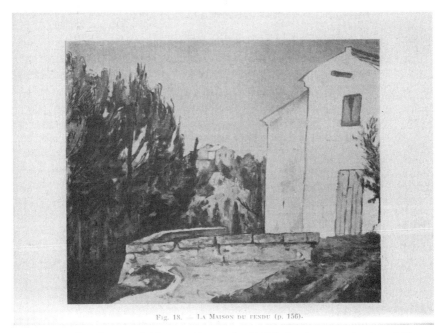

Fig. 18. — LA MAISON DU PENDU (p. 156).

Figure 1.15 Page from André Breton, *L'amour fou* (1937) showing reproduction of *The Abandoned House* (1878–9).

suspect angle: the horizontal black patch above the window, the crumbling, towards the left, of the wall on the first level. It is not a matter of anecdote, here: it is a question, within painting for example, of the necessity of expressing the relationship which cannot fail to exist between the fall of a human body, a cord strung around its neck, into emptiness, and the place itself where this drama has come to pass, a place which it is, moreover, human nature to come and inspect. Consciousness of this relation for Cézanne suffices to explain to me why he pushed back the building on the right in such a way as to hide it in part and, consequently, to make it appear *higher*. I willingly admit that, because of his particular aptitude to perceive these halos and to concentrate his attention on them, Cézanne was led to study them in their immediacy, considering them in their most elementary structure.[77]

The much better-known, entirely dissimilar painting by Cézanne bearing the title *The House of the Hanged Man, Auvers-sur-Oise* (*La Maison du pendu, Auvers-sur-Oise*) (plate 1b) – shown in the first Impressionist exhibition in 1874 and at many others

[77] Breton, *Mad Love*, 106 (translation slightly modified).

since – was dated *c.* 1873 by John Rewald, while *The Abandoned House* reproduced in *Mad Love* was dated by Rewald 1878–9. Right painting, wrong title, wrong date; the house in this canvas prioritized by Breton to demonstrate his thesis that Cézanne had the sensitivity and insight of a seer, a property long claimed by Surrealist poets and painters such as Breton himself, Victor Brauner, Ernst and André Masson, supposedly finely tuned to the disjointed language of the unconscious (or 'mouth of shadows' as Breton termed it after Victor Hugo), had nothing to do with hanged men.[78] It might have had no sinister aspect at all for all we know. The 'halo' reading is Breton's of this painting, not Cézanne's of his *motif.*

What is more puzzling about Breton's slip on the title and its extension into his interpretation of the painting – even if it does not achieve the same proportions as Freud's considerably more repercussive gaffe in his essay on Leonardo da Vinci – is that he must have known the heavily worked and textured *House of the Hanged Man* because in the 1930s it usually hung in the Louvre (it is now in the Musée d'Orsay).[79] This is still more the case because at the moment he was in Lorient with Lamba and as he wrote up their 'villa of the Loch' experience for inclusion in *Mad Love* (between 28 August and 1 September), the squarish, grainy painting was on display under its own correct title at the Orangerie in the large 1936 Cézanne retrospective that ran from May till October (correctly dated there 1873).[80] The summer exhibition began before he went to Lorient and ended after his return. It could have been a third prompt – alongside the 'delirious' episode at Le Fort-Bloqué and the general debate on Cézanne in Surrealist circles – for the peculiar note on the artist slipped into the book in the midst of the Henriot section (the *avant-propos* in the exhibition booklet by Jacques-Émile Blanche titled 'Les Techniques de Cézanne' covers exactly the ground on the artist that Breton thought was most overworked).[81]

Bonnet has given a reason for Breton's lapse: *The Abandoned House* appeared under the title *Das Haus des Gehängten* when reproduced in the 1918 book by Meier-Graefe, *Cézanne und sein Kreis* dated 'gegen 1885'.[82] This is the same incorrect year used and title translated by Breton. Since the other three paintings he mentioned in his Cézanne sidebar in *Mad Love* are all reproduced by Meier-Graefe with the titles and dates he gave, we can assume with Bonnet that this was the reference source he had

[78] André Breton, 'Le La' ['The Tone Setting', 1961], *Poems of André Breton: A Bilingual Anthology*, eds and trans Jean-Pierre Cauvin and Mary Ann Caws, Austin TX: University of Texas Press, 1982, 228–9. Breton was referring in this phrase to the long poem 'Ce que dit la bouche d'ombre' of the 1850s, which gave its title to the collection he owned by Victor Hugo, *La Bouche d'ombre*, Paris: Gallimard, 1943.

[79] Sigmund Freud, 'Leonardo da Vinci and a Memory of his Childhood' [1910], *Art and Literature*, Penguin: Harmondsworth, 1990, 151–231. Breton had mentioned this 'admirable piece by Freud' a few pages earlier in the course of a deliberation on the interpretation of arbitrary phenomena: Breton, *Mad Love*, 86.

[80] The dates on which he wrote of the incident with Lamba are marked on the manuscript and given by Bonnet in Breton, *Oeuvres complètes*, vol. 2, 1693.

[81] Jacques-Émile Blanche, 'Les Techniques de Cézanne', Paris: Musée de l'Orangerie, *Cézanne*, 1936, 9–16.

[82] Julius Meier-Graefe, *Cézanne und sein Kreis*, Munich: R. Piper and Co., 1918, 145.

to hand; either that or its 1927 English-language equivalent.[83] Meier-Graefe's is a far more passionate and sensual Cézanne than is commonplace in the literature on the artist and he is delivered in an elevated prose style. This would have been agreeable to the 'Romantic' ear of Breton who, as well as having an extremely high regard for the art and writing of Germany, had a good understanding of the language. Roger Fry, on the other hand, found Meier-Graefe's 'rather breathless and involved phrasing', which had been conscientiously translated, a little too coarse for the English ear[84]:

> One day he considered himself as the chosen, and the next he grovelled on the floor contemplating suicide. A man in search of God whom he does not find, capable of smashing the world if he does not find Him, a Gothic creature. At times one could have taken him for one of the zealous partisans of the Huguenot period. He was possessed by an absolutism of ideas for which no sacrifice was too great; he was dangerously overwrought, naïve to the point of being ludicrous and withal incalculable. What he really wanted remained vague, and his picture did not contribute to supply enlightenment; awkward deformations painted from memory on principle, directed against nature, in opposition to every form of tradition. All that was evident was the intention to give something different from what had hitherto been considered as art. Nothing was less Gothic than the savage form of these pictures. Only his spirit was Gothic, his incorruptible Protestantism, the refusal to learn from others anything which one must find out for oneself, the determination to begin at the beginning and to build the road to heaven with his own hands.[85]

Overwrought is the word. As well as showing through in such histrionic passages, Meier-Graefe's day jobs as novelist and playwright are evident in the total absence of visual analysis in his writing; in fact, he rarely refers to actual paintings at all in the book. His Romantic leanings come through in his use of the terms 'romanticism' for certain of Cézanne's 'black idylls around 1870',[86] and 'Baroque' for some of the works of that period such as *Murder*,[87] as well as in the unexpected attribution here of a 'Gothic nature' to Cézanne.[88] This is as close as the Provençal artist ever came to a German makeover. Breton would have loved it.

[83] On the back of the reproduction of *The Abandoned House* that he used for *Mad Love*, Breton noted Meier-Graefe's name as well as Vollard's, referring to plate 20 of Vollard, *Paul Cézanne*, where the painting does indeed appear under its title *La Maison abandonée* (he also made a note of plate 44 of that book, where the painting appears again along with several others captioned 'Peintures exposées au Salon d'Automne de 1904'). Breton inscribed both titles on the back of his reproduction suggesting he simply plumped for the one that best illustrated his thesis: http://www.andrebreton.fr/fr/item/?GCOI=56600100050570 (accessed 10 January 2015). Although Vollard reproduced a little-known work titled *Le Meurtre* in his *Minotaure* essay on Cézanne, Breton must have meant the oil painting of that title now in the Walker Art Gallery in Liverpool dated *c.* 1868, which was shown at the Orangerie dated *c.* 1874–5 and is reproduced dated *c.* 1870 in Meier-Graefe, *Cézanne und sein Kreis*, 92.
[84] Roger Fry, 'In Praise of Cézanne', *The Burlington Magazine for Connoisseurs*, vol. 52, no. 299, February 1928, 98–9, 99.
[85] Meier-Graefe, *Cézanne*, 20–1.
[86] Meier-Graefe, *Cézanne*, 23.
[87] Meier-Graefe, *Cézanne*, 23.
[88] Meier-Graefe, *Cézanne*, 35.

Cézanne's *Card Players* and Surrealism's Cartomancy

As demonstrated by its inclusion within the discussion of the goings-on in Lorient, underlying the near-anthropomorphic metaphor of a hanged man erroneously projected by Breton onto certain details of *The Abandoned House* – in the decaying wall to the left as we look at the painting and in the air of suspension and semi-concealment carried by the house itself to the right (an argument that might have been strengthened had Breton not limply rendered the beam sticking out of the front of the house, used for drawing hay up into the opening below it, as a 'horizontal black patch') – is Breton's inquiry into the epistemology of chance.[89] This is his proposition that unacknowledged feelings might be the causal template for what are thought of as chance events, which tilt an individual's life one way or another, and their till-now unfathomable relation with place. Inherited from Dada though rooted in Symbolist poetry, the hand played by chance in matters of love, death and violence had long preoccupied Breton. Accordingly, he argued in *Mad Love* in the language of clairvoyance that the apparently arbitrary cards dealt by life to an individual were in fact susceptible to interpretation: '[e]very life contains these homogeneous patterns of facts, whose surface is cracked or cloudy', he wrote, '[e]ach person has only to stare at them fixedly in order to read his own future.'[90] As Breton wrote, the idea of 'objective chance' within Surrealism lies in incidents recounted in his *Nadja* (1928) and its first extension into a theory is in *Communicating Vessels* (1932) where it is closely associated with a statement credited by Breton to Friedrich Engels: '"Causality cannot be understood except as it is linked with the category of objective chance, a form of the manifestation of necessity."'[91] This led to Breton's own definition of chance in *Mad Love* as '"the encounter of an external causality and an internal finality."'[92]

The experience of coincidence and exploration of chance took place within Surrealist art and writing from their beginnings and meant that cards, card games and cartomancy held a particular, ritualistic place of significance among the individual and collective activities that focused the life of Surrealist groups. In *Mad Love*, Breton described whimsically how some days he sought to fathom the wishes, intentions and movements of women in his life by rearranging objects in his apartment and selecting sentences from books opened at random. 'Other days,' he continued, 'I used to consult my cards, interrogating them far beyond the rules of the game, although according to an invariable personal code, precise enough, trying to obtain from them for now and the future a clear view of my fortune and my misfortune.'[93] Sometimes, Breton sought 'better results' by including personal items among the configuration of cards, including a small statuette in raw rubber oozing a black liquid with its hand to its ear as though listening (figure 1.16): 'nothing prevents my declaring,' he wrote, 'that this last object,

[89] Breton, *Mad Love*, 106.
[90] Breton, *Mad Love*, 87.
[91] Quoted in André Breton, *Communicating Vessels* [1932], trans Mary Ann Caws and Geoffrey T. Harris, Lincoln and London: University of Nebraska Press, 1990, 91–2 (this quotation said by Breton to be by Engels remains obscure: Breton, *Oeuvres complètes*, vol. 2, 1402).
[92] Breton, *Mad Love*, 21.
[93] Breton, *Mad Love*, 15–16.

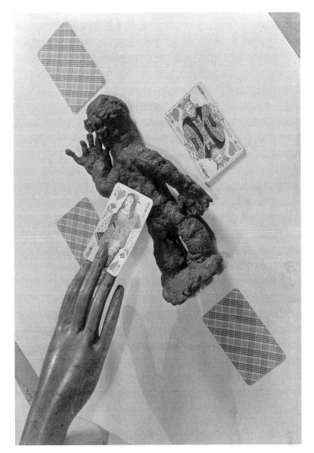

Figure 1.16 Man Ray, *Myself and her* (*Moi, elle*), 1934 (photograph published in André Breton, *L'amour fou*, 1937). © Man Ray Trust/ADAGP-DACS/Telimage 2018.

mediated by my cards, has never told me about anything other than myself, bringing me back always to the living centre of my life.'[94]

Breton and the Surrealists carried out research on playing cards while in Marseille awaiting transport out of Vichy France between 1939 and 1942.[95] The design of their own 1940–1 Marseille cards (figures 1.17 a, b and c) display a coalition of the traditional pack and the tarot (they were partly modelled on the frequently copied, late fifteenth-century *Tarot de Marseille*). On the one hand, the set retained the structure of the first by replacing the four familiar suits with Love, Dream, Revolution and Knowledge, and

[94] Breton, *Mad Love*, 16.
[95] Mark Polizzotti, *Revolution of the Mind: The Life of André Breton*, revised and updated, Boston: Black Widow Press, 2009, 444.

Figure 1.17 (a, b, c) Cards from the Surrealist 'Marseille Pack', 1940–1. Author's collection.

the Kings, Queens and Jacks with Geniuses, Sirens and Magi; on the other, it was accompanied by a symbolic language resonant of magic and the occult.[96]

The Surrealists' enthusiasm for the poetic properties and divinatory reputation of the tarot had been advertised on the cover of the joint third and fourth number of *Minotaure* as early as December 1933 when Breton's by-then former friend Derain, who was familiar with such practices and had read the cards to Breton during their acquaintance (at some point between 1919 and 1921, probably), created a cover that included four tarot cards.[97] Later, Kurt Seligmann devoted a lengthy and flatly credulous section of his 1948 *Mirror of Magic* to the tarot in which he wrote of the seer-like properties of those who read the cards and of the role of the appearance of the tarot in stimulating foresight:

Who has not, even if only once in his life, had that sensation called foreknowledge? Some future event is witnessed so clearly, so plastically, that its beholder knows immediately and with absolute certainty this *will* happen. And it does!

There are people specially gifted with such prescience or premonition, the born diviners. They stimulate their abnormal sensibility in many ways. Gazing at the crystal produces an autohypnotic condition; in fact, any glistening or colourful object when stared at for a time, may become equally stimulating to the imagination. Some clairvoyant people are able to tell where the stone which they press against their forehead was found. They can describe the landscape in which the stone lay, as well as the person who picked it up, etc.

The primary function of the tarot cards seems to be such stimulation. In scrutinizing the vividly coloured images, the diviner will provoke a kind of autohypnosis, or if he is less gifted, a concentration of the mind resulting in a profound mental absorption. The tarot's virtue is thus to induce that psychic or mental state favourable to divination.

[96] See André Breton, 'The Marseilles Deck' [1943], *Free Rein*, 48–50. Also see Bernard Noël, *Marseille – New York: 1940–1945. Une Liaison surréaliste*, Marseille: André Dimanche, 1985; Georges Raillard, 'Marseille: Passage du surréalisme', Marseille: Centre de la Vieille Charité, *La Planète affolée: Surréalisme, Dispersion et Influences, 1938–1947*, 1986, 47–65; Marseille: Musée de Marseille, *Le Jeu de Marseille: Autour d'André Breton et des Surréalistes à Marseille en 1940–1941*, 2003; Giovanna Costantini, 'Le Jeu de Marseille: The Breton Tarot as Jeu de Hasard', Arthur Versluis, Lee Irwin, John Richards and Melinda Weinstein (eds), *Esotericism, Art, and Imagination*, East Lansing MI: Michigan State University Press, 2008, 91–111; and Tessel M. Bauduin, *Surrealism and the Occult: Occultism and Western Esotericism in the Work and Movement of André Breton*, Amsterdam: Amsterdam University Press, 2014, 138–9, 142.

[97] The cover illustrated his reading inside based on the four aces of the tarot: André Derain, 'Critérium des As', *Minotaure*, no. 3/4, December 1933, 8. For his recollection of Derain's card reading sandwiched between 'deux superbes soliloques sur l'art et la pensée médiévale', see André Breton, '"C'EST A VOUS DE PARLER, JEUNE VOYANT DES CHOSES..."' [1952], *Perspective cavalière*, Paris: Gallimard, 1970, 13–20, 18. A few years earlier, it had been especially the tarot cards and alchemical and occultist illustrations in Grillot de Givry's *Musée des Sorciers* (1929) that had caught the eye of Michel Leiris, 'A propos du *Musée des sorciers*' (book review), *Documents*, Year 1, no. 2, May 1929, 109–16.

The striking tarot figures, specially the trumps or major arcana, appeal mysteriously and waken in us the images of our subconscious.[98]

As Simone Perks has suggested, by 'associating the visions received by the diviner with images of the subconscious, Seligmann gives a Surrealist inflection to divination'.[99] If it already sounds like a concoction forcing alignment of magic with Surrealist ideas sourced in psychoanalysis, Seligmann did not stop there, stating further along in *The Mirror of Magic* that the power of stimulation held by tarot cards made them 'the "poetry made by all" of the Surrealist postulate'.[100] Indeed, the identification between Surrealism and the tarot was so close at that time that Brauner based his painting *The Surrealist* of 1947 (figure 1.18) on The Magician, Magus or Juggler, the first card of the major arcana (to which Seligmann gave over a subsection of his book), and would paint a symbolic portrait of Breton that year combining that card with the one of The Popess, titling it after the sixth card of the major arcana, *The Lovers*.[101]

Because Breton had long been interested in divination and the tarot by the time he wrote *Mad Love*, it is no great leap to the conclusion that his attraction to and interpretation of the painting by Cézanne that he called *The House of the Hanged Man* was determined not just by an atmosphere evoked by that title, but the enhancement it underwent through its rhyme with The Hanged Man, the twelfth card of the major arcana of the tarot pack, which adds metaphorical layers of gaming and destiny to the painting brought to mind by the Henriot house.[102] This is confirmed by Breton's decision to place the reproduction of that painting back-to-back in *Mad Love* with the postcard of a building he directly associated with esotericism, the sixteenth-century star-shaped edifice a few miles outside Prague that he had visited in 1935, captioned here 'A FLANC D'ABIME, CONSTRUIT EN PIERRE PHILOSOPHALE.... '[103] (figure 1.19). The

[98] Kurt Seligmann, *The Mirror of Magic: A History of Magic in the Western World*, New York: Pantheon, 1948, 409.

[99] Simone Perks, '*Fatum* and *Fortuna*: André Masson, Surrealism and the Divinatory Arts', *Papers of Surrealism*, no. 3, spring 2005, n.p.

[100] Seligmann, *Mirror of Magic*, 416. For the now well-worn phrase '[p]oetry must be made by all. Not by one', see the *Poésies* (1870) of the pre-Surrealist Comte de Lautréamont, *Maldoror and Poems* [1869 and 1870], trans. Paul Knight, Harmondsworth: Penguin, 1988, 279.

[101] The significance of Brauner's painting is explored by Daniel Zamani, 'The Magician Triumphant: Occultism and Political Resistance in Victor Brauner's *Le Surréaliste* (1947)', *Abraxas*, no. 1, 2013, 100–11. This period of the late 1940s, representing a high point of Surrealism's fascination with magic and the occult, also saw its immersion in the tarot as can be seen in the leading theme of Breton's *Arcane 17* of 1944 (just before embarking on that book, in fact, he requested in a letter of March that Patrick Waldberg source some tarot cards for him in London, referring to the December 1933 'Derain' cover of *Minotaure* for guidance: Breton, *Oeuvres complètes*, vol. 3, 1165). For some excellent bibliographical (if not at all analytical) information on Surrealism and the tarot, see Patrick Lepetit, *The Esoteric Secrets of Surrealism: Origins, Magic, and Secret Societies* [2012], trans. Jon E. Graham, Rochester VT and Toronto: Inner Traditions, 2014, 129–41. For the earlier period of Surrealism, see the comparison between Masson's *Man with an Orange* (1923) and *The Magician* by Perks, '*Fatum* and *Fortuna*', n.p.

[102] This connection has been suggested without reference to Surrealism by one C. Rousseau, quoted in James C. Harris, 'The House of the Hanged Man at Auvers', *Archives of General Psychiatry*, vol. 63, no. 1, January 2006, 125–6.

[103] For details, see Bonnet in Breton, *Oeuvres complètes*, vol. 2, 1730–1.

Figure 1.18 Victor Brauner, *The Surrealist* (1947). Oil on canvas, 60 × 45 cm. The Solomon R. Guggenheim Foundation, Peggy Guggenheim Collection, Venice. © Solomon R. Guggenheim Foundation, Peggy Guggenheim Collection, Venice © ADAGP, Paris and DACS, London 2018.

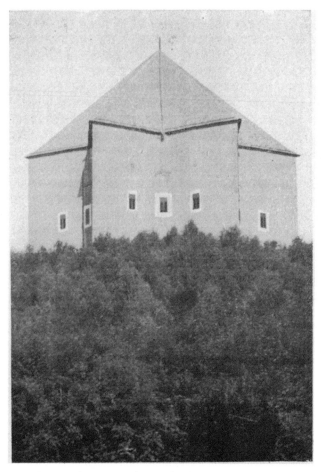

Figure 1.19 Page from André Breton, *L'amour fou* (1937) showing reproduction of postcard with star-shaped building.

Hanged Man is the most enigmatic card of the tarot ('in some packs,' writes one specialist, 'his head is surrounded by a halo'[104]) and was reproduced years later in Breton's *L'Art magique* on the page facing some examples from the *Tarot de Marseille*. Breton demonstrated there his reading of the scholarship on the tarot by mentioning the eighteenth-century 'correction' of The Hanged Man as Prudence or Man with a Raised Foot (*pede suspenso*) in the famous essay of Antoine Court de Gébelin.[105]

[104] Alfred Douglas, *The Tarot: The Origins, Meaning and Uses of the Cards*, Harmondsworth: Penguin, 1972, 80.
[105] Breton, *L'Art magique*, 164.

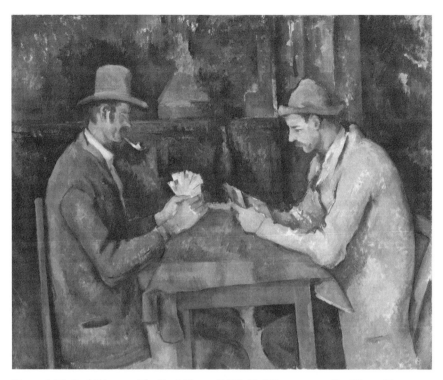

Figure 1.20 Paul Cézanne, *The Card Players* (1892–3). Oil on canvas, 60 × 73 cm. The Courtauld Gallery, London. © The Samuel Courtauld Trust, The Courtauld Gallery, London.

The themes of chance and fate with which *Mad Love* is largely taken up, and Surrealism's longstanding meditation on card playing as emblematic of these, no doubt informed Breton's characterization of Cézanne's *Card Players* (figure 1.20) as one of the paintings among those that were the outcome of a subject with a 'halo'. Breton could have seen two paintings from the two *Card Players* series at the 1936 Cézanne show at the Orangerie. One was the 1890–2 New York Metropolitan Museum group of three players watched over by a fourth male, dated 1890 in the Orangerie booklet, and the other was one of the three compositions with two figures of 1892–6, then in the Paris collection of Auguste Pellerin (now in a private collection in Switzerland) and dated by Rewald 1892–3. Well before the Orangerie exhibition, Breton had access to the 1892–3 version of the two-figure *Card Players* that hung in the Louvre (now in the Musée d'Orsay). Although he did not go into detail (beyond the 1892 date he gave, which I am assuming was taken from Meier-Graefe), as to which *Card Players* represents the 'haloed' subject perceived by Cézanne, Bonnet argues that it was one of the two-figure compositions, 'due to their background, gloomier and more complex than that of the two other paintings [of three players] where the individuals stand out

against a rather light wall, which is hard to place among those works in the category of "subjects with a halo."[106]

This conjecture gains some credence from Breton's estimation that around *The Card Players* 'floats a half-tragic, half-guignolesque menace in every point resembling the one pictured in the card game of Chaplin's film *A Dog's Life....*'[107] As Bonnet notes, this was another error on Breton's part because although there is indeed a scene in the 1918 film of that title where two men in hats and jackets, one with a moustache, sit opposite each other at a table comparable with the one in *The Card Players*, upon which, for a short time, a bottle stands between them pushed back towards its farther edge as we look, there is no card game (figures 1.21 and 1.22). This is the scene in which Charlie retrieves the wallet that two thieves have stolen from him by knocking one of them unconscious and performing his gestures to his partner from behind by shoving his arms beneath those of the comatose thief while concealed by a curtain. Given Breton's frequently expressed fascination with the curtain as a metaphor, we might assume that his remark about the other painting with a 'halo' subject by Cézanne, the *Young Man before a Skull*, in which 'metaphysical unease falls on the painting *through the pleats of the curtain*', was the memory trigger that brought that not very menacing scene from *A Dog's Life* inaccurately back to his mind.[108]

Therefore, if we accept that Breton was thinking of one of the two-figure *Card Players* in his discussion of the 'menace' that surrounds the 'halo' paintings, and if we can say further that his main reference source was the German version of Meier-Graefe's book, then we can add that it was probably the Courtauld *Card Players* that Breton found disquieting, for that is the version reproduced there (oddly, the English language version reproduces a different *Card Players*, the one then in the Pellerin collection, which was also shown at the Orangerie and reproduced in the exhibition booklet).[109]

I want to argue in conclusion that it is the two-figure composition and 'innocent' rurality of the *Card Players*, whichever version of the painting we choose, that is relevant to Breton's interpretation of the picture. I mentioned earlier that his temporary rethinking of Cézanne in the 1930s responded to Dalí's recent pronouncements on that artist's

[106] 'en raison de leur fond plus sombre et plus complexe que celui des deux autres toiles où les personnages se détachent sur un mur plutôt clair, ce qui place difficilement ces oeuvres dans la catégorie des "subjets à halo,"' Breton, *Oeuvres complètes*, vol. 2, 1732.

[107] Breton, *Mad Love*, 106.

[108] Breton, *Mad Love*, 106. For evidence that Breton viewed the curtain as a powerful metaphor, see the 1941 interview with *View* magazine in which he discussed the motif and its presence in paintings by Edward Hopper, Morris Hirschfield and de Chirico, reprinted in André Breton, *What is Surrealism? Selected Writings*, ed. Franklin Rosemont, London: Pluto Press, 1978, 199–206, 201–2. Bonnet's further suggestion that Breton got confused by the 1917 Chaplin film *The Immigrant*, which, as she says, contains 'une partie de dés et une partie de cartes célèbres' in the second scene, is also worth taking on, as it contains four characters including Charlie himself (like the four man New York Metropolitan painting) and might mean that Breton's memory was subject to a condensation of the two films, Breton, *Oeuvres complètes*, vol. 2, 1733.

[109] For an unconvincing attempt a few years later to turn Cézanne into a fully-fledged precursor by extending Breton's briefly held idea of the artist to other paintings, particularly those featuring the Harlequin, see Jean with Mezei, *History of Surrealist Painting*, 12–13.

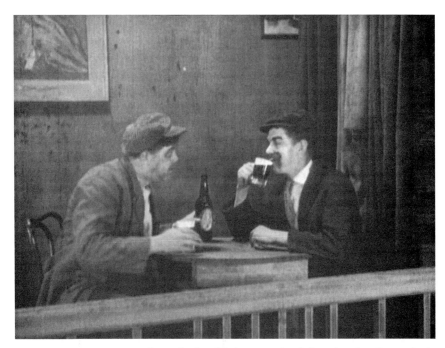

Figure 1.21 Screen capture from Charlie Chaplin, *A Dog's Life* (1918). © Roy Export SAS.

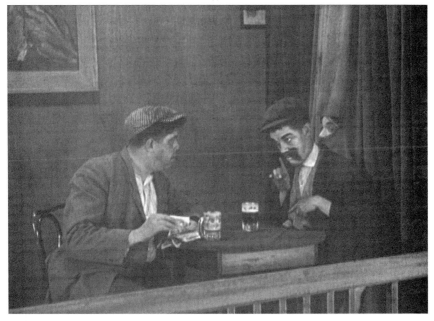

Figure 1.22 Screen capture from Charlie Chaplin, *A Dog's Life* (1918). © Roy Export SAS.

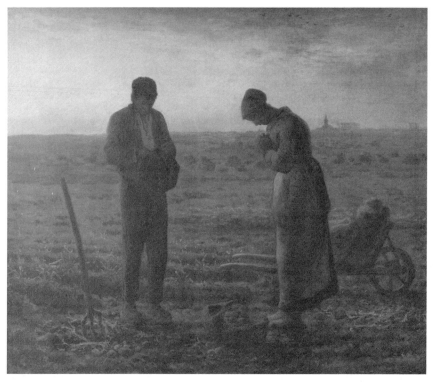

Figure 1.23 Jean-François Millet, *The Angelus* (1857–9). Oil on canvas, 56 × 66 cm. Musée d'Orsay, Paris. © Photo Josse/Scala, Florence.

apples in his essay on the Pre-Raphaelites in the same number of *Minotaure* as Breton's own article on desire and love (framed by his visit the previous year to Tenerife, soon to become part five of *Mad Love*).[110] But there was another source for Breton's volte-face: Dalí was concurrently poking around in the supposed depths of Jean-François Millet's pious, sentimental image of rural labour, *The Angelus* (figure 1.23, 1857–9) and coming up with plenty to talk about. Attracted to the 'bad taste' of *The Angelus* and its endless reproduction on postcards, tea sets, cushion covers, ink wells and so on, which obscured the original painting behind a screen of over-familiarity, Dalí aimed his Oedipal reading of *The Angelus* at the simpering admirers who crowded around it, exposing the lurid underside of the painting's manifest drama as though he were turning a stone over with his foot. Freely layering interpretations across *The Angelus* through associations that accrued to his own anxieties and childhood memories, dipped in the developing fluid of Freudian psychoanalysis, Dalí reached the extravagant conclusion (heavily abbreviated here) that the two figures are praying over the corpse of their buried son;

[110] André Breton, 'Le Château Étoilé', *Minotaure*, no. 8, June 1936, 25–39.

moreover, he added that the female figure to the right of the *Angelus* is a cannibalistic maternal variant of Saturn, Abraham, William Tell and others, who, in the manner of the praying mantis, is about to devour her son to the left, who anticipates this in a state of arousal that is concealed, in Dalí's reading, by the hat he holds.[111]

Most importantly, however, in his quest to show that an offensively inoffensive painting could be taken by the Surrealists and turned to their own purposes – carried out in his writing about *The Angelus* and also in the ten or so oil paintings he completed between 1929 and 1935 that refer to it, as well as his 1934 etchings illustrating *Les Chants de Maldoror* – Dalí blended Millet and Lautréamont:

> No image seems to be capable of illustrating more 'literally', in a more delirious way, Lautréamont and, in particular, *Les Chants de Maldoror*, than the one done about 70 years ago by the painter of tragic cannibalistic atavisms. . . . It is precisely Millet's *Angelus*, a painting famous all over, which in my opinion would be tantamount in painting to the well-known and sublime 'fortuitous encounter on a dissecting table of a sewing machine and an umbrella.' Nothing seems to me, indeed, to be able to illustrate this encounter as literally, in as horrifying and ultra-obvious a way, as the obsessive image of *The Angelus*.[112]

Breton read those words in the booklet that accompanied the exhibition of Dalí's celebrated *Maldoror* illustrations in 1934 at the Galerie Quatre Chemins. No doubt he had stayed abreast of the artist's outlandish findings on *The Angelus* up to then, which were first aired in *Minotaure* in 1933 (some of Dalí's etchings were reproduced in the joint third and fourth number of the review under Derain's tarot cover at the end of that year and others appeared when the collection was advertised for sale in *Minotaure* in 1934).[113]

A profound, violent tension undercut the seemingly modest, becalmed attitudes of the peasants in *The Angelus* in Dalí's interpretation. It was the same just-hidden menace that impressed itself on Breton in the emaciated, caricatural features of the *Card Players* against the background of his recent memory of the murder near Lorient, as though one player were about to eviscerate the other. Breton had no intention of following Dalí in seeking a narrative, psychoanalytic or otherwise, of the relations between Cézanne's peasant card players or in other paintings by the artist; he states clearly enough that his interest in *The Abandoned House/The House of the Hanged Man* 'is not a matter of

[111] Salvador Dalí, *Le Mythe tragique de l'Angelus de Millet*, Paris: Jean-Jacques Pauvert, 1963. For more commentary on Dalí's interpretation of *The Angelus*, see Dawn Ades, *Dalí*, London: Thames and Hudson, 1982, 140–9; Elkins, *Why Are Our Pictures Puzzles?* 231–45; Steven Harris, *Surrealist Thought in the 1930s: Art, Politics, and the Psyche*, Cambridge: Cambridge University Press, 2004, 125–7; Venice: Palazzo Grassi, *Dalí*, 2005, 190–4; Jordana Mendelson, *Documenting Spain: Artists, Exhibition Culture, and the Modern Nation, 1929–1939*, University Park PA: Penn State, 2005, 185–219.

[112] Salvador Dalí, 'Millet's *Angelus*' [1934], *Collected Writings*, 279–82, 280 (translation slightly modified).

[113] Salvador Dalí, 'Interprétation Paranoïaque-critique de l'Image obsédante "L'Angelus" de Millet', *Minotaure*, no. 1/2, February 1933, 65–7. His own fascination with Millet's *Angelus* took up much space in his paintings and writings in the mid-1930s, yet the final version of the book only appeared in the 1960s because apparently he lost the manuscript in France at the time of the German invasion in 1940 and only came across it again in 1962.

anecdote'.[114] Yet Dalí's discovery that even Millet's paintings might harbour 'hallucinations and sensory disturbances in the shadows',[115] and that 'good so nicely brings out evil'[116] – the terms the younger Breton had used to privilege Lautréamont's writing over modernist art like Cézanne's – must have made him realize in the midst of his later discussion of chance and divination in *Mad Love*, just for a brief moment in 1936, that a Surrealist interpretation of Cézanne-as-seer was possible over that of greengrocer or bricklayer, and had to go all the way down to the unconscious.[117]

[114] Breton, *Mad Love*, 106 (translation slightly modified).
[115] Breton, 'Characteristics', *Lost Steps*, 117.
[116] Breton, 'Characteristics', *Lost Steps*, 117–18.
[117] It should be noted briefly that before he joined the Surrealists, André Masson had rated Cézanne very favourably, up until about 1920: Georges Charbonnier, *Entretiens avec André Masson* [1957], Paris: Ryôan-ji, 1983, 29–30. Then after his second Surrealist phase ended in 1943, he would once again praise Cézanne highly, comparing his card players – 'en soie de pétrification' – to the children constructing houses of cards in the paintings of Jean-Baptiste-Siméon Chardin, professing in later years of the version then in the Louvre: '[j]'ai toujours considéré les *Jouers de cartes* comme un chef-d'oeuvre', André Masson, '[Editor's] Préface', '"Cézanne est le premier peintre. . ."' [1959]; 'Peinture tragique' [1946], *Le rebelle du surréalisme: écrits*, ed. Françoise Will-Levaillant, Paris: Hermann, 1976, xi–xxvi, xix; 139–40, 140; 119–24, 122; 185 n. 72.

2

Painting as Propaganda and Prophecy:
René Magritte and Pierre-Auguste Renoir

To this day, the four-year blip in René Magritte's *oeuvre* that constitutes the 'Renoir style' has been discussed only in passing and mainly by obligation in the scholarship on the artist. The failure of this exceptional mini-canon to attract the positive reception ultimately afforded Magritte's second aberration of the 1940s, namely the 'Vache' paintings of 1948, means that, unlike them, the Renoir works remain bad and not merely 'bad'. André Breton was one of the first critics of the style and surely the most vociferous. His repudiation in both private and public statements of the unique experiment reveals the extent to which Magritte deviated from Breton's Surrealism and its theory of art, leading to a kind of self-expulsion from the movement. Careful attention to the detail and context of their contestation by Breton brings up the fairly straightforward elimination of Pierre-Auguste Renoir from the Surrealist canon. But more expansively and intricately, it dissects Breton's uncharacteristic and till now unexamined sympathy for the pre-Surrealist art of Gustave Courbet and Édouard Manet.

The purpose of this chapter, then, is to engage Magritte's Renoir style as a vehicle to unite the critical readings of Renoir, Courbet and Manet undertaken by Breton, with the aim of elucidating his mediumistic theory of art. This has remained surprisingly obscure until now in art historical writing on Breton and Surrealism in spite of the often-cited notice given it by Walter Benjamin. That is possibly because it is not to be found among the texts collected in Breton's canonical volume, *Surrealism and Painting* (1965), where Courbet and Manet equally go unmentioned. The deeper, theoretical reasons for art history's own continued resistance to Magritte's Renoir style can only be touched on here and gone into in depth elsewhere.

Painting: Magritte, Renoir and the twentieth century

During the three years he spent close to the Surrealist group in Paris from 1927–30, Magritte could view Impressionist paintings daily in the Louvre where the Caillebotte bequest was then housed. The only evidence, if it can be called that, of any attention he gave to pictures by Impressionists during that period is, of course, in a kind of iconoclastic counter-interest. This can be shown by contrast between Renoir's serene

yet vigorously and heavily impastoed portrait, painted for the market and titled *Woman Reading* (plate 2a, 1874–5) (one of the paintings donated by Gustave Caillebotte, who had bought it in 1883), which is profusely layered at the hair and unnaturalistically rendered on the hair, face and scarf at the throat where there is no facial modelling but only touches of colour, and Magritte's own much more simplified version of a female reader, the flatly depicted cartoon 'woman' of *The Submissive Reader* (plate 2b), painted in 1928 in Paris. The essential subgenre of the female reader shared by the two paintings does nothing to bridge the gulf separating them. If Magritte was working self-consciously within the schooling and tradition of that genre, then his incursion was not meant to explore nature further or the relationship between painting and nature or even the one between colour, form and space on a flat surface. With the aid of a style whose illustrationalism pointed ironically, as ever, towards its own artifice – far more blatantly by dint of its absurdity than the sincerely consigned Impressionist brush stroke was able – Magritte's aim was to end such exploration altogether by stepping to one side of the genre of the female reader in a second movement of irony and isolating it as a 'problem' – in short, by denaturalizing it.

Unexpectedly then, to say the least, it would be mainly this principal factor dividing the two artists, their entirely dissimilar handling of paint, which Magritte would attempt to ameliorate from 1943 in Brussels under German occupation in the so-called Renoir works (figure 2.1). The new (or old) style would spawn around seventy oil paintings and nearly fifty gouaches, fizzling out in the spring of 1947 as far as the paintings were concerned. This production was irregular and shows a steadily dwindling commitment: twenty-seven were completed in 1943, twenty in 1944, five in 1945, ten in 1946 and about five in 1947 up to the end of the period in May. The last ones seem less effusive. David Sylvester's descriptions for them in the catalogue raisonné refer to a 'residual "Impressionist" style', while close examination of Magritte's mark-making in the series as a whole reveals far more variety than the current labels for it acknowledge.[1] It counsels, perhaps, for the one settled on by Magritte himself: 'Sunlit Surrealism' ('Le Surréalisme en plein soleil'). In each of these years, then exclusively from May 1947, Magritte continued to paint in the numb, unadorned, familiar way, relying on subject matter to communicate the 'bright side' of life, but these make up only about a quarter of his output in the four-year period.

In early 1939, Magritte had declared himself 'tired' of painting.[2] His renewed enthusiasm, distantly anticipating the Renoir style, is voiced in a well-known passage of a 1941 letter to former Surrealist Paul Éluard:

[1] David Sylvester (ed.), *René Magritte: Catalogue Raisonné, vol. 2: Oil Paintings and Objects, 1931–1948*, London: The Menil Foundation/Philip Wilson Publishers, 1993, 91, 375.
[2] Letter probably of April 1939 to Marcel Mariën, René Magritte, *La Destination: Lettres à Marcel Mariën (1937–1962)*, Brussels: Les Lèvres nues, 1977, 22; Sylvester (ed.), *René Magritte: Catalogue Raisonné, vol. 2*, 74.

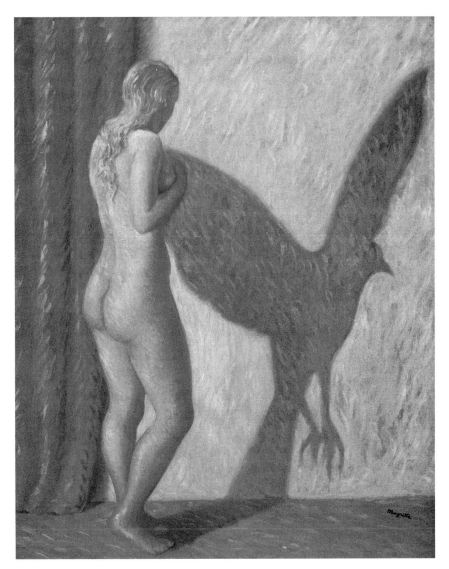

Figure 2.1 René Magritte, *The Uncertainty Principle* (1944). Oil on canvas, 65 × 50 cm. Private collection. © akg-images. © ADAGP, Paris and DACS, London 2018.

My attack of exhaustion is almost over (I don't think it will ever finish entirely) and for some time I've been enjoying working. No doubt I needed to find the means of realizing what was tormenting me: pictures in which I would exploit the 'bright side' of life. By this I mean all the traditional paraphernalia of charming things, women, flowers, birds, trees, the atmosphere of happiness, etc. And I have succeeded

in freshening the air of my painting: a quite powerful charm has now replaced the disquieting poetry I used to strive to achieve in my pictures.[3]

The paintings by which Magritte fully resolved his 'torment' and that overshadowed, he believed, the earlier 'disquieting poetry' only arrived sixteen months later and they were deeply confusing for his friends and contemporaries.[4] Written three years into the Renoir period, a passage from a letter of April 1946 from Magritte's friend the art critic and former dealer Paul Gustave Van Hecke to the equally aghast Belgian Surrealist living in London, E. L. T. Mesens, remains the principal statement of alarm:

A major question which arises is that Magritte, being stubborn, pig-headed and hooked on his present errors (and horrors!) will insist on exhibiting his recent works in New York (and no doubt in your gallery in London too). Alas, his [illegible word] is more and more like what [Giorgio] de Chirico's was with its series of horses and gladiators, although the latest Magrittes are even much worse. To crown all, he flies into a rage at the slightest hint that this is the case. The poor crazy fellow believes that what he is doing now represents the 'high point' of his painting. Christ, what a catastrophe! . . .[5]

Francis Picabia is the third after de Chirico and Magritte himself in the unholy trinity of modernist 'bad painters', producing bafflingly poor, out-of-signature work, inexplicable and derided until postmodernism came along with the theoretical, thematic and lexical means to expound and vindicate it. Yet the perennially unfavourable because unfathomable Renoir paintings continue to resist even postmodernism's seemingly inexhaustible resources for assimilating the 'bad', which would successfully revive the 'Vache' paintings from the 1980s (figure 2.2).[6]

[3] Letter of 4 December 1941 to Paul Éluard quoted in David Sylvester, *Magritte*, London: Thames and Hudson/Menil Foundation, 1992, 257. For a different translation and the original French text, see Sylvester (ed.), *René Magritte: Catalogue Raisonné, vol. 2*, 91, 290–1.
[4] The link between the Éluard letter and 'Sunlit Surrealism' is substantiated by the later use of the same term 'poésie inquiétante', meant to define the old style to be replaced by the new one after Renoir, in the first manifesto statement that defended it: René Magritte, 'Surrealism in the Sunshine: 1. Quarrel of the Sun' [1946], *Selected Writings*, ed. Kathleen Rooney and Eric Plattner, trans. Jo Levy, Minneapolis MN: University of Minnesota Press, 2016, 90–3, 92.
[5] Van Hecke quoted Sylvester (ed.), *René Magritte: Catalogue Raisonné, vol. 2*, 93.
[6] For the saga of the 'Vache' paintings and their delayed reception in the age of postmodernism, see Gilda Axelroud, 'Reassessing René Magritte's *Période Vache*: From Louis Forton's *Pieds Nickelés* to George Bataille', Gavin Parkinson (ed.), *Surrealism, Science Fiction and Comics*, Liverpool: Liverpool University Press, 2015, 82–103; Bernard Blistène, 'The Roguish Language of Magritte's [*sic*]', *Bad Painting, Good Art*, Vienna: Museum Moderner Kunst, 2008, 138–48; Frankfurt: Kunsthalle, *René Magritte 1948: La Période Vache*, 2008; Bernard Marcadé, 'I'll Find a Way to Slip in a Great Big Incongruity from Time to Time': *Tate Etc.*, no. 11, autumn 2007: http://www.tate.org.uk/context-comment/articles/ill-find-way-slip-great-big-incongruity-time-time; Marseilles: Musée Cantini, *René Magritte: La période 'vache'*, 1992; Gisèle Ollinger-Zinque, *Magritte in the Royal Museums of Fine Arts of Belgium, Brussels*, Ghent: Ludion, 2005, 28–9; Noéllie Roussel, '*La Période Vache*: A Latter-Day Epidemic', Los Angeles: Los Angeles County Museum of Art, *Magritte and Contemporary Art: The Treachery of Images*, 2006, 177–87; Sylvester, *Magritte*, 268–75; Bart Verschaffel, '*Vache* Painting, Metaphysical Painting? René Magritte and the Sublime', Montreal: Montreal Museum of Fine Arts, *Magritte*, 1996, 67–80.

Figure 2.2 René Magritte, *Famine* (1948). Oil on canvas, 46.5 × 55.5 cm. Musées royaux des Beaux-Arts de Belgique, Brussels. © Scala, Florence. © ADAGP, Paris and DACS, London 2018.

Plainly, given the almost staged contrast with Renoir, Magritte was seeking the artistic style at the opposite end of the scale from his own. With the disappearance of that distance went the doubly ironic purchase held by his art. This is clearly available in the disparity between *Woman Reading* and *The Submissive Reader* (a title surely more appropriate to Renoir's tableau, even though the English alternative for Magritte's *soumise*, 'subjugated', significantly alters the behavioural aspect of his painting). Once the rich tactility of the surface of such canvases as *Woman Reading* is considered, it becomes equally unexpected that Magritte should carry out this act of mimicry in the 1940s with the aid of reproductions of the Impressionist's pictures and not through visits to museums.[7] In this way some irony is restored to the practice, even if that is not what the artist had intended. But what did he intend? Why Renoir?

[7] It was widely known that Magritte was satisfied with reproductions over the real thing, as he stated in interview late in life: '[f]or me, a reproduction is enough!' René Magritte, 'Magritte Interviewed by Michel Géoris' [1962], *Selected Writings*, 205–8, 208.

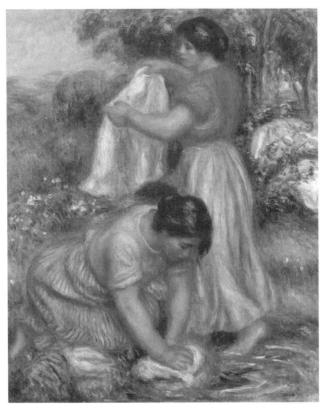

Figure 2.3 Pierre-Auguste Renoir, *Washerwomen* (*c*. 1912). Oil on canvas, 65 × 55 cm. Private collection. © Paul Fearn / Alamy Stock Photo.

Although it seems to have begun around the mid-1890s, so consists of two-thirds of his fifty-five-year career, Renoir's so-called late phase comprising large nudes and young women as well as landscapes, portraits, still lives and scenes of domestic harmony has always received a mixed reception ranging from eulogy through doubt to outright vituperation (figure 2.3). For an example of the first, we need only look at the unadulterated appreciation, which ends up taking in the entire *oeuvre* of the ageing Renoir, penned by the novelist and critic Octave Mirbeau. Written for the March 1913 exhibition of recent work staged at the Bernheim-Jeune galleries in Paris, probably under the auspices of Félix Fénéon, this assessment of Renoir summarizes the attractiveness of the artist for generations in a language close to that used later by Magritte when writing to Éluard of the 'charming things' of his new painting:

> [Renoir's] whole life and his whole work are a lesson in happiness. He has
> painted with joy, with enough joy to not feel he ever had to cry out the joy of

painting, which sad painters lyrically proclaim. He has painted women, children, trees and flowers with the admirable sincerity of a man who believes that nature offers itself to his palette as simply as if it had been created, for all eternity, to be painted.[8]

The opinion was shared by the much younger Guillaume Apollinaire who quoted this passage in his equally gushing review of the Bernheim-Jeune exhibition in which he averred: '[h]is latest pictures are always the most beautiful and also the youngest. . . . These last works are so calm, so serene, and so mature that I do not believe he can surpass them.'[9] In February the previous year, in a review of the Paris leg of the travelling Futurist exhibition, Apollinaire had even called Renoir 'the greatest painter of our time and one of the greatest painters of all times', defending the recent work and asserting what he believed incorrectly would be the acquired taste of the 'wonderful and voluptuous nudes that will be the delight of times to come'.[10] According to Sylvie Patry, 'the aura surrounding the painter had continued to grow' since his 1904 retrospective at the Salon d'Automne and his pre-eminence, due in part to his 'moderate' modernism, would be proclaimed in America until 1940.[11] The Bernheim-Jeune event coincided exactly with the Armory Show held in New York where four of Renoir's paintings of the 1880s were hung. Clive Bell and Walter Pach who were among the organizers shared Apollinaire's view on the supremacy of the artist.[12]

Other admirers of Renoir were bemused by the direction his art had taken in the twentieth century. The Impressionist painter Mary Cassatt saw some of the paintings in preparation for the Bernheim-Jeune exhibition while paying the old man a visit at his last home in Cagnes-sur-Mer on the French Riviera in January 1913. After that viewing, she wrote in a letter that he was 'doing the most awful pictures or rather studies of enormously fat red women with very small heads. [Ambroise] Vollard persuades

[8] 'sa vie tout entière et son oeuvre sont une leçon de bonheur. Il a peint avec joie, avec assez joie pour ne pas crier à tous les échos cette joie de peindre que les peintres tristes proclament lyriquement. Il a peint les femmes, les enfants, les arbres, les fleurs avec l'admirable sincérité d'un homme qui croit que la nature se propose à sa palette aussi simplement que si elle avait été créé, de toute éternité, pour être peinte', Octave Mirbeau in *Renoir*, Paris: Bernheim-Jeune & Cie, 1913, n.p. This opinion of Renoir's uncomplicated relationship with his subject matter was almost universal: 'He liked passionately the obviously good things of life, the young human animal, sunshine, sky, trees, water, fruit; the things that everyone likes', Roger Fry, 'Renoir' [1919], *Vision and Design* [1920], Harmondsworth: Penguin, 1961, 209–13, 211. However, Renoir's *joie de vivre* is overdone by his supporters: witness, for some contrast, the artist's letter telling the critic Claude Roger-Marx that he was reluctant to show at the 1889 Exposition Universelle, insisting that 'je trouve tout ce que j'ai fait mauvais et que ce me serait on ne peut plus pénible de le voir exposé', Claude Roger-Marx, *Renoir*, Paris: Librairie Floury, 1937, 68.

[9] Guillaume Apollinaire, 'The Art World' [1913], *Apollinaire on Art: Essays and Reviews 1902–1918* [1960], ed. Leroy C. Breunig, trans. Susan Suleiman, Boston, Mass: MFA, 2001, 278–9, 278.

[10] Guillaume Apollinaire, 'Art News: The Futurists' [1912], *Apollinaire on Art*, 204.

[11] Sylvie Patry, '"One Must do the Painting of One's Time,"' Los Angeles: Los Angeles County Museum of Art, *Renoir in the 20th Century*, 2010, 358–75, 361.

[12] Patry, '"One Must do the Painting of One's Time,"' *Renoir in the 20th Century*, 361.

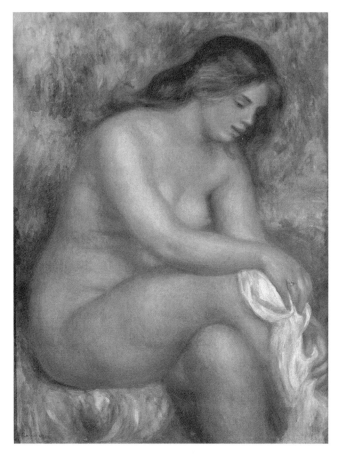

Figure 2.4 Pierre-Auguste Renoir, *Bather Drying Her Leg* (1910). Oil on canvas,
84 × 65 cm. Sao Paolo Museum of Modern Art. © White Images/Scala, Florence.

himself that they are fine. J. Durand-Ruel knows better' (figure 2.4).[13] The artist's
death in 1919 led to reassessments that boosted his reputation and auction prices,
but the critical reception of the later nudes remained mixed.[14] Gustave Coquiot,
who was the author of monographs on Paul Cézanne, Georges Seurat and Henri

[13] Cassatt quoted in Nancy Mowll Mathews (ed.), *Cassatt and Her Circle: Selected Letters*, New York:
Abbeville Press Publishers, 1984, 308 (Cassatt refers here to Renoir's dealer Vollard and to the
Paris art dealer Joseph Durand-Ruel, son of Paul). For Maurice Denis's rapturous response
upon seeing the last paintings at Renoir's house and his apparently limitless admiration for
Renoir's work as a whole, see Sylvie Patry, 'Renoir and the Nabis', *Renoir in the 20th Century*,
146–54, 151.
[14] For this and a slightly differently weighted account of Renoir's reputation over these years to the one
I am giving here, see Mary Tompkins Lewis, 'Introduction: The Critical History of Impressionism: An
Overview', Mary Tompkins Lewis (ed.), *Critical Readings in Impressionism and Post-Impressionism:
An Anthology*, Berkeley, Los Angeles, London: University of California Press, 2007, 1–19, 7–8.

de Toulouse-Lautrec, felt similarly to Cassatt. He announced the 'vulgarity' of the style in his 1925 book on Renoir by recalling that the artist was 'intoxicated' by the female flesh he painted: 'he is delirious,' he wrote, 'among that pile of buttocks, breasts and bellies.'[15]

Much later, on viewing the Wildenstein exhibition in New York in 1950, Clement Greenberg gave a tentative review of 'Renoir's famous and much debated last phase.'[16] He conceded its weaknesses but argued that 'there are exceptions' and that 'the exceptions may even be worth the price', even though, 'the little flower pieces' he referred to only seemed to emphasize 'the general dead level' of the other paintings dating from the twentieth century.[17] Let us pause to remind ourselves that this is the period of Renoir's art that Magritte had chosen only seven years earlier to perk up his own failing inspiration. Since then, the Museum of Modern Art in New York has acted on its belief that Renoir did not belong to its modernist narrative by de-accessioned the last of its five paintings by the artist, while the reputation of the later works particularly has been assailed by art historians to the point of controversy.[18] However, Apollinaire and many of his contemporaries viewed Renoir's work as central to the history of modern art. I can demonstrate the appeal his work held for artists of that period as a means of broaching his reception in Surrealism.

Like Cassatt, Edgar Degas and Claude Monet (and unlike important artists of the generation that followed such as Paul Gauguin, Seurat and Vincent van Gogh), Renoir long outlived Impressionism to witness – somewhat incongruously for modernist

[15] 'il délire dans cet amas de fesses, de tétons et de ventres', Gustave Coquiot, *Renoir*, Paris: Albin Michel, 1925, 217.

[16] Clement Greenberg, 'Renoir and the Picturesque' [1950], *The Collected Essays and Criticism, vol. 3, Affirmations and Refusals, 1950–1956*, ed. John O'Brian, Chicago and London: The University of Chicago Press, 1993, 22–6, 24.

[17] Greenberg, *Collected Essays and Criticism, vol. 3*, 24. Greenberg ends his review with a typical eulogy to the 'profusion of pleasure' of Renoir's later work: 'a foaming, pouring, shimmering profusion like nothing else in painting', Greenberg, *Collected Essays and Criticism, vol. 3*, 25.

[18] Patry, '"One Must do the Painting of One's Time,"' *Renoir in the 20th Century*, 360. Perhaps the key moment and maybe even the last word in the narrative of opprobrium at the offensiveness of Renoir's later painting came in responses to the supposedly revisionist touring exhibition *Renoir* of 1985 that began in January in London at the Hayward Gallery then went on to Paris and Boston. Much of the onslaught took place in the same journal: Lynn Nead, 'Pleasing, Cheerful and Pretty'?: Sexual and Cultural Politics at the Hayward Gallery' (exhibition review), *Oxford Art Journal*, vol. 8, no. 1 ('Caricature'), 1985, 72–4; Tamar Garb, 'Renoir and the Natural Woman', Desa Philippi, 'Desiring Renoir: Fantasy and Spectacle at the Hayward', Orton, '"Reactions to Renoir Keep Changing,"' *Oxford Art Journal*, vol. 8, no. 2 ('Renoir Re-Viewed'), 1985, 3–15, 16–20, 28–35. Also see Kathleen Adler, 'Reappraising Renoir' (books review), *Art History*, vol. 8, no. 3, September 1985, 374–80. Another critical outcome of the Hayward exhibition was an interpretation of the 'late phase' nudes that are dated from 1897, which suffers from an overly biographical psychoanalytic reading of Renoir's bicycle accident of that year and subsequent illness: Marcia Pointon, 'Biography and the Body in Late Renoir', *Naked Authority: The Body in Western Painting 1830–1908*, Cambridge: Cambridge University Press, 1990, 83–97, 85. For a later restatement of Renoir's 'misogyny', see Tamar Garb, 'Painterly Plenitude: Pierre-Auguste Renoir's Fantasy of the Feminine', *Bodies of Modernity: Figure and Flesh in Fin-de-Siècle France*, London: Thames and Hudson, 1998, 145–77. The Boston leg of *Renoir* was met by less political and more diverse reaction to the charms of the later Renoir: Various, 'Renoir: A Symposium', *Art in America*, vol. 74, no. 3, March 1986, 103–25, 107, 117 (two women give an opinion on Renoir compared to twelve men).

narratives of art – the arrival of the early twentieth-century avant-gardes and the First World War. His death in December 1919 virtually coincided with the birth of Surrealism that year in the form of the poems of *The Magnetic Fields* (1920), the first use of automatic writing, co-authored in late May or early June by Breton and Philippe Soupault.[19] At the same time, more or less, Dada was heading from Zurich to Paris in the capable hands of Tristan Tzara. Like the ordinary public and private affairs of this world, such matters seem to exist on another planet to Renoir's art. Its seasoned, unflagging pleasures inevitably held no interest to that generation of young non-conformist poets and artists, many of whom had served in the war.[20] This historical context helps clarify their disinterest in the artist who continued to produce his cavorting nudes as that conflict got underway. Yet it is also the deep background against which we comprehend Magritte's turn to Renoir during the later war of 1939–45, as well as the negative assessment by most Surrealists of that latter period, who viewed art as historically determined, albeit elusively for its contemporary audience.

Although they left the pre-Surrealist artists and poets cold, Renoir's work both early and late did attract the attention of painters of the previous generation, some of whom the Dadas and Surrealists admired, such as Giorgio de Chirico and Pablo Picasso, and others they did not, like Henri Matisse. In 1920 de Chirico was approaching the end of the 'metaphysical' period of his painting that had already gained the approval of some of the future Surrealists. He wrote that year, with unusual insight, but in a typically idiosyncratic way that was quite against the grain of the standard interpretations of Renoir's *oeuvre* pro and con, on what he saw as the mood of 'melancholy and . . . weary tedium' that imbued Renoir's later scenes of domestic bourgeois life.[21] De Chirico's commentary took place seemingly in anticipation of his own Renoiresque paintings to come such as *Still Life with the Apollo Belvedere and Fruit* (c. 1930) and perhaps *Bather in the Sun (Ariadne Abandoned)* of the same year. The second of these could be read as an amalgamation of Renoir's divisive late nudes (it was hung with eleven other comparable nudes on its first showing at de Chirico's solo exhibition in Milan in 1932) and that artist's similarly posed *Young Shepherd in Repose (Portrait of Alexander Thurneyssen)* (1911). De Chirico wrote quite favourably of the late manner even though it was the earliest, pre-Impressionist Renoir of 'extraordinary solidity' recalling the tradition of 'grande pittura' that he admired the most and that he thought had been temporarily put paid to in Renoir's career by Impressionism.[22]

[19] Mark Polizzotti, *Revolution of the Mind: The Life of André Breton*, revised and updated, Boston: Black Widow Press, 2009, 95.
[20] One writer has declared of this period leading up to and following the First World War: '[e]ven in the years 1910–19, Renoir's work is characterized by optimism', Laurence Madeline, 'Picasso 1917 to 1924: A "Renoirian" Crisis', *Renoir in the 20th Century*, 122–30, 128.
[21] Giorgio de Chirico, 'Auguste Renoir' [1920], trans. Katherine Robinson, *Metaphysical Art*, no. 14/16, 2016, 65–8, 67. I say this was unusual because, as Kathleen Adler pointed out, such serious writing on Renoir was rare as late as the 1980s, scholarship on the artist being 'largely confined to biography, often based on reminiscence, and to introductory essays or brief texts accompanying illustrated books aimed at the non-specialist reader', Adler, 'Reappraising Renoir' 374.
[22] Jole de Sanna (ed.), *De Chirico and the Mediterranean*, New York: Rizzoli, 1998, 247; de Chirico, 'Auguste Renoir', 66.

Picasso had numerous opportunities in the first two decades of the twentieth century to study Renoir's paintings up close. They were available especially at Paul Rosenberg's gallery and in the collections of Vollard and Gertrude Stein, as well as Paul Guillaume's, preserved today at the Musée de l'Orangerie in Paris.[23] His return to a relatively conservative figuration at the beginning of the First World War and exploration of the classical tradition from then, along with his visit to Italy in 1917, made Picasso more sensitive to Renoir. In the second decade of the twentieth century, Renoir was admired as a French 'classic' by collectors and artists who had been put off by Cubism's 'difficulty'.[24] Retrospectively, he has been viewed by some as '*the* representative national artist in the late teens and '20s.'[25] His 'rejection of Impressionism' around 1883 'grew from an increased concern with line and the purity of form and composition, all important elements of Classicism', in the words of one writer who viewed Renoir's late manner as 'totally permeated with the spirit of Classical art'.[26] He was an obvious artist close-at-hand, then, for Picasso to examine as his attention turned towards the classical tradition at a politically and culturally conservative time, and the portrait he drew of Renoir from a photograph and the large nudes of that time (figure 2.5) bear witness to this.

The admiration that Renoir's work engendered in de Chirico and Picasso, as well as in Breton's mentors Paul Valéry and Apollinaire, might help explain the odd, approving and inconclusive remark made in 1921 by Breton, reckoning that Renoir 'holds up against any test we subject him to'.[27] However, by the time he wrote the important essay 'Distance' in 1923, in response to what became known as the *rappel à l'ordre*, he was lumping Renoir and Cézanne together as banal traders in the hackneyed genres of the nude and still life.[28] By then, Breton was starting to lose patience with Renoir's work for the self-imposed limits created by its physicality and sensuality when early Surrealism was already seeking more. From there, the reputation of Renoir among the Surrealists would decline through the artist's association with Impressionism, which, as I noted in my Introduction, would be scorned by Breton for overshadowing Symbolism and ultimately accused under the authority of the Gauguin specialist Charles Chassé and Gauguin himself of 'attempting to achieve a position of subservience in relation to positivism'.[29]

In his last years, Breton was dismissive of the efforts of the ageing Renoir by comparison with the dedicated labour of one of his favourite artists, Gustave Moreau,

[23] Madeline, 'Picasso 1917 to 1924: A "Renoirian" Crisis', *Renoir in the 20th Century*, 123. Also see the pages devoted to Picasso and Renoir by Michael C. Fitzgerald, *Making Modernism: Picasso and the Creation of the Market for Twentieth-Century Art*, Berkeley, Los Angeles, London: University of California Press, 1995, 98–109.

[24] Patry, '"One Must do the Painting of One's Time,"' *Renoir in the 20th Century*, 362.

[25] Paul Tucker in Various, 'Renoir: A Symposium', 123.

[26] Keith Wheldon, *Renoir and his Art*, London: Hamlyn, 1975, 80, 106.

[27] André Breton, 'Ideas of a Painter' [1921], *The Lost Steps* [1924], trans. Mark Polizzotti, Lincoln and London: University of Nebraska Press, 1996, 62–6, 64.

[28] André Breton, 'Distance' [1923], *The Lost Steps*, 103–6, 106.

[29] André Breton, 'Concerning Symbolism' [1958], *Surrealism and Painting* [1965], trans. Simon Watson Taylor, New York: Harper & Row, 1972, 357–62, 360.

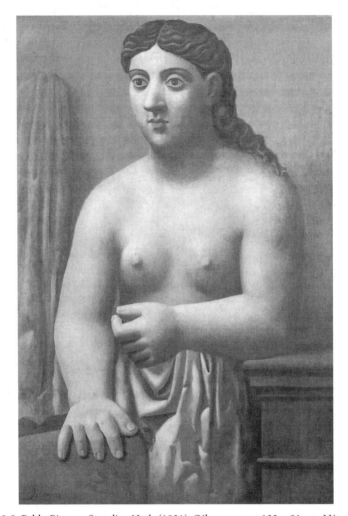

Figure 2.5 Pablo Picasso, *Standing Nude* (1921). Oil on canvas, 132 × 91 cm. Národni Gallery, Prague. © Bridgeman Images. © Succession Picasso/DACS, London 2018.

on the canvas *Le Retour des Argonautes* (1897). Typically, it was the contrast between the magical and mundane that Breton underscored:

> It is essential to oppose vehemently those who accuse Moreau of a 'reactionary' technique and cannot forgive him for having swum against the Impressionist tide of his time. Even if new forms of plastic expression did prevail historically, his contribution to the vast field of art remains incomparably more important than the exercises in vocalization of most of his denigrators. Moreau's project, shortly before his death, to 'paint this ship Argo whose mast, hewed from a Dodona

oak-tree, uttered oracles' makes up for Renoir gloating over one of the last of his innumerable dishes piled with fruit and not only imagining – but proclaiming – that he was 'continuing to make progress.'[30]

Breton's youthful indulgence of the artist and this later hostility are not too dissimilar to modernism's on–off relationship with Renoir across the twentieth century. However, this survey of critical commentary only makes Magritte's adoption in the 1940s of a generic version of his style seem more confusing.

The beginning of an explanation comes when we turn to the period of occupation, or 'the circumstances' as Magritte referred to it in letters. It is surprising how little attention has been given in the sprinkling of writing on his Renoir style to the detail of life in Belgium under Nazi rule yet a brief account of events during that historical period is essential in discussion of those canvases. Let me demonstrate, then, that it was just as Magritte was striving to ape Renoir's fluffy signature stroke by thumbing through sunny books on Impressionism in April 1943 that the Belgian people were undergoing their harshest period under occupation.

The nation had been allowed at first to administer itself, for the most part, under what Nico Wouters calls 'an apolitical form of rule concentrating on economic exploitation of the occupied territory.'[31] Yet the initially tolerant façade of the German occupying forces had soon given way to increasing propaganda, interference in public and private affairs and news censorship in July 1940.[32] Food rationing had begun at the same time as the German invasion. From June 1941, the demands made upon the German economy by the invasion of the Soviet Union led to the draining of resources from occupied countries such as Belgium and greater hardship for its population.

Martin Conway indicates a 'broad shift' in German policy beginning towards the end of 1941 from one of 'attempted conciliation with Belgian society (though not its political leadership) to one of oppression, racial persecution and support for pro-Nazi extremists.'[33] This added up to a greater invasiveness in Belgian political and social life. Attempts to introduce the first anti-Jewish measures from October 1940 had been resisted by the Belgian government. From that time, Jews were registered separately and made to mark their race onto their identity cards, but from May 1942 they were forced to wear the yellow Star of David. Then in August that year, deportation began to Auschwitz and Bergen-Belsen via Mechelen transit camp less than twenty miles from

[30] André Breton, 'Gustave Moreau' [1961], *Surrealism and Painting*, 363–6, 363–5 (translation modified).

[31] Nico Wouters, 'New Order and Good Government: Municipal Administration in Belgium, 1938–1946', *Contemporary European History*, vol. 13, no. 4 ('Political Legitimacy in Mid-Twentieth Century Europe'), November 2004, 389–407, 393.

[32] Paul Struye, 'The Policy of the German Occupation and the Reaction of the Belgian Population', Jan-Albert Goris (ed.), *Belgium Under Occupation*, trans. Jan-Albert Goris, New York: The Moretus Press, 1947, 13–26, 18–19.

[33] Martin Conway, *The Sorrows of Belgium: Liberation and Political Reconstruction, 1944–1947*, Oxford: Oxford University Press, 2012, 14.

Brussels.[34] References to the 1914–18 war were removed from schoolbooks, as were Jewish authors; performances of music by Russian and Jewish musicians were barred along with verses deemed subversive in operas. The occupation changed fundamentally when forced labour was introduced into Belgium on 6 October 1942. From then, according to Wouters, the 'evasion of all forms of public authority by ordinary people, already strong before, now became a widespread, "normalised" attitude among the public in general. . . . Thousands of ordinary people went into hiding and had to rely on the black market for daily survival.'[35] Magritte and his friends would have experienced and witnessed certain of these measures and known about the rest from one or other of the ninety-five clandestine press publications that circulated in Belgium during the period.[36]

They were about to be impacted more distressingly and portentously because three years into the occupation the situation become almost unbearably repressive for all Belgians, leading to what Wouters calls 'the crisis atmosphere of 1943'.[37] The treatment of the population from the middle part of that year was described as follows in a volume published soon after the war on behalf of the Belgian Government Information Center in New York by the writer and diplomat Jan-Albert Goris who was its Director (and who, coincidentally, became a friend, promoter and collector of Magritte soon after – he owned for a while the 1952 masterpiece *Personal Values* and sat for his portrait in 1958)[38]:

> German ordinances naming new violations and punishing them by death increased rapidly. A law of April 28, 1943 – a real code of terror – extended the application of the German penal law to many domains, augmented the penalties previously provided, and distinctly decreed the death penalty for 15 large categories of infractions. It could be said, without exaggeration, that under the German regime 'everything which was not forbidden under pain of death was obligatory under threat of forced labour. . . .' The establishment of forced labour and of the deportation of thousands of workers to Germany was the culminating point of this policy, which went as far as reducing a whole people to a state of servitude without precedent in modern history. . . . Thousands of Belgians were condemned to death or deported, with or without trial. Innocent hostages were executed in reprisal for

34 Michel Dumoulin, Vincent Dujardin, Emmanuel Gerard and Mark Van den Wijngaert, *Nouvelle Histoire de Belgique: vol. 2, 1905–1950, La Belgique sans Roi, 1940–1950*, trans. Anne-Laure Vignaux, Brussels: Éditions Complexe, 2006, 73; Struye, 'The Policy of the German Occupation', 18.
35 Wouters, 'New Order and Good Government', 399–400. See also Dumoulin, Dujardin, Gerard and Van den Wijngaert, *Nouvelle Histoire de Belgique: vol. 2*, 44–6.
36 Etienne Verhoeyen, *La Belgique occupé: de l'an 40 à la liberation* [1993], trans. Serge Govaert, Brussels: De Boeck Université, 1994, 383.
37 Wouters, 'New Order and Good Government', 403.
38 Goris published his novels and other writings under the pen name Marnix Gijsen: see David Sylvester (ed.), *René Magritte: Catalogue Raisonné, vol. 4: Gouaches, Temperas, Watercolours and Papiers Collés 1918–1967*, London: The Menil Foundation/Philip Wilson Publishers, 1994, 207; David Sylvester (ed.), *René Magritte: Catalogue Raisonné, vol. 3: Oil Paintings, Objects and Bronzes 1949–1967*, London: The Menil Foundation/Philip Wilson Publishers, 1994, 24, 101; René Magritte and Harry Torczyner, *Letters Between Friends*, trans. Richard Miller, New York: Harry N. Abrams, 1994, 23.

crimes in which they had had no part. . . . Belgians were thrown into prison simply because they happened to be in places where the Gestapo had tried in vain to find other Belgians they wanted to arrest. . . . In certain prisons run by executioners the political prisoners were submitted to abominable treatment. No torture was spared them when it was a question of extorting a confession.[39]

Allied bombing had targeted Luftwaffe airfields and ports such as Knokke and Zeebrugge at first, but by 1943 urban areas were under fire.[40] The attempted bombardment on 5 April of the ERLA Motor Works in the Antwerp suburb of Mortsel (thirty-two miles from Brussels), which had been taken over to maintain Luftwaffe planes, led to appalling devastation when most of the American bombs fell on civilian areas of the town, leading to 936 dead and 1,342 injured.[41]

The desperate atmosphere put Magritte in the apparently compensatory habit of skimming through books on Renoir and Impressionism, writing to his friend the young Belgian Surrealist Marcel Mariën in April 1943 for assistance in finding them.[42] Among the ones he obtained were the slim volumes of 1941 by serial monographers Charles Kunstler (son of Claude and former infant friend of Alfred Jarry) and Charles Terrasse (figures 2.6 and 2.7), which Magritte must have fanned through in a few minutes. These volumes made for a safe subject matter to keep the press ticking over under the occupation. This is illustrated by the anodyne commentary by Kunstler in *Renoir: peintre fou de couleur*, where Renoir is rescued from the decadent wing of Impressionism:

> By contrast with his morose, degraded and bitter contemporaries, by contrast with Degas, Lautrec and Forain, who contemplated nature only in order to seek out its defects, ugliness, miseries, Renoir wanted to see in it only beauties. Like Watteau, with whom he had such affinities, he refused to populate that circle of Hell, that putrid swamp of black, muddy water.[43]

The language used to contrast the innocent bliss of Renoir's nudes (figure 2.8) with the lewd sexual proceedings to be found in Jean-Louis Forain (figure 2.9) is not

[39] Struye, 'The Policy of the German Occupation', 25–6.
[40] For details of Luftwaffe bombing of Belgium, see under 'Bombardements' in Paul Aron and José Gotovitch (eds), *Dictionnaire de la Seconde Guerre mondiale en Belgique*, Brussels: André Versaille, 2008, 68–71.
[41] Aron and Gotovitch (eds), *Dictionnaire*, 69. A rare English language report of the disastrous incident can be found at this address: http://ww2today.com/5th–april–1943-belgium-tragedy-in-usaaf-daylight-bombing-raid (accessed 8 May 2014).
[42] Sylvester (ed.), *René Magritte: Catalogue Raisonné, vol. 2*, 91. See the letter dated 23 April 1943 sent to Mariën in Magritte, *La Destination*, 50–1.
[43] 'À l'encontre de ses contemporains moroses, dénigrants et amers, à l'encontre de Degas, de Lautrec, de Forain, qui ne contemplaient la nature que pour en rechercher les tares, les laideurs, les misères, Renoir n'en voulait voir que les beautés. Comme Watteau, avec lequel il avait tant d'affinités, il se refusait à peupler ce cercle de l'Enfer, ce marais fétide, aux eaux noires, boueuses …', Charles Kunstler, *Renoir: peintre fou de couleur*, Paris: Librairie Floury, 1941, n.p.

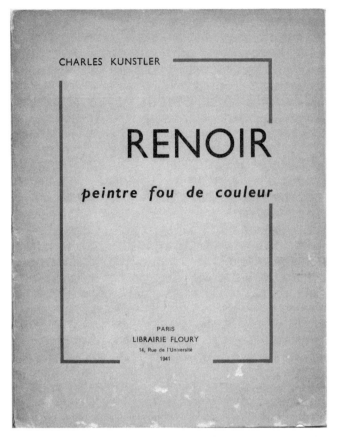

CHARLES KUNSTLER

RENOIR

peintre fou de couleur

PARIS
LIBRAIRIE FLOURY
14, Rue de l'Université
1941

Figure 2.6 Cover of Charles Kunstler, *Renoir: peintre fou de couleur*, Paris: Librairie Floury, 1941.

unlike the sermonizing encountered by the audience of *Degenerate 'Art'* (1937). The nontoxic, generic Impressionism of Renoir's *oeuvre* is emphasized further in Kunstler's book by the all-colour reproductions, among which nine out of fifteen paintings date from 1903 onwards. Those in Terrasse's *Cinquante portraits de Renoir* have a wider temporal span (and all except one are in black and white). But the theme of the latter and its compressed biographical essay with its discovery-of-antiquity, rejection-of-Impressionism narrative sat easily with the cultural policy of the Third Reich, showing how certain species of modern art could be made to acclimatize to the occupation.[44]

[44] Charles Terrasse, *Cinquante portraits de Renoir*, Paris: Librairie Floury, 1941. The same inoffensive prose and standard, École de Paris painting (in spite of its inclusion of Picasso's spiky, relatively offensive *Le Femme au chat* of 1941) can be found in the third of the publications mentioned by Mariën as among Magritte's wartime reading matter: Georges Besson, *Couleurs des maîtres: 1900–1940*, Lyon: Les Éditions Braun & Cᴵᵉ, 1942.

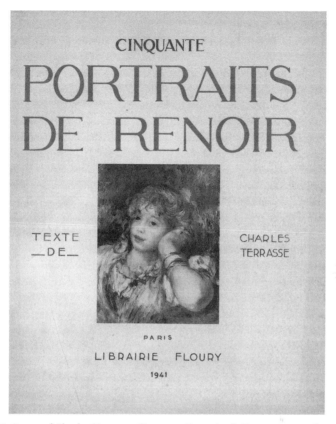

Figure 2.7 Cover of Charles Terrasse, *Cinquante Portraits de Renoir*, Paris: Librairie Floury, 1941.

His letters may have become elliptical but Magritte did not exactly keep his head down through all of this as has been claimed of other Surrealists in Belgium, where the group stopped virtually all action for the duration of the war.[45] Although some of the work on display was pretty bland, his earlier wartime exhibition at the Galerie Dietrich in January 1941 showed no especial compromise. Yet Magritte must have begun looking over his shoulder from the moment that Raoul Ubac's exhibition at the same gallery in May that year was condemned by the Nazis as an 'act of sabotage on the mental level' and closed down, especially since Paul Nougé wrote the preface for that exhibition.[46] It had been denounced by the former semi-Surrealists René Baert and Marc Eemans whose collaborationist activities included contributions to the pro-Nazi

[45] Xavier Canonne, *Surrealism in Belgium: 1924–2000*, Brussels: Mercatorfonds, 2007, 45. For documentation of Surrealist activity in Belgium during the war, see Marcel Mariën, *Activité surréaliste en Belgique (1924–1950)*, Brussels: Éditions Lebeer Hossman, 1979, 323–40.
[46] Canonne, *Surrealism in Belgium*, 43; Sylvester (ed.), *René Magritte: Catalogue Raisonné, vol. 2*, 103.

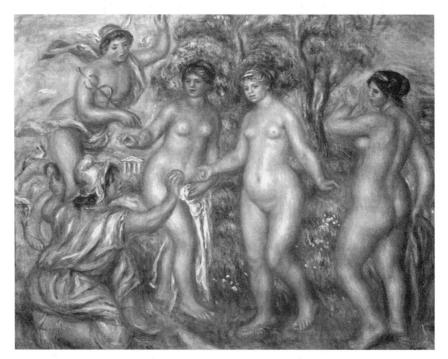

Figure 2.8 Pierre-Auguste Renoir, *The Judgment of Paris* (*c.* 1913–14). Oil on canvas, 73 × 92.5 cm. Hiroshima Museum of Art. © Granger Historical Picture Archive/Alamy Stock Photo.

Rexist movement's newspaper *Le Pays réel*, as well as spying for the Rexists on Magritte and Nougé.[47]

Whatever his reasoning, Magritte now dispensed with elements of his signature style, diluting the core metaphor of his work, which lay in the mild-mannered delivery of the extraordinary. As seen in the undemanding canvases of 1940–1 that he referred to in his letter to Éluard – the insipid daub *The Magnet*, the incomprehensibly maudlin *The Orient* and the multi-figure picture *The Break in the Clouds*, which 'may well have been the deadest picture he ever painted' in the sage opinion of Sylvester – Magritte was still just about 'Magritte' without the iconography of pipes and bowler hats as long as he kept with the neutral, flatly painted non-style.[48] If he forwent that too his painting would fail to register as his own at all. That is what he now did with the aid of Impressionism for the earliest of the new works.

The generally recognized first outcome of Magritte's unprecedented turn to Renoir was *Treatise on Light* (plate 3a, 1943). This is a painting that met the aims set out to

[47] Conway, *Sorrows of Belgium*, 17–19. Also see Martin Conway, *Collaboration in Belgium: Léon Degrelle and the Rexist Movement 1940–1944*, New Haven and London: Yale University Press, 1993. In 1939, Magritte had designed a poster for the Comité de vigilance des intellectuels antifascistes indicating the support for Hitler of Rex's leader Léon Degrelle.
[48] Sylvester, *Magritte*, 258.

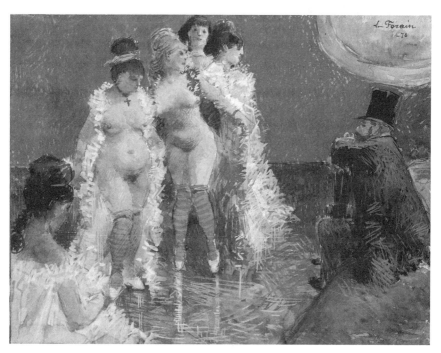

Figure 2.9 Jean-Louis Forain, *The Client* (*c*. 1876). Watercolour and gouache on paper, 24.9 × 32.7 cm. Collection of the Dixon Gallery and Gardens, Memphis, Tennessee. Image courtesy The Dixon Gallery and Gardens, Memphis, Tennessee.

Éluard, but on stylistic grounds that had not been considered by the artist till then, which is not surprising. On Mariën's testimony, *Treatise on Light* was painted, probably in the spring of 1943, after Magritte came across a reproduction of Renoir's *Bathers* (plate 3b, 1918–19), the same late painting that an emotional Matisse had been quoted twenty years earlier as calling nothing less than 'his masterpiece, one of the most beautiful pictures ever painted'.[49] Magritte was increasingly in the mood to go some way along with that. Yet he would still have had enough Surrealist humour to enjoy the spectacle of the maternal giants of the painting alongside the unintended ambiguities and spatial oddities caused by luxuriant brushstroke and staging. Under inspection, for instance, and visible even in a poor reproduction, the hat to the bottom left of *Bathers* almost disappears into the lavish foliage while the right arm of the upper bather seems pushed up close to, or even submerged beneath the supposedly distant tree to the left while hovering on an impossible tide of lush, bulging greenery created to fill the narrow

[49] Sylvester (ed.), *René Magritte: Catalogue Raisonné, vol. 2*, 91–2; see the remarks by Marcel Mariën in *René Magritte, Manifestes et autres écrits*, Brussels: Les Lèvres Nues, 1972, 13. Matisse is quoted from two years after Renoir's death by Frank Harris, 'Henri Matisse and Renoir: Master Painters', *Contemporary Portraits: Fourth Series*, London: Grant Richards Ltd., 1924, 133–41, 139. Also see Roger Benjamin, 'Why Did Matisse Love Late Renoir?' *Renoir in the 20th Century*, 136–43.

angle between the two torsos. Finally, the rendering of the foreground recliner retains too much of the studio setting for the illusion of the countryside to bear; the presence of the couch pushes through from under the grass, especially in the way it drops towards the lower edge of the canvas. Such features might seem overdone, clumsy or unfinished to the connoisseur, but they could have found a sympathetic and accidental Surrealist audience in Brussels.

Magritte retained only the uppermost nude for *Treatise on Light*, turning her gaze towards the viewer and adjusting the position of her left arm to where the left breast of the lower bather would have been. In this way he 'corrected' and updated Renoir by means of an eroticism for which the paintings seem to call out. He performed a similar manoeuvre soon after by retaining the posture of the *Young Shepherd in Repose (Portrait of Alexander Thurneyssen)* (plate 4a, 1911) and adding to it the predetermined upright 'Venus-penis' through transformation and relocation of the unused pipes in Renoir's painting, to create *The Ocean* (plate 4b, 1943). It is as though the blameless boy were being revisited across the intervening thirty-two years as an ageing, hedonistic sea god, reclining among the same foamy foliage (the approximate ages of boy and man in 1911 and 1943 also happen to match the artist's own, more or less). The logic at work in Magritte's erotic modifications of Renoir in *Treatise on Light* and *The Ocean* has about it something of Marcel Duchamp's later and better-known amendment of Auguste Rodin's *The Kiss* (1886) in the etching *Selected Details After Rodin* (figure 2.10, 1968), where the right hand of the male figure is redirected from the outside of the female's left thigh to between her legs, which, as Duchamp said, 'is such a natural place for the hand to be'.[50]

Magritte shaded the limbs and torso of the recliner of *Treatise on Light* in the six or seven spectral colours in keeping (unusually for him) with the title of the painting. He also created a lively, exaggerated surface reminiscent of, though far from identical to Renoir's, alongside tumbling, cascading or flicked brushstrokes that equally signify a generic 'Impressionism'. The lighter than normal hue and strident artificiality of the colours of the painting clash with the title, which lightly and allusively promises a theory akin to the Impressionist preoccupation with luminosity. But the amusement caused by the poetic juxtaposition with the picture and the mild dig, if it was one, at the earnestness of Impressionist enquiry is hardly the 'general hilarity' claimed by Sylvester.[51] If that interpretation of Sylvester's were followed, about Magritte poking fun at Impressionism, the painting would take on more the aura of an art school prank by an artist running on only a residue of irony; or it would if we did not know it were by Magritte, a name that signifies strongly stylistically and against which the painting accrues its many-sided interest. But it must be insisted upon here that Impressionism was not a target of Magritte's at all. Proof of that lies not only in the wholly un-ironic remark heard in his letters about wanting to brighten things up and the behaviour reported by Van Hecke, but also the protestations to Breton and manifestos that followed, which I look at in the next sections.

[50] Marcel Duchamp quoted in Arturo Schwarz (ed.), *The Complete Works of Marcel Duchamp*, two vols., revised and expanded, London: Thames and Hudson, 1997, vol. 2, 875.
[51] Sylvester, *Magritte*, 259.

Figure 2.10 Marcel Duchamp, *Selected Details After Rodin* (1968). Etching, 35 × 24 cm. Private collection. © White Images/Scala, Florence. © Association Marcel Duchamp/ ADAGP, Paris and DACS, London 2018.

Propaganda: Magritte, Communism and Surrealism

The scandal caused by the reheated, reactionary style is brought more into focus by the recollection that, bolstered by his experience with the Surrealists in Paris in the late 1920s, Magritte had long identified his art as a form of revolutionary consciousness like all manifestations of Surrealism. In his November 1938 lecture at the Koninklijk Museum van Schoone Kunsten in Antwerp, where he had defended the proletarian revolution, he had told the large audience of art lovers unequivocally that 'Surrealist thought is revolutionary on all levels and is, of necessity, opposed to the bourgeois conception of art', a belief he managed to cling to in later years as he painted the

portraits of America's capitalist aristocracy.[52] Magritte's rhetoric of social transformation and the role of art in it already reveals an outlook quite at odds with Picabia's various attacks on art and his indifference to politics. It is inconsistent, as well, with the 'constructive schizophrenia' of Picabia's postmodernist and 'bad painting' descendants from the 1960s to the 1980s such as Jörg Immendorff and Martin Kippenberger who painted to show the worthlessness of modern painting 'from an awareness that the intention to have any kind of actual impact on life, history, politics or the present by means of art is basically hopeless.'[53]

This difference is brought out further through comparison of Picabian 'bad painter' Albert Oehlen's title *Farbenlehre* (*Colour Theory*), given to his 1985 exhibition, with Magritte's *Treatise on Light*. Both refer to a history of colour theory that is usually sourced in Goethe's repudiation of Isaac Newton, one that was instrumental for modernist artists from the Neo-impressionists to Wassily Kandinsky. Yet in Oehlen's own terms, the first title pointedly alludes to the failed utopianism of modernist abstraction in the service of 'a fundamental theory of failure', whereas Magritte's title (given by Nougé) seems more intent on emphasizing the optimism of the project of 'Sunlit Surrealism', while achieving a poetic juxtaposition of art and science.[54] Unlike 'bad painters', Magritte's anachronistic practice was not meant to undermine either style or medium: as we heard, he painted women, flowers, birds and trees during the occupation in rough approximation of Renoir's handling because, yes, like Renoir, he actually thought such subject matter could bring people (mainly himself) happiness in an unpleasant world.

Magritte had declared his communist sympathies throughout the 1930s, in the pages of the Belgian Communist Party newspaper *La Voix du Peuple* and elsewhere; his enrolment in the Communist Party announced on 8 September 1945 bears out forcefully the sincerity of his commitment to revolutionary struggle, or perhaps we should say to the fight against fascism given the way the geopolitical stakes were understood immediately after the Second World War. In making this allegiance, Magritte demonstrated his distance from the Parisian Surrealists who had rejected Soviet communism ten years earlier and been resolute critics of Stalinism and socialist realism ever since. But he also chose to forget Surrealism's tragic (or sometimes comic) misunderstandings with organized communism in France between 1927 and 1935.[55] That experience was now played out again as farce on a smaller scale in Belgium over an eighteen-month period leaving Magritte and Nougé surprised, apparently, by the frankly unsurprising, banal and conservative official Party line on culture. Magritte

[52] René Magritte, 'Life Line' [1938], *Selected Writings*, 58–67, 62.
[53] Friedrich Petzel, 'The Good, the Bad, and the Terrific', Vienna: Museum Moderner Kunst, *Bad Painting, Good Art*, 2008, 194–212, 204 (the term 'constructive schizophrenia' is Immendorff's, quoted by Petzel, 206).
[54] Petzel in *Bad Painting, Good Art*, 206.
[55] For the full story, see Carole Reynaud-Paligot, *Parcours politique des surréalistes 1919–1969*, Paris: CNRS Éditions, 2000. Georgette Magritte reported later that her husband's adhesion to the Party took place, like that of others after the war, out of a sense of solidarity with Russia: quoted from 1974 in René Magritte, *Écrits complets*, ed. André Blavier, Paris: Flammarion, 1979, 239.

soon gave up on his naïve adherence to the Party and later informed Patrick Waldberg of what the French Surrealists had discovered for themselves before the war: that '[i]ntellectual conformism was as patent in that milieu as in the most benighted sectors of the bourgeoisie'.[56] In the meantime, however, Magritte's membership of the Communist Party had exacerbated the conflicted position his new style had created with his Surrealism. This was an awkward one-foot-in-one-foot-out stance confirmed in the Surrealist exhibition he curated at the Galerie des Éditions La Boétie in Brussels from 14 December 1944 to 1 February 1945 that corroborated his centrality to Belgian Surrealism while displaying mainly the canvases in the Renoir style that were kicking up a fuss.

As is clear from the letter from Van Hecke to Mesens, this agitation came from his supporters, but, more seriously, it also radiated from the headquarters of Surrealism in Paris. In June 1946, Magritte arrived in the French capital and imprudently attempted to convince a distracted André Breton, just back from a five-year stay in America, of the value to Surrealism of the Renoir paintings. His confidence might have been bolstered by the reproduction of the second version of *The Red Model* (1935) on the cover of the recent expanded edition of Breton's *Le Surréalisme et la peinture* (1945) and he was perhaps hoping that Breton would finally get around to devoting a monographic text to his work (Magritte is alluded to only briefly in the book). The outcome of that encounter was an entirely un-ironic exchange of letters with Breton from June to August where Magritte advanced boldly his 'solar period' as the next stage in the movement's evolution. In the face of the poor critical take up of the Renoir works, Magritte protested to Breton, fatally for his argument, that they would be understood once Surrealism lightened up a bit. Unlike the period up to 1939, he asserted, its artists 'no longer exist to prophesy (our prophecies were always unpleasant, it must be admitted)', but 'to make joy and pleasure, which are so ordinary and beyond our reach, accessible to us all'.[57] They were, then, invitations to optimism – propaganda for pleasure – in an art unmarked, at first sight, by his very public enrolment in a Communist Party demanding compliance with the doctrine of socialist realism.

This facile line of reasoning was sustained in Magritte's subsequent letters, which badgered Breton about the importance of metaphors of light and the sun in the poet's own writing. Breton's riposte complemented its essential argument about originality (everyone's sun is their own) through its performance of the metaphor of the sun as multiple (friendship, style, inspiration, the creative act). But its main purpose was to refute Magritte's mimicked Renoirian sun or light in favour of self-discovered 'light':

> You will end by convincing me that you have no sun within you. And how can it be, since you feel the need to look for the sun in Renoir? You go looking for it there but it doesn't follow you and besides Magritte's sun would, by definition, be

[56] Magritte quoted in Patrick Waldberg, *René Magritte*, trans. Austryn Wainhouse, Brussels: André de Rache, 1965, 209 (translation modified).
[57] Magritte quoted in Sylvester (ed.), *René Magritte: Catalogue Raisonné, vol. 2*, 132.

different. Let me assure you that none of your latest canvases give me any impression of the sun (of Renoir, yes): really, not the slightest illusion. Is this my fault, after all? ... Contrary to what you think, I too love the light, but only created light.[58]

The point was that Breton had always sought a prophetic faculty for the mind and had pursued this in all of his theoretical writings and with increasing intensity since the mid-1930s, which fuelled the abhorrence of Impressionism that I outlined in my Introduction. It was a quest that lay at the heart of Breton's theory of art, explicitly rejected by Magritte's undisguised turn to Impressionism, as I will show now.

Prophecy: Breton, Gustave Courbet and Édouard Manet

Rooted in Sigmund Freud's findings, Breton's *Manifesto of Surrealism* (1924) had asserted that Surrealist writing plumbed the unconscious in search of what was unique to the individual. This programme was carried into painting by Breton the following year when he wrote of 'a *purely internal model*', not the Impressionist one taken from nature, as the first and last point of reference for the movement's painters.[59] Ten years later in April 1935, he amplified the relation of Surrealist painting with social and political history at the moment of the Popular Front in France. In the Prague lecture 'Political Position of Today's Art', Breton claimed that, enacted through the deepest exploration of the Id, 'art is no longer a question of the creation of a personal myth, but rather, with Surrealism, *of the creation of a collective myth*', in the sense that a myth was a metaphorical expression of an age deriving from the unconscious and could, quite literally, indicate the future of that age insofar as it was a chart of the clandestine manoeuvrings of desire.[60] This is the argument that Walter Benjamin had in mind when he added a footnote to 'The Work of Art in the Age of Mechanical Reproduction' (1936) that has been widely cited since though never really understood: '"The work of art," says André Breton, "is valuable only in so far as it is vibrated by the reflexes of the future."'[61]

As his initial case study in 'Political Position of Today's Art', Breton took a rare foray into the *oeuvre* of Gustave Courbet:

As you know, it was at his instigation that the Vendôme Column, the symbol of Napoleon's victories, was condemned to destruction, and Courbet is there in his shirtsleeves, magnificently robust and alive, watching it fall onto its bed of manure.

[58] Letter of 14 August 1946 quoted in Sylvester (ed.), *René Magritte: Catalogue Raisonné, vol. 2*, 133.
[59] André Breton, 'Surrealism and Painting' [1925–8], *Surrealism and Painting* [1965], 1–48, 4.
[60] André Breton, 'Political Position of Today's Art' [1935], *Manifestoes of Surrealism*, trans Richard Seaver and Helen R. Lane, Ann Arbor: University of Michigan Press, 1972, 212–33, 232.
[61] Walter Benjamin, 'The Work of Art in the Age of Mechanical Reproduction' [1936], *Illuminations*, trans. Harry Zorn, London: Pimlico, 1999, 211–44, 242–3 n. 17. For evidence that he read Breton's 1935 Prague lecture/essay, see Walter Benjamin, *The Arcades Project* [1982], trans Howard Eiland and Kevin McLaughlin, Cambridge, Mass. and London: The Belknap Press, 1999, 468.

The serious, childlike expression on the face of this man at this moment, a man who is also a very great artist, has always captivated me. This head, in fact, is the one in which there takes place a wholly original explosion of the contradiction that still possesses us Western writers of the left when it is a question of giving our work the meaning we would like our acts to have, with the aid of certain outside circumstances. I leaf through a Courbet album today: here are forests, here are women, here is the sea, here are priests coming back drunk and staggering from some solemn rite beneath the gibes of field-hands but here also is the magic scene entitled *Le Rêve*, where the realism, however deliberate it is, manages to hold its own only in the execution, since there is not the slightest trace of it in the general conception.[62]

Breton indicated that the art of Courbet shared the same themes as that of his contemporaries without overtly depicting the events of the Paris Commune, a characteristic it shared with Arthur Rimbaud's poetry.[63] Those events 'do not lead him to give directly polemical meaning to his art', insisted Breton, as had been stipulated as the purpose of art by the Soviet bureaucracy the year before his lecture and subsequently encouraged later in the 1930s when socialist realism became the official style of Soviet communist culture.[64] Breton was writing in the earliest period of the thoroughly converted Louis Aragon's 'espousal of socialist realism as the only language of the people', in the words of Simon Baker, through the ex-Surrealist's lectures in France, the US and USSR from January to June 1935 that were immediately printed in the communist cultural review *Commune*.[65] He was seeking, then, to salvage Courbet's realism from what he called the following year 'the dogma of "socialist realism"' and explain its persevering power over its audience through an emerging theory of magic linked to psychoanalysis.[66]

[62] Breton, *Manifestoes*, 218. The editors of his *Oeuvres complètes* assert that Breton was referring to a rarely seen photograph of Courbet published in *L'Art vivant*, no. 87, 1 August 1928, 180; however, it is highly unlikely that Courbet does figure in this picture and, as they say, his appearance does not match Breton's description anyway: André Breton, *Oeuvres complètes*, vol. 2, Paris: Gallimard, 1992, 1578.

[63] Breton relates only a handful of poems of 1871 – 'The Hands of Jeanne-Marie', 'The Stolen Heart', 'Parisian Orgy'/'Paris is Repopulated' and 'Parisian War Song' plus two lost poems – directly to the Commune in his Rimbaud case study: Breton, *Manifestoes*, 220. For a longer and often heavily inferential survey purporting to link Rimbaud's poetry to the events of 1870–1, apparently unaware of Breton's remarks, see Kristin Ross, *The Emergence of Social Space: Rimbaud and the Paris Commune* [1988], London and New York: Verso, 2008.

[64] Breton, *Manifestoes*, 219.

[65] Simon Baker, *Surrealism, History and Revolution*, Oxford: Peter Lang, 2007, 311. For Aragon's adoption of socialist realism over the three years after he left Surrealism in 1931, see Angela Kimyongür, *Socialist Realism in Louis Aragon's Le Monde réel*, Hull: The University of Hull Press, 1995, 15. Apart from Breton's lecture, expeditious resistance elsewhere in Surrealism to the approved style is shown by the red band bearing the slogan '"Face au réalisme socialiste"' that Salvador Dalí's *La Conquête de l'irrationnel* (1935) came wrapped in.

[66] André Breton, 'Nonnational Boundaries of Surrealism' [1936–7], *Free Rein* [1953], trans Michel Parmentier and Jacqueline d'Amboise, Lincoln and London: University of Nebraska Press, 1995, 7–18, 12. The definition of socialist realism emphasizing both 'realistic depiction of revolutionary development, and aims: the socialist instruction of the reader' had been given in *Commune* in June 1934: Kimyongür, *Socialist Realism in Louis Aragon's Le Monde réel*, 16. For the deep roots of socialist realism in the Russian Association of Proletarian Writers in the 1920s, its formalization yet strategically muted implementation in the pronouncements of Stalin's cultural spokesman Andrei

'Courbet's work proved to be particularly capable of withstanding time', Breton argued in 'Political Position of Today's Art', not in spite but because of its refusal to depict contemporary events consciously.[67] That gesture demonstrated, for Breton, its rootedness in the perennial, unconscious human drives that gave rise to such local events and the recognition of those profoundest desires by subsequent audiences. The 'magic' of Courbet's *Le Rêve*, now known as *Bather Sleeping by a Brook* (figure 2.11, 1845), lay in its assembly of components that originated in outer events but mirrored them only through the most obscure symbolism, peculiar to the artist. For Breton, this gave the painting a mediumistic quality in the sense that it created an image deeply redolent of the temper of its moment alongside an inscrutability for its contemporary audience due to its thickly veiled language, but also a longevity well beyond the affairs of its own time, precisely for that reason.

This is, in fact, an amplification of an earlier observation by Breton who had already ascribed mediumistic properties to the artist in the establishing pages of *Nadja* (1928), when he averred that the 'magnificent light in Courbet's paintings is for me the same as that of the Place Vendôme, at the time the Column fell'.[68] It is as though the momentous accomplishment of 16 May 1871 were implicit in the, nevertheless, apparently innocent canvases that preceded it. That opinion in *Nadja* about Courbet's paintings is immediately followed by a section making a longer and more familiar case for divination in de Chirico's early work:

If today a man like Chirico would confide – entirely and, of course, artlessly, including the least consequential as well as the most disturbing details – what it was that made him paint as he did, such a step, taken by such a man, would mean an enormous step taken for exegesis. . . . Chirico acknowledged at the time that he could paint only when *surprised* (surprised first of all) by certain arrangements of objects, and that the entire enigma of revelation consisted for him in this word: surprise.[69]

Breton presumably had in mind paintings such as *The Enigma of Fatality* (figure 2.12, 1914), which is reproduced later in *Nadja* and bears no comparison to Courbet's work in its style, content or genre. His point, however, was that great art might be conditioned

A. Zhdanov in the 1930s and its brutal realization after the Second World War, along with the reaction in France, but with only the barest notice of Breton's responses in the earlier period: see David Caute, *Communism & the French Intellectuals, 1914–1960*, London: Andre Deutsch Limited, 1964, 318–47; Sarah Wilson, *Picasso/Marx and Socialist Realism in France*, Liverpool: Liverpool University Press, 2013, 52–3, 185–6, 190, 196–7. The wide-ranging Surrealist rejoinder to socialist realism in the 1950s from Breton, Adrien Dax, Jean Schuster and José Pierre is briefly surveyed by Gérard Durozoi, *History of the Surrealist Movement* [1997], trans. Alison Anderson, Chicago: The University of Chicago Press, 2004, 530–2.

67 Breton, *Manifestoes*, 218.
68 André Breton, *Nadja* [1928], trans. Richard Howard, New York: Grove Weidenfeld, 1960, 14–15.
69 Breton, *Nadja*, 15. Of course, Breton had long-esteemed the 'prophetic' nature of de Chirico's enterprise specifically: see André Breton, 'Characteristics of the Modern Evolution and What it Consists of' [1922–4], *Lost Steps*, 107–25, 115.

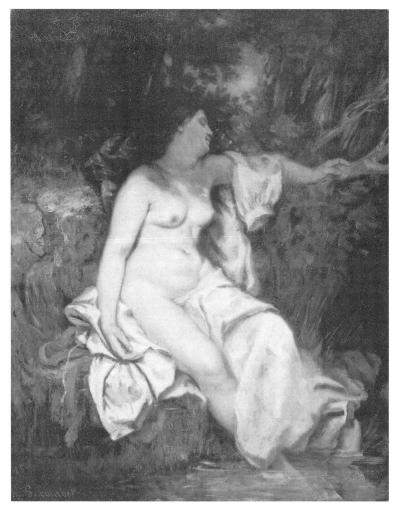

Figure 2.11 Gustave Courbet, *Bather Sleeping by a Brook* (1845). Oil on canvas, 81 × 65 cm. The Detroit Institute of Arts. © DeAgostini Picture Library/Scala, Florence.

and limited by such manifest, transient particularities of culture as style and so on, but it also reveals the latent, primal drives that give rise to them and that unconsciously regulate and silently preside over all human affairs. In this way, Courbet and de Chirico are presented at the outset of *Nadja* as conspirators among a litany of seers that also includes Victor Hugo, Gustave Flaubert and J. K. Huysmans. They were all targeted by 'those perpetual solicitations which seem to come from beyond, which momentarily possess us before one of those chance arrangements, of a more or less unfamiliar character, whose secret we feel might be learned merely by questioning ourselves

Figure 2.12 Giorgio de Chirico, *The Enigma of Fatality* (1914). Oil on canvas, 136 × 95 cm. Emanuel Hoffman-Stiftung, Kunstmuseum Basel. Photo: Öffentliche Kunstsammlung Basel, Martin P. Bühler. © DACS 2018.

closely enough.'[70] There is a strong chance that Breton was originally turned onto this comparison with and interpretation of Courbet by de Chirico himself who had published a brief article on the artist in November 1924, at the precise moment he was in Paris fraternizing with the Surrealists, paying tribute to him as 'profoundly sensitive to the poetic aspect of the world in which he lived' and even able to 'reveal the fantasy and lyricism of the world'.[71]

[70] Breton, *Nadja*, 17.
[71] Giorgio de Chirico, 'Gustave Courbet' [1924], trans. Katherine Robinson, *Metaphysical Art*, no. 14/16, 2016, 42–5, 45.

The passage on the two artists in *Nadja* clarifies Breton's later, abrupt and otherwise confusing comparison in the course of the lectures he gave in the law department at the University of Haiti in Port-au-Prince from late December 1945 till late January 1946 to accompany the exhibition of Wifredo Lam's paintings at the nearby Centre d'Art. Breton arrived there as a kind of cultural ambassador for France on the invitation of his friend the Surrealist Pierre Mabille who had been made French cultural attaché to Haiti after the war.[72] Repeating the remarks about the role that was played in the demolition of the Vendôme Column by Courbet, the 'great poet', 'great visionary' and revolutionary, Breton went on to compare the *Bather Sleeping by a Brook* (again called by him *Le Rêve*) to the stylistically emphatically divergent canvases of de Chirico.[73] Speaking in the immediate aftermath of yet another war, he surely meant, then, that just as Courbet's work made no effort to show the outer garb of human passions in the form of the Franco-Prussian War, Commune and *semaine sanglante*, de Chirico's pictures of the period of about 1911–21 that were admired by the Surrealists appear to turn not at all on immediately recognizable historical events – primarily the one in which most of the Surrealists had been caught up: the First World War. However, they continued to have a relative relationship with such events, or, as Breton put it in 'Political Position of Today's Art', the quality of their painting 'resides in imagination alone, independently of the exterior object that brought it to birth'.[74]

In the lecture in Haiti, Breton also gave unexpectedly effusive credit to the other main figure of early modernism, Édouard Manet, as 'the magnificent painter of *Olympia* [1863] and of *Bar of the Folies-Bergère* [*sic*] [1882]' while skipping the Impressionists, as I mentioned in my Introduction, as optical realists who were 'indifferent to philosophy and poetry'.[75] Manet had already featured prominently in 'Political Position of Today's Art', where Breton had extended the idea of avant-garde painting as a

[72] Breton's visit to Haiti has become best known for the revolution his appearance sparked, the outcome of the appalling poverty, racism and suppression of civil rights in that country, which he viewed at first hand. See the accounts by eyewitnesses Paul Laraque, 'André Breton in Haiti' [1971] and René Depestre, 'André Breton in Port-au-Prince' [1991], Michael Richardson (ed.), *Refusal of the Shadow: Surrealism in the Caribbean*, trans Krzysztof Fijalkowski and Michael Richardson, London and New York: Verso, 1996, 217–28 and 229–33. Also see Jean-Louis Bédouin, *Vingt ans de surréalisme, 1939–1959*, Paris: Denoël, 1961, 73–8; Maria Clara Bernal, 'André Breton's Anthology of Freedom: The Contagious Power of Revolt', Dawn Ades, Rita Eder and Graciela Speranza (eds), *Surrealism in Latin America: Vivísimo Muerto*, Los Angeles: Getty Research Institute, 2012, 133–42.

[73] 'grand poète', 'grand visionnaire', André Breton, 'Conférences d'Haïti, III' [1946], André Breton, *Oeuvres complètes*, vol. 3, Paris: Gallimard, 1999, 233–51, 234.

[74] Breton, *Manifestoes*, 220. The distance taken from history in this formulation, by which art originates in it yet is liberated from it by the imagination, was repeated a few weeks after by Breton in interview with the Tenerifean cultural journal *Indice* with reference to Charles Baudelaire, Courbet, Rimbaud and the Comte de Lautréamont, again under the shadow of socialist realism: 'The artistic imagination must remain free. By definition it stands aside from any fidelity to circumstances, especially the *intoxicating* circumstances of history. The work of art, under penalty of ceasing to be itself, must remain free of any sort of practical end', André Breton, 'Interview with *Indice*' [1935], *What is Surrealism? Selected Writings*, ed. Franklin Rosemont, London: Pluto, 1978, 144–7, 144.

[75] 'le magnifique peintre d'*Olympia* et du *Bar des Folies-Bergère* [*sic*]', '[i]ndifférents à la philosophie comme à la poésie', Breton, *Oeuvres complètes*, vol. 3, 236, 235.

materialist form of divination by insisting that the future was imminent in that artist's painting as much as it was in Surrealist art and poetry:

> I was shown, some time ago, a still life of Manet's that the jury unanimously refused just after it was painted, on the pretext that it was impossible to make anything out in it at all. This little canvas represents nothing more or less than a dead rabbit hung head down, painted with a clarity and a precision that leave it no reason to envy photography. The poetic works of the end of the last century that were considered the most hermetic or the most delirious are becoming clearer day by day. When the majority of the other works that offer no resistance to immediate comprehension have grown dim, when those voices in which a very large audience was pleased to recognize effortlessly its own voice have been stilled, it is strikingly clear that these difficult works have contradictorily begun to speak *for us*.... It is now beyond question that Surrealist works will share the same lot as all previous works that are *historically situated*. The climate of Benjamin Péret's poetry or Max Ernst's painting will then be the very climate of life. Hitler and his acolytes are, unfortunately, very well aware that it was necessary not only to persecute Marxists but also to forbid all avant-garde art in order to stifle leftist thought even for a short time. It is up to us to unite in opposing him through the invincible force of that which *must be*, of *human becoming*.[76]

Writing at the time in a materialist milieu, Breton preferred to bridge Karl Marx and Freud than to use the term 'divination' or any of its synonyms, correlates or terminology.[77] However, he would do so in the passages where he salvaged Cézanne's art for Surrealism through its second sight and in other commentaries on postponed understanding in *Mad Love* (1937), on which he was hard at work at the time of 'Political Position of Today's Art'.[78]

Also in *Mad Love*, Breton would describe the Hôtel de Ville in explicitly historical and autobiographical, and implicitly political and alchemical terms, as the expression 'in a quite specifically organic and *essential* way', of a Paris 'chang[ing] from blue to red'.[79] He must have known that Manet's morbid hunting trophy paintings *Rabbit* (figure 2.13, 1881) and *Dead Eagle Owl* (1881) along with two other commemorative panels were originally meant to decorate the Hôtel de Ville (it was presumably their loose handling for distant contemplation that enhanced the puzzlement of the jury, but which in the

[76] Breton, *Manifestoes*, 233.
[77] During the brief period he was a leading member of the left revolutionary alliance Contre-Attaque from autumn 1935 till March 1936, Breton temporarily saw the group as the means to 'reconcile Surrealism as a *method of creating a collective myth* with the much more general movement involving the liberation of man', Breton, *Manifestoes*, 210.
[78] Although aware of Breton's favourable allusions to both Courbet and Cézanne, one former Surrealist said of him: 'il bannit ... tout le courant naturaliste qui va de Courbet à Cézanne', José Pierre, *André Breton et la peinture*, Lausanne: L'Age d'Homme, 1987, 91. By then, Breton had already commented under the rubric of 'magic' on how, again, the light in Courbet's painting 'denies' (dément) his 'naturalism', André Breton, *L'Art magique* [1957], Paris: Éditions Phébus, 1991, 221.
[79] André Breton, *Mad Love* [1937], trans. Mary Ann Caws, Lincoln and London: University of Nebraska Press, 1987, 47.

Figure 2.13 Édouard Manet, *Rabbit* (1881). Oil on canvas, 97.5 × 61 cm. National Museum Wales, Cardiff. © Art Collection 2/Alamy Stock Photo.

wake of the twentieth-century avant-gardes had become increasingly legible, according to Breton), rebuilt by the new bourgeois republic after being torched by Communards in 1871.[80] The suggestion being made by Breton in 'Political Position of Today's Art', then, was that the dead rabbit by Manet was an *unconscious* 'political' statement by the artist, rememorative as much as commemorative of social unrest and revolutionary martyrdom, and was recognized as such, again unconsciously, by the confused jury of the Salon of 1882 (from there, Manet's painting went to Bernheim-Jeune where Breton probably saw it as a teenager, perhaps under Fénéon's tutelage, before it was sold in 1917).[81]

[80] See the interpretation of the Hôtel de Ville in *Mad Love* that was first given by Margaret Cohen, *Profane Illumination: Walter Benjamin and the Paris of the Surrealist Revolution*, Berkeley, Los Angeles, London: University of California Press, 1993, 155, 161–2, 171.

[81] His editors state that Breton meant to refer here to Manet's *Rabbit* of 1866, later owned by his one-time employer Jacques Doucet; however, as they acknowledge, unlike the 1881 *Rabbit*, that painting was not refused by the Salon jury, which confirms my identification of the later painting as the one he had in mind: Breton, *Oeuvres complètes*, vol. 2, 1585–6 n. 3.

Breton believed it was this latent content of vanguard art from Courbet and Manet onwards – like the concealed, violent past of the Hôtel de Ville buried under the reconstituted structure – that was only gradually revealed over time, which explained the vexed reaction of its contemporaries and its delayed reception, and to which he gave the status of 'myth'. In the year after the Prague lecture, he argued similarly in 'Nonnational Boundaries of Surrealism' that, without consciously intending to record it, the genre of the Gothic novel was 'symptomatic' of revolutionary Europe at the close of the eighteenth century.[82] He went on to contend in that text that the Surrealist group could likewise forge a '*collective myth* appropriate to our period' by profound means of self-exploration.[83] These were far superior to the gross reliance on the conscious mind that characterized socialist realism, according to the Surrealists, where the outcome was merely vulgar propaganda.

All of this was under-explained by Breton in his 1946 letter to Magritte because he must have thought it was obvious. Surrealist art might well have appeared pessimistic to the painter in the run up to the Second World War, but that was the point. It was hardly the role of Surrealism to suppress its depiction of the emerging disposition of the times, deeply sought in the Id, in favour of an art of the Ego meant to cheer people up, and that continued to be the case after the conflict. Magritte's position on Surrealist painting appears hinged to an apparent lack of appreciation of the significance to it of psychoanalysis, with which he had mainly an intellectual relationship as opposed to any belief that it might hold genuine diagnostic value (shown in his lack of interest in self-analysis or in interpretation of his art, especially by psychoanalysis).[84] It parades an equal detachment from how psychoanalysis had affected the development of Breton's version of Surrealism towards divination. Setting out from a kind of reverse causality in which art is supposed to decorate a grim reality, Magritte's new Renoir style and its theory accordingly marked a fundamental break with Surrealism's long held

[82] Breton, *Free Rein*, 15.

[83] Breton, *Free Rein*, 14–15.

[84] Magritte read Freud, of course, placing confidence in the discovery and theory of the unconscious at first, and he could even declare the 'capital importance' of Freud's writings in the *London Bulletin* in 1939: René Magritte, 'Bourgeois Art' [1939], *Selected Writings*, 68–9, 69. But by the late 1950s he was publicly expressing reservations about the notion of 'unconscious activity' and ridiculing the 'seriousness of specialists in the unconscious' with lightly veiled reference to Breton's writings: René Magritte, 'Magritte's Speech on Being Elected as a Member of the Académie Picard' [1957], *Selected Writings*, 173–4, 173. In 1962 at the time of his exhibition at the Walker Art Center in Minneapolis, Magritte would state his scepticism as follows: 'Psychoanalysis only allows us to interpret that which is open to interpretation. . . . Art, as I see it, resists psychoanalysis: it evokes the mystery without which the world would not exist – that is, mystery which is not to be confused with a sort of problem, however hard to solve. . . . No one in his right mind believes that psychoanalysis could elucidate the world's mystery. . . . Psychoanalysis has nothing to tell us about works of art that evoke the mystery of the world. Perhaps psychoanalysis is itself the best subject to be treated by psychoanalysis', René Magritte, '"Psychoanalysis . . .,"' trans. Harry Torczyner, *Selected Writings*, 204. Further remarks around the same period dismissing psychoanalysis, as though he had discovered his theme, can be found in René Magritte, 'Jan Walravens: Meeting with Magritte' [1962] and 'Magritte Interviewed by Marcel Fryns (I)' [1962], *Selected Writings*, 198–202, 199; 209–10, 210.

prognosticative role. Consequently, it also occasioned a rupture with the movement in its new era in the postwar period in which new commonalities were being sought between prophecy in occult, magic and superstition and the predictive capacity of the mind, as Breton and the majority of Surrealists now entertained it in their investigation of myth. This was a connection that the Belgian Surrealists behind Magritte seemed to misunderstand and be determined to ignore anyway.[85]

Painting, propaganda, prophecy

By August 1946, Magritte was importunately writing to Breton about his new theory of painting and culture as 'Extramentalisme', and he had Joë Bousquet, Jacques Michel, Louis Scutenaire, Jacques Wergifosse and the usually less indolent Mariën and Nougé on board.[86] The clunky term was soon dropped with a loud clang in favour of the marginally less cumbersome 'Amentalisme', which itself became subordinate to the more elegant (and marketable) 'Sunlit Surrealism'. Its ill-judged manifesto was drafted from 11 August 1946 up to the circulation to relevant persons and the publication of the final version in October. The body of documents it left behind refutes Surrealism's main areas of investigation point for point while advertising the search for 'an enchantment', no less – the term is used several times throughout the drafting process – 'which will bring the reign of pleasure into being'.[87] Demanding the use of 'sunny colours and words' and proclaiming the initial signatories' preference for charming as opposed to depressing things, 'Sunlit Surrealism' received few takers although, naturally, the typically recalcitrant Picabia was delighted and signed up with relish.[88] Breton's

[85] As early as 1934, Magritte had anticipated the efficacy of poetry 'to discover the secrets of the universe, which would give us power over the elements. Magic would be possible. This would truly satisfy the deep human longing for the marvelous', but this was never extended into a fuller investigation of magic or the occult: René Magritte, 'Ariadne's Thread' [1934], *Selected Writings*, 45. In a letter of 31 January 1948 sent to the crime novelist and former Surrealist Léo Malet, Magritte dismissed the 'old wives' magic making now highly respected by good Surrealists', quoted in Sylvester (ed.), *René Magritte: Catalogue Raisonné, vol. 2*, 148. Using remarks made by Magritte about 'enchantment' and titles of paintings such as *Black Magic* and *White Magic*, one author has argued for the presence of magic in his work but seems unsure about whether he means magic in the way I am using it here or prestidigitation: Ben Stoltzfus, 'Magritte's Smoke and Mirrors: Reading, Writing, and Art-Magic', Patricia Allmer and Hilde Van Gelder (eds), *Collective Inventions: Surrealism in Belgium*, Manchester Metropolitan University and Leuven University Press, 2007, 84–96.

[86] The lengthiest contemporary polemic against Breton in defence of 'Sunlit Surrealism' (including a retrospective critique of Bretonian Surrealism from its origins in psychoanalysis and automatism to its current interest in the occult and Hopi Kachinas) was, in fact, given by Mariën in a lecture of January 1947 that became a sort of postface for his book that year: Marcel Mariën, *Les Corrections naturelles*, Brussels: Librairie Sélection, 1947, 101–25.

[87] René Magritte, 'Surrealism in the Sunshine: 4. Manifesto No. 2 – November 1946' [1946], *Selected Writings*, 97–9, 98. The full dossier of the artist's published and unpublished manifestos devoted to 'Sunlit Surrealism', which continued to be written up to 24 September 1947, can be found in Magritte, *Selected Writings*, 90–102.

[88] Magritte, *Selected Writings*, 98.

Figure 2.14 Francis Picabia, *Five Women* (*c.* 1941–3). Oil on cardboard on canvas, 101.5 × 75 cm. Friedrich Christian Flick Collection. Image courtesy Friedrich Christian Flick Collection. © ADAGP, Paris and DACS, London 2018.

response to Magritte on receipt of the manifesto was a brief telegram, the second and final sentence of which read: 'You are joking', however, as Sylvester writes: 'there can be little doubt it was serious'.[89]

This is confirmed by Magritte's encounter with the far more enthusiastic Picabia whom he had visited in his studio in the course of that trip to Paris in the summer of 1946. Picabia's indefatigably pleasure-seeking figurative paintings of the preceding

[89] Sylvester (ed.), *René Magritte: Catalogue Raisonné, vol. 2*, 135.

years (figure 2.14) met his own current, supposedly Renoirean hedonistic disposition so closely that Magritte agreed, for one of the few times in his life, to compose an appreciation of another artist. Written at some point between June and October as a catalogue preface but not published at the time, the text contains no specific mention of Surrealism. Yet it shows Magritte as emphatically hostile towards the new bearing of the movement as he was utterly charmed by Picabia's antics:

faced with Picabia's pictures there's no need to think of 'revelations' in the coffee grounds or 'prophecies' that require too much patience to be verified. . . . In 1946, he opposes the intrusive forces of the past with movement and flashes of bright light revealing the whole of life in its magnificent isolation. . . . You only have to want pleasure to reign supreme despite the spectacle of a world peopled with ruin and idiotic anxieties. . . . [The paintings of Picabia] are superficial, like the joyous life of lovers and, as it were, leave out those who miss the 'profundity' of the blackout and the music of the guns. They inaugurate a new reign of pleasure which must be placed within the limits of our life.[90]

The discrepancy illustrated by Magritte here, between his idea of effective, relevant painting and Surrealism's, is stark and provocative.

Breton would now ruthlessly bring the disagreement to its culmination by setting out the unbridgeable distance between a redrafted Surrealism and the rejuvenated Magritte and his friends in the text 'Before the Curtain'. This was his preface to the catalogue of the major exhibition *Le Surréalisme en 1947*, beginning in July of that year in Paris, concerned with esotericism and magic and including zero paintings by Magritte.[91] In that text, Breton claimed that the 1938 exhibition that preceded it 'proved to be, alas, only too premonitory' in the light of the world events that succeeded it.[92] He went on to ratify the new direction for Surrealism in his most unstinting tribute to the wholly unMagrittean tome *The Golden Bough* (1890, 1906–15) by quoting J. G. Frazer's characterization of magic as '"the mother of freedom and truth,"'[93] (even though Frazer was actually saying that the freedom and truth it had bestowed on humanity came about because 'magic has paved the way for science', the last bit edited out by Breton).[94]

[90] René Magritte, 'Francis Picabia: Animated Painting' [1946], *Selected Writings*, 89.
[91] Magritte is not mentioned in the list of contributors in the exhibition catalogue, but elsewhere it has been stated that he was represented in the retrospective section 'Surrealists in Spite of Themselves', Sylvester (ed.), *René Magritte: Catalogue Raisonné, vol. 2*, 147.
[92] André Breton, 'Before the Curtain' [1947], *Free Rein* [1953], 80–7, 81.
[93] Breton, *Free Rein*, 85.
[94] See J. G. Frazer, *The Golden Bough: A Study of Magic and Religion* [1890, 1906–15], London and Basingstoke: Macmillan, 1976, 63. The Surrealists honoured *The Golden Bough* by making it the fourth step in the staircase depicting twenty-one book spines that led up to the first room of the 1947 show: André Breton, 'Projet initial' [1947], *Oeuvres complètes*, vol. 3, 1367–70, 1368. There is textual evidence in the form of 'the whirling splendour of the pages of Frazer's *Golden Bough*' that Breton was reading the book near the beginning of his time in America: André Breton, 'Autodidacts Called "Naives"' [1942], *Surrealism and Painting*, 291–4, 293.

I showed near the beginning of this chapter that the impulse in Magritte's art towards 'the "bright side" of life' had begun years before his Communist Party membership. However, Breton perceived a close association between the retrograde style and manifesto of 'Sunlit Surrealism', on the one hand, and Magritte's adherence to the Party, on the other. Still smouldering at what he saw as the painter's incompetent dismissal of Surrealism's historically determined predictive capacity and his back-to-front understanding of the purpose of painting, Breton now made this connection in 'Before the Curtain' in his last word on Magritte's new style, theory and politics. This was conveyed by way of the annihilating footnote that contrasted Surrealism's commitment to a revision of all values with a passage quoted from Magritte's manifesto:

> Is there any need to stress that the aforementioned attitude is diametrically opposed to the one recently adopted by some of those members of the former Surrealist group in Brussels who rallied around Magritte? Because they realized, as we did, that events had often confirmed beyond all expectations some of our most venturesome declarations, they took it into their heads to foster in their works only that which was 'charm, pleasure, sunshine, objects of desire' and exclude anything that might be 'sadness, boredom, threatening objects'! Even though this might be on their part a desperate attempt to straighten out their position with respect to the resolution of the Leningrad Writers Committee (1946) prescribing an unconditional optimism, it is difficult not to liken that gesture with that of a (backward) child who, in order to make sure he will have a pleasant day, would dream up the idea of blocking the pointer of the barometer at the 'fair weather' mark.[95]

Sensitive since the mid-1930s to the imposition of the official culture of propaganda by the Soviet Union – to socialist realism above all – as shown by 'Political Position of Today's Art', Breton had taken issue with the prohibitive declaration of what was presented to him as the 'Comité des écrivains de Leningrad' in an interview with *Le Littéraire* in October 1946.[96] By this was meant, in fact, the resolution of 14 August that year by the Central Committee of the Communist Party of the Soviet Union, which had not exactly insisted on optimism but had attacked the pessimistic tone and apolitical content of the 'literary-artistic magazines' *Zvezda* and *Leningrad*.[97] The resolution had been reported in *Le Littéraire* on 14 September 1946, meaning Breton became aware of it around the time he received Magritte's manifesto of 'Sunlit Surrealism'.[98] The two unwelcome announcements from Moscow and Brussels were subsequently tied together in Breton's mind.

[95] Breton, *Free Rein*, 282 n. 4.
[96] André Breton, 'Interview de Jean Duché' [1946], *Oeuvres complètes*, vol. 3, 588–99, 594; André Breton, 'Interview with Jean Duché (*Le Littéraire*, October 5, 1946)', *Conversations: The Autobiography of Surrealism* [1952], trans. Mark Polizzotti, New York: Paragon House, 1993, 196–208, 203.
[97] The content of the 14 August resolution as it was reported a few days later in the propaganda organ *Kul'tura i Zhizn* can be read here: http://www.cyberussr.com/rus/zvezda-e.html (accessed 22 May 2014).

There is some evidence that Breton was not merely imagining a relationship between 'Sunlit Surrealism' and the artist's political commitment. A few weeks prior to Breton's attack on the Belgian former Surrealists in 'Before the Curtain', Magritte's failed adventure with the Renoir style had fizzled out absolutely simultaneously with his involvement in organized communism. Magritte had voiced a rare reservation about socialist realism during his brief tryst with the Party, immediately after the war, and spoke twenty years later of his attempt to 'make people see that art was not to be as the communists understood it, i.e. an art of propaganda, but I failed, just as the Surrealists in France failed.'[99] The laboured defence of 'Sunlit Surrealism' – the effort to 'counter … the pessimistic postwar state of mind' – seems in this light as much an attempt to convince the Communist Party as Surrealism of the value of the new Renoir style.[100]

Its demise corresponded with Magritte's first one-man exhibition with Alexander Iolas held at the dealer's Hugo Gallery in New York in April 1947. The show had been delayed for over a year because the American public had so disliked his Renoir paintings, as Iolas recalled a few years later in a letter to Magritte.[101] Sylvester alludes to a 'growing submissiveness on Magritte's part to the insistent pressure exerted by Iolas' by the time of his second exhibition at the Hugo Gallery in May 1948.[102] In November 1947, his new dealer had made the prodding request that he stick with 'the mysterious, poetic quality of your former pictures, which by their compact technique were much more Magritte than those in which the Renoiresque technique and colouring strike everyone as outmoded. … I should say rather "less Magritte-like."'[103] Magritte's response, agreeing to the commercial demand, assured Iolas that '[t]he period you call "Renoiresque" is over and the pictures belonging to that phase will be keenly competed for "later."'[104]

[98] See the editorial note in Breton, *Oeuvres complètes*, vol. 3, 1322–3 n. 5. Mariën has indicated that there are unspecific responses to Breton's interview with *Le Littéraire* as a whole in Nougé's preface to Magritte's exhibition at the Galerie Dietrich that began on 30 November 1946; both exhibition and preface promoted 'Sunlit Surrealism', Mariën, *Activité surréaliste en Belgique*, 394. Further evidence that neither a satire of Impressionism nor anything else was intended by the Renoir style can be found in Magritte's remarks in that catalogue about his change of title of a gouache in the exhibition from *High Society* to *Spring Tide* because of his fear that 'there was a possibility of it being interpreted as a satire on high society through the presence of a box of cigars./It is not a question of satire but of a poetic effect', quoted in Sylvester (ed.), *René Magritte: Catalogue Raisonné, vol. 2*, 138; René Magritte, 'On Titles' [undated], *Selected Writings*, 112–16, 113.

[99] René Magritte, 'Magritte Interviewed by Jacques Goossens' [1966], *Selected Writings*, 217–22, 221. For his attempt to persuade communist intellectuals of the danger of styles of art prescribed by the Party and a comparison with Nazi cultural policy, see René Magritte, 'Magritte and the Communist Party: I. "Clarification …"' [1945], *Selected Writings*, 104.

[100] Magritte, *Selected Writings*, 99.

[101] Letter of 5 March 1950 from Iolas cited in Sylvester (ed.), *René Magritte: Catalogue Raisonné, vol. 2*, 141.

[102] Sylvester (ed.), *René Magritte: Catalogue Raisonné, vol. 2*, 153.

[103] Letter of 21 November 1947 from Iolas quoted in Sylvester (ed.), *René Magritte: Catalogue Raisonné, vol. 2*, 154–5, 155. Also see Iolas's letter of 5 February 1948 confirming the unsaleability of the 'Renoiresque works', Sylvester (ed.), *René Magritte: Catalogue Raisonné, vol. 2*, 156.

[104] Letter of 27 November 1947 from Magritte quoted in Sylvester (ed.), *René Magritte: Catalogue Raisonné, vol. 2*, 155.

The paintings in the Renoir style are certainly competed for, but only because of the Magritte name that Iolas built from that point on. For art history they remain as unsalvageable as they were for Breton's Surrealism and possess, therefore, a peculiar subversive force. They are too 'late' for Impressionism, too Impressionist for Surrealism, too droll for modernism and too sincerely felt to find a neat fit with postmodernism's panoply of theoretical terms (parody, kitsch, camp and so on).[105] Underachieving on all counts, they absent themselves from the canon, accidentally attaining a marginal, untouchable quality (unlike the 'Vache' daubs, they have never been exhibited as a stand-alone body of work). In that sense, and in spite of Magritte's own aspirations towards an uplifting and popular art, those paintings almost seem to reverse accidentally into a meta-avant-garde position. Similarly, and under a further layer of irony, Breton's hard-to-compass, medieval theory of art-as-divination carries a far more scandalous charge in its rejection of commonplace academic positivism than the now thoroughly domesticated ones of Georges Bataille. Although Breton was never reconciled with 'Sunlit Surrealism', the antagonism between the Impressionist Magritte and the occultist Breton is laid to rest when perceived in that way. In later years, their disagreement really was, when Breton finally acceded to Magritte's requests in the 1960s for his first dedicated essays on the proverbial, anaesthetized and, by then, classic style governing the apparently effortless conjuration of marvels.[106]

[105] In one major theoretical survey of twentieth-century art, the later 'antimodernist' work of de Chirico and Picabia receives only passing mention (and is not reproduced) while Magritte's 1940s paintings are not mentioned at all, which might be regarded as confirmation of the peculiar evasion by the Renoir style of the categories of modernism and antimodernism, as well as postmodernism: Hal Foster, Rosalind Krauss, Yve-Alain Bois, Benjamin H. D. Buchloh and David Joselit, *Art Since 1900: Modernism, Antimodernism, Postmodernism* [2004], London: Thames & Hudson, 2016, 182–3.

[106] André Breton, 'René Magritte' [1961] and 'René Magritte's Breadth of Vision' [1964], *Surrealism and Painting*, 269–70, 401–3. The rapprochement seems to have begun, ironically, with Magritte's conciliatory and measured response to the survey that was included in *L'Art magique*, stating 'the investigations of the magician and the artist render the universe *enchanting*', where that term is closely aligned with Magritte's own conviction that the world was an unsolvable 'mystery', René Magritte, '"A Judgement on Art ..."' [1957], *Selected Writings*, 175–6, 175. Loyal testimonials along with definitions of Surrealism, equally trimmed to suit his theory of his own painting, can be found in interviews given in 1962–6: Magritte, *Selected Writings*, 198–225.

Method and Poetry: Georges Seurat's Surrealist Dialectic

I have shown that Pierre-Auguste Renoir's canonical status within early modernism was refuted by the Surrealists on the whole, through indifference, while Paul Cézanne's reputation was given a rough ride by them apart from the brief respite in the 1930s. However, those of Georges Seurat and Paul Gauguin would receive very different treatment within the movement. For much of the remainder of this book, I examine the interpretations of those two artists within Surrealism and expand on them.

A favourite of formalists, modernists and classicists since the 1920s, Seurat seems the far more unlikely candidate at first for retrospective surrealization. Yet in that decade, André Breton had touted the artist's name with approval alongside that of his favourite Gustave Moreau, those of two other Symbolist-related painters, Gauguin and Odilon Redon, as well as Pablo Picasso's in the article 'Distance' of March 1923 that attempted to identify what Breton perceived as the crisis in art caused by the First World War. This was the return to figuration and craft by artists through their infatuation with the classical tradition.[1] Breton also tackled in that text what he called the 'overly formal research' in art criticism, especially as that was applied to Cubism, an approach that was just beginning a domination of the reception of Seurat that would last for over half a century.[2] That sequestration is now well known, even if the detail of its history has never been fully narrated to my knowledge. The purpose of the current chapter is to demonstrate that there was a parallel Surrealist interpretation of the artist and to contextualize that within the evolution of Breton's theoretical and critical writings over the same period, arguing for its ultimately dialectical structure.

Seurat in the 1920s: Calls to order and to dream

In the year following that early mention of Seurat, the artist's name turned up again, more notably for historians, in Breton's *Manifesto of Surrealism* (1924). This was in the

[1] André Breton, 'Distance' [1923], *The Lost Steps* [1924], trans. Mark Polizzotti, Lincoln and London: University of Nebraska Press, 1996, 103–6.

[2] Breton, *Lost Steps*, 106. His editors allege that it was *L'Esprit nouveau*, the periodical of Purism, that Breton had in mind here: André Breton, *Oeuvres complètes*, vol. 1, Paris: Gallimard, 1988, 1321.

familiar sentence referring mainly to precursors in the visual arts, appended as a footnote to supplement the proverbial list of pre-Surrealist writers that followed the definition of Surrealism as '[p]sychic automatism in its pure state, by which one proposes to express – verbally, by means of the written word, or in any other manner – the actual functioning of thought. Dictated by thought, in the absence of any control exercised by reason, exempt from any aesthetic or moral concern'.[3] Seurat heads the inventory of painters 'in the modern era' whom Breton regarded as close to Surrealism yet 'had not *heard the Surrealist voice*'.[4] That is to say, those individuals had not obeyed their *own* inner voice, the one by which Breton detected 'authentic' Surrealism, synonymous with authentic writing and art. It is tempting to match Seurat's proclaimed aim made to the Belgian poet Émile Verhaeren to thwart 'efforts restricted by routine and dreary practices'[5] with Breton's insistence in the *Manifesto* that automatism guaranteed its user liberation from the 'preconceived ideas' still clung to even by the movement's precursors.[6] However, it could not be clearer that Seurat strayed far from the creative programme posted there.

The techniques or enquiries that characterize Surrealism's interventions in art at its beginnings in the *Manifesto of Surrealism* and subsequently as they changed with the development of the movement through the 1930s – the speed, spontaneity and licence one witnesses in the 'literary' or poetic art of André Masson and often in that of Joan Miró; the adaptation of or to the unconscious, dream or psychoanalytic theory in that of Giorgio de Chirico, Salvador Dalí or Max Ernst; or the outright philosophical reflection on the nature of words and things that drove the painting of René Magritte even during the period in which he adopted a thin version of Renoir's brushstroke – must be set against the purely painterly, scrupulous and methodical practice of the artist whom Edgar Degas called 'the notary'.[7] Seurat's theoretical interests lay less in books of literature, poetry or philosophy than in theories of colour and form more directly yoked to the act of painting. His custom was to create studies of his major paintings, many in the case of the earliest important statements *Bathers at Asnières* (1883–4) and *A Sunday on La Grande Jatte – 1884* (1884–6). Seurat's first truly perceptive supporter Félix Fénéon wrote in 1886 following the display of the second of these at the eighth Impressionist exhibition of 15 May to 15 June of the 'deliberate and scientific manner' of the Neo-impressionists.[8] Four years after the

3 André Breton, 'Manifesto of Surrealism' [1924], *Manifestoes of Surrealism*, trans Richard Seaver and Helen R. Lane, Ann Arbor: University of Michigan Press, 1972, 1–47, 27.
4 Breton, *Manifestoes*, 27 n. 1.
5 'efforts vinculés par les routines et les pratiques mornes', Émile Verhaeren, 'Georges Seurat', *La Société nouvelle*, vol. 7, no. 1, 1891, 429–38, 432.
6 Breton, *Manifestoes*, 27.
7 'Degas appelait Seurat le notaire', Gustave Kahn, 'Au temps du pointillisme', *Mercure de France*, tome 171, no. 619, 1 April–1 May 1924, 5–22, 13.
8 'manière consciente et scientifique', Félix Fénéon, 'VIII^e Exposition Impressionniste, du 15 Mai au 15 Juin, Rue Laffitte, 1' [1886], *Oeuvres plus que complètes*, vol. 1, ed. Joan U. Halperin, Geneva and Paris: Librairie Droz, 1970, 29–38, 35.

appearance of Breton's *Manifesto*, Seurat's friend the Symbolist poet Gustave Kahn testified to the artist's fastidiousness by recalling that he 'completed a large canvas every two years'.[9]

Seurat's process of painting, then, as much as his preparatory method, was slow and steady. As another friend the Symbolist writer Teodor de Wyzewa recalled soon after his death: '[h]e wanted to make of painting a more logical art, more systematic, where less room would be left for chance effects'.[10] Even Breton himself would later concede that '[n]othing could be more premeditated than his enterprise'.[11] Once the extensive studies he made were drafted onto canvas as in the *Grande Jatte*, Seurat was prepared to 'sign on to years of probing' in the words of Richard Shiff who adds rather ominously: '[t]he depths he attempted to explore were indeterminate'.[12] The darkening mood of Shiff's phrase opens a passage of a sort into the shadow land of Surrealism. In this chapter, though, it will be necessary to take a scenic route through abstract art to get there, in search of a definition of the 'Surrealist Seurat' that the Surrealists themselves were reluctant to give.

The logical, disciplined attention paid by the 'rigidly proper' Seurat to his regulated and precise craft, apparently at the expense of intuition and accident, makes all the more remarkable his continual presence throughout Breton's *Surrealism and Painting* (1965), where only Marcel Duchamp and Picasso are cited with greater frequency.[13] Admittedly, no single essay is devoted entirely to the artist in that volume, yet Seurat's attendance at all in Breton's writings on art spanning 1925 to 1965 went against the main current of the art market as well as state-sponsored and popular taste in France for most of that period. This might already go some way towards explaining the enthusiasm shown towards Seurat by the Surrealists. Their proclamations of hostility towards nationalism and the state were frequent and given most fervently and enduringly at the time of the

[9] Gustave Kahn, 'Georges Seurat, 1859–1891' [1928], *The Drawings of Georges Seurat*, New York: Dover, 1971, v–xiii, vi.

[10] 'Il voulait faire de la peinture un art plus logique, plus systématique, où moins de place serait laissé au hasard de l'effet', Teodor de Wyzewa, 'Georges Seurat', *L'Art dans les deux mondes*, no. 22, 18 April 1891, 263–4, 263.

[11] 'Rien de plus prémédité que son entreprise', André Breton, 'Conférences d'Haïti, III' [1946], André Breton, *Oeuvres complètes*, vol. 3, Paris: Gallimard, 1999, 233–51, 239. Breton repeats almost word-for-word the phrase of Roger Fry who came late to Seurat a few years before the arrival of *Bathers at Asnières* at the National Gallery in London: 'Nothing can be imagined more deliberate, more pre-ordained than this method', Roger Fry, 'Seurat', *Transformations: Critical and Speculative Essays on Art*, London: Chatto & Windus, 1926, 96, 189. An earlier statement by Fry of 1920 was meant as a personal view of his taste of the preceding decade given in the language of formalism but it was, rather, the opinion of history: 'my most serious lapse was the failure to discover the genius of Seurat, whose supreme merits as a designer I had every reason to acclaim', Roger Fry, 'Retrospect' [1920], *Vision and Design* [1920], Harmondsworth: Penguin, 1961, 222–37, 226.

[12] Richard Shiff, 'Seurat Distracted', Jodi Hauptman (ed.), *Georges Seurat: The Drawings*, New York: Museum of Modern Art, 2007, 16–29, 18.

[13] The phrase comes from Richard Thomson, *Seurat*, Oxford and New York: Phaidon, 1985, 11.

riot at the banquet held for the poet Saint-Pol-Roux in July 1925.[14] As detailed by Françoise Cachin, the official evaluation of Seurat's significance in his own country following his death was subdued in comparison with the recognition of the artist's achievement elsewhere.[15] France finally bought its first Seurats in 1947 (three panels for the *Poseuses* of 1887–8 purchased at the second, posthumous sale of Fénéon's collection) and Seurat could be described by one writer as France's Leonardo at the time of the major retrospective at the Art Institute of Chicago early in 1958.[16] However, his reputation was still mixed at the official level compared to those of the generation after Impressionism – Cézanne, Gauguin and Vincent van Gogh – towards the end of the period covered by *Surrealism and Painting*.

In the decades after Seurat's death, the promotional and critical efforts of his friends Fénéon and Paul Signac, who had been appointed by the family to arrange the artist's professional affairs with another painter Maximilien Luce, led to few sales of his work in France outside of the circle of his contemporaries.[17] In 1900, his family sold the *Grande Jatte* for 800 francs and *Circus* (1890–1) for 500 (roughly £2,341 and £1,463 respectively in today's currency).[18] Duchamp's recollection late in life of the period around 1907 was that 'Seurat was completely ignored' by his own friends and acquaintances in Montmartre – 'one barely knew his name' – though there is some conflict within the personal and historical accounts of Seurat's status among artists at the time.[19] It is usually conceded that his paintings or technique were admired or even partly emulated by some Fauves in the early years of the twentieth century and by abstract artists, Cubists, Futurists and Purists in the years following the large showing of 205 paintings, studies and drawings at the Bernheim-Jeune galleries from 14 December 1908 to 9 January 1909.[20] All of the major works except the *Poseuses* were displayed at that event, coordinated by Fénéon, who oversaw the exhibition and transaction of contemporary works at the gallery from 1906 till he retired in 1924.

[14] The protest against nationalism, xenophobia and colonialism at the banquet for Saint-Pol-Roux is fondly recalled in André Breton, *Conversations: The Autobiography of Surrealism* [1952], trans. Mark Polizzotti, New York: Paragon House, 1993, 87–9; recorded in Gérard Durozoi, *History of the Surrealist Movement* [1997], trans. Alison Anderson, Chicago: The University of Chicago Press, 2004, 90–2; and in Mark Polizzotti, *Revolution of the Mind: The Life of André Breton*, revised and updated, Boston: Black Widow Press, 2009, 210–13. Also see the report of the incident, which includes the main eyewitness and historical accounts, in Raymond Spiteri and Donald LaCoss, 'Introduction: Revolution by Night: Surrealism, Politics and Culture', *Surrealism, Politics and Culture*, Aldershot and Burlington VT: Ashgate, 2003, 1–17.
[15] Françoise Cachin, 'Seurat in France', New York: Metropolitan Museum of Art, *Georges Seurat: 1859–1891*, 1991, 423–4.
[16] Germain Bazin, 'Seurat est le Vinci français', *Arts*, no. 654, 22–28 January 1958, 14.
[17] Joan Ungersma Halperin, *Félix Fénéon: Aesthete & Anarchist in Fin-de-Siècle Paris*, New Haven and London: Yale University Press, 1988, 211.
[18] John Rewald, *Post-Impressionism: From Van Gogh to Gauguin*, New York: The Museum of Modern Art, 1956, 426.
[19] Pierre Cabanne, *Dialogues with Marcel Duchamp* [1967], trans. Ron Padgett, London: Thames and Hudson, 1971, 22.
[20] See the brief account of the study of Seurat by artists of that generation given by Alfred H. Barr, Jr., *Cubism and Abstract Art*, New York: The Museum of Modern Art, 1936, 22.

In 1910, Duchamp's friend Guillaume Apollinaire could still refer briefly and flippantly in his art criticism to Seurat as 'the microbiologist of painting',[21] but after he read Signac's republished *D'Eugène Delacroix au néo-impressionisme* (1899) in 1911 Apollinaire revised his opinion, writing of Seurat as a 'great painter' whose 'importance has not yet been fully appreciated'.[22] Later that year in a review of an exhibition from which the artist's work had been excluded he referred to 'the great painter Seurat, whose name I wish particularly to emphasize'.[23] From that point up to the First World War, Seurat's status only grew in the estimation of Apollinaire perhaps due to further discussion with his artist friends. Soon he was calling him 'one of the greatest French painters'[24] and 'one of the greatest painters of the nineteenth century and an innovator whose reputation will grow with the centuries',[25] before bemoaning his absence from the walls of the Musée du Luxembourg in 1914 as part of his ongoing campaign against the conservatism of that institution.[26] Apollinaire's insightful appraisal of Seurat and glowing enthusiasm for the artist were no doubt communicated to his protégé Breton in the three years they knew each other from 1915–18, but his art criticism failed to reconcile a larger audience to the artist. There were no solo exhibitions given over to his art in that decade, no books and only four articles, according to Kenneth Silver.[27] As Breton would later complain, the general public in France had greeted Seurat's art with jeering disdain before the First World War.[28]

The reputation of Seurat truly reached its nadir among museums and collectors in the 1920s in his own country, at the very moment Breton began to cite him and as his stock began to rise among artists and critics. His work was shown by Fénéon at Bernheim-Jeune again when sixty-two paintings and drawings were hung in a solo exhibition of 15–31 January 1920. Probably because of that event, Apollinaire's friend the poet André Salmon eulogized Seurat, in a way that would hardly have appealed to Breton, as part of 'the great tradition', as a link in the distinguished chain of French classicism that included former Fauves André Derain and Maurice de Vlaminck and reached back to the Renaissance via Jean-Dominique-Auguste Ingres, Eugène Delacroix and Jacques-Louis David to Raphael.[29]

21 Guillaume Apollinaire, 'The Art World' [1910], *Apollinaire on Art: Essays and Reviews 1902–1918* [1960], ed. Leroy C. Breunig, trans. Susan Suleiman, Boston, Mass: MFA, 2001, 100–5, 101.

22 Guillaume Apollinaire, 'From Eugène Delacroix to Neo-Impressionism' (book review) [1911], *Apollinaire on Art*, 176–7, 176.

23 Guillaume Apollinaire, 'An Opening' [1911], *Apollinaire on Art*, 188.

24 Guillaume Apollinaire, 'New Trends and Artistic Personalities' [1912], *Apollinaire on Art*, 217–20, 219. See, for instance, his extensive quotation of Robert Delaunay on Seurat's importance: Guillaume Apollinaire, 'Reality, Pure Painting' [1912], *Apollinaire on Art*, 262–5.

25 Guillaume Apollinaire, 'The Salon des Artistes Français', [1914], *Apollinaire on Art*, 367–70, 369.

26 Guillaume Apollinaire, 'Seurat's Drawings' [1914], *Apollinaire on Art*, 379–80, 380.

27 Kenneth E. Silver, *Esprit de Corps: The Art of the Parisian Avant-Garde and the First World War, 1914–1925*, Princeton NJ: Princeton University Press, 1989, 337.

28 Breton, *Conversations*, 246. Also see the remarks made a few years after Breton, reporting the 'laughing crowd' that had assembled around the *Grande Jatte* at the eighth and last Impressionist exhibition in 1886, and the 'incredible abuse' heaped on Seurat's innovations by press and public alike, given by Rewald, *Post-Impressionism*, 90, 97.

29 André Salmon, 'Georges Seurat', *The Burlington Magazine for Connoisseurs*, vol. 37, no. 210, September 1920, 115–17 and 120–2, 116.

Yet in that decade all of Seurat's major paintings were sold to collections abroad: *Chahut* (1889–90) to the Netherlands in 1922 (the Louvre had turned it down in 1914); *Bathers at Asnières* to England from Fénéon's collection and the *Grande Jatte* to America both in 1924; and *Young Woman Powdering Herself* (1889–90) and *Poseuses* to England and the United States respectively in 1926. John Quinn had purchased *Circus* in 1923 on the advice of Duchamp's close friend Henri-Pierre Roché who acted as the American collector's European art buying agent.[30] Bequeathed by Quinn to the Louvre upon his death in 1924, the painting returned to France in 1927, presumably met by an embarrassed or bemused silence within that venerable institution since the critic Florent Fels marked its homecoming with the words 'Seurat is unknown to the general public'.[31] The absence of all these major works from France meant that as late as 1957 Germain Bazin could lament the impossibility of organizing a Seurat retrospective in that country in spite of his efforts and those of René Huyghe since the war.[32] From 1908 to 1928, *Parade de Cirque* (1887–8) hung around on sale at Bernheim-Jeune with Fénéon in attendance for most of that time.[33] Breton must have seen the forlorn masterpiece there because as a teenager around 1910 or 1911 'he sometimes stopped to exchange a few words' with Fénéon according to his biographer.[34] He might even have seen it when it was shown in the 1908–9 Seurat exhibition held at the gallery. It

[30] Calvin Tomkins, *Duchamp: A Biography*, New York: Henry Holt and Company, 1996, 218; Metropolitan Museum of Art, *Georges Seurat*, 363.

[31] 'Seurat est inconnu du grand public', Florent Fels, 'Seurat entre au Louvre', *Nouvelles littéraires*, 22 November 1924, 3. Apparently, on his first trip to Paris in 1924 ten years before he joined the Surrealists, Hans Bellmer 'concentrated his attention on the works of Seurat', which barely affected his own later paintings and drawings but at least gave him a last sighting of several of those unwanted works before they were shipped out of France: Peter Webb with Robert Short, *Hans Bellmer*, London, Melbourne, New York: Quartet, 1985, 21.

[32] Bazin, 'Seurat est le Vinci français', 14.

[33] Halperin, *Félix Fénéon*, 385.

[34] Polizzotti, *Revolution of the Mind*, 18. More work should be done on Fénéon as potentially an intellectual mentor for Breton and Surrealism, especially since Breton compared his own early art criticism to Fénéon's prescient appreciation of Seurat and Paul Valéry's appreciation of Renoir when he wrote in later life of the importance of 'l'oeil de la jeunesse', André Breton, '"C'est à vous de parler, jeune voyant des choses"' [1952], *Perspective cavalière*, Paris: Gallimard, 1970, 13–20, 14. A renowned anarchist in spite of his self-effacement, known to Alfred Jarry and Apollinaire, publisher of Arthur Rimbaud and responsible in 1890 for 'the first generally circulated edition' of *Les Chants de Maldoror* (1869) by the Comte de Lautréamont, Fénéon could not have failed to make a mark on Breton who with Louis Aragon in January 1925 made a note of his address (appropriately, it was 15 rue Eugène Carrière at the time) in the collective notebook of the Bureau de recherches surréalistes to ensure he was added to the 'liste de services de la revue' and years later wrote warmly to Jean Paulhan that he 'got to know [Fénéon], was amazed by him, admired and loved him' on receiving a copy of Paulhan's edition of the writings of Fénéon in 1949: quoted in Halperin, *Félix Fénéon*, 172, 11; Paule Thévenin (ed.), *Bureau de recherches surréalistes: cahier de la permanence, octobre 1924-avril 1925*, Paris: Gallimard, 1988, 79. As late as 1951, Breton was privileging Fénéon's authoritative scholarship on Rimbaud: André Breton, 'Foreword to the Germain Nouveau Exhibition' [1951], *Free Rein* [1952], trans Michel Parmentier and Jacqueline d'Amboise, Lincoln and London: University of Nebraska Press, 1995, 241–3, 241; also see André Breton, 'Caught in the Act' [1949], *Free Rein*, 125–69, 130–1. In addition to Halperin, see the two articles by John Rewald, 'Félix Fénéon (1)', *Gazette des Beaux-Arts*, vol. 32, July–December 1947, 45–62 and 'Félix Fénéon (2)', *Gazette des Beaux-Arts*, vol. 33, January–June 1948, 107–26.

eventually followed the *Grande Jatte* and *Poseuses* into the welcoming arms of American collectors in 1930.

Only one sale of a Seurat was made in the 1920s in France. That was the sparsely drawn red, yellow and mainly blue oil on canvas sketch for *Circus* dated 1890–1 (figure 3.1) that had been on display at the 1908–9 show. It was purchased from Fénéon by the fashion designer Jacques Doucet in 1924 on the razor-sharp advice of his young librarian and art adviser, the author that year of the *Manifesto of Surrealism*, André Breton.[35]

In spite of the trusted Apollinaire's advocacy of Seurat, Breton's quick wittedness and curiosity about the artist who prioritized 'exacting logic', as Roger Fry put it,[36] are not at all easy to explain in the shadow thrown by the *Manifesto* across 'logical methods', which, according to Breton, were 'applicable only to solving problems of secondary interest'.[37] It is true that in the years after the appearance of the *Manifesto*, in his earliest extended discussions of art and Surrealism in *La Révolution surréaliste* (twelve issues, 1924–9), Breton observed Seurat's deployment of what he called 'the litho [ce chromo] … used so mockingly and so literally as the basis of inspiration for his painting *Le Cirque*'.[38] The elusive, sardonic humour he and others have perceived there would eventually lead Breton to a theory of the artist inclusive to Surrealism, as I show later in this chapter. Yet to this he added hesitantly in parentheses: 'it is open to question

[35] See Breton, *Conversations*, 76. Breton had urged Doucet to purchase work by Seurat in 1923: see Breton, *Oeuvres complètes*, vol. 3, 1232. Breton had known Duchamp for a few years by then; alongside Duchamp's friendship with Quinn's agent Roché, this helps explain the letter Duchamp sent on 22 December 1923 to Doucet who collected and commissioned his work (for which we do not have Doucet's letter in which a request for information about Seurat must have been made) where he expressed some admiration for Seurat's painting, especially *Chahut*, 'which, in my view, is his best', and contempt for Paul Signac and Lucie Cousturier 'his vile imitators/wigmakers', alongside ignorance as to the whereabouts of his paintings (this is odd, since he must have known through Roché or through his acquaintance with Quinn that the collector had owned *Circus* since January that year), which must have been the substance of Doucet's inquiry: Marcel Duchamp, *Affectt Marcel._ The Selected Correspondence of Marcel Duchamp*, eds Francis M. Naumann and Hector Obalk, trans. Jill Taylor, London: Thames and Hudson, 2000, 139. For Duchamp's activities in the art market following Quinn's death, see Tomkins, *Duchamp*, 270–4.

[36] Fry, *Transformations*, 195.

[37] Breton, *Manifestoes*, 9.

[38] See André Breton, 'Surrealism and Painting' [1925–8], *Surrealism and Painting* [1965], trans. Simon Watson Taylor, New York: Harper & Row, 1972, 1–48, 24 (translation modified); 'ce chromo dont Seurat semble s'être si moqueusement, si littéralement inspiré pour peindre *Le Cirque*', André Breton, 'Le Surréalisme et la peinture', *La Révolution surréaliste*, no. 9/10, 1 October 1927, 36–43, 38. In the full passage, Breton writes 'pinned on the wall of Picasso's studio, the litho which Seurat used …', Breton, *Surrealism and Painting*, 24 (translation modified). Breton was referring to Seurat's admiration for the posters of Jules Chéret; the inspiration he drew from them was widely reported from as early as 1889 and the comparisons were commonplace: see Robert L. Herbert, 'Seurat and Jules Chéret' [1958], Norma Broude (ed.), *Seurat in Perspective*, Englewood Cliffs NJ: Prentice Hall, Inc., 1978, 111–15; Thomson, *Seurat*, 204, 207, 212–21. For an objection to Herbert's cuddly Chéret, see Jonathan Crary, *Suspensions of Perception: Attention, Spectacle, and Modern Culture*, Cambridge, Mass. and London: MIT, 1999, 269 n. 273. Picasso was a step ahead of other Cubists into Seurat's own sources: as recorded by André Salmon in 1920 about his contemporaries: 'the first

Figure 3.1 Georges Seurat, sketch for *Circus* (1890–1). Oil on canvas, 55 × 46 cm. Musée d'Orsay, Paris. © Photo Josse/Scala, Florence.

Cubist studios were hung with photographs of works by Ingres and Seurat, notably the *Chahut*, one of the great icons of the new devotion', Salmon, 'Georges Seurat', 115; and as also witnessed a few years later by Florent Fels around the time Breton was writing: 'une reproduction de son *oeuvre Le Cirque* qui entre au Louvre, est épinglée au mur des ateliers des peintres du monde entier', Fels, 'Seurat entre au Louvre', 3. Reproductions of both *Chahut* and *Circus* appeared 'entre deux bois nègres' in the studios of young artists around 1910 (which might confirm the importance of the 1908–9 Bernheim-Jeune exhibition) according to Claude Roger-Marx, *Seurat*, Paris: Les Éditions G. Crès & Co., 1931, 8.

whether what he is generally considered to have achieved technically in the field of "composition" is truly significant.[39] This doubt was expressed in the face of what was already being lauded as the 'formal design' of Seurat's work. But there is open-mindedness here, as opposed to the incomprehension Breton had conveyed and the tone of outright censure he had chosen a few years earlier in speaking of Cézanne's reputation. Nevertheless, we are still left wondering along with Breton at this juncture as to where the 'surrealist' elements lie in the art of Seurat.

His vacillation over the artist and our own reservations about the task he had set himself are perfectly warranted given the historical evidence. It demonstrates that Breton's query, first raised in *La Révolution surréaliste* in 1927, took place in the midst of enthusiasm for Seurat's work in France by those advancing and defending what Alfred H. Barr, Jr. called at the time, in accounting for Seurat's prominence at the end of the decade, 'the so-called neo-classic phase [of vanguard art] of the last ten years'.[40] This goes some way further towards making a Surrealist Seurat incomprehensible. Silver has charted the 'new esteem' achieved by Seurat's art with the advent of the classical revival of the 1920s, arguing 'the degree to which Cézanne was devalued was the degree to which Seurat gained new prestige'.[41] There was, for instance, Salmon's 1920 *Burlington* article on the artist, written by a critic who thought revolutionary art 'tended only towards the rediscovery of the ways of Classicism', and who imagined even Cubism had classical roots.[42] Further tributes to Seurat came in the pages of Purism's mouthpiece *L'Esprit nouveau* in 1920. A colour reproduction of *Young Woman Powdering Herself* was used to exemplify the idea insisted upon in the dry statement that opened the first issue of the journal that 'the spirit of construction is as necessary to create a painting or a poem as it is to build a bridge' (figure 3.2).[43] This was followed by the heavily illustrated article on Seurat in that same number of the journal by the artist Roger Bissière aligning him (and Cézanne) with Giotto, Nicolas Poussin, Jean-Antoine Watteau, Jean-Baptiste-Siméon Chardin, David and Ingres.[44] Meanwhile, Lucie Cousturier's 1921 monograph reasonably compared Seurat to Pierre Puvis de Chavannes, and in the same breath hypothesized the relationship between the structure of his compositions and those of Greek architecture.[45] Amédée Ozenfant compared his composition to that of the 'old Greek geometers', claiming

[39] Breton, *Surrealism and Painting*, 24.
[40] Alfred H. Barr, Jr., *The Museum of Modern Art First Loan Exhibition, New York, November 1929: Cézanne, Gauguin, Seurat, van Gogh*, New York: Museum of Modern Art, 1929, 26.
[41] Silver, *Esprit de Corps*, 336.
[42] Salmon quoted from 1925 in Christopher Green, *Cubism and its Enemies: Modern Movements and Reaction in French Art, 1916–1928*, New Haven and London: Yale University Press, 1987, 188, 59.
[43] 'L'esprit constructif est aussi nécessaire pour créer un tableau ou un poème que pour bâtir un pont', 'L'Esprit nouveau', *L'Esprit nouveau*, no. 1, 1920, 3–4, 3.
[44] Roger Bissière, 'Notes sur l'art de Seurat', *L'Esprit nouveau*, no. 1, 1920, 13–28.
[45] Lucie Cousturier, *Seurat* [1921], Paris: Les Éditions Georges Crès & Co., 1926, 18. Comparison of Seurat with both Ingres and Puvis had been commonplace among his acquaintances; for the 'classicism' of his work as understood in the 1930s, see Robert Rey, *La Renaissance du sentiment classique: Degas, Renoir, Gauguin, Cézanne, Seurat*, Paris: Beaux-Arts, 1931, 94–137.

his landscapes had 'the dryness of the great French tradition', while paying homage in a telling phrase to Seurat's 'common sense' in *Cahiers d'Art* in 1926.[46] Finally, Waldemar George praised his 'classic style, of a modern sentiment' in a monograph in popular format on Seurat that Breton owned, and which appeared exactly contemporary with Breton's tentative note on the artist's composition when it was reprinted from *La Révolution surréaliste* in *Surrealism and Painting*.[47]

These opinions could be found among the eight monographs and thirty-four articles that accompanied the five solo exhibitions devoted to Seurat in the 1920s.[48]

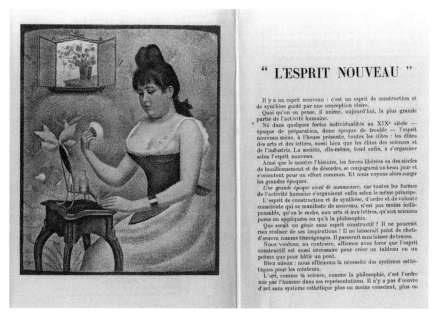

Figure 3.2 Reproduction of *Young Woman Powdering Herself* as it appeared in *L'Esprit nouveau* no. 1, 1920.

[46] 'les vieux géomètres grecs', 'le sec de la grande tradition française', 'bon sens', Amédée Ozenfant, 'Seurat', *Cahiers d'Art*, no. 7, September 1926, 172. Ozenfant had sought alignment for Cubism and, implicitly, his new aesthetic, with Ingres, Cézanne, Seurat and Henri Matisse as early as 1916: Amédée Ozenfant, 'Notes on Cubism' [1916], Charles Harrison and Paul Wood (eds), *Art in Theory, 1900–1990: An Anthology of Changing Ideas*, Oxford and Cambridge, Mass.: Blackwell, 1992, 223–5, 224; and explicitly so later by returning to the same artists and reproducing alongside Ingres' work Seurat's *Young Woman Powdering Herself* and several of the other later masterpieces with Cézanne's five figure *Card Players* (1890–2) in Amédée Ozenfant and Charles-Edouard Jeanneret, *La Peinture modern*, Paris: Les Éditions G. Crès & Co., 1925 (*Chahut* adorns the book jacket in a kind of photomontage, supposedly illustrating the relationship between form and colour, which had been used originally in the first Seurat-heavy number of *L'Esprit nouveau*).
[47] 'style classique, d'un sentiment moderne', Waldemar George, *Seurat*, Paris: Librairie de France, 1928, n.p.
[48] Silver, *Esprit de Corps*, 337.

They represent a complete revision of opinion of his work among critics and collectors if not yet at the level of France's institutions and that of the general public. This change of heart registered the mood of a postwar cultural elite in that devastated nation that found in Seurat's art 'an image of the world', in Silver's words, 'that they found reassuringly ordered, geometric, and much like the world that they themselves hoped to reconstruct'.[49] The awakening to Seurat as a modern classic was perfectly consistent with the artist's obvious interest in classicism fed by his time at the École des Beaux-Arts in 1878–9, an education that had led to deep suspicion among his own circle of painters.[50] However, such features of his art are entirely irreconcilable with Breton's counter-argument *against* the shortsighted ideology of clarity, order, reason and progress inherited from the same tradition, which the Surrealists blamed for the war. This was displayed in Breton's protest of the 1920s aimed in the *Manifesto* against the 'absolute rationalism that is still in vogue', his impatient claim there that 'experience . . . leans for support on what is most immediately expedient . . . protected by the sentinels of common sense',[51] and his advancement of hallucination, fantasy, superstition, the unconscious, dream and the marvellous ('romantic *ruins*, the modern *mannequin*') as the bases for a new epistemology.[52] Breton's budding enthusiasm for Seurat seems willfully contrary if not perverse in the midst of the conflicting cultural remedies touted in the 1920s that helped recuperate the artist. Indeed, his attitude towards Seurat remained intuitive and largely unexplored in his own writings in that decade. Where might we find a space for Seurat in Surrealism given these incompatibilities?

Abstractionist and Surrealist

The beginning of an answer to this question can be found given accidentally in a 1936 article in the *Burlington Magazine* by the then-abstract painter Jean Hélion whose work carried occasional glimpses of content indebted to Surrealism but who was closer stylistically to Fernand Léger in the 1930s. In fact, as a founder member of the Association Abstraction-Création set up in 1931, he was more alarmed than anything else at the growing importance of Surrealist painting internationally and, as seen in my first chapter, he had been implicitly subject to derision by Salvador Dalí's ridicule of Abstraction-Création only recently.[53]

[49] Silver, *Esprit de Corps*, 337.
[50] I refer to the well-known remark in the letter from Camille Pissarro to Signac made at a low point in their relations with the ambitious younger artist in 1888: '*Seurat est de l'École des Beaux-Arts*, il en est impregné . . . Prenons donc garde, là est le danger', quoted (with ellipsis) in John Rewald, *Georges Seurat*, Paris: Éditions Albin Michel, 1948, 115.
[51] Breton, *Manifestoes*, 9, 10.
[52] Breton, *Manifestoes*, 16.
[53] Salvador Dalí, 'Abjection et Misère de l'Abstraction-Création', *La Conquête de l'irrationnel*, Paris: Éditions Surréalistes, 1935, 19–20.

The teleological assimilation of Seurat's work to abstract art that would be carried out by Hélion was typical of arguments privileging form, abstraction or both and they dominated in the period I am looking at in this chapter. Hélion's name by no means heads the list of these chronologically. They had begun in the second half of the 1920s when *Parade de Cirque* (figure 3.3) had been called by Roger Fry 'as abstract, as universal and as unconditioned as pictorial art ever attained to, at least, before the days of Cubism'.[54]

Comparable arguments isolating form, style or geometry continued to lead the scholarship on Seurat from the 1930s (with the exception, as we will see, of the writing of Meyer Schapiro). This is evident, for instance, in the schematic drawings of the 'straight-line' and 'curved line' organization of the *Grande Jatte* published by Daniel Catton Rich in 1935.[55] Hélion's *Burlington* article was published only three months after the closure of *Cubism and Abstract Art* at the Museum of Modern Art (MOMA) in New York, which featured three small oils and a drawing by Seurat as well as two

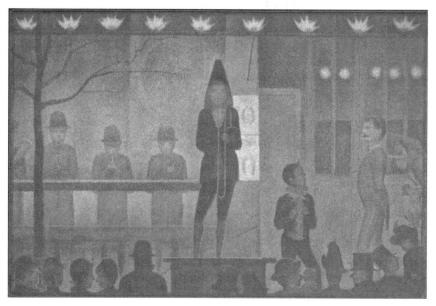

Figure 3.3 Georges Seurat, *Parade de Cirque* (1887–8). Oil on canvas, 99.5 × 150. The Metropolitan Museum of Art, New York. www.metmuseum.org.

[54] Roger Fry, 'Seurat's *La Parade*', *The Burlington Magazine for Connoisseurs*, vol. 55, no. 321, December 1929, 289–91 and 293, 290.
[55] Daniel Catton Rich, *Seurat and the Evolution of La Grande Jatte*, Chicago: The University of Chicago Press, 1935, 27, 29. Also see Robert J. Goldwater, 'Some Aspects of the Development of Seurat's Style', *The Art Bulletin*, vol. 23, no. 2, June 1941, 117–30; and Lionello Venturi, 'Piero della Francesca-Seurat-Gris' [1953], Broude (ed.), *Seurat in Perspective*, 108–10.

paintings by Hélion himself, so he might have seen the exhibition.[56] He would certainly have known its catalogue, which integrated Seurat into MOMA's expanding modernist teleology by claiming that his theory of art was 'as abstract as that of the later Cubists, Suprematists or Neo-plasticists'.[57] In later years, Clement Greenberg, Robert L. Herbert and Norma Broude repeated Hélion's view that the obvious 'outcome' of Seurat's sometimes flattish and caricatural, even cartoon-like style was abstract art in Europe and America, an opinion that was shared in France by the mid-1950s.[58] The habit has been hard to break in the years after modernism. In a review of Seurat's drawings at MOMA in 2008, Yve-Alain Bois attacked this precursor game as 'seriously flawed', and even 'toxic' and 'utterly useless' while outdoing his predecessors by adding a whole roster of European artists to the post-Seurat canon, such as Robert Delaunay, Wassily Kandinsky, Piet Mondrian and American ones like Sol LeWitt, Agnes Martin, Robert Rauschenberg, Robert Ryman and Richard Serra (ending his review essay with the inert observation: 'Seurat, we could say, invented process art').[59]

Of course, like those critics and artists who were inclined towards modernism as an ideology, Surrealism, too, would seek to rationalize and strengthen its position by de-specifying itself historically. As I am showing, this was carried out with reference to precursors such as Seurat and Gauguin mainly after the Second World War in the wake of the canonical status achieved by those artists, largely through the efforts of American museums, critics and collectors. Once that historical specificity is returned, modernist abstraction and Surrealism can be seen to inform each other and Hélion's interpretation of Seurat clarifies Breton's early, against-the-odds interest in the artist.

Whatever the lines of inquiry it helps extend, the point of Hélion's article was to give abstract art some historical foundations in earlier modern art by arguing for the pure opticality of Seurat's work. The spare and orderly painting *The Gravelines Canal*,

[56] Hélion's biographical entry in the book of the exhibition reads '[l]ives in Paris', though he was in the process of moving to New York at that time: Barr, *Cubism and Abstract Art*, 211.

[57] Barr, *Cubism and Abstract Art*, 22.

[58] 'Seurat's interest was to secure for painting most economically and expeditiously the maximum of the effects proper to it as a two-dimensional art imprisoned on a plane surface.... The emphasis of his system lay mostly upon the abstract elements of painting – tone, colour, mass, line it foreshadows some of the effects that post-Cubism aimed at.... For the "inhumanity" of which modern art has been accused we can blame history, but Seurat was one of the principal channels by which it entered painting', Clement Greenberg, 'Seurat, Science, and Art: Review of *Georges Seurat* by John Rewald' [1943], *The Collected Essays and Criticism, vol. 1, Perceptions and Judgments, 1939–1944*, ed. John O'Brian, Chicago and London: The University of Chicago Press, 1986, 167–70, 168, 169; 'Seurat's planar and often geometric forms encourage us to stress his importance as a forebear of modern abstract art', Robert L. Herbert, 'Seurat's Drawings', Chicago: The Art Institute of Chicago, *Seurat: Paintings and Drawings*, 1958, 22–5, 24; 'after 1886 ... Seurat turned his attention to the prophetically modernist concept that the emotional content of a work of art may be established and conveyed in exclusively abstract terms, through predictable and measurable combinations of colour, value, and line', Norma Broude, 'Introduction', Broude (ed.), *Seurat in Perspective*, 1–12, 1. And in France: 'L'esprit d'abstraction est donc ce qui apparaît comme l'essentiel de l'oeuvre de ce peintre', Marcel Brion, *Art abstrait*, Paris: Éditions Albin Michel, 1956, 252.

[59] Yve-Alain Bois, '"Georges Seurat: The Drawings," Museum of Modern Art, New York' (exhibition review), *Artforum*, vol. 46, no. 8, April 2008, 359–60, 359, 360.

Evening (figure 3.4, 1890), for instance, 'has no other reality than that of its optical existence', Hélion commented.[60] Although it begins by taking elements from the outside world such as boats, a lamp post, the sky, a building, a harbour and anchors, these are only the raw materials for an art that adapts and arranges unstructured nature. These rudiments are taken, oriented, refined, 'reformed, rebuilt, reconceived' and 'written' for sight, not for the body, Hélion asserted:

> Seurat's picture goes entirely through my eyes. I feel no resistance, no difficulty of accommodation, no need to walk into it. It makes me live entirely through sight. It is organized for sight as a radio-set for waves. Its organization is not like mine, but compatible with mine. It is intelligible, it is within the range of man's means, of man's intelligence, the way it has been formed and developed by our culture, a culture that is not natural, but proper to man.[61]

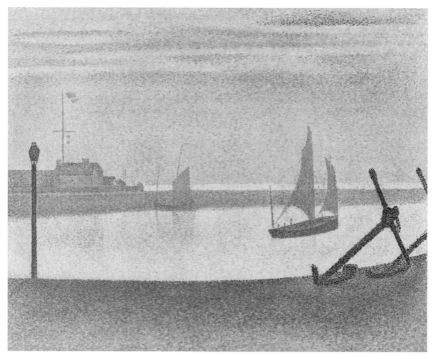

Figure 3.4 Georges Seurat, *The Gravelines Canal, Evening* (1890). Oil on canvas, 65.4 × 81.9 cm. The Museum of Modern Art, New York. © Digital image, The Museum of Modern Art, New York/Scala, Florence.

[60] Jean Hélion, 'Seurat as a Predecessor', *The Burlington Magazine for Connoisseurs*, vol. 69, no. 44, July 1936, 4 and 8–11 and 13–14, 4.
[61] Hélion, 'Seurat as a Predecessor', 4.

The weight placed on the optical in painting here could not be greater – 'it makes me live entirely through sight' – and it seems at first that because of this, equally, such an art could not be further from the ambition held by Surrealism. As I noted already, Breton argued in his first dedicated writings on Surrealism and painting in 1925 that the decoration of the 'external world' through painting was a waste of the artist's gifts. He set out his differences with realism and Impressionism by insisting 'the plastic work of art will either refer to a *purely internal model* or will cease to exist'.[62] It was exactly the emphasis on 'mere' opticality, then, that Surrealism sought to overturn by transforming or re-infusing art with poetics or more precisely with metaphor to create an art not simply of perception but of allusion; one that did not rest as surface pattern on the retina but pointed beyond itself. It was for this reason that Breton did not question Seurat's actual achievement in supremely gridded compositions such as *The Bridge at Courbevoie* (figure 3.5, 1886–7) in the same extended essay in *La Révolution surréaliste*. Rather, he wondered whether that accomplishment mattered. Surely art should be doing something else?

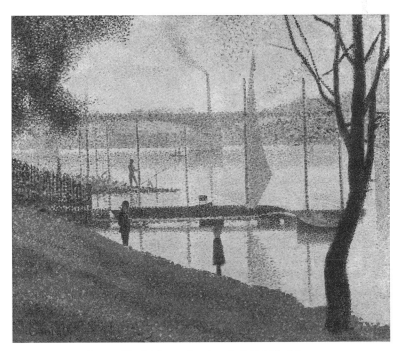

Figure 3.5 Georges Seurat, *The Bridge at Courbevoie* (1886–7). Oil on canvas, 46.5 × 53.5 cm. The Courtauld Gallery, London. © The Samuel Courtauld Trust, The Courtauld Gallery, London.

[62] Breton, *Surrealism and Painting*, 4.

Well it turns out that it was through his prioritization of specifically *painterly* opticality taken to an extreme degree – noted and honoured by Hélion in the context of the abstraction dreaded by Surrealism, ironically – that Seurat achieved this 'something else'. It was by this process that his painting was nudged by degrees away from external reality and closer to the dialectical sureality that is both derived by the imagination from that material and imposed by the mind upon it. Here is Hélion on Seurat again:

> Once he has seized the elements, he stylizes them beyond all resemblance, even to caricature, without consideration for taste, prettiness, normality. The appearance of his picture is never compatible with that of nature. Compared with figures by Courbet or even the deformed figures of Cézanne, Seurat's personages look like pictures of dummies full of straw. He did not care.... [The figures in the *Grande Jatte*, plate 5] exist entirely in sight, no more referring to any possible existence outside the picture.[63]

This excellent description of the purely painterly, non-representational purpose of Seurat's art is close to Fry's earlier observation that the 'syntax of actual life' in *Parade de Cirque* 'has been broken up and replaced by Seurat's own peculiar syntax with all its strange, remote and unforeseen implications'.[64] It strikes me as closer to defining the active–passive procedure his method surely demanded than Tamar Garb's agenda-driven half-truth that 'Pointillism posited an authorial subject who was entirely in control'.[65] But as Fry lets on here, it is equally if accidentally a definition of the surreal, as another modernist critic T. J. Clark also unintentionally revealed in his Rimbauldian observation that Seurat's technique 'show[s] us a world where "Je est un autre."'[66] This was perhaps irresistibly so for Hélion given the ubiquity of Surrealist painting by the time he wrote about the artist in 1936, the year of the *International Surrealist Exhibition* at the temporary New Burlington Galleries in London and of *Fantastic Art, Dada, Surrealism* at MOMA. Hélion was rejecting reference to nature and diminishing the significance for abstraction even of Cézanne, as still too governed by the world beyond the painting – 'Cézanne looks at the motif. Seurat looks at his canvas' – and the resulting departure from outer reality achieved by Seurat led to some eccentric results conducive to the Surrealists and their friends.[67]

Since Breton's view on the 'correct' subject matter for art did not change substantially over the years – after all, he republished *Surrealism and Painting* with the same core argument in augmented editions in 1945 and 1965 after its first 1928 outing – we can

[63] Hélion, 'Seurat as a Predecessor', 10.
[64] Fry, 'Seurat's *La Parade*', 290.
[65] Tamar Garb, 'Powder and Paint: Framing the Feminine in Georges Seurat's *Young Woman Powdering Herself*, *Bodies of Modernity: Figure and Flesh in Fin-de-Siècle France*, London: Thames and Hudson, 1998, 115–43, 143.
[66] T. J. Clark, *Farewell to an Idea: Episodes from a History of Modernism*, New Haven and London: Yale University Press, 1999, 108.
[67] Hélion, 'Seurat as a Predecessor', 10.

explore this further by moving forward to the postwar period to look at Marcel Duchamp's repudiation of 'retinal painting' made in an interview in *Arts* late in 1954, which would become a touchstone for the Surrealists and would be quoted admiringly by Breton in later life. The first time he did this was only a few weeks after Duchamp's remarks had appeared in print. Breton's aim was to give some justification for the inclusion of ostensibly motley works in the exhibition *Pérennité de l'art gaulois* (figure 3.6, 1955) by Impressionists, 'Post-' and Neo-impressionists. These included, unusually, Claude Monet (five paintings), Renoir (his *Woman Reading* of 1874–6 discussed in my chapter on Magritte) and Cézanne (the two-figure *Card Players* of 1892–3 then in the Louvre), as well as Gauguin, Seurat and van Gogh, and Kandinsky, contemporary abstract artists and Surrealists, alongside the Gaulish coins equally and thankfully free 'from Graeco-Latin contagion' in Breton's words.[68] This massive and now-forgotten exhibition was held in 1955 at the Musée pédagogique in Paris's Latin Quarter, the modern art half of which Breton had helped curate with the art critic and Gauguin specialist Charles Estienne and the expert on Celtic art Lancelot Lengyel. This is what Breton wrote:

> The organizers [of the exhibition] thought that it might be fruitful to allow certain aspects of contemporary art to benefit from this very particular scrutiny. The criterion which presided over the choice and presentation of the works of this nature is exactly that which emerges from some remarks made very recently by Marcel Duchamp: 'Since the advent of Impressionism, the new works of art *halt at the retina*. Impressionism, Fauvism, abstraction, consist always of *retinal* painting. Their physical preoccupations – the reactions of colours etc. – put the reactions of the grey matter into the background. This does not apply to all the protagonists of these movements, a few of whom have *gone beyond* the retina. . . . Men like Seurat or Mondrian were not retinal painters even though they appeared to be so.'[69]

Breton was becoming immersed alongside Estienne at the time, not just in Celtic art but in the promotion, partly through the gallery *À l'Étoile Scellée*, of the abstract art of Jean Degottex (whose February 1955 exhibition at the gallery overlapped with *Pérennité*

[68] André Breton, 'The Presence of the Gauls' [1955], *Surrealism and Painting*, 333–6, 336.

[69] Breton, *Surrealism and Painting*, 336. Breton quotes from Alain Jouffroy, 'Interview exclusive, Marcel Duchamp: l'idée de jugement devrait disparaître', *Arts*, no. 491, 24–30 November 1954, 13 (he alters Duchamp's 'productions visuelles' to 'productions nouvelles' and misses Cubism out of Duchamp's list of retinal art movements: André Breton, 'Présent des Gaules' [1955], *Le Surréalisme et la peinture* [1965], Paris: Gallimard, 1979, 333–6, 336). There is an earlier allusion by Duchamp to the blight of 'retinal art' in an interview with James Johnson Sweeney, even though that term is not used: 'I was interested in ideas – not merely in visual products. I wanted to put painting once again at the service of the mind. And my painting was, of course, at once regarded as "intellectual" "literary" painting,' 'Marcel Duchamp', *The Museum of Modern Art Bulletin*, vol. 13, no. 4/5 ('Eleven Europeans in America'), 1946, 19–21, 20. The famous term was still making the rounds in Surrealism in the second half of the 1960s, servicing a speculative argument about a lineage extending from late-nineteenth century painting to Surrealist art, which I am expanding into an alternative history of modern painting in this book: see Gérard Legrand, *Gauguin*, Paris: Club d'Art Bordas, 1966, 52.

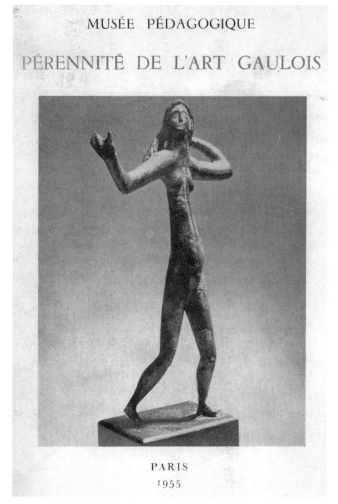

Figure 3.6 Cover of catalogue for *Pérennité de l'art gaulois* (1955). Author's collection.

de l'art gaulois), René Duvillier, Marcelle Loubchansky and the now entirely obscure André Pouget, as well as others.[70] That is why he added a footnote to Duchamp's designation of retinal painting to clarify what he assumed was the latter's usage of the

[70] See Renée Mabin, 'La galerie "À l'Étoile scellée,"' Olivier Penot-Lacassagne and Emmanuel Rubio (eds), *Mélusine*, no. 28 ('Le surréalisme en héritage: Les avant-gardes après 1945'), Lausanne: L'Age d'Homme, 2008, 295–307. For more on the attempted alliance of Surrealism and gestural abstraction in the first half of the 1950s, see Steven Harris, 'The Gaulish and the Feudal as *lieux de mémoire* in Post-War French Abstraction', *Journal of European Studies*, vol. 35, no. 2, 2005, 201–20. As *Pérennité de l'art gaulois* got under way, Breton's catalogue essay on the Gauls appeared in *Combat-Art* alongside one by Estienne under the banner heading 'De l'art des Gaulois à l'art moderne ou l'histoire d'une résistance': André Breton, 'Présent des Gaules' and Charles Estienne, 'Aux origines de l'esprit moderne', *Combat-Art*, no. 14, 7 February 1955, 2.

term 'abstraction', namely, it was meant as 'the label for a school of art and not in its general acceptation'.[71]

This is to say that optical painting as figurative art like Seurat's or even abstract art in the way Hélion had expressed it (if not exactly in the way he meant it) is not retinal. That remains so even if Seurat himself in his notes on artistic method advanced the importance of the 'synthesis' of tonal values and colours caused by 'the phenomena of the duration of the impression of light on the retina'.[72] The paintings that result from the method are not mere pattern but are allusive and metaphorical. At the very least, humans are transformed by it into dummies by Seurat (figure 3.7) – archetypes of the Surrealist imaginary – at the most, the world we live in becomes irrelevant to those paintings.[73]

[71] Breton, *Surrealism and Painting*, 336 n. 1. Breton's editors suggest that the 1923 essay 'Distance', with which I began this chapter, already rehearses this replacement of Cézanne with Gauguin and Seurat at the head of twentieth-century art in terms that would be amenable to Duchamp's later rejection of '*peinture rétinienne*', Breton, *Oeuvres complètes*, vol. 1, 1317.

[72] Seurat quoted from a letter of August 1890 to his friend Maurice Beaubourg in Walter Pach, *Georges Seurat*, New York: Duffield and Company, 1923, 25. This important statement was quoted accurately in French for the first time in a generally unreliable book owned and used by Breton: Gustave Coquiot, *Georges Seurat*, Paris: Albin Michel, 1924, 231–5, 233. For a facsimile of the relevant parts of the letter, see John Rewald, *Georges Seurat*, trans. Lionel Abel, New York: Wittenborn & Company, 1943, 61.

[73] Similar statements have regularly been made about the residents of Seurat's paintings since his own day: 'l'hiératisme de tous ces personages' in the *Grande Jatte*, 'presque de bois', at first displeased Verhaeren, 'Georges Seurat', 431; while they were mocked as 'marionettes' by the anonymous critic in *La Liberté*, quoted by Stephen F. Eisenman, 'Seeing Seurat Politically', *The Art Institute of Chicago Museum Studies*, vol. 14, no. 2 ('The *Grande Jatte* at 100'), 1989, 211–19, 215; as 'poupées de bois ...' by Henry Fèvre, 'L'Exposition des impressionnistes' [1886] and as 'en bois, naïvement sculptées au tour comme les petits soldats qui nous viennent d'Allemagne en des boîtes d'esquilles de sapin qui sentent bon la résine ...' by Octave Maus, 'Les Vingtistes parisiens' [1886], Ruth Berson, *The New Painting: Impressionism 1874–1886: Documentation*, vol. 1, San Francisco: Fine Arts Museums of San Francisco, 1996, 445–7, 445 and 462–4, 464; then as 'wooden figures ... a band of petrified, immobile creatures, mannequins whose role is to grab the public's attention and make them laugh,' in August 1886 by the equally amused Jean Le Fustec, critic for *Le Journal des artistes*, quoted by Richard Thomson, 'Seurat's *Circus Sideshow*: A Parade of Paradoxes,' New York: The Metropolitan Museum of Art, *Seurat's Circus Sideshow*, 2017, 54–5. The background staffage of Seurat's 'single mosaic of boredom' was confirmed as forming 'for the most part wooden verticals, like puppets from the toy-box, intensively preoccupied with strolling stiffly about' by Ernst Bloch, *The Principle of Hope* [1959], trans Neville Plaice, Stephen Plaice and Paul Knight, Oxford: Basil Blackwell, 1986, 814; also see the assessment, given under the heading '"primitive" art', that the *Grande Jatte* reiterated Seurat's 'love of flat and toy-like forms. The pair of cadets in the background ... are close to the sheets of toy soldiers [Seurat] had in his studio, and throughout the *Grand Jatte* and its drawings there are echoes of the doll-like figures of coloured broadsides', Robert L. Herbert, *Seurat's Drawings* [1962], London: Studio Vista, 1965, 110–13. The routine characterization of the figures of the *Grand Jatte* as 'children's toys' is noted by and augmented with 'lead soldiers' by Thomson, *Seurat*, 115; Alfred Paulet's frequently cited 'lead soldiers' of 1886 is quoted again and supplemented ('soldiers tin') by T. J. Clark, *The Painting of Modern Life: Paris in the Art of Manet and His Followers*, Princeton NJ: Princeton University Press, 1984, 264, 265, 266; and they are referred to merely as 'the wooden figures in the *Grande Jatte*' by John House, 'Reading the *Grande Jatte*', *Art Institute of Chicago Museum Studies*, no. 2 ('The *Grande Jatte* at 100'), 115–31, 129. All of this led to the similar evaluation of Seurat's figures in the *Grand Jatte* – '[t]wo military cadets, stiff as wooden soldiers' – and a set of new ones about the figures in other paintings (the three musicians in the left background of *Parade de Cirque* are 'dummies', the spectators in that painting, *Chahut* and *Circus* are 'marionettes', the dancers in *Chahut*

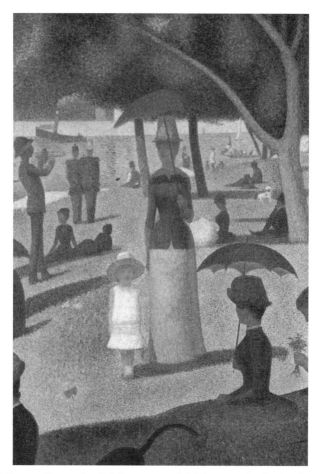

Figure 3.7 Georges Seurat, detail (of woman and child at centre) of *A Sunday on La Grande Jatte – 1884* (1884–6). Oil on canvas, 207 × 308 cm. The Art Institute of Chicago. © The Art Institute of Chicago/Art Resource, NY/Scala, Florence.

are 'dancing-doll women' and the audience in *Circus* are 'manufactured dolls') by Joan U. Halperin, 'The Ironic Eye/I in Jules Laforgue and Georges Seurat', Paul Smith (ed.), *Seurat Re-Viewed*, University Park PA: The Pennsylvania State University Press, 2009, 113–46, 123, 129, 130, 133. There were also the exaggerated appraisals of the 'ugly, over-simplified, wooden figures' of the *Bathers* by Benedict Nicolson, 'Seurat's *La Baignade*', *The Burlington Magazine for Connoisseurs*, vol. 79, no. 464, November 1941, 139–41 and 145–6, 146; and of the foreground recliner in the same painting as 'trite as a tailor's dummy' by Kenneth Clark, 'Seurat: *Une Baignade, Asnières*' [1958], *Looking at Pictures*, London: John Murray, 1960, 133–41, 138. The 'people' in Seurat's later painting *The Bridge and the Quays, Port-en-Bessin* (1888) resemble toy figures in a model town or pedestrians in an architect's rendering and were regarded as 'improbable' even by Félix Fénéon, 'Tableaux', *Oeuvres plus que complètes*, vol. 1, 162–70, 163. Also see the (favourable) remark regarding the 'black parallel legs of the vulgar puppets in the *Chahut*' by Salmon, 'Georges Seurat', 122; the assessment of the figures in the late paintings as 'mannequins capable only of . . . three expressions – sadness, gaiety and neutral calm' by Meyer Schapiro, 'Seurat' [1958], *Modern Art, 19th and 20th Centuries: Selected Papers*, vol. 2,

That is why Breton could also detach Gauguin, Redon and Seurat from Impressionism's 'retinal' opticality a few years later in March–April 1958 on the occasion of the exhibition *Dessins Symbolistes* by quoting Duchamp's notion again in order to explain the criticism pitched at such artists by purveyors of colour from Fauvism to abstract expressionism. The latter had long been in the ascendancy in the US by then and Breton probably had its promoters in mind as he wrote these words: 'it was only to be expected that the belated followers of what Marcel Duchamp once called, with his most disdainful smile, "retinal" art should have reacted extremely violently [against Gauguin, Redon and Seurat].'[74] It also explains why Clement Greenberg and Duchamp could use the same language to praise Seurat as a revolutionary yet from entirely dissimilar points of view.[75]

Duchamp's own admiration for Seurat is usually explicated by art historians through comparison with the 'scientific' aspect of his work and Seurat's own apparent interest in the science of colour, or through Duchamp's curiosity about the machine from 1912 alongside the 'mechanical' technique of 'Pointillism' (as that method was understood by some).[76] But Duchamp himself seems to have changed his mind over this. In 1915, he rather grandiosely called Seurat '[t]he greatest scientific spirit of the nineteenth century, greater in that sense than Cézanne',[77] before averring much later in the 1960s after a

London: Chatto & Windus, 1978, 101–9, 108; the description of the trombone player of *Parade de Cirque* as 'a skillfully managed marionette' by Crary, *Suspensions of Perception*, 229; and the characterization of the woman in the *Young Woman Powdering Herself* (unfortunately and misleadingly withdrawing the figure from what I am showing to be a commonplace of Seurat's style across genders) as 'a glorious inflated modern doll filled with nothing but air', and as a 'giant blown-up doll, a grown man's toy' by Garb, *Bodies of Modernity*, 137, 143. A further set of comparisons with Egyptian statues and toys has been catalogued by Paul Smith, '"Souls of Glass": Seurat and the Ethics of "Timeless" Experience', Smith (ed.), *Seurat Re-Viewed*, 199–221, 218 n. 32.

[74] André Breton, 'Concerning Symbolism' [1958], *Surrealism and Painting*, 357–62, 360–1.

[75] Although he did not care for the *Grande Jatte*, Greenberg wrote of the talent to 'sense contemporary reality naïvely and express it directly, untrammeled by reminiscences and precedents that in an art such as painting could be escaped from only by dint of conscious effort on the part of a sophisticated genius like Seurat', Clement Greenberg, 'The Camera's Glass Eye: Review of an Exhibition of Edward Weston' [1946], *The Collected Essays and Criticism, vol. 2, Arrogant Purpose, 1945–1949*, ed. John O'Brian, Chicago and London: The University of Chicago Press, 1986, 60–3, 60. 'I'm sure that when people like Seurat started to do something, they really just wiped the past right out', Duchamp quoted in Cabanne, *Dialogues*, 103.

[76] Broude (ed.), *Seurat in Perspective*, 6; Thierry de Duve, *Pictorial Nominalism: On Marcel Duchamp's Passage from Painting to the Readymade* [1984], trans Dana Polan with Thierry de Duve, Minneapolis MN and Oxford: University of Minnesota Press, 1991, 171; 'judging from the exception [Duchamp] makes of Seurat [to retinal painting], he was fully admiring of real rigour in the application of the principles of modern optics', Rosalind Krauss, 'Where's Poppa?' Thierry de Duve (ed.), *The Definitively Unfinished Marcel Duchamp*, Cambridge, Mass. and London: MIT, 1991, 433–59, 446; Linda Dalrymple Henderson, *Duchamp in Context: Science and Technology in the Large Glass and Related Works*, Princeton NJ: Princeton University Press, 1998, 8, 72. For a game effort against the odds to distance Seurat from science, see Paul Smith, *Seurat and the Avant-Garde*, New Haven and London: Yale University Press, 1997, 23–48; and Paul Smith, 'Introduction', Smith (ed.), *Seurat Re-Viewed*, 1–13, 2–5.

[77] Marcel Duchamp, 'A Complete Reversal of Art Opinions by Marcel Duchamp, Iconoclast' [1915], *Studio International*, vol. 189, no. 973, January–February 1975, 29. This remark was made the year after Apollinaire reported, intriguingly, that Duchamp's briefly held job at the Bibliothèque Sainte-Geneviève in Paris in 1913 placed him in close physical proximity with fellow librarian,

lifetime of iconoclasm: '[a]ll painting, beginning with Impressionism, is anti-scientific, even Seurat',[78] at the same time remarking 'I like Seurat a lot'[79] and affirming, as Hélion had, 'Seurat interests me more than Cézanne.'[80] Duchamp and the Surrealists could not have conceded a limited version of Hélion's argument for Seurat's opticality, then, the one that made him a retinal painter. They could accept that interpretation only at its most extreme. In the case of Duchamp, who once reportedly proclaimed 'I have forced myself to contradict myself in order to avoid conforming to my own taste',[81] that extreme was where the rigid truth to opticality built on his method ultimately led beyond the discernment of the eye to the subversion of 'routine and outmoded practices', or in the words of Robert J. Goldwater, writing of Seurat, to 'some means other than his own taste, sensibility, and judgment by which to produce a good work of art' (or as Hélion put it, 'he did not care' where his procedure took him).[82] In the case of the Surrealists, that extreme was where his art made contact with another, metaphorical dimension that was indifferent and even blind to the world. It is unlikely that Hélion would have wanted his argument to be taken so far into 'poetry', but for the Surrealists there was nowhere else to go.

A dialectical visuality of the sea

From here, I want to move towards a major case study in Breton's later writing where a fully developed dialectical theory of Seurat's art, which has remained unexamined till now, confirms the dialectical surreality that I have drawn out with reference to Hélion in order to bridge Breton's early, unformulated interest for Seurat to his later,

mathematician and colour theorist Charles Henry, 'whose scientific investigations concerning painting exerted a great influence on Seurat and ultimately led to the birth of divisionism', Guillaume Apollinaire, 'An Engraving That Will Become a Collector's Item' [1914], *Apollinaire on Art*, 388–9, 389. This assessment was later sustained by the research of Rewald, *Post-Impressionism*, 99–101; and consolidated by Sven Lövgren, *The Genesis of Modernism: Seurat, Gauguin, van Gogh and French Symbolism in the 1880s*, trans. Albert Read, Stockholm: Almqvist & Wiksell, 1959, 67–72. For more moderate evaluations of Henry's contributions to the art of Seurat, who knew Henry in the 1880s, see William Innes Homer, *Seurat and the Science of Painting*, Cambridge, Mass.: MIT, 1964, 181–2 and 188–217; Robert L. Herbert, *Seurat: Drawings and Paintings*, New Haven and London: Yale University Press, 2001, 137–53 (from an article first published in French in 1980); John House, 'Meaning is Seurat's Figure Painting', *Art History*, vol. 3, no. 3, September 1980, 345–55, 351; Thomson, *Seurat*, 144–5; Martin Kemp, *The Science of Art: Optical Themes in Western Art from Brunelleschi to Seurat*, New Haven and London: Yale University Press, 1990, 318–19; Michael F. Zimmermann, *Seurat and the Art Theory of his Time*, Antwerp: Fonds Mercator, 1991, 227–75 and 279–320; and Brendan Prendeville, 'Seurat and the Act of Sensing: Perception as Artifact', Smith (ed.), *Seurat Re-Viewed*, 149–62, 152–3.

78 Cabanne, *Dialogues*, 39.
79 Cabanne, *Dialogues*, 69.
80 Cabanne, *Dialogues*, 93. For a speculative interpretation of Duchamp's inscrutable references to Seurat (which suppresses the one about Seurat being 'anti-scientific'), see de Duve, *Pictorial Nominalism*, 171–3.
81 Quoted in Harriet and Sidney Janis, 'Marcel Duchamp: Anti-Artist' [1945], Robert Motherwell, *The Dada Painters and Poets: An Anthology* [1951], Cambridge, Mass. and London: The Belknap Press of Harvard University Press, 1981, 306–15, 307.
82 Goldwater, 'Some Aspects of the Development of Seurat's Style', 128.

Duchamp-inspired advocacy. Although he would not have known of Hélion's 1936 *Burlington* article, it came at a time that Breton's interest in Seurat was growing to a noteworthy extent in resistance to the enduring version of the artist as a modern French painter in the 'classical' mould of Ingres and Puvis de Chavannes. This understanding of Seurat overlapped elsewhere, and more prominently in English language art history, with formalist accounts of the artist's significance. By contrast, we can designate Breton's enthusiasm for Seurat as initially poetic, allusive, metaphorical and analogical. This was registered programmatically and unequivocally in the lecture 'Qu'est-ce que le surréalisme?' given on 1 June 1934 in Brussels in which Breton submitted an account of the origins and theoretical development of Surrealism, quoting extensively from publications by the Surrealists including his own *Manifesto of Surrealism* where the precursor list was amended to reflect his reading of the intervening ten years and his increasing knowledge of art. To that end, Picasso and Seurat were promoted from the footnote to the main text, the former being 'Surrealist in Cubism' while Seurat is called 'Surrealist in design/pattern [le motif].'[83]

Breton's interest in Seurat would be unflagging from this point on and well into the 1950s, linked more than once to the similar talented youth and early deaths of established pre-Surrealists the Comte de Lautréamont and Arthur Rimbaud.[84] It might have been stepped up in the Brussels lecture due to the exhibition *Seurat et ses amis: La Suite de l'impressionisme*, which took place in December 1933 and January 1934 at the address of the *Gazette des Beaux-Arts* on rue du Faubourg-Saint-Honoré and was accompanied by an article by Signac in that periodical apparently known to Breton judging from textual evidence of the 1940s.[85] The title of this exhibition alone demonstrates the new centrality given Seurat in histories of art after Impressionism. Forty-six of his paintings, studies and drawings were shown (though only one major work, *Circus*) out of 177 in total while presenting the artist as the leader of a 'school', confirmed in the introduction penned as a kind of final testament by Signac who would die a few months after the event.[86] In addition, Breton must have seen the exhibition *Seurat* that took place from 3 to 29 February 1936 at Paul Rosenberg's gallery on the Rue de Boëtie because he owned the slim booklet of the show where fifty-one mainly small oil paintings are catalogued with sixty mature

[83] André Breton, 'What is Surrealism?' [1934], *What is Surrealism?* ed. Franklin Rosemont, London: Pluto Press, 1978, 112–41, 122 (translation modified); André Breton, *Qu'est-ce que le surréalisme?* Brussels: René Henriquez, 1934, 16.

[84] See the remarks on Seurat in André Breton, 'Interview with *Halo-Noviny*' [1935], 'Originality and Freedom' [1941], 'Situation of Surrealism Between the Two Wars' [1942–3] and 'Speech to Young Haitian Poets' [1945], *What is Surrealism?* 141–3, 142; 206–8, 207; 236–7, 238; 258–61, 260.

[85] Paul Signac, 'Le néo-impressionisme: documents', *Gazette des Beaux-Arts*, vol. 11, 1934, 49–59. See Breton's remarks in the 1946 Haiti lecture I come to shortly about the scandal caused by the tethered monkey of the *Grande Jatte* of which his editors write: 'Breton évoque ces reactions d'après Paul Signac' in the 1934 article in the *Gazette des Beaux-Arts* (though he could, of course, have read the same text by Signac in the booklet that accompanied the exhibition): Breton, *Oeuvres complètes*, vol. 3, 242, 1232.

[86] Signac's text was translated when the theme was revived in cooperation with the *Gazette des Beaux-Arts* for the smaller exhibition that ran from 20 January till 27 February in London: Wildenstein & Co. Ltd, *Seurat and his Contemporaries*, 1937.

drawings and some other works.[87] Furthermore, it is almost certain that he would have seen the massive historical exhibition of French art mounted at the new Musée d'Art moderne in the Palais de Tokyo to coincide with the 1937 Exposition Internationale des Arts et Techniques dans la Vie Moderne titled *Chefs-d'Oeuvre de l'Art français* in which the *Grande Jatte* was shown with six other smaller paintings and a drawing by Seurat.

Quite apart from these events in Paris and his growing involvement in art exhibitions, there is another reason for Breton's enhanced understanding and citation of Seurat in his writings from the mid-1930s. Even though *Parade de Cirque* had finally disappeared from the walls of Bernheim-Jeune and only *Circus* was now permanently on display in Paris, he would have uncommon opportunities to view again over the next decade several of Seurat's major paintings that had been dispersed abroad in the 1920s. He spent at least a fortnight in London in June 1936 organizing and opening the *International Surrealist Exhibition*, which was only a fifteen-minute walk from the National Gallery where the *Bathers at Asnières* resides. While in the capital, Breton could also have gone to see the Courtauld collection of Édouard Manet and the Impressionists in Home House at 20 Portman Square where among the Cézannes, Gauguins, Renoirs and van Goghs hung Seurat's *Young Woman Powdering Herself* (figure 3.8) (in the front parlour on the ground floor in the early 1930s (figure 3.9) when the permanent collection could be viewed for free on Saturdays).[88] Furthermore, while in America during the Second World War, Breton would certainly have seen the *Grande Jatte* again when he passed through Chicago on the way to Reno in 1945.[89]

[87] See the installation photographs of the Rosenberg exhibition in César M. de Hauke, *Seurat et son oeuvre*, vol. 1, Paris: Gründ, 1961, 262–70. Seurat's general lack of visibility in France as late as the 1950s was such that one writer mistook the 1957 show at the Musée Jacquemart-André as the first in that country in more than thirty years: Raymond Charmet, '70 oeuvres de Seurat', *Arts*, no. 645, 20–6 November 1957, 16.

[88] For a contemporary account of the layout of Home House and its collection, see Christopher Hussey and Arthur Oswald, *Home House, No. 20 Portman Square: An Architectural and Historical Description*, London: Country Life Ltd., 1934; a full catalogue was available from 1935. The *Young Woman Powdering Herself* was well known to the Surrealists and was identified by Breton on a later viewing at the May–June 1952 exhibition *L'Oeuvre du XXe Siècle* at the then Musée National d'Art Moderne as one of Seurat's '*masterpieces*, in other words creations which stand out with special urgency and clarity from a particular artist's body of work', over thirty years after it had illustrated the perfectly non-Symbolist theory of Purism in *L'Esprit nouveau*: André Breton, '125 Soaring Achievements at the Musée d'Art Moderne' [1952], *Surrealism and Painting*, 349–53, 351. In the 1970s, a Surrealist curator, art critic and historian would reproduce the painting as 'one of the most beautiful of Symbolist portraits', José Pierre, *Symbolism*, [1976], trans. Désirée Moorhead, London: Eyre Methuen, 1979, n.p. It was also referred to in the 1950s by Gérard Legrand in his ambivalent response to Seurat's arrival in 'Ouvrez-vous?' meant to imply some triviality or superficiality inherent to the painting: 'Oui, mais comme à un nuage de poudre de riz', The Surrealist Group, 'Ouvrez-vous?' *Médium: Communication surréaliste*, no. 1, November 1953, 1 and 11–13, 13.

[89] See the evidence of his visit to Chicago in Franklin Rosemont, *André Breton and the First Principles of Surrealism*, London: Pluto Press, 1978, 94; Paris: Musée national d'art moderne, Centre Georges Pompidou, *André Breton: La beauté convulsive*, 1991, 363; Penelope Rosemont, *Dreams & Everyday Life: André Breton, Surrealism, Rebel Worker, SDS & the Seven Cities of Cibola in Chicago, Paris & London. A 1960s Notebook*, Chicago: Charles H. Kerr, 2008, 78.

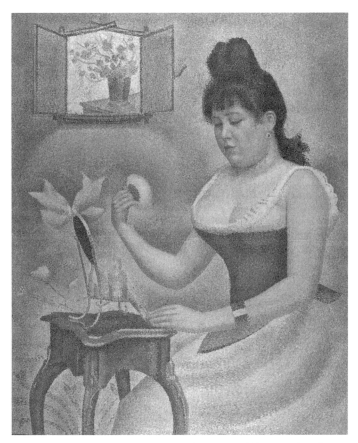

Figure 3.8 Georges Seurat, *Young Woman Powdering Herself* (1889–90). Oil on canvas, 95.5 × 79.5 cm. The Courtauld Gallery, London. © The Samuel Courtauld Trust, The Courtauld Gallery, London.

Breton's developed knowledge and increased appreciation of the art of Seurat were aired before his return to Europe from the Americas in the lectures he gave in Haiti in late 1945 and early 1946, mentioned in my Introduction and second chapter. The texts remained unpublished in his lifetime; among them is his major statement on Seurat. Under the guise of an art historian complete with colour slides, Breton imparted a steady, conventional, simplified introduction to modern art since 1880 for a large, professionally mixed audience. His main aim was to provide an overview of the art of the painters who followed Impressionism and to this end Breton gave his lengthiest analysis of Seurat's work. This would be a dialectical reading and it is signalled initially by a unification of Seurat's painting with Henri Rousseau's at the origins of modernism, or, as Breton reasoned it: 'the modern taste in art fluctuates

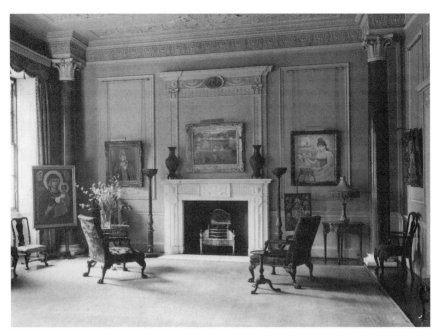

Figure 3.9 Photograph of the interior of Home House in the early 1930s. The Conway Library, The Courtauld Institute of Art, London. Image courtesy of the Conway Library, The Courtauld Institute of Art, London. © Country Life.

between an intellectually evolved *oeuvre*', such as that of Seurat, and 'a totally instinctive *oeuvre*', like Rousseau's.[90]

That fallacious appraisal of Rousseau's sophisticated project demonstrates that Breton's presentation of early modernism carried as many misleadingly compressed judgements as any university survey course, alongside its expected surrealist biases, omissions and emphases. However, its lengthy passages on Seurat, supported by Breton's reading of Signac's *D'Eugène Delacroix au néo-impressionisme*, were introduced by way of an original thesis that enriches and gives a historico-theoretical rationale based in dialectics for the hypothesis of the abstract-made-surreal that I made earlier in this chapter. Breton approached this initially by asking: 'what idea is formed, at the beginning, in the sensibility of Seurat?'[91] This is his answer:

> It is during his military service in a Brittany port at Brest that Seurat assumes, I am arguing, his taste for a visuality of the sea. From that date, in fact, he would opt for the little ports and beaches as motifs. He knew the boat *by heart*. His correspondence, moreover, bears witness to a complete knowledge of boats:

[90] 'le goût moderne en art oscille entre une oeuvre intellectuellement … une oeuvre totalement instinctive', Breton, *Oeuvres complètes*, vol. 3, 236.

[91] 'quelle idée se faire, avant tout, de la sensibilité de Seurat?' Breton, *Oeuvres complètes*, vol. 3, 240.

'The masts,' he wrote, 'are so slender, so fine, so graciously arranged in the air. And those yards that make a cross shape with them at intervals and that rise thinner and thinner and shorter and shorter up to their spindly summits; those lattice tops whose whiteness stands out among the guy ropes, like the wooden part of a harp under these inverted strings; and those thousands of tensed ropes in every direction, from high to low, from starboard to port, from fore to aft, separated, mingling, parallel, oblique, perpendicular, intersecting in a hundred ways, and all fixed, appropriate, tidy, vibrating at the slightest breath of air; all this so harmonious, so complete, so admirably matched in its least details, *that a coquette could not invest more art and magic in the sensual arrangement of her evening preparations.*'[92]

Breton takes what he calls 'an animism' from this.[93] It is surely drawn from the third chapter of Freud's *Totem and Taboo* (1913) where animism is associated with magic to this extent: 'the principle governing magic, the technique of the animistic mode of thinking, is the principle of the "omnipotence of thoughts."'[94] Animism, in this sense, is said by Freud to have survived the succeeding epochs (religious and scientific) in only one field in our civilization, namely, art.

As I noted in my introduction to this book, Benjamin Péret had recently called on both Freud and J. G. Frazer to theorize a modern relevance for magic in *La Parole est à Péret* (1943).[95] Although Breton would bring the relevant chapter from *Totem and Taboo* to bear on the thorny task of defining 'magic art' in tribal societies later on in the 1950s, Freud went unmentioned in his Haiti lecture.[96] Rather, he extrapolated this animism of Seurat's initially by means of an interpretation indebted to 'mechanical selection', the notion developed by Le Corbusier and Ozenfant in *L'Esprit nouveau* arguing that objects constructed by the human hand acquire beauty through their

[92] 'C'est durant son service militaire dans un port de Bretagne, à Brest, que Seurat prend, nous dit-on, le goût visuel de la mer. À dater de là, en effet, il élira pour motifs les petits ports et les plages. Il connaît le bateau *par cœur*. Sa correspondance d'alors témoigne d'un amour, en toute connaissance, des bateaux.

 "Les mâts, écrit-il, sont si élancés, si fins, si gracieusement étagés dans les airs. Et ces vergues qui les coupent en croix de distance de distance, et qui montent de plus en plus minces et de plus en plus courtes, jusqu'à leurs grêles sommets; ces hunes à jour dont la blancheur se détache au milieu des haubans comme un bois de harpe sous ces cordes renversées; et ces milliers de manœuvres tendues dans tous les sens, de haut en bas, de tribord à bâbord, de l'avant à l'arrière, séparées, confondues, parallèles, obliques, perpendiculaires, croisées de cent façons, et toutes fixées, propres, bien peignées, vibrant au moindre souffle; tout cela si harmonieux, si complet, si admirablement assorti dans ses moindres détails, *qu'une coquette ne mettrait pas plus d'art et de magie dans les dispositions voluptueuses de sa toilette de bal*," quoted in Breton, *Oeuvres complètes*, vol. 3, 240 (Breton's italics).

[93] 'un animisme', Breton, *Oeuvres complètes*, vol. 3, 240.

[94] Sigmund Freud, 'Totem and Taboo' [1913], *The Origins of Religion*, ed. Albert Dickson, trans. James Strachey, Harmondsworth: Penguin, 1985, 43–224, 143.

[95] See Richard Spiteri, 'Péret, Freud et Frazer', *Mélusine*, no. 16 ('Cultures – Contre-cultures'), ed. Henri Béhar, Paris: L'Age d'homme, 1997, 125–31.

[96] André Breton, *L'Art magique* [1957], Paris: Éditions Phébus, 1991, 28–32.

'request' for refinement in their structure as that is determined by their function.[97] However, Breton then adds a proviso that draws Seurat in the direction of Surrealist poetics and dialectics:

> But this idea, if it were not strongly underlaid by a poetic view of things, would risk leading to an *emaciated* conception of the work of art, reduced to relying essentially on mechanical progress. Consequently, Seurat, his thought gliding from the boat that drifts far out at sea to the woman devotedly immersed in her mirror in the evening, utters the words *magic* and *sensuality*. Magic and sensuality, which are indeed the most valued assets [plus hautes ressources], entail here the intermingling [confondre] on the emotional level of the boat and the woman in their so different attire, the relations between them supporting each other from the fact that the one and the other at that instant help in their better fulfillment of life.[98]

Whether arguing for a 'fluctuation' between Seurat's intellect and Rousseau's instinct as the synthesizing movement in the history of modern art, or a 'fusing', 'intermingling' or 'merger' – or even an 'interpenetration' to use one of Friedrich Engels' terms for the operation of the dialectic – of boat and woman expounding a hitherto concealed erotic relationship between the two, it is clear that Breton was seeking a dialectical language here.[99] Breton owned the *Dialectics of Nature* and numerous other volumes by both Engels and Karl Marx. They obviously informed his own conception of dialectics, which is not, however, reducible to their definitions and terminology, especially by the 1940s when Breton was distancing himself from Marxism. Moreover, as is now well known, he had been a close reader of Hegel since at least 1919 and had long been aware of the adaptation of Hegel's dialectic in a tradition of writing on aesthetics extending from German Romanticism through the work of Victor Hugo and Charles Baudelaire to that of Apollinaire.[100]

[97] See Le Corbusier-Saugnier [Le Corbusier and Amédée Ozenfant], 'Des Yeux qui ne voient pas . . .: III: Les Autos', *L'Esprit nouveau*, no. 10, 1921, 1139–51. For a commentary on 'mechanical selection', see Briony Fer, David Bachelor and Paul Wood, *Realism, Rationalism, Surrealism: Art between the Wars*, New Haven and London: Yale University Press, 1993, 26–7.

[98] 'Mais cette idée, si elle n'était fortement sous-tendue par une vue poétique des choses, risquerait cependant de conduire à une conception *décharnée* de l'œuvre d'art, réduite à s'appuyer essentiellement sur le progrès mécanique. Aussi Seurat, sa pensée glissant de la barque qui vogue au loin sur la mer à la femme tout entière tendue vers son miroir le soir, prononce-t-il les mots de *magie* et de *volupté*. La magie et la volupté qui sont en effet les plus hautes ressources consistent ici à confondre sur le plan émotionnel la barque et la femme dans leurs apprêts si différents, les rapports entre elles se soutenant du fait que l'une et l'autre à cet instant aident de leur mieux à l'accomplissement de la vie', Breton, *Oeuvres complètes*, vol. 3, 241.

[99] Friedrich Engels, *Dialectics of Nature* [1883], trans. Clemens Duff, London: Wellred Publications, 2007, 63. Dialectics is also termed there 'the science of inter-connections' and 'the reflection of the motion through opposites', Engels, *Dialectics of Nature*, 63, 214.

[100] For this lineage and outline of the French reception of Romanticism, see Charles Rosen and Henri Zerner, *Romanticism and Realism: The Mythology of Nineteenth-Century Art*, London and Boston, Mass.: Faber and Faber, 1984, 16–23; and for Friedrich von Schlegel's 1798 definition of the movement as a dialectic one, see Nina Athanassoglou-Kallmyer, 'Romanticism: Breaking the Canon', *Art Journal*, vol. 52, no. 2 ('Romanticism'), summer 1993, 18–21, 19. A convincing discussion of the operation of Hegel's *Aesthetics* (1835) in Breton's thought from the time of *The Lost Steps* (1924) and especially as it functions in 'Surrealist Situation of the Object: Situation of the Surrealist Object'

Indeed, Breton's terminological inconsistency or imprecision might be the outcome of his free recollection of various sources of the dialectical method in social science, philosophy and mysticism. In December 1942, he had stressed the centrality of the dialectic, 'that of Heraclitus, of Meister Eckhart, of Hegel', in his lecture 'Situation of Surrealism Between the Two Wars' given at Yale University;[101] at the beginning of his stay in Haiti, he continued to sponsor '*true* dialectical materialism' – while 'reserv[ing] possible rights for the *sacred*' – when he welcomed (and perhaps scripted) as an interviewee the poet René Bélance's statement that 'Surrealism is the application of dialectical materialism to the realm of art';[102] and he would highlight the importance of dialectics again with reference to his recent discovery of Charles Fourier in the interview with Jean Duché of October 1946 that I referred to in my last chapter.[103] In the midst of these statements, we see in this lecture an explicit formulation of the dialectic of Seurat's art, from the diverse, public, rational and mechanical subject matter of the sails and masts of marines such as *The 'Maria', Honfleur* (figure 3.10, 1886) that

(1935) can be found in Steven Harris, *Surrealist Art and Thought in the 1930s: Art, Politics, and the Psyche*, Cambridge: Cambridge University Press, 2004, 16–18 and 93–5. For his own lengthiest discussion of German Romanticism, which turns on a dialectical reading, see André Breton, 'Introduction to Achim von Arnim's *Strange Tales*' [1933], *Break of Day*, trans Mark Polizzotti and Mary Ann Caws, Lincoln and London: University of Nebraska Press, 1999, 88–110.

[101] Breton, *What is Surrealism?* 246.
[102] André Breton, 'Interview with René Bélance (*Haiti-Journal*, Haiti, December 12–13 1945)' [1945], *Conversations*, 191–5, 194.
[103] André Breton, 'Interview with Jean Duché (*Le Littéraire*, October 5 1946)' [1946], *Conversations*, 196–208, 207. Breton's remark in the Haiti lecture about the mutual support of two quite different entities in 'their better fulfillment of life' also betrays the reorientation his own dialectical theory of poetry was currently undergoing, in which '[t]he analogical image … moves between the two confronting realities. … From the first of these realities to the second one, it creates a vital tension straining toward health, pleasure, tranquillity, thankfulness, respect for customs. Disparagement and depressiveness are its mortal enemies', André Breton, 'Ascendant Sign' [1947], *Free Rein*, 104–7, 107.
　　When I insist on the presence of the dialectic and its application in Breton's statements throughout this period, I mean to contradict Meyer Schapiro who had been an interlocutor of Breton's on dialectical materialism among many other things in New York during the war from 1941 and who was quite wrong to claim later on that '"the word 'dialectics' disappeared from [Breton's] writings"' following a debate with him on the subject that Schapiro believed had shown Breton's loose understanding of the term, reported to Mark Polizzotti, *Revolution of the Mind: The Life of André Breton*, New York: Farrar, Straus and Giroux, 1995, 505 (this passage was dropped from the second, re-edited version of Polizzotti's biography of Breton, published in 2009). In 1948, Breton wrote of the 'deeply moving dialectical effect' of confinement and creative liberty that constituted the art of the mentally ill, and went much further in his scandalized 1951 riposte to Albert Camus's vilification of Lautréamont by advising the younger writer not to '[blame] Hegel for most of the calamities in our times' and 'to avail himself of the resources of dialectics', André Breton, 'The Art of the Insane, the Door to Freedom' [1948] and 'Yellow Sugar' [1951], *Free Rein*, 217–20, 220 and 244–6, 246. His best-known statement on Hegelian dialectics came the following year but has always been given in isolation and is more understandable within the history and alongside the case study I am giving in this chapter, in which he concedes 'any specialist could teach me a thing or two when it comes to interpreting [Hegel's] writings' while declaring that he had 'become imbued with his views' since discovering Hegel at the age of sixteen, ending with the unambiguous and much quoted declaration: '[w]hen Hegelian dialectic ceases to function, for me there is no thought, no hope of truth', Breton,

Figure 3.10 Georges Seurat, *The 'Maria', Honfleur* (1886). Oil on canvas, 53 × 63.5 cm. The National Gallery, Prague. © DeAgostini Picture Library/Scala, Florence.

'interpenetrates' in Breton's term with the warm and tender image of the self-absorbed preparation of the *coquette*, lovingly portrayed in *Young Woman Powdering Herself*. This is achieved within the scope of Breton's dialectical notion of 'convulsive beauty' theorized in his *Mad Love* of 1937 – two of the three conditions of which beauty are 'erotic-veiled' and 'magic-circumstantial', meaning that it arouses passionate feelings

Conversations, 118. Breton was confidently wielding the term in the context of the visual arts as late as 1964: see André Breton, 'Silbermann: "This is the Price"' [1964], *Surrealism and Painting*, 407–9, 407.

Much more consideration of Breton the dialectician is required in the scholarship on Surrealism, especially as one writer who knew his work well attested soon after his death: '[j]e ne connais pas de dialectique plus rigoureuse que la sienne', René Nelli, 'André Breton', *Cahiers du sud*, year 53, no. 390/391, October–December 1966, 309–11, 310 (repub. as René Nelli, 'André Breton' [1966], Daniel Fabre and Jean-Pierre Piniès (eds), *René Nelli et les*, Cahiers du sud, Carcassonne: Garae/Hésiode, 1987, 79–81, 80). For an alternative view – namely, that Surrealism was not truly dialectical but refused synthesis – see Bruce Baugh, *French Hegel: From Surrealism to Postmodernism*, New York and London: Routledge, 2003, 53–69; and for some speculations about the Hegelianism in Breton's writing up to the *Second Manifesto of Surrealism* (1930), see Jean-Michel Rabaté, 'Breton's Post-Hegelian Modernism', James Swearingen and Joanne Cutting-Gray (eds), *Extreme Beauty: Aesthetics, Politics, Death*, New York and London: Continuum, 2002, 17–28.

and is the outcome of a meaningful encounter (of the kind I referred to in my chapter on Cézanne) – condensing Seurat's dialectic poetically in a single punning sentence: 'he knew the boat *by heart*.'[104]

There is more to it than this, however. Breton's main enquiry into the dialectical function of the art of Seurat, inferred from the lengthy passage attributed to the artist, implicitly sustains and is enhanced by its potential extension into a historico-theoretical interpretation of Surrealism's contradictory aesthetic position to Purism's, as well as the inner logic of Surrealist art itself. But it only achieves these on the way to its more notable and expansive historical construal of the inner logic of the competing claims on Seurat in the twentieth century between classicism and Surrealism, as I set them out earlier in this chapter.[105] Ultimately it even accommodates Seurat's frequently quoted remark made of literary people and critics to Charles Angrand and much later recalled by Angrand for Gustave Coquiot, which had entertained only one half of the dialectic: 'they see poetry in what I do. No, I apply my method and that's all.'[106] No, the Surrealist would have countered: your method is the very means by which your work is invested with poetry.[107]

Breton's formidable and comprehensive proposal of a dialectical motor driving content, creation and reception of Seurat's art as well as the historical logic of modern art itself is all the more remarkable for being based on thoroughly erroneous information. Firstly, the quotation he attributed to the artist is not in Seurat's correspondence, as he thought, but was republished from the writing found among the remaining pages of the notebook he kept during his year of military service in Brest (beginning in November 1879) in the 1924 monograph by Coquiot that Breton owned.[108] Secondly,

[104] André Breton, *Mad Love* [1937], trans. Mary Ann Caws, Lincoln and London: University of Nebraska Press, 1987, 8–10, 13–19. There is a good chance that Breton was countering the conclusions reached in the 1926 *Cahiers d'Art* essay by Ozenfant that I mentioned earlier in this chapter in which geometry, discipline and reason form the foundation of Seurat's art, but which also uses the word 'magie' to convey its effects and faces a reproduction of the marine painting *Port-en-Bessin, entrée de l'avant-port* (1888): Ozenfant, 'Seurat', 172.

[105] For a discussion of the 'opposed developments' of Purism and Surrealism out of Apollinaire's essay 'The New Spirit and the Poets' (1918) following the 'structure of [the] rhetorical opposition of "Classical" and "Romantic" values', which opposition Breton seeks to overcome here in the service of a magical theory of Seurat's art, see Fer, Batchelor and Wood, *Realism, Rationalism, Surrealism*, 77, 83.

[106] '"ils voient de la poésie dans ce que je fais. Non, j'applique ma méthode et c'est tout,"' Seurat quoted by Angrand quoted by Coquiot, *Georges Seurat*, 41.

[107] One writer who knew Seurat got some way towards formulating this dialectic when he wrote of the artist soon after his death as 'de la race des peintres théoriciens réunissant la pratique à l'idée, et l'inconsciente fantaisie à l'effort réfléchi', even though the company he imagined for Seurat of Leonardo, Albrecht Dürer and Nicolas Poussin was hardly one the Surrealists would have recognized: de Wyzewa, 'Georges Seurat', 263.

[108] Coquiot, *Seurat*, 122–3. The transcription is faithful except for Breton's curious replacement of the original word 'parure' ('finery') with 'toilette' in the all-important passage he emphasized, a word he then reinserts in his subsequent interpretation: Breton, *Oeuvres complètes*, vol. 3, 240 (I have restored from Coquiot the missing word 'minces', illegible to the editors in Breton's manuscript). The editors of this third volume of his *Oeuvres complètes* could not locate the lengthy

and more importantly, Fénéon had told John Rewald at some point in the years just preceding Breton's quotation of the passage in 1946 that the descriptions of boats in the notebooks were not Seurat's own at all but 'copied by him from some publication'.[109] This becomes obvious when its lyrical manner is compared to the telegrammatic style of the artist's mainly staccato, blunt and factual letters.

That publication, which has remained obscure to this day in the scholarship on Seurat, can now be identified as the first instalment of the four-volume history of the French at sea, edited and partly authored by Amédée Gréhan and titled *La France maritime*, which appeared in 1837 and was republished several times from 1848 (figure 3.11). Each volume contained a set of accounts of maritime life, biographical, anecdotal, descriptive or historical, edited by Gréhan to create a general impression of how the French have viewed the experience of the sea. The poetic passage accurately transcribed by Seurat (except for a slight edit towards the end) was taken from page twelve of the first volume and is from a text of three pages, each of two columns, titled 'Le navire' ('The Ship') and signed 'Chevalier'.[110] This was the work of the journalist, novelist and historian of Brittany, Pierre-Michel-François Chevalier, called Pitre-Chevalier (figure 3.12). Future editor of the popular magazine *Musée des familles*, where he had written similarly at the time on maritime themes, exploration, colonization, the slave trade and local history (and where Jules Verne published his earliest stories), Pitre-Chevalier knew the history, geography and politics of the north west region and coast of France well.[111] He would later author *La Bretagne ancienne et moderne* (1844) and the weighty tome *Nantes et la Loire-Inférieure* (1850, co-edited with the folklorist Émile Souvestre). Pitre-Chevalier made further contributions to this first volume of *La France maritime* as a naval historian under the title 'Combat du Mars contre le Northumberland, 19 May 1744' (signed 'L. Chevallier'),[112] and again to the third volume (as 'P. Chevalier'), the second of which was an essay on

quotation in the Seurat scholarship presumably because they looked only at the artist's correspondence, where Breton himself thought it resided; rather, they suggest he could have received this document from his neighbour in New York, Schapiro, who had published on Seurat in ways conducive to Breton only a few years before the Surrealist arrived in the city and with whom he probably discussed the artist: Breton, *Oeuvres complètes*, vol. 3, 1232. See Meyer Schapiro, 'Nature of Abstract Art', *Marxist Quarterly*, vol. 1, no. 1, January–March 1937, 77–98, 84. The brief remarks in the second of these point toward the conclusions reached later in Schapiro, 'Seurat' [1958], *Modern Art, 19th and 20th Centuries*, 101–9.

[109] Rewald, *Georges Seurat*, 1943, 75 n. 5. This book was placed prominently among others in the shop window display installed by Duchamp at the Gotham Book Mart in New York in April 1945 to promote Breton's *Arcane 17* (1944). When Rewald referred to his knowledge of the passage being copied out in his later expanded volume on Seurat, he made it clear that Fénéon proffered the information 'in conversation with the author', John Rewald, *Seurat: A Biography*, London: Thames and Hudson, 1990, 212 n. 6.

[110] Chevalier, 'Le navire', Amédée Gréhan (ed.), *La France maritime*, vol. 1, Paris: Chez Postel, 1837, 10–12.

[111] See for instance P. Chevalier, 'La traite des noirs', *Musée des familles*, no. 3, 1936, 129–37; P. Chevalier, 'Le lévrier du duc de Bretagne', *Musée des familles*, no. 5, 1838, 209–18.

[112] L. Chevallier, 'Combat du Mars contre le Northumberland, 19 May 1744', Amédée Gréhan (ed.), *La France maritime*, vol. 1, Paris: Chez Postel, 1837, 358–60. This was the minor naval engagement that took place during the War of the Austrian Succession between HMS *Northumberland* and two French ships of the line, the *Mars* and the *Content*, actually on 8 May that year.

Figure 3.11 Title page of Amédée Gréhan (ed.), *La France maritime*, vol. 1, Paris: Dutertre, 1853. Bibliothèque Municipale de Lyon. Image courtesy BML.

Nantes, obviously a trailer for his later book on Verne's birthplace (it was a hypnotically interesting city for Breton, too).[113]

[113] P. Chevalier, 'Nantes', Amédée Gréhan (ed.), *La France maritime*, vol. 3, Paris: Chez Postel, 1837, 252–7. For Breton's early connection with and important experiences and encounters in Nantes, see Polizzotti, *Revolution of the Mind*, 27, 34–9; and for his estimation: 'Nantes: perhaps, with Paris, the only city in France where I feel that something worthwhile can happen to me, where certain eyes burn all too brightly for their own sake … where for me the rhythm of life is not the same as elsewhere, where certain beings still nourish a spirit of supreme adventure', see André Breton, *Nadja* [1928], trans. Richard Howard, New York: Grove Weidenfeld, 1960, 28–31 (for more, see my sixth chapter on Gauguin).

Figure 3.12 Photograph of Pitre-Chevalier, Atelier Nadar, 1861. Bibliothèque Nationale de France, Paris. © BNF.

Proposing to examine 'in its details and in its totality, at rest and in action, this marvellous floating machine',[114] 'Le navire' is an ornate eulogy to the ship and initially and particularly to the charms of 'the French schooner'.[115] In Pitre-Chevalier's text it is remorselessly and tiresomely characterized as a dainty *coquette*:

> light, elegant, neatly formed, soaring like a little fish; the schooner with its sheer gently lowered in the middle and raised coquettishly towards the rear like the arched back of a Creole; with all of its harmonious proportion; its elongated shoulders, its sharp poulaine and its hips shaped like a heart above the water. The schooner is the little mistress of our ports; whether she flies on the waves where her wake leaves no traces, or glides and frolics among reefs, she is the swallow of the sea.
>
> A ship such as the brig of Le Havre or of Nantes is less attractive, less elegant, less coquettish than the schooner. . . .[116]

Effusive and adoring throughout, we discover that it was in fact Pitre-Chevalier who knew the ship 'by heart' not Seurat. We also learn the importance to Pitre-Chevalier of the relationship between utility and beauty in the vessel when, just before he plunges into the passionate accolade that captured Seurat's attention, he writes of the extraordinarily complex equipment as it meets the eye: 'each part of this machinery is necessary', he declares, yet 'the beauty found there is so intimately linked to utility that at first sight one sees only, in place of design, an elegant coquetry, and one is carried away by the well-groomed appearance of the ship, that which is, above all, for its protection and is its indispensable attire'.[117] The argument is so oddly close to Breton's, given after Le Corbusier and Ozenfant's on mechanical selection, that it is almost as though the Surrealist read the whole text and not just the fragment copied out by Seurat.

This and the other three volumes of *La France maritime* are illustrated throughout with etchings of ships of various kinds that frequently demonstrate the delicate complexity of naval equipment that Pitre-Chevalier indicated (figure 3.13). No doubt

[114] 'dans ses détails et dans son ensemble, dans son repos et dans son action, cette merveilleuse machine flottante', Chevalier, 'Le navire', 10.

[115] 'la goëlette française', Chevalier, 'Le navire', 10.

[116] 'légère, élégante, fine de formes, élancée comme un petit poisson; la goëlette avec sa tonture doucement abaissée au milieu et relevée coquettement vers l'arrière comme les reins cambrés d'une créole; avec toutes ses proportions harmonieuses, ses épaules alongées, sa poulaine aiguë et ses hanches en cœur, au-dessus de l'eau. La goëlette, c'est la petite maîtresse de nos ports; qu'elle vole sur les flots où son sillage ne laisse point de traces, qu'elle glisse et se joue au milieu des récifs, c'est l'hirondelle de la mer.

Un navire, c'est le brick du Havre ou de Nantes, moins joli, moins fin, moins coquet que le goëlette . . .', Chevalier, 'Le navire', 10.

[117] 'chaque pièce de cet appareil a sa nécessité'; 'le beau s'y trouve si intimement lié à l'utile, qu'au premier aspect on n'y voit, au lieu de calcul, qu'une élégante coquetterie, et l'on est porté à prendre pour la toilette du navire, ce qui en est avant tout la défense et l'indispensable vêtement', Chevalier, 'Le navire', 12. For more loving commentary about ships and the sea in his fiction, see Pitre-Chevalier, *Un ménage a bord: Histoire conjugale du Capitaine Lenoir*, Paris: Figaro, 1837.

Figure 3.13 From Amédée Gréhan (ed.), *La France maritime*, vol. 1, Paris: Chez Postel, 1837. Bibliothèque Municipale de Lyon. Image courtesy BML.

the book supplemented for Seurat historically and technically the Impressionist imagery of boating on the Seine that he would have known well. But it also introduced him to harbour drawing and etching, the subgenre of maritime visual culture, even though he did not sketch any ships at the time. He would only embark on the marines in 1885 after making his name as a painter of modern life in Paris and at five years distance from his military service, not in Brest but further east along the Channel coast at Grandcamp, Honfleur, Port-en-Bessin, Le Crotoy and Gravelines (all some way north of Pitre-Chevalier's beloved Nantes). It is not unreasonable to view those paintings as the realization of a long-held aspiration to paint the sea that began while Seurat was in Brest at the beginning of the decade. More confident appraisal of his marines alongside the engravings in *La France maritime* is enticing and even cautiously rewarding. This is especially the case for comparison of those illustrations with his marine harbour paintings containing ambitious renderings of masts and rigging such as *The 'Maria', Honfleur* and *Corner of a Dock, Honfleur* (1886). In these, the technical detail of the various boats shows a truer co-existence of industry and leisure than that sought hard for by T. J. Clark in Monet's 1870s paintings of the river at Argenteuil, one easily associable with the reciprocity of utility and beauty that I just showed Breton extending dialectically into a poetics of the image.[118]

It matters little that the poetic passage quoted by Breton was not Seurat's own; it obviously held some value for the artist and presumably reflected his own feelings

[118] Clark, *Painting of Modern Life*, 179–99.

since he took the trouble to transcribe it to his notebook and retain it. Furthermore, Rewald, Kenneth Clark and others have made comparable speculations to Breton's about the formative nature of Seurat's brief period of military service.[119] We might even surmise that the pleasure Seurat took from the elaborate passage stood in for that he normally gained from his artistic practice since he did not paint and sketched little during that year. If Breton's interpretation made accidentally via Pitre-Chevalier receives substantial weight from the subsequent importance Seurat gave to marine painting, it takes on remarkable resonance for the closeness of the *Young Woman Powdering Herself* to the description of the *coquette* found by Seurat and written out by him in this passage. Although Breton does not mention the Courtauld painting in the Haiti lecture, it was obviously on his mind as he expanded the fragment from the notebook into a theory of the artist.[120]

In the Haiti lecture, Breton remained initially within his dialectical reading of Seurat's painting in viewing *Chahut* (figure 3.14) as another 'synthetic conception' in the sense that it arrested the gestures of the dancers at their very extremity.[121] This was in keeping with the third condition of convulsive beauty, 'exploding-fixed', where movement expires at its limit, illustrated in *Mad Love* by the photograph by Man Ray that immobilizes a dancer (figure 3.15).[122] Yet Breton broke off because he wanted to pin down the mocking humour he had discerned in Seurat's work since his earliest writings on the artist in the 1920s, returned to recently in his *Anthology of Black Humour* (1945). Distribution of the book had been prevented in 1940 by the Vichy government in France and it was just out as he arrived to speak in Port-au-Prince. In the introduction to the *Anthology*, Breton had referred to art in which 'humour can be sensed but at best

[119] See Rewald, *Seurat*, 3; 'there is no evidence that the young Seurat showed the faintest interest in open-air painting till after he had spent his year of military service at Brest; and it is characteristic of him that the revelation of light should have come to him as he gazed on the sea during the hours of sentry duty', Clark, *Looking at Pictures*, 134. Also see the remarks in Germain Seligman, *The Drawings of Georges Seurat*, New York: Curt Valentin, 1947, 34; and Henri Perruchot, *La vie de Seurat*, Paris: Hachette, 1966, 25–6. The opposite view is given by Zimmermann who asserts that during his military service, 'Seurat the realist was at that time almost blind to the beauties of the sea', Zimmermann, *Seurat and the Art Theory of his Time*, 61.

[120] As I noted earlier, Breton saw Schapiro often in New York, so he could well have discussed Seurat with him. His own reading of the artist postdates the one claiming that the 'Eiffel Tower offers indeed a formal resemblance to the art of Seurat [who] identified the "progress" of art with technical invention, rationalized labor, and a democratic or popular content', Meyer Schapiro, 'Seurat and *La Grande Jatte*', *The Columbia Review*, no. 17, November 1935, 9–16, 15; and it precedes the much more widely-known and influential one of 1958 – observing the forms of Seurat's paintings as colluding with the contemporary ones of industry and architecture and stating 'Seurat's taste for the mechanical and his habit of control extend also to the human' – by Schapiro, 'Seurat', *Modern Art, 19th and 20th Centuries*, 108. For an interpretation presumably informed by Schapiro that links *Young Woman Powdering Herself* not to nautical forms and themes but to the Eiffel Tower, see Garb, *Bodies of Modernity*, 116–19.

[121] Breton, *Oeuvres complètes*, vol. 3, 242.

[122] Breton, *Mad Love*, 10–13.

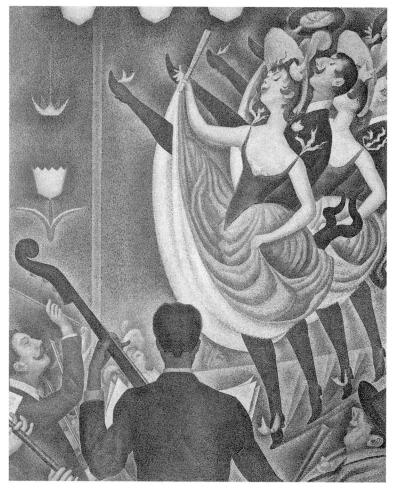

Figure 3.14 Georges Seurat, *Chahut* (1889–90). Oil on canvas, 171.5 × 140.5 cm. Rijksmuseum Kröller-Müller, Otterlo. © DeAgostini Picture Library/Scala, Florence.

remains hypothetical – such as in the quasi-totality of Seurat's painted opus.'[123] He then examined the humour of *Chahut* in the 1946 lecture as follows:

> this painting seems to me to shelter a good many other intentions, which have not yet been aired and make it one of the works whose impact is still in large part *to come*. Not enough has been made in *La Chahut* [*sic*] of its contribution to an *icy* humour that is entirely modern, which, *freezing* here impossibly the scene which insists upon the

[123] André Breton, 'Lightning Rod', *Anthology of Black Humour* [1945/1966], trans. Mark Polizzotti, San Francisco: City Lights, 1997, xiii–xix, xvii.

Figure 3.15 Man Ray, 'explosive fixed', 1937, photograph from André Breton, *L'amour fou* (1937). Collection Man Ray Trust. © Man Ray Trust/ADAGP-DACS/Telimage 2018.

most boisterous treatment, engenders a feeling of extreme vanity and absurdity, corroborated by the inane or blissfully satisfied expressions of one and all.[124]

[124] 'ce tableau me paraît receler bien d'autres intentions qui n'ont pas encore été mises en évidence et font de lui une des œuvres dont la répercussion est encore en grand partie *à venir*. On n'a pas assez fait dans *La Chahut* la part d'un humour *glacé* à la moderne, qui, *figeant* ici comme par impossible la scène qui se veut la plus endiablée, engendre un sentiment de vanité extrême et d'absurde, corroboré par les expressions niaises ou béatement satisfaites des uns et des autres', Breton, *Oeuvres complètes*, vol. 3, 243.

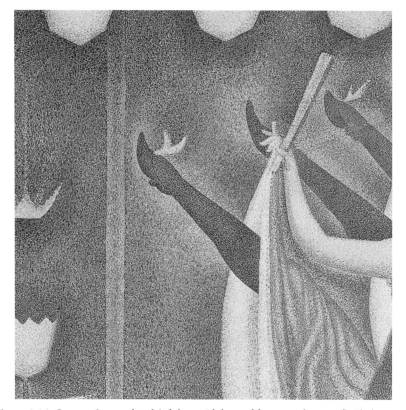

Figure 3.16 Georges Seurat, detail (of shoe with bow of foremost dancer of) *Chahut* (1889–90). Oil on canvas, 171.5 × 140.5 cm. Rijksmuseum Kröller-Müller, Otterlo. © DeAgostini Picture Library/Scala, Florence.

The 'exploding-fixed' humour was extended towards the 'magic-circumstantial' through the isolation by Breton of the brightly lit bow on the shoe of the foremost dancer (figure 3.16), which for him was the key component in the composition. He perceived in this bow the 'entirely poetic heroine' of *Chahut*, as a core form insofar as it binds the painting analogically.[125] Its 'wings' compliment and even reinforce the movement of the dancer's raised leg; they match the shapes of the upturned corners of the mouths and moustaches of the figures in the painting, as well as the leaves of the tulip-shaped gas jet at centre left; and its colouration harmonizes with the wall lighting. It is as though it were a 'Will-o'-the-wisp', in Breton's words, which 'communicates to the canvas its exorbitant life', and it is 'these elements of great humour and the magic of certain lighting bringing about the strange distribution of organic elements' that

[125] '[h]eroïne toute poétique', Breton, *Oeuvres complètes*, vol. 3, 243.

establish synthesis in Seurat's later work.[126] This is a reading Breton extended to *Parade de Cirque* in which he acclaimed the artist's rendering of the light of the acetylene gas jets then still in use in Paris and it is one we will see is of value for my next chapter in comprehending the Surrealist reception of Seurat's drawings.[127]

It is perhaps not surprising that Seurat's work was available to Breton's dialectical reading, nor in that case that those paintings could be esteemed by critics of art who were ideologically diametrically at odds, given the artist's admiration from an early age for both Ingres and Delacroix and the usually stereotypical ways in which those artists were opposed to each other in the claims made upon them by competing camps of artists and writers. In the early 1960s, Robert L. Herbert hinted at the possibility that Seurat's exceptional drawings could also be seen in divergent terms, perhaps recalling the presence of the artist's work at *Cubism and Abstract Art*. Adopting the art historical language of that period, which just about remained that of his own time, Herbert saw them as each two things:

> an arrangement of certain flat forms and a number of illusionary realities which those forms suggest. In the twentieth century, dominated by formalistic considerations, the former has assumed such prominence that our view of the latter has been prejudiced. We delight in investigating the abstract components of art, and too often give a secondary place to the artist's ties with the tangible world. Because Seurat did not deal in anecdote, because he seldom showed the features of his subjects, he is too readily presumed to have been interested only in form for its own sake.[128]

While pointing in the direction of a more content-led means of interpreting the artist, Herbert's subject is not the Surrealist Seurat, naturally. Although 'illusionary realities' might be taken to imply a proto-Surrealist sensibility in the drawings, this is then corrected by reference to 'the artist's ties with the tangible world' to designate Seurat the political artist or at least the social historian who painted peasants as 'simple people of immense dignity, always at work'.[129]

Written at the time that the challenge to the dominance of formalism in modernist art history was beginning, Herbert's passage revealed at once the possibilities held by Seurat's drawings for discussion beyond their formal properties and the suppression of such interpretation by art historians. It also helped make possible later remarks close to Surrealism once the battle had been won, like John Russell's accreditation of Seurat as

[126] 'feu follet'; 'communique à la toile sa vie exorbitante'; '[c]es éléments de grand humour et la magie de certains éclairages entraînant la distribution insolite des éléments organiques', Breton, *Oeuvres complètes*, vol. 3, 243.

[127] The Surrealist reading of the drawings that I give in my next chapter will not be a dialectical one, but that has been asserted without reference to Surrealism by Bernd Growe, 'The Pathos of Anonymity: Seurat and the Art of Drawing', Erich Franz and Bernd Growe, *Georges Seurat: Drawings* [1983], Boston, Mass: Little, Brown and Company, 1984, 13–50, 42.

[128] Herbert, *Seurat's Drawings*, 95–6.

[129] Herbert, *Seurat's Drawings*, 96.

'a supreme master of the poetic imagination'.[130] However, neither Herbert nor Russell was aware that Surrealism had long since reached that conclusion, partly through Breton's fascination for the paintings, as I detailed in this chapter, but also by means of the surrealization of those peerless drawings. This extended quite beyond their formal geometries, of course, and it was an interpretation less attuned to the local connection with the social world that Herbert thought they made available than to their 'indeterminate depths' advertised by Seurat and remarked much later by Shiff. I look at them in the context of Surrealism in my next chapter.

[130] John Russell, 'Afterword', *Art Institute of Chicago Museum Studies*, no. 2 ('The *Grande Jatte* at 100'), 238–9, 239.

Between Dog and Wolf: Georges Seurat, Brassaï and the City of Light

As well as being the leading artist-theorist of Neo-impressionism, Georges Seurat has long been acknowledged as the creator of some of the greatest drawings in the modern canon. There are known to be five hundred in his *oeuvre* of which 270 date from the period that Seurat was establishing himself as an important artist.[1] The mature style in which linearity gives way to tonality and delicate *sfumato* arrived at some point in the first half of 1882 or perhaps late in 1881, and they significantly decrease in number after 1885.[2] Relatively few were exhibited in Seurat's lifetime, typically alongside the paintings and usually to great acclaim, as when eight were shown at the 1888 Salon des indépendants revealing their author as 'a real seer' in the phrase of the painter and critic J. E. Schmitt.[3] Certain of them such as *The Echo* (figure 4.1, 1883) are recognizable as preparatory studies for his major paintings. Others are entirely independent drawings, mainly figures, buildings, sketches of street scenes and country life, and there are a few portraits (figure 4.2), sometimes of a scale and finish demonstrating that Seurat considered them as major works. To an audience in the middle third or so of the twentieth century as much as to us today, their 'surrealist' attributes were evident and far more so than any to be found in Seurat's paintings, yet there has been as little attempt to define those traits in the one medium as in the other in terms of the poetics of their content and style.

Deeply ambiguous and powerfully obscure, the subject matter of Seurat's drawings is not at all consistent nor are their settings or even the time of day they are supposed to illustrate, all of which will be discussed in this chapter. Their deceptively vapourous content is married to and might be said to begin in their most striking characteristics. These are given in a combination of materials and process that were part of what has been called 'the proliferation of tonal drawing media' in France between 1850 and 1900,[4]

[1] Jodi Hauptman, 'Introduction', Jodi Hauptman (ed.), *Georges Seurat: The Drawings*, New York: Museum of Modern Art, 2007, 9–15, 10.

[2] Robert L. Herbert, *Seurat's Drawings* [1962], London: Studio Vista, 1965, 44; Richard Thomson, *Seurat*, Oxford and New York: Phaidon, 1985, 23; John Leighton and Richard Thomson, *Seurat and the Bathers*, London: National Gallery, 1997, 16.

[3] Quoted in Michelle Foa, *Georges Seurat: The Art of Vision*, New Haven and London: Yale University Press, 2015, 157.

[4] Lee Hendrix, 'Introduction', Lee Hendrix (ed.), *Noir: The Romance of Black in 19th-Century French Drawings and Prints*, Los Angeles: The J. Paul Getty Museum, 2016, 1–3, 1.

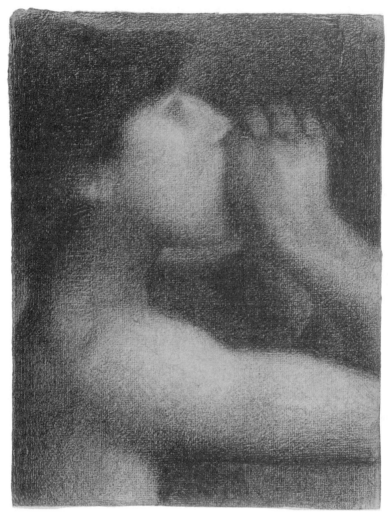

Figure 4.1 Georges Seurat, *The Echo* (1883). Conté crayon on paper, 31.2 × 24 cm. Yale University Art Gallery. © Yale University Art Gallery.

consisting in nearly all cases in Seurat's work of thick, black, lustrous conté crayon (as opposed to chalky charcoal) pressed with varying degrees of pressure onto quarter-sheets of dense, lined, laid Michallet paper, a sub-variety of Ingres paper that loses its milky whiteness following contact with the air.[5] Robert L. Herbert stated (without

[5] Michelle Sullivan and Nancy Yocco, 'Diversity and Complexity of Black Drawing Media: Four Case Studies', Hendrix (ed.), *Noir*, 117–23, 121. For an excellent account of the materials used in Seurat's drawings, see Karl Buchberg, 'Seurat: Materials and Techniques', Hauptman (ed.), *Georges Seurat:*

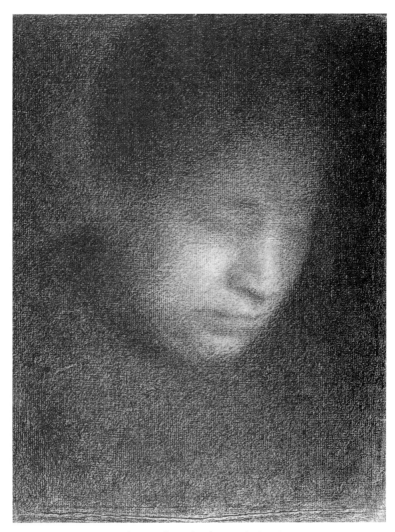

Figure 4.2 Georges Seurat, *The Artist's Mother* (1882–3). Conté crayon on paper, 30.5 × 23.3 cm. J. Paul Getty Museum, Los Angeles. Digital image courtesy of the Getty's Open Content Program.

The Drawings, 31–41; and for more information about the sources, quality and sizes of Seurat's paper, see Anthea Callen, 'Hors-d'oeuvre: Edges, Boundaries, and Marginality, with Particular Reference to Seurat's Drawings', Paul Smith (ed.), *Seurat Re-Viewed*, University Park PA: The Pennsylvania State University Press, 2009, 18–42, 27–8, 34–7. A recent technical report discovered Seurat's use of thin, fast-drying shellac resin as a fixative to prevent smudging and improve tooth for subsequent applications of conté: Chris McGlinchey and Karl Buchberg, 'The Examination of Drawings by Georges Seurat Using Fourier Transform Infrared Spectroscopy (Micro-FTIR)', *e-Preservation Science*, no. 6, 2009, 118–21.

illustration) that '[u]nder a microscope its myriad tufts can be seen to project from the surface in little comma-shaped hooks. When Seurat lightly stroked its surface, the hooks caught the crayon here and there, leaving the valleys between them untouched.'[6] However, our examination of darkened, intermediate and lightly touched locations of the *Female Nude* (1879–81) in the possession of The Courtauld Institute of Art revealed less available finesse in the contact and no bristled features (figure 4.3). These areas evince not so much a sensitively grazed surface than a worked one, resulting in a dry-looking, matted terrain under raking light (figure 4.4), irregular clumping (figure 4.5) and a minutely uneven, resistant ground (figure 4.6), more tooth than tuft. The outcome is the appearance to the naked eye of a heavily veiled or lightly gridded frontal plane as textured as any painting by Pierre-Auguste Renoir or any pastel by Edgar Degas. That slightly mismatched comparison of the optically 'downy' layer of Renoir and the haptically coarse surface of Degas already sets out a visual topography I will have to negotiate in considering Seurat's drawings and their surrealization in the 1930s.

There have been many attempts to put into words the stunning results regularly achieved with his materials by Seurat in which the terms 'mystery' and 'mysterious' appear with particular regularity, as they had when they came in for consideration in Surrealism.[7] This is perhaps because all other terminology stops short of accounting satisfactorily for the very strange effects, mood and atmosphere created by the multifarious passages of dark, greasy stick across light, grainy paper where Seurat's astonishing versatility with the conté crayon fluctuates through many degrees of tone

6 Herbert, *Seurat's Drawings*, 47.
7 The terms and their variants are to be found in Claude Roger-Marx, *Seurat*, Paris: Les Éditions G. Crès & Co., 1931, 12; Pierre Mabille, 'Dessins inédits de Seurat', *Minotaure*, no. 11, May 1938, 2–9, 3; Meyer Schapiro, 'Seurat' [1958], *Modern Art, 19th and 20th Centuries: Selected Papers*, vol. 2, London: Chatto & Windus, 1978, 101–9, 104; Herbert, *Seurat's Drawings*, 74; José Pierre, *L'Univers surréaliste*, Paris: Somogy, 1983, 58; Erich Franz and Bernd Growe, 'Introduction', *Georges Seurat: Drawings* [1983], Boston, Mass.: Little, Brown and Company, 1984, 7–11, 10 (here with rare reference to their appearance in *Minotaure*); Thomson, *Seurat*, 73, 134; Shiff, 'Seurat Distracted', Hauptman (ed.), *Georges Seurat: The Drawings*, 16–29, 19; Richard Thomson, 'The Imperatives of Style: Seurat's Drawings, 1886–1891', Hauptman (ed.), *Georges Seurat: The Drawings*, 169–83, 183; Bridget Riley, 'Seurat as Mentor', Hauptman (ed.), *Georges Seurat: The Drawings*, 185–95, 191, 195. The closest painting in mood to the drawings is the nocturne *Parade de Cirque* (1887–8), which is virtually their culmination and has received the same descriptive epithet from Alfred H. Barr, Jr., *The Museum of Modern Art First Loan Exhibition, New York, November 1929: Cézanne, Gauguin, Seurat, Van Gogh*, New York: Museum of Modern Art, 1929, 26; William Innes Homer, *Seurat and the Science of Painting*, Cambridge, Mass.: MIT, 1964, 175; Françoise Cachin, *Seurat: Le rêve de l'art-science*, Paris: Gallimard, 1991, 96; and Joan U. Halperin, 'The Ironic Eye/I in Jules Laforgue and Georges Seurat' and Richard Hobbs, 'Seurat and Mallarmean Thought' in Smith (ed.), *Seurat Re-Viewed*, 113–46, 128 and 223–40, 234; and Richard Thomson, 'Seurat's *Circus Sideshow*: A Parade of Paradoxes', New York: The Metropolitan Museum of Art, *Seurat's Circus Sideshow*, 2017, 19, 21, 75, 105. The 'mysterious atmosphere' of *A Sunday on La Grande Jatte – 1884* (1884–6) was evoked in support of the idea of the artist as 'supreme ruler' of his creation in an affirmation of the Symbolist context for Seurat's work that is diametrically opposed to the Surrealist interpretation I am disclosing here: Sven Lövgren, *The Genesis of Modernism: Seurat, Gauguin, van Gogh and French Symbolism in the 1880s*, trans. Albert Read, Stockholm: Almqvist & Wiksell, 1959, 56.

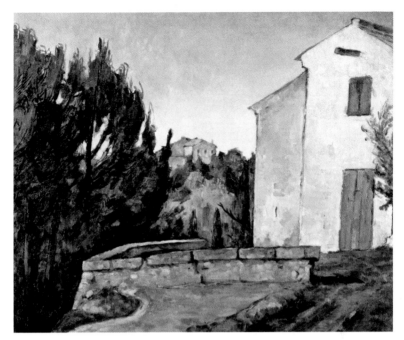

Plate 1a Paul Cézanne, *The Abandoned House* (1878–9). Oil on canvas, 50.5 × 60.4 cm. Private collection. © Christie's Images/Bridgeman Images.

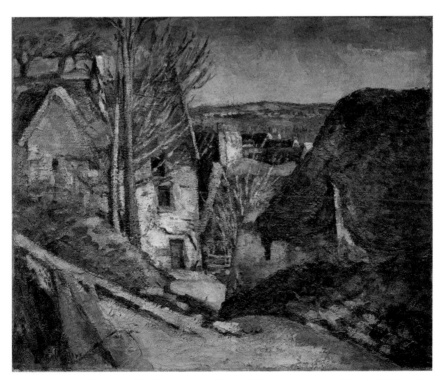

Plate 1b Paul Cézanne, *The House of the Hanged Man, Auvers-sur-Oise* (*c.* 1873). Oil on canvas, 55 × 66 cm. Musée d'Orsay, Paris. © Photo Scala, Florence.

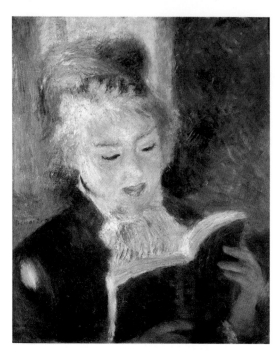

Plate 2a Pierre-Auguste Renoir, *Woman Reading* (1874–5). Oil on canvas, 47 × 38 cm. Musée d'Orsay, Paris. © Photo Scala, Florence.

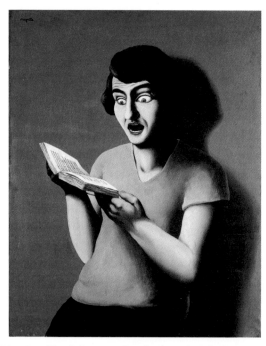

Plate 2b René Magritte, *The Submissive Reader* (1928). Oil on canvas, 92 × 73 cm. Private collection. © BI, ADAGP, Paris/Scala, Florence. © ADAGP, Paris and DACS, London 2018.

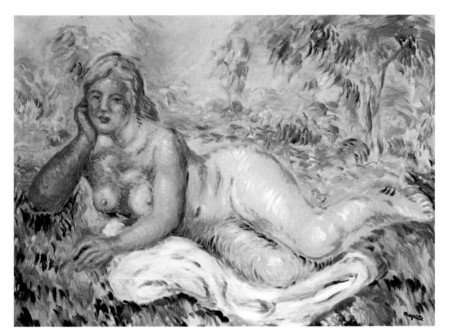

Plate 3a René Magritte, *Treatise on Light* (1943). Oil on canvas, 55 × 75 cm. Private collection. © Christie's Images. © ADAGP, Paris and DACS, London 2018.

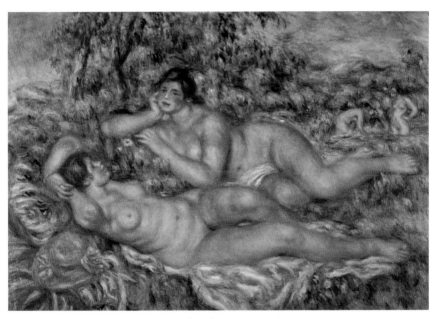

Plate 3b Pierre-Auguste Renoir, *Bathers* (1918–19). Oil on canvas, 110 × 160 cm. Musée d'Orsay, Paris. © Photo Scala, Florence.

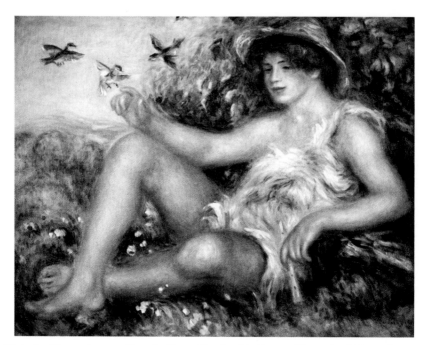

Plate 4a Pierre-Auguste Renoir, *Young Shepherd in Repose (Portrait of Alexander Thurneyssen)* (1911). Oil on canvas, 73 × 91 cm. Rhode Island School of Design Museum, Providence. © World History Archive/Alamy Stock Photo.

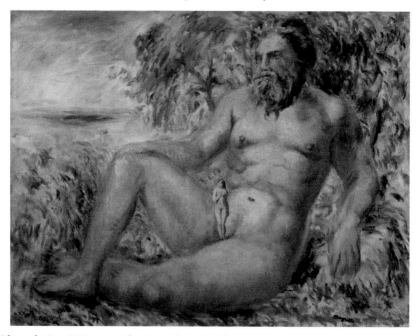

Plate 4b René Magritte, *The Ocean* (1943). Oil on canvas, 50 × 65 cm. Private collection. © Bridgeman Images. © ADAGP, Paris and DACS, London 2018. 000

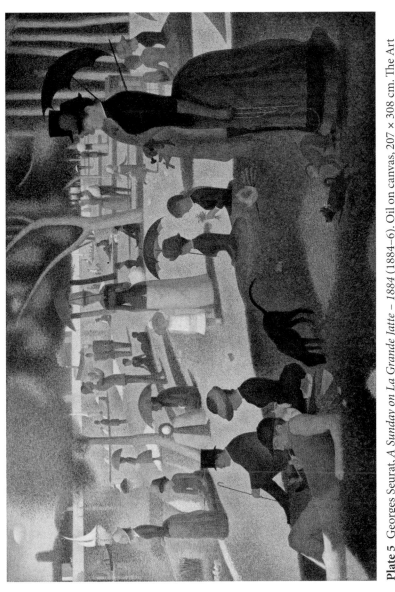

Plate 5 Georges Seurat, *A Sunday on La Grande Jatte – 1884* (1884–6). Oil on canvas, 207 × 308 cm. The Art Institute of Chicago. © The Art Institute of Chicago/Art Resource, NY/Scala, Florence.

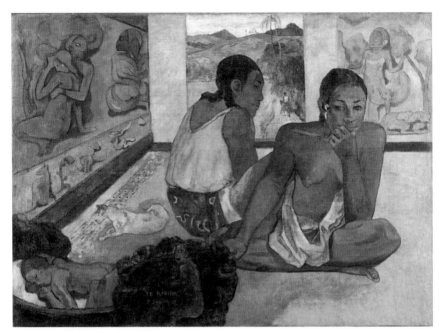

Plate 6a Paul Gauguin, *Te Rerioa (The Dream)* (1897). Oil on canvas, 95 × 132 cm. The Courtauld Gallery, London. © The Samuel Courtauld Trust, The Courtauld Gallery, London.

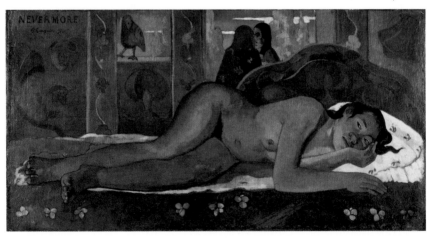

Plate 6b Paul Gauguin, *Nevermore* (1897). Oil on canvas, 60.5 × 116 cm. The Courtauld Gallery, London. © The Samuel Courtauld Trust, The Courtauld Gallery, London.

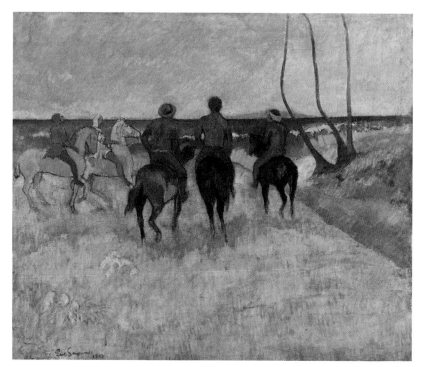

Plate 7a Paul Gauguin, *Riders on the Beach* (1902). Oil on canvas, 66 × 76 cm. Museum Folkwang, Essen. © Photo Scala, Florence.

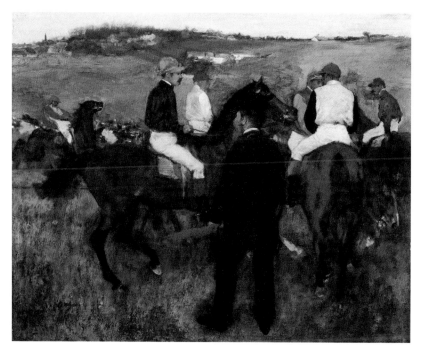

Plate 7b Edgar Degas, *Racehorses (Leaving the Weighing)* (1878). Oil on panel, 32.5 × 40.4 cm. Private collection. © Christie's Images, London/Scala, Florence.

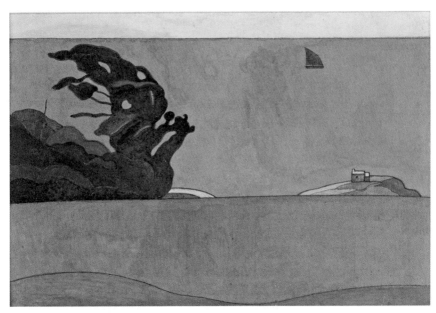

Plate 8a Charles Filiger, *Pouldu Landscape* (*c*. 1890–3). Gouache on paper, 26 × 38.5 cm. Musée des Beaux-Arts, Quimper. Transfert de propriété de l'Etat à la Ville de Quimper en 2013 – Collection du musée des beaux-arts de Quimper.

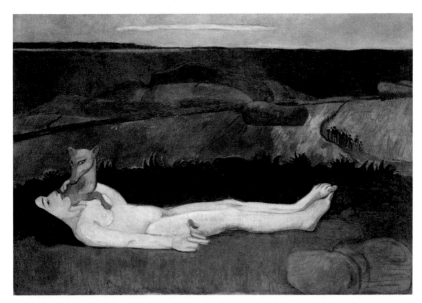

Plate 8b Paul Gauguin, *The Loss of Virginity* (1890). Oil on canvas, 90 × 31 cm. Chrysler Museum of Art, Norfolk, Virginia. © 2018 Chrysler Museum of Art.

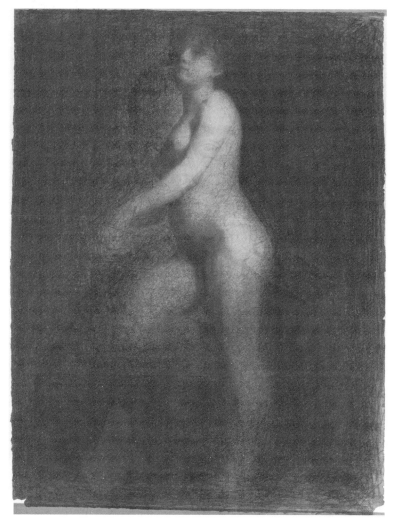

Figure 4.3 Georges Seurat, *Female Nude* (1881–2). Conté crayon and graphite on paper, 63.2 × 48.3 cm. The Courtauld Gallery, London. © The Samuel Courtauld Trust, The Courtauld Gallery, London.

and technique from pitch black coating to thin masking to mazy, wiry scribble. The sensation of process they give off is even more flagrant than that conveyed by the dotted matrix of Seurat's paintings. This is present not just in the memory of the rub of the crayon enclosed and visible within the black, speckled trace it left behind, but also in the denotation of handmade manufacture inscribed inside the heavy surface of the paper and on its ragged edge. These attributes insist on the objecthood of the drawings and prevent them being viewed as 'windows onto the world'. However, the deckle edges

Figure 4.4 Georges Seurat, detail of *Female Nude* (1881–2). Conté crayon and graphite on paper, 63.2 × 48.3 cm. The Courtauld Gallery, London. Photograph by Giovanni Verri ×20 on non-contact USB Dinolite microscope. © The Samuel Courtauld Trust, The Courtauld Gallery, London.

Figure 4.5 Georges Seurat, detail of *Female Nude* (1881–2). Conté crayon and graphite on paper, 63.2 × 48.3 cm. The Courtauld Gallery, London. Photograph by Giovanni Verri ×20 on non-contact USB Dinolite microscope. © The Samuel Courtauld Trust, The Courtauld Gallery, London.

Figure 4.6 Georges Seurat, detail of *Female Nude* (1881–2). Conté crayon and graphite on paper, 63.2 × 48.3 cm. The Courtauld Gallery, London. Photograph by Giovanni Verri ×20 on non-contact USB Dinolite microscope. © The Samuel Courtauld Trust, The Courtauld Gallery, London.

have not always been shown in reproduction or exhibition and their exposure is more a feature of their publication and display today than in their own time.[8]

In my previous chapter I alluded to André Breton's familiarity in the early 1920s with Seurat's work and his advice on its purchase to his then-employer Jacques Doucet. Breton had probably read Guillaume Apollinaire's adoring review of Lucie Cousturier's 1914 article on Seurat's drawings, which consisted almost entirely of a lengthy quotation from Cousturier as to how Seurat 'proceeds as poets do' by negating realism through the imposition of his method on the external world.[9] This is an argument close to the one made by Jean Hélion over twenty years later about the paintings. Breton might even have sought out Cousturier's original piece in *L'Art décoratif*, where it was accompanied by reproductions of seven drawings.[10] In any case, he owned her 1921 monograph made up of that article and an earlier one on the paintings that had appeared in the same journal in 1912.[11]

[8] As late as the 1980s, the drawings had their '"saw-toothed" deckle edges' routinely cropped: see Callen, 'Hors-d'oeuvre', Smith (ed.), *Seurat Re-Viewed*, 34–5.

[9] Guillaume Apollinaire, 'Seurat's Drawings' [1914], *Apollinaire on Art: Essays and Reviews 1902–1918* [1960], ed. Leroy C. Breunig, trans. Susan Suleiman, Boston, Mass.: MFA, 2001, 379–80, 379.

[10] Lucie Cousturier, 'Les Dessins de Seurat', *L'Art decoratif*, year 16, no. 31, January–June 1914, 99–106 (Apollinaire quotes extensively from 103).

[11] Lucie Cousturier, *Seurat*, Paris: Éditions Georges Crès et Cⁱᵉ, 1921.

If those distinctive, umbrageous works made a powerful impression on Breton, he was not alone in this. Unsurprisingly, their strange and agile, seemingly inexhaustible seductive charm soon reached the larger circles that had also experienced the shock waves of Surrealism in the 1920s. This was made manifest in the appearance in 1929 of five drawings and a painted study for *Poseuses* (1887–8) in the journal *Documents* edited by Georges Bataille and Carl Einstein, one or the other of whom was presumably responsible for the brief passages that accompanied their reproduction.[12] That text merely though accurately compares Seurat's drawings to those of Hans Holbein and Jean-Auguste-Dominique Ingres whom the artist admired, noting his fascination with 'certain peculiarities of light'.[13] But there is no attempt to engage with them through Bataille's emerging theoretical paradigm of 'base materialism', nor through the ethnographic theory that was a staple of *Documents*. Even the choice of works shown is not terribly interesting: four were borrowed from Félix Fénéon's collection, but of these only the study for *Bathers at Asnières* (1883–4) now known as *Man in a Bowler Hat* (1883) is a prime example of Seurat's advanced technique. Most noteworthy in retrospect, perhaps, given the heated confrontation about to take place between Breton's Surrealists and the group close to Bataille at *Documents*, is the appearance of the very painted study for *Circus* acquired by Doucet on the advice of Breton. When he and his friends in the Surrealist group turned to Seurat's drawings, it was precisely with the aim of adapting them to the technical and thematic concerns of the movement. It is with the elicitation and elaboration of those concerns in the context of the lighting of *Minotaure* and that of the city of Paris, as it was memorably depicted in the review by Brassaï, that this chapter will be taken up.

From the mysterious to the marvellous

In May 1938, then, ten of Seurat's drawings were reproduced as the lead article for the second to last number of *Minotaure*, the quality art review that the Surrealists had virtually but not entirely requisitioned earlier that decade (figure 4.7). Published alongside a text by Pierre Mabille under the (slightly inaccurate) title 'Dessins inédits de Seurat', the high production values maintained by *Minotaure* made it an appropriate place to showcase Seurat's woolly, apparently tenebrous drawings almost as *objets d'art*, meaning that a large audience was given unusual access to their fine detail for the first time, especially the five that were shown one to a page.[14] Borrowed from the collections of César M. de Hauke and Fénéon who were hard at work by then on Seurat's catalogue raisonné, the position of these drawings at the head of the review speaks clearly enough for their perceived

[12] Anonymous, 'Quelques esquisses et dessins de Georges Seurat', *Documents*, no. 4, September 1929, 183–7.
[13] 'certaines bizarreries d'éclairage', Anonymous, 'Quelques esquisses et dessins de Georges Seurat', 183.
[14] The 1882 drawing sometimes titled *Night Walk* and the one of 1882–3 now known as *The Black Bow*, each given a full page in *Minotaure*, had been reproduced before: see César M. de Hauke, *Seurat et son oeuvre*, vol. 1, Paris: Gründ, 1961, 98, 106.

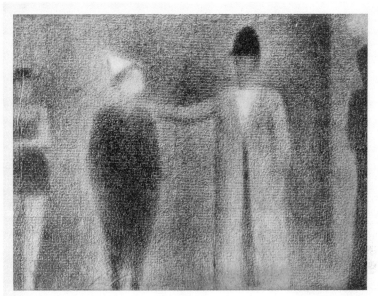

Les photographies des dessins inédits de Seurat reproduits ici, nous ont été obligeamment communiqués par M. César de Hauke et M. Félix Fénéon. Nous les en remercions chaleureusement.

(*N. d. l. R.*).

Dessins inédits de Seurat

L a nuit ardente n'a inscrit sur ce grand front pudique aucune trace directe, de cauchemars fantastiques. Les dessins de Seurat évoquent davantage les mystères de l'aube et du crépuscule. À l'heure de l'éveil, comment savoir ce que l'œil contient encore de la rosée du rêve et ce qu'il perçoit déjà de la ville? Dans l'étrange cité des gris, la lumière insinue son progressif triomphe. Des morceaux d'espace rebelles à la traversée des rayons se font objets. Un monde dépouillé de détails supporte l'étonnement du poète. Êtres et choses, oublieux de leur laborieuse fabrication, surgissent sans passé de la communion nocturne. Les fantômes cristallisent leur fluidité. Vont-ils dissiper aussi vite leurs corps tissés dans la lumière?

Débarrassé des accidents singuliers, des éclats, des ombres trop précises, l'univers est rendu à son unité. Intervalles ou « valeurs », contrastes voisins chantent la symphonie cosmique des ondes sensibles. L'identité de la lumière et de la conscience supprime les frontières entre l'homme et les choses. Du blanc au noir, par le jeu du papier et de la « mine » un seul frémissement, un seul témoignage.

Mais lorsque le jour a vaincu, les hommes effacent avec assurance leur certitude primitive, ils s'obligent à recréer pièce à pièce un monde à leur volonté.

Surmontant les notes fugitives, instants brefs de la sensibilité infaillible, Seurat se fait peintre conscient. Il défie la nature qui l'a ému.

Par intelligence, par la science, il possède la clef de l'univers en l'équation de la lumière. Les pigments, exactement juxtaposés, recomposeront sur la toile l'architecture des ondes mouvantes. Dans l'émerveillement de l'œuvre permanente, la conscience croit à sa victoire.

En ce voyage que chaque humanité répète, heureux l'acte lucide où se retrouve l'émotion de l'éveil.

C'est elle qui au delà des problèmes résolus donne aux dessins de Seurat leur sens fondamental.

3

Figure 4.7 From 'Dessins inédits de Seurat', *Minotaure*, no. 11, May 1938. Image courtesy the Book Library, Courtauld Institute of Art, London.

importance to the Surrealists.[15] It can even be interpreted as a public act of appropriation given that *Minotaure* had been the main site of Surrealist theory since 1933. Breton

[15] Although the de Hauke catalogue raisonné would only arrive in 1961, its research is mentioned as already underway in April 1935 by Daniel Catton Rich, *Seurat and the Evolution of La Grande Jatte*, Chicago: The University of Chicago Press, 1935, vii. Even though it appeared well after his death in 1944, Fénéon was the true author of that publication according to John Rewald, 'Félix Fénéon (2)', *Gazette des Beaux-Arts*, vol. 33, 1948, 107–26, 124.

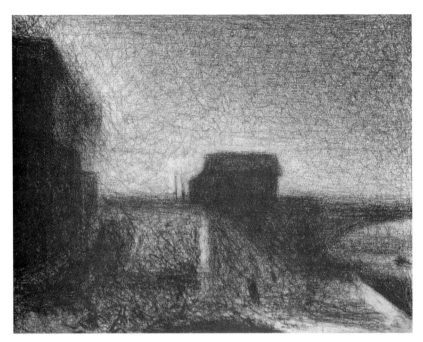

Figure 4.8 Georges Seurat, *The Bridge of Courbevoie* (1886). Conté crayon on chamois paper, 23.2 × 30 cm. Berggruen collection. © akg-images/André Held.

probably approached Fénéon and requested the drawings, though it is possible that the job fell to one of the others on the Surrealist-slanted editorial board of the review, consisting by then of Breton, Marcel Duchamp, Paul Éluard, Maurice Heine and Pierre Mabille.

A glimpse at the drawings is enough to typecast broadly their Surrealist properties as those must have been inferred by the group at *Minotaure*. By then, Surrealism had behind it nearly twenty years of technical innovation, creative contribution and critical debate on drawing, painting, photography, sculpture and film. Comparison with some of this art and writing is instructive in helping us understand the attraction that Seurat's drawings held for the group. The tangled, casually drawn filler lines of *The Bridge of Courbevoie* (figure 4.8, 1886) are close enough to the results gained from the method of automatic drawing (figure 4.9), which rose to a position of primacy in the movement in the early 1920s, to bear comment. While the open, braided linearity of those drawings made by their pioneer André Masson is quite distinct from the carefully wrought, smudged tonality of the drawings of Seurat, except in certain passages of finer loop and curl, Masson himself wrote of his admiration for the studies of everyday life of Seurat and his preference for them over the 'fantastic art' of Gustave Moreau and Odilon Redon that is more closely associated with Symbolism.[16] Equally, Seurat's exploitation of the

[16] André Masson, 'A Crisis of the Imaginary' [1944], *Horizon*, vol. 12, no. 67, July 1945, 42–4, 42. Masson claimed in this text that Surrealist painters in general held Seurat in higher regard than Moreau and

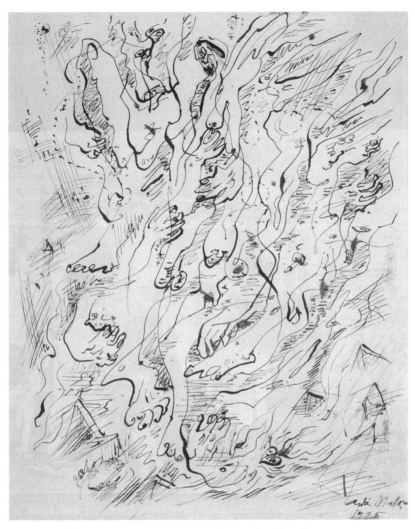

Figure 4.9 André Masson, *Automatic Drawing* (1925–6). India ink on paper, 30.4 × 24.1 cm. Centre de création industrielle, Musée national d'art moderne, Centre Georges Pompidou, Paris. Photo © Centre Pompidou, MNAM-CCI, Dist. RMN-Grand Palais/Philippe Migeat. © ADAGP, Paris and DACS, London 2018.

raised surface of the Michallet paper, caused by the low three dimensional crosshatching of laid lines and chain lines, which became 'an integral part of the composition' of certain

Redon (an opinion his editor regarded as one based on Breton's writings from *Surrealism and Painting* up to 1944), stating elsewhere that he had admired Seurat since viewing a drawing by the artist in 1914: André Masson, 'Une crise de l'imaginaire' [1944], *Le rebelle du surréalisme: écrits*, ed. Françoise Will-Levaillant, Paris: Hermann, 1976, 23–6, 24; 52–3 n. 57; 182–3 n. 42.

drawings according to Karl Buchberg, recalls Max Ernst's Surrealist technique of frottage.[17] There, similarly, nascent patterns are sought by rubbing a soft pencil against paper laid over a surface containing shallow furrows and minute gradients.[18]

Quite aside from their 'accidental' iconography of stilted, arrested mannequin-like figures, equally present in the paintings, as I showed (and comparable to the rigid human forms fashioned by artists close to Surrealism from Paul Delvaux to Balthus), the imagery of Seurat's drawings, which is the direct outcome of his chosen media, is frequently close to that of Surrealist artists. Through that association, the figure drawing of a lone woman turned in a three-quarter rear view now known as *The Black Bow* (figure 4.10, 1882–3), which might very well have been meant as an innocent figure study and was viewed merely as an experiment in 'irradiation' under Herbert's self-confessed modernist formalism, morphs under the Surrealist gaze following its reproduction in *Minotaure* into a scene of private ritual or of punishment, due to the darkening of the area of the right side of the sheet she faces with head bowed into a conté crayoned wall or shadowy recess.[19] This meets a comparable iconography throughout Surrealism in the art of Giorgio de Chirico, Masson and Man Ray, available for view in earlier numbers of *Minotaure* (figures 4.11 and 4.12). Furthermore, the isolated figures in village and city that are frequently met in Seurat's drawings have a descendant in de Chirico's townscapes, as has been indicated elsewhere.[20] Finally, the apparent melancholy, boredom or alienation of individuals next to rivers and canals, in suburbs, parks and other public spaces, was a feature of Seurat's *oeuvre* that the Surrealists saw echoed in their own art and writings.[21]

Beyond the specifics of both Symbolist and urban, modernist subject matter that laid the ground for their Surrealist reception and interpretation is the obvious 'lack of precision', as Richard Thomson puts it, of drawings such as *The Armchair* (*c.* 1882–3) and the one now known as *The Haunted House* (1882–3).[22] Works such as these exemplify Bernd Growe's contradiction of Seurat's famous insistence on the uncomplicated application of his method, which I questioned myself on behalf of

[17] Buchberg, 'Seurat: Materials and Techniques', Hauptman (ed.), *Georges Seurat: The Drawings*, 38 (see the discussion on this page of Seurat's exploitation of chain and laid lines, and the 'conspicuous flaws in the sheet' in *Square House* of *c.* 1882–4). Also see Leighton and Thomson, *Seurat and the Bathers*, 18.

[18] One art historian even uses the word 'frottages' to press the case, so to speak, for the sheet as pictorial determinant: Yve-Alain Bois, '"Georges Seurat: The Drawings," Museum of Modern Art, New York' (exhibition review), *Artforum*, vol. 46, no. 8, April 2008, 359–60, 360.

[19] Irradiation is 'the concept … that light and dark tones mutually exalt each other as they come together', Herbert, *Seurat's Drawings*, 56; also see Callen, 'Hors-d'oeuvre', Smith (ed.), *Seurat Re-Viewed*, 33. Seurat's 'instinct to ritualize' is observed by Thomson, 'The Imperatives of Style' in Hauptman (ed.), *Georges Seurat: The Drawings*, 183; and again in the drawings: Thomson in *Seurat's Circus Sideshow*, 80, 81. Elsewhere, *Parade de Cirque* has been said to describe 'une mystèrieuse cérémonie d'initiation', Cachin, *Seurat*, 96; and as 'exuding a powerful sense of ritual', Thomson in *Seurat's Circus Sideshow*, 68.

[20] Bois, '"Georges Seurat: The Drawings,"' 359–60.

[21] Pierre, *L'Univers surréaliste*, 58.

[22] Thomson, *Seurat*, 64.

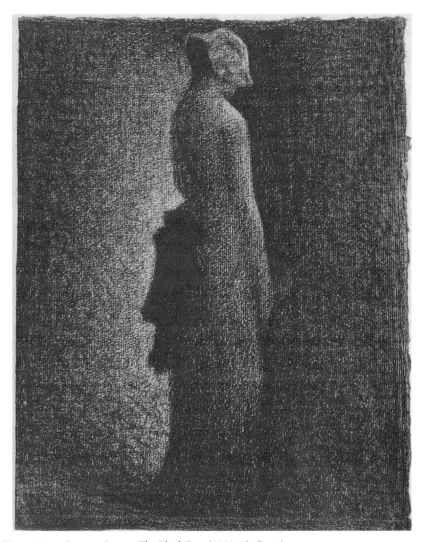

Figure 4.10 Georges Seurat, *The Black Bow* (1882–3). Conté crayon on paper, 31.5 × 24.5 cm. Musée du Louvre, Département des Arts Graphiques, Fonds du Musée d'Orsay, Paris. © Photo Josse/Scala, Florence.

Surrealism in my previous chapter, contending: '[h]is drawings are anything but the result of mere application of a method to a given reality; they call that reality fundamentally into question.'[23] On top of their iconographic prescience – *The Haunted*

[23] Bernd Growe, 'The Pathos of Anonymity: Seurat and the Art of Drawing', Franz and Growe, *Georges Seurat*, 13–50, 37.

Figure 4.11 Giorgio de Chirico, *The Enigma of the Oracle* (1910). Oil on canvas, 42 × 61 cm. Private collection. © Cameraphoto/Scala, Florence. © DACS 2018.

House as a sort of fortuitous study for René Magritte's *Empire of Light* (1953–4) – they carry an immense readerly ambivalence. This was noted by Thomson who views the murky and powerfully Symbolist sheet *The Lamp* (figure 4.13, 1882–3), once owned by Fénéon, as evidence of Seurat's 'imaginative capacity that could make magic from a mundane interior'.[24] What could be more surreal?[25]

[24] Thomson, *Seurat*, 73. For his part, Herbert touched on the charge of 'occult feeling' carried by the subject matter of *The Lamp*, especially in comparison with the work of Odilon Redon, just as he submitted that Seurat 'lets us feel the orchestra pit as the site of an occult ritual' in *The Bandleader* (1887–8), but then in both cases he moved on without further comment: Herbert, *Seurat's Drawings*, 63, 150. For one writer, *The Haunted House* has a 'stylization [that] lends the quality of the fantastic', Germain Seligman, *The Drawings of Georges Seurat*, New York: Curt Valentin, 1947, 23. In the early years of Surrealism's iconography, though without mention of it, one critic saw in Seurat's drawings evidence of what we might consider a comparable 'vie fantastique' once the drawings were separated from the paintings, comprising 'personnages fins, pincés aux hanches et coiffés comme pour un bal nocturne d'insectes au clair de lune; petit modèle qui garde encore dans la lumière de l'atelier l'étonnement d'être dévêtue subitement, qui n'est pas encore une *Poseuse* mais une jeune fille nue', Florent Fels, 'Les dessins de Seurat', *L'Amour de l'art*, vol. 8, 1927, 43–6, 46.

[25] I noted Hans Bellmer's interest in Seurat in the 1920s in my previous chapter, but in the Surrealists' game of the 1950s 'Ouvrez-vous?' the artist got a mixed response at the door, even from the movement's painters Adrien Dax ('Non'), Simon Hantaï and Wolfgang Paalen (both 'Oui'), The Surrealist Group, 'Ouvrez-vous?' *Médium: Communication surréaliste*, no. 1, November 1953, 1 and 11–13, 13. There is reference to Seurat, in passing only, ironizing further the irony of the *Grande Jatte*, in the plate titled 'The Grande Jatte hibernators' in the third chapter of Max Ernst, *The Hundred Headless Woman* [1929], trans. Dorothea Tanning, New York: George Braziller, 1981, 115.

Figure 4.12 Man Ray, untitled photograph, *c.* 1930. Collection Man Ray Trust. © Man Ray Trust/ ADAGP-DACS/Telimage 2018.

Bridging this gap between the technical aspects of Surrealist picture making and the subject matter of that visual culture, we can approach the drawings with a terminology drawn from poetic method and effect, which demonstrates vividly why they suited the Surrealist sensibility. The power of metaphorical suggestion carried by their linkage of media and content is truly astounding, quite apart from the happy visual congruity between their peppery surfaces and the mottled ones of the divisionist canvas, which

Figure 4.13 Georges Seurat, *The Lamp* (1882–3). Conté crayon on paper, 30.5 × 24 cm. Henry Moore Family Collection. Photo by courtesy of the Kröller-Müller Museum, Otterlo, the Netherlands.

was willingly engineered by Seurat.[26] There is their unsurpassable 'realism' created by the barely grazed surface of paper that evokes the granular appearance of darkness as

[26] See the technical report highlighting the ground preparation of the paintings sometimes 'textured in a manner that helped create the appearance of the chain and laid lines of the hand-made paper', McGlinchey and Buchberg, 'The Examination of Drawings by Georges Seurat Using Fourier Transform Infrared Spectroscopy (Micro-FTIR)', 118.

the eyes adjust to night vision; the perfect analogy between the coarse paper and the texture of fabric and clothing (enshrined in the French terms for the paper: *à grain* or *torchon* [dishcloth]), taken by Seurat towards a high level of self-consciousness in *Embroidery (The Artist's Mother)* (figure 4.14, 1882–3) that is close to the painted dots and powder joke of *Young Woman Powdering Herself* (1889–90);[27] the implied buzz and

Figure 4.14 Georges Seurat, *Embroidery (The Artist's Mother)* (1882–3). Conté crayon on paper, 32 × 24 cm. The Metropolitan Museum of Art, New York. www.metmuseum.org

[27] See the discussion of analogy in Seurat's use of paper and depiction of fabric in Foa, *Georges Seurat*, 163, 165.

hum of insect-packed summer gardens; the implications of mist and fog or the dazzling, blinding sunshine or heat haze in especially gauzy sheets such as the diaphanous *Three Young Women (study for La Grande Jatte)* (1884); the fuzziness of individuals as espied from afar through a telescope when subject to atmospheric perspective; 'the oft-cited twilight atmosphere of the bourgeois interior', as that effect was described by a historian of street lighting;[28] and the sensual heat, steam and smell of a hot day or warm evening, where pollen and dust are captured on the fizzy, flecked, vibrant, noisy surfaces of Seurat's overwhelmingly tactile paper stock (figure 4.15).

All the above is either implied or inferred; it is at least available, and to a group of individuals like the Surrealists given to a poetics of seeing, such a means of understanding the drawings would have been unavoidable, whether Seurat sought to be poetically allusive or not. It entails the transformation of Seurat into, or his confirmation as, a Symbolist, depending on how one looks at it. He certainly was one for critics and writers such as Paul Adam, Jean Ajalbert, Jules Christophe, Henri de Régnier and especially Gustave Kahn. There is no direct commentary in Surrealism on Symbolist thought as a context for Seurat. However, both the language of his drawings as I have begun to free them by visual analogy from their author's intention into a more 'readerly' space, and 'nature' in his paintings as it was observed in my previous chapter by Hélion, escaping from the artist as he relentlessly applied his method – stylized 'beyond all resemblance, even to caricature, without consideration for taste, prettiness, normality'[29] – meet Breton's demand in the critical essay he wrote on Symbolist poetry for *Minotaure* in 1936, that the value of Symbolism like all the work that followed it in the twentieth century, came about not from a conscious intention by the author to create *mystery*, but from the mind's preparedness to be mystified: 'to abandon itself purely and simply to the *marvellous*.'[30]

28 Wolfgang Schivelbusch, *Disenchanted Night: The Industrialization of Light in the Nineteenth Century* [1983], trans. Angela Davies, Berkeley, Los Angeles, London: University of California Press, 1995, 184.

29 Jean Hélion, 'Seurat as a Predecessor', *The Burlington Magazine for Connoisseurs*, vol. 69, no. 44, July 1936, 4 and 8–11 and 13–14, 10.

30 André Breton, 'Marvellous versus Mystery' [1936], *Free Rein* [1953], trans Michel Parmentier and Jacqueline d'Amboise, Lincoln and London: University of Nebraska Press, 1995, 1–6, 6; André Breton, 'Le Merveilleux contre le Mystère: A propos du symbolisme', *Minotaure*, no. 9, October 1936, 25–31. Although it would have made the procedure attempted in my chapters on the artist more straightforward, Seurat cannot simply be aligned with Surrealism through Symbolism, even though the extensive overlap between the styles and substance of Neo-impressionism and Symbolism has been recently restated by Cornelia Homburg (ed.), *Neo-Impressionism and the Dream of Realities*, New Haven and London: Yale University Press, 2014. This is partly because of the indifference shown towards him by writers such as Émile Hennequin, J. K. Huysmans and Teodor de Wyzewa, and the general inclination of the Symbolists for Pierre Puvis de Chavannes, Moreau and Redon, and partly because Surrealism had mixed feelings about that movement anyway. Earlier in the 1930s, for instance, Breton had reckoned 'Naturalist writers … on the whole, much more poetic than Symbolists', expressing his admiration for the Naturalist writer and journalist Robert Caze whose circle Seurat frequented: André Breton, *Communicating Vessels* [1932], trans Mary Ann Caws and Geoffrey T. Harris, Lincoln and London: University of Nebraska Press, 1990, 79, 80 (rendering of translation slightly modified). For the major study of three of the artists I treat in this book in the context of Symbolism, see Lövgren, *Genesis of Modernism*; and see the comments on Seurat and Caze, Seurat and the Symbolist aesthetic, as well as speculations on the Symbolist audience for the marine paintings in Thomson, *Seurat*, 94, 130–2, 177–81. In later years, Kahn put his and his

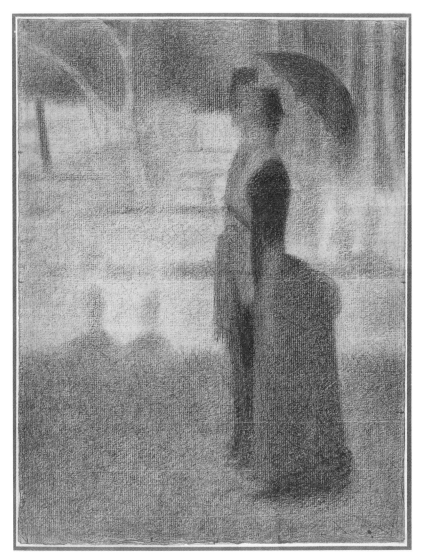

Figure 4.15 Georges Seurat, *The Couple*. Conté crayon on paper, 31.2 × 23.6 cm. British Museum. © Trustees of the British Museum, London.

Symbolist friends' admiration for the paintings of Seurat and Paul Signac at least partly down to their youthful naïvete: Gustave Kahn, 'Georges Seurat, 1859–1891' [1928], *The Drawings of Georges Seurat*, New York: Dover, 1971, v-xiii, viii; for the Surrealists, 'l'auteur de *La Parade* [*sic*] et du *Chahut* n'ait été symboliste que par inadvertance', Pierre, *L'Univers surréaliste*, 58. For more on Symbolism as a context for Seurat, see New York: Metropolitan Museum of Art, *Georges Seurat: 1859–1891*, 1991, 233–5; Paul Smith, *Seurat and the Avant-Garde*, New Haven and London: Yale University Press, 1997, 75–8, 81–3; and Hobbs in Smith (ed.), *Seurat Re-Viewed*, 223–4.

Testament to the acknowledgement of the capacity of Seurat's drawings to achieve the Surrealist marvellous came years later in the prominent inclusion of two of them in the small March–April 1958 exhibition *Dessins Symbolistes* at Mira Jacob's Bateau-Lavoir gallery for which Breton, who was by then immersed in late nineteenth-century art due largely to his friendship with the art critic Charles Estienne (see my later chapters on Gauguin in this book), wrote the 'Préface-Manifeste' that appeared in the booklet accompanying the show.[31] One of the drawings on display was an early, sketchy study owned by Breton who had bought it from Fénéon. The other was a superb drawing in the mature style that belonged to the dealer and collector Vitale Bloch (it is now in the Kröller-Müller Museum in The Netherlands) and was reproduced at the back of that slim publication (figure 4.16).[32] This is a simple and graceful yet metaphorically profuse work, now titled (too prescriptively for the Surrealist taste) *Young Woman (study for La Grande Jatte)* (1884–5). Thanks partly to the well-known painting that the drawing helped prepare, we just about recognize a delicately, translucently shaded female seated on the ground with head tipped slightly away and features characteristically concealed in penumbra. Yet the sheer reduction of detail attracts proliferative interpretation, especially once linked to the Surrealist iconography of mannequins, ghosts, spirits and disembodied shadows. As smoothly rounded as a sculpture by Hans Arp (figure 4.17), it also resembles a pool of spilt ink, which adds a subtext to its already Rorschachian interpretive properties. However, the typically matte texture of the drawing intercedes unavoidably between the eye and the sheet to insist upon its own tactility and our touch and through them those of the artist himself; more so because of the resemblance of the 'head' and 'body' to a thumb and palm print, as though Seurat was proudly marking the absolute uniqueness of his style with his own imprimatur.

It should be said that none of this crops up in the brief poetic statement by Mabille that accompanied the appearance of Seurat's drawings in *Minotaure*, written by him perhaps because Breton was away in Mexico at the time.[33] Yet the layering of analogy is the most significant feature of the text. Its brevity may have made the overall illustration-heavy feature quite similar in its form to the one that had appeared in *Documents*; it is, however, quite different in its intention. This is tilted by Mabille towards Surrealism by means of the analogies it finds between the world and mind thanks to the poetic power of evocation held by Seurat's drawings. According to him, they do not partake of the 'fantastic nightmares' of the blackest night that the Surrealists admired in the Gothic tradition.[34] Mabille viewed them, instead, as liminally set between day and night, white and black, in a 'strange city of greys', inducing, rather, 'the mysteries of

[31] André Breton, 'Préface-Manifeste', Paris: Le Bateau-Lavoir, *Dessins Symbolistes*, 1958, n.p.; reprinted as André Breton, 'Concerning Symbolism' [1958], *Surrealism and Painting* [1965], trans. Simon Watson Taylor, New York: Harper & Row, 1972, 357–62.
[32] By the early 1960s, Breton owned three minor sketches by Seurat, all of which had previously been in the Fénéon collection and were dated 1879–80: de Hauke, *Seurat et son oeuvre*, vol. 2, 35, 39.
[33] See the short note by Breton announcing his departure in *Minotaure*, no. 11, May 1938, 1.
[34] 'cauchemars fantastique', Mabille, 'Dessins inédits de Seurat', 3.

dawn and dusk'.³⁵ By this, he meant to refer to those familiar moments at the beginning and end of the day when sunlight is not strong enough to show the colours, details or even features that allow confident identification of individual objects because only their outlines remain. As it gets darker at dusk, depth of space is disallowed between one object and another, they merge and odd coalitions of forms can ensue.

As seen in my first chapter, 'the mysteries of dawn and dusk' had been entertained in the years preceding Mabille's text on Seurat's drawings by Salvador Dalí in his writings and paintings of the early 1930s in *Minotaure* that explored Jean-François Millet's incredibly popular image of rural labour, *The Angelus* (1857–9), usually interpreted as depicting the recital of that prayer at six in the evening. Dalí's Oedipal reading outlined earlier was partly motivated by the time of day registered in the *Angelus*. This is brought out in the title of a chapter of his book on the painting, which is repeated in one of his re-renderings of the canvas: *The Atavisms of Dusk* (or *Atavisms of Twilight*) (1933). It is confirmed in Dalí's psychoanalytic diagnosis, too, since the so-called 'crepuscular state', reflected in the French title *Les Atavismes du crépuscule*, had long been the term given by psychoanalysis to the moment in sleep most conducive to the remembering of a dream.

But, of course, the bedrock of such speculations by Surrealists like Mabille and Dalí about the peculiarly psychic properties of dusk lies in the in-between state that Breton demarcated as the mental origin of Surrealist activity in the *Manifesto of Surrealism* (1924). It is there that the unanticipated yet descriptively telling phrase appears: '"[t]here is a man cut in two by the window,"' 'heard' by Breton at a lower level of consciousness, '[o]ne evening … before I fell asleep'.³⁶ Positioned psychologically, conceptually and anecdotally in a half-world between conscious and unconscious, wakefulness and sleep, the visual and aural, day and night, Breton's phrase was a fitting locution to launch Surrealism on the back of its first experiments with automatic writing and it was never far from the minds of the Surrealists. Without citing it, Mabille argued for a similar transitional state in Seurat's drawings, which existed also between the subject and object and between consciousness and light:

At the moment of waking, how do we know what the eye still contains of the dew of the dream and what it already perceives of the city? … A world plucked of its details bears the astonishment of the poet. Beings and things, forgetting their laborious manufacture, appear suddenly without a past from their nocturnal communion. Ghosts crystallize their spectral fluidity. Are their spun bodies going to dissipate as quickly in the light?³⁷

³⁵ André Breton, 'Manifesto of Surrealism' [1924], *Manifestoes of Surrealism*, trans Richard Seaver and Helen R. Lane, Ann Arbor: University of Michigan Press, 1972, 1–47, 21.
³⁶ 'A l'heure de l'éveil, comment savoir ce que l'œil contient encore de la rosée du rêve et ce qu'il perçoit déjà de la ville? … Un monde dépouillé de détails supporte l'étonnement du poète. Êtres et choses, oublieux de leur laborieuse fabrication, surgissent sans passé de la communion nocturne. Les fantômes cristallisent leur fluidité. Vont-ils dissiper aussi vite leurs corps tissés dans la lumière?' Mabille, 'Dessins inédits de Seurat', 3.
³⁷ 'l'étrange cité des gris'; 'les mystères de l'aube et du crépuscule', Mabille, 'Dessins inédits de Seurat', 3.

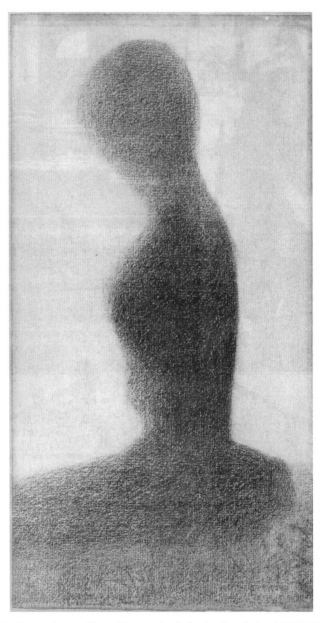

Figure 4.16 Georges Seurat, *Young Woman (study for La Grande Jatte)* (1884–5). Conté crayon on paper, 31.2 × 16.2 cm. Kröller-Müller Museum, Otterlo. © sticht kröller-müller museum.

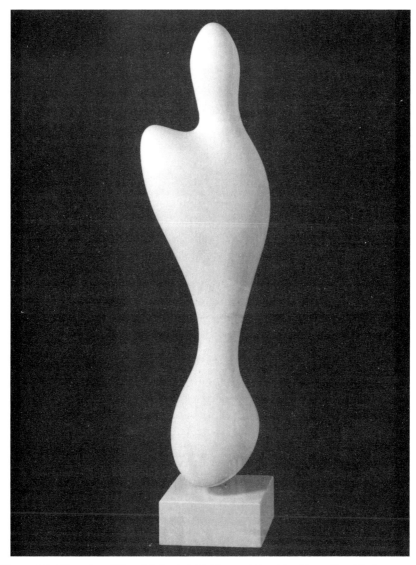

Figure 4.17 Hans Arp, *Winged Being* (1961). Plaster, 140 × 35 × 30 cm. Tate Modern, London. Image courtesy the Conway Library, Courtauld Institute of Art, London © Tate, London 2018. © DACS 2018.

The psychological and pictorial state described by Mabille with reference to Seurat's drawings, in which the 'identity of light and consciousness suppresses the frontiers between man and things', also comes towards the end of a long period in which Surrealism had reflected on the relational nature of the fabricated and found object.[38] Obviously, it dovetails, too, with my earlier discussion in this chapter and my previous one about the stiff and artificial looking figures in Seurat's drawings. Those characteristics are emphasized by the inclusion on the same page as Mabille's brief text of Seurat's almost (again) ritualistic, static-filled drawing of a scene from the circus or theatre, probably, now titled *Two Clowns* (1886–8), even though it could almost be a rendering of faceless dummies in a shop window display.

This drawing and others evoking the 'nocturnal communion' identified by Mabille could also be interpreted in line with the evening encounters of the Surrealists themselves; not with their dreams and certainly not at church, but with each other at the café in the spiritual exchanges that took place at the regular group meetings at cocktail hour, six o'clock, which would indeed be dusk in Paris at year's end. In this sense, Seurat's drawings reawaken the *noctambulisme* of the Second Empire, which had been captured most evocatively by Julien Lemer in *Paris au gaz* (1861) and Alfred Delvau in the latter part of *Les Heures parisiennes* (1866) as 'l'heure du gaz' from autumn through most of spring.[39] Both books were read by Walter Benjamin who was considering the period, concurrently with the Surrealists in the 1930s but unknown to them, as the final curtain of the *flâneur*, who would become as superfluous as the arcades without gas lighting.[40]

Mabille's language confirms the relevance of the speculative comparisons between Seurat's drawings and Surrealist visuality and poetics that I made earlier. It also suggests others that are specific to *Minotaure* and even more particularly to do with the photographic culture of Surrealism, as played out in that periodical and elsewhere. It entails their resemblance with certain forms of scientific photography, 'mediumistic' activity and Surrealist experiment with light sensitive paper. The blurred lines of X-ray images are suggested, as is the ghostly fuzziness of 'thoughtography' or 'projected thermography', along with some of the alleged psychic projective photography of the dead that was as current in the 1930s as it had been in the 1880s, and of which Seurat himself must have been aware as he drew what Erich Franz called the 'disembodied, feather-light, prim apparition of the *Child in White*' (figure 4.18).[41] The transparency, tonal variation and hard black ground of photograms also come to mind, as in the 'rayographs' made by Man Ray since the early 1920s, a few of which were shown in the

38 'L'identité de la lumière et de la conscience supprime les frontières entre l'homme et les choses', Mabille, 'Dessins inédits de Seurat', 2. See especially André Breton, 'Surrealist Situation of the Object: Situation of the Surrealist Object' [1935], *Manifestoes*, 255–78.

39 Julien Lemer, *Paris au gaz*, Paris: E. Dentu, 1861, 3; Alfred Delvau, *Les Heures parisiennes*, Paris: Librairie centrale, 1866.

40 Walter Benjamin, *Charles Baudelaire: A Lyric Poet in the Era of High Capitalism* [1935–9], trans. Harry Zohn, London: Verso, 1992, 50–1.

41 Erich Franz, 'Withdrawn Proximity: The Development of Georges Seurat's Drawings', Franz and Growe, *Georges Seurat*, 51–91, 82.

Figure 4.18 Georges Seurat, *Child in White (study for La Grande Jatte)* (1884). Conté crayon on paper, 30.5 × 23.5 cm. Solomon R. Guggenheim Museum, New York. Solomon R. Guggenheim Founding Collection, Gift, Solomon R. Guggenheim. © Solomon R. Guggenheim Museum, New York.

tenth issue of *Minotaure* in winter 1937, only months before Seurat's drawings appeared in the review (figure 4.19). All of these were so many means of seeing, envisioning or imagining beyond narrow opticality, and they rescued Seurat's work from the clutches of what we saw Duchamp refer to in my last chapter as 'retinal art'. Such comparators were also the means by which the drawings fitted into *Minotaure*, rhyming both formally and conceptually with its typical content as we can now explore further with reference to the photography of Brassaï.

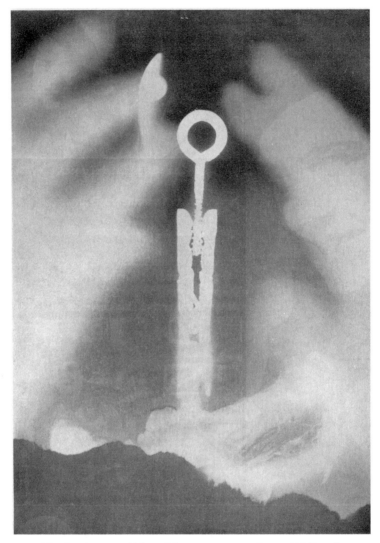

Figure 4.19 Man Ray, 'rayograph' from *Minotaure*, no. 10, winter 1937. Lost. Image courtesy the Book Library, Courtauld Institute of Art, London.

Night according to Seurat and Brassaï

Brassaï began walking Paris by night on his arrival in the city in 1924, the year of the publication of Breton's *Manifesto*. He only began taking photographs of it late in 1929, in the years immediately after the Surrealists had advertised the nighttime walk as part of the lifestyle of modernity in Louis Aragon's *Paris Peasant* (1926), Philippe Soupault's *Last Nights of Paris* (1928) and Breton's *Nadja* (1928), at the time Seurat's drawings

were reproduced in *Documents*.[42] He never joined the Surrealist group even though he was asked to in the early 1930s and he did not really understand the Surrealists' attitude towards the world. That much can be judged from his expression of disappointment late in life at the discrimination they observed towards canonical painters like Paul Cézanne, Georges Braque and Henri Matisse, for which he was taken to task by sympathizers towards the movement.[43]

More interested in literature than photography and preferring comparison of his work with that of artists rather than photographers, Brassaï was drawn to the Parisian culture of the past rather than the present, especially that of the nineteenth century. He pointed to Restif de la Bretonne's *Paris Nights* (1788–94), Gérard de Nerval's *October Nights* (1852) and Charles Baudelaire's *Paris Spleen* (1869), and we may recall here Baudelaire's meditation on the arrival of twilight: the 'interior holy day', as he put it, 'the sparkling of stars and bursting forth of street lamps' – driving some people crazy but poets to their greatest work – to confirm the appeal for the Surrealists of both that hour of day and Seurat's apparently pre-Haussmanian depiction of it.[44] Brassaï also admired the novels of Honoré de Balzac and Marcel Proust as further antecedents and guides to his early specialism, nocturnal photography.[45] He saw himself as an updated Constantin Guys, as Baudelaire had presented that artist in 'The Painter of Modern Life' in the mid-nineteenth century,[46] even though the set-up and exposure time of his medium often

[42] Marja Warehime, *Brassaï: Images of Culture and the Surrealist Observer*, Baton Rouge LA and London: Louisiana State University Press, 1996, 14.

[43] 'Aussi de grands peintres comme Cézanne, Courbet, Manet. Corot, Braque, Bonnard, Matisse, ne les intéressaient guère. Même en Picasso, [les surréalistes] n'aimaient que le côté parfois surréaliste et critiquaient sévèrement "son farouche attachment à la réalité,"' Brassaï, 'Rencontre avec Brassaï', *Culture et communication*, no. 27, May 1980, 8–15, 14 (Brassaï was referring to the reservation about Picasso's 'indefectible attachment to the external world', Breton, 'Pablo Picasso: 80 carats ... with a Single Flaw' [1961], *Surrealism and Painting*, 116–18, 117 [translation modified]). Here is one polemical and rather lop-sided response to Brassaï's remark from a supporter of the movement that fails to see that Cézanne was important to abstract art *because* he was crucial to Cubism: 'On the one hand, it is obvious that far from being opposed to reality, Surrealism instead bets on the wide scope of this reality and consequently scorns the fragmentary or constrained aspects of reality to which Cézanne clung uselessly, with a vision that was narrow compared to contemporaries such as Gauguin, Munch or Seurat. On the other was the assumption that Cézanne was a great painter simply because his work played a decisive part in the evolution of modern art. Although it may certainly have seemed necessary to the early Cubists, this was not the case for de Chirico, Kandinsky or Mondrian', Édouard Jaguer, 'Brassaï and the Eyes of the Wall', Barcelona: Fundació Antoni Tàpies, *Brassaï*, 1993, 39–44, 44 n. 3.

[44] Charles Baudelaire, 'Evening Twilight', *Paris Spleen and La Fanfarlo* [1869 and 1847], trans. Raymond N. MacKenzie, Indianapolis IN and Cambridge: Hackett Publishing Company, Inc., 2008, 44–5, 45 (translation modified). For further, earlier reflections relevant to Seurat and the Surrealists, particularly Mabille, see Charles Baudelaire, 'Evening Twilight' and especially 'Morning Twilight', *The Flowers of Evil* [1859], trans. Keith Waldrop, Middletown CT: Wesleyan University Press, 2006, 125, 135. Particularly close to Brassaï's envisionment of unseen Paris are the passages on Les Halles in the early hours by Gérard de Nerval, 'October Nights' [1852], *Selected Writings*, trans. Richard Sieburth, London: Penguin, 1999, 204–44, 220–7.

[45] Brassaï, 'Rencontre avec Brassaï', 10; Sylvie Aubenas, 'Brassaï and Paris by Night', Sylvie Aubenas and Quentin Bajac, *Brassaï: Paris Nocturne* [2012], trans. Ruth Sharman, London: Thames & Hudson, 2013, 95–123, 103.

[46] Aubenas and Bajac, *Brassaï: Paris Nocturne*, 196.

made for a far more protracted process than the sketch-and-go routine of Guys.[47] Paradoxically, however, the slur in the image of the city caused by the long shutter speed of Brassaï and the haste of Guys' first-and-last-draft modus operandi sometimes led to a comparable envisioning of movement and change. Sharing with Guys an attraction to the humdrum and fringe urban subject matter befitting modernity, Brassaï transformed it into something beguiling through his compelling compositional acuity and gift for seeking out the strange in the commonplace, cloaked in alluring shades of chiaroscuro.

Published in 1932 and containing sixty-four photographs (including endpapers), Brassaï's first superb collection *Paris de nuit* made his name and brought him to the attention of the Surrealists. That volume introduced a wide audience to a world that was at once familiar and unfamiliar, in the sense that Brassaï granted access to a typical spectacle at the very same moment of finding and fixing the fissures in its spectacularity. In this little book, then, we are allowed to witness showgirls observed from above the stage or relaxing, not from the stalls or in performance; jaded not thrilled (female) spectators of the can-can (figure 4.20), so unlike the attentive, lecherous spectator of Seurat's *Chahut* (1889–90); rarely visited corners of the city seen by night; individuals out for the evening caught waiting rather than behaving; empty sentry posts; public statues after the tourists have left; preparation of Les Halles vegetable market before the shoppers arrive; a pause in the entertainment at the Cirque Medrano (figure 4.21), the old haunt of Impressionists such as Degas and Renoir (when it was called the Cirque Fernando) then Henri de Toulouse-Lautrec and Seurat, and later Picasso (who took Brassaï along with him); workmen 'invisibly' mending Paris's infrastructure; prostitutes, heavily posed in side streets; the homeless huddled under bridges by firelight; wet, empty streets.[48] Capturing overlooked scenes of the city and the unspoken, unmemorable gaps that lie between the moments in the lives of its inhabitants, Brassaï's liminal photography in *Paris de nuit* captures similar 'interim states' to those perceived by T. J. Clark in Degas's art, showing Paris and its people as unready-to-be-seen, as though waiting for the time when they will be ready to be seen.[49]

Some of its subject matter touches quite specifically on Seurat's – a few of the locations and some of the nighttime thrills, for instance, people at work, *chiffoniers* and lone figures often turned away from the viewer. However, the main imagery of *Paris de nuit*, specifically its delineation of everyday pleasure and commerce in an unmistakably contemporary, mainly electrically- and increasingly neon-lit Paris, is quite dissimilar to the anywhere and anywhen of Seurat's drawings. Indeed, where the Hungarian Brassaï frequently pointed his camera at the major tourist sights, the Parisian Seurat never

[47] Charles Baudelaire, 'The Painter of Modern Life' [1859–63], *The Painter of Modern Life and Other Essays* [1964], ed. and trans. Jonathan Mayne, London: Phaidon, 1995, 1–41.

[48] See the account of their visit to the Medrano and its outcome in Brassaï, *Conversations with Picasso* [1964], trans. Jane Marie Todd, Chicago and London: The University of Chicago Press, 1999, 18–20; and Brassaï, 'Rencontre avec Brassaï', 10.

[49] 'The painter has chosen a moment in between illusions, so to speak, in which the audience lets off steam and the corps de ballet stands at ease', T. J. Clark, *The Painting of Modern Life: Paris in the Art of Manet and His Followers*, Princeton NJ: Princeton University Press, 1984, 224.

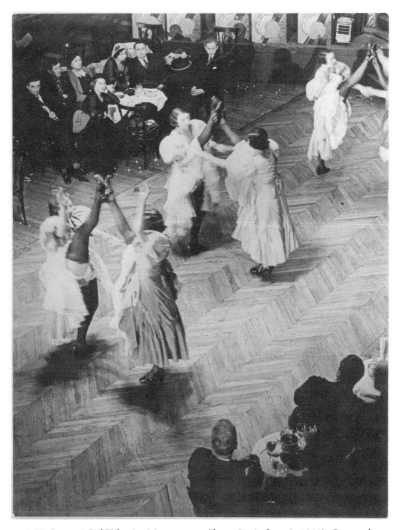

Figure 4.20 Brassaï, Bal Tabarin, Montmartre (from *Paris de nuit*, 1932). Centre de création industrielle, Musée national d'art moderne, Centre Georges Pompidou, Paris. Photo © Centre Pompidou, MNAM-CCI, Dist. RMN-Grand Palais/Image Centre Pompidou, MNAM-CCI. © Estate Brassaï – RMN-Grand Palais.

depicted those monuments of his city, and even the wrecking ball of Haussmannization seems to lie, for him, still in the future. This could well have been the outcome of dissimilar ideological positions taken on the nature of modernism that determined (because they were buried in) the respective media of the two. Brassaï's photography captures the ephemeral detail of urban Paris whereas Seurat's crayon blurs it in the

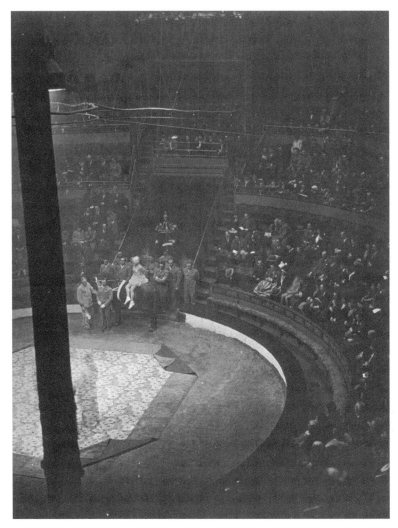

Figure 4.21 Brassaï, the Cirque Medrano (from *Paris de nuit*, 1932). Centre de création industrielle, Musée national d'art moderne, Centre Georges Pompidou, Paris. Photo © Centre Pompidou, MNAM-CCI, Dist. RMN-Grand Palais/Image Centre Pompidou, MNAM-CCI. © Estate Brassaï – RMN-Grand Palais.

service of the eternal in humanity (appropriately mummified to that end in some instances), to the extent that it is often uncertain whether we are still looking at the urban parts of the city at all in many drawings.[50] Brassaï's modernity is the amnesiac

[50] For a similar argument – that to 'reconcile the fleetingness of appearances with the lastingness of ideas had been one of the goals of the modern movement ever since Baudelaire', and that this was achieved in Seurat's drawings – see Growe in Franz and Growe, *Georges Seurat*, 41.

one of post-Haussmann Paris portrayed a generation or two after the fuss about the rebuilding had died down. Seurat's is the one of the *banlieue*, typically 'poetic' terrain for modern painters in the 1880s: that under-populated, working landscape that began just ahead of where Haussmann's city ended – 'the curious ground between town and country' as Clark put it – its literary melancholy rediscovered by means of Seurat's aesthetic of grayscale indistinctness.[51]

But there is more to say about media because it is when we turn to the *formal* qualities of Brassaï's photography that we begin to see some correspondence with Seurat's drawings and – ironically – in this way come closer to the appeal that the latter took on for the Surrealists in the era of *Minotaure*. The original 1932 edition of *Paris de nuit* is surprisingly small, thin and flimsy in its simple black spiral binding. Designed initially more like a school exercise pad than a posh and self-important photographer's volume, its subsequent reprints have appeared as conventionally bound books in larger format. This change has come about because, although the size of the photographs that make up the first edition has been retained, the reprints reinstated the margins that Brassaï had done without.

Although there is detail of shop signage, cars, cobbles, clothing, architecture and so on in *Paris de nuit*, two factors serve to lightly smudge or smear the crisp edges, corners and surfaces of the otherwise garishly lit, electrified city, quite apart from atmospheric conditions such as the fog and rain that Brassaï revelled in reproducing. One of these is his camera technology, which meant that exposure time at night without a flash could be as long as ten minutes leading to blur.[52] This form of realism was perfect for the representation of time passing, speed, dancers in motion, weary or imperfect night vision, early hours tiredness, after hours wooziness or drug induced bleariness (figure 4.22).

The other, more important factor was Brassaï's printing process, which was meant to be visible to contemporaries like the Surrealists in the reproductions in *Paris de nuit*, but has largely been lost in later reprints. The original images were made using 'sheet-fed' photogravure prints, the outcome of a matte process leading to a mild imprecision, haziness or even fuzziness, depending on the size of object in the camera field. Photogravure has its origin in the research and experiments of Henry Fox Talbot but was devised by the Czech printer Karel Klíč in 1879, about two years before Seurat shifted from his linear drawing style to the mature tonal one, though to my knowledge no connection has been made between his style and the one manufactured by Klíč and evident in his images.[53] Although it is a machine process used by high volume presses,

[51] Clark, *Painting of Modern Life*, 25.
[52] Quentin Bajac, 'The Latent Images of the Night', Aubenas and Bajac, *Brassaï: Paris Nocturne*, 185–216, 198.
[53] William Crawford, *The Keepers of Light: A History & Working Guide to Early Photographic Processes*, Dobbs Ferry NY: Morgan & Morgan, 1979, 246. For a classic study of the process that is contemporary with Brassaï's use of it, see H. Mills Cartwright, *Photogravure: A Text Book on the Machine and Hand Printed Processes*, Boston, Mass.: American Photographic Publishing Co., 1930.
 One writer on late nineteenth-century art, who was resistant to formalism, unintentionally linked Seurat's drawings for the *Grande Jatte* to Surrealist themes through photography (though,

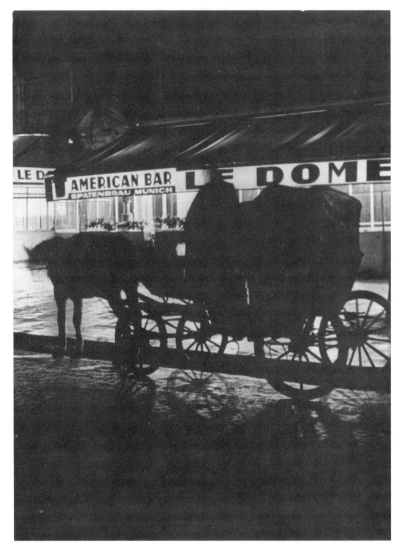

Figure 4.22 Brassaï, a carriage in front of Le Dôme (from *Paris de nuit*, 1932). Centre de création industrielle, Musée national d'art moderne, Centre Georges Pompidou, Paris. Photo © Centre Pompidou, MNAM-CCI, Dist. RMN-Grand Palais/Image Centre Pompidou, MNAM-CCI. © Estate Brassaï – RMN-Grand Palais.

admittedly, the central sentence is a *non sequitur*): 'Seurat's drawings are strongly reminiscent of photographic negatives. It is uncertain whether the artist was influenced by photography, but it seems not unlikely. There is no doubt that by his style of drawing Seurat endeavoured to attain a carefully calculated effect. The drawings give a strong feeling of dream and illusion, a feeling that is augmented by the tranquility and firm stability that characterize the figures. Here Seurat gives a view of the world in which the objective realities are changed to a strongly subjective, contemplative

as opposed to 'hand-pulled' photogravure in which the ink is thicker and rubbed into the plate manually then printed onto higher quality paper, the technique used by Brassaï for *Paris de nuit* nevertheless allowed a warm and softening, delicate tonal scale that helped reduce the shrill electric light glare of modern Paris. There is no testimony that Brassaï had Seurat in mind but plenty of evidence among the matte not gloss pages of *Paris de nuit* that photogravure nudges the formal values of Brassaï's photographs closer to Seurat's drawings, sometimes conferring a period quality reminiscent of gas lighting.

The faintly offset focus given by photogravure, tactile by visual proxy, is faithful to the way Brassaï wanted his photographs to look, but it has been betrayed by publishers since using later, cheaper printing processes. Although they claim their editions are 'produced by photogravure from Brassaï's original plates', the more-or-less identical English-language 1987 Thames and Hudson and 2001 Bulfinch versions of *Paris de nuit* give the pages a shiny patina that the photographer did not intend, while dimming the strong tar-blacks and snow-whites in a reduced tonal scale.[54] These versions do achieve the matte appearance (not texture) and smudging of detail by the accumulation of subtle and faint black clouding and diffused haloes of white. But this style has been equally misunderstood as bad printing by readers seeking what they perceive to be the 'realist' clarity given in the more familiar combination of hard edged content and the high sheen of glossy, plastic-coated photography paper – a smooth, flat, sharp and 'clean' aesthetic of featureless surface and sharp contour.

The spongy, textural opulence of the reproductions in *Paris de nuit* was entirely intended, then, and the process that brought it about makes available quite contradictory effects of void and opacity. In one account by writers on Brassaï, for instance, 'the photogravure printing on velvet-surface paper gives the black a wonderful depth and produces a whole spectrum of subtle halftones',[55] while, in another, the procedure gives effects that are 'sometimes soft, velvety, grainy, palpable; sometimes hard, imposing, unyielding, compact, and dense like blocks of black'.[56] The print of the book is so heavy that over eighty years after its publication, the smeared and sooty, porous or hard blacks of the

picture with marked aesthetic aims', Lövgren, *Genesis of Modernism*, 52. Lövgren repeated these terms for the painting itself, referring to its 'atmosphere of unreality' and 'fluctuation between dream and reality', as though his departure from modernist formalism and affirmation of Seurat's cultural context demanded a language close to Surrealism; indeed, writing in the period after the historicization of Surrealism, Lövgren was at ease if imprecise in using the words '"surrealist"' and '"surrealistic"' to characterize some of the poetry and art of the 1880s: Lövgren, *Genesis of Modernism*, 5, 73 n. 2, 66, 67.

[54] Even though its range of tonality matches and even exceeds the original, a 1979 German version of *Paris de nuit* misses the point completely by publishing the book in the same size as the 1932 version while shrinking the photographs and placing them within a *white* border, each facing a *white* page carrying the title of the photograph, so that the enveloping journey into night pulled off by Brassaï in the book design the first time around is lost: Brassaï, *Nächtliches Paris/Paris de nuit*, Munich: Schirmer/Mosel, 1979.

[55] Aubenas and Bajac, *Brassaï: Paris Nocturne*, 15.

[56] Richard Stamelman, 'Photography: The Marvelous Precipitate of Desire', *Yale French Studies*, no. 109 ('Surrealism and Its Others'), 2006, 67–81, 69.

first edition of *Paris de nuit* can still stain the fingers like today's newspaper ink. This might explain Brassaï's choice of the exercise book format, to accentuate the associations with reportage and pen and ink drawing, and perhaps through that with Guys, the great forerunner of the war photographer, who 'throw[s] ink and colours on to a white sheet of paper' in Baudelaire's well-known characterization, 'like a barbarian, or a child'.[57] This dark, saturated blush also intimated Brassaï's admiration for Rembrandt (figure 4.23), whom

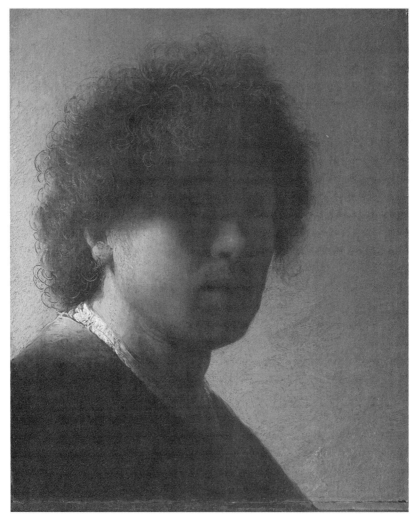

Figure 4.23 Rembrandt, *Self-Portrait* (1628). Oil on panel, 22.6 × 18.7 cm. Rijksmuseum, Amsterdam. Image courtesy Rijksmuseum, Amsterdam.

[57] Baudelaire, *Painter of Modern Life*, 6 (and see the pages subheaded 'The Annals of War', 18–21).

Seurat, too, had begun to look at closely, just as his drawings entered their maturity at the beginning of the 1880s.[58]

Light according to Seurat and Brassaï

Although Brassaï has become renowned as the greatest recorder of the Paris night by camera, he was nowhere near the first. As I am going to show, it was not a coincidence that nocturnal urban photography began in the same decade that Seurat started his own practice of night walking and sketching. Brassaï was familiar and sometimes acquainted with his immediate precursors in the genre who published in the illustrated press, such as Léon Gimpel, André Kertész and Germaine Krull. However, it is thought unlikely that he was aware of the Alpine painter and photographer Gabriel Loppé who walked the darkening streets of Paris and London with his camera from about 1890 till early in the next century, beginning around the time Seurat was winding down his own project of drawing what most have interpreted in his work as the darkening city. Quentin Bajac notes the similarities between Loppé's photography and Brassaï's, pointing to Loppé's 'interest in the effects of light and atmosphere (rain, mist, fog, gas lights, lightning)', conditions that Seurat relied upon his subtle manipulation of the conté stick across the Michallet paper to capture.[59]

Like Loppé's night photography, there is a strong chance that the nocturnal wandering and drawing of Seurat began because of important technological advancement in the street lighting of Paris. Given the vast alteration it entailed in the illumination of the city, we must obviously view the style of Brassaï's night photography also as an outcome of the transformation it wrought on the capital, but only in the sense of a nostalgic resistance to electric lighting that was in line with Brassaï's reverence for a largely nineteenth-century Parisian culture. Paris was slow to adopt gas street lighting compared to other major European and American cities, introducing the new technology on a large scale only from 1829.[60] However, by the mid-1840s that technology was well established in the private and public places of Paris, inaugurating what Hollis Clayson called appropriately 'the glory days of gaslight' in the city.[61] The brightness of the gas flame varied considerably, 'from the dim tallow candle to the

[58] Aubenas and Bajac, *Brassaï: Paris Nocturne*, 196; Stamelman, 'Photography: The Marvelous Precipitate of Desire', 74; Goldwater, *Seurat's Drawings*, 60–2; Thomson, *Seurat*, 29–30.

[59] Aubenas and Bajac, *Brassaï: Paris Nocturne*, 190. The suggestion made in this book that Loppé photographed Paris in London by night 'between 1880 and 1900' is probably inaccurate; at the time of writing, no nocturnal photograph by him has been securely dated earlier than 1890: Aubenas and Bajac, *Brassaï: Paris Nocturne*, 190. I am very grateful to S. Hollis Clayson for guidance on this matter.

[60] Andreas Blüm and Louise Lippincott, *Light! The Industrial Age 1750–1900: Art & Science, Technology & Society*, Amsterdam and Pittsburgh PA: The Van Gogh Museum and The Carnegie Museum of Art, 2000, 182.

[61] Schivelbusch, *Disenchanted Night*, 32; Hollis Clayson, 'Outsiders: American Painters and Cosmopolitans in the City of Lights, 1871–1914', Frédéric Monneyron and Martine Xiberras (eds), *La France dans le regard des États-Unis/France as Seen by the United States*, Perpignan and Montpellier: Presses Universitaires de Perpignan and Publications de l'Université Paul Valéry, 2006, 57–71, 67.

relatively bright wax candle'.[62] Experimentation with electric arc lighting began as early as 1844 when the Place de la Concorde was lit by gigantic arc lights, yet electric would remain a minor technology for decades.[63] Relocated under Haussmannization, the Théâtre de la Gaîté was installed with 1,338 individual gas jets as late as 1862 (Baron Haussmann himself had no confidence in electric lighting), but it was due precisely to the oxygen usage of gas lighting causing poor air and headaches in the theatre, as well as discolouration of the interiors of buildings, that the slow transition to electric lighting began soon after that time.[64]

One report of 1911 and another exactly coincident with the high point of Brassaï's practice fixed the date of the full emergence of electricity at February 1878, when the Avenue de l'Opéra was lit for the *Exposition universelle*.[65] The difference between the soft flame of gas and the brilliant, powerful one of electricity was widely remarked upon from the moment Thomas Edison's incandescent electric light triumphed at the *Exposition Internationale de l'Électricité* in Paris in 1881.[66] It was following that invention, as Wolfgang Schivelbusch put it, that '[b]etween 1880 and 1920 electricity began to permeate modern, urban life'.[67] The new technology had immediately impacted the display and appearance of art in the so-called 'electric Salon' of 1879 and

[62] Schivelbusch, *Disenchanted Night*, 41.

[63] Clayson in Monneyron and Xiberras (eds), *La France dans le regard des États-Unis/France as Seen by the United States*, 68.

[64] Schivelbusch, *Disenchanted Night*, 47, 50; Blüm and Louise Lippincott, *Light!* 166. It is worth noting as a measure of local government priorities that while its supposed medicinal effects were promoted as a selling point at first, the danger posed by gas lighting to health through its contamination of the natural environment was well known from at least the early 1850s: Martin Bressani, 'Paris: Light into Darkness, Gaslight in Nineteenth-Century Paris', Sandy Isenstadt, Margaret Maile Petty and Dietrich Neumann (eds), *Cities of Light: Two Centuries of Urban Illumination*, New York and London: Routledge, 2015, 28–36, 29; Schivelbusch, *Disenchanted Night*, 40. For a scrupulous narration of the transformation of Parisian lighting from the Middle Ages to the 1880s, see Simone Delattre, *Les Douze heures noires: La nuit à Paris au XIXe siècle*, Paris: Albin Michel, 2000, 79–118.

[65] A. N. Holcombe, 'The Electric Lighting System of Paris', *Political Science Quarterly*, vol. 26, no. 1, March 1911, 122–32, 122; M. R. Boutteville, 'L'Éclairage public à Paris des origines à la fin du XIXᵉ siècle', *Revue scientifique*, year 71, no. 20, 28 October 1933, 609–15, 615. The second of these, dating from the period of *Paris de nuit* and *Minotaure*, was summarized in English: Anonymous, 'History of the Public Lighting of Paris', *Nature*, vol. 132, no. 3345, 9 December 1933, 888–9. Also see the rapturous, contemporary account a few months after its illumination of 'the Avenue de l'Opéra inundated with electric light; Rue Quatre Septembre shining with its thousand gas jets', Edmondo de Amicis, *Studies of Paris*, trans. W. W. Cady, New York: G. P. Putnam's Sons, 1879, 32. The lighting of the Avenue de l'Opéra is a key event in the chronology given in the massive history of electricity in France by François Caron and Fabienne Cardot (eds), *Histoire générale de l'électricité en France, vol. 1, Espoirs et conquêtes 1881–1918*, Paris: Fayard, 1991, 162. For a historical account of the growth of electricity generally, mainly in Germany, America and Britain, see Thomas P. Hughes, *Networks of Power: Electrification in Western Society, 1880–1930*, Baltimore MD and London: The Johns Hopkins University Press, 1983.

[66] Schivelbusch, *Disenchanted Night*, 58–61; Robert Friedel and Paul Israel with Bernard S. Finn, *Edison's Electric Light: The Art of Invention*, Baltimore MD: The Johns Hopkins University Press, 2010, 161, 179–81; Clayson in Monneyron and Xiberras (eds), *La France dans le regard des États-Unis/France as Seen by the United States*, 68. For the reaction of the French press to Edison at the 1881 *exposition*, see Robert Fox, *Science, Industry, and the Social Order in Post-Revolutionary France*, Aldershot and Brookfield VT: Ashgate, 1995, 223–35.

[67] Schivelbusch, *Disenchanted Night*, 73.

in critical debate as to whether or not Édouard Manet had captured the full intensity of the electrically lit café-concert in *A Bar at the Folies-Bergère* (1882).[68] That is to say that this process of the illumination of the capital was beginning exactly as Seurat was instituting and refining his drawing style in and around Paris and it had become well established not long before Brassaï began to document the nightlife of the city.

The arc lighting that began to appear selectively in a few of the main thoroughfares of Paris following on from Haussmannization (which had rationalized and augmented the city's gas lighting) made the city safer for nightwalkers like Brassaï and Seurat.[69] It would also have made it more possible for Loppé to take reasonable photographs with a long enough exposure time and for Seurat to see what he was doing with his conté crayon. But this was only a partial transformation of the city. Just as pre-Haussmann Paris was and still is left behind in fragments here and there, so those older streets and lots of others continued to be lit by gas for many years to come, initially because the new technology was so expensive. Although he did not grasp the full nature of the social and technological transformation, Germain Seligman recognized that Seurat relished this transitional lighting:

> Problems of local lighting were particularly dear to the artist, since the colour or tint of a given item is not only its original colour but the resultant [*sic*] of it in combination with the colours of neighbouring items as well as with the lighting, the irradiation of a gas lamp being so different from that of an oil lamp or bright sunshine.
>
> The intensities of light from these different sources are astoundingly expressed in Seurat's graphic work; it is almost as if the degree of their vibrations could be put into figures.[70]

Those drawings by Seurat that were realized at night in the city reflect an incongruously lit Paris, then, at the beginning of an adjustment between technologies. The stroller could pass from broad streets brightly lit as though by daylight to the many narrower gas-illuminated lanes full of shadows that were now so murky by contrast that the eye struggled at first to see anything there at all and where nighttime was not obliterated as it was by electric lighting.[71] Illustrating this inconsistency, Schivelbusch reports that in

68 Clark, *Painting of Modern Life*, 211.
69 Social historians debate the effect of city lighting on crime. Although the two views are not necessarily contradictory, see the association of gaslight with crime and prostitution in Blüm and Lippincott, *Light!* 212; and the opinion that in the mid-nineteenth century, even before electric lighting, '[m]ore lights meant more tourists and less crime', Christopher Prendergast, *Paris and the Nineteenth Century*, Oxford and Cambridge, Mass.: Blackwell, 1992, 32. One enquiry into the value of nineteenth-century lighting in Europe and America for purposes of regulation, on the one hand, and leisure, on the other, ends inconclusively on the question of crime: Mark J. Bouman, 'Luxury and Control: The Urbanity of Street Lighting in Nineteenth-Century Cities', *Journal of Urban History*, vol. 14, no. 1, November 1987, 7–37.
70 Seligman, *Drawings of Georges Seurat*, 32.
71 See the report of the effects on the eye of varying strengths of street lighting quoted from the journal *Progrès médical* in 1880 by Schivelbusch, *Disenchanted Night*, 118. I take the idea of the obliteration of night by electric and its preservation by gas from Bressani in Isenstadt, Petty and Neumann (eds), *Cities of Light*, 28.

the 1870s and 1880s, 'several European capitals installed arc-lights on some of the main shopping streets, with the result that the surrounding streets, still lit by gas, seemed to be in twilight'.[72] The ambiance that photography could capture might be one of crime and lurking danger, or of potential pleasure, or merely one of stylish modern urbanity, depending largely on who is doing the inferring.[73] Such variety in lighting slowly disappeared along with the shadows when gas lighting increased in brightness in competition with electricity, which might help explain why Seurat's drawings fizzle out after 1885. Both improved (though short-lived) gas alongside electric technology advanced from street lighting to complete city lighting at that time, accelerating towards a full electric supply for Paris from 1888 following the destruction by fire the previous year of the gas-lit Opéra Comique.[74]

By the end of the nineteenth century, electric street lighting had become so widespread in the major European cities that a Society of Night Photographers could be founded in London. Some critics already dismissed night photography as old hat as early as 1913, twenty years before Brassaï's first contributions to *Minotaure*, the majority of which took place in the first half of the 1930s when the transition to electric lighting was well under way though still far from complete.[75] In fact, Brassaï included in *Paris de nuit* a photograph of the oldest police station in Paris badly lit by a single gas lamp on the corner of the much older rue de la Huchette on the Left Bank (figure 4.24).[76]

[72] Schivelbusch, *Disenchanted Night*, 115. For eyewitness accounts of this discrepancy in street light, see Joachim Schlör, *Nights in the Big City: Paris, Berlin, London 1840–1930* [1991], trans Pierre Gottfried Imhof and Dafydd Rees Roberts, London: Reaktion, 1998, 66.

[73] Paul Morand's foreword for *Paris de nuit* chooses the themes of criminality and mystery in its prologue, referring briefly to Eugène Sue's *Mysteries of Paris* (1842–3), Alexandre Dumas' *Mohicans of Paris* (1854) and Surrealist favourite Horace Walpole's *Castle of Otranto* (1764): Paul Morand in Brassaï, *Paris by Night*, Boston, New York, London: Bulfinch, 2001, n.p.

[74] Holcombe, 'Electric Lighting System of Paris', 122–3. Born in 1883, the Director of the Lighting Research Laboratory at General Electric in America reminisced in mid-life: 'I well recall the last years of gas-lighting when great ingenuity was combined with scientific knowledge to keep gas-lighting in successful competition with electric lighting which was on the rise. All kinds of lamps, burners, and mantles, higher gas-pressure, electric ignition and portable study lamps came into use to stem the rapidly rising tide of electric lighting. But to no avail', Matthew Luckiesh, *Torch of Civilization: The Story of Man's Conquest of Darkness*, New York: G. P. Putnam's Sons, 1940, 113.

[75] Aubenas and Bajac, *Brassaï: Paris Nocturne*, 190, 192. Also see the remarks made in 1926 about the lamp posts of the Parc des Buttes-Chaumont in the nineteenth arrondissement in the north-east of Paris 'illuminating the park with their incandescent gas jets', Louis Aragon, *Paris Peasant* [1926], trans. Simon Watson Taylor, London: Picador, 1987, 151; and those of 1928 about the 'faulty gas jet', the 'group of gasometers . . . ten large black tanks that one might have thought to be the prey of giant serpents', and the 'simple gas jets' – where the term 'bec de gaz' appears with identical frequency to the much older though repurposed 'réverbère' ('street lamp') – in Philippe Soupault, *Last Nights of Paris* [1928], trans. William Carlos Williams, Cambridge: Exact Change, 1992, 94, 117, 143 (for the previous, mid-eighteenth- to mid-nineteenth-century usage of 'réverbère', to denote oil reflector lanterns, see Schivelbusch, *Disenchanted Night*, 87, 93, 184).

[76] As late as the 1950s, a detective novel by a former Surrealist that partakes of the nocturnal atmosphere of the drawings and photographs I am looking at here records the following on the rundown Rue Blottière in the fourteenth arrondissement: '[k]eeping a bleary watch over the door stood an ancient street lamp, still lit by gas. There aren't many of them left, and when you do see one you're always surprised not to see a body swinging from it', Léo Malet, *The Rats of Montsouris* [1955], trans. Peter Hudson, London: Pan, 1991, 29.

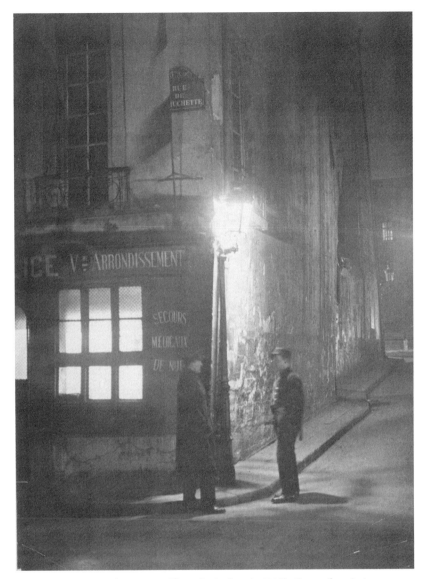

Figure 4.24 Brassaï, police station (from *Paris de nuit*, 1932). Centre de création industrielle, Musée national d'art moderne, Centre Georges Pompidou, Paris. Photo © Centre Pompidou, MNAM-CCI, Dist. RMN-Grand Palais/image Centre Pompidou, MNAM-CCI. © Estate Brassaï – RMN-Grand Palais.

Light and shade in *Minotaure*

It was not so much the distinctive qualities of Brassaï's photography itself that led to the full acknowledgement of a Surrealist Seurat in *Minotaure*, but rather the light and shade style of the review that Brassaï had a significant role in fostering, together with the larger trend for the nocturne in Surrealism and beyond, extending through the 1930s. However, there is strong evidence that the Surrealists saw a direct connection between the artist and the photographer. This can be found as early as the first number of *Minotaure* where a set of Brassaï's photographs of nudes were showcased alongside some nineteenth-century photographs and two drawings, one by Renoir, the other by Seurat, for an essay by the same Maurice Raynal who had introduced Brassaï into the *Minotaure* circle (figure 4.25).[77] Already we see a formative comparison being set up between the light and shade of the drawings and photographs on the left-hand page, including prominently Seurat's *Model Facing Front* (study for *Poseuses*) (1886), then owned by Maximilien Luce, and the three nude female torsos by Brassaï on the facing page.

This connection was confirmed at the back of the same eleventh issue of *Minotaure* that starred Seurat, where a single page prose poem by Paul Recht titled 'L'homme qui perd son ombre' faces a full page photograph by Brassaï (figure 4.26) – his first in the journal since the seventh, June 1935 number – obviously meant to mirror the presence of the drawings by Seurat at the front of the review.[78] Recht's text is typical *Minotaure* fare. Borne by a poetics of polarities – black and white, night and day, man and his shadow, earth and sky, yes and no, the Equator and the Poles of the Earth – it might even have been inspired by Seurat's drawings, given that the replacement of person by shadow is an available reading of them and that the text lies in relation to them at the opposite extremity of the journal. It is met by Brassaï's photograph of a profile in shadow cast by a self-portrait by then-sculptor (but future Western movie actor) Jacques Berthier with a further three-quarter, conventionally lit photograph of the same sculpture reduced in size and superimposed over the top of it. It is rather arty and no match for the night photographs he had become famous for and by then largely left behind. However, Brassaï's photograph like Recht's poem sounds a neat-enough echo of the 'phantoms' of Seurat's drawings lauded at the other end of that number of *Minotaure* by Mabille as occupying a world '[r]id of . . . too precise shadows'.[79]

In closing this chapter, I want to shift to a more critical position to one side of Mabille and the other writers on Seurat to whom I have referred. This should confirm what a lure the artist was for Surrealism along the lines I set out in the first half of it. I do this in order to indicate a peculiar and dominant trait marking the reception of and scholarship on Seurat, including that carried out by the Surrealists. This is the mechanical and uniform designation of Seurat's drawings by writers such

[77] Maurice Raynal, 'Variété du corps humain', *Minotaure*, no. 1, February 1933, 41–4.
[78] Paul Recht, 'L'homme qui perd son ombre', *Minotaure*, no. 11, May 1938, 63.
[79] 'Débarrassé . . . ombres trop précises', Mabille, 'Dessins inédits de Seurat', 3.

as Herbert as unambiguously nocturnes or depictions of dusk/twilight.[80] It is true that Seurat voiced his admiration to Kahn for James McNeill Whistler's recommendation given in his 'Ten O'Clock Lecture' (1885) (which Gauguin probably knew and might even have attended, and Stéphane Mallarmé had translated for Fénéon's *Revue Indépendante* in 1888) that painters practise their art in the evening after artificial lighting has come on.[81] However, the drawings do not confirm the overall interpretive supposition at all. If those of the music hall are clearly concerned with the relation of darkness and light, then that is equally obviously *not* the case with the studies for *Bathers at Asnières* and the *Grande Jatte*, and there is little in the outdoor scenes and most of the indoor ones to indicate what time of day they are meant to record.

In many cases, such identification has been tacked on by titles given in Seurat's absence, as in the rhythmic, swaying masterpiece known as *Night Stroll* (figure 4.27, 1887–8). This is perhaps the most remarkable, engaging and ambiguous of the drawings reproduced in *Minotaure*. It is ambiguous precisely because we do not know whether it is night or day, city or countryside, dream or reality, while under the Surrealist gaze the two figures to the right become hallucinations of the foreground promenader. Indeed, as in many of these works, it is difficult even to determine racially the figures populating the sheet. It is noteworthy that in spite of the 'literary' titles given many of Seurat's drawings, presumably by the Symbolists, which help invest them with intrigue and even invite narrative embellishment – *The Black Bow, Family Reunion, The Veil, Following the Path, The Haunted House* – such temptation was resisted by the artist's modernist spectators. They were relieved, apparently, that Seurat's 'detachment and abstraction could find no interest in narrative detail' and that he 'eliminated anecdotal detail … which more readily suits our anti-literary taste (which he helped form!)', in the words of one of them.[82] All such ambiguity and excessive readability only added to their poetics of sureality, I have been arguing, constituting the 'unconscious fantasy' exceeding authorial control that Teodor de Wyzewa identified as the opposite pole of

[80] Herbert, *Seurat's Drawings*, 48, 86.

[81] Kahn, *The Drawings of Georges Seurat*, vi–vii. For Gauguin's potential knowledge of Whistler's lecture, see Alan Bowness, *Gauguin* [1971], London: Phaidon, 1991, 10. Although Brassaï showed little interest in the artist, Whistler's portrayal of the transformative effects of darkness meets with those achieved by his own night photography: 'And when the evening mist clothes the riverside with poetry, as with a veil, and the poor buildings lose themselves in the dim sky, and the tall chimneys become campanili, and the warehouses are palaces in the night, and the whole city hangs in the heavens, and fairy-land is before us – then the wayfarer hastens home; the working man and the cultured one, the wise man and the one of pleasure, cease to understand, as they have ceased to see, and Nature, who, for once, has sung in tune, sings her exquisite song to the artist alone…', James McNeill Whistler, 'Mr. Whistler's "Ten O'Clock"' [1885], Joshua C. Taylor (ed.), *Nineteenth-Century Theories of Art*, Berkeley, Los Angeles, London: University of California Press, 1987, 502–13, 506. For a limited discussion of Whistler and Seurat's *Parade de Cirque* in the context of the nocturne in nineteenth-century French poetry (but with no attention to the transformation from gas to electric lighting), see William Sharpe, 'The Nocturne in *fin-de-siècle* Paris', Barbara T. Cooper and Mary Donaldson-Evans (eds), *Modernity and Revolution in Late Nineteenth-Century France*, Newark NJ and London and Toronto: University of Delaware Press and Associated University Presses, 1992, 108–25.

[82] Herbert, *Seurat's Drawings*, 70, 84.

pur, l'on peut dire qu'en matière de variations du corps humain, la liberté poétique de la nature a toujours magnifiquement débordé la prosodie des hommes. Éternelles ou non, les règles ne sont belles que lorsqu'elles sont outrepassées.

★

Toute l'histoire du nu féminin oscille entre trois aspects, le plantureux, le mince et la moyenne mesure instaurée par les canons sous le signe d'une perfection académique.

Un dessin de Renoir, un dessin de Seurat et des photographies du temps.

Au temps des cavernes, le nu féminin se portait assez redondant. Les belles brutes plastiques de la préhistoire aurignacienne, celles de Willendorf ou de Lespugue ont créé leurs formes à la faveur des régimes carnés offerts par des chasseurs heureux et qui n'avaient plus rien à faire qu'à sculpter des beautés bien nourries à la gloire de leurs estomacs satisfaits. Il serait puéril de parler d'esthétique ou de naturalisme à propos de ces ancêtres pourtant flagrants de l'art flamand ou de l'École du torchon gras.

Citons encore la civilisation du nu égyptien créant une nouvelle humanité, toute d'élégance et de style,

Figure 4.25 Double page of *Minotaure*, no. 1, February 1933, 42–3. Image courtesy the Book Library, Courtauld Institute of Art, London.

délicatement entrelardée mais plus vivante des Florentines. Nous laisserons en passant à l'art, en l'occurrence celui des Primitifs, la responsabilité d'avoir imposé aux pauvres martyrs romains cette maigreur classique qui n'a pas réussi à faire croire que ces gens-là n'avaient tout de même pas à donner aux fauves de l'arène autre chose que des os à sucer. En revenant aux Vénitiennes et aux Florentines, nous remarquons que le charme de ces fausses

et portée au goût de l'abstraction. Ces vertus ont peut-être contribué en quelque sorte à la création du corps mince d'Isis. Mais il est certain que les rigueurs du climat égyptien, inondation et sécheresse alternées, en attendant les fameuses dix plaies d'Égypte, sont pour quelque chose dans la création de ces corps graciles et de ces visages émaciés.

La Renaissance alternera la vénusté des Vénitiennes bien nourries et casanières avec la grâce

Nus (photographies de Brassaï).

grasses, de ces fausses maigres, se rattache bien plus à l'ethnographie qu'à l'art. Venise triomphante, lumineuse et riche ne pouvait admettre qu'un nu capitonné, luxuriant et doré. A Florence, ville bourgeoise, hypocrite, tourmentée, riche et ladre, convenait mieux un nu plus ardent, plus inquiet, plus avare, aux proportions plus discrètes, plus raffinées certainement.

.

43

Figure 4.25 (*Continued*).

Photo Brassaï. D'APRÈS JACQUES BERTHIER

Figure 4.26 Page of *Minotaure*, no. 11, May 1938, 63–4. Image courtesy the Book Library, Courtauld Institute of Art, London.

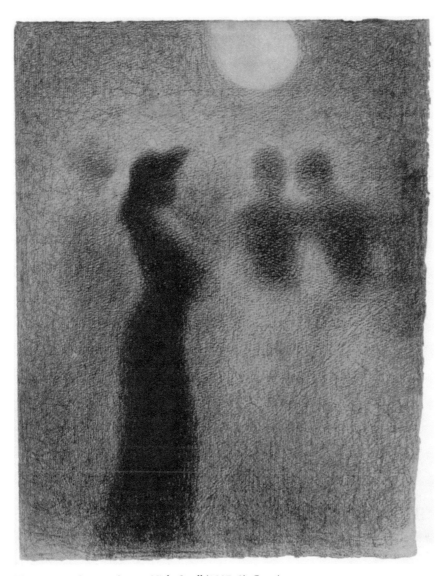

Figure 4.27 Georges Seurat, *Night Stroll* (1887–8). Conté crayon on paper, 31.5 × 24.1 cm. Private collection.

the 'reasoned effort' that comprised Seurat's labour, and the marvellous (not mysterious) sought by Breton.[83]

Extrapolating Mabille's brief comments on their in-between status, I tried to show in this chapter how the combination of materials and style lends the drawings precisely that interpretable quality that bought them a place among the metallic, shadowy photographs of Brassaï's and that helped also give *Minotaure* its distinctiveness. The lush surfaces of Brassaï's photographs that helped set the house style for *Minotaure* were as much objects to be looked *at* as looked *into*. That is to say the eye is as much stopped at and seduced by their surface as by whatever lies 'inside'. This paved the way for the alignment of Seurat's drawings with a Surrealist poetics and theory that together sought to find and fix the point at which contradictions meet.[84] I referred passingly in this chapter and more extensively in the previous one (argued through Hélion) to the irony that such a signally 'modernist' art of surface and form could insist so much on a Surrealist reading. We see this brewing as early as the very first number of the journal in these 'spun bodies', to use Mabille's apt and agreeable phrase. It demonstrates that night, specifically, was only one means towards creating the house style of the review and that it was really a matter of a conceptual pictorialism given by the monochrome, shown to be enforced by the process of black and white reproduction, turning the already yellowing sheets of Seurat's drawings paler and in that way increasing their similarity with Brassaï's photographs.

[83] 'inconsciente fantaisie'; 'effort réfléchi', Teodor de Wyzewa, 'Georges Seurat', *L'Art dans les deux mondes*, no. 22, 18 April 1891, 263–4, 263.

[84] The classic statement is Breton's, of course: 'Everything tends to make us believe that there exists a certain point in the mind at which life and death, the real and the imagined, past and future, the communicable and the incommunicable, high and low, cease to be perceived as contradictions. Now, search as one may one will never find any other motivating force in the activities of the Surrealists than the hope of finding and fixing this point', André Breton, 'Second Manifesto of Surrealism' [1930], *Manifestoes of Surrealism*, 117–94, 123–4. For the suggestion that '*Minotaure* illustrates this aim', where 'everything gets jumbled, night and day', and even that the journal itself lay at the in-between state where Mabille located Seurat's drawings, see Gérard Fabré, 'Between Tame Dog and Wild Wolf: A Twilight Zone', trans. R. F. M. Dexter, Geneva: Musée d'Art et d'Histoire, *Focus on Minotaure: The Animal-Headed Review*, 1987, 175–85, 179, 183.

Civilization, Realism, Abstraction: Paul Gauguin and Surrealism, 1948–53

Like the other late nineteenth-century 'fathers' of modernism viewed under the lens of Surrealism in this book – Paul Cézanne, Georges Seurat and Vincent van Gogh (but not the Pierre-Auguste Renoir of near-unanimously unwelcome memory) – Paul Gauguin was among the historical persons whom the Surrealists imagined waiting on their doorstep in the game 'Ouvrez-vous?' with which the first number of their new journal *Médium: Communication surréaliste* commenced in November 1953. Of those, Gauguin was the one they admired the most at that moment judging from the fourteen 'yeses' he received from the sixteen respondents, equal with Francisco Goya and Henri Rousseau. Only one artist in the whole game, the inevitable Gustave Moreau, scored higher – a 100 per cent tally in his case – but by the end of the 1950s Gauguin would be the more acclaimed pre-Surrealist artist, at least in André Breton's eyes.[1]

The Surrealists came to Gauguin in that decade, quite late, while his reputation was well into its ascendancy among some critics and collectors and after he had entered the Louvre. So it was a reception closely aligned historically, even though it was entirely dissimilar in its particulars, with the one Gauguin received from modernist critics. But it was quite unlike Breton's prescient, tenacious advancement of Seurat from the early 1920s before that artist had become wholly established by modernists and even before French defenders of the classical tradition had completely cottoned on to his legacy. It has been asserted that Breton decorated his room in the Nantes hospital where he worked in 1915 with reproductions of Gauguin's paintings.[2] However, Breton's actual references to Gauguin in *Surrealism and Painting* only appear in the 1965 revised edition because they took place in his writings on art entirely between 1955 and 1961. Additionally, as I noted in my first chapter, where Cézanne was largely ignored in Breton's *L'Art magique* (1957), Gauguin fully arrived within the Surrealist canon in that volume as the sixth most cited artist (equal with the now communist so reputationally damaged Pablo Picasso). His high visibility in Surrealism continued from that decade on. The Surrealist

[1] The Surrealist Group, 'Ouvrez-vous?' *Médium: Communication Surréaliste*, no. 1, November 1953, 1 and 11–13, 11.
[2] André Cariou, 'La Passion d'André Breton pour la vie et l'oeuvre de Charles Filiger', André Cariou (ed.), *Charles Filiger-André Breton: À la recherche de l'art magique*, Quimper: Musée des beaux-arts, 2006, 17–20, 20 n. 2.

writer Gérard Legrand, who wrote much of *L'Art magique* under Breton's name, published a monograph on Gauguin in 1966 that came partly out of the experience of researching that book. Then, in 1982, the now-former Surrealist José Pierre, who had proclaimed in the 1970s that with Gauguin 'Symbolist painting reached its highest summit' due to his 'expression of myth, of dream and of the unconscious', wrote a novel based on information about the artist's life in the Marquesas Islands.[3] It was Legrand who complained that 'Gauguin had to wait for the thirties and above all the post-war period to be given his proper place'.[4] Tracking initially his delayed reception in France will help introduce the reasons for Surrealism's even later recognition of the artist.

Gauguin in France

Although the esteem shown Gauguin within Surrealism from the 1950s was not present earlier in the life of the movement, as I will show, the delayed obituary-article on the artist of September 1903 by peeved art critic François Thiébault-Sisson had initially established his public image in a way that should have appealed to the first generation of Surrealists, as much as it had initially and temporarily put off bourgeois art lovers. Appearing not too prominently in the conservative broadsheet *Le Temps*, predecessor of *Le Monde*, it mobilized numerous now-familiar stereotypes of the creative individual, setting Gauguin up as a feral near-genius and long-spent 'outsider artist' well before the latter term took on its familiar usage. Its rhetoric was more or less copied throughout most of the French press:

> From a social as much as an artistic point of view, Gauguin was a kind of anarchist for whom a horror of convention and a disregard for all rules would lead to an equally simplistic conception of art and life. ... The painted dispatches that he sent from his island showed not simply an increasingly marked depression year by year, but a vision that was more and more obscured by nightmares in which alcohol was largely in evidence. One could sense his madness plainly in them, and in taking away the artist, death has taken away only a wreck, to tell the truth. The boat submerged long ago.
> Yet this madness had, if not genius, then the lesser part of genius.[5]

[3] José Pierre, *Symbolism*, [1976], trans. Désirée Moorhead, London: Eyre Methuen, 1979, n.p.; José Pierre, *Gauguin aux marquises: roman*, Paris: Flammarion, 1982.
[4] 'Gauguin a dû attendre les années trente et surtout la deuxième après-guerre pour être remis à sa place', Gérard Legrand, *Gauguin*, Paris: Club d'Art Bordas, 1966, 52.
[5] 'Au point de vue social comme au point de vue artistique, Gauguin fut une façon d'anarchiste que l'horreur de la convention et le mépris de toute règle conduisirent à une conception de l'art et de la vie également simplistes. ... Les envois de peinture qu'il faisait de son île n'accusaient pas seulement, chaque année, une dépression plus marquée, mais une vision de plus en plus obscurcie par un cauchemar où l'alcool était pour beaucoup. On y sentait à plein le détraqué, et la mort, en enlevant l'artiste, n'a enlevé, à vrai dire, qu'une épave. Le bateau était submergé depuis longtemps. Mais ce détraqué avait eu, sinon du génie, du moins des parties de genie', François Thiébault-Sisson, 'Paul Gauguin', *Le Temps*, no. 15,418, 2 September 1903, 2.

Gauguin had been in Paris intermittently in the first half of the 1890s and particularly close to Symbolist poets and writers in the winter of 1890–1, though he was not yet what we would today call an 'activist'. Before his last years in the Marquesas he was essentially apolitical, unconnected to the bombings that had taken place during that high period of anarchism in the capital and that were still recent at his death.[6] Yet, no matter: he had been lauded by writers sympathetic to anarchism such as Octave Mirbeau and, less enthusiastically, Félix Fénéon, ten years earlier at the time of his important solo show at Durand-Ruel.[7] The term added further refinement and frisson to the portrayal of the nonconformist artist for the delectation of the readers of *Le Temps* and, a generation later, the Surrealists. Thiébault-Sisson went on to admonish the dead artist mainly for his loathing of Paris and Europe and his turn towards the

[6] While there is no statement of fidelity to anarchism, one monograph on the artist reasonably states that Gauguin held some 'anarchic views and regularly declared himself in opposition to property, civilization and the nation state', Stephen F. Eisenman, *Gauguin's Skirt*, London: Thames and Hudson, 1997, 84. For anarchism, art and culture in late nineteenth-century Paris, see Joan Ungersma Halperin, *Félix Fénéon: Aesthete & Anarchist in Fin-de-Siècle Paris*, New Haven and London: Yale University Press, 1988; John. G. Hutton, *Neo-Impressionism and the Search for Solid Ground: Art, Science, and Anarchism in Fin-de-Siècle France*, Baton Rouge LA and London: Louisiana State University Press, 1994; Alexander Varias, *Paris and the Anarchists: Aesthetes and Subversives During the Fin-de-Siècle*, London: Palgrave Macmillan, 1996; David Sweetman, *Explosive Acts: Toulouse-Lautrec, Oscar Wilde, Félix Fénéon and the Art & Anarchy of the Fin de Siècle*, New York: Simon & Schuster, 1999; and Robyn Roslak, *Neo-Impressionism and Anarchism in Fin-de-Siècle France*, Aldershot and Burlington VT: Ashgate, 2007. The classic study of Surrealism's politics includes an account of the movement's sympathy towards anarchism: Carole Reynaud Paligot, *Parcours politique des surréalistes 1919–1969* [2001], Paris: CNRS Éditions, 2010, 30–51, 235–59. There is also the collection of short 1950s texts by the Surrealists that show the movement's support for the cause of anarchism: José Pierre (ed.), *Surréalisme et anarchisme*, Paris: Plasma, 1983. Among these is Breton's recollection that it was in anarchism immediately after the First World War that 'Surrealism, long before it achieved self-definition, first recognized its own reflection', written during a period in which Surrealism was again rallying to anarchism: André Breton, 'Tower of Light' [1952], *Free Rein* [1953], trans Michel Parmentier and Jacqueline d'Amboise, Lincoln and London: University of Nebraska Press, 1995, 265–7.

[7] Belinda Thomson, *Gauguin* [1987], London: Thames and Hudson, 1990, 171. Although Gauguin's stereotypically bohemian statements about money, society and civilization have been compared to those of Karl Marx, they are driven by the same idealist misanthropy that is reflected in the escapist content of his paintings: for an extreme example of his fantasy of another world fuelled by disgust at his lot in this one, which is typical of his correspondence at the time, see the letter to Émile Schuffenecker of summer 1890 in Arsène Alexandre, *Paul Gauguin: sa vie et le sens de son oeuvre*, Paris: Bernheim Jeune & Cⁱᵉ, 1930, 110–11; and for the comparison with his bohemian acquaintances and with Marx, as well as the acknowledgement of 'the extreme rareness, if not absence, of works that correspond to this [political and social critique of capitalism]' – an absence, I would argue, that is filled by his synthesis of idealism and misanthropy – see Philippe Dagen, 'Gauguin's Politics', trans. Anna Hiddleston, London: Tate Modern, *Gauguin: Maker of Myth*, 2010, 40–7, 45. Gauguin's late written statements about colonialism, race and sexuality, however, show signs of being carefully thought through: see Eisenman, *Gauguin's Skirt*, 153–95. It was not lost on the Surrealists that Gauguin's grandmother was the socialist and feminist activist Flora Tristan and this strengthened their growing attachment to the artist in later years: see her unpublished correspondence dating from 1839 alongside the appreciation by André Breton, 'Flora Tristan', *Le Surréalisme, même*, no. 3, autumn 1957, 4–5 and 12.

'half-savages of Tahiti'.[8] This evaluation went much easier on the Pont-Aven and Le Pouldu paintings. It also redoubled the literary and folklorish idea of Brittany to which Gauguin had succumbed and then amplified by reproducing it in his art and statements about the region. As much as they prepared the ground for his reception by Surrealism, the myths of both the artist and Brittany propagated by Thiébault-Sisson's widely-read characterization would have found a no doubt thrilled audience among the mainly conservative readers of *Le Temps*.[9] Some of them probably went on to collect Gauguin's pictures in later years.

Gauguin's friends and admirers Maurice Denis, Georges-Daniel de Monfreid, Charles Morice and Armand Séguin wrote articles in admiration and defence of the apparently lonely, misanthropic, alcoholic, melancholic, reportedly (though not really) leprous, mad near-genius.[10] This support included Denis's eulogy in *L'Occident* in

[8] 'les demi-sauvages de Taïti', Thiébault-Sisson, 'Paul Gauguin', 2. Throughout his brief text, Thiébault-Sisson uses the nautical imagery of the shipwreck to allude at once to Gauguin's origins and supposed ruin (he states incorrectly that Gauguin's father was a Breton sailor, an understandable fabrication that was only finally dispelled by Charles Chassé in 1921), as well as his five years at sea in the merchant marine as a young man, the coastal location of some of the paintings produced in Le Pouldu in Brittany and his extraordinary journeys by sea to Panama, Martinique and French Polynesia. For some detail, see Wayne Andersen with Barbara Klein, *Gauguin's Paradise Lost*, London: Secker & Warburg, 1972. And for the overlong discussion of Gauguin's parentage with the apparently serious aim of comprehending his 'temperament', see Charles Chassé, *Gauguin et le groupe de Pont-Aven: documents inédits*, Paris: H. Floury, 1921, 8–9.
[9] For the same art critic's censure in *Le Temps* ten years earlier of Gauguin's habit of 'distorting' nature and painting 'shapeless' figures, see François Thiébault-Sisson, 'Les Petits Salons' [1893], Marla Prather and Charles F. Stuckey (eds), *Gauguin: A Retrospective*, New York: Hugh Lauter Levin Associates, Inc., 1987, 218.
[10] The leprosy claim was quashed as early as 1904 in Victor Segalen's remarkable first hand if not face-to-face testimony written from the Pacific Islands that nevertheless threw further petrol on the flames by calling Gauguin a 'monster' in the sense that he could not be inserted into any of the 'catégories morales, intellectuelles ou sociales, qui suffisent à définer la plupart des individualités', Victor Segalen, 'Gauguin dans son dernier décor', *Mercure de France*, tome 50, June 1904, 679–85, 683, 679. Marking out Gauguin's *person* in a manner close to that chosen to define Surrealism as a *practice* in the *Manifesto of Surrealism* (1924) a generation later – '[d]ictation of thought in the absence of any control exercised by reason, exempt from any aesthetic or moral concern' – it is likely that Segalen's article was known to some of the first Surrealists: André Breton, 'Manifesto of Surrealism' [1924], *Manifestoes of Surrealism*, trans Richard Seaver and Helen R. Lane, Ann Arbor: University of Michigan Press, 1972, 1–47, 26 (translation modified). Indeed, Segalen's information given in that article – first questioned by Arsène Alexandre in 1930 and now long discredited – that Gauguin was working on a Brittany landscape at the time of his death (the painting *Breton Village in the Snow* of c. 1889–90, the colours of which Segalen believed he found on Gauguin's palette but which the artist had actually transported with him to the Marquesas Islands) would have a long life in Surrealism, perhaps because it was repeated by de Monfreid among others and used to close the book by Chassé, *Gauguin et le groupe de Pont-Aven*, 90. Breton thought the anecdote demonstrated Gauguin's 'elective love' of Brittany: André Breton, 'Alfred Jarry as Precursor and Initiator' [1951], *Free Rein*, 247–56, 252. Also see Charles Estienne, 'Gauguin et le sens de la nature', *L'Observateur*, no. 149, 19 March 1953, 23. Elsewhere, the painting was taken as 'un triomphe du *modèle intérieur*' by a younger Surrealist, even though he knew about Alexandre's misgivings: Legrand, *Gauguin*, 33–4, 60. Segalen recorded later in a premonitory Surrealist or Dalinian vein that when sold at the auction of Gauguin's possessions in Papeete in Tahiti in September 1903 the painting was held on its side and mistaken by the auctioneer for an image of Niagara Falls, to the amusement of the audience, before being purchased by Segalen himself for seven francs: Victor Segalen, 'Hommage à Gauguin', Paul Gauguin, *Lettres de Gauguin à Daniel de Monfreid*, Paris and Zurich: Éditions Georges Crès et Cⁱᵉ,

October and Morice's longer one in the *Mercure de France*.[11] It also comprised the responses Morice received from a letter sent out to Symbolists and their friends, such as Eugène Carrière, Gustave Geffroy, Antoine de la Rochefoucauld, Odilon Redon and Paul Signac, asking opinions about the artist's ability, theory, work and influence, which were positive and admiring and published in the November 1903 issue of the *Mercure*.[12] Gauguin's name remained visible in the *Mercure* through this debate launched about his significance. Émile Bernard's notes on the so-called École de Pont-Aven were published in December, some lines of which had already been aired in the *Mercure* nearly ten years earlier, where Bernard sought to diminish Gauguin's teaching and pre-eminence.[13] Gauguin's importance was reasserted by Denis in the following month.[14] Then Morice quickly added to Denis's repudiation of Bernard's assessment in a review of the Gauguins recently shown at the first Salon d'Automne in 1903 and at Ambroise Vollard's gallery, also expressing the hope that they would be shown one day at the Musée du Luxembourg.[15] Two years later in 1906, the major retrospective of 227 works at the Salon d'Automne took place, which was very well received across the critical spectrum.[16] However, Gauguin's flat planes of hard, often bright colour and his recourse to dream, memory, imagination, fantasy and mysticism along with his rough-hewn symbolic, traditional or non-European and non-classical subject matter had strayed far from the essential realism of canonical French art up to and including Impressionism and Fauvism. For that reason, it continued to bemuse the government, the main cultural institutions and the general population of France.

1918, 1–77, 68, 70 (the picture is indeed reproduced on its side here as if to confirm the resemblance or lack of it); the story was familiar to Legrand, *Gauguin*, 32.

[11] Reprinted as Maurice Denis, 'L'Influence de Paul Gauguin' [1903], *Théories, 1890–1910: Du symbolisme et de Gauguin vers un nouvel ordre classique* [1912], Paris: L. Rouart et J. Watelin, 1920, 166–71; Charles Morice, 'Paul Gauguin', *Mercure de France*, tome 48, October 1903, 100–35.

[12] Charles Morice (ed.), 'Quelques opinions sur Paul Gauguin', *Mercure de France*, tome 48, November 1903, 413–33. The only weak response to Morice's letter was from Maximilien Luce; although living in Paris at the time, Luce claimed he could not remember what Gauguin's paintings looked like, which might, in fact, be a reflection of his knowledge of Gauguin's dismissive attitude towards Neo-impressionism: Morice (ed.), 'Quelques opinions', 424; equally, it might be evidence of Luce's recollection of Gauguin's widely reported studio dispute with Seurat in 1886: see John Rewald, *Post-Impressionism: From Van Gogh to Gauguin*, New York: The Museum of Modern Art, 1956, 41. This November issue of the *Mercure* also contains notice of forthcoming events to mark Gauguin's passing, including among others a lecture by Morice titled 'Le Maître de Tahiti: Paul Gauguin' and a partial reading of *Noa Noa* at the Théâtre Sarah-Bernhardt, 575–6.

[13] Émile Bernard, 'Notes sur l'École dite de "Pont-Aven"', *Mercure de France*, tome 48, December 1903, 675–82; Émile Bernard, 'Lettre ouverte à M. Camille Mauclair', *Mercure de France*, tome 14, June 1895, 332–9 (Bernard stated incorrectly in the later essay that this letter had appeared in 1894).

[14] Maurice Denis, 'Une lettre de M. Maurice Denis', *Mercure de France*, tome 49, January 1904, 286–7.

[15] Charles Morice, 'Les Gauguins du Petit Palace et de la rue Laffitte', *Mercure de France*, tome 49, April 1904, 386–96, 391. For an attempt to detail the precise indebtedness of the still-Impressionist Gauguin to Bernard in the summer of 1888 at the time of the first stay in Pont-Aven, see Rewald, *Post-Impressionism*, 195–6.

[16] Isabelle Cahn, 'Belated Recognition: Gauguin and France in the Twentieth Century, 1903–1949', Boston, Mass.: Museum of Fine Arts, *Gauguin Tahiti*, 2004, 285–301, 291.

Morice bemoaned the enduring if weakening critical and institutional resistance to Gauguin at the time of the retrospective held in the spring of 1910 at Vollard's where a previous exhibition had taken place in 1905 and where the artist had been backed in his lifetime, as did Guillaume Apollinaire in his fervent review of the show.[17] However, recognition was well on its way; the safely Impressionist *Still Life with Oranges* (1880) entered the Luxembourg in that year. That event was uncontroversial, following on from the history of extraordinary resistance to non-Salon artists by the state institution, devoted since 1818 to the preservation of contemporary art (its doors had been prised open to nonconformist art by the subscription set up by Claude Monet in 1889 and supported by Gauguin to ensure Édouard Manet's *Olympia* (1863) enter its halls, then further by the protracted, uneasy and partial acceptance of Gustave Caillebotte's bequest of his collection of Impressionist paintings in 1894–6).[18] The Tahitian work was attracting interest from buyers at that time.[19] Its international reputation was helped immeasurably by Roger Fry's hugely successful 1910–11 exhibition *Manet and the Post-Impressionists*, when Gauguin's *Barbarian Poems* (1896) featured on the poster and where his work was by far the highest represented (forty-six works compared to second place van Gogh's twenty-five out of a total of 228 in all media recorded in the catalogue).

The paintings from Pont-Aven and Le Pouldu were sought after in the decade that followed, in which Gauguin's work was showcased alone twice in Paris galleries. Yet it was only in the years after the publication of Charles Chassé's important study of 1921, *Gauguin et le groupe de Pont-Aven*, that increasing ministerial support for exhibitions of his work ensured it was bought by French museums. Chassé's book included new information collected from still-living witnesses and protagonists that was of great value, especially from the owner of the out-of-the-way inn Buvette de la Plage, Marie Henry, as well as Paul Sérusier, de Monfreid, Émile Schuffenecker and others who had known Gauguin. He finally attained comprehensive state recognition from 1927 when his work entered the Louvre with the still-reluctant purchase of *The White Horse* of 1898 and Vollard's gift of *La Belle Angèle* of 1889, along with the acquisition of the manuscript of *Noa Noa* (c. 1893–1903).[20] Early the following year, an exhibition of his sculpted and carved works took place at the Luxembourg that scored a remarkable success with an unsuspecting public, soon after which a commemorative plaque was placed at his birthplace of 56 rue Notre-Dame-de-Lorette in Paris, inaugurated in December 1933.[21] In February and March 1934, the exhibition *Gauguin, ses amis,*

[17] Guillaume Apollinaire, 'The Gauguin Exhibit' [1910], *Apollinaire on Art: Essays and Reviews 1902–1918* [1960], ed. Leroy C. Breunig, trans. Susan Suleiman, Boston, Mass: MFA, 2001, 96–7.

[18] See his approval of Monet's scheme in the letter of June 1890 to Bernard in Paul Gauguin, *Letters to his Wife and Friends* [1946], trans. Henry J. Stenning, Boston, Mass.: MFA, 2003, 143–5, 144. For the Caillebotte will and bequest, see Kirk Varnedoe, *Gustave Caillebotte*, New Haven and London: Yale University Press, 1987, 197–203.

[19] Cahn, 'Belated Recognition', 292–4.

[20] Cahn, 'Belated Recognition', 295.

[21] Cahn, 'Belated Recognition', 294, 297.

l'École de Pont-Aven et l'Académie Julian took place at the Galerie Beaux-Arts, fitting into the thematic footprint left at the same gallery the previous year by *Seurat et ses amis: la suite de l'Impressionisme*.[22]

Isabelle Cahn has written of the surge of interest in the artist's life in the years leading up to the Second World War, which helped bring about biographical and fictional accounts of his adventures by Chassé, Raymond Cogniat, Charles Kunstler, W. Somerset Maugham (his 1919 novel *The Moon and Sixpence* was translated into French in 1932) and the then important and relatively comprehensive study *Gauguin* (1938) by John Rewald, among others. Three further paintings and some ceramics and other sculpted and carved objects entered the Louvre between 1938 and 1944.[23] By the time of the major publication of his letters in French in 1946 and English in 1949, Gauguin's painting had become as inseparable from his personal legend as van Gogh's. It was tied closely, of course, to specific geographical locations that fortified the resilient and easily consumable narrative of the artist as a 'modern primitive' at odds with European civilization. Given their scepticism about the clichés of that civilization, it was only to be expected that the Surrealists would embrace it with some hesitation.

Initial Surrealist contact

The young Surrealists had a strong living bond with Gauguin in the person of Saint-Pol-Roux, the Symbolist poet they revered, who was probably present at the farewell banquet held for the artist in Paris in March 1891. Saint-Pol-Roux advised the Breton ethnographer and writer Victor Segalen in 1902 to visit the artist in Polynesia and soon came into possession of some of Gauguin's work on Segalen's return.[24] Segalen wrote the long essay I noted earlier that introduced the first edition of Gauguin's letters to de Monfreid in 1918.[25] He died prematurely in 1919, the same year as Renoir, at the time

[22] Wladyslawa Jaworska, *Gauguin and the Pont-Aven School* [1971], London: Thames and Hudson, 1972, 250.
[23] Cahn, 'Belated Recognition', 296.
[24] Rewald, *Post-Impressionism*, 485; Anne Pingeot, 'The House of Pleasure', *Gauguin Tahiti*, 263–71, 265. Segalen famously arrived on Hiva Oa in the Marquesas Islands (via New Caledonia) on 3 August 1903, three months after the artist's death. He was able to consult Gauguin's papers in the 'House of Pleasure' and speak to those who knew him before travelling back to Papeete with Gauguin's remaining possessions, purchasing twenty-four lots at the subsequent auction in September, including seven paintings. He also bought four of the five carved and painted panels from the 'House of Pleasure' and it was these that Saint-Pol-Roux (who had written to Segalen in the Marquesas requesting paintings and wood carvings by Gauguin) took on extended loan from 1905: Pingeot in *Gauguin Tahiti*, 266, 268. Also see Gilles Manceron, 'Koké and Tépéva: Victor Segalen in Gauguin's Footsteps', *Gauguin Tahiti*, 273–83; and Charles Forsdick, 'Gauguin and Segalen: Exoticism, Myth and the "Aesthetics of Diversity"', *Gauguin: Maker of Myth*, 56–63, 58–60. Segalen's lifelong fascination with Gauguin is reflected in his bibliography: see Forsdick, 'Gauguin and Segalen', 233 n. 5.
[25] Victor Segalen, 'Hommage à Gauguin' [1918], Gauguin, *Lettres de Paul Gauguin à Georges-Daniel de Monfreid*, 1–77.

that the first experiments with automatic writing were being carried out by Breton and Philippe Soupault. Also in that year appeared Charles Morice's important biographical study of Gauguin in which the young future Surrealists might have read the following: 'I note here that, with very few exceptions, poets will always show a spontaneous and profound deference to Gauguin and his art, which can be explained easily and logically by the importance that the artist attributed in his work to poetic thought, that is to say: "literary" thought.'[26] Whether he was tempted by this dubious tribute to both Gauguin and 'literature' or not, Breton's archive shows that he owned the 1921 edition of *Les Immémoriaux*, Segalen's 1907 ethnographic novel inspired by Gauguin's writings and illustrated by his drawings and de Monfreid's woodcuts, though it is not known when it entered his library.[27]

Rejecting contemporary criticism, the Surrealists identified Gauguin and Saint-Pol-Roux instead (along with the Marquis de Sade, their momentary friend Joseph Delteil, Soupault and the early nineteenth-century historian and critic Alphonse Rabbe) as 'our most remarkable contemporaries' in the final 1924 number of their review *Littérature* in the year Surrealism was launched, quoting selections from Gauguin's *Avant et après* (1903).[28] These were meant to show, on the part of the artist, an equal gravity in writing, passion in love and nonconformism in the face of literature to their own. However, their enthusiasm for Gauguin went underground from that point at the same time as their admiration for Saint-Pol-Roux took wing.[29] Cahn wrote of the late 1920s that 'the taste for "Negro" art, pre-Columbian art, Russian ballet, and Surrealism created a favourable climate for re-establishing Gauguin's relevance, in which the artist emerged as a forerunner of the return to exoticism'.[30] There is a sign of this, perhaps, in Louis

[26] 'Je note qu'à de très rares exceptions près les poètes marquèrent toujours, à la personne de Gauguin et à son art, une spontanée et profonde déférence, qui s'explique fort logiquement par la prépondérance que l'artiste attribuait, dans son oeuvre, à la pensée poétique, disons: à la pensée "littéraire"', Charles Morice, *Paul Gauguin*, Paris: H. Floury, 1919, 23.

[27] This can be viewed at http://www.andrebreton.fr/fr/item/?GCOI=56600100043241 (accessed 30 June 2014).

[28] 'D'ailleurs, à défaut de lecteurs sérieux, il faut que l'auteur d'un livre soit sérieux.'/'Ces nymphes, je les veux perpétuer ... et il les a perpétuées, cet adorable Mallarmé. . . .'/'Je hais la nullité, la demi-route. Et dans les bras de l'aimée qui me dit: "O mon beau Rolla, tu me tues," je ne veux pas être obligé de lui dire, "Non, je te rate."'/'Ceci n'est pas un livre', Anonymous, 'Nouveauté', *Littérature*, no. 13, June 1924, 23–4, 23. See these quotations in Paul Gauguin, *Avant et après*, Leipzig: K. Wolff, 1918, 4, 187, 184.

[29] Proof that Gauguin reposed in the unconscious of the first generation of Surrealists can be found in the passage of the automatic text by one of its pioneers that runs: '[t]he splash of tails then transforms the calm surface on which Gauguin's islands lie dreaming', Robert Desnos, *Mourning for Mourning* [1924], trans. Terry Hale, London: Atlas, 1992, 21. For tantalising speculations on travel and more specifically the Pacific islands as a site for understanding this early and short-lived allure Gauguin held for Surrealism, see Robert McNab, *Ghost Ships: A Surrealist Love Triangle*, New Haven and London: Yale University Press, 2004, 62–6.

[30] Cahn, 'Belated Recognition', 298. For a review of the Luxembourg show that figures Gauguin as a precursor of modern artists (the Cubists and Surrealists, by implication) in his exaltation of the non-Western, see Robert Rey, 'L'exposition Gauguin au Musée du Luxembourg', *Beaux-Arts*, year 6, no. 4, 15 February 1928, 56.

Aragon's *Paris Peasant* (1926), which logs speculation that Breton's ornate walking stick might have been 'a product of the exotic, intellectual genius of Gauguin, the man of coral and of green water'.[31] But there is no record of the 1928 Luxembourg exhibition making a mark on the Surrealists. It might very well have been this official recognition that put them off him in the 1920s and 1930s, in fact. Yet Gauguin, much more than Seurat whom they helped rehabilitate during this period as we saw in my previous two chapters, came with a bait for Surrealism, since widely broadcast anti-European, anti-French, anti-colonial, pro-'Orient' sentiments were the norm within the group from the mid-1920s.[32] This observance of a shared sympathy towards the cultures of indigenous peoples was aired only briefly at the time, at the 1931 anti-colonialism exhibition *The Truth About the Colonies*, organized by the Surrealists and the Parti communiste français, where Gauguin's remark from *Avant et après* about missionaries destroying Marquesan art was quoted beneath a wooden boat from the Marquesas Islands.[33]

Breton certainly understood Gauguin's professed sympathies with colonized peoples, then, at the time he crossed the path that had been left by the artist in Martinique in June–September 1887. This visit was a brief stopover on the island with his family and André Masson's in April and May 1941 on their way to America. However, that brush with Gauguin left barely any trace on Surrealism.[34] The surprisingly superficial nature of the acquaintance up to that period was only highlighted by the sole paragraph given to the artist in Breton's pedagogical art history lectures in Haiti in December 1945 and January 1946. There, as in *Martinique: Snake Charmer* (1948), Gauguin's relatively academic style came out second best to the near-stereotypical naivety of Henri Rousseau's. However, Breton concluded his short appraisal even then by remarking on the debt that modern painting owed to the

[31] Louis Aragon, *Paris Peasant* [1926], trans. Simon Watson Taylor, London: Picador, 1987, 163.
[32] For their most infamous protest against nationalism, xenophobia and colonialism at the banquet created for Saint-Pol-Roux on 2 July 1925, see the footnoted references in my third chapter, on Seurat. And for the 'Orientalism' that is often said to compromise Surrealism's sincerely felt opposition to colonialism through its reliance on racial and cultural stereotypes of the non-white non-European, see the short texts that first appeared in the third issue of *La Révolution surréaliste* on 15 April 1925, which are usually attributed to Antonin Artaud, 'Letter to the Chancellors of the European Universities', 'Address to the Dalai Lama' and 'Letter to the Buddhist Schools', Patrick Waldberg (ed.), *Surrealism*, London: Thames and Hudson, 1965, 57–60.
[33] 'Beneath a wooden boat from the Marquesas Islands … an array of evidence was assembled, including a comment attributed to Paul Gauguin ("Marquesian [*sic*] art has been destroyed by missionaries")', Adam Jolles, *The Curatorial Avant-Garde: Surrealism and Exhibition Practice in France, 1925–1941*, University Park PA: The Pennsylvania State University Press, 2013, 122. Jolles does not give the original French, but this was presumably the Surrealists' rendering of the following passage from Gauguin's journals: 'To return to the Marquesan art. This art has disappeared, thanks to the missionaries', Paul Gauguin, *The Intimate Journals of Paul Gauguin* [1903, pub. 1918] trans. Van Wyck Brooks, London: William Heinemann, 1923, 45 (this remark was known to the Surrealists in the original French version: Gauguin, *Avant et après*, 52).
[34] Apart from the passing mention by Breton to Gauguin's one-time presence on the island in 'The Creole Dialogue' written with Masson, there is nothing on him in the book conceived on Martinique: André Breton, *Martinique: Snake Charmer* [1948], trans. David W. Seaman, Austin TX: University of Texas Press, 2008, 44.

'*disquieting mystery*' of Gauguin's art as well as the one it owed to its formal qualities, adding of the former: '[i]t is undeniable that Surrealist painting remains a tributary of that contribution.'[35]

As I noted in the introduction to this chapter with reference to the game 'Ouvrez-vous?' and to *L'Art magique* and *Surrealism and Painting*, it was only really in the 1950s that Gauguin was given what he would have felt was his due, no doubt, in the movement. This is shown further where Breton aligned his work as well as Rousseau's, Seurat's, the Cubists' and Surrealists' with what was perceived as the most important modern art in 1952 in his essay on the May–June Paris exhibition *L'Oeuvre du XXe Siècle* organized by the Congress of Cultural Freedom (itself part subsidized by the American Central Intelligence Agency) at the then Musée National d'Art Moderne.[36] Breton's remarks about the 'moribund Musée du Luxembourg' as it was at the beginning of the twentieth century were made in a manner obviously informed by and echoing the annoyed statements of Morice, de la Rochefoucauld and Louis Vauxcelles in the years after Gauguin's death, concerning the artist's scandalous absence from the Luxembourg, as they saw it.[37] The point had been made again more extensively by Apollinaire in 1914 ('[t]he Luxembourg has nothing by Seurat, and almost nothing by Cézanne. Guys, Lautrec, and Gauguin are, for all intents and purposes, not represented there ... no Matisse, no Picasso, no Derain [etc.]').[38] Similar observations can be traced back to Gauguin himself who poured scorn on the institution in 1902 as prison, tomb and 'house of prostitution,'[39] to Alfred Jarry in the 1890s and even further back to Fénéon in 1886, the same year Seurat moved to the centre of the Parisian avant-garde and Gauguin went to Brittany for the first time.[40]

[35] '*inquiétude du mystère*'; 'Il est indéniable que la peinture surréaliste lui demeure tributaire de cet apport', André Breton, 'Conférences d'Haïti, III' [1946], *Oeuvres complètes*, vol. 3, Paris: Gallimard, 1999, 233–51, 237. This is the lecture I discussed at length in my third chapter and mentioned in my Introduction where Breton cited Gauguin's own rebuttal of Impressionism, first quoted by Jean de Rotonchamp, *Paul Gauguin, 1848–1903*, Paris: Édouard Druet et Cᶦᵉ, 1906, 210.

[36] Richard Kuisel, *Seducing the French: The Dilemma of Americanization*, Berkeley, Los Angeles, London: University of California Press, 1993, 28.

[37] André Breton, '125 Soaring Achievements at the Musée d'Art Moderne' [1952], *Surrealism and Painting* [1965], trans. Simon Watson Taylor, New York: Harper & Row, 1972, 349–53, 349; Cahn, 'Belated Recognition', 289, 290; Morice, 'Paul Gauguin', 134–5.

[38] Guillaume Apollinaire, 'An International Fine-Arts Exhibition in Paris' [1914], *Apollinaire on Art*, 408–9.

[39] Paul Gauguin, 'Racontars de Rapin' [pub. 1951], *The Writings of a Savage* [1974], ed. Daniel Guérin, trans. Eleanor Levieux, New York: The Viking Press, 1978, 215–28, 224 (this article was refused by the *Mercure de France* in 1902 and demonstrates Gauguin's awareness of and contribution to the anti-academic tone of the journal).

[40] See the attack on the commercial art of the Musée du Luxembourg (under the thin veil of the department store 'Au Luxe Bourgeois') and prescient veneration of Pierre Puvis de Chavannes, Monet, Degas, Whistler, Cézanne, Renoir, Manet, van Gogh and Rousseau, swayed by the *Mercure de France* of the first half of the 1890s, in chapter 32 of Alfred Jarry, *Exploits & Opinions of Doctor Faustroll, Pataphysician* [pub. 1911], trans. Simon Watson Taylor, Boston: Exact Change, 1996, 83–6; also the remarks on the absence of Degas, Pissarro, Manet and others by Félix Fénéon, 'Le Musée du Luxembourg', *Le Symboliste*, year 1, no. 2, 15–22 October 1886, 7–8, 8 (some of this text has been translated by John Rewald, 'Félix Fénéon (1)', *Gazette des Beaux-Arts*, vol. 32, July–December 1947, 45–62, 55).

Breton's complaint about the Luxembourg's early lapses was obviously meant to conjure up such a history of nonconformism by Gauguin, his contemporaries and their supporters. Yet it only emphasizes how slow the Surrealists themselves had been to become fully convinced of Gauguin as a precursor. Why did it happen at this late stage in his general critical appraisal and what forms did the Surrealist interpretation take? An investigation into the Surrealist vogue for Gauguin from the late 1940s, here, will lead to an unexpected swerve away from some of the more obvious themes that might connect Surrealism to the artist, which I have touched on already. It will also entail new interpretations of the Surrealist Gauguin in my next chapters.

Surrealist painting and the Gauguin centenary

The beginning of an answer to my question comes straight away, in fact: to a certain extent, the enhancement of Gauguin's standing in Surrealism mirrored the larger expansion of his status in France and elsewhere after the Second World War. In spite of the earlier institutional approval shown his work, it was only in the five-year window of 1948–53, within which fell the hundredth anniversary of his birth and fiftieth anniversary of his death, that Gauguin's art and its after-effects were fully assessed by art historians in France and elsewhere. The Surrealists' attention was caught most productively by the slightly late, so-called 'exposition du centenaire' of 6 July–14 November 1949, titled simply *Gauguin* and held at the Orangerie des Tuileries as it was then named. During 1948, journalists and critics in France had lamented the absence of an exhibition marking Gauguin's birth that would match the non-commemorative one devoted to van Gogh held in January the previous year (also at the Orangerie), which had inspired among other things the book by Antonin Artaud *Van Gogh le suicidé de la société* (1947).[41] The exhibition that followed in 1949 was only the fifth significant exposure of Gauguin's work in France (in his review of the exhibition, Denys Sutton could still describe 'Gauguin's *oeuvre* . . . and stylistic development' as merely 'tolerably well known') and the largest since the first of these, the 1906 Salon d'Automne retrospective.[42]

Sixty-one paintings are recorded among the 101 works in the catalogue of *Gauguin*. Several of them spoke directly to longstanding poetic, literary or theoretical themes of Surrealism. Most obvious among those were sleep and dream, eroticism and the role of the sovereign imagination (the creation from memory or without a model), themselves inherited by the Surrealists from Symbolist and Decadent writers and artists. Also

[41] Cahn, 'Belated Recognition', 299. See Antonin Artaud, 'Van Gogh, the Man Suicided by Society' [1947], *Selected Writings*, ed. Susan Sontag, trans. Helen Weaver, New York: Farrar, Straus and Giroux, 1976, 483–512.

[42] Denys Sutton, 'The Paul Gauguin Exhibition', *The Burlington Magazine*, vol. 91, no. 559, October 1949, 283–6, 283.

present were glimpses of occultism and Satanism, highlighted by Sutton in his review of the exhibition.[43] All was lit by an attitude of social disobedience.

We can devise a Gauguin after Surrealism through inspection of paintings shown at the 1949 exhibit such as *Te Rerioa (The Dream)* of 1897 (plate 6a). This picture can be viewed productively in line with the earlier, tender Impressionist era painting *The Little One is Dreaming (Study)* (figure 5.1, 1881) (called casually and anachronistically yet accurately by Belinda Thomson: 'a strange foretaste of his later preoccupations with the world of the unconscious'[44]) and *Clovis Asleep* (1884). The comparison sets out the

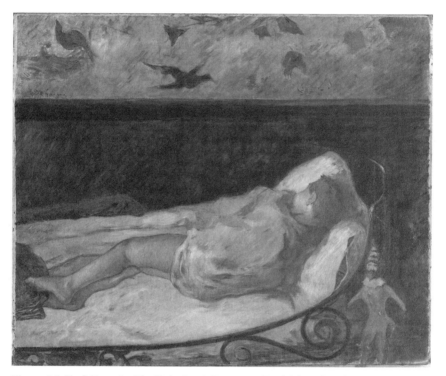

Figure 5.1 Paul Gauguin, *The Little One is Dreaming (Study)* (1881). Oil on canvas, 60 × 74 cm. Ordrupgaard, Copenhagen. Photo: Anders Sune Berg.

[43] Sutton, 'The Paul Gauguin Exhibition', 284. For a now-dated discussion of Gauguin in the light of Symbolist terminology, see H. R. Rookmaaker, *Synthetist Art Theories: Genesis and Nature of the Ideas on Art of Gauguin and his Circle*, Amsterdam: Swets & Zeitlinger, 1959, 176–224 (it is dated partly by the critique by Richard Shiff, *Cézanne and the End of Impressionism: A Study in the Theory, Technique, and Critical Evaluation of Modern Art*, Chicago and London: The University of Chicago Press, 1984, 26); and for a partial discussion of dreams and Symbolist aesthetics in relation with his painting, see Hal Foster, 'The Primitivist's Dilemma', New York: Museum of Modern Art, *Gauguin: Metamorphoses*, 2014, 48–59. The most comprehensive study of Gauguin and eroticism is by Nancy Mowll Mathews, *Paul Gauguin: An Erotic Life*, New Haven and London: Yale University Press, 2001.

[44] Thomson, *Gauguin*, 25.

difference between Gauguin the earlier ambitious bourgeois Impressionist and Gauguin the later post-Manet, post-Parisian nonconformist, even though the dreamt birds that are also wallpaper in the two paintings of the 1880s already introduce a pictorial coalition of sleep and dream or reality and fancy that would be worked with greater sophistication in what Stephen Eisenman called the 'fantastic' setting of the tapestry-like *Te Rerioa*.[45] More than in the earlier paintings, the topic of dreams seems to be approached frontally on the thinly painted, unprimed, coarse-grained hessian support of *Te Rerioa* and written onto the three main figures. These are the child sleeping in a cot, the foreground daydreamer and the female behind her. The latter's head is heavily loaded with paint, detached from yet strategically boundaried by the more finely rendered vertical doorway opening or mural. Her musings are therefore associated with the possibly imaginary rider it frames who is departing for the hills.

Gauguin himself was struck by the uncertainty and undecidability of his own painting, accidentally predicting the formalist complaint by forecasting the realist one: '[e]verything is dreamlike in this canvas', he marvelled: 'is it that of the child, the mother, the horseman on the path or even the dream of the painter!!! They will say that all this is beside the point of painting. Who knows. Perhaps not.'[46] The dissonance introduced by Gauguin through the title is continued by means of the non-communicating figures. It is extended further by the self-conscious representational complexity of the painting. The colouration, between russet and raw umber, of the wood reliefs on the walls, and the dimensions of its figures, for instance, is close enough to that of the exposed arm of the comparably scaled reposing child (figures 5.2 and 5.3) to provoke consternation in the viewer as to what is 'real' and what is not (or as to what 'reality' is in painting). Meant to re-emphasize the disorientation caused by the non-linearity of dreams, *Te Rerioa* also compares relevantly with Max Ernst's pictures-within-pictures made mainly in the early 1930s using a by-then fully developed technique of collage. These deploy image, detail and pattern to muster the odd temporal and spatial jump cuts experienced in dreams (figure 5.4). As in the non-realist (or non-Newtonian) time and space of dream explored by Ernst and other Surrealists, meaning disappears from *Te Rerioa* in a cloud of representational ambiguity under a withdrawal of narrative determinacy.

A comparable effect of epistemological uncertainty, even if it is less dramatic, is achieved in the similarly earth-toned though decorative and muted-by-grey colouration of *Nevermore* (plate 6b, 1897). Apparently, it was made from the same bolt of imperfect hessian as *Te Rerioa*, by which Gauguin inadvertently disclosed his poverty, deliberately showed his disdain for Salon and Impressionist finesse, or did both. Almost but not quite featuring one of Manet's by-then canonical gaze-returning females, the picture is usually regarded as a response to *Olympia* (copied in 1891 by Gauguin in front of the

[45] Eisenman, *Gauguin's Skirt*, 133.
[46] 'Tout est rêve dans cette toile; est-ce l'enfant, est-ce la mère, est-ce le cavalier dans le sentier ou bien encore est-ce le rêve du peintre!!! Tout cela est à côté de la peinture, dira-t-on. Qui sait. Peut-être non', letter of 12 March 1897, Gauguin, *Lettres de Gauguin à Daniel de Monfreid*, 166–9, 167 (Gauguin's punctuation retained).

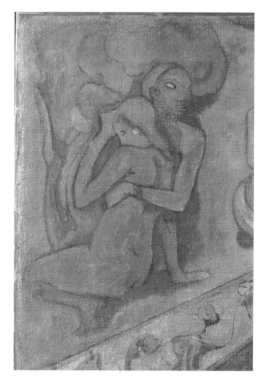

Figure 5.2 Paul Gauguin, detail of (the reliefs on the walls of) *Te Rerioa (The Dream)* (1897). Oil on canvas, 95 × 132 cm. The Courtauld Gallery, London. © The Samuel Courtauld Trust, The Courtauld Gallery, London.

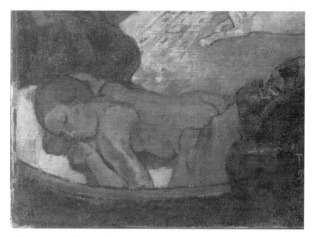

Figure 5.3 Paul Gauguin, detail of (the arm of the sleeping child of) *Te Rerioa (The Dream)* (1897). Oil on canvas, 95 × 132 cm. The Courtauld Gallery, London. © The Samuel Courtauld Trust, The Courtauld Gallery, London.

Figure 5.4 Max Ernst, *Facteur Cheval* (1932). Paper and fabric collage with pencil, ink and gouache on paper, 64.3 × 48.9 cm. The Peggy Guggenheim Collection, Venice. Peggy Guggenheim Collection, Venezia (Solomon R. Guggenheim Foundation, New York) © ADAGP, Paris and DACS, London 2018.

original, safely ensconced by then in the Luxembourg), even though it traverses a far more explicitly erotic terrain than that painting. However, the reclining Pahura in *Nevermore* does not meet the viewer within a bubble of optical communication or reciprocal miscommunication but looks away distracted. It is as though she were focusing internally, like the prostrate subject of psychoanalysis, either listening to the two figures behind her, imagining the raven or a bit of each. Gauguin said as much in a letter to de Monfreid in which he wrote that the bird was in fact not the one of Edgar Allan Poe's poem (which had been read out at the farewell banquet for the artist back in Paris), but 'the devil's lookout bird'.[47] He went on to marry its decorative quality to its imaginative content by asserting that it was not the painted subject matter of silk, velvet and gold, but the optical textures of pigment that 'are made rich by the artist's hand', adding that 'the imagination of man alone has enriched the dwelling with its fantasy'.[48]

With the diminishment of the critical reception of Symbolist painting behind the triumph of Impressionism, such an attitude towards art was usually termed 'Surrealist' by the time *Nevermore* appeared at the 1949 Gauguin retrospective in Paris. That is because the iconographic and spatial language of Surrealist art was not just familiar by then, but for many, over-familiar. This was attested to and confirmed by cultural events that preceded it in France, mainly the publication of the death-by-narration that is Maurice Nadeau's *History of Surrealism* (1945) and assaults on the movement by Henri Lefebvre, Jean-Paul Sartre and Tristan Tzara that came around the time Surrealism was attempting to relaunch itself in Paris with its international exhibition *Le Surréalisme en 1947*. After a quarter of a century of Surrealist art and art theory, Surrealists themselves and viewers of the representational labyrinth of *Te Rerioa* and the obviously related, internally preoccupied subject of *Nevermore* might have seen that Gauguin's apparently realist art performed, in fact, an estrangement from optical realism. This was accomplished by anti-narratives of dream, fantasy, deficient memory and otherwise fraught interiority that had an inheritance and theoretical elaboration, if not a stylistic heir, in Surrealism.

Yet in spite of the thematic parallels with Surrealism that Breton must have observed in the light of the retreat from realist, retinal art, evident in such paintings in *Gauguin* at the Orangerie, he did not compare Ernst or any other artist to Gauguin. As I explained, Surrealists had shown little interest till then in Gauguin's art. In fact, Surrealism was absent from the roll call in Sutton's exhibition review of avant-gardes and artists who were thought to bear the imprint of his work, from the Nabis through Picasso and the Fauves to the Camden Town Group.[49] So the impact of Gauguin's style and general approach to painting, of Gauguin as a *painter*, seemed to end with the generation that preceded Surrealism. That was the generation that came after the artist's death and probably flocked to the 1906 Salon d'Automne, whereas Cubism had

[47] 'l'oiseau du diable qui est aux aguets', Gauguin, *Lettres de Gauguin à Daniel de Monfreid*, 160–6, 165; Rewald, *Post-Impressionism*, 486.

[48] 'devenue riche par la main de l'artiste', 'l'imagination de l'homme seule a enrichi de sa fantaisie l'habitation', Gauguin, *Lettres de Gauguin à Daniel de Monfreid*, 165.

[49] Sutton, 'The Paul Gauguin Exhibition', 286.

long since interceded for the artists who followed them, even for those such as Salvador Dalí, René Magritte and, some of the time, Ernst, who traded in a spatial illusionism that at least compares with Gauguin's. Recent scholarship has proposed the presence of hidden faces and figures in Gauguin's work and posited the artist as a forerunner of Marcel Duchamp in the ways he 'conceived art as a *cosa mentale*', while Gauguin mock-guiltily recorded his discernment of a head-shaped form in a plank of pine that became *Arii matamoe* (1892) over thirty years before Ernst turned identical misperception into a creative method.[50] But there is no evidence that Dalí, Ernst or any other Surrealist painter (or anyone else for that matter) noticed such 'crypto-images' in the art of Gauguin or knew about his casual yet remarkable admission of his inference of figuration from arbitrary surfaces.[51]

Breton would not mention any Surrealist artists in his pointed surrealization of Gauguin in 1950, then, for the simple reason given in the following decade by William S. Rubin: 'Surrealist art was not in the least affected by Gauguin.'[52] Colourists such as Ernst, Masson, Matta, Joan Miró, Wolfgang Paalen, Toyen and others looked closely at Gauguin's work, no doubt; Ernst especially so, since his close friend Paul Éluard with whom he co-habited for a while in the early 1920s owned Gauguin's *Ondine/In the Waves* (1889) during that period.[53] Ernst had even created a backhanded homage shortly before Surrealism took wing in the gouache and ink *Dada Gauguin* (1920), the pale blue ground of which doubles as foam-flecked ocean and cloud-streaked sky, a backdrop for the multi-faceted, much-travelled painter of reputedly exotic lands (figure 5.5). Playing 'Ouvrez-vous' all those years later, younger Surrealist artists Adrien Dax and passer-through Simon Hantaï professed excitement at Gauguin's imaginary arrival, as did Toyen, while Paalen declared that he would greet the artist 'with joy'.[54] Yet Gauguin's example for Surrealism was not at all based on his style and had little to do with his content or colour symbolism, but was down to an epistemological position on progress and the past taken by the artist. This was first elaborated by the art historian René Huyghe in the long essay that appeared in the small booklet of the 1949 retrospective. That text merged with Surrealism's longstanding interest in primitivism and intensification of curiosity about the occult, and particularly its growing attachment in the 1950s to medievalism. It would also meet the lengthy discussion of the culture of the Celts that took place in the movement also in the 1950s, which I will demonstrate later is indissociable from the Surrealists' admiration of Gauguin.

50 Dario Gamboni, *Paul Gauguin: The Mysterious Centre of Thought* [2013], trans. Chris Miller, London: Reaktion, 2014, 8; see Gauguin's letter of June 1892 to Daniel de Monfreid: Gauguin, *Lettres de Gauguin à Daniel de Monfreid*, 90–3. Also see my review of Gamboni's book: Gavin Parkinson, 'Gauguin's Vision, or Credulity as Method', *Art History*, vol. 38, no. 5, November 2015, 970–5.
51 Gamboni, *Paul Gauguin*, 128. The connection with Surrealism is never made but see the further relevant citations and discussions in Gamboni, *Paul Gauguin*, 62, 136–7, 218 and 248; and in Dario Gamboni, 'Editorial: Visual Ambiguity and Interpretation', *Res*, no. 41, spring 2002, 5–15.
52 William S. Rubin, *Dada & Surrealist Art*, London: Thames and Hudson, 1968, 130.
53 McNab, *Ghost Ships*, 65–6.
54 'Oui, avec l'espoir qu'il restera longtemps (A. D.) . . . Oui, distrait et tourmenté (S. H.). – Oui, avec joie (W. P.) . . . Oui, amicalement (T.)', (Breton said he would receive him 'avec grands honneurs'), The Surrealist Group, 'Ouvrez-vous?' 11.

Figure 5.5 Max Ernst, *Dada Gauguin* (1920). Gouache and ink on paper, 30.3 × 40 cm. Art Institute of Chicago. © The Art Institute of Chicago/Art Resource, NY/Scala, Florence. © ADAGP, Paris and DACS, London 2018.

René Huyghe's Gauguin: between Surrealism and Medievalism

For Breton, it was the peculiar yet till then understated concordance between the Surrealists' and Gauguin's philosophical positions as that was revealed initially by *Where Do We Come From? What Are We? Where Are We Going?* (1897–8), which demonstrated the artist's antecedence. This accord came to prominence a year after the 1949 exhibition when a series of twelve broadcasts about contemporary culture were set up by the pioneer of French radio Pierre Barbier, taking place under the same title as Gauguin's important painting and consisting of interviews with Breton, Ernst, the philosopher Stéphane Lupasco and others.[55] When asked about the situation of Surrealism in 1950, Breton took the opportunity given by the shared title of painting and programme to align Gauguin's work entirely with the movement in what would

[55] Breton, *Oeuvres complètes*, vol. 3, 1329. It is worth mentioning that in 1947 Breton seems to have asked the same question as Gauguin's title in the first person in his important critical account of post-war pessimism and reappraisal of Surrealist poetics: '[w]e hide in order to ask ourselves: "Where do I come from? Why do I exist? Where am I going?"' André Breton, 'Ascendant Sign' [1947], *Free Rein*, 104–7, 105.

remain his longest statement on the artist. The core of it favourably addressed the artist's philosophical inclinations:

> It's a shame there are no television cameras here, so that we could discuss it in front of Gauguin's famous painting, a corner of which bears these words on a golden background! In that triple question resides the one true enigma, next to which the one that legend places in the Sphinx's mouth is a pathetic cliché. I've always been astonished by the platitude of that interrogation, which caused Oedipus to assume such grand airs … But with it, we're in the heart of Greek myth, and specifically facing one of the first machinations aimed at persuading man that he is master of his circumstances, that nothing that surpasses his understanding can block his way; to *infatuate* him, in short, forcing him to value his powers of elucidation, leaving him to shirk the sense of his own mystery. Gauguin was very clear on that point. You'll recall that he said, 'Always keep the Persian, the *Cambodian*, and a little of the Egyptian in mind. The great error is the Greek, no matter how beautiful it is.'[56]

This mildly opportunistic statement, allying Gauguin's distaste for Greek art and European art and civilization with the Surrealists' opposition to what Breton called 'Greco-Latin culture' in the same interview, is a reaffirmation of his statement made about some of the shortcomings of Symbolist poetry in 1936 in the article 'Marvellous versus Mystery', to which I referred in the previous chapter on Seurat and Brassaï.[57] Against the habit of certain poets such as Stéphane Mallarmé, whom he accused of seeking to fabricate mystery in their work, Breton had argued there that 'the poet and the lover must aim, in the presence of the form haunting them, at being infinitely less mystifying than mystified'.[58] In doing this, he devised an epistemological position that cast the individual as neither the clarifying genius nor self-conscious obscurantist of phenomena but, rather, their perplexed object, bemused at the spectacle of his or her own creation, like Gauguin before *Te Rerioa*.

[56] André Breton, 'Interview with J.-L. Bédouin and P. Demarne (for the Radio Programme *Where Do We Come From? What Are We? Where Are We Going?* July 1950)', *Conversations: The Autobiography of Surrealism* [1952], trans. Mark Polizzotti, New York: Paragon House, 1993, 231–7, 231–2 (translation modified, ellipsis in original). The 'triple question' preoccupied Breton for a while after as the one of Arthur Rimbaud and Germain Nouveau, as though Gauguin had asked the fundamental question also of late nineteenth-century poetry: André Breton, 'Foreword to the Germain Nouveau Exhibition' [1951], *Free Rein*, 241–3, 241. Breton and the Surrealists were still unaware at the time that Gauguin had written warmly about Rimbaud ('un ami') in the Papeete journal *Les Guêpes* (*The Wasps*) in 1899 (apparently, Gauguin had only just heard of Rimbaud's death, eight years earlier) in the context of a sarcastic diatribe against colonialism and Jean-Baptiste ('Commandant') Marchand: see Bengt Danielsson and Patrick O'Reilly, *Gauguin: journaliste à Tahiti & ses articles des Guêpes*, Paris: Musée de l'Homme, 1966, 24.

[57] Breton, *Conversations*, 232.

[58] André Breton, 'Marvellous versus Mystery' [1936], *Free Rein*, 1–6, 6. My return to Breton's earlier article here is fully justified by his remarks in that text about Gauguin's contemporaries, the main survivors of Symbolism (in Breton's eyes) into the twentieth century: the Comte de Lautréamont, Charles Cros, Rimbaud, Nouveau and Tristan Corbière, as well as Jarry and Maurice de Maeterlinck, 'who did not try to find out where the Sphinx, with all his claws in their flesh, was leading them, and who did not attempt to outwit him', Breton, *Free Rein*, 5 (rendering of translation modified).

Breton readily admitted in the interview that his entire argument about Gauguin had been derived from the lengthy essay in the 1949 centenary *Gauguin* catalogue (figure 5.6) written by the art historian René Huyghe who was then Chief Conservator of the Department of Paintings and Drawings at the Louvre. Huyghe's essay was the first attempt to hypothesize a convincing link between Gauguin's art and Surrealism by means of a general theory of knowledge and civilization drawn from psychoanalysis, as opposed to recourse to individual cultural categories such as dream, primitivism, eroticism and so on. However, there is a strong chance that its core interpretation predated both Surrealism and psychoanalysis since it is reminiscent of the appreciation by the Symbolist poet and critic Achille Delaroche, originally made in the art and literature review *L'Hermitage* in early 1894. Delaroche's response to Gauguin's recent one-man show at Durand-Ruel had contended that through his powerful mental as opposed to visual stimulus, Gauguin gave 'his dream a local habitation . . . unpolluted . . . by the lies of our civilization!'[59] Rejecting academic proportion and perspective, Delaroche had written: 'the fantastic and the marvellous spring forth' from Gauguin's art, indicating '[s]upernatural vegetation that prays, flesh that blossoms, on the indeterminate threshold of the conscious and the unconscious'.[60] As is well known, all of this was greeted with satisfaction by the artist himself who felt that the assessment matched his own aims. He demonstrated this by copying out Delaroche's essay in his *Avant et après* to confirm his consent.[61] Given the circulation of that book in Surrealist circles in the early 1920s, as noted earlier in this chapter, it is likely that it played a role in tilling the (Freudian) ground cultivated by the first Surrealists and, consequently, also facilitating the late Surrealist reception of Gauguin.[62]

Huyghe's related contention filtered through Surrealism was made in the first section of his Orangerie essay. He detailed there the rupture with Impressionism forced by Gauguin and his friends, on the basis of the importance given by the artist and Surrealism to the 'inexpressible' and unconscious:

> Odilon Redon used to say: 'Everything is done by quietly submitting to what the unconscious brings.' Gauguin, too, will be fascinated by the inexpressible, by the problem of its language; he will try to discover how to suggest the inexpressible for lack of being able to explain it, how all that speaks to the senses – line, colour, image – also speaks to the soul and has for it a mysterious sense which escapes

[59] Achille Delaroche, 'Concerning the Painter Paul Gauguin, From an Aesthetic Point of View' [1894], Gauguin, *Intimate Journals*, 20–4, 21.

[60] Delaroche in Gauguin, *Intimate Journals*, 21, 22.

[61] Thomson, *Gauguin*, 175; Gauguin, *Avant et après*, 21–7.

[62] Delaroche's essay is remarkable for its proto-Surrealist themes: the author also hailed Gauguin's 'power of suggestion that is capable of aiding the flight of the imagination or of serving as the decorator of our own dreams, opening a new door on the infinite and the mystery of things', and wrote without any knowledge of a nascent psychoanalysis, but perhaps some of Hegelian dialectics, of the new art of Gauguin as 'the connecting link between the conscious and the unconscious', and its role of 'resolving the antinomy between the sensible and the intellectual worlds', Delaroche in Gauguin, *Intimate Journals*, 22, 23.

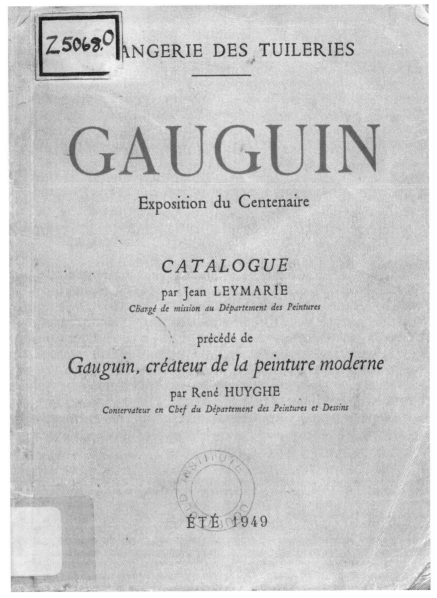

Figure 5.6 Cover of *Gauguin*, Orangerie des Tuileries, Paris, 1949. Image courtesy Book Library, Courtauld Institute of Art, London.

reason and logic and supersedes them. Thus, like Redon, he anticipated the eventual developments of modern art and half opened the door to Surrealism.[63]

This notion of a philosophical observation of and subservience to the unconscious that predetermined style, which was ethical and had a historical rationale, became the central theme of Huyghe's essay. Making a broad-brush association of the unconscious with the philosophy of the Middle Ages and its temporary displacement by the rationalism of the Renaissance and Enlightenment, in spite of the efforts of the Romantics, it was a condensed and relatively lightweight version of the art history he was concurrently preparing for publication elsewhere. This would be politically slanted, informed by detailed reading in the histories of philosophy, religion, science and pedagogy, and would be appraised with approval by the Surrealists.

Quoting the artist's rejection of the Greeks in the fourth part of his essay, subtitled 'Naissance du monde moderne', Huyghe went on to present Gauguin as nothing less than the artist-philosopher who heralded not just modern art but the modern perception of the world:

> he revolted against ancient culture, against this Greco-Latin tradition which founded Europe but which was dying of its own sclerosis. He was not alone: more clearly and more categorically than anyone else, due to the accident of his origins and genius, he expressed a disquiet that came to light with the Romantics and which, as we saw, made swift progress thereafter. . . . This being the case, did he not already express the problem that dominates our times? Over the last few years, did we not witness our civilization's dramatic effort to go beyond the limits of its overly rigidified thought, to rediscover beyond an overly codified culture the primordial ground, this unconscious which nowadays obsesses literature, art, philosophy, psychology, even medicine – all of modern life?[64]

63 René Huyghe, *Gauguin* [1954], trans. Helen C. Slonim, New York: Crown Publishers Inc., 1959, 7–8 (translation modified substantially); René Huyghe, 'Gauguin, créateur de la peinture moderne', Paris: Orangerie des Tuileries, *Gauguin: Exposition du centenaire*, 1949, xii. Redon's remark was made in the course of comments about the importance to his creative method of the '"inconscient", ce très haut et mystérieux personnage', in a letter of 16 August 1898 to his friend and monographer André Mellerio: '[t]out se fait par la soumission docile à la venue de l'"inconscient"', Odilon Redon, *Lettres d'Odilon Redon, 1878–1916*, Paris and Brussels: G. van Oest & Cᵢᵉ, 1923, 33, 34. The core argument of Huyghe's catalogue essay received wide circulation about a week before the exhibition opened in a publication that Breton wrote for regularly and read: René Huyghe, 'Gauguin: Créateur de la peinture moderne', *Arts*, no. 221, 1 July 1949, 1 and 5. The following week, the 'centenary' show dominated both front and back pages of the publication: *Arts*, no. 222, 8 July 1949, 1 and 8.

64 Huyghe, *Gauguin*, 74 (translation modified substantially); Huyghe, 'Gauguin, créateur de la peinture moderne', xxxii–xxxiii. Breton's quotation of the well-known anti-Greece passage by Gauguin was lifted from Huyghe, 'Gauguin, créateur de la peinture moderne', xxxii; and as Huyghe noted, it first appeared in a letter of October 1897 to the loyal de Monfreid that had appeared in print in 1918 in Gauguin, *Lettres de Paul Gauguin à Georges-Daniel de Monfreid*, 187–90, 190; then again, fortuitously supporting Breton's statement about Gauguin as an ally of the Surrealists in their offensive against 'Greco-Latin culture', around the same time Breton made it, in the 1950 reprint: Paul Gauguin, *Lettres de Gauguin à Daniel de Monfreid* [1918], ed. Annie Joly-Segalen, Paris: Georges Falaize, 1950, 112–13, 113.

Huyghe continued by comparing Gauguin's attitude to that taking root in Germany in the nineteenth century in the writings of Novalis. This was an assertion that was perfectly conducive to Surrealism. Even more so were the comparisons with Arthur Rimbaud that followed:

> The first to be conscious of a rupture from which the modern world would emerge, the first to have escaped Latin, European civilization (with Rimbaud, however!), to rediscover primordial impulses among barbarian tales and savage gods, the first to have dared, lucidly and radically, to transgress and repudiate outer reality and rationalism, was Gauguin.... When Occidental art used the known as its pole, Gauguin gave it the unknown as an aim, towards which, young Rimbaud alone had launched his *Bateau Ivre*.[65]

Surrealism by no means dominates Huyghe's essay by name. In fact, at the very moment Breton was claiming it as a Surrealist reading of Gauguin, another essay by Huyghe was circulating in the catalogue of the July–September 1950 exhibition *Gauguin et le groupe de Pont-Aven* at the Musée des Beaux-Arts in Quimper that borrowed heavily from the Orangerie catalogue, in which Huyghe maintained that Gauguin had synthesized form and content whereas 'Surrealism, pursuing the descent into the unconscious, sacrificed the plastic', while abstraction, on the other hand, had forgone content.[66] Equally, the parallels Huyghe drew between music and Gauguin's art, prompted by the artist's own writings and elaborated in his lifetime by Delaroche, were edited out of the warm appraisal by Breton, probably due to his dislike of, or at least staged bafflement about music.[67]

However, it is undeniable that all of the main emphases of Huyghe's essay were coloured by Surrealism: the general curve of its history pitched vigorously against the initiation of rationalism and naturalism in Greek and Roman philosophy and art; the weakening of that culture in the later Middle Ages, then its return to prominence through Thomas Aquinas's attempt to synthesize Aristotle's philosophy with Christian tenets in the thirteenth century; its advancement in 'bourgeois positivism' until the return to a tolerance of discussion of the irrational in art and psychoanalysis in the mid-nineteenth century – all might have been extracted from the discourse of pre-war

[65] Huyghe, *Gauguin*, 91 (translation modified); Huyghe, 'Gauguin, créateur de la peinture moderne', xxxvii. The presence of Novalis and Rimbaud in the pre-Surrealist pantheon had been sustained since the *Manifesto*: Breton, *Manifestoes*, 19, 27, 39 n. 1.

[66] 'Le surréalisme, poursuivant la descente dans l'inconscient, a sacrifié la plastique', René Huyghe, 'Gauguin', Quimper: Musée des beaux-arts, *Gauguin et le groupe de Pont-Aven*, 1950, 7–14, 11. As well as twenty-two paintings, drawings and other works by Gauguin, this exhibition showed fourteen paintings and watercolours produced in Pont-Aven and Le Pouldu by Charles Filiger, and since most of these had never been seen in public and Breton was currently obsessed by and collecting that artist's work, it is more than likely that he attended the event.

[67] For his coinage of the term 'Orphic art', well before Apollinaire used the term for Robert Delaunay's brand of Cubism, see Delaroche in Gauguin, *Intimate Journals*, 22–3. The main musicophobic statement (even though it is not as severe as some have imagined) is André Breton, 'Golden Silence' [1946], *Free Rein*, 70–4.

Surrealism.[68] In fact, there is a very good reason for assuming that they were and it is one that is quite apart from a casual awareness of the movement. Although Breton made much of Huyghe's objectivity in his interview, saying 'rather than appearing to "blow my own horn," I've preferred to yield the floor to an art historian, an impartial witness of life and intellect', Huyghe had been close enough to Surrealism as a young and precocious curator at the Louvre around 1929–34 to participate with Breton and Nusch Éluard in the game of the 'exquisite corpse' (he kept the resulting composition until 1962) (figure 5.7).[69] Presumably, therefore, he became well acquainted with Surrealist themes and ideas at their living source within the group. The overview of Surrealist art in his 1939 book about contemporary French painting goes some way towards confirming that.[70]

It turns out that the widely distributed account of Gauguin's place in the bold if sketchy, philosophically informed model of artistic development from the Middle Ages to modernity, given by Huyghe at the time of the centenary, was part of a much larger work in progress. This was revealed in the 1950s and followed closely by the Surrealists. In 1952, he published the article 'La pensée médiévale et le monde moderne' in the special issue of *Cahiers du sud* devoted to 'Perspectives on Medieval Thought'.[71] Huyghe argued that the Middle Ages were not merely a distant historical entity, but an epistemological event with immense current relevance. He proposed two periods that were broken by a fifty year passage from 1150–1200, leaving behind not simply two styles but 'two conceptions of the world'.[72] The first of these survived in Romanesque architecture and sculpture, he argued, after which, from the thirteenth century, 'a profound revolution takes place, of which the visible trace is the passage from the Romanesque to the Gothic . . . it is the modern world that is born, our very civilization,

[68] Huyghe, *Gauguin*, 91. Surrealism's flat out scepticism about the period of the Renaissance up to the beginning of modernism in the mid-nineteenth century (with some exceptions made for various artists and writers in between) is widely advertised. Breton's 1936 essay on Symbolist poetry, for instance, which was first published in *Minotaure* and to which I alluded above and in my Introduction and fourth chapter, makes a statement that compares with Huyghe's, even though it allows an extra century before the realist 'reaction' set in, beginning: 'Splendid nineteenth century, before which you have to leap back to the fourteenth in order to soar into the same formidable sky of tiger-cat skin!' Breton, *Free Rein*, 1. For the continuity of Breton's attitude on the epistemological hiatus between the Middle Ages and nineteenth century, see the important early essay that announced 'Latin civilisation has had its day' and extended the Surrealist captivation with the medieval castle begun in the *Manifesto*: 'One of these suits of armour seems almost my size; if only I could put it on and find in it a little of the consciousness of a fourteenth-century man', André Breton, 'Introduction to the Discourse on the Paucity of Reality' [1924], *Break of Day* [1934], trans Mark Polizzotti and Mary Ann Caws, Lincoln and London: University of Nebraska Press, 1999, 3–20, 18, 4. Breton referred again to the 'admirable fourteenth century' in the *Second Manifesto of Surrealism* (1930), and its conjunction there with the reputed alchemist Nicolas Flamel (*c.* 1330–1418) might explain his specificity (though another important figure to Surrealism, Meister Eckhart, published most of his writings in that century too): André Breton, 'Second Manifesto of Surrealism' [1930], *Manifestoes*, 117–94, 173.
[69] Breton, *Conversations*, 234.
[70] René Huyghe, *Le peinture française: les contemporains*, Paris: Éditions Pierre Tisné, 1939, 53–5.
[71] For more on *Cahiers du sud* and Surrealism, see Alain Paire, *Chronique des Cahiers du sud, 1914–1966*, Paris: IMEC, 1993, 109–19.
[72] 'deux conceptions du monde', René Huyghe, 'La pensée médiévale et le monde moderne', *Cahiers du sud*, year 39, no. 312 ('Perspectives sur la pensée médiévale'), 1953, 181–96, 182.

Figure 5.7 Untitled 'exquisite corpse' by André Breton, Nusch Éluard and René Huyghe (*c.* 1933). Pastel and coloured wax crayon on paper, 31.8 × 24.1 cm. Sold at Christie's 2011, current location unknown. © Christie's Images/Bridgeman Images. © ADAGP, Paris and DACS, London 2018.

even.'[73] The blank, even abstract massiveness of the Romanesque, he insisted, had a denotation that corroborated an active subjectivity, which stood out from the passivity belied by the Gothic. The former 'starts from ideas, from concepts that it introduces into real life and which it imposes there', he wrote, whereas 'the Gothic, by contrast, lends itself to the dictation of this real life'.[74]

By the 'modern world' of his title, Huyghe meant the one that existed from the late Middle Ages up to the nineteenth century; the one that had prioritized and was formed by positivism, realism and rationalism. Making a broad philosophical distinction between the dominance of the Neoplatonism of Plotinus and Saint Augustine up to the late twelfth century and the Aristotelianism of Aquinas and Roger Bacon that had eclipsed it, Huyghe argued that where the first had posited a physical world of 'Non-Being ... presenting only marked-out reflection, diluted from pure models', the second was deeply attached to nature and had established new habits of experiencing the world through the senses, particularly vision.[75] Both Romanesque and Byzantine art, then, were deeply informed by symbolism, whereas the Gothic relied equally heavily upon truth-to-nature, which reached its climax in the Renaissance and nadir in the indolent and feigned realism of nineteenth-century academic art. The modern world was so mightily steeped in the Aristotelian legacy, Huyghe maintained, that modern art had only recently been able to begin the escape from realism:

> [Nicolas de] Condorcet admired Aristotle, and Auguste Comte, the Pope of positivism, proclaimed him 'the incomparable Aristotle.' In this way, the eighteenth century in its novelty and the nineteenth century in its pride are both placed under the same invocation; in this way, the profound connection that binds them and makes them interdependent is made clear. When the science of the nineteenth century would refuse any confirmation that had not been demonstrated by experience in the physical world, it was simply confirming itself at the end of the great enterprise hatched and formulated in the eighteenth.[76]

What Huyghe called the 'excess of scientism' met its 'inevitable' reaction in the late nineteenth century with 'the discredit of realism and its positive convictions'.[77] He

[73] 'une révolution profonde s'est accomplie, dont la marque visible est ce passage du roman au gothique ... c'est le monde moderne qui est né, notre civilisation même', Huyghe, 'La pensée médiévale et le monde moderne', 182.

[74] 'part d'idées, de concepts qu'il introduit dans la vie réelle et qu'il y impose; le gothique, au contraire, se prête à la dictée de cette vie réelle', Huyghe, 'La pensée médiévale et le monde moderne', 182.

[75] 'Non-Être ... ne présente que le reflet particularisé, abâtardi des modèles purs', Huyghe, 'La pensée médiévale et le monde moderne', 185.

[76] 'Condorcet admirait Aristote et Auguste Comte, pape du positivisme, le proclamait "l'incomparable Aristote." Ainsi le XIIIᵉ siècle, dans sa nouveauté, et le XIXᵉ siècle, dans son orgueil, se plaçaient l'un et l'autre sous la même invocation; ainsi se dégage le lien profond qui les relie et les rend solidaires. Quand le XIXᵉ siècle, scientifique, se refusera à toute affirmation qui ne serait démontrée par l'expérience, dans le monde physique, il se révèlera simplement au terme de la grande entreprise éclose et formulée au XIIIᵉ', Huyghe, 'La pensée médiévale et le monde moderne', 188.

[77] 'excès de scientisme', 'le discrédit du réalisme et des convictions positives', Huyghe, 'La pensée médiévale et le monde moderne', 191.

situated Eugène Delacroix and Charles Baudelaire as precursors whose visionary tendencies eclipsed the 'mere' visuality of realism. This was confirmed for Huyghe in their theoretical writings, where he heard echoes of Plotinus's third-century Neoplatonism and even Abbot Suger's appeal towards a higher Truth beyond materialism in the mid-twelfth century. Huyghe claimed of this reaction to realism and positivism: 'Symbolism was the first sign of it.'[78] Early modern art, that is to say, 'adopting anew, without knowing it, the Neoplatonian and Augustinian convictions that would establish Romanesque art, reduces "reality" to being no more than an allusion, harbouring and revealing a spiritual truth.'[79] According to Huyghe, this transition was manifested in the art and statements of Gauguin and Redon.

Breton's own writing was responsible in part, no doubt, for Huyghe's account of the episteme of modern thought and its culture. This must have been especially the case for the *Manifesto of Surrealism* (1924), which had been widely read and quoted by then; increasingly so after it was republished by Éditions du Sagittaire on Breton's return to France from America in 1946. From that year, readers could reacquaint themselves with the scene-setting attack in the *Manifesto* on the 'realistic attitude, inspired by positivism, from Saint Thomas Aquinas to Anatole France', deemed by Breton 'hostile to any intellectual or moral advancement' and 'made up of mediocrity, hate, and dull conceit'.[80] However, when Breton read and lauded what he called at the time Huyghe's 'luminous and peremptory' article in *Cahiers du sud*, he would have been impressed as much by the ways in which its conclusions coincided with Surrealism's present as with its past, or let us say by the materials it contributed to Surrealism's efforts to root its contemporary concerns of the 1950s in its own past.[81] That is, first, because this was the period in which the movement as a whole was looking more than ever towards magic, occultism and the Middle Ages as means towards understanding and criticising the existing state of 'Greco-Roman' European culture and civilization, and Huyghe's article, like his essay in the *Gauguin* catalogue, showed how their concurrent interpretation of Gauguin's work could be assimilated to that new paradigm. Secondly, Huyghe's historically contextualized relegation of realism to a pre-modern past bolstered the Surrealists' campaign against the socialist realism of the Soviet Union that was being helpfully elucidated in *Les Lettres françaises* in the mid-1950s by Aragon and condemned by Breton in response in *Arts*, and which was implicated in his agreement with Huyghe that realism was now 'discredited in advance for its inherent backwardness'.[82]

[78] 'Le symbolisme en fut le premier signe', Huyghe, 'La pensée médiévale et le monde moderne', 191.
[79] 'adoptant à nouveau, sans le savoir, les convictions néo-platoniciennes et augustiniennes qui fondèrent l'art roman, réduit la "réalité" à n'être plus qu'une allusion, recélant et révélant une vérité spirituelle', Huyghe, 'La pensée médiévale et le monde moderne', 191.
[80] Breton, *Manifestoes*, 6.
[81] 'lumineux et péremptoire', André Breton, 'Sur le réalisme. À propos d'un article de René Huyghe' [1952], *Oeuvres complètes*, vol. 4, Paris: Gallimard, 2008, 1199 (this comment remained unpublished in Breton's lifetime).
[82] 'par avance disqualifiée pour vice de retard', Breton, *Oeuvres complètes*, vol. 4, 1199. The major statement is André Breton, 'Of "Socialist Realism" as a Means of Mental Extermination' [1952], *Free Rein*, 274–7.

These two essays by Huyghe were the first published evidence of the research that became the major study of 1955, *Dialogue avec le visible*, translated into English soon after as *Ideas and Images in World Art*.[83] In this book, Huyghe elaborated further his theory of the rise and fall and rise again of symbolism in art from the Middle Ages to modernity. Here it was given a sharpened political critique, however, with its claim that 'the gradual rise, from the twelfth century on, of the bourgeoisie contributed to the restoration in the West of the direct sense of material reality, which had characterized the harshly positivist Romans.'[84] It took the colour symbolism of Gauguin and his followers from the Académie Julian who called themselves Nabis to rescue European art from its literalism, according to Huyghe, and through them: '[t]he way [was] paved for Cubism, and the abstract art which followed it.'[85] There was much in the richly informed, extensive art historical arc drawn by Huyghe in *Dialogue avec le visible*, which states its bias plainly against mimetic 'passive, barren realism' and for 'active, inspired' and 'poetic' realism, that the Surrealists would have recognized as their own.[86] Yet the author's declared Bergsonism put off Breton and Legrand from incorporating his conclusions more extensively when they used *Dialogue avec le visible* as factual support for their similarly ambitious survey *L'Art magique*, along which channel Gauguin was brought definitively into the Surrealist canon.[87]

Huyghe's essay in the *Gauguin* catalogue, with its Surrealist-inflected account of the centuries-long catastrophe of realism in Europe and of Gauguin's primary role in forcing an epistemological revolution that ended it, continues to constitute an important cultural event alongside the 1949 'centenary' showing of the artist's work. Both the text and the display were crucial means by which Gauguin was understood in the twentieth century and this has been augmented by their extensive afterlife. Taking place at mid-century, the exhibition was not only the largest and most prominent showing of Gauguin's work in France since the 1906 Salon d'Automne, but it would remain so until the 1988 show at the National Gallery of Art in Washington that went on to the Art Institute of Chicago then arrived at the Grand Palais in Paris. In addition to this, the catalogue essay by Huyghe was recycled in its entirety for the 1954 monograph *Gauguin*, translated into English for an American publisher in 1959. Its grand narrative might lack nuance, detail and complexity and it may not be cutting edge art history, but its argument has gained a huge audience because that book has been reprinted every decade since in French, English, German, Spanish, Swedish and Japanese versions, usually at the time of retrospectives of the artist's work and most recently in English in

83 René Huyghe, *Dialogue avec le visible*, Paris: Flammarion, 1955.
84 René Huyghe, *Ideas and Images in World Art: Dialogue with the Visible* [1955], New York: Harry N. Abrams, Inc., 1959, 138.
85 Huyghe, *Ideas and Images in World Art*, 161.
86 Huyghe, *Ideas and Images in World Art*, 155.
87 See André Breton, *L'Art magique* [1957], Paris: Éditions Phébus, 1991, 214 (for Huyghe's contribution to the inquiry into magic art in this book, see 320). Huyghe had earlier introduced Bergson as a kind of unwanted precursor to Surrealism in his discussion of the movement's art: Huyghe, *Le peinture française*, 54. The Surrealists continued to confirm the relevance of *Dialogue avec le visible* to their reading of Gauguin well into the 1960s: see Legrand, *Gauguin*, 36 n. 1.

2011 to coincide with the Tate Modern exhibition *Gauguin: Maker of Myth* that went on to the National Gallery of Art in Washington in February that year.

Charles Estienne's Gauguin: between Surrealism and abstract art

Marcel Jean missed the point when he gave only a couple of lines to Gauguin in his preamble to his *History of Surrealist Painting* in 1959.[88] Gauguin had already entered the pre-Surrealist lineage by then and Huyghe could jot down Surrealism's ancestry in Symbolist art generally and Gauguin's particularly without a supporting argument by the 1970s. In that decade, he declared of modern art after Impressionism that 'from Symbolism to Surrealism, from Gauguin and Redon to Max Ernst and Yves Tanguy, Art would no longer propose to explore the external, objective world, which was assigned to the physical sciences, but to the inner, subjective world, which is sunk in the shadows of the unconscious. . . .'[89] As I have explained, Huyghe was largely responsible for originating that association, which later on could be routinely tendered in this way.

However, there was another version of Gauguin on offer as filtered through the culture of Surrealism at mid-century. It supplemented the one given by Huyghe and promoted by Breton, similarly triangulating the artist and the movement with the revival of interest in the Middle Ages in France in the 1950s. Rather than using the glue of the history of philosophy though, this Surrealist-limned Gauguin would be secured by means of the more recent history of abstract art and a concept of the artist-pedagogue. Translated into numerous languages in the 1950s and 1960s, it can be found in the lush, all-colour, compact 1953 study *Gauguin*, published through Skira by Charles Estienne in the same series 'The Taste of Our Time' as Georges Bataille's *Manet* of 1955.[90] Estienne had been chief among those in 1948 who were justifiably fretting about the possibility of Gauguin being ignored in France on his centenary, suggesting in *Combat* that his rejection by the French state and the subsequent scarcity of his paintings in France was the reason for this lapse (as would continue to be the case for Seurat).[91] In five-year retrospect, those concerns must have seemed exaggerated as

[88] Marcel Jean with Arpad Mezei, *The History of Surrealist Painting* [1959], trans. Simon Watson Taylor, New York: Grove Press, 1960, 13, 21 (nothing by Gauguin is reproduced by Jean while Seurat, on the other hand, is treated prominently with *Circus* and *Chahut* given a full page each).

[89] 'du Symbolisme au Surréalisme, de Gauguin et de Redon à Max Ernst et à Tanguy, l'Art se proposa d'explorer, non plus ce monde extérieur, objectif, qui est imparti aux science physiques, mais ce monde intérieur, subjectif, qui s'enfonce dans les ombres de l'inconscient', René Huyghe, *Ce que je crois*, Paris: Bernard Grasset, 1976, 54. A more recent art historian took 'such poetic-minded artists as de Chirico and Chagall' as the 'Surrealist' offspring of Gauguin: Charles Stuckey, 'Gauguin Inside Out', Eric M. Zafran (ed.), *Gauguin's Nirvana: Painters at Le Pouldu 1889–90*, New Haven and London: Yale University Press, 2001, 129–41, 141.

[90] Charles Estienne, *Gauguin*, trans. James Emmons, New York: Skira, 1953. Estienne's book appeared on its initial publication in French, English, German and Italian versions; it was republished in Italian and Spanish in 1967 then again in 1989 in French in a larger format.

[91] Charles Estienne, 'Centenaire de Gauguin', *Combat*, no. 1220, 9 June 1948, 4; Cahn, 'Belated Recognition', 299.

Estienne's book was published to coincide with yet another exhibition starring the artist titled *Exposition d'oeuvres de Paul Gauguin et du Groupe de Pont-Aven*, staged at the Hôtel de Ville in Pont-Aven in August and September 1953. It took place around the time Breton typically spent his summer holiday in Brittany. Since he owned the catalogue of the show and was very friendly by then with Estienne, who was from the region and spent long periods there at the family home in the small port of Argenton in Finistère, there is every chance they saw it together.[92]

Estienne came to prominence as an art critic from 1940 when he was made a correspondent for the magazine *Beaux-Arts*. He wrote especially on Paul Sérusier whom he then saw as a precursor of both Cubism and Surrealism and compared with Tanguy, portraying both artists as vernacular abstractors of the 'Celtic' landscape of his native Brittany.[93] During that period, he was teaching history in one lycée after another, mainly in Brittany where he had come into contact with artists (notably the early twentieth-century Pont-Aven painter Jean Lachaux who had known Sérusier).[94] Estienne's principal promotional efforts as a writer and curator in the 1940s would be in the service of abstract art, yet by late in that decade he had further divided his theoretical interests between Gauguin's art and Surrealism, as I will show.[95] Breton probably became aware of Estienne on arriving back in Paris from New York in 1946. By then, the critic was spending much of his time in the capital and was displaying a knowledge of and attraction to Surrealism in several art periodicals including *Combat* and *Terre des Hommes*.[96] Estienne recalled that his first encounter with Breton had been at *Le Surréalisme en 1947*.[97] Breton would have read Estienne's astute review of that exhibition in *Combat*,[98] in which year Estienne elsewhere compared van Gogh to the Comte de Lautréamont.[99] Breton's archive shows that he certainly knew of Estienne's

[92] This was only one of many publications Breton owned on Gauguin, more than on almost any other non-Surrealist artist including Gustave Moreau, in fact. For biographical material on Estienne, see René de Bihan, 'Les Trois Bretagne de Charles Estienne', Brest: Musée des Beaux-Arts, *Charles Estienne, une idée de nature*, 1984, n.p.

[93] Charles Estienne, 'À Châteauneuf-du-Faou chez Paul Sérusier', *Beaux-Arts*, no. 25, June 1941, 3. Also see the brief, early piece pondering the importance of the ideas of the Dutch painter and frequenter of Pont-Aven and Le Pouldu, Jan Verkade, for Sérusier's development as an artist: Charles Estienne, 'Sérusier et le Père Verkade', *Beaux-Arts*, no. 89/90, December 1943, 13.

[94] Paris: Centre National des Arts Plastiques, *Charles Estienne & l'art à Paris 1945–1966*, 1984, 98; Nathalie Reymond, 'L'art à Paris entre 1945 et 1950, à travers les articles de Charles Estienne, dans *Combat*', Centre Interdisciplinaire d'Étude et de Recherche sur l'Expression Contemporaine (ed.), *L'Art et idéologies: l'art en Occident, 1945–1949*, Saint-Étienne: Université de Saint-Étienne, 1978, 173–94, 175.

[95] It is recorded that Estienne bought a copy of the re-edition of Max Ernst's *Une Semaine de bonté* (1934) as early as 1944: Centre National des Arts Plastiques, *Charles Estienne*, 100.

[96] See the brief, enthusiastic comparison of the work of Masson (then on view at the Galerie Louise Leiris) to the poetry of Benjamin Péret in an article said to have received its tone from the recent novel by Julian Gracq, *The Dark Stranger* (1945): Charles Estienne, 'André Masson ou la mythologie de la nature', *Terre des Hommes*, no. 13, 22 December 1945, 3; also, the early, tentative attempt to discuss Surrealism and current abstract art in the same breath: Charles Estienne, 'Surréalisme et peinture', *Combat*, no. 564, 31 March 1946, 2.

[97] See http://www.fabriquedesens.net/A-propos-d-Andre-Breton (accessed 4 August 2016).

[98] Charles Estienne, 'Surréalisme et peinture', *Combat*, no. 940, 16 July 1947, 2.

[99] Charles Estienne, 'La Réponse de Van Gogh', *Fontaine*, year 8, no. 59, April 1947, 139–47.

writings by 1948.[100] When Estienne stated in that year that is would be 'intolerably scandalous' if there were to be no Gauguin retrospective, he argued similarly to Huyghe that the artist had opposed a rationalism inaugurated during the Renaissance.[101] But this interpretation would be impacted by his immersion in contemporary art and would take in the 1950s a different inflection to the more academic and historically deeply rooted one formulated by Huyghe.

Estienne was becoming deeply absorbed in Surrealist art and writing at the end of that decade, as can be seen in his criticism. From 1952 he would go on to attempt, with partial and temporary success, to bring about a rapprochement between Surrealism and abstract art. This effort is understood by Steven Harris as follows:

> Perceiving an affinity between the Surrealist theory of automatic expression and the abstract painter Wassily Kandinsky's proposal that art was the expression of 'inner necessity' – an affinity underscored by the Surrealists themselves, who had admired Kandinsky's work since the 1930s – Estienne set himself a double task: on the one hand, to convince the Surrealists of the identity of Surrealist and abstract procedures, by means of his writing on Kandinsky; and, on the other, to convince contemporary abstract artists of the relevance to their own working process of Surrealist theory and practice.[102]

In this way, Estienne became one of the main promoter-theorists of lyrical abstraction, embarking on the task of convincing Breton of the value of contemporary non-Surrealist painting.[103] To achieve this, his writings on Kandinsky built on observations made by Breton himself who had positioned that artist alongside Surrealists like Masson on the occasion of Kandinsky's first solo exhibition in Britain, held at

[100] Breton kept a clipping from a November 1948 issue of *Combat* of Estienne's review of the Adolf Wölfli exhibition, the first event organized by the Compagnie de l'art brut of which Breton had been a founder member that year: see http://www.andrebreton.fr/fr/item/?GCOI=56600100865180 (accessed 17 June 2014).

[101] 'intolérablement scandaleux', Estienne, 'Centenaire de Gauguin', 4. When the exhibition finally happened a year later and he gave it a surprisingly short if favourable review (in spite of its lack of depth, he said), Estienne passed over Huyghe's essay but referred briefly and admiringly to Leymarie's concise effort in the same catalogue: Charles Estienne, 'Gauguin à l'Orangerie', *Combat*, no. 1556, 6 July 1949, 4. Estienne soon returned to Gauguin in *Combat* while the show was still running, repeating the claim made in these earlier articles that he was the 'principal initiateur de la peinture moderne', Charles Estienne, 'Gauguin et nous', *Combat*, no. 1562, 13 July 1949, 4.

[102] Steven Harris, 'The Gaulish and the Feudal as *lieux de mémoire* in Postwar French Abstraction', *Journal of European Studies*, vol. 35, no. 2, 2005, 201–20, 204.

[103] His success in this can be measured from Breton's note on the cover of *Combat-Art* on 1 March 1954 (shared with Estienne's controversial, double history/aesthetic essay 'Une révolution: le tachisme' affirming Surrealism's currency and stating post-war non-figurative art was 'une protestation contre la réalité extérieure'), announcing his support for Estienne's 'Salon d'Octobre' of new painters: André Breton, 'October Lesson' [1954], *Surrealism and Painting*, 337–8; Charles Estienne, 'Une révolution: le tachisme', *Combat-Art*, no. 4, 1 March 1954, 1 and 2, 1; Centre National des Arts Plastiques, *Charles Estienne*, 93. In response to criticism of his article, Estienne gave a mini-history of his efforts at a rapprochement between abstraction and Surrealism since 1946: Charles Estienne, 'Dont acte', *Combat-Art*, no. 5, 5 April 1954, 1 and 2.

Guggenheim Jeune in London in 1938. Proclaiming that he knew 'of no art since Seurat with more philosophical foundation than that of Kandinsky', Breton meant to refer to the artist's rejection of the mere representation of the world in favour of a rampantly suggestive line discovering poetic analogies everywhere in nature.[104]

These brief speculations were added to by Estienne in articles on abstract art published in various journals after the war, some of which were collected as the slim volume of 1950 titled *L'Art abstrait: est-il un académisme?* (figure 5.8). In this widely-read book, Surrealist automatism and the movement's non-academic commentary on the relationship between poetry and painting – namely, the emphasis placed by the Surrealists on a subjective 'sounding' in (or, as identical with) the act of painting and writing – is viewed as the means to bypass the regulatory interference created by taught practice in schools. Estienne associated such pedagogy with 'objective art' or what he called 'cold abstraction' and elsewhere (in contrast with Kandinsky's 'living' language), 'the dead signs of a scholastic frigidity'.[105] Surrealist 'techniques' for making art that were originally developed in the writing of poetry were viewed by Estienne, then, as means of avoiding 'official' artistic schooling:

> If Breton and the Surrealists were able to point at certain moments to certain means to capture poetry – through a hypnogogic state for example – it was to quickly adopt others; and automatism, the Surrealist means par excellence, existed only as the sign of the all-consuming liberty that set everything alight to achieve its aim: the creation of man by himself at the starkest centre of the created work.[106]

Since Kandinsky had indeed taught at the Bauhaus, as Estienne acknowledged, he offers a poor test case on first sight for this anti-methodical argument against teaching. With his efforts straining at the seams, Estienne tried to get around this by affirming the primacy, over his institutional pedagogy and technical instruction, of Kandinsky's 'spiritual' teaching – '[t]he best, the only masters are spiritual masters', he insisted[107] – which message, he writes unconvincingly, seems to have been overlooked by

[104] André Breton, statement in *Wassily Kandinsky*, London: Guggenheim Jeune, 1938, n.p. (for another translation, see André Breton, 'Kandinsky' [1938], *Surrealism and Painting*, 286). Breton had bought work by Kandinsky as early as 1929 at the painter's first solo show in Paris; when Kandinsky moved to Paris in 1933 Breton welcomed him enthusiastically and the artist even engaged in meetings of the Surrealist group at that time: Mark Polizzotti, *Revolution of the Mind: The Life of André Breton*, New York: Farrar, Straus and Giroux, 1995, 392 n. 1.

[105] Charles Estienne, *L'Art abstrait: est-il un académisme?* Paris: Éditions de Beaune, 1950, 9; 'les signes morts d'une froide scholastique', Charles Estienne in *Kandinsky*, Paris: Éditions de Beaune, 1950, 3.

[106] 'Si Breton et les surréalistes ont pu indiquer à certains moments certains moyens de pister et piéger la poésie, – l'hypnagogie par exemple –, c'était pour en adopter rapidement d'autres; et l'automatisme, moyen surréaliste par excellence, n'a jamais existé que comme signe de la dévorante liberté qui fait feu de tout bois pour atteindre son but: la création de l'homme par soi-même au coeur le plus nu de l'oeuvre créée', Estienne, *L'Art abstrait*, 8.

[107] Estienne, *L'Art abstrait*, 8.

Figure 5.8 Cover of Charles Estienne, *L'Art abstrait: est-il un académisme?* (1950).

Kandinsky's own students judging by the complete absence of any of them among the most important contemporary painters.[108]

Estienne sent a dedicated copy of *L'Art abstrait* to Breton who kept up with Estienne's other writings on Kandinsky. These were steered in the direction of Surrealism not just through reference to the movement's by-then copious bibliography, but also to its precursors. In one instance, in a catalogue essay for a Kandinsky show of 1949 in Paris that immediately preceded the Gauguin 'centenary' exhibition, Estienne called upon Novalis and Rimbaud, the same poets about to be referred to by Huyghe in his Orangerie essay in *Gauguin*, to petition for the emotional, intuitive (not rational, mathematical) and therefore poetic propensity (in the Surrealist sense of an improvised self-sounding) in Kandinsky's method of picture-making in his *période parisienne* from 1934.[109]

[108] Estienne, *L'Art abstrait*, 9. Estienne was presumably unaware at the time of the Danish Surrealist painter and writer on art Vilhelm Bjerke-Petersen, then living in Sweden, who had studied under Kandinsky and Paul Klee in 1930–1, and whose work Breton had known since the 1930s.

[109] Charles Estienne, 'Actualité de Kandinsky', Paris: Galerie René Drouin, *Kandinsky: époque parisienne 1934–1944*, 1949, n.p. (this exhibition ran from 2 June to 2 July 1949). Also see the passing reference to Novalis (and Breton) in Charles Estienne, 'Deux éclairages: Kandinsky & Miró', *XXe siècle*, no. 1, June 1951, 21–38, 22, 24.

Breton's sympathy towards Estienne's writing on Kandinsky arose not just from his own longstanding enthusiasm for the work of the Russian artist but also from his campaign against Soviet-sponsored socialist realism in *Arts*. Arguing that with official Soviet art, 'we are back to the "dull" dominant of the official salons from before Impressionism', Breton cited Kandinsky as among those who had been fortunate enough to leave Russia before the state intervened to curb individual technique, style and content.[110] He went on to place Gauguin in the lineage of artists since William Blake who would not have found favour with 'the improvised critical tribunals that sit in Russia, their sole code consisting of a few rudimentary academic notions while they are equipped with an ever-increasing list of prohibitions'.[111] Alongside his reflections at that moment of the Cold War on the cultures of Brittany and Russia, Breton took Gauguin and Kandinsky as historical figures who emblematized the resistance to academicism, realism and statism, as well as anything else that he saw as suppressing individual creative freedom.

He did not need much more persuasion, then, of Estienne's confirmation of the daddy of abstract art in the pre-Surrealist canon. Accordingly, Breton returned to the artist frequently from the early 1950s, arguing like Estienne for the 'spiritual' emphasis of Kandinsky's teaching over his instruction and technique. In his 1954 essay on Celtic art, for instance, Breton cited the well-known term 'inner need' from *Concerning the Spiritual in Art* (1911) where the core argument of that book is manifested: '[i]t is evident ... that colour harmony must rest only on a corresponding vibration in the human soul', wrote Kandinsky, 'and this is one of the guiding principles of the inner need'.[112] This quotation was actually taken by Breton from the catalogue of the 1949 Kandinsky exhibition at the Galerie Drouin for which Estienne had written the introduction, but Kandinsky's book was unusually visible in France at the time Breton was writing anyway, because it was republished in translation in the same year with a postface by Estienne.[113]

In arguing against the contemporary academicization of painting and abstraction specifically, Estienne was already recalling and giving preference to the alternative

[110] André Breton, 'Why is Contemporary Russian Painting Kept Hidden from Us?' [1952], *Free Rein*, 257–64, 262.
[111] Breton, *Free Rein*, 263.
[112] Wassily Kandinsky, *Concerning the Spiritual in Art* [1911], trans. M. T. H. Sadler, New York: Dover, 1977, 26; 'the codification of purely technical procedures which some practitioners are attempting to impose as a didactic criterion endangers what a true master such as Kandinsky has made paramount: *the principle of inner need*', Breton, 'The Triumph of Gaulish Art' [1954], *Surrealism and Painting*, 324–32, 325 (translation slightly modified). Breton would go so far as to recommend the term as a guide to the most significant art since the late nineteenth century in the booklet that accompanied *Dessins Symbolistes* in 1958: Breton, *Surrealism and Painting*, 357. Kandinsky is a constant presence throughout Breton's *L'Art magique*; and a painting by him was shown at *L'Écart absolu* in 1965, the last Surrealist exhibition Breton curated: see Breton, *Oeuvres complètes*, vol. 4, 1351–2.
[113] Charles Estienne, 'Postface', Wassily Kandinsky, *Du Spirituel dans l'art* [1911], trans. 'M. et Mme. de Man', Paris: Éditions de Beaune, 1954, 105–9. For further reflection on the later Kandinsky as evidence of his 'romantisme', see Charles Estienne, 'Hommage à Kandinsky', *Combat-Art*, no. 19/20, 11 July 1955, 2. A bibliography of Estienne's writings is available in Musée des Beaux-Arts, *Charles Estienne, une idée de nature*, n.p.

case of Gauguin. This version of Gauguin had entered history by way of his role as a 'teacher' of Sérusier, most famously, and through him his young friends at the Académie Julian, in the inescapable anecdote about the creation of the small painting *The Talisman* (figure 5.9, 1888) in the Bois d'Amour that edges the Aven under Gauguin's calculatedly rapid guidance. This was a paradoxically assertive yet permissive method of instruction. It laid emphasis not on any prescribed or canonical aesthetic, but on an experience of seeing and, primarily, feeling that was exclusive to a subject; a subject being tasked, yes, but with the aim of fathoming what was unique to him or herself. As a scholar of the same Sérusier who had told Charles Chassé in the early 1920s of 'the hatred of official instruction, above all' that had bonded the painters of the École de Pont-Aven, Estienne knew that often-repeated story better than most.[114] It was originally recounted by Denis in his tribute to Gauguin in *L'Occident* in 1903 and reprinted several times since in the various editions of his *Théories, 1890–1910*.[115] Denis's early essay placed enormous emphasis on the informal and deliberately incomplete schooling given the rebels of the Académie Julian by Gauguin. He 'was no professor', but had 'an intuitive gift', Denis wrote:

> The mystery of his ascendancy was to furnish us with one or two very simple and essential verities at a time when we were completely lacking in instruction.... And we extracted a law, instructive principles, and a method from his contradictions.... Gauguin freed us from the hindrances imposed upon our painters' instincts by the idea of copying ... we completed the rudimentary teaching of Gauguin by substituting for his over-simplified idea of pure colour the idea of beautiful harmonies.... He had taught [the circle from the Académie Julian], perhaps without wanting to.... The paradoxes which he brought out in conversation ... concealed basic teachings, deep truths, eternal ideas, which no art in any era has been able to do without.[116]

Estienne must have been aware, too, of Denis's other writings in the *Mercure de France* and elsewhere in the period immediately following Gauguin's death, resolutely insisting in the face of Bernard's version of events on the overriding importance to the upstarts at the Académie Julian of Gauguin's unorthodox tutelage. This was a heretical pedagogy

[114] 'surtout la haine de l'enseignement officiel', Chassé, *Gauguin et le groupe de Pont-Aven*, 78.
[115] Maurice Denis, 'The Influence of Paul Gauguin' [1903], Herschel B. Chipp (ed.), *Theories of Modern Art: A Source Book by Artists and Critics*, Berkeley and Los Angeles: University of California Press, 1968, 100–5, 101; Denis, *Théories, 1890–1910*, 166–7. The anecdote was alluded to in Charles Estienne, 'Paul Sérusier ou le solitaire', *Terre des Hommes*, no. 17, 19 January 1946, 8; naturally, it was brought up one more time in Estienne, *Gauguin*, 38. The title of *The Talisman* would have had an obvious appeal to the later Breton whose interests had shifted towards magic and it was probably his closeness to Estienne that led him to recall the story of the painting, while getting its author as Gauguin not Sérusier, comparing it with the gouache he owned by Filiger titled *Symbolist Architecture with Two Green Bulls* (c. 1900–1914): Breton, 'Alfred Jarry as Precursor and Initiator', *Free Rein*, 255. He referred again to *The Talisman* and its narrative on the occasion of *Dessins Symbolistes*: Breton, *Surrealism and Painting*, 362.
[116] Denis in Chipp (ed.), *Theories of Modern Art*, 102, 103, 104.

Figure 5.9 Paul Sérusier, *The Talisman* (1888). Oil on wood, 27 × 21 cm. Musée d'Orsay, Paris. © Photo Scala, Florence.

that Denis emphasized by placing the word 'students' in quotation marks in the tribute in *L'Occident*.[117]

Sérusier himself had acclaimed Gauguin's instruction in an 1891 letter to the older artist who had responded with uncharacteristic modesty: 'perhaps I have a small

[117] Denis, *Théories, 1890–1910*, 167 n. 1; Denis in Chipp (ed.), *Theories of Modern Art*, 101 n. 1. Gauguin's lightness of touch as a teacher is conveyed by Rewald, *Post-Impressionism*, 299–302.

part in it but, you see, I am convinced that artists produce only what is already in them'.[118] Estienne could have read this in the expanded third version of Sérusier's *A B C de la peinture* (first ed. 1921) in 1950, which showed in Sérusier's own teaching and in the half century that had followed Gauguin's death how far-reaching his curt tuition had been. From this we can safely infer that Estienne's earliest writing on Sérusier, which coincided with the second printing of *A B C de la peinture* in 1942 – where the lengthy accompanying essay on Sérusier by Denis that quadrupled the length of the book gave another airing to the yarn about *The Talisman* – led him through Gauguin's 'lesson' to abstract art, then to Surrealist automatism and from that anti-academy recommending auto-examination as an artistic practice to these reflections on the shortcomings of art school instruction.[119] This is confirmed where Estienne returned to Sérusier in *L'Art abstrait*, citing his opinion from *A B C de la peinture* that style 'is the array of preferred forms. Preferred by the artist, coming from him, discovered by him....'[120] In its increasing sympathy towards the École de Pont-Aven as much as abstract art, Breton's writing of the 1950s displays its enthusiastic take up of Estienne's ideas in that decade. This is further attested to in his evaluation of Sérusier in 1958 at the time of *Dessins Symbolistes* as, alongside Charles Filiger, the 'most important [artist] to emerge from Pont-Aven ... whose theoretical speculations, *A B C de la peinture*, lead quite naturally to later credos such as Kandinsky's *Concerning the Spiritual in Art*'.[121]

Estienne's *L'Art abstrait* had already referred throughout to Surrealist texts. By the time his monograph on Gauguin came out in 1953 (figure 5.10), he had become close to several Surrealists and entered into group activities. This involvement would continue through the 1950s. It was through this association that his poetry and theory (of art and poetry) evolved to show him as what we might now call an unreconstructed Romantic. His connection with the Surrealists entailed the inclusion of Estienne's writings in their

[118] 'j'en ai peut-être une petite part, mais, voyez-vous, je suis convaincu que les artistes ne font que ce qui est bien en eux', Gauguin quoted in Paul Sérusier, *A B C de la peinture, Correspondance* [1921], Paris: Librairie Floury, 1950, 54.

[119] Maurice Denis, 'Paul Sérusier: sa vie, son oeuvre', Paul Sérusier, *A B C de la peinture* [1921], Paris: Librairie Floury, 1942, 35–121, 42. Here the account of Gauguin's spiritual instruction is used directly to support Denis's own half-century old statement about a plane surface covered in an arrangement of colours, whereas, as I noted in my Introduction to this book, a very similar declaration to the one by Denis had helped establish the terms of the six 'emotional elements of design' in the initial attempt taken to devise a formalist art criticism by Roger Fry, 'An Essay in Aesthetics' [1909], *Vision and Design* [1920], Harmondsworth: Penguin, 1961, 22–39. Estienne quoted from and noted the 1942 edition of Sérusier's book in Charles Estienne, 'Sérusier, peintre de la lumière intérieure', *Combat*, no. 711, 17 September 1946, 2 n. 2. A few years later, in a textbook example of an anti-formalist, pro-Surrealist statement made for the opening of a show of contemporary abstraction at the gallery *À l'Étoile Scellée*, he opposed to Denis's plane surface Gauguin's remarks made in a letter to André Fontainas from Tahiti in March 1899 about closing his eyes to see without understanding his dream: Charles Estienne, 'La Coupe et l'épée' [1953], Musée des Beaux-Arts, *Charles Estienne, une idée de nature*, n.p. These remarks were probably read in Paul Gauguin, *Lettres de Gauguin à sa femme et à ses amis*, ed. Maurice Malingue, Paris: Éditions Bernard Grasset, 1946, 286–90, 288.

[120] 'Le style, disait Sérusier, est l'ensemble des formes préférées. Préférées par l'artiste, venues de lui, découvertes par lui ...', Estienne, *L'Art abstrait*, 11; see Sérusier, *A B C de la peinture*, 1950, 10.

[121] Breton, *Surrealism and Painting*, 362.

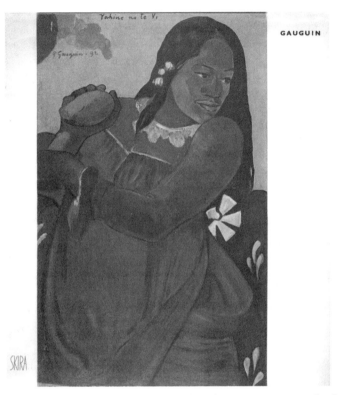

Figure 5.10 Cover of Charles Estienne, *Gauguin* (1953). Image courtesy Book Library, Courtauld Institute of Art, London.

journals. He also attended extended gatherings in Brittany and in the medieval village of Saint-Cirq-Lapopie (painted by the minor Neo-impressionist Henri Martin who moved there in 1912) where Breton had owned a twelfth-century house since 1950. Estienne was virtually a member of the group in that decade and the early 1960s (figure 5.11).[122] He drew upon both his knowledge of Surrealism's past and his ongoing participation in its activities to write the brief essay that constitutes his small and slim volume *Le Surréalisme*

[122] In spite of his apparent fidelity, I say Estienne was only 'virtually' a member, partly because of thoroughly non-Surrealist activities such as his contribution of screams for an event staged by Yves Klein in 1957: Yves Klein, 'The Blue Cries of Charles Estienne', *Overcoming the Problematics of Art: The Writings of Yves Klein* [2003], ed. and trans. Klaus Ottmann, Putnam CT: Spring Publications, 2014, 24; but mainly because he only signed two of the Surrealists' tracts to my knowledge, both in the 1960s: The Surrealist Group, 'Run If You Must' [1961], Michael Richardson and Krzysztof Fijalkowski (eds and trans), *Surrealism Against the Current: Tracts and Declarations*, London and Sterling, Virginia: Pluto Press, 2001, 167–71; and The Surrealist Group, 'Le "Troisième Degré" de la Peinture' [1965], José Pierre (ed.), *Tracts surréalistes et déclarations collectives, 1922–1969*, tome 2: 1940–1969, Paris: Le Terrain Vague, 1982, 238–9, 409–10. He also signed the mainly Surrealist-conceived *Declaration on the Right to Insubordination in the Algerian War* or *Declaration of the 121* of 1960 against military fascism and colonialism in Algeria: Pierre (ed.), *Tracts*, tome 2, 205–8,

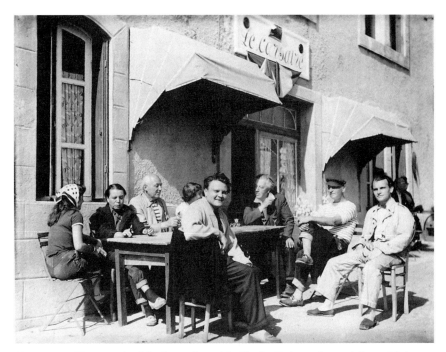

Figure 5.11 Photograph of the Surrealists with Charles Estienne (second from right) at Ouessant, August 1957. Image: Association Atelier André Breton.

(figure 5.12, 1956) in which the arguments about Surrealism and abstraction, and affirmation of Gauguin and Seurat as precursors are both present.[123]

390–6. His contributions to Surrealist journals continued his ruminations on contemporary abstraction at first, then became poetic writings or poems on nature, sometimes inspired by contemporary art or his own theory of it, predicting his greater interest in writing poetry over the following years: Charles Estienne, 'Libre champ aux signes', *Médium: Communication surréaliste*, no. 3, May 1954, 14–15 (this is a critique of the recent book by Michel Tapié, *Un Art autre* of 1952 in which Estienne quotes Gauguin from *Diverses Choses* in support of his idea that art draws its language indirectly from nature); Charles Estienne, 'Bâtissez sur le sable', *Médium: Communication surréaliste*, no. 4, January 1955, 55–6; Charles Estienne, 'Une Idée de Mer', *Le Surréalisme, même*, no. 1, October 1956, 121–4; Charles Estienne, 'Un été, trois chansons', *Le Surréalisme, même*, no. 2, spring 1957, 146–9. His most important direct contribution to the group was probably the orchestration of the *enquête* with Pierre gauging opinion on the orientation and subject matter of contemporary art and Surrealist painting within it: Charles Estienne and José Pierre (eds), 'Situation de la peinture en 1954', *Médium: Communication surréaliste*, no. 4, January 1955, 43–54. The high regard in which Estienne was held by the Surrealists is evident in their tributes to him following his early death in 1966: José Pierre, Alain Joubert, Philippe Audoin, Robert Benayoun, Jean-Claude Silbermann and Jean Schuster, 'Le chevalier à la charrette', *L'archibras*, no. 2, October 1967, 54-6.

123 Charles Estienne, *Le Surréalisme*, Paris: Éditions Aimery Somogy, 1956, 7, 9, 11. This book might have emerged specifically from Estienne's article the previous year examining the work of Toyen, Paalen, Hantaï and the recently deceased Tanguy – artists who suited his bridge-building between Surrealism and abstraction – ending with a remarkably uninhibited statement claiming the absolute consequence of Surrealism to contemporary painting: Charles Estienne, 'La peinture et le surréalisme sont d'aujourdhui comme d'hier', *Combat-Art*, no. 15, 7 March 1955, 2.

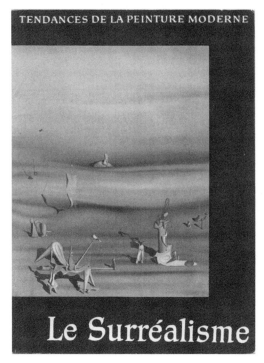

Figure 5.12 Cover of Charles Estienne, *Le Surréalisme* (1956). Image courtesy Book Library, Courtauld Institute of Art, London.

His popular study *Gauguin* does not contain an academic thesis, as such, in the manner of Huyghe's comprehensive, over-ambitious historical and philosophical contextualization of the artist. But it does unsurprisingly draw Gauguin into the tangled web of abstraction and Surrealism that Estienne had woven in the preceding years. Already present in a different argument in his article 'Abstraction ou surréalisme' of January 1953 – in which Estienne casually maps a Surrealist grand narrative based on Breton's *modèle purement intérieur* (cited in my Introduction and third chapter) across the art of Gauguin, Seurat, Cézanne, Rousseau, Cubism and Kandinsky, up to the contemporary abstraction of Simon Hantaï – this conscription begins in the opening pages of *Gauguin* with the insistence that we are 'obliged' to call Gauguin an abstract artist if we heed Kandinsky's later writings.[124] Estienne went on to exploit the Redon

[124] Estienne, *Gauguin*, 16; Charles Estienne, 'Abstraction ou surréalisme', *L'Observateur*, no. 142, 29 January 1953, 21. This short essay in which Cézanne's painting is viewed as closer to Surrealism than 'le pompiérisme foncier' of the estranged Magritte and Dalí was apparently prompted by Hantaï's current exhibition at *À l'Étoile Scellée* directed by Breton. The unlikely inclusion of Cézanne in an otherwise Surrealist-friendly linage consisting of Rimbaud, Kandinsky and Artaud had been proposed seven years earlier in a major article: Charles Estienne, 'De Kandinsky à la jeune peinture française', *Combat*, no. 667, 27 July 1946, 2. The 'grande ligne Gauguin-Kandinsky' was

quotation that Huyghe had used to support his argument about the same sources in the unconscious and dream that were 'so triumphantly exploited later on by the Surrealists', as Estienne put it, 'and whose first mature expression in modern painting we owe to Gauguin and his followers'.[125] This was the boldest claim made by an art critic to date of an ancestral lineage extending back from the Surrealists to Gauguin and the Pont-Aven and Le Pouldu painters. It was quickly followed by direct quotation from the very usable Delaroche who saw Gauguin's painting 'resolving the antinomy between the sensible and the intellectual worlds', a phrase regarded by Estienne as 'an astonishing presage indeed of the Surrealists' credo that sense perception and mental representation are but the dissociated products of "a single, original faculty."'[126] Estienne's phrase was still ringing in the ears of José Pierre thirty years later. It prompted him to infer from Gauguin's late musings an equally 'astonishing prescience of pictorial automatism',[127] and see its evidence in such paintings as *Mahana no atua* (figure 5.13, 1894), in the abstract, biomorphic foreground forms of which he saw 'a freedom as total as that of a wood carving by Hans Arp or of a "surrealist" Rothko of 1947–8'.[128]

Aside from Delaroche, Estienne referred to three writers at the centre of his book whom, he believed, stood alone in understanding Gauguin's achievement in its entirety through acquaintance with both his writings and his art. Given his increasing Surrealist proclivities at the time of writing, it was to be expected that they are those through which I have traced the Surrealist version of Gauguin in this chapter:

> I can think of very few critics who up to now have grasped the unbroken, organic continuity and interaction of Gauguin's life, art and writings, and the significance (not merely anecdotal, but intrinsic) of his two trips to Tahiti. Perhaps the only ones are Victor Segalen and, more recently, René Huyghe and André Breton. Segalen's 'Hommage à Gauguin' ... Huyghe's preface to the Gauguin exhibition at the Orangerie (1949) and his study of the *Ancien Culte Mahorie* [1951], the radio interview with André Breton ... these are the critical appraisals in which the complementary aspects of the man Gauguin ... are interwoven to give us an overall picture of their creative issue.[129]

One might have expected at least Denis and Morice to get a look in here. However, it seems that Estienne wanted to make a marriage of the first and latest interpretations of

reconsidered in terms of magic when Breton's book *L'Art magique* appeared: Charles Estienne, 'André Breton et le cercle magique: coté critique d'art', *Combat-Art*, no. 44, 6 January 1958, 4; it was a narrative that was still being pondered in the later 1960s on the basis of Estienne's writings by Legrand, *Gauguin*, 51–2.

125 Estienne, *Gauguin*, 17.

126 Estienne, *Gauguin*, 18; Delaroche in Gauguin, *Intimate Journals*, 23 (see my footnote 62, above).

127 'étonnante prescience de l'automatisme pictural', José Pierre, *L'Univers surréaliste*, Paris: Somogy, 1983, 59.

128 'une liberté aussi totale qu'un bois découpé de Hans Arp ou qu'un Rothko "surréaliste" de 1947–1948', Pierre, *L'Univers surréaliste*, 60.

129 Estienne, *Gauguin*, 57. See Huyghe's analysis in Paul Gauguin, *Ancien culte mahorie*, Paris: La Palme, 1951, n.p.

Figure 5.13 Paul Gauguin, *Mahana no atua* (*Day of the God*) (1894). Oil (possibly mixed with wax) on canvas, 68.3 × 91.5 cm. The Art Institute of Chicago, Helen Birch Bartlett Memorial Collection. © The Art Institute of Chicago/Art Resource, NY/ Scala, Florence.

the artist that underlined the synthetic properties of the *oeuvre*: Delaroche's and Segalen's that were given when Gauguin was the sole European avant-gardist capable of appreciating the indigenous art of the Pacific Islands, and Huyghe's and Breton's made well after the domestication of such artefacts.

Estienne's comparison of Delaroche's writing on Gauguin with Surrealist theory, made under Breton's quotation about the poetic reunification of sense perception and mental representation, helped mesh Surrealist art more tightly conceptually (as opposed to stylistically) with Gauguin's than ever. Breton's statement had appeared initially in his 1933 article 'The Automatic Message'.[130] However, Estienne knew it had been recycled and recontextualized recently by Breton on the occasion of the Paris exhibition *Océanie*, held in the summer of 1948 at the Galerie Andrée Olive (in the heart of Surrealist country on Quai de l'Horlage). Estienne wrote out the quotation himself in his review of that exhibition, then again, specifically derived from Breton's more recent usage, further on in *Gauguin*.[131] In the catalogue of *Océanie*, Breton had

[130] André Breton, 'The Automatic Message' [1933], *Break of Day*, 125–43, 143.
[131] Charles Estienne, 'Une esthétique vivante: l'art océanien', *Combat*, no. 1227, 16 June 1948, 4; Estienne, *Gauguin*, 60. Its centrality is shown by being aired one more time in the introduction to extracts from his forthcoming book on Gauguin, by Estienne, 'Gauguin et le sens de la nature', 23.

written of the 116 items on show (some from his own collection) dialectically as 'the expression of the greatest effort ever to account for the interpenetration of mind and matter, to overcome the dualism of perception and representation.'[132] Estienne would have read those words again when they were republished in the same year of his own book on Gauguin in Breton's *La Clé des champs*. The use of this quotation to articulate a space for Gauguin within Surrealism across 1948–53, the years on which I have focused this chapter, shows clearly enough why Estienne's writings were valued by Breton as a theoretical means by which Gauguin's art could be conceptually assimilated to Surrealist painting in spite of its obvious visual dissimilarity.

Even this reflorescence of enthusiasm for tribal artefacts from the Pacific in 1948 was not sufficient to recall to Breton's mind Gauguin who goes unmentioned in his text 'Oceania' and would only be discovered (or rediscovered) for Surrealism the following year, as we saw, at the Orangerie. The reason for this, as I have begun to show here, is that it was initially Gauguin's regional 'medievalism' as much as his 'primitivism' that excited the Surrealists and Estienne. This furthers the explanation for their dual endorsement of Kandinsky as a father figure for Surrealism, marked by Estienne in one of his many publications on the painter by recording Kandinsky's debt to 'at once, Russian religious art from the tenth to the fourteenth centuries (painted icons) and the folklore of his country.'[133] I want to go on to make an argument in my next chapters that is more or less latent throughout this one and will probably have been anticipated by readers. That is to say that the devotion to Gauguin latterly shown by Breton, which extended throughout the group, also reflects an increasing interest in Brittany and in Celticism among the Surrealists in the 1950s. Ultimately, I intend to go beyond this and show, under the rubric of 'folk Surrealism', that the debate on Brittany and its mythic and cultural past in Surrealism leads to further new understanding of Gauguin, partly through examination of the work he created in Le Pouldu. This linked his art to folkloric themes and rural narratives, and through them to an earlier phase of Surrealism where those themes had been touched on only implicitly.

[132] André Breton, 'Oceania' [1948], *Free Rein*, 170–4, 172. Breton had used the same dialectical phrase – 'a synthesis of sensorial perception and mental representation' – in interview in 1946 when discussing the revival in Surrealist art of 'so-called primitive vision', André Breton, 'Interview with Jean Duché (*Le Littéraire*, 5 October 1946)', *Conversations*, 196–208, 202.

[133] 'à la fois l'art religieux russe du Xᵉ au XIVᵉ siècle (la peinture d'icônes) et le folklore de son pays', Estienne in *Kandinsky*, 3. Also see the notice given 'northern' folkloric themes in Sérusier's work in Charles Estienne, 'De Sérusier le nordique à Kandinsky l'oriental', *Combat*, no. 880, 7 May 1947, 2.

Dialectic of Brittany: Paul Gauguin's 'Myth' and Surrealist 'Celtomania'

Both its nervous friends and its dismissive enemies noticed that Surrealism became deeply immersed in the search for a 'new myth' from the mid-1930s, then occultism from the early 1940s, at the very moment that the most reactionary forces in Europe were also advertising their devotion to the same cultural explorations.[1] In their written statements after the Second World War from the time of *Le Surréalisme en 1947* and its themes of magic, the occult, superstition, alchemy, the tarot and so on, and well into the 1960s, the Surrealists argued resolutely where their interest lay in such areas of enquiry. Their intention to wrest esotericism from the forces of reaction is typified in the phrase of Robert Benayoun in his polemic against the under-informed research into the occult enshrined in the bestselling book *The Morning of the Magicians* (1960) by Louis Pauwels and Jacques Bergier: 'they will not succeed in relegating the Black Arts to the blackshirt.'[2]

Surrealism's interest in those cultural, intellectual and political currents was a kind of reflexive symptom; 'reflexive' in the sense that the movement was not merely a passive receptacle of trends, but a critical and combative participant in them. That was also the case for the intensification of the movement's enquiry into the Middle Ages. This diverse and vigorous area of Surrealist activity, mainly effective in the 1950s but long anticipated as I showed in my last chapter, was informed by and energetically enriched the massive revival of folklore and regionalism in France at the midpoint of the twentieth century that aided in the reappraisal and revalidation of the medieval

[1] Contemporary criticism of André Breton's mission to create a new myth at the time of the Nazi preoccupation with mythology and the occult is documented by Ellen E. Adams, *After the Rain: Surrealism and the Post-World War II Avant-Garde*, unpublished Ph.D. thesis, Institute of Fine Arts, New York University, 2007, 67–75. For a remarkably detailed catalogue of individual Surrealists' awareness of and contribution to the literature on the occult, see Patrick Lepetit, *The Esoteric Secrets of Surrealism: Origins, Magic, and Secret Societies* [2012], trans. Jon E. Graham, Rochester VT and Toronto: Inner Traditions, 2014.
[2] Robert Benayoun, 'The Twilight of the Wheeler-Dealers' [1961], Dawn Ades and Michael Richardson with Krzysztof Fijalkowski (eds and trans), *The Surrealism Reader: An Anthology of Ideas*, London: Tate, 2015, 145–50, 149 (translation modified). For discussion of the extended Surrealist resistance to that book and its attendant publications, see my *Futures of Surrealism: Myth, Science Fiction and Fantastic Art in France 1936–1969*, New Haven and London: Yale University Press, 2015.

period. As with Surrealism's concentrated study of the history and function of myth and the occult at the very time that the Nazis were viewing art, culture and ritual in the same way, Surrealist medievalism might well be approachable by historians contextually as the outcome of a more widespread interest in the Middle Ages and regionalism in France. But it cannot be determined along the same lines for reason of the movement's dissenting intervention in the area, as it had been in the case of esotericism as much as psychoanalysis, Marxism and feminism.

Regionalism and medievalism in France from the Second World War

In my previous chapter, I pointed to references to the Middle Ages in André Breton's writings as early as the *Manifesto of Surrealism* (1924). An upsurge of interest in all aspects of the medieval in France generally began during the occupation when Maréchal Pétain had introduced a culture of regionalism into the lower, so-called Free Zone of the country as part of his nationalist and racialist official government policy. Frederic Spotts put it like this:

> Of all the ideals of the 'National Revolution' that he and his government dreamed of imposing on France – work, family, soil, homeland, regionalism – the last was especially dear to his heart. Within a few weeks of coming to power he announced his intention of recreating the regional provinces of yore and a few months after that spoke of reviving cultures of even greater yore. To some extent this reflected the traditional fascist view that the simple rural existence is virtuous and urban life one of debauch. It now took the form of reviving the sentiment, customs, folklore, dress and language of a medieval past.[3]

Of course, the fictional contrast of innocent countryside with sinful metropolis was inherited by fascists, not created by them. It was a 'place myth' of Brittany that Paul Gauguin had both immersed himself in and propagated in his art much to the regret of his later twentieth-century critics in art history and cultural studies. Perhaps unsurprisingly given the resilience of that myth in the years after Gauguin's death, which was only increased as the École de Pont-Aven took on canonical status, Pétain's regional ideal ultimately found its most receptive audience in the north in Brittany, while, Spotts adds, in the Free Zone 'it was in the Midi that it drew the greatest response.'[4] And it was in these two regions of France that Breton chose to spend his time outside Paris (more so in the south once he bought his house in Saint-Cirq-Lapopie in the Midi-Pyrénées in 1950).

[3] Frederic Spotts, *The Shameful Peace: How French Artists and Intellectuals Survived the Nazi Occupation*, New Haven and London: Yale University Press, 2008, 87–8.
[4] Spotts, *Shameful Peace*, 88.

As evidence of this tendency towards regionalism in the Midi, which corresponds roughly to the medieval territory of Occitania (a term revived in the mid-nineteenth century), Spotts points to the special issue of *Cahiers du sud* that appeared in 1942, devoted to 'Le Génie d'Oc et l'homme méditerranéen.'[5] Like the later 1951 special titled 'Lumière du Graal' and the 1966 'Les Cathares et le problème du mal', that issue of *Cahiers* was edited by René Nelli who had known Breton and Paul Éluard in the second half of the 1920s and took enthusiastically to Marxism and Surrealism at that time.[6] The first of these publications was packed with contributions on the language, poetry, troubadours, Cathares, philosophy, mythology and folklore of the Oc Country, while the second appeared at the time that Surrealism itself was being drawn increasingly towards the Middle Ages and medieval themes, even though neither volume contained articles from or about Surrealism.[7] Like the Surrealists, however, Nelli, the contributors to the journal and *Cahiers* editor Jean Ballard (who had conceived the idea of an issue dedicated to 'Le Génie d'Oc') adopted the regionalist and medieval themes towards combative not conformist ends. As Nelli explained later:

> In [Ballard's] mind, the volume espoused a double meaning: it had to record, defend and exalt the values characteristic of the ancient civilisation of the Oc Country, but also to make of that culture, seven centuries old, the symbol of the entirety of Occidental humanism threatened by Hitlerism. It was, in the name of poetry and *Amors*, a camouflaged protest against the temporary triumph of Force.[8]

During the period in which he developed his own scholarship on the history and poetry of Occitania, love, myth, the troubadours and Catharism, Nelli had sustained his relationship with Breton who owned dedicated copies of most of his books from the late 1920s onwards. Indeed, Breton had nearly contributed to 'Le Génie d'Oc', according to Nelli, in the unlikely company of his former friend Louis Aragon.[9] Years

[5] Spotts, *Shameful Peace*, 88.

[6] See the biographical note in Carcassonne: Bibliothèque Municipale, *Hommage à René Nelli*, 1980, n.p.

[7] The nearest to Surrealism in the earlier publication were the contributions by René Nelli, 'De l'amour Provençal' and by a writer who was by then working with Breton on the radio in New York at the Voice of America and would become his translator: Édouard Roditi, 'Poétique des troubadors', *Cahiers du sud*, year 29, vol. 20, no. 249 ('Le Génie d'Oc et l'homme méditerranéen'), August–September–October 1942, 44–68; 69–77.

[8] 'Dans son esprit l'ouvrage épousait une double signification: il devait inventorier, défendre, exalter les valeurs propres de l'ancienne civilisation d'Oc, mais aussi, faire de cette culture, vieille de sept cents ans, le symbole de tout l'humanisme occidental menacé par l'Hitlérisme. C'était, au nom de la poésie et d'*Amors*, une protestation camouflée contre le triomphe momentané de la Force', René Nelli, 'Les *Cahiers du sud* à Carcassonne', *Cahiers du sud*, year 50, vol. 56, no. 373/374, September–November 1963, 69–75, 72. For republication of this and other texts by Nelli, see Daniel Fabre and Jean-Pierre Piniès (eds), *René Nelli et les Cahiers du sud*, Carcassonne: Garae/Hésiode, 1987.

[9] Nelli, 'Les *Cahiers du sud* à Carcassonne', 72.

later, Surrealist poetry (particularly that of Breton and Éluard) was the subject of a 1951 *Cahiers du sud* article by Nelli titled 'Des troubadours à André Breton', which argued that 'it is to the Provençal twelfth century much more than to Romanticism (and without excluding an evident lineage from Novalis to Breton) that Surrealist eroticism is bound.'[10]

Alongside Nelli's other writings, that rather one-sided assessment must have furthered Breton's interest in myth, poetry, art and love in medieval Europe, and he spelled out as much in the dedication he added to Nelli's copy of *L'Art magique* of 1957.[11] The same can be said of the chapters on medieval literature and especially the links made between Celtic myth and Arthurian romance purportedly based on 'the most recent archaeological discoveries about the Celts' in the widely circulated history *Love in the Western World* (1939) by Denis de Rougemont whom Breton read and had known in America during the war.[12] But it was from Brittany that Breton had derived these medievalist subthemes and it was by regularly visiting the region that he was able to ripen them into a metaphor or myth that has obvious commonalities with the one adopted and promulgated by Gauguin. By drawing out this myth in a 'dialectic of Brittany' in this chapter, where I introduce associated subthemes of rurality and folklore, I am going to show how such aspects of Surrealist medievalism in the 1950s explain Breton and the Surrealists' allegiance to Gauguin far more convincingly than the more predictable, modernist avenue of enquiry provided by 'primitivism'.[13]

Surrealism, Brittany and Celticism

Only one slim book exists on Breton and Brittany and to my knowledge nothing substantial of an analytical nature has been written that aims to interpret the very

[10] 'c'est au XIIe siècle provençal plus encore qu'au romantisme (et sans exclure une filiation évidente de Novalis à Breton) que l'érotique surréaliste se rattache', René Nelli, 'Des troubadors à André Breton', *Cahiers du sud*, year 38, no. 309, September–October 1951, 303–10, 306 (repub. as René Nelli, 'Des troubadours à André Breton' [1951], Fabre and Piniès (eds), *René Nelli et les Cahiers du sud*, 172–9). Also see the passionate testimony marking Breton's death: René Nelli, 'André Breton', *Cahiers du sud*, year 53, no. 390/391, October–December 1966, 309–11 (repub. as René Nelli, 'André Breton' [1966], Fabre and Piniès (eds), *René Nelli et les Cahiers du sud*, 79–81).

[11] See *Hommage à René Nelli*, n.p.

[12] Denis de Rougemont, *Love in the Western World* [1939], trans. Montgomery Belgion, Princeton NJ: Princeton University Press, 1983, 126.

[13] Research by Surrealists into Occitania and the territories and tales of the medieval south of France continued after the period I am looking at here and up to the present day: see, for instance, Guy-René Doumayrou, *Essai sur la géographie sidérale des Pays d'Oc et d'ailleurs*, Paris: 10/18, 1975; Guy-René Doumayrou, *Évocations de l'esprit des lieux: Les jalons d'un espace-temps poétique autour du Languedoc*, Béziers: Centre International de Documentation Occitane, 1987; Bernard Roger, *Initiations et contes de fées: Une évocation des cheminements initiatiques dans les contes populaires d'Europe*, Paris: Éditions Dervy, 2013 (both writers published in the *Bulletin de la liaison surréaliste* in the early 1970s). I am grateful to Michael Richardson for alerting me to these more recent writings.

strong link between Surrealism specifically and the region.[14] Yet it may turn out that the geography, history and culture of Brittany, or at least the ways in which they were processed within the movement, are fundamental to an understanding of Surrealism and its origins.

Long before he took a serious interest in Gauguin, Breton had got to know certain areas of Brittany well through visits to the home of his parents who had lived there since around 1918 when they had moved permanently to the seaport of Lorient (figure 6.1), which is indeed named after the Orient.[15] Breton's family on his mother's

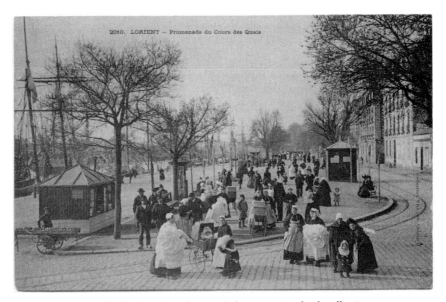

Figure 6.1 Postcard of Lorient in early twentieth century. Author's collection.

[14] Marc Le Gros, *Andre Breton et la Bretagne*, Quimper: Blanc Silex, 2000. Also see Jean-Pierre Guillon, 'André Breton et la Bretagne', *Les Cahiers de l'Iroise*, year 34, no. 1 ('Bretagne: des lettres et des arts'), January–March 1987, 1–7. The potential for a full study of Surrealism and Brittany is evident in the detailed entry on the subject in Jean-Paul Clébert, *Dictionnaire du surréalisme*, Paris: Seuil, 1996, 102–3.

[15] The city was established as a settlement in the seventeenth century through expansion from the other coastal town of Port-Louis by means of trade with India, becoming known as 'L'Orient' and subsequently undergoing development later in that century. Breton was born not in Brittany but in the Orne region in Lower Normandy; however, he spent the first four years of his life largely in Lorient or in the coastal town of Saint-Brieuc in northern Brittany (where Émile Bernard had painted ten years earlier in 1888, the year Alfred Jarry moved away) with his maternal grandfather Pierre Le Gouguès whom he remembered fondly later in life to Gérard Legrand as a 'vieux Breton taciturne' who loved 'raconter des histoires'', André Breton, *Poésie & autre*, ed. Gérard Legrand, Paris: Le Club du meilleur livre, 1960, 10; Gérard Legrand, *Breton* [1960], Paris: Pierre Belfond, 1977, 26. Also see Mark Polizzotti, *Revolution of the Mind: The Life of André Breton*, revised and updated, Boston: Black Widow Press, 2009, 8.

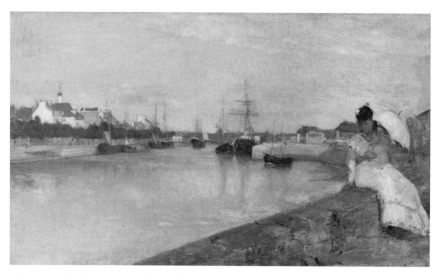

Figure 6.2 Berthe Morisot, *The Harbour at Lorient* (1869). Oil on canvas, 43.5 × 73 cm. National Gallery of Art, Washington D.C. Courtesy National Gallery of Art, Washington.

side were from Lorient. His mother was born there in 1871, two years after Berthe Morisot painted *The Harbour at Lorient* (1869), which she gave to Édouard Manet (figure 6.2).[16] Although Breton wrote on a visit in 1946 of 'Lorient, which I hated more than any city in France', he viewed it with greater partiality upon seeing it in ruins following the Allied bombing of January and February 1943 (Lorient had been a German submarine base and 90 per cent of the town had been flattened by the air strikes, which left his parents' house standing).[17] In spite of his antipathy, Breton had visited Lorient every summer from 1919 until his father's death in 1955, retreating to the family home during many key moments in the turbulent course of Surrealism. He revisited the area with the art critic, poet and former Surrealist Alain Jouffroy towards the end of his life in April 1966.[18]

[16] Morisot was in Lorient from early June till probably early August visiting her sister and main model Edma who appears in the painting and who had moved to the city earlier that year after marrying a naval officer stationed there: Charles F. Stuckey and William P. Scott with Suzanne G. Lindsay, *Berthe Morisot: Impressionist*, Hudson Hills: New York, 1987, 27–9. The city or its surroundings would be depicted later by Pont-Aven artists, as in Henry Moret's *Outskirts of Lorient* (1892).

[17] Quoted in Polizzotti, *Revolution of the Mind*, 487–8.

[18] Polizzotti, *Revolution of the Mind*, 555. The reader should refer to this book for major personal episodes that frequently entailed a return to Lorient, a notable one being the car journey through Brittany taken by Breton with Valentine Hugo alongside Paul and Nusch Éluard in July 1931: Polizzotti, *Revolution of the Mind*, 328. Breton's regular visits to Brittany from 1946 to Camaret, Combourg, Huelgoat (where Victor Segalen died), Guimiliau, Île de Sein, Laval, Ouessant, Paimpont, Pont-Aven and Quiberon (which he had visited regularly since 1922) are cited by Le Gros, *Andre Breton et la Bretagne*, 31. For a

Breton's interest in the history of Brittany fomented after the Second World War, partly through such visits, and his attachment to the region spread to his friends in and close to Surrealism in the 1950s. This was probably strengthened through debate among the Surrealists that was caused by and contributed to historical, religious and philosophical discussion marking the bimillenium of the military campaigns by the Romans under Caesar against the Gallic tribes that had taken place between 58 and 50 BC. A strand of left wing nationalism had connected the people of France to the Celts since the eighteenth century.[19] This had been bolstered in debates from about 1900 as to whether France was a Latin or Celtic nation. It was sharpened in the years leading up to the First World War by increasing nationalism and the establishment in 1911 by Robert Pelletier of the Ligue Celtique Française and the review *L'Etendard celtique* (replaced by *Revue des nations* in 1913), and by Jacques Reboul's steadfast advocacy of Celticism in the nationalist and traditionalist journal *La Renaissance contemporaine*. Mark Antliff argues that the new Celticism attracted, among others, figures associated with the Puteaux Cubists including Albert Gleizes, whom Antliff sees as especially active in dissociating Cubism from Greco-Roman classical culture and assigning it instead to the indigenous Celtic tradition, though the depth of this sympathy has been disputed in subsequent scholarship.[20]

The attention given to the subject in the 1940s and 1950s marked this later period as the 'heyday of Celticism and Arthurian Romance'.[21] It also supplemented the terrain of contestation already explored by Surrealism and Breton whose objection to the 'Greco-Latin culture' that he thought had been inaugurated by the Gallic Wars, and his nostalgia for the civilization of the Gauls or Celts that had preceded it and been supplanted by the

compressed 'chronologie Bretonne', see André Cariou (ed.), *Charles Filiger-André Breton: À la recherche de l'art magique*, Quimper: Musée des beaux-arts, 2006, 62–3. Since 1971, the Festival Interceltique de Lorient has been a significant event on the Breton calendar, consolidating the importance of the town to the region and strengthening its ties with the Celtic culture of Brittany.

[19] Catherine Bertho, 'L'invention de la Bretagne: Genèse sociale d'un stéréotype', *Actes de la recherche en sciences sociales*, vol. 5 ('L'identité'), November 1980, 45–62, 47. For the political and intellectual background of Celticism in France, reaching back as far as the Middle Ages, see Eugen Weber, *My France: Politics, Culture, Myth*, Cambridge, Mass. and London: Belknap Press, 1991, 21–39.

[20] See the now well-known *Montjoie!* article admired by Reboul: Albert Gleizes, 'La tradition et le cubisme' [1913], Mark Antliff and Patricia Leighten (eds), *A Cubism Reader: Documents and Criticism, 1906–1914*, trans Jane Marie Todd and Others, Chicago and London: The University of Chicago Press, 2008, 460–6; Mark Antliff, *Inventing Bergson: Cultural Politics and the Parisian Avant-Garde*, Princeton NJ: Princeton University Press, 1992, 106–34. Also see David Cottington, *Cubism and its Histories*, Manchester and New York: Manchester University Press, 2004, 146–7. The strength of Gleizes' nationalism is questioned and the brevity of his allusion to the Celts underlined by Peter Brooke, *Albert Gleizes: For and Against the Twentieth Century*, New Haven and London: Yale University Press, 2001, 42–3. For a summary of the positions, see Antliff and Leighten (eds), *A Cubism Reader*, 466–70.

[21] Keith Busby and Jane H. M. Taylor, 'French Arthurian Literature', Norris J. Lacy (ed.), *A History of Arthurian Scholarship*, Cambridge: D. S. Brewer, 2006, 95–121, 102. The authors indicate, especially, the writings of Roger Sherman Loomis and Jean Marx (neither the Surrealists' friend Jean Markale nor the Surrealists themselves feature in their chapter). For Marx, who published on the subject at the height of the Surrealists' interest in Celticism and Arthurian Romance (and was included in the 1951 special number of *Cahiers du sud*, 'Lumière du Graal'), but to my knowledge was not referred to by them, see Jean Marx, *La légende arthurienne et le Graal*, Paris: PUF, 1952.

expansion of the Roman Republic across Gaul, led him to the view that Europe had been '*occupied* by the Greco-Latins' for two thousand years.[22] If the Celtic acceptance of Christianity were played down or the Celtic defiance of it played up, this stance could just about be made to fit with the contextual account of the importance of Gauguin's art given by René Huyghe, which I rehearsed in my last chapter, of resistance to the Greeks and Romans through the Neoplatonism of Plotinus and Saint Augustine from the third and fifth centuries followed by the full conquest of that philosophy, art and culture (and the 'mental system', as it would soon be called by Charles Estienne, that they both fostered and illustrated) by Aristotelianism around the late twelfth century.[23]

That renewed form of defiance of modern civilization based on philosophical, artistic, cultural or more broadly epistemological grounds – epistemological in the sense that it was the very priorities given the various branches of knowledge and the conditions and methods of the acquirement of that knowledge since the Middle Ages that were being questioned by the Surrealists – was now manifested in Surrealism's activities, issuing from the amplification of its curiosity about the medieval period, Brittany and Celticism. This move is contextualized by Steven Harris as an 'ahistorical turn to the distant past in light of contemporary disappointments, in particular the defeat of the revolutionary option that had been central to the Surrealist avant-garde project from the 1920s onwards.'[24] However, it was implicit in Surrealism's earlier attraction to the occult and alchemy, as well as the paraphernalia of the Middle Ages as that was supported by the typical props of the Gothic novel.

The revised geographico-cultural orientation of Surrealism that ensued in the 1950s is shown early on in print in Breton's most sustained remarks on Brittany tendered in a 1952 interview. This was given to the evening newspaper of Lorient, *La Liberté du Morbihan* (created by the Resistance in 1944 and named after the *département* in

[22] "'Il y a plus de deux mille ans, dit-il, que nous sommes *occupés* par les Gréco-latins,'" quoted in Claude Roy, *Somme toute*, Paris: Gallimard, 1976, 413. The charge was put in print in André Breton, 'Le Surréalisme et la tradition' [1956], *Oeuvres complètes*, vol. 4, Paris: Gallimard, 2008, 945–7. Breton always used the Roman-derived term 'Gauls' (*Galatai* or *Galli*) to refer to the alleged barbarians who lived north of the Mediterranean world; I am using the Greek-derived 'Celts' (*Keltoi*), which is more familiar in English-language scholarship, though the people that the terms were supposed to categorize called themselves neither: D. F. Allen, *The Coins of the Ancient Celts*, ed. Daphne Nash, Edinburgh: Edinburgh University Press, 1980, 1; Fraser Hunter and Others, 'In Search of the Celts', Julia Farley and Fraser Hunter (eds), *Celts: Art and Identity*, London: The British Museum, 2015, 19–35, 20, 23. For the debate that has raged, especially since the late 1980s and mainly in Britain, over whether or not the word and idea of the 'Celts' accounts sufficiently for ethnic, linguistic and cultural diversity in Europe, see: Patrick Sims-Williams, 'Celtomania and Celtoscepticism', *Cambrian Medieval Celtic Studies*, no. 36, winter 1998, 1–35; the papers collected under the heading 'Celticity' in the first part of Gillian Carr and Simon Stoddart (eds), *Celts from Antiquity*, Cambridge: Antiquity Publications Ltd, 2002, 5–50; and Patrick Sims-Williams, 'Post-Celto-Scepticism: A Personal View' [1999], Dónall Ó Baoill, Donncha Ó hAodha and Nollaig Ó Muraíle (eds), *Saltair Saíochta, Sanasaíochta agus Seanchais: A Festschrift for Gearóid Mac Eoin*, Dublin: Four Courts Press, 2013, 422–8.

[23] 'l'ordre mental', Charles Estienne, 'La ligne de l'hérésie', Paris: Musée pédagogique, *Pérennité de l'art gaulois*, 1955, 85–6, 85.

[24] Steven Harris, 'The Gaulish and the Feudal as *lieux de mémoire* in Postwar French Abstraction', *Journal of European Studies*, vol. 35, no. 2, 2005, 201–20, 203.

Brittany in which the city resides), and published under the apparently uncontroversial title 'Quelle est la part de l'âme bretonne dans l'inspiration des surréalistes?' (as though the region or its people possessed an innate 'lifeblood' or 'soul'). Initial remarks compared Julien Gracq's novel set in Brittany, *Au Château d'Argol* (1938), with the Gothic novel as well as with the mood of Thomas Hardy's *Jude the Obscure* (1895), which Breton esteemed in this latter part of his life.[25] He then went on to insist on Surrealism's internationalism while genially conceding the extensive debt he felt it owed Brittany:

> On a personal note, my maternal ancestry is purely Breton and, as it were, my family name might lead one to suspect that the filiation does not end there …
>
> For the information of the readers of this interview and without yielding, needless to say, to any regionalist bias (Surrealism is resolutely international), I'll add that the atmosphere of Brittany, both inland and on the coast, has strongly permeated Surrealism, because of the admiration held for the poetry of [Tristan] Corbière and [Alfred] Jarry (from *Black Minutes of Memorial Sand* [1894] to *La Dragonne* [pub. 1943]), which are saturated with it. A recent book for which I advocated strongly, *La Nuit du Rose-Hôtel* [1950] by Maurice Fourré is also entirely bathed in it ….
>
> In the field of painting and inseparable from this, we have always given a privileged place to the École de Pont-Aven due to the profound reaction that it began against primary realism.…[26]

25 Given his typical distaste for fiction, Breton's fleeting reference to 'Thomas Hardy's beautiful book, *Jude the Obscure*' in the course of one of his customary, lyrical appraisals of the transformative power of love in *Arcanum 17* is unexpected: André Breton, *Arcanum 17* [1944], trans. Zack Rogow, Toronto: Coach House Press, 1994, 39. However, the resistance to social convention displayed by Jude Fawley and Sue Bridehead and particularly their rejection of Christian teaching, along with their profound intimacy which for the unfortunate Phillotson seemed 'an extraordinary affinity' that made them 'seem to be one person split in two' wanting only 'to share each other's emotions, and fancies, and dreams', as well as the ways their love and their lives are destroyed by a censuring society, is clearly redolent of other instances in culture indicated by the Surrealists the transgressive characteristics of *amour fou*: Thomas Hardy, *Jude the Obscure* [1896], London: Penguin, 1978, 295, 293. A few years after his remarks in *Arcanum 17*, Breton wrote of seeing a 'wild and proud couple' leaving an inn he was staying at, 'borne away by the ray of light that springs from *Jude the Obscure*', an observation that has the rustic sentimentality of one of Pierre-Auguste Renoir's country dances while confirming the close association he imagined between Brittany and Hardy's Wessex in *Jude* and also of the novel with Arthurian myth and medievalism since he was staying in Paimpont Forest at the time – thought to be the model for Brocéliande, the mythic forest that emerged in literature in 1160 – the alleged location of Merlin's tomb as well as other motifs of the Arthurian narrative: André Breton, 'The Engineer' [1949], *Free Rein* [1953], trans Michel Parmentier and Jacqueline d'Amboise, Lincoln and London: University of Nebraska Press, 1995, 206–16, 209. Breton owned the 1931 French edition of *Jude* translated by F. W. Laparra and prefaced by Edmond Jaloux (who had been an early admirer of Breton) but it is not currently known when he read it; see his copy via this link: http://www.andrebreton.fr/fr/item/?GCOI=56600100821391 (accessed 13 June 2012). For André Masson's interest in Brittany since 1923 and his depictions of Brocéliande, see Jean-Paul Clébert, *Mythologie d'André Masson*, Geneva: Pierre Cailler, 1971, 25–6.

26 'En ce qui me concerne, je suis d'ascendance maternelle purement bretonne et, n'est-ce pas, mon patronyme donnerait à penser que cette filiation ne s'arrête pas là …

 À l'intention des lecteurs de votre interview et sans pour cela ceder – il va sans dire – à aucun prejudge régionaliste (le surrealism est résolument international) j'ajoute que l'atmosphère de la

As I showed, the Surrealist attraction to the École de Pont-Aven was, in fact, relatively recent at the time Breton was speaking and due largely to the writings of Estienne. Nevertheless, Breton went on to refer to one symptom of this, his own article on Jarry of the previous year giving particular attention to 'the astonishing artist Charles Filiger, admired by [Remy de] Gourmont and Jarry, who remained faithful to Brittany till his death, which took place in Plougastel in 1930.'[27] At that moment, Breton was in the middle of a remarkable quest to uncover information about Filiger and acquire as much of his work as he could, as I outline in my final chapter.

Given the space, Breton would have said a lot more on the subject. Jacques Vaché who would be one of the main inspirational figures for the first Surrealists was also born in Lorient; Jarry and Henri Rousseau hailed from Laval on the Brittany-Normandy border; Saint-Pol-Roux who was greatly admired by the Surrealists had left Paris in 1898 to settle in Roscanvel, then the fishing port of Camaret (both on the coast of Finistère); and Filiger, the 'mediumistic' artist and one-time friend and follower of Gauguin, had lived in Plougastel-Daoulas in the region (till his death in Brest, in fact, in 1928).[28] Although it is now located in the Pays de la Loire region, Nantes is still

Bretagne, tant côtière que terrienne, a fortement inprégné le surréalisme, du fait de l'admiration portée à la poésie de Corbière et à l'oeuvre de Jarry (des *Minutes de sable* à *La Dragonne*) qui en sont saturées. Un livre récent dont j'ai fait grand cas, *La Nuit du Rose-Hôtel*, de Maurice Fourré, y baigne aussi tout entire

 Dans le domaine de la peinture, inseparable de celui-ci, nous avons toujours fait une place de choix à l'école de Pont-Aven raison de la profonde reaction qu'elle amorçait contre le réalisme primaire', André Breton, 'Interview d'Yves Pérès' [1952], *Oeuvres complètes*, vol. 3, Paris: Gallimard, 1999, 643–9, 646–7. Breton had published Fourré's novel in the very short-lived esoteric series he edited at Gallimard titled 'Révélations', see Polizzotti, *Revolution of the Mind*, 505. The Breton background of Corbière had been a feature of his entry in André Breton, 'Tristan Corbière 1845–1875', *Anthology of Black Humor* [1941/1945, 1966], trans. Mark Polizzotti, San Francisco: City Lights, 1997, 155–6. It was a trait accentuated and probably even overdone in an assessment that he would have known very well (especially the part about 'a Breton bretonning in the grand old style!'): Paul Verlaine, *The Cursed Poets* [1888], trans. Chase Madar, Copenhagen and Los Angeles: Green Integer, 2003, 21. In the same year as this interview, Breton ended the major set of radio interviews or *Entretiens* with a remarkable and obviously pre-planned statement in which he placed himself alongside Chateaubriand as a native of the moors of northern France and identified Surrealism with them too, showing how important Brittany had become to the movement in his mind: André Breton, *Conversations: The Autobiography of Surrealism* [1952], trans. Mark Polizzotti, New York: Paragon House, 1993, 177.

27 'l'étonnant artiste Charles Filiger, admire de Gourmont et de Jarry, qui reste fidèle à la Bretagne jusqu'à sa mort, survenue à Plougastel en 1930', Breton, *Oeuvres complètes*, vol. 3, 647. Breton was referring to the article he had published in *Arts* on 2 November 1951, reprinted as André Breton, 'Alfred Jarry as Precursor and Initiator' [1951], *Free Rein*, 247–56.

28 Saint-Pol-Roux knew Filiger but it is unlikely that he came up for discussion when Breton first met the poet after writing to him from Lorient on 1 September 1923 to arrange a visit, which happened a week later: Cariou (ed.), *Charles Filiger-André Breton*, 17; André Breton, *Oeuvres complètes*, vol. 1, Paris: Gallimard, 1988, 1685; Guillon, 'André Breton et la Bretagne', 3. It was presumably part of Saint-Pol-Roux's reply to him that was published with the passages quoted from Gauguin's *Avant et après* (1903) in Anonymous, 'Nouveauté', *Littérature*, no. 13, June 1924, 23–4, 23. The Surrealists' collective homage to Saint-Pol-Roux was published the following year, a few weeks before the bridge-burning riot I mentioned in my third chapter, in *Les Nouvelles littéraires*, 9 May 1925, 5 (see Breton, *Oeuvres complètes*, vol. 1, 899–902, 1685–7). On his visit, Breton would not have seen

regarded as the capital city of old Brittany and it was there that Breton went as a male nurse in July 1915 (after being called up in February for basic army training in the part-medieval, agricultural town of Pontivy, thirty-seven miles north east inland from Lorient), later calling it in *Nadja* (1928) 'perhaps, with Paris, the only city in France where I feel that something worthwhile can happen to me.'[29] It was the birthplace of first generation Surrealist Jacques Baron, while Benjamin Péret, Breton's closest comrade in Surrealism from the mid-1930s on, was born in the town of Rézé near Nantes. Among Surrealists of later generations, the painter and writer Yves Elléouët was perhaps the one who refracted his Breton origins most self-consciously through his work, and recent scholarship has shown the important role played by Estienne in encouraging Elléouët and others along this path from the mid-1950s.[30]

Most prominent and relevant to a discussion of Surrealism, Gauguin and Brittany – in spite or perhaps because of its obvious differences from Gauguin's painting, as I am going to argue – is the work of Yves Tanguy. Breton referred to Tanguy in his reflections on Surrealism and Brittany in 1952 and, naturally, he read certain characteristics of the culture and coast of the region into his paintings. Presumably, these were as equally 'saturated' and 'bathed' in its 'atmosphere' as the poetry and fiction he mentioned. Tanguy's father had been a naval officer from the remarkably preserved village of Locronan near Douarnenez and the artist felt a strong attachment to Brittany throughout his life. The ambiguous forms of certain of his paintings apparently recalled for Breton 'the children of a legend from Brittany [metamorphosed] into grass', while the spiky half-figures of others such as *On Slanting Ground* (figure 6.3, 1941) reminded him of distantly viewed versions of the cross- or banner-carrying participants who made up the Troménies or Pardons he had seen in his own childhood, as he wrote in his 1942 essay on the artist, the best known being the one in Locronan.[31] In the same text, he linked

Gauguin's carvings from the 'House of Pleasure', which we left in Saint-Pol-Roux's possession in 1905 in my last chapter, because the poet's terrible poverty had forced him to try to sell them during the First World War through Félix Fénéon at Bernheim-Jeune before Victor Segalen asked for them back in 1916 to help him write his 'Hommage à Gauguin' (1918): four ended up in Segalen's collection and after his death in 1919 they passed to his family then entered the French state collection in 1952: Anne Pingeot, 'The House of Pleasure', Boston, Mass.: Museum of Fine Arts, *Gauguin Tahiti*, 2004, 263–71, 268–71. There is a chance, of course, that Fénéon allowed Breton to see them while they were stored at Bernheim-Jeune. Also see Charles Forsdick, 'Gauguin and Segalen: Exoticism, Myth and the "Aesthetics of Diversity"', London: Tate Modern, *Gauguin: Maker of Myth*, 2010, 56–63, 60. For reference to this loan to Saint-Pol-Roux, see Victor Segalen, 'Hommage à Gauguin' in Paul Gauguin, *Lettres de Paul Gauguin à Georges-Daniel de Monfreid*, Paris: Éditions Georges Crès et Cᶦᵉ, 1918, 1–77, 69.

29 André Breton, *Nadja* [1928], trans. Richard Howard, New York: Grove Weidenfeld, 1960, 28; Polizzotti, *Revolution of the Mind*, 27.

30 Lepetit, *Esoteric Secrets of Surrealism*, 176–7; Renée Mabin, 'Origines de la création et créations des origines', Quimper: Musée des beaux-arts, *Yves Elléouët*, 2009, 14–21.

31 André Breton, 'Yves Tanguy: What Tanguy Veils and Reveals' [1942], *Surrealism and Painting* [1965], trans. Simon Watson Taylor, New York: Harper & Row, 1972, 176–80, 178, 180. Breton was reluctant to note the resemblance of certain of Tanguy's plains and painted forms to Brittany's beaches and megaliths, a comparison routinely made elsewhere. Also see the persuasive likeness between Tanguy's late paintings and stones on the shore at Douarnenez and the cliffs at Douarnenez Bay in Finistère in Karin von Mauer, *Yves Tanguy and Surrealism*, Ostfildern-Ruit: Hatje Cantz, 2001, 126.

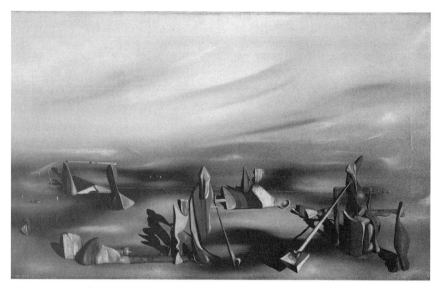

Figure 6.3 Yves Tanguy, *On Slanting Ground* (1941). Oil on canvas, 47.8 × 71.4 cm. The Solomon R. Guggenheim Foundation, Peggy Guggenheim Collection, Venice. © Mondadori Portfolio/Walter Mori/Bridgeman Images. © ARS, NY and DACS, London 2018.

Tanguy's origins to Brittany by way of nearby Saint-Renan and Jarry's absinthe and ink habit, as well as a 'Douarnenez sailor' whose anchor gets caught 'in the window bars of a house in Ys', the legendary city said to lie under the bay of that imagined sailor's fishing port, where Tanguy's ashes would be scattered.[32]

Ideology and Miserabilism: Brittany as 'place myth' and 'new myth'

By the time the Surrealists began to immerse themselves in the 'atmosphere' of Celtic Brittany in the mid-twentieth century, it was well-known that affirmations like the poet Adrien Mithouard's of Gauguin's 'Celtic blood' were wide of the mark.[33] It was equally

[32] Breton, *Surrealism and Painting*, 180; Lepetit, *Esoteric Secrets of Surrealism*, 190–3; André Cariou, 'Yves Tanguy et la Bretagne', Quimper: Musée des beaux-arts, *Yves Tanguy: L'univers surréaliste*, 2007, 60–5. Much more information about Tanguy's life in and research on Brittany, its legends and myths can be found in a study by the artist's niece based entirely on his Breton background: Geneviève Morgane-Tanguy, *Yves Tanguy: Druide surréaliste*, Paris: Éditions Fernand Lanore, 1995.

[33] 'le sang du celte originel', Mithouard in Charles Morice (ed.), 'Quelques opinions sur Paul Gauguin', *Mercure de France*, tome 48, November 1903, 413–33, 427. See the correction of the record made at the high point of Surrealist Celticism in the book owned by Breton and signed for him by Charles Chassé, *Gauguin et son temps*, Paris: La Bibliothèque des Arts, 1955, 24. Breton's copy with Chassé's dedication can be viewed at http://www.andrebreton.fr/work/56600100784471 (accessed 1 June 2015). Chassé's denunciation of Jarry in Les Sources d'Ubu-Roi (1921), which Breton and Philippe Soupault had violently rejected in the review Littérature the year after the publication of the book, must have been forgotten.

understood by then that Brittany had long become the site of a place myth and deemed that Bretons were no more 'ethnically "Celtic" than the rest of the French' in the words of Maura Coughlin, in spite of the centrality achieved by ancestral Celticism in regional cultural identity in Brittany in the nineteenth century.[34] 'A place myth,' writes Coughlin, 'is what develops as artists and writers engage with a rural place, its local culture of the past and present.'[35] She derives the term from its usage by Nina Lübbren who devoted a chapter to the subject in her *Rural Artists' Colonies in Europe* (2001) that gives special treatment to Pont-Aven, writing of artists 'admitting certain aspects of the environment and rejecting others, moving between realities of a place, the ideal image of what that place should be like, and the possibilities opened or foreclosed by the conventions of pictorial tradition.'[36] In turn, Lübbren acknowledges that the term was coined by the sociologist Rob Shields to help explain the means by which places become 'symbolic formations', through a process, according to Shields, that includes 'over-simplification (i.e. reduction to one trait), stereotyping (amplification of one or more traits) and labelling (where a place is deemed to be of a certain nature).'[37] This is to say that a place myth as understood by both Coughlin and Lübbren is an invention of ideology. It names not merely a distortion or invention of reality but a depreciation of a place, people and culture by a dominant class or outside group, which is sometimes unaware that it is complicit in that self-interested promotion of beliefs and values.[38]

The landscape, prehistoric 'monuments', castles, costumes, superstitions, myths, legends and folklore of Brittany had encouraged a remarkably powerful place myth since the arrival in the region of the Celtic specialist Jacques Cambry in 1799 to take an inventory of monuments that had outlasted the Revolution. Coughlin contends that this had far-reaching consequences:

> Like many Romantic era writers, Cambry ascribed these prehistoric monuments to the culture of the Druids, and read them as an alternative, native French tradition to Mediterranean classicism.... Cambry set in motion a romantic, nationalist interpretation of Neolithic monuments as a native tradition of France that was resistant to the Roman Empire[39]

Coughlin points to the publication of the collection of oral songs and bardic poems *Barzaz Breiz* (1839) as a significant means by which Celtic Brittany was appropriated

[34] Maura Coughlin, 'Celtic Cultural Politics: Monuments and Morality in Nineteenth-Century Brittany', Marion Gibson, Shelley Trower and Garry Tregidga (eds), *Mysticism, Myth and Celtic Identity*, London and New York: Routledge, 2013, 130–41, 131.

[35] Coughlin in Gibson, Trower and Tregidga (eds), *Mysticism, Myth and Celtic Identity*, 130.

[36] Nina Lübbren, *Rural Artists' Colonies in Europe 1870–1910*, New Brunswick NJ: Rutgers University Press, 2001, 115.

[37] Lübbren, *Rural Artists' Colonies in Europe*, 115; Rob Shields, *Places on the Margin: Alternative Geographies of Modernity*, London and New York: Routledge, 1991, 47.

[38] For Breton's Brittany as itself an 'abstraction' or ideology – 'une certaine forme d'idéologie: celle qui nourrit, qui nourrira toujours sa haine à l'égard des latins' – see Le Gros, *André Breton et la Bretagne*, 26.

[39] Coughlin in Gibson, Trower and Tregidga (eds), *Mysticism, Myth and Celtic Identity*, 132, 133.

mentally, marshalled, she alleges, by 'an educated Breton elite'.[40] Among these were Émile Souvestre who published *Voyage dans le Finistère* in 1835 and who we came across in my third chapter as editor of *Nantes et la Loire-Inférieure* (1850).[41] His co-editor Pitre-Chevalier also got in on the act of furnishing Brittany with a tempestuous and mystical past in the pages of the *Musée des familles* and in his *La Bretagne ancienne et moderne* (1844). As Coughlin states, by the end of the nineteenth century, 'many decades of fervent Celtomania had their grip on Brittany'.[42]

This primitivization of the past by Coughlin – a Whiggishness on the part of the historian that interprets the attitudes of our predecessors from the height of the present as inevitably more mentally sluggish, credulous, literalist and unsophisticated than our own – renders previous generations before we came along as passive consumers of this construction of Brittany. It underestimates comprehensively the capacity of vanguard artists such as Gauguin, as well as the Breton people themselves, to harness the manufactured Brittany for reflexive, metaphorical ends in which ethnicity is a state of mind. It aims to replace poetic myth with historical myth. That is, it imposes a putatively transparent narrative of the past – read and interpreted as Truth by the alternative, let us say 'positivist' means of origin and 'real' space in time – on the 'actual' past. This is part and parcel of the discourse of the academic historian: 'the discourse of history', as Roland Barthes described it, where 'the historian intends to "absent himself" from his discourse and where there is, consequently, a systematic absence of any sign referring to the sender of the historical message: history seems to *tell itself*'.[43] Such is Brittany as reflected in the materialist, liberal, superficially left-leaning scholarship of Lübbren, which carries a distant thrum of Marxist history in its presumed aim to dispel class and colonialist stereotypes naturalized by the processes of legitimation that are characteristic of ideological systems of discourse. It becomes a terrain and history without a subject, without an unconscious.

Like Gauguin who 'openly embraced popular clichés' in the words of Belinda Thomson, the Surrealists recognized the difference between these two ways of understanding the past and present.[44] They endeavoured to privilege the right of the artist and poet to impose a metaphor or myth on the historical past and geographical present while introducing a dialectic by allowing interventions of a more scholarly nature. This is what Surrealism aimed at in the post-war period. It was spurred in this significantly by the fiction of Gracq, whose play *Le Roi pêcheur* (1948) carried an important foreword in which the Grail legend was removed from the 'closed' system of Christianity and resituated in the 'open' organism of Breton Celtic myth, while the

[40] Coughlin in Gibson, Trower and Tregidga (eds), *Mysticism, Myth and Celtic Identity*, 132, 133; Bertho, 'L'invention de la Bretagne', 49, 58.
[41] Also see Bertho, 'L'invention de la Bretagne', 59–60.
[42] Coughlin in Gibson, Trower and Tregidga (eds), *Mysticism, Myth and Celtic Identity*, 138. For an impressive roll call of French writers who visited Brittany in the 1820s and 1830s and helped develop its stereotype, including Honoré de Balzac, Victor Hugo, Gustave Flaubert, Jules Michelet and Stendhal, see Wladyslawa Jaworska, *Gauguin and the Pont-Aven School* [1971], London: Thames and Hudson, 1972, 242 n. 48.
[43] Roland Barthes, 'The Discourse of History' [1967], *The Rustle of Language*, trans. Richard Howard, Berkeley and Los Angeles: University of California Press, 1989, 127–40, 131.
[44] Belinda Thomson, 'Landscape and Rural Narrative', *Gauguin: Maker of Myth*, 111–32, 112.

Surrealist group was posited by Gracq point-for-point as a modern embodiment of the companionship of the Round Table.[45] Surrealism drew also on more conventional scholarship in the form of the revisionist art history of André Malraux in *Voices of Silence* (1951), credited by Breton with rescuing Gallic coins from obscurity (an oblivion that Breton said had not been eased by Georges Bataille's 1929 account of the 'mad or barbaric' style of the horses inscribed onto Gallic coins, which Bataille thought signified the unsystematic and irrational civilization they came from in contrast with their organized, disciplined Greek and Roman enemies).[46]

The new predominance given the myth of the ancestral past of Celtic Brittany by Surrealism in the 1950s took place through partnership with such specialists as Lancelot Lengyel (whose 1954 classic *L'Art gaulois dans les médailles* was reviewed elatedly by Estienne as bringing 'a new reverberation to the analysis of Greek humanism', and in which he and Breton read the tribute to Malraux's pioneering study) and Estienne's friend the scholar Jean Markale (born Jean Bertrand) who were drawn into Surrealist activities from that point.[47] Writing of Markale's brief tale 'In

[45] Julien Gracq, *Le Roi pêcheur*, Paris: José Corti, 1948, 12–13. Gracq was not the originator of this thesis that Arthurian myth was drawn from Celtic legend: see, for instance, Roger Sherman Loomis, *Celtic Myth and Arthurian Romance*, New York: Columbia University Press, 1927.

[46] André Breton, 'The Triumph of Gaulish Art' [1954], *Surrealism and Painting*, 324–32, 328. Malraux had speculated on the relations between Celtic coins the year before, in fact, in the third volume of his 'Psychologie de l'art', André Malraux, *La Monnaie de l'absolu*, Paris: Albert Skira, 1950, 191–206; Breton was referring to the augmented arguments made in André Malraux, *The Voices of Silence* [1951], trans. Stuart Gilbert, New York: Doubleday & Company, 1953, 131–46 (also see further discussion on 336–7); and repudiating those by Georges Bataille, 'Le Cheval académique', *Documents*, year 1, no. 1, April 1929, 27–31, 27. This was a difference of opinion and not a major theoretical dispute between the two as had been the case in earlier years (and anyway, Bataille's apparently negative language used to describe Celtic coins was not really a denial of their aesthetic worth as Breton thought), though an attempt to make it into one has been made by Denis Hollier, 'The Use Value of the Impossible', *October*, no. 60, spring 1992, 3–24, 6 n. 10. Remarkably, Malraux wrote of the 'forms of the Atrebates [the Belgic tribe of northern Gaul and Britain], whose abstractions were still governed by a feeling for movement akin to that of André Masson', Malraux, *Voices*, 140; and equally remarkably Breton did not take advantage of this reference to the former Surrealist artist and friend of Bataille to enhance his own argument. A near-contemporary commentary saw Breton's interpretation of Celtic coins as typically territorial, but favours it over Bataille's reading: Georges Duthuit, *Le Musée inimaginable, vol. 2*, Paris: Librairie José Corti, 1956, 109–11. For a suggestion that, as well as Masson's brand of automatism, those of Jacques Hérold, Wolfgang Paalen, Gordon Onslow Ford and Joan Miró might be compared fruitfully with the designs inscribed onto Celtic coins, see José Pierre, *L'Univers surréaliste*, Paris: Somogy, 1983, 34.

[47] Lancelot Lengyel, *L'Art gaulois dans les médailles*, Montrouge-Seine: Éditions Corvina, 1954 (see the accolade lent to Malraux who 'revient l'honneur d'avoir reconnu dans certaines pièces de vraies oeuvres d'art', 25). '[U]n son nouveau à l'analyse de l'humanisme grec', Charles Estienne, 'Abstraction et symbolisme: les médailles gauloises', *France-Observateur*, no. 206, 22 April 1954, 19. Estienne forwarded a clipping of this review to Breton, then, not long after, he would credit the archaeologist Henri Hubert, author of two books on the Celts in 1932, as a precursor of Lengyel and a key initiator of the new trend for Celticism: Charles Estienne, 'De l'art des Gaulois à l'art moderne ou l'histoire d'une résistance: Aux origines de l'esprit moderne', *Combat-Art*, no. 14, 7 February 1955, 2. A recent reading of Lengyel affirms the connection between Celtic coins and Surrealist art and theory, among other things: Raphaël Neuville, 'Les Ors surréalistes de la monnaie gauloise', *Les Cahiers de Framespa*, no. 15, 2014, n.p.: http://framespa.revues.org/2827 (accessed 30 May 2016). For Markale's eulogy to Estienne, see Jean Markale, 'À Travers le miroir', Brest: Musée des Beaux-Arts, *Charles Estienne, une idée de nature*, 1984, n.p.

Arianrod's Room', published in *La Brèche: Action surréaliste* in 1962, J. H. Matthews
alluded to the range of exploration of Celtic myth in Surrealism that I have begun
to describe here:

> In contrast with the formal character of these seriously researched volumes
> [Markale's *L'Épopée celtique en Bretagne* of 1971 and *Women of the Celts* of 1972],
> 'Dans la chambre d'Arianrod' typifies one form of response to myth engendered
> and fostered in Surrealism.
>
> At one extreme stands the probing and enlightening interpretation of myth
> patterns such as we find illuminating the Surrealist mentality and sensibility in
> André Breton's *Arcane 17* [1944]. At the other extreme is imaginative transposition
> of similar thematic material, as in Maurice Fourré's use of the figure of Merlin in
> his novel *Tête-de-nègre* (*Black Man's Head* [1960]) and Markale's text.[48]

This dialectical approach taken towards Brittany and the Celts across Surrealism,
intermingling empirical and factual documentation of the past and present with the
implementation and embellishment of metaphors (or metonyms or myths or
stereotypes or clichés or signifieds) of the region, its past and its people, culminated in
a series of events. The first and perhaps most important was Breton's essay that I
touched on above, 'Triomphe de l'art gaulois', which appeared in *Arts* in August 1954.
Another was the vast polemical exhibition of February and March 1955 *Pérennité de
l'art gaulois* that I mentioned in my third chapter on Georges Seurat, meant to identify
a 'rebellion sometimes secret, sometimes open against the Latin-Mediterranean order',
in Estienne's Bretonian phrasing, and to trace a 'line of heresy' from Celtic art through
the painting I have looked at in this book up to that of contemporary abstract artists as
well as Surrealists.[49] A third was a cluster of publications in Surrealist journals well into

[48]　J. H. Matthews (ed. and trans.), *The Custom-House of Desire: A Half-Century of Surrealist Stories*,
Berkeley, Los Angeles, London: University of California Press, 1975, 215. Matthews was introducing
a short fiction by Markale inspired by research on the Middle Welsh (fourteenth century) *Book of
Taliesin* and it is translated on 215–16 (first published as Jean Markale, 'Dans la chambre d'Arianrod',
La Brèche: Action surréaliste, no. 2, May 1962, 43–4).

[49]　'rébellion tantôt secrète, tantôt ouverte contre l'ordre latin-méditerranéen', Estienne in *Pérennité de
l'art gaulois*, 86. In defence of contemporary abstraction in the previous year, Estienne had indulged
in a similar polemical language, complaining of the enslavement of subjectivity in Europe 'sous
vingt siècles de civilisation helléno-latino-chrétienne', Charles Estienne, 'Une révolution: le
tachisme', *Combat-Art*, no. 4, 1 March 1954, 1 and 2, 1; and he continued to mark the 'oppression
spirituelle gréco-latine' during the run of *Pérennité de l'art gaulois*: Estienne, 'De l'art des Gaulois à
l'art moderne', 2. No fewer than 501 exhibits are listed in the catalogue for the exhibition, the second
part of which was curated by Breton, Lengyel and Estienne who came in for some criticism due to
its speculations and 'misuses', as some thought, of Celtic art: see André Breton, 'Braise au trépied de
Keridwen' [1956], *Oeuvres complètes*, vol. 4, 948–53, 946, 1416. For an example of a review that leads
out and ends with acerbic commentary on its 'protohistoire abusive', see René de Solier, *Pérennité de
l'art gaulois* (Musée Pédagogique)', *La Nouvelle Revue Française*, year 3, vol. 5, no. 28, 1 April 1955,
726–9, 729.

the 1960s.[50] Such activities by the Surrealists kept alive the Celtic and medieval metaphors or stereotypes of Brittany, critically assessed later by Coughlin, Lübbren and others, long after the sound of Gauguin's clogs resounding on its granite soil had dimmed.[51]

Fred Orton and Griselda Pollock believed they caught Gauguin out by close examination of the numerous half-truths, falsifications and exaggerations he conveyed in such 'observations' about Brittany. They also ridiculed the efforts of his followers and their historians to play up the 'medieval', pious, rustic, remote, barren, harsh, traditional, antiquated or backward stereotypes of Brittany generally. However, their materialist analysis really misses the point by falling victim to a category mistake. This is encapsulated in their use of the terms 'myth', 'reality' and 'truth':

> What kind of practices do we, as historians of art practices, need to engage with in order to produce history instead of myth, knowledge instead of cliché and tautology?
>
> In March 1888 [Gauguin] wrote to Émile Schuffenecker, 'I love Brittany; I find there the savage, the primitive. When my clogs resound on the granite soil, I hear the muffled, dull powerful tone which I seek in my painting.' Unfortunately he does

[50] These publications on Celticism began to appear in January 1955: Adrien Dax, 'Actualité de l'art celtique', Jean Markale, 'Mystères et enchantments des littératures celtiques', Lancelot Lengyel, 'La découverte de l'Art celtique bouleverse l'histoire de l'Art occidental', *Médium: Communication surréaliste*, no. 4, January 1955, 5–6; 7–10; 11–14; Lancelot Lengyel, 'Le Moment historique de la prise de conscience de l'Amour-Passion et le Symbolisme dans les sources celtiques du Mythe de Tristan', *Le Surréalisme, même*, no. 2, spring 1957, 12–25; Lancelot Lengyel, 'La force créatrice des moyens platiques', *Le Surréalisme, même*, no. 4, spring 1958, 38–45; Robert Tatin, 'Toi, ma celte', *Bief: Jonction surréaliste*, no. 1, 15 November 1958, n.p.; Jean Markale, 'Rome et l'épopée celtique', *Cahiers du sud*, tome 49, year 46, no. 355, April–May 1960, 334–56. Also see the preface for Markale's collection *Les Grands bardes gallois* (1956) by Breton, arguing for a revival of the 'affective' analogical role of language as opposed to the functional one imposed, apparently, by the 'légions romaines', Breton, 'Braise au trépied de Keridwen', *Oeuvres complètes*, vol. 4, 951. The reader should also consult the respective books of Lengyel and Markale, especially the study in which Surrealist art and writing are taken to be the contemporary heritage of that civilization, seemingly on the back of *Pérennité de l'art gaulois*: Jean Markale, *Les Celtes et la civilisation celtique: Mythe et histoire*, Paris: Payot, 1969, 445–7; 470–3. For a brief survey of the Celticist period of Surrealism, see José Pierre, *André Breton et la peinture*, Lausanne: L'Age d'Homme, 1987, 321–5; for its link with Surrealism's quest from the mid-1930s for a 'new myth', see Marc Eigeldinger, 'Celtisme et surréalisme', Paul Viallaneix and Jean Ehrard (eds), *Nos Ancêtres les Gaulois*, Clermont-Ferrand: Association des Publications de la Faculté des Lettres et Sciences Humaines, 1982, 411–17; and for a brief discussion of Arthurian myth in the context of Surrealism, see Françoise Han, 'Surréalisme et merveilleux celtique', *Europe*, no. 475/476 ('Surréalisme'), November–December 1968, 238–40. A comprehensive bibliography and fuller account of this phase and its repercussions in the movement up to the present day can be found in the chapter on Celticism in Lepetit, *Esoteric Secrets of Surrealism*, 175–215. Its ongoing relevance was shown when Celticism formed the central theme of a recent exhibition of Leonora Carrington's work: Dublin: Irish Museum of Modern Art, *Leonora Carrington*, 2013.
[51] Oddly, Breton did not mention in any of his writings on Celticism, to my knowledge, Arthur Rimbaud's 'Bad Blood' (1873) – 'From my Gallic ancestors I have blue-white eyes, a narrow skull, and clumsiness in wrestling', etc. – much-loved and frequently quoted from elsewhere by him and the Surrealists: Arthur Rimbaud, 'Bad Blood' [1873], *Rimbaud: Complete Works, Selected Letters*, ed. and trans. Wallace Fowlie, Chicago and London: The University of Chicago Press, 1966, 175–83.

not say just what it was that he found savage and primitive about Brittany. Later in that same year he wrote to Vincent van Gogh mentioning the effect of 'rustic and *superstitious* simplicity' which he had achieved in the figures in a picture he was working on. Once again, he chooses not to elucidate this remark or offer any clue as to what caused that effect. These unclear and problematic references have contributed to the myth presented above and elsewhere

Monet spent the summer and the fall of 1886 in Brittany but the reality of the place does not appear in his pictures. Just as he did in Argenteuil so in Brittany, he turned his back on what was awkward in the modern world

When we encounter terms such as savage, primitive, rustic or superstitious in the letters of Gauguin we cannot take them at face value or assume them to be a truth about Brittany, an objective statement of fact, and let them speak as if in explanation of the paintings.[52]

These particulars come as a surprise to Orton and Pollock. It is as though early modern artists in the vicinity of Symbolism such as Gauguin and Claude Monet were supposed to suppress their tendencies towards suggestion and improvisation and behave like investigative journalists, or the more conscientious tourist guides, and represent the 'reality' of Brittany. The suggestion is that they had an ethical responsibility to depict Brittany naturalistically in the way Orton and Pollock attempt to do in their historical materialist survey of the region. Yet their account draws on description from late nineteenth-century sources that were invested in academic or commercial forms of easily consumable realism, the kind of putatively transparent writing that was itself characterized as 'myth' by Barthes.

In fact, Gauguin was unambiguous about the disparity that existed between his art and this 'realistic', visible world of everyday experience that materialist history seeks to recover. This was understood by his first followers who were thrilled on sight by his paintings from Martinique and Pont-Aven, displaying what Maurice Denis called 'splendid dreams in comparison with those miserable realities of the official teaching!'[53] His contemporaries were perfectly apprised of Gauguin's *modus operandi*. This capacity for absorbing the stereotypes of a region then imposing a myth on the landscape that is nevertheless personal was lauded by the artist Armand Seguin in an 1891 article in the regionalist newspaper *L'Union agricole et maritime*, published in Quimperlé in Finistère:

[52] Fred Orton and Griselda Pollock, 'Les Données Bretonnantes: La Prairie de Représentation' [1980], *Avant-Gardes and Partisans Reviewed*, Manchester and New York: Manchester University Press, 1996, 53–88, 56, 59–60, 65, 69. The authors quote from letters reproduced respectively in Victor Merlhès, *Correspondance de Paul Gauguin: Documents, témoignages*, Paris: Fondation Singer-Polignac, 1984, 172; and Paris: Institut Neerlandais, *Oeuvres écrites de Gauguin et van Gogh*, 1975, 22 ('superstitieuse' is not italicised in the second, though it is in the original letter).

[53] 'Rêves splendides auprès des réalités misérables de l'enseignement officiel!' Maurice Denis, 'L'Influence de Paul Gauguin' [1903], *Théories, 1890–1910: Du symbolisme et de Gauguin vers un nouvel ordre classique* [1912], Paris: L. Rouart et J. Watelin, 1920, 166–71, 169.

Gauguin is above all a painter of sensations, all of which emanate from memories and literary assimilations or, rather, all of which correspond in our mind to certain literary reminiscences. He is almost . . . a philosopher-painter, sadly ironic, each of whose canvases synthesizes a character but in such a cruel fashion – when it does not raise our thoughts towards distant horizons – in such a cruel fashion that it has for us a surprisingly true character, and, moreover, was not understood till then in that way.

In his decorative arabesques, in his rare science of composition, he alone has understood Brittany, not as it is, certainly not; yet it thus answers more to the preconceived idea than to the real vision and with such truth that it seems that reality is made into a dream for our illusions. The Brittany of the past that one desires and had hoped for – remote moors, sad houses, solitude, melancholy.[54]

Gauguin even elucidated his intentions unequivocally in the second of the letters selectively extracted from by Orton and Pollock in the quotation above. The 'picture he was working on' was *Vision of the Sermon (Jacob Wrestling with the Angel)* (figure 6.4, 1888), which 'implicitly linked Gauguin's anti-naturalist, anti-Impressionist stylization to his perception of the transcendental intensity of the folk mind's inventions', in the words of Kirk Varnedoe,[55] and in those of Belinda Thomson was 'an attempt to depict the fervour of a faith grafted onto more ancient Celtic superstitions.'[56] The passage Orton and Pollock quote is excerpted from a letter to van Gogh of September 1888 as it was reproduced in the French publication used by the two authors, even though most

[54] 'Gauguin est surtout un peintre de sensations qui, toutes, émanent de souvenirs et d'assimilations littéraires ou qui, toutes, correspondent en notre esprit, à certaines réminiscences littéraires. C'est presque . . . un peintre philosophe, tristement ironique, dont chaque toile synthétise un caractère mais d'une façon si cruelle – lorsqu'elle n'élève notre pensée vers des horizons lointains – d'une façon si cruelle que se caractère nous surprend, vrai, et cependant jusqu'alors non compris ainsi.

En ses arabesques décoratives, en sa rare science de composition, lui seul a compris la Bretagne, telle, certes non; cependant elle répond ainsi plus à l'idée préconçue qu'à la réelle vision et d'une telle vérité, qu'il semble que la réalité se soit faite rêve pour nos illusions. Bretagne que l'on désire, qu'autrefois l'on a espérée – landes perdues, maisons tristes, solitude, mélancolie', Seguin quoted in Pont-Aven: Musée de Pont-Aven, *Seguin, 1869–1903*, 1989, 61. For an alternative translation, see Thomson, 'Paul Gauguin: Navigating the Myth', *Gauguin: Maker of Myth*, 10–23, 22. Thomson writes as follows: '[h]is melancholic scenes of Breton rural life corresponded, he made clear, not to how Pont-Aven or Le Pouldu actually looked but to his own subjective vision. . . . This sometimes meant fusing experienced reality with pre-existing, cultural stereotypes: presenting Brittany as the land of superstitions and sad desolation', 18.

[55] Kirk Varnedoe, 'Gauguin', New York: Museum of Modern Art, *'Primitivism' in 20th Century Art: Affinity of the Tribal and the Modern*, vol. 1, 1984, 179–209, 183.

[56] Thomson, *Gauguin: Maker of Myth*, 134. More recently, Thomson has addressed the 'veiled allusion to an indigenous folkloric tradition (wrestling)' in the picture, Belinda Thomson, 'The Conflicted Status of Narrative in the Art of Paul Gauguin', Peter Cooke and Nina Lübbren (eds), *Painting and Narrative in France*, London and New York: Routledge, 2016, 176–89, 180. For more on the very real presence of superstition in Brittany and elsewhere in rural France, see Judith Devlin, *The Superstitious Mind: French Peasants and the Supernatural in the Nineteenth Century*, New Haven and London: Yale University Press, 1987.

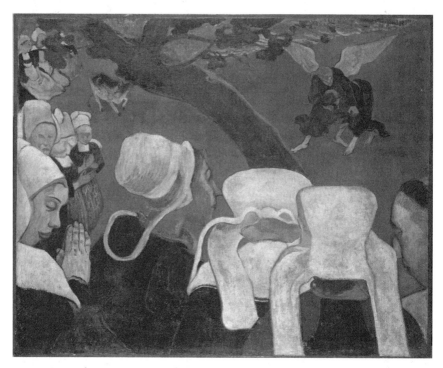

Figure 6.4 Paul Gauguin, *Vision of the Sermon (Jacob Wrestling with the Angel)* (1888). Oil on canvas, 72.2 × 91 cm. Scottish National Gallery, Edinburgh. © DeAgostini Picture Library/Scala, Florence.

of it was translated in Rewald's *Post-Impressionism: From Van Gogh to Gauguin* (on which they spend three pages in order to show how they are not 'indebted' to it[57]). Another part of it runs as follows:

> the cow under the tree is tiny in comparison with reality, and is rearing up – for me in this painting the landscape and the fight only exist in the imagination of the people praying after the sermon, which is why there is a contrast between the people, who are natural, and the struggle going on in the landscape which is non-natural and out of proportion.[58]

It hardly seems worth reiterating further that Gauguin's art is concerned not with mimesis but with metaphor. Gauguin emphasized this often enough. His taste for what

[57] Orton and Pollock, *Avant-Gardes and Partisans Reviewed*, 55.
[58] Gauguin quoted in Washington: National Gallery of Art, *The Art of Paul Gauguin*, 1988, 103; the letter was published and translated for the first time, minus the part about the cow but fully related to *Vision of the Sermon*, by John Rewald, *Post-Impressionism: From Van Gogh to Gauguin*, New York: The Museum of Modern Art, 1956, 201–2.

was then called 'abstraction' became a point of disagreement with van Gogh as I noted in my Introduction to this book.[59] Furthermore, it is generally accepted among scholars that while in Le Pouldu from June 1889 to early November 1890, he became far more sensitized to the traditional art of Brittany and his work took an increasingly imaginary turn, even if the combination of people and apparition in what José Pierre called the 'fantastic space' of *Vision of the Sermon* was rarely repeated afterwards.[60]

This brew held a particular appeal for the Surrealists during the period they were becoming more interested in the imaginary Celtic past of Europe and its equally imaginary survival into the present. Gauguin (or his colour yellow) even receives passing though clearly strategic mention in the novel that anticipated and helped facilitate this trend in Surrealism, Gracq's *Au Château d'Argol*, which harnessed the

[59] In a letter to Émile Bernard of about 5 October 1888, van Gogh confessed: 'I never work from memory.... And I can't work without a model. I'm not saying that I don't flatly turn my back on reality to turn a study into a painting – by arranging the colour, by enlarging, by simplifying – but I have such a fear of separating myself from what's possible and what's right as far as form is concerned.... Others may have more clarity of mind than I for abstract studies – and you might certainly be among them, as well as Gauguin and perhaps myself when I'm old.... But in the meantime I'm still living off the real world. I exaggerate, I sometimes make changes to the subject, but still I don't invent the whole of the painting', Vincent van Gogh, *The Letters: The Complete Illustrated and Annotated Edition, Vol. 4, Arles 1888–1889*, eds Leo Jansen, Hans Luijten and Nienke Bakker, London and New York: Thames & Hudson, 2009, letter 698, 313–14, 314. In the following month he told his brother Theo that what became Gauguin's *Human Misery* (1888) with its Breton women recalled in an Arles vineyard was painted 'completely from memory', van Gogh, *The Letters, Vol. 4*, letter 717, 352–3, 352. Also see Gauguin's casual yet obviously polemical dismissal of 'l'exactitude', referred to in my Introduction, in the description he made of the same painting in a letter of November 1888 to Bernard: Merlhès, *Correspondance de Paul Gauguin*, 275. Later, van Gogh made his position on painting without a model quite distinct from Gauguin's in the sort of manifesto statement I have quoted from and will return to towards the end of this book, in a letter sent to Bernard on about 26 November 1889: 'When Gauguin was in Arles, I once or twice allowed myself to be led into abstraction, as you know, in [*Augustine Roulin (La berceuse)* (1889), *Woman Reading a Novel* (1888)], and at that time abstraction seemed an attractive route to me. But that's enchanted ground, – my good fellow – and one soon finds oneself up against a wall', Vincent van Gogh, *The Letters: The Complete Illustrated and Annotated Edition, Vol. 5: Saint-Rémy-Auvers 1889–1890*, eds Leo Jansen, Hans Luijten and Nienke Bakker, London and New York: Thames & Hudson, 2009, letter 822, 146–53, 148.

[60] 'espace fantastique', Pierre, *L'Univers surréaliste*, 58. See, for instance, Belinda Thomson, *Gauguin* [1987], London: Thames and Hudson, 1990, 100, 111, 114. Gauguin's appropriation of Brittany is compared with Orientalism and called 'Bretonism' in an annihilating article that extends the Orton–Pollock argument to postcolonial terrain and Gauguin's Tahitian paintings, sparing no aspect of Gauguin's life, art or myth: Abigail Solomon-Godeau, 'Going Native', *Art in America*, vol. 77, no. 7, July 1989, 118–29 and 161, 122; and for a second demolition of the Brittany and Tahitian work, see Griselda Pollock, *Avant-Garde Gambits 1888–1893: Gender and the Colour of Art History*, London: Thames and Hudson, 1992. One art historian alluded critically yet briefly to such readings before opining: 'I can only imagine Gauguin befuddled by our persistent search for the truth of his symbolism as if it were an unalloyed photographic referent, one which – exactly as such, as verisimilar and so forth – he flatly disowned', Edward D. Powers, 'From Eternity to Here: Paul Gauguin and the Word Made Flesh', *Oxford Art Journal*, vol. 25, no. 2, 2002, 89–106, 89; and a full and nuanced rebuttal exists in Stephen F. Eisenman, *Gauguin's Skirt*, London: Thames and Hudson, 1997. Attempts to at least add some shading to such criticism of Gauguin can be found among the essays in Norma Broude (ed.), *Gauguin's Challenge: New Perspectives After Postmodernism*, London: Bloomsbury, 2018.

romantisme noir that according to Catherine Bertho had dominated the image of Brittany since the nineteenth century.[61] It is apparently not set in the Middle Ages since a journey by car (*'voiture'*) takes place at one point and 'the blades of a propeller' are used for analogical purposes in another.[62] Yet every feature of the mythic and medieval landscape of the 'melancholy country' of Brittany as Gauguin chose to understand it and Gracq describes it – dolmens, rain and mists, moors, peasants familiar with local legend, an eleventh-century castle built partly from granite stones and features of the 'perilous gorges [and] precipitous crags, veiled in the thick curtain of the woods' – is retrieved in *Au Château d'Argol*.[63] It is placed there in the metonymical service of a loose retelling of the Grail narrative of Perceval, rerouted through the typical scenography of the Gothic novel and theorized in its detail by means of Hegel's dialectic.[64]

Gracq's use of the same metonymical shorthand pervades *A Dark Stranger* (1945), his later tale of torpor set at the seaside in the 'Hôtel des Vagues', located close to Carantec on the north western coast of Brittany. Gauguin is alluded to again, here, when the brooding narrator studies the waves and beach under a grey sky in a reflection that supports the dialectical reading I am giving:

> On a level with this isolation, this majesty unfurled beneath the heavy, fleeting clouds, one could only imagine . . . well: behind a fold in the sand, the smoke from the funeral pyre of Shelley or the solemn string of Gauguin's horsemen galloping bareback with their long noble sweeping gestures; those horses, brothers of the sea, dappled and restless like that very element itself, great horses rising from the sea in the most immemorial catastrophes of ancient legend.[65]

The eruption in Gracq's Brittany of one or the other of the *Riders on the Beach* (plate 7a, both 1902), actually painted in Gauguin's last period on Hiva Oa in the Marquesas and memorializing the shore of Atuana, is a kind of exaggerated version of the apparition of Breton women in Arles in Gauguin's rural drama *Human Misery* (figure 6.5, 1888), 'abstracted' from memory and with little regard for 'exactitude' in the latter part of the period of turbulent cooperation between Gauguin and van Gogh. In both cases, a

[61] Julien Gracq, *Château d'Argol* [1938], trans. Louise Varèse, London: Pushkin Press, 1999, 20; Bertho, 'L'invention de la Bretagne', 48.

[62] Gracq, *Château d'Argol*, 67, 93–4.

[63] Gracq, *Château d'Argol*, 135, 29, 17, 77.

[64] See the author's introduction: Julien Gracq, *Au Château d'Argol* [1938], Paris: Librairie José Corti, 1945, 7–11; and for a proposal as to the novel's Hegelian traits, see Jean-François Marquet, 'Au Château d'Argol et le mythe hégélien', Jean-Louis Leutrat (ed.), *L'Herne* ('Julien Gracq'), Paris: Éditions de l'Herne, 1972, 53–62. One commentator has pointed out that the writing of *Au Château d'Argol* coincided with the important discussion of the Gothic novel by Breton: Michel Murat, *Julien Gracq*, Paris: Pierre Belfond, 1991, 41. See André Breton, 'Nonnational Boundaries of Surrealism' [1936–7], *Free Rein*, 7–18; André Breton, 'Limites non frontières du surréalisme', *La Nouvelle Revue Française*, vol. 48, no. 281, 1 February 1937, 200–15.

[65] Julien Gracq, *A Dark Stranger* [1945], trans. W. J. Strachan, London: Peter Owen Limited, 1951, 31.

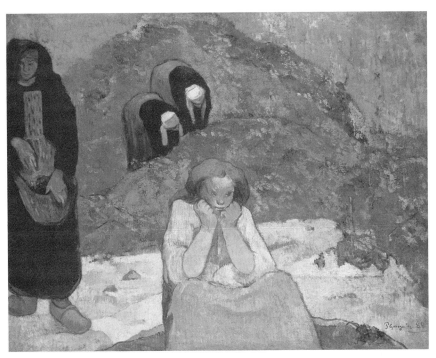

Figure 6.5 Paul Gauguin, *Human Misery* (1888). Oil on canvas, 73.5 × 92.5 cm. Ordrupgaard Collection, Copenhagen. © Bridgeman Images.

reality is reached that consists of a synthesis of what has been perceived externally and recalled 'inwardly'.

This is emphatically so in the case of the echo image of the *Riders on the Beach*. Gracq would have noticed the arrival of the strangely costumed riders on the left of the first version, 'two cavaliers who seem to emerge from another place or time' as described by one source, and might have known they were based partly on the jockeys of the paintings of Edgar Degas (plate 7b) and partly on the horsemen of the *Elgin Marbles*.[66]

Whether Gauguin believed what he wrote about Brittany or not – and he must have been blind if he was unable to see the 'ridiculous countryside' of Pont-Aven and quaint

[66] George T. M. Shackelford, 'Splendor and Misery: Gauguin in the Marquesas Islands', *Gauguin Tahiti*, 242–59, 248. For the importance of the topography of Brittany to Gracq's fiction and its occurrences throughout his *oeuvre*, see Denis Labouret, 'Julien Gracq de Bretagne', *Europe*, no. 1007 ('Julien Gracq'), March 2013, 62–9; and for the author's own rather grave perspective on that 'province de l'âme', expressing scepticism as to its mythic and folklorish associations while confirming its Surrealist ones in the upper coastal town of Ploumanac'h, 'où le paysage dévoile partout la nudité corrosive des sculptures d'[Hans] Arp et des peintures de Tanguy', see Julien Gracq, 'Tableau de la Bretagne', *Lettrines 1*, Paris: José Corti, 1967, 189–97, 196, 191.

artists' shops mocked by Paul Signac after passing through the village, or the modern industry alongside the 'pretty and picturesque' features remarked in the tourist books of the last two decades of the nineteenth century – his purpose was similar to that of the Surrealists, their precursors and such friends as Gracq: to entertain its metaphor or myth for the benefit of his art.[67] Gauguin had no intention of depicting the region naturistically in painting any more than Gracq in his fiction so why should we believe he aimed to in his words? The 'unfortunate' under-explanation of his terms in his letters lamented by Orton and Pollock was a poetic allusion to place meant to take in Brittany's assumed, 'savage' Celtic and medieval history, its weather, rough pasture land, its harsh areas of hilly wilderness (such as the region of the Monts d'Arrée, sparsely populated and marshy to this day), its granite buildings and its people.[68]

The Orton–Pollock thesis rests on a malignant usage of the term 'myth', understood as a lie through the alternative option it utilizes – one that is found everywhere in the form of knowledge that characterizes academic writing like this, but is quite foreign to the avant-garde poetry and art it writes on – of a materialist position on reality and truth that Gauguin had about as much interest in as the Surrealists.[69] Lacking a dialectic, it cannot do justice to the complexity it recognizes in Brittany. This was accomplished innocently by the American explorer Frederick Samuel Dellenbaugh in a first-hand account of Finistère, which lies at the western extremity of the region. Dellenbaugh's article was not among the sources consulted by Orton and Pollock yet it is contemporary with the École de Pont-Aven. It freely uses the terminology those two authors scorned ('rugged', 'primitive', 'backward', 'quaint and ancient' and 'bleak and

[67] Letter of summer 1891 from Signac to Maximilien Luce quoted in Rewald, *Post-Impressionism*, 290; Orton and Pollock, *Avant-Gardes and Partisans Reviewed*, 61. Like Coughlin and Lübbren, Pollock assumes the worst of artist 'tourists' like Gauguin and van Gogh whom she believes are as blind and self-deluded to the 'reality' of geographical location as contemporary tourists, as though they cannot juggle several realities at once and as if stereotypes of place have value only in advertising: Griselda Pollock, 'On Not Seeing Provence: Van Gogh and the Landscape of Consolation, 1888–9', Richard Thomson (ed.), *Framing France: The Representation of Landscape in France, 1870–1914*, Manchester and New York: Manchester University Press, 1998, 81–118.

[68] Part of Varnedoe's essay about the stylistic features of the Tahitian work runs on a similar argument to mine here: 'they suggest the scope of his ambitions to respond not just to his experience of the island in the 1890s, nor only to the allure and falsehoods of Tahiti's myths since 1767, but also to the larger questions of the Tahitians' role in human history. Rather than a stripping away toward some essential truth, his Tahitian primitivism emerged as a composite elaboration of this layered richness ... Gauguin's larger vision of Polynesia was ... based on varying parts of experience, research, and speculation. ... These intimations of an unknown past woven into the present were what he set his art to capture', Varnedoe, *'Primitivism' in 20th Century Art*, 189, 190.

[69] Like the academic writing on Surrealism, the Gauguin scholarship is now heavily invested in Gauguin's myth-making as a 'lie' (not a metaphor) and this goes some way towards explaining its overall tone of flatness and reserve as opposed to the ecstatic response the artist's work received from the Surrealists. The idea of myth as fiction (as viewed from an 'outside', objectivist position) and not as metaphor (as viewed from an 'inside', poetic standpoint, accepting Gauguin as a seer) was a significant force in shaping the 2010–11 Tate Modern exhibition and catalogue, *Gauguin: Maker of Myth*. Yet as one writer on myths of wilderness, the countryside and the city asserted: 'The term "myth" does not imply falsehood to be contrasted with reality. An environmental myth can contain both fact and fancy. The important question is not "is it true?" but "whose truth is it?"' John Rennie Short, *Imagined Country: Environment, Culture and Society* [1991], Syracuse NY: Syracuse University Press, 2005, xxii.

wild'), while closely examining the region's modern fishing industry; it observes the relatively low numbers of tourists while noting that Finistère was 'only' fifteen hours by train from Paris; and it comments on the 'Parisianized' upper classes in the region that is 'the furthest removed from the world of Paris'.[70] Dellenbaugh's dialectic is best achieved where the present is synthesized with the past in a partly subjective eyewitness description of fishing boats:

> You linger on the pier at evening and watch the return. The brown-red sails sweep past into the harbour under the century-worn battlements, till all the air is luminous and the sails coming out of the misty horizon turn crimson, speeding the dark hulls over a crimson sea. The colour dies away and the boats come down upon you like spectres; the imagination is set free to the music of the tide breaking gently at your feet. The mind runs back into the past, and sees in these dark wings the leathern sails of the Veneti who some twenty centuries ago ruled this wild coast from the mouth of the Loire to Brest, and considered themselves invincible by land or sea. They are congregating for the conquest of the Roman host on the morrow
>
> The gloom and the mystery deepen; the lighthouse far out on the horizon of Penfret flashes its warnings around the horizon, and the gray nightfall seems to undulate with the heaving sea in unison with your dreaming.[71]

Although they differed in their articulation of the traditions of the region, Gauguin and the later Surrealists thought similarly to Dellenbaugh in the sense that the myth of Brittany was a metaphor or poetic reality that underlay and erupted through their representations in dialectical relation with the one viewed and experienced daily.[72] Precisely this has been said of Gracq, too, for whom 'there was no gap between the *reality* of the territory and the imaginative, *surreal* drift, which that basic raw material permitted or provoked.'[73] Their shared aim was to make a subjective investment to generate a personal, mythic understanding of place that was inseparable from the materialist one. This metaphorical re-presentation of place 'resolv[ed] the antinomy between the sensible and the intellectual worlds' in Gauguin's case, making his art an intermediary or 'connecting link between the conscious and the

[70] F. S. Dellenbaugh, 'Finistère: The Artist's Corner of Brittany', *Journal of the American Geographical Society of New York*, vol. 20, 1888, 295–336, 295, 296, 297, 298, 308, 309, 313, 315, 316, 327, 333.

[71] Dellenbaugh, 'Finistère', 319–20.

[72] For Gauguin's well-known, passionate assertion '[j]e trouve *tout* poétique et c'est dans les coins de mon coeur qui sont parfois mysterieux que j'entrevois la poesie', see the letter to van Gogh from Pont-Aven sent on about 10 September 1988: Douglas Cooper (ed.), *Paul Gauguin: 45 lettres à Vincent, Théo et Jo van Gogh*, The Hague and Lausanne: Staatsuitgeverij/La bibliothèque des arts, 1983, 221. And for evidence that superstition, ritual, folklore and myth live on under modernity in Brittany (like everywhere else), see the study by Ellen Badone, *The Appointed Hour: Death, Worldview, and Social Change in Brittany*, Berkeley, Los Angeles, London: University of California Press, 1989.

[73] 'il n'y ait pas de coupure entre la *réalité* du territoire et la dérive imaginaire, *surréelle*, que cette matière élémentaire autorise ou provoque', Labouret, 'Julien Gracq de Bretagne', 65.

unconscious', as Achille Delaroche proposed in the reading admired and quoted from by Gauguin himself.[74]

While Yves Tanguy's paintings look entirely dissimilar to Gauguin's, then, they meet them on that terrain set out by psychoanalysis, where 'the unconscious beleaguers the ego and the world of objects' in Breton's words, not on the surface of things but 'behind the scenes of life' and prone to interventions in that life that make its presence felt.[75] As Breton wrote that about Tanguy while far from Brittany in 1942, he was pondering the widespread debate during the Second World War on the desirability of a 'new myth' in these terms:

'… in what measure can we choose or adopt, and *impose* a myth fostering the society that we judge to be desirable?' But I might also note a certain return to the study of the philosophy of the Middle Ages as well as of the 'accursed' sciences (with which a tacit contact has always been maintained through the intermediary of 'accursed' poetry) which has been taking place during this war.[76]

Aligning the interest in medieval philosophy evident in *Cahiers du sud* and elsewhere with the scorned practices of esotericism and more specifically alchemy as that had captured the attention of the Surrealists, Breton confirmed here their tie with the modern tradition of the *poète maudit*. Initiated in the poetry and experiences of Charles Baudelaire, the Comte de Lautréamont and Arthur Rimbaud, that tradition of resistance had its logical outcome, as far as he was concerned, in the current preoccupation of Surrealism with the creation of a mythic experience of the world that could compare with that of the Middle Ages.

[74] Achille Delaroche, 'Concerning the Painter Paul Gauguin, From an Aesthetic Point of View' [1894], in *Paul Gauguin, The Intimate Journals of Paul Gauguin* [1903, pub. 1918] trans. Van Wyck Brooks, London: William Heinemann, 1923, 20–4, 23. Near to our own day, that particular remark was described as 'redolent of Schelling and Hegel', Naomi Margolis Maurer, *The Pursuit of Spiritual Wisdom: The Thought and Art of Vincent van Gogh and Paul Gauguin*, Madison and Teaneck NJ: Fairleigh Dickinson and London: Associated University Presses, 1998, 28. Also see the tantalizing remarks reporting the Hegelian content of Paul Sérusier's early clarification of Gauguin to younger artists made soon after Gauguin's death by Denis, *Théories, 1890–1910*, 170; and the letter of 29 January 1915 from Sérusier to Denis denying any knowledge of Kant by artists of the earlier epoch (made during the First World War, however), together with the remark by Denis recalling the citation of Hegel among Symbolist critics in the late 1880s and early 1890s: Maurice Denis, 'Paul Sérusier: sa vie, son oeuvre', Paul Sérusier, *A B C de la peinture* [1921], Paris: Librairie Floury, 1942, 35–121, 101, 64. Hegel is listed without further comment among the authors discussed by the Nabis by Suzanne Barazzetti-Demoulin, *Maurice Denis*, Paris: Éditions Bernard Grasset, 1945, 29; and this is repeated by Caroline Boyle-Turner, *Paul Sérusier*, Ann Arbor MI: UMI Research Press, 1983, 35. Although the Hegelian context for Gauguin and the Nabis in late nineteenth-century France remains a blind spot for historians for now, it certainly existed because Hegel's writings were experienced as a revelation from 1866 by Stéphane Mallarmé: see Guy Michaud, *Mallarmé* [1953], trans Marie Collins and Bertha Humez, London: Peter Owen, 1966, 51–62. Additionally, both Gustave Kahn and Jules Laforgue had a knowledge of German philosophy according to Sven Lövgren, *The Genesis of Modernism: Seurat, Gauguin, van Gogh and French Symbolism in the 1880s*, trans. Albert Read, Stockholm: Almqvist & Wiksell, 1959, 66.

[75] Breton, *Surrealism and Painting*, 176, 179.

[76] André Breton, 'Prolegomena to a Third Surrealist Manifesto or Not' [1942], *Manifestoes of Surrealism*, trans Richard Seaver and Helen R. Lane, Michigan: University of Michigan Press, 1972, 279–93, 287–8 (translation modified).

The Surrealists' defiance through myth of the 'depreciation of reality' – a derogation of the real later assumed, on the contrary, by Coughlin, Lübbren and Orton and Pollock to be the inevitable outcome of the negative stereotyping that took place through the creation of place myths – was instituted because that diminishment was carried out 'in place of its exaltation', in Breton's words.[77] During the high years of Surrealist 'Celtomania', this diminution of reality came up for discussion within the group. It was soon labelled 'miserabilism' by Breton who saw it countered under modernity by the poetry of Baudelaire and Rimbaud and the art of Gauguin, Seurat and most recently the Surrealists.[78] In fact, Gauguin turns out to be the most consistent exponent of that exaltation. He is mentioned in each of the three texts, by Robert Benayoun, Charles Estienne and José Pierre, that accompanied and developed Breton's statement against miserabilism when it appeared in *Arts* in 1956 defining that exaltation as achievable through a dialectic of the imaginary and real.[79] This is what is meant by a myth in Surrealism and it demonstrates why, by the way, Breton could condemn René Magritte's lopsided longing to escape from sadness, boredom and so on, in favour of 'the whole traditional range of charming things' via his Renoirean 'Sunlit Surrealism', as 'anti-dialectical' in 1946.[80]

[77] André Breton, 'Away with Miserabilism!' [1956], *Surrealism and Painting*, 347–8, 348.

[78] Miserabilism was defined later within Surrealism as the theoretical justification for unhappiness given under whatever political, ideological or philosophical system: 'the cynical rationalization of misery, suffering and corruption: the dominant ideology of Power in our time', Penelope Rosemont, *Surrealist Experiences: 1001 Dawns, 221 Midnights*, Chicago: Black Swan Press, 2000, 168. That ideology became perhaps the key area for examination and resistance by the Chicago Surrealists from the 1960s: see, for instance, Rosemont and Joseph Jablonski, 'Miserabilism and Anti-Miserabilism: Some Characteristics of the Current Period and Some Possibilities for Surrealist Intervention' [1986], Rosemont, *Surrealist Experiences*, 125–8. For a volume of Surrealist texts that frequently take their cue from the theme, defining miserabilism as 'the summation of all ideological excrescences of the "accumulation of misery" that Marx correlated with the accumulation of capital', see Franklin Rosemont, *Revolution in the Service of the Marvelous: Surrealist Contributions to the Critique of Miserabilism*, Chicago: Charles H. Kerr, 2003, 17; and for another that pitches Breton's brief article against the full product range of modern capitalism, see David Roediger, *History Against Misery*, Chicago: Charles H. Kerr, 2006.

[79] All four have been reprinted together: André Breton, 'Sus au misérabilisme!' Robert Benayoun, 'Le cinéma-croûton', Charles Estienne, 'À Messieurs de la biennale de Venise', José Pierre, 'L'Araignée et le Papillon' [1956], José Pierre (ed.), *Tracts surréalistes et déclarations collectives, 1922–1969*, tome 2: 1940–1969, Paris: Le Terrain Vague, 1982, 146–7; 147–8; 148–51; 151–3. Breton associated 'miserabilism' with nineteenth-century academicism, then, in his own day, Nazism, Stalinism and existentialism, defining its opposite through the unlikely example given by the writings of the academic engraver and sculptor Émile Soldi as a dialectic of the imaginary and real: Breton, *Surrealism and Painting*, 348. It should be noted that Estienne, a native of Brittany as I indicated, had gone so far as to open his scandalized 1948 article calling for a Gauguin centenary with the indefatigable clogs-on-granite quotation and went on to describe dialectically the Polynesia met with in all its banality and beauty in *Noa Noa* as 'enchantée et réelle' in which there are 'grandioses naïvetés, mais aussi quelque chose du merveilleux', Charles Estienne, 'Centenaire de Gauguin', *Combat*, no. 1220, 9 June 1948, 4.

[80] See the letter of 4 December 1941 from Magritte to Paul Éluard and the one of 8 October 1946 from Magritte to Marcel Mariën reporting Breton's response to the manifesto of 'Sunlit Surrealism', both quoted in David Sylvester (ed.), *René Magritte: Catalogue Raisonné, vol. 2: Oil Paintings and Objects, 1931–1948*, London: The Menil Foundation/Philip Wilson Publishers, 1993, 290, 135. As Breton's editors point out, the rhetorical tilt towards optimism urged in the text against miserabilism followed the shift in Breton's thinking about metaphorical imagery by means of poetic analogy along the same lines in the post-war period and set out in André Breton, 'Ascendant Sign' [1947], *Free Rein*, 104–7; see Breton, *Oeuvres complètes*, vol. 4, 1367.

Magic Art, Folklore and Rural Tales in Le Pouldu: André Breton, Paul Gauguin and Charles Filiger

André Breton's reference in his 1942 essay on Yves Tanguy to the legendary myth of Ys – as though it also stood as a semi-phonetic contraction of the artist's name (as in his own, Breton/Bretagne) – already shows a belief in the close identification of the geographies of self with those of folklore and local fable, as well as a recollection of the storytelling that would help make Brittany a privileged Surrealist place after the Second World War.[1] This was further anticipated in the trip he took to the region in the summer of 1936 that I discussed in my first chapter on Paul Cézanne and was recorded in *Mad Love* (1937). In the third part of that book, Breton had speculated on the enduring unconscious presence of a specific folk tale, namely *Cinderella* (1697), in shaping an unbidden poetic sentence he experienced: 'le Cendrier Cendrillon' (the wordplay is lost in English: 'the Cinderella Ashtray'). Furthermore, it predetermined his discovery at the Saint-Ouen flea market of the large wooden spoon ending in a small shoe on the underside of the handle, a craft object that reminded him of 'one of those kitchen implements that Cinderella must have used before her metamorphosis'.[2] It is appropriate, of course, that Breton's path towards that prophetic object (meant seriously in the usual sense of having 'divinatory qualities') and first steps towards a theory of magic were guided by the enchanted events related in that story.

Uncharacteristically, Breton made nothing in *Mad Love* of the fact that his walk with Alberto Giacometti to the flea market on 'a lovely spring day in 1934', and the one soon after with Jacqueline Lamba on the night of 29–30 May that year also in Paris, corresponded closely to the dates of the murder by Michel Henriot on 8 May in Brittany – 'where the inhabitants are marked by a Celtic aloofness as stony as the mournful coasts of their country', in the imagination of one author writing in the 1950s[3] – and the widespread response of the media to it, which Breton only found out about later.[4] He might well have pondered this at some point. In this last chapter, I am going to make the related claim that as he looked at Paul Gauguin's paintings in a substantially

[1] André Breton, 'Yves Tanguy: What Tanguy Veils and Reveals' [1942], *Surrealism and Painting* [1965], trans. Simon Watson Taylor, New York: Harper & Row, 1972, 176–80, 180.
[2] André Breton, *Mad Love* [1937], trans. Mary Ann Caws, Lincoln and London: University of Nebraska Press, 1987, 34.
[3] Alister Kershaw, *Murder in France*, London: Constable & Company Limited, 1955, 118.
[4] Breton, *Mad Love*, 25.

altered cultural climate in the 1950s, he did continue to reflect on that event and the association he had conjured between it and his unhappy day out with Lamba on the way towards Le Pouldu two years later, as recollected in *Mad Love*. By revisiting this narrative previously examined in my first chapter, I will arrive at another way of understanding a Surrealist Gauguin, this time determined by a 'folk Surrealism' residing in an enchanted Brittany. This is meant as a further step in my larger, revisionary historiography of early modern art based in Surrealism that contests the one of modernist formalism. For now, I am putting to one side the much larger and complex question of the relationship between modern art and folklore.

Surrealist readings: From myth to folklore

That episode of discord in love, 'a banal theme of popular songs', was foreshadowed – predicted, Breton would have said, and did, in fact – by the reading material taken there by him and Lamba.[5] Choosing his words carefully, Breton had already conceded on that score: 'I cannot pretend not to know how medieval such a way of seeing, in the eyes of certain positivistic minds, may seem', before extending his divinatory interpretation of his and Lamba's experience there to the books that the couple took along:

> [O]n the eve of our departure, my wife having asked one of our friends to lend her for these few days something light to read, the friend had brought her two English novels: *La Renarde* [*Gone to Earth*], by Mary Webb, and *La Femme changée en renard* [*Lady into Fox*], by David Garnett. I had been struck, in that moment, by the analogy of these two titles (our friend, making a hasty choice in his library, must not have remembered which of these corresponded to the content that he liked). Also remarkable, I had known the second of these works for a long time, and I had enjoyed rereading it in the days before this. This 20 July in particular, the two volumes and just they alone were in our room, within easy reach on little tables *on either side* of the bed
>
> Through what mystery did they manage to enter into the composition with the other elements such as this house, this stream – the Loch itself – this fort (which none of us could identify), provoking in us simultaneously an affective state *in total contradiction* to our real feelings? Why, very precisely, had these two books accompanied us to Brittany?[6]

Why indeed? Breton had no exact answer ready for this question beyond the 'medieval' interpretation that they were a kind of warning to the lovers of the murderous deed of Henriot, the keeper of silver foxes, which although in the past was awaiting them in Brittany. We will find him covertly pursuing this question through the painting of Gauguin later in life.

[5] Breton, *Mad Love*, 99.
[6] Breton, *Mad Love*, 110–11 (translation modified).

However, to the 'positivistic mind' the choice of books comes as evidence of the friend's empathetic response to the holidayers' request for reading and also to the Surrealist perception of society and civilization because they share a folklorish, pagan flavour that is attuned to the then still embryonic Surrealist Brittany.[7] The author Mary Webb is now almost forgotten, but in her time she was a celebrated, regionalist author, admired by her French translator Jacques de Lacretelle for her 'poetic observation and her sentiment for nature'.[8] Her books are set in her native and beloved Shropshire, include use of its dialect and hold much in common with Thomas Hardy's fiction, which Webb admired. She went so far as to correspond with Hardy, successfully seeking permission to dedicate to him her final and best-known novel *Precious Bane* (1924), which would win the Prix Femina Vie Heureuse in 1925. It was probably its success that ensured the earlier *Gone to Earth* (1917) was also translated into French and published as *La Renarde* in 1933.

Based partly on the author's own personality and cast in the mould of Hardy's equally unfortunate Tess Durbeyfield, the central character of *Gone to Earth* is Hazel Woodus, a free-spirited, naïve, nature-loving country girl addicted to sorrow and heading for much worse.[9] Hazel's self-identification with her pet fox and 'with all things hunted and snared and destroyed' is sustained on both narrative and metaphorical levels in the pursuit and struggle over her that takes place between what de Lacretelle called her 'two rival assassins', the pastor Edward Marston who marries her and the amoral local squire John Reddin by whom she gets pregnant.[10] The story gains much of its dramatic traction from class contrast, through which Hazel's intuitive love of nature and superstitious disposition play off Edward's learned Christianity, which he violently discards in the final part of the novel along with a middle-class respectability we are led to take as cruel and hypocritical. Hazel's innate occultism is highlighted particularly where her credulous immersion in the local legend of Hunter's Spinney is contrasted with Edward's rational, distanced, cultured and ultimately patronizing liking for 'nature myths' and 'old tales'.[11]

[7] Breton added a note on the manuscript to the effect that the friend who lent the books to Lamba could not have known about the '*drame du loch*' because he had only recently returned from a 'très long voyage dans le Pacifique' (and therefore could not have been a consciously determining factor in the narrative specific to Brittany), which strongly suggests that it was the traveller and screenwriter Jacques Viot who had contributed to the first issue of *Le Surréalisme au service de la révolution* in 1930: André Breton, *Oeuvres complètes*, vol. 2, Paris: Gallimard, 1992, 1734. I am very grateful to Robert McNab for this suggestion.

[8] 'son observation poétique et son sentiment de la nature qui l'ont poussée à écrire', in Mary Webb, *La Renarde* [1917], trans Marie Canavaggia and Jacques de Lacretelle, Paris: Éditions du Siècle, 1933, 9.

[9] Hazel's scene-setting encounter with the drunk John Reddin on her way home seems to be drawn immediately from the opening, equally fateful encounter between Parson Tringham and John Durbeyfield in Hardy's *Tess of the D'Urbervilles* (1891): Mary Webb, *Gone to Earth* [1917], London: Virago, 1979, 25.

[10] Webb, *Gone to Earth*, 17; 'deux assassins rivaux', Lacretelle in Webb, *La Renarde*, 11.

[11] Webb, *Gone to Earth*, 72–4.

Yet it is to Hunter's Spinney that Hazel is drawn by a power beyond her comprehension to meet Reddin in an incidence of *amour fou* that leaves Reddin uncharacteristically confused by his tears and Hazel with child.[12] If he got around to reading *Gone to Earth*, Breton might have seen something of Nadja in the childlike Hazel who is introduced as 'a rover, born for the artist's joy and sorrow [whose] spirit found no relief for its emotions' and who is described later in the novel as 'completely outside the influence of the canons of society'.[13] It is finally outside of a society and beyond a God that cannot comprehend their love that she and Edward, taking his cue from his adversary in love Reddin, eventually resolve to live, in a culminating sequence of events redolent of rural legend and folk song that would be described equally by any Surrealist as a second occasion of *amour fou*.[14]

The other novel Lamba took to Brittany, *Lady into Fox* (1922), is by David Garnett who at first seems an unlikely author to appeal to Breton. A member of the Bloomsbury group, Garnett dedicated the novel to Duncan Grant (and would later marry his and Vanessa Bell's daughter, Angelica Bell). Yet as a tale of metamorphosis, *Lady into Fox*, which has been described along with his other novels as embodying Garnett's 'pagan spirit', would in fact have held the Surrealists' interest from its opening statement: '[w]onderful or supernatural events are not so uncommon, rather they are irregular in their incidence', once it was translated into French in 1924 as *La Femme changée en renard*.[15] Beginning in 1879 in Oxfordshire, the core idea in the novel of a female protagonist hunted to death like a fox is identical to *Gone to Earth*. However, where Webb's story is set in a society that is rejected due to its morally corrupt conception of love only at its conclusion, this rejection takes place right at the beginning of *Lady into Fox*. Moreover, the latter is even more strongly reminiscent of folk songs and legends than *Gone to Earth* because it tells the story of the actual *transformation* into a fox of Mrs. Tebrick (born Silvia Fox) soon after her marriage to Richard Tebrick.

12 Webb, *Gone to Earth*, 188–95.
13 Webb, *Gone to Earth*, 12, 207.
14 Webb, *Gone to Earth*, 280, 282. In her introduction to the novel, Erika Duncan described Webb's writings accurately as 'like the refrains of a folk song', Webb, *Gone to Earth*, 1.
15 Carolyn G. Heilbrun, *The Garnett Family*, London: George Allen & Unwin Ltd., 1961, 199. The French translation with its recourse to the marvellous in the same year as the publication of the *Manifesto of Surrealism* (1924) would have confirmed the appeal of the tale to the Surrealists: 'Les faits merveilleux ou surnaturels ne sont pas aussi rares qu'on le croit; il faudrait plutôt dire qu'ils se produisent sans ordre', David Garnett, *La Femme changée en renard* [1922], trans Jane-Simone Bussy and André Maurois, Paris: Bernard Grasset, 1924, 1. This initial French version of the novel included the same woodcuts by Garnett's first wife Rachel ('Ray') Alice Marshall that had illustrated the English language version; when it was republished in 1932 under the same translation, these were replaced by woodcuts drawn in a different though stylistically similar design by Jean Lébédeff: David Garnett, *La Femme changée en renard* [1922], trans Jane-Simone Bussy and André Maurois, Paris: Arthème Fayard & Cie, 1932. The commission might have come about because Lébédeff had illustrated the 1921 re-edition of Paulin Paris's translation-adaptation of the *Roman de Renart* (1861) in what has been called 'a series of woodcuts made in late medieval or early Renaissance style', Kenneth Varty and Jean Dufournet, 'The Death and Resurrection of the *Roman de Renart*', Kenneth Varty (ed.), *Reynard the Fox: Social Engagement and Cultural Metamorphoses in the Beast Epic from the Middle Ages to the Present*, New York and Oxford: Berghahn Books, 2000, 221–44, 231.

Most of *Lady into Fox* details Silvia Tebrick's increasingly bestial fox-like behaviour alongside Richard's cumulative degradation and obstinate devotion (he even has sex with her fox self on one occasion). These are shown most powerfully in the final third of the narrative after the escape of his vixen-wife into the wild:

> … by now he had come to hate his fellow men and was embittered against all human decencies and decorum. For strange to tell he never once in these months regretted his dear wife whom he had so much loved. No, all that he grieved for now was his departed vixen. He was haunted all this time not by the memory of a sweet and gentle woman, but by the recollection of an animal. … I believe that if he had known for certain she was dead, and had thoughts of marrying a second time, he would never have been happy with a woman. No, indeed, he would have been more tempted to get himself a tame fox, and would have counted that as good a marriage as he could make … though his wife was now nothing but a hunted beast, [he] cared for no one in the world but her. … But this devouring love ate into him like a consumption, so that by sleepless nights, and not caring for his person, in a few months he was worn to the shadow of himself.[16]

Told in the third person, the tale avoids the 'unreliable narrator' genre. Yet it is not entirely certain that Richard is not mad and he even thinks himself so: '"Indeed I am crazy now! My affliction has made me lose what little reason I ever had … and I feed myself on dreams."'[17] Again, as in *Gone to Earth*, Richard's behaviour is adjusted to the passion entailed by *amour fou* that breaks with all societal norms and conventions. It is the 'carnal love' addressed by Breton, which he expects mankind will recognize one day 'for his only master, honouring you even in the mysterious perversions you surround him with'.[18]

It is hard to imagine two novels more suitable than these for the lovers to take on holiday to Brittany in the midst of Breton's composition of *Mad Love*.[19] However, I

[16] David Garnett, *Lady into Fox* [1922], London: Hesperus Press, 2008, 50–1.
[17] Garnett, *Lady into Fox*, 52–3.
[18] Breton, *Mad Love*, 76.
[19] For a lengthier gloss and interpretation of *Lady into Fox*, see D. B. D. Asker, *Aspects of Metamorphosis: Fictional Representations of the Becoming Human*, Amsterdam and Atlanta GA: Rodopi, 2001, 40–1. Garnett's novel was very popular in France; the theme was reversed (fox into lady) by Vercors (pen name of Jean Bruller) whose novel set in England titled *Sylva* refers directly to Garnett's and might well contain an allusion to Surrealism since its narrative begins in October 1924, coinciding with the publication date of the *Manifesto of Surrealism*, and embarks with the words 'Dusk is falling, it is five o'clock', recalling Breton's anti-narrative remarks summarized in the phrase placed in the mouth of Paul Valéry (who is also mentioned in Vercors' novel): 'The Marquise went out at five o'clock' (a sentence well-known to Vercors, no doubt, since he was one of the founders of Éditions de Minuit, which published the Nouveaux Romanciers who all refer at some point to the famous slogan): Vercors, *Sylva* [1961], trans. Rita Barisse, New York: Crest, 1963, 9, 132; André Breton, 'Manifesto of Surrealism' [1924], *Manifestoes of Surrealism*, trans Richard Seaver and Helen R. Lane, Michigan: University of Michigan Press, 1972, 1–47, 7. For more on the departing Marquise and the Nouveau Roman, see my article 'The Delvaux Mystery: Painting, the *Nouveau Roman*, and Art History', *Nottingham French Studies*, vol. 51, no. 3, autumn 2012, 298–313, 310–11; and Gavin Parkinson, *Futures of Surrealism: Myth, Science Fiction and Fantastic Art in France 1936–1969*, New

want to bypass any further discussion of the obvious relevance of both to the central theme of that volume or, rather, use that theme of *amour fou* as it is aligned with the geography of Brittany in the latter part of Breton's book as a bridge to the closely related rural, pagan and vernacular spirit of *Gone to Earth* and *Lady into Fox* that leads in turn back to the path between Surrealism, Brittany and Gauguin.

Gauguin and Breton in Brittany and Le Pouldu

It will be recalled from my first chapter that after getting off the bus at around three o'clock on that rather dull 20 July in Brittany, Breton and Lamba are directed from the beach location of Le Fort-Bloqué to the remote coastal hamlet of Le Pouldu, which lies fifteen miles north west of Lorient and is sparsely signposted and hard to find to this day. We are not told if they arrived, but we assume they did since they were assured by the locals that there was nowhere else to go in the area on an overcast afternoon and, although over six miles, the distance to Le Pouldu can be walked briskly in two and a half hours (Breton mentions it getting close to half past four at one point in the lovers' despondent promenade).[20] Breton had visited Le Pouldu at least once before in July 1929 and must have known about Gauguin's own perambulations along the windy lower coast of rustic Brittany, which the artist had admired since his first visit to Pont-Aven in July–October 1886 for its imagined 'medieval' rurality.[21] He should also have known of the crucial period Gauguin spent in Le Pouldu at the time of the so-called third trip to Brittany in June 1889–February 1890, during which the artist also visited Lorient with Paul Sérusier at least once.[22]

It was irritation with what he saw as the commercialization and artiness of Pont-Aven – 'the tourists and the "pompiers" were becoming more and more numerous in the region', as Sérusier recalled it to another native of Brittany, Charles Chassé – and search for greater tranquillity, as Marie Henry remembered, that led Gauguin to seek in late June an alternative in Le Pouldu where he had visited briefly the year before.[23] In

Haven and London: Yale University Press, 2015, 205 n. 23. Garnett reversed the direction of the metamorphosis himself in the equally successful novel that followed *Lady into Fox* about a man who arranges to be exhibited in a zoo: David Garnett, *A Man in the Zoo*, London: Chatto & Windus, 1924. For his own memoirs, see the three volumes of David Garnett, *The Golden Echo, The Flowers of the Forest, The Familiar Faces*, London: Chatto & Windus, 1953, 1955, 1962 (the creation of and initial reaction to *Lady into Fox* is recalled in Garnett, *Flowers of the Forest*, 243–50). For another rural tale, in which the personification of the fox as the soldier Henry Grenfel is carried out without recourse to the supernatural but by means of a metaphorical language of spells and enchantment, see D. H. Lawrence, *The Fox* [1921], London: Hesperus Press, 2002, 10, 12.

[20] Breton, *Mad Love*, 103.
[21] Mark Polizzotti, *Revolution of the Mind: The Life of André Breton*, revised and updated, Boston: Black Widow Press, 2009, 287.
[22] Charles Chassé, *Gauguin et le groupe de Pont-Aven: documents inédits*, Paris: H. Floury, 1921, 56.
[23] "'les touristes et les 'pompiers' devenaient de plus en plus nombreux dans la région,'" Chassé, *Gauguin et le groupe de Pont-Aven*, 23, 26.

spite of the title Chassé gave his study of 1921, *Gauguin et le groupe de Pont-Aven*, the book is dominated by the activities and art that took place not in Pont-Aven but in Le Pouldu. The alternative title would have been incomprehensible, presumably, since Le Pouldu was and still is little-known to a larger public. Chassé affirmed the significance of the location and the time Gauguin spent there towards the conclusion of his book through the opinions given by the teacher of philosophy Henri Mothéré (since 1893 Marie Henry's companion, so with a particular interest in the priority of Le Pouldu) and Georges-Daniel de Monfreid:

> Obviously, if you asked M. Mothéré, he would tell you that the school would be better called the École de Pouldu than the École de Pont-Aven since it was in Pouldu above all, according to him, that the genius of Gauguin took flight and this theory could be supported by the declaration of M. de Monfreid who wrote to me: 'My friend *never* spoke to me about Pont-Aven. He always said: "When I was *in Pouldu* …," "I did this in Pouldu," "I am returning to Pouldu," etc. …'[24]

The companionship enjoyed by Gauguin and his followers Sérusier, Meyer de Haan and Charles Filiger in Le Pouldu made for a vivid and no doubt crowd-pleasing theatrical turn both in its performance and in its recollection by André Gide. The unsuspecting writer apparently showed up at the Buvette de la Plage in 1889 in the course of a July–August walking holiday in Brittany and wrote later of how he sat for dinner in the vicinity of the noisy Gauguin, Sérusier and de Haan. Even if Gide really did witness that piece of theatre in Le Pouldu, its unruliness was no doubt augmented in its nevertheless strangely incomplete and probably fictional 'recollection' when he logged it in his memoir in 'literary' fashion in 1920.[25] This occasion was recorded two years before Breton led Gide to divulge his 'superficiality' and 'pretensions' in the Dada review *Littérature* through innocent conversation, and a decade and a half before Breton and Lamba got stranded nearby.[26]

Set on a rocky peninsula and populated by only a few houses and farms at the time, the distance from metropolitan life along with the concentration and inspiration allowed poetically inclined imaginative painters by the relatively blank landscape

[24] 'Evidemment, si vous interrogiez M. Mothéré, il vous dirait que l'école aurait dû bien plutôt s'appeler École du Pouldu qu'École de Pont-Aven, puisque c'est au Pouldu que, selon lui, le génie de Gauguin a surtout pris son envol, et cette théorie pourrait s'appuyer sur la déclaration de M. de Monfreid qui m'écrit: "*Jamais* mon ami ne me parlait de Pont-Aven. Il répétait toujours: 'Quand j'étais *au Pouldu* …', 'J'ai fait ceci au Pouldu', 'Je retourne au Pouldu', etc. …'," Chassé, *Gauguin et le groupe de Pont-Aven*, 84.

[25] In this frequently quoted passage, Gide was hesitant about the name of the hamlet and whether or not the third was Filiger (it was de Haan; Filiger was in Pont-Aven in 1889 and arrived in Le Pouldu the following year); he also breaks off his account of the dinner abruptly giving no word as to what he discussed with the artists and no depth whatsoever to his impressions of the experience beyond his 'excitement' at their rowdiness: André Gide, *If it Die …* [1920], trans. Dorothy Bussy, London: Secker & Warburg, 1950, 199–200.

[26] See the very different recollected encounter to the one set out by Gide, lethally spiked with irony: André Breton, 'André Gide Speaks to Us of His Selected Works' [1922], *The Lost Steps* [1924], trans. Mark Polizzotti, Lincoln and London: University of Nebraska Press, 1996, 68–9, 68.

around Le Pouldu increased and diversified the productivity of Gauguin, Sérusier, de Haan and Filiger towards greater abstraction. On the one hand, Gérard Legrand tended to overstate the case on both Gauguin and the location, calling the artist 'the hermit of Pouldu' and averring that it was in that 'edge-of-the-world atmosphere that he painted his harshest, most primitivist canvases'.[27] On the other hand, Fred Orton and Griselda Pollock tried to exaggerate the effects of tourism and commerce in the area by asserting that in the 1880s Le Pouldu was one of the areas being developed as a *balnéaire* or sea-bathing resort when really it was visited by only a few ramblers like Gide and by fishermen.[28]

Gide remembered there being only four houses in the hamlet, two of which were inns, implying it was quite isolated and would have been regarded as an unpromising place where one would stop only briefly and pass through while meandering along the coast. This all changed when one Alphonse Marrec of Quimper visited, soon after setting up the six-room Hôtel Marrec in 1896, which brought the tourist industry to Le Pouldu. That historical event is emphatically confirmed by the fact that this little hotel was quickly supplanted by Marrec's sixty-room Hôtel des Bains, opened in 1906 and viewable in period postcards looming over the beach and dwarfing its surrounding terrain (figure 7.1) (it is now an apartment building).

Le Pouldu had developed further by the time an obviously disappointed Chassé reached it to carry out his research in 1920 (Breton was equally disappointed when he visited with Suzanne Muzard nine years later), using the same term 'station balnéaire' where the Buvette de la Plage was now part of 'a long road of pretty houses descending towards the beach'.[29] The phrase 'petite station balnéaire' was also used by the people who gave Breton and Lamba directions to Le Pouldu, so the hamlet must have been limited still in its commercial development in 1936.[30] Le Pouldu did indeed transition fully into a small beach resort and now has suburbs and even a sizeable *office de tourisme*. However, researching there as late as 1970, Wayne Andersen did not think the local landscape around it had changed much since Gauguin's time, suggesting that the 'rugged coast where it takes the full force of the wind and sea' gave the location an

[27] 'l'ermite du Pouldu'; 'ambiance de bout du monde qu'il peignit ses toiles les plus âpres, les plus primitivistes', Gérard Legrand, *Gauguin*, Paris: Club d'Art Bordas, 1966, 51, 15.
[28] Fred Orton and Griselda Pollock, 'Les Données Bretonnantes: La Prairie de Représentation' [1980], *Avant-Gardes and Partisans Reviewed*, Manchester and New York: Manchester University Press, 1996, 53–88, 65. The authors quote from several Brittany guidebooks and claim that even before the 1880s, 'the creation of road and other facilities of communication made travel both easy and comfortable', Orton and Pollock, *Avant-Gardes and Partisans Reviewed*, 65. However, the facts need to be made relative to the rest of France at the time and also to our own experience today. As well as indicating the fifteen-hour trip from Gare Montparnasse, for instance (meant to show not the isolation but accessibility of Finistère), F. S. Dellenbaugh stated that the Brittany he stayed in during the 1880s had 'largely escaped the polishing or elevating process, and the crowds of tourists, because of its lack of extensive railway communications, and of its situation so far in the west', F. S. Dellenbaugh, 'Finistère: The Artist's Corner of Brittany', *Journal of the American Geographical Society of New York*, vol. 20, 1888, 295–336, 295, 297.
[29] 'station balnéaire'; 'une longue rue de coquettes maisons descendant vers la plage', Chassé, *Gauguin et le groupe de Pont-Aven*, 25.
[30] Breton, *Oeuvres complètes*, vol. 2, 770.

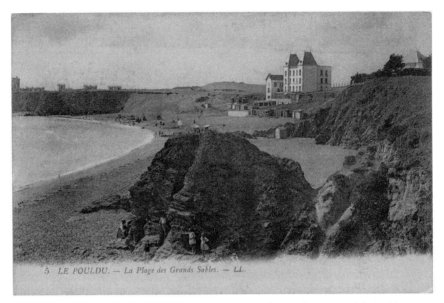

Figure 7.1 Postcard showing the Hôtel des Bains and the beach at Le Pouldu (n.d.). Author's collection.

appeal to 'artists of a more formal or mystical bent' that Pont-Aven lacked being 'characteristically more of an Impressionists' village'.[31]

Filiger and Gauguin: Inferring a 'folk Surrealism'

After the Second World War, a key stimulus for the Surrealists' acquaintance with Gauguin, Brittany and its culture was the appearance of Alfred Jarry's *Oeuvres complètes* (1948). Jill Fell has shown the powerful impact that the republication there of Jarry's 1894 *Mercure de France* Filiger article had on Breton whose 'pursuit of the painter's work became a private quest, lasting over ten years', as he searched private collections in Brittany for paintings by the elusive artist (although Filiger was still in Brittany when Chassé was researching his 1921 study of Gauguin, he was not locatable for interview).[32] The near-abstraction of Filiger's early work, such as the remarkable, flatly painted yet

31 Wayne Andersen, 'Gauguin's Motifs from Le Pouldu – Preliminary Report', *The Burlington Magazine*, vol. 112, no. 810, September 1970, 609–10 and 613–20, 615.

32 Jill Fell, 'The Fascination of Filiger: From Jarry to Breton', *Papers of Surrealism*, issue 9, summer 2011, n.p.; André Cariou (ed.), *Charles Filiger-André Breton: À la recherche de l'art magique*, Quimper: Musée des beaux-arts, 2006, 10. See the comments about the obscure artist by Charles Chassé, 'Charles Filiger', Paris: Le Bateau Lavoir, *Filiger, 1863–1928: Pont-Aven*, 1962, n.p.

proto-Dalinian *Pouldu Landscape* (plate 8a, 1890), had been overtaken later by a Christian mysticism. Those subsequent works had been valued highly in the 1890s by contemporaries such as Albert Aurier, Émile Bernard, Félix Fénéon and Remy de Gourmont for their mystical qualities and medieval timbre. That period gave way, in turn, to the 'total paganism', as Chassé called it, of Filiger's hard-to-date 'chromatic notations' in the twentieth century (figure 7.2).[33] Breton's obsession with the latter style came from its eschewal of any external reality, begun in Le Pouldu, in favour of an intricate, symmetrical design sourced in the mind of the artist alone. Those characteristics gave them a close resemblance to the paintings of mediumistic artists such as Augustin Lesage and Fleury-Joseph Crépin that Breton was concurrently purchasing and promoting under the new banner of *art brut*.[34]

Figure 7.2 Charles Filiger, *Chromatic Notation* (1915–28). Watercolour and pencil on paper, 24.5 × 29.5 cm. Private collection. © DeAgostini Picture Library/Scala, Florence.

[33] 'un paganisme intégral', Charles Chassé, *Le Mouvement symboliste dans l'art du XIXe siècle*, Paris: Librairie Floury, 1947, 115.
[34] André Breton, 'Joseph Crépin' [1954], *Surrealism and Painting*, 298–307.

Breton's research on Filiger and hunt for his work in Brittany from late in the 1940s and through the 1950s took him to several of the locations where Gauguin and his friends had painted. He did not document this activity and it remained largely unknown in his lifetime because it took place occasionally during his summer holidaying in Brittany centred on Lorient.[35] However, it is partially revealed in 'Alfred Jarry as Precursor and Initiator', the article Breton alluded to in the 1952 interview he gave about Brittany, where a case is made for a Filiger exhibition prompted by Jarry's *Mercure* article on the forgotten painter and Breton's own recent discovery of works of art by him.[36] Breton's search in Brittany was assisted partly by Chassé's writing on Gauguin's time in Le Pouldu – he quoted from Paul-Émile Colin's letter stating that Filiger 'joined Gauguin in Le Pouldu in [July] 1890', also referring to Colin's mention of the collective embellishment of the public rooms of the Buvette de la Plage[37] – and was initially sparked by Chassé's 1947 book on Symbolist art, according to André Cariou, from which Breton willingly endorsed the author's remark about Filiger's 'total paganism'.[38] Also in the Jarry article, Breton divulged one of his visits to Pont-Aven in 1949 when he had purchased his first work by Filiger, the gouache now titled *Symbolist Architecture with Two Green Bulls* (figure 7.3, c. 1900–14), and credits a collector 'M. Le Corronc, of Lorient'.[39]

[35] Cariou (ed.), *Charles Filiger-André Breton*, 8.

[36] André Breton, 'Alfred Jarry as Precursor and Initiator' [1951], *Free Rein* [1953], trans Michel Parmentier and Jacqueline d'Amboise, Lincoln and London: University of Nebraska Press, 1995, 247–56, 253–6. The Filiger exhibition at Mira Jacob's gallery Le Bateau-Lavoir that I noted above might have been the eventual outcome of Breton's appeal; indeed, this first show of Filiger's work was built around Jacob's major collection of 'chromatic notations', which also informed her later monograph: Mira Jacob, *Filiger L'Inconnu*, Strasbourg: Éditions des Musées de Strasbourg, 1989. See Paris: Sotheby's, *Collection Mira Jacob, Galerie Le Bateau-Lavoir*, 2004, 87.

[37] Breton, *Free Rein*, 253; see Chassé, *Gauguin et le groupe de Pont-Aven*, 52, 53–4; and see the letter reprinted in Chassé, *Mouvement symboliste*, 115. Chassé published the letter by Henri Mothéré chronicling Marie Henry's memory of the decoration of three walls and the ceiling of the inn: Chassé, *Gauguin et le groupe de Pont-Aven*, 48–50. Most of the paintings and frescoes were saved except for the west wall featuring Meyer de Haan's *Breton Women Scutching Flax (Labour)* (1889), which was wallpapered over then rediscovered in 1924: see Robert Welsh, 'Gauguin and the Inn of Marie Henry at Pouldu', Eric M. Zafran (ed.), *Gauguin's Nirvana: Painters at Le Pouldu 1889–90*, New Haven and London: Yale University Press, 2001, 61–71.

[38] Breton, *Free Rein*, 254; André Cariou, 'La Passion d'André Breton pour la vie et l'oeuvre de Charles Filiger', Cariou (ed.), *Charles Filiger-André Breton*, 17–20, 17.

[39] Breton, *Free Rein*, 255, 291 n. 13; Cariou (ed.), *Charles Filiger-André Breton*, 63. This collector must have been the sculptor and furniture maker Jean Le Corronc who had lived in Pont-Aven near the beginning of the century and organized exhibitions there of Gauguin's larger circle, including Filiger: Cariou (ed.), *Charles Filiger-André Breton*, 17. Breton corresponded with Chassé about his progress in collecting Filiger: see Cariou (ed.), *Charles Filiger-André Breton*, 18–19; and Chassé acknowledged in print Breton's esteem for Filiger and his mission to locate and collect his work: see Charles Chassé, *The Nabis & Their Period* [1960], trans Michael Bullock, London: Lund Humphries, 1969, 69. Chassé annotated and dedicated to Breton copies of the French original of this book – which repeats much of the material on Filiger (spelt 'Filliger' here as it had been four years earlier by John Rewald in his *Post-Impressionism: From Van Gogh to Gauguin*) from the earlier *Mouvement symboliste* – and also his earlier *Gauguin et son temps* to that effect. See Breton's signed copy: http://www.andrebreton.fr/work/56600100092981 (accessed 1 June 2015).

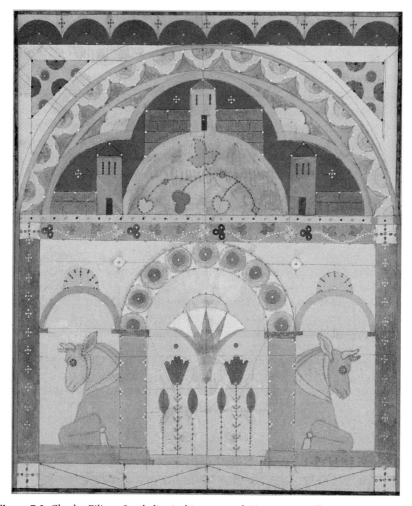

Figure 7.3 Charles Filiger, *Symbolist Architecture with Two Green Bulls* (*c*. 1900–14). Gouache and watercolour on paper on cardboard, 25.5 × 21 cm. Musée des Beaux-Arts, Quimper. Transfert de propriété de l'Etat à la Ville de Quimper en 2013 – Collection du Musée des Beaux-Arts de Quimper.

We do not have a record that Breton visited Le Pouldu on his mission of the late 1940s and 1950s to track down and acquire Filiger's work. But it is almost certain he did since, first, as I noted above, the locale in and around Le Pouldu had great importance for the shift taken by Filiger towards the simplification that preceded his symmetrical, decorative style and it was known that he had still lived there as late as 1917; and, secondly, Breton visited Plougastel-Daoulas in 1953 in the steps of the artist

whom he thought had died there in 1930.[40] Nor can we state with conviction that Breton revisited the exact area in which he had believed in 1936 that he and Lamba had come under the spell of Michel Henriot, the murderer with a '*fox's* profile' as Breton had recalled in *Mad Love*, a feature apparently still worthy of memorialization and elaboration elsewhere in the 1950s.[41] However, we do know that Breton continued to insist upon the possibility that the past might erupt in the present. In 1950, he argued in the essay 'Pont-Neuf', which coincided precisely with his first expressions of admiration for Gauguin and earliest acquisitions of Filiger's work, for an unconscious sensitivity on the part of each individual in the city manifesting itself in an imaginary map as 'alternating zones of well-being and discomfort' in which 'the places he haunts could be shown in white, the ones he avoids in black, and the rest in various shades of gray according to the degree of attraction or repulsion.'[42] 'Peek[ing] through the successive layers of time', Breton continually and predictably evokes medieval Paris throughout that text along with the landmarks of *Nadja* (1928) and *Mad Love*: the Place Dauphine, the flower market 'where sheer freshness is re-engendered night after night', the Tour Saint-Jacques and the Hôtel de Ville.[43]

What 'Pont-Neuf' shows is that Breton's 'medieval' theory, proposing that previous events pervade geographies to create enchanted ground, was sustained from the 1920s to the 1950s, and possesses kinship with Gauguin's and Julien Gracq's densely chronologized terrains and rejection of positivist, ocularist geographies. There is every reason to believe, then, that Breton returned in mind if not body to that triangular stretch of land that extends north west from Lorient to Le Pouldu on the coast then south east along the shoreline to Le Fort-Bloqué as his interest in Gauguin grew from about 1950. This is especially so since, by then, he knew all about Gauguin's liking for the supposedly medieval and sorrowful charms of Le Pouldu and about Bernard's judgement that Filiger's inspiration came from 'the Byzantines and. . . the popular images of Brittany', which Breton quoted from Chassé in the text on Jarry.[44] As I noted in Chapter 5, that coalition of the abstract, the medieval and the regional was shared with Wassily Kandinsky's work and remarked by Charles Estienne. So it was surely discussed with Breton, then, who would soon explore it with Estienne in the curatorial project examining Celtic coins and modern art, *Pérennité de l'art gaulois*, that included Gauguin, Sérusier, Filiger and Kandinsky in its display.

[40] For first-hand testimony of Filiger in Le Pouldu in 1917, see Tadé Makowski quoted in Wladyslawa Jaworska, *Gauguin and the Pont-Aven School* [1971], London: Thames and Hudson, 1972, 245–6 n. 122.

[41] Breton, *Mad Love*, 107. 'He somewhat resembled a fox himself with his pointed questing nose, his sloping forehead, his narrow jaw, and the likeness was heightened by a certain menacing timidity in his make-up, a fanged wariness. Perhaps he, too, had been struck by the similarity and loved the animals for resembling him', Kershaw, *Murder in France*, 120.

[42] André Breton, 'Pont Neuf' [1950], *Free Rein*, 221–8, 222.

[43] Breton, *Free Rein*, 224.

[44] Breton, *Free Rein*, 255; Bernard quoted in Chassé, *Mouvement symboliste*, 116; Émile Bernard, 'Notes sur l'École dite de "Pont-Aven,"' *Mercure de France*, tome 48, December 1903, 675–82, 681. Bernard's quotation is repeated often: see Charles Chassé, *Les Nabis et leur temps*, Lausanne and Paris: La Bibliothèque des Arts, 1960, 96 (Chassé, *Nabis & Their Period*, 69); Chassé in *Filiger*, n.p.

Receptive to art and writing 'bathed' in or 'permeated' and 'saturated' with the 'atmosphere of Brittany', as he put it in the interview about the region, Breton theorized an equal sensitivity of person to place.[45] In *L'Art magique* (1957), he would compare Filiger to the poet Tristan Corbière who 'made use of Breton folk songs', according to one specialist on the poet (and whose ominous imagery has even been called 'typical of Celtic folklore').[46] Breton would also claim in that volume that the visual equivalent of the poetry of Germain Nouveau could be found in the art of Filiger, who 'rediscovers in moorland flowers and the weathered griffons of Armorican churches the "extreme remoteness" of a religion so close to extinction that it turns back to witchcraft.'[47] Although quite dissimilar to Filiger's own and Gauguin's earlier Brittany paintings, the anachronistic mood of rusticity and superstition of Filiger's later works, conjured and admired by Breton, recalls that of the rural myth and local legend woven into the 'folklore-influenced' paintings of 1889–90 by Gauguin, as they were characterized by Sven Lövgren.[48] Discussing these, Belinda Thomson recently indicated that Gauguin 'often introduced words or mottoes into the very surfaces of his works after the manner of folk art'.[49]

This is a further subtext that informs Breton's attraction to Gauguin in the 1950s. It is certainly the one that exists behind his reproduction in *L'Art magique* of what Legrand later called the 'essentially pagan' painting *The Loss of Virginity* (plate 8b, 1890).[50] Set at the same dimensions as his 1891 copy of Manet's *Olympia* and rediscovered in time for the 1949 'centenary' exhibition at the Orangerie, after more than half a century during which it was thought lost, the painting had been kept in the collection of Filiger's one-time patron Antoine de la Rochefoucauld.[51] Titled *L'Eveil du printemps* in the exhibition catalogue of *Gauguin*, which is what Breton called it in *L'Art magique*, the imagined, ritualistic drama of *The Loss of Virginity* that Breton pondered at the Orangerie consists in a composition of horizontal planes, presenting a pale, naked girl in the foreground with eyes open holding a red-tipped cyclamen between the fingers of one hand and a fox with the other that rests against her left shoulder while reaching across to her right breast; two groups of individuals can be

45 André Breton, 'Interview d'Yves Pérès' [1952], *Oeuvres complètes*, vol. 3, Paris: Gallimard, 1999, 643–9, 646–7.
46 André Breton, *L'Art magique* [1957], Paris: Éditions Phébus, 1991, 235; Val Warner, 'Introduction', *The Centenary Corbière: Poems and Prose of Tristan Corbière*, ed. and trans. Val Warner, Cheadle: Carcanet New Press, 1975, xi–lxiv, xxii, xxi. Also see the brief recapitulation of the remarks about '[l]a persistance d'un *climat* (celui de l'Ouest, et tout particulièrement de la Bretagne)' in Breton, *L'Art magique*, 150.
47 'retrouve dans les fleurs des landes et les frustes griffons d'églises armoricaines l'"extreme lointain" d'une religion tellement exténuée qu'elle redevient sorcellerie', Breton *L'Art magique*, 235.
48 Sven Lövgren, *The Genesis of Modernism: Seurat, Gauguin, van Gogh and French Symbolism in the 1880s*, trans. Albert Read, Stockholm: Almqvist & Wiksell, 1959, 119.
49 Belinda Thomson, 'The Conflicted Status of Narrative in the Art of Paul Gauguin', Peter Cooke and Nina Lübbren (eds), *Painting and Narrative in France*, London and New York: Routledge, 2016, 176–89, 176.
50 'essentiellement païenne', Legrand, *Gauguin*, 15.
51 See Denys Sutton, '*La Perte du Pucelage* by Paul Gauguin', *The Burlington Magazine*, vol. 91, no. 553, April 1949, 102–5. For more on its loss and reappearance, see Maurice Malingue, 'Du nouveau sur Gauguin', *L'Oeil*, no. 55/56, July–August 1959, 32–9, 34.

seen arriving in the right-hand background. The encounter in the picture takes place within a landscape recognizable in several other paintings of the time, including *Harvest, Le Pouldu* (figure 7.4, 1890), which has been examined closely in relation with the actual terrain of the area by Andersen who stated it was painted about 200 yards south west, no less, of *The Loss of Virginity*.[52] Andersen established that in *Harvest, Le Pouldu*, the 'strip of land in the distance extends from below Bas Pouldu, to at least as far as Fort-Bloqué', so it is the last stretch of land that was covered by Breton and Lamba in their lengthy walk to the hamlet.[53] It might even contain the 'very long and smooth beach [that] stretched its harmonious curve between the sea and the sky' and revealed a settlement nearby, coinciding with (or causing, we positivists would say) the conclusion of their 'delirium' as well as their journey.[54]

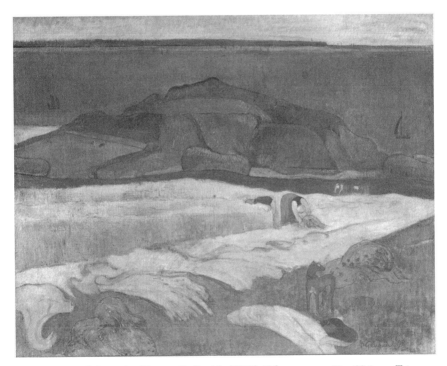

Figure 7.4 Paul Gauguin, *Harvest, Le Pouldu* (1890). Oil on canvas, 73 × 92.1 cm. Tate Gallery, London. © Tate, London 2018.

[52] Andersen, 'Gauguin's Motifs from Le Pouldu', 616.
[53] Andersen, 'Gauguin's Motifs from Le Pouldu', 616.
[54] Breton, *Mad Love*, 104. Andersen identified the nearby sites of another eleven canvases by Gauguin; these did not include *Landscape at Le Pouldu* (1890), but that picture would have been viewed by Breton at the Orangerie in 1949. As here, several of these paintings contain isolated houses like the one in Cézanne's painting *The Abandoned House* (1878–9) and it is a measure of Cézanne's much greater fame and Gauguin's relative unfamiliarity in the mid-1930s that Breton thought of the

In addition, and beyond the physical location represented in these paintings, it is the occurrence of the fox in *The Loss of Virginity* that brings the reader of *Mad Love* up short. Present in at least seven more works by Gauguin since the painted wood relief *Be in Love and You will be Happy* of 1889 (figure 7.5), often said to resemble the features of de Haan,[55] and called by Gauguin in a letter to Bernard the 'Indian … symbol of perversity', the fox has been prominent since the twelfth century in the French then European folk traditions through that parody of the Celtic romance the *Roman de Renart*.[56] Although (or because) it was a symbol of evil in Christian doctrine, the fox is ubiquitous in church ornament because 'to the itinerant artisans working on the great cathedrals of Europe he clearly embodied the defiance they desired to throw in the face of their oppressors'.[57] Carvings of foxes were available for recurring viewing by both Gauguin and Breton in one medieval church after another in Brittany – at Chapelle Saint-Fiacre in Le Faouët, for instance – and also across France where, as 'a symbol of sexual temptation and perversity', the fox replaced Eve in Gauguin's art through 'its sexual connotations from Brittany folklore and Oriental sources', suggesting that 'the figure's internal thoughts were haunted by illogical, even immoral counsel'.[58] Perhaps more than for Gauguin, whose work since 1888 had 'evoked Breton folk traditions, sinister undercurrents of rural sexuality' in Thomson's words,[59] the fox must have seemed a truly appropriate figure of folklore for Breton as he flicked through his summer reading in the countryside of Brittany, in the lingering shadow of Henriot's murder of the wife who refused his sexual advances, and under the summative

former rather than the latter when recalling in *Mad Love* the vacant 'villa of the loch' of Michel Henriot seen on the way to Le Pouldu. Gauguin (several times), Sérusier and Filiger even painted versions of the lone house on the rocky outcrop between beaches belonging to the notary Henri-Louis Froidevaux, titled *La Maison du Pan-Du* or *Pendu*.

55 Jaworska, *Gauguin and the Pont-Aven School*, 106.
56 Letter of September 1889 in Paul Gauguin, *Letters to his Wife and Friends* [1946], ed. Maurice Malingue, trans. Henry J. Stenning, Boston: MFA Publications, 2003, 125. Also see Gauguin's phrase 'the fateful animal of perversity for the Indians' in a letter to van Gogh of somewhere between 10 and 13 November 1889: Vincent van Gogh, *The Letters: The Complete Illustrated and Annotated Edition, Vol. 5: Saint-Rémy-Auvers 1889-1890*, eds Leo Jansen, Hans Luijten and Nienke Bakker, London and New York: Thames & Hudson, 2009, letter 817, 135–8, 138; and the same assertion made in a letter to Theo of 20 or 21 November: Douglas Cooper (ed.), *Paul Gauguin: 45 lettres à Vincent, Théo et Jo van Gogh*, The Hague and Lausanne: Staatsuitgeverij/La bibliothèque des arts, 1983, 163. For the speculation that Gauguin had in mind the 'celebrated, clever jackals attributed to the Sanskrit Vidya-Pati', see Henri Dorra, *The Symbolism of Paul Gauguin: Erotica, Exotica, and the Great Dilemmas of Humanity*, Berkeley, Los Angeles, London: University of California Press, 2007, 297–8 n. 85.
57 Martin Wallen, *Fox*, London: Reaktion, 2006, 50.
58 Bogomila Welsh-Ovcharov, 'Paul Gauguin's Third Visit to Brittany, June 1889-November 1890', Zafran (ed.), *Gauguin's Nirvana*, 15–59, 54; Kenneth Varty and Jean Dufournet, 'The Death and Resurrection of the *Roman de Renart*', Varty (ed.), *Reynard the Fox*, 221–44, 235; Wayne V. Andersen, 'Gauguin and a Peruvian Mummy', *The Burlington Magazine*, vol. 109, no. 769, April 1967, 238–43, 241; Charles Stuckey, 'Gauguin Inside Out', Zafran (ed.), *Gauguin's Nirvana*, 129–41, 138. For an inventory of churches in France and Europe decorated with the fox motif, see Elaine C. Block and Kenneth Varty, 'Choir-Stall Carvings of Reynard and Other Foxes', Varty (ed.), *Reynard the Fox*, 125–62.
59 Belinda Thomson, 'Paul Gauguin: Navigating the Myth', London: Tate Modern, *Gauguin: Maker of Myth*, 2010, 10–23, 17.

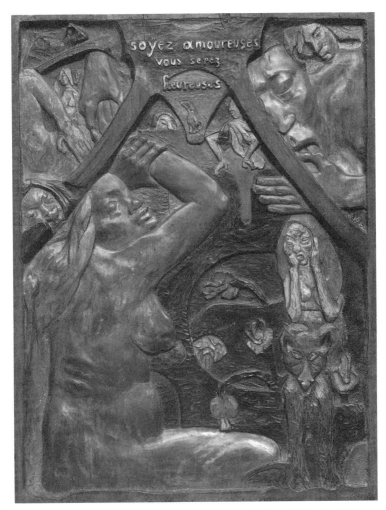

Figure 7.5 Paul Gauguin, *Be in Love and You will be Happy* (1889). Wood relief, 95 × 72 × 6.4 cm. Museum of Fine Arts, Boston. © 2018 Museum of Fine Arts, Boston. www.mfa.org

slogan of *Mad Love*: '[t]here has never been any forbidden fruit. Only temptation is divine.'[60]

Although Andersen insisted that the imagery of *The Loss of Virginity* is close to 'hackneyed academic themes of a maiden seduced by an animal-lover', what he meant is that it is recognizably a folklorish theme.[61] Its 'hackneyed' character is entirely to the

[60] Breton, *Mad Love*, 93.
[61] Andersen, 'Gauguin's Motifs from Le Pouldu', 616.

point, as I argued in my last chapter, for it is precisely its easily absorbed stereotype that bespeaks the medieval rurality imagined by Gauguin and admired by Breton. It is this folklorish dimension within modernity, as much as that is denigrated as a bourgeois ideology by art historians and cultural theorists such as Maura Coughlin, Nina Lübbren and Orton and Pollock and equally by contemporary critics sceptical of the 'inauthenticity' of folk song and folk dance, that gives the painting its poetic, metaphorical or mythic substance.[62] As I showed, that quality of *The Loss of Virginity* is bonded to what Yves Elléouët called around the time of *L'Art magique* the 'very peculiar sensuality' of the tableau – its mood of superstitious, pagan, erotic transgression – giving the painting a particular pre-eminence in Surrealism, compared by Elléouët to certain poems in *Les Fleurs du mal* (1857) by Charles Baudelaire.[63]

Breton was using the word 'magic' by the 1950s to characterize such effects achieved in painting and poetry. That is how he referred to Gauguin in *L'Art magique* when he reproduced *The Loss of Virginity* in the book. Quoting from Estienne's monograph on the artist, he went so far as to assert '[m]agic is everywhere in the *oeuvre* of Gauguin', and to credit his art as 'a mythological quest'.[64] This was a means to unfasten it from readings that lamented its 'literary' burden while giving precedence to its 'decorative' aspects[65]:

The *oeuvre* of Gauguin, and especially his Polynesian *oeuvre*, bears witness to a perpetual surmounting of 'plastic ends,' which were, for him, only *means*, entirely informed by the one authentic end of artistic activity: Poetry. Gauguin is, ahead of the immediate terrain marked by Surrealism, the sole painter to have intuited that he harboured a magician within himself, and to have given to this a 'barbaric' definition or approximation, more fertile than the splendid dreams of Gustave Moreau.[66]

[62] For this critique, see especially Dave Harker, *Fakesong: The Manufacture of British 'Folksong', 1700 to the Present Day*, Milton Keynes and Philadelphia PA: Open University Press, 1985. Also see Bob Pegg, *Folk: A Portrait of English Traditional Music, Musicians and Customs*, London: Wildwood House, 1976; and most recently Georgina Boyes, *The Imagined Village: Culture, Ideology and the English Folk Revival* [1993], Leeds: No Masters Co-Operative, 2010.
[63] 'sensualité très particulière', Yves Elléouët, 'Gauguin (Paul)', Paris: Galerie Daniel Cordier, *Boîte-Alerte*, 1959, 128 (this was an entry in the 'Lexique succinct de l'érotisme', in what was the catalogue of Surrealism's eighth collective exhibition titled *EROS* (*Exposition InteRnatiOnale du Surréalisme* of 15 December 1959 to 29 February 1960).
[64] 'La magie est partout dans l'oeuvre de Gauguin'; 'une quête de la mythologie', Breton, *L'Art magique*, 235.
[65] Breton, *L'Art magique*, 235.
[66] 'l'oeuvre de Gauguin, et singulièrement son oeuvre polynésienne, témoigne d'une perpétuelle transcendance des "fins plastiques," qui ne sont pour lui que des *moyens*, entièrement informés par la fin véritable de l'activité artistique: la Poésie. Gauguin est, avant les abords immédiats du surréalisme, le seul peintre à avoir aperçu qu'il portait un magicien en lui, et à en avoir donné une définition ou approximation barbare, plus féconde que les splendides rêves de Gustave Moreau', Breton, *L'Art magique*, 236–7.

This was high praise indeed from Breton who had long viewed Moreau's work as the summit of fin-de-siècle painting. Clearly, it was the formalist interpretation of Gauguin's paintings he had in his sights, which disparaged, ignored or argued for the lesser relevance of their content as mere 'literature', as Clement Greenberg would have put it.[67] This had been promulgated for two decades by then and, as I outlined in the Introduction to this book, it had risen to a crescendo in the 1950s with the triumph of modernist criticism and art history. By concluding, now, with some remarks on Vincent van Gogh's reception in and just to one side of Surrealism, I will demonstrate whether for or against individual artists, the movement made it possible to counter formalist histories of modern art by privileging poetry and, by the middle of the twentieth century as shown in Breton's *L'Art magique*, esotericism and more specifically magic.

[67] No doubt Breton knew about Greenberg's comment that Surrealist painting 'suffered from being literary and antiquarian' and was 'more literature or document than painting or art', Clement Greenberg, 'Surrealist Painting' [1944], *The Collected Essays and Criticism, vol. 1, Perceptions and Judgments, 1939–1944*, ed. John O'Brian, Chicago and London: The University of Chicago Press, 1986, 225–31, 226, 231. For his later remarks, which Breton would not have read, about 'the "mystical literature" that [Camille] Pissarro accused Gauguin of trying to inject into modern art', see Clement Greenberg, 'Review of the Exhibitions of Paul Gauguin and Arshile Gorky' [1946], *The Collected Essays and Criticism, vol. 2, Arrogant Purpose, 1945–1949*, ed. John O'Brian, Chicago and London: The University of Chicago Press, 1993, 76–80, 78; and for 'Gauguinesque decoration', see Clement Greenberg, 'Cézanne and the Unity of Modern Art' [1951], *The Collected Essays and Criticism, vol. 3, Affirmations and Refusals, 1950–1956*, ed. John O'Brian, Chicago and London: The University of Chicago Press, 1993, 82–91, 90. Breton might have known of the sources of Pissarro's complaint about his former student: see the letter of 20 April 1891 concerning *Vision of the Sermon* and Gauguin being a schemer not a seer, and the one of 13 May that year in Camille Pissarro, *Letters to his Son Lucien* [1946], ed. John Rewald, trans. Lionel Abel, London and Henley: Routledge & Kegan Paul, 1980, 163–4 and 169–71. Also see the later illuminating remarks about 'the illustrated subject – or let's say "literature"', in Clement Greenberg, 'Complaints of an Art Critic' [1967], *The Collected Essays and Criticism, vol. 4, Modernism with a Vengeance, 1957–1969*, ed. John O'Brian, Chicago and London: The University of Chicago Press, 1993, 265–72, 271.

Epilogue: Disenchanted Ground, or Vincent van Gogh, Antonin Artaud and Magic in 1947

The chapters in this book have been concerned with Surrealism's resistance to or adjustment of the canon of early modernism. As I have shown, that bearing was often taken by linking the transformational, metaphorical or transmutational capacities of analogy to magic, occultism, alchemy and esotericism generally in discussion of those late nineteenth-century artists otherwise conscripted into the narrative of modernism. It even led André Breton to place Georges Seurat with Uccello and Marcel Duchamp in the 'esoteric' tradition on one occasion.[1] Surrealism's regulation of the canon of both pre-modern and modern painting towards its own poetic orientation is made plain in Breton's *L'Art magique* (1957) and confirmed at the close of the discussion of Paul Gauguin in that book. Reminding readers there of Francis Picabia's remark about Paul Cézanne's 'mind of a greengrocer' – the notional Cézanne-as-seer we saw tendered in *Mad Love* (1937) had long since quietly expired – Breton argued that Gauguin's addition of magic to art through a poetic supplement fell on mainly fallow ground for twenty years after the artist's death until the arrival of Surrealism.[2]

The growing reputation during the early twentieth century of Vincent van Gogh, whom Breton called in *L'Art magique* 'the type of magician "who fails" in spite of the splendour of his wheat fields and skies baked from the same enamel',[3] was not enough to entice artists of the period to follow the example of van Gogh's generation into 'magic art' (Breton had already written of the Fauves high-handedly as merely decorative 'incompetents').[4] Van Gogh's 'failure' was present for Breton in all but a handful of paintings, such as the almost cartoonishly metaphorical *Gauguin's Chair* (figure 8.1, 1888), called a 'phantom portrait' by Wladyslawa Jaworska.[5] It was acutely evident in the stubborn miserabilism that his work disclosed: 'the interminable and sorrowful vibration of his vision', as Breton termed it, that came from his powerlessness to 'transform and annul traumas' through his art, a failure countered by the capacity of

[1] André Breton, 'Testimony 45: On Marcel Duchamp' [1945], *What is Surrealism?* ed. Franklin Rosemont, London: Pluto Press, 1978, 254–5, 255.
[2] André Breton, *L'Art magique* [1957], Paris: Éditions Phébus, 1991, 237 n. 1.
[3] 'le type du magician "qui échoue" malgré la splendeur de ses blés et de ses ciels cuits du même émails', Breton, *L'Art magique*, 237–8.
[4] 'incompétents', Breton, *L'Art magique*, 235.
[5] Wladyslawa Jaworska, *Gauguin and the Pont-Aven School* [1971], London: Thames and Hudson, 1972, 72.

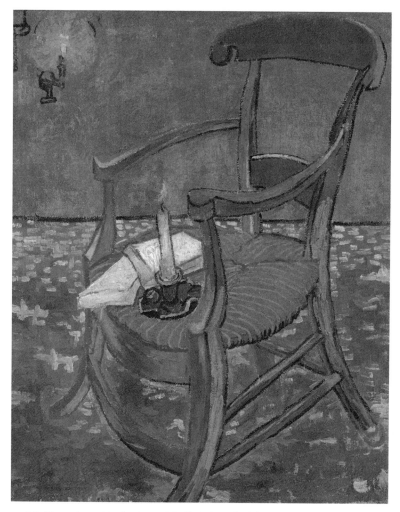

Figure 8.1 Vincent van Gogh, *Gauguin's Chair* (1888). Oil on canvas, 90.5 × 72.7 cm. Van Gogh Museum, Amsterdam. Image courtesy Van Gogh Museum, Amsterdam. © Vincent van Gogh Foundation.

Gauguin's to achieve precisely that.[6] On this point, Breton was declaring a difference with Alfred Jarry whose Doctor Faustroll had identified van Gogh as nothing less than a modern alchemist.[7]

[6] 'la vibration interminable et douloureuse de son regard', 'métamorphose et annule les traumatismes', Breton, *L'Art magique*, 238.

[7] See the reference to this in André Breton, 'Alfred Jarry as Precursor and Initiator' [1951], *Free Rein* [1953], trans. Michel Parmentier and Jacqueline d'Amboise, Lincoln and London: University of Nebraska Press, 1995, 252.

The spread of van Gogh's popularity in the twentieth century had surely been assisted by the acclaim heaped by Surrealism on the art of the insane, in stark contrast with the crude scepticism the artist's work had earlier received from contemporaries such as Paul Signac for its supposedly symptomatic betrayal of the pitiable mental state of its creator.[8] However, Breton's harsh verdict that van Gogh had 'made the high walls of appearance collapse before him', then been unable 'to survey the beyond of their ruins' – a conclusion obviously reached through negative comparison with the mentally ill artists he admired – had already been answered ten years earlier by his former Surrealist comrade Antonin Artaud in *Van Gogh, the Man Suicided by Society*, in which the artist is spoken of glowingly in esoteric terms.[9] This was the ardent tract of 1947 that Breton himself would describe in interview two years after *L'Art magique* as Artaud's '*hyperlucid*' work, the incontestable masterpiece' of his writing life.[10] Artaud's tribute to van Gogh was written over the period that Breton and the Surrealists were preparing the exhibition *Le Surréalisme en 1947*, dedicated to magic and esotericism, and it was one shaped partly by Artaud's opposition to that event. Breton must have been aware of this but never mentioned it and it has escaped commentators on Artaud and Surrealism to this day. I will trace the ambivalent shadow cast by Surrealism across Artaud's volume on van Gogh as a means of closing this book.

Re-enchanting Artaud

On 25 May 1946, the very day Breton arrived back at the port of Le Havre following his enforced stay in America during the Second World War, Artaud was relocated to the Hospice d'Ivry in Paris from the asylum of Paraire in Rodez in the south of France.[11] Artaud had been kept there since February 1943 undergoing over fifty sessions of appalling electro-shock treatment following his mental collapse in September 1937, also in Le Havre, and previous internment in three psychiatric institutions.[12] The two

8 For the private remark of 1894 made in his journal about van Gogh as 'n'est intéressant que par son côté phénomène fou ... et dont les seuls tableaux intéressants sont ceux faits au moment de sa maladie, à Arles', see Paul Signac, 'Extraits du journal inédit de Paul Signac, 1: 1894–1895', *Gazette des Beaux-Arts*, tome 36, year 91, vol. 36, 1949, 97–128, 104.
9 'fait s'effondrer devant lui des murailles d'apparences sans jamais survoler l'au-delà de leurs ruines', Breton, *L'Art magique*, 238.
10 'l'ouvrage *hyperlucide*, le chef-d'oeuvre incontestable', André Breton, 'Sur Antonin Artaud' [1959], *Oeuvres complètes*, vol. 4, Paris: Gallimard, 2008, 981–3, 983. Breton might have had in mind the few 'magic' paintings by van Gogh that he had gestured towards in *L'Art magique* when he pronounced in this interview: 'Depuis Rimbaud et Lautréamont nous savons que les chants les plus beaux sont souvent aussi les plus hagards. *Aurelia* [1855] de [Gérard de] Nerval, les *Poèmes de la folie* de [Friedrich] Hölderlin, les toiles de l'époque d'Arles de van Gogh sont ce que nous mettons le plus haut dans leur oeuvre', Breton, *Oeuvres complètes*, vol. 4, 981.
11 Mark Polizzotti, *Revolution of the Mind: The Life of André Breton*, revised and updated, Boston: Black Widow Press, 2009, 483.
12 Isabelle Cahn, 'Van Gogh/Artaud: Les suicidés de la société', Paris: Musée d'Orsay, *Van Gogh/Artaud: Le suicidé de la société*, 2014, 15–31, 15.

met up at the beginning of June 1946 after a long silence that had lasted from the moment of Artaud's confinement. Artaud's renewed correspondence with Breton from that time already serves up the theme of *Van Gogh, the Man Suicided by Society*, where it states: 'It is a fact that I am anti-social, but is that society's fault or mine [*sic*].'[13]

Breton agreed to give an address in a tribute event for Artaud on 7 June 1946, only a few days after his return to Paris, at the Théâtre Sarah-Bernhardt where Charles Morice had lectured towards the end of 1903 on the recently deceased Gauguin.[14] He did not mention these various coincidences of time and place, but he must have noticed their correspondence with his theory of 'convulsive beauty' as set out in *Mad Love* and discussed in my third chapter in relation to the painting of Seurat, for it was one of that theory's three conditions, namely 'magic-circumstantial', denoting a meaningful encounter, which marked the reawakening of Breton's relations with Artaud. However, it was precisely its opposite – a missed encounter, on the theoretical plane in this case – that would soon bring two quite differently struck chords of disenchantment to Artaud's appraisals of post-war Surrealism on the one hand, and the art of van Gogh on the other. I will trace their affinity in this epilogue.

Keen to rekindle interest in Surrealism in the capital after five years away, Breton reminded his audience at the Théâtre Sarah-Bernhardt of Artaud's brief passage through Surrealism at its beginnings in the mid-1920s. He went on to confess that in his own memory of that time, 'it is the personality of Antonin Artaud that stands out in its dark magnificence', and to admit that Artaud could claim sole responsibility for the third issue of *La Révolution surréaliste*, which 'among all the other issues, is the one that reaches the highest phosphorescent point'.[15] That was not to say that Artaud was the most Surrealist of the Surrealists, even though Artaud himself had declared as much in a letter back in 1924; in fact, Breton regretted the lack of restraint espoused in that number of the journal.[16]

Not long after that incendiary publication, Artaud had stated his not unrelated indifference to the politics of the Surrealists. Some of the group began to turn towards communism in 1925 through reflection on the question of colonialism. Subsequent alliances took place between *La Révolution surréaliste* and the pro-communist magazine and group *Clarté* as well as *L'Humanité*, the review of the Parti communiste français (PCF).[17] Although they moved further in the direction of communism

[13] 'Que je sois antisocial est un fait, mais est-ce la faute de la société ou la mienne [*sic*]', Antonin Artaud, 'À André Breton [letter of 2 June 1946]', *Oeuvres complètes*, vol. 14(i), Paris: Gallimard, 1978, 128–38, 138.
[14] See the diary entries of 1 June and 3 June 1946 and the partial account of the 7 June event in Jacques Prevel, *En compagnie d'Antonin Artaud*, Paris: Flammarion, 1974, 16–19; 20–3.
[15] André Breton, 'A Tribute to Antonin Artaud' [1946], *Free Rein*, 77–9, 78.
[16] 'J'ai fait connaissance avec tous les dadas qui voudraient bien m'englober dans leur dernier bateau Surréaliste, mais rien à faire. Je suis beaucoup trop surréaliste pour cela', Antonin Artaud, 'À madame Toulouse [letter of October 1924]', *Oeuvres complètes*, vol. 1(ii), Paris: Gallimard, 1976, 111–12, 112.
[17] Carole Reynaud Paligot, *Parcours politique des surréalistes 1919-1969* [2001], Paris: CNRS Éditions, 2010, 56–62.

towards the end of that year, the Surrealists did not join the PCF with the exception of Pierre Naville who contended that the Surrealist revolution of the mind was unattainable prior to the overthrow of the bourgeoisie and insisted that the Surrealists clarify their priorities.[18] Breton responded late in 1926 in the well-known text 'In Self-Defense', refusing to see a separation between the revolution of the mind being plotted by Surrealism and the one in society being prepared by communism.[19] Artaud did see a distinction, however, breaking with the Surrealists at the beginning of the series of decisive meetings in November and December with the *Clarté* group that would end in the adherence of several of the Surrealists to the PCF in 1926–7. For Artaud, revolt was apolitical, 'individual and spiritual', not collective and social.[20] He was attacked for his troubles in the Surrealist tract *Au grand jour* in May 1927 (to which he responded the following month on the basis that 'all the exacerbation of our quarrel revolves around the word "Revolution"'),[21] and for good measure by Breton in the *Second Manifesto of Surrealism* (1930) for 'looking for lucre and notoriety' by dabbling in commercial film and theatre.[22]

Artaud's interest in Buddhism and especially the *Tibetan Book of the Dead* or *Bardo Thodol* had been awakened during his time with the Surrealists. Furthermore, in his response to *Au grand jour*, Artaud had said 'Surrealism was never anything else than a new sort of magic to me,' continuing '[l]et the occult's thick walls crumble down once and for all on these incapable gabblers'.[23] Beyond this, his earliest full expression of a curiosity about esotericism can be found in 'Witchcraft and the Cinema' of about 1928, imagining a 'whole occult life' made available by the cinema, where images 'probe … for hitherto unused possibilities in the depths of the mind'.[24] However, he only began reading consistently on Gnosticism, Eastern mysticism and religion, occultism, alchemy and magic around 1933 at the time of writing *Heliogabalus or the Crowned Anarchist* (1934). Although he remained critical in the 1930s of the movement's adoption of politics, Artaud understood the *idea* of Surrealism positively and retrospectively through his reading of such sources, while viewing its ongoing

[18] Gérard Durozoi, *History of the Surrealist Movement* [1997], trans. Alison Anderson, Chicago: The University of Chicago Press, 2004, 132–4.
[19] André Breton, 'In Self-Defense' [1926], *Break of Day* [1934], trans. Mark Polizzotti and Mary Ann Caws, Lincoln and London: University of Nebraska Press, 1999, 22–39, 34–5.
[20] 'individuelle et spirituelle', Reynaud Paligot, *Parcours politique des surrealists*, 63.
[21] André Breton [and Louis Aragon and Paul Éluard], 'Au grand jour' [1927], *Oeuvres complètes*, vol. 1, Paris: Gallimard, 1988, 928–42, 929 n. 1; Antonin Artaud, 'In the Dark or The Surrealist Bluff' [1927], *Collected Works*, vol. 1, trans. Victor Corti, London: Calder and Boyars, 1968, 191–8, 192 n. 1.
[22] André Breton, 'Second Manifesto of Surrealism' [1930], *Manifestoes of Surrealism*, trans. Richard Seaver and Helen R. Lane, Ann Arbor: University of Michigan Press, 1972, 116–94, 130. Upon the republication of the *Second Manifesto* in 1946, Breton tried to diminish the differences between himself and Robert Desnos and Artaud, writing: 'the wrongs I have upon occasion ascribed to them fall by the wayside', Breton, *Manifestoes*, 114. For an account of Artaud's view of Surrealism immediately following his expulsion, see Odette Virmaux, 'Artaud et le Surréalisme: Note sur *Point final*', *Europe*, year 62, no. 667/668 ('Antonin Artaud'), November–December 1984, 27–32.
[23] Artaud, *Collected Works*, vol. 1, 195.
[24] Antonin Artaud, 'Witchcraft and the Cinema' [c. 1928], *Collected Works*, vol. 3, trans. Alastair Hamilton, London: Calder and Boyars, 1972, 65–7, 66.

political involvement with the movement Contre-Attaque led by Georges Bataille as further evidence of its regression.[25]

This interpretation is evident in his Mexico City lecture 'Surréalisme et révolution' of 26 February 1936, given early in his stay in Mexico, which took place from February till October that year, and also in one of the texts he wrote in August on the sculptor Luis Ortiz Monasterio:

> [T]he mystery of Surrealism ... has been a hidden mystique. A new genre of occultism, and like every hidden mystique it is expressed allegorically.... To reconnect with the secret of things, Surrealism had opened a path. Like the Unknown God of the Cabirian Mysteries, like the Aïn Souph [Ein Sof or Ayn Sof], the living hole of abysses in the Kabbalah, as for the Nothing, the Void, the Non-Being devourer of nothingness of the ancient Brahmas and Vedas, we can say of Surrealism what it is not, but in order to say what it is we must employ approximations and images. It resuscitates, by a kind of incantation in the void, the spirit of the ancient allegories.[26]

> Surrealism seeks a higher reality and, to attain it, destroys temporary forms in quest of what in the language of the ancient Vedas is called the *Non-Manifested*.... Imbeciles have called the Surrealist movement destructive. It is undoubtedly destructive of transitory and imperfect forms, but this is because it is looking beyond forms for the occult and magical presence of a fascinating reality.[27]

Artaud had written letters destined for France's Ministers of Foreign Affairs and Education to say he was planning the trip to Mexico because it 'offers a perfect example of primitive civilisations with a magic spirit',[28] comparing in the second of these 'the secret of Mexican high magic' with the work of contemporary artists in Europe.[29] While there, he published on what he imagined to be the potential to revive the 'magic soul of the ancient Mexican people' in 'Les Forces occultes du Mexique'.[30]

[25] Antonin Artaud, 'Surréalisme et révolution', *Oeuvres complètes*, vol. 8, Paris: Gallimard, 1971, 171–83, 171–3.

[26] Quoted in Patrick Lepetit, *The Esoteric Secrets of Surrealism: Origins, Magic, and Secret Societies* [2012], trans. Jon E. Graham, Rochester VT and Toronto: Inner Traditions, 2014, 38 (translation modified significantly and augmented with the opening phrase '[L]e mystère du Surréalisme ... a été une mystique cachée. Un occultisme d'un nouveau genre, et comme toute mystique cachée elle s'est exprimée allégoriquement ..', Artaud, *Oeuvres complètes*, vol. 8, 173). Artaud meant here the pre-classical, Greek mystery cult of the Cabeiri centred on Thebes and the islands of Lemnos and Samothrace, which eventually spread throughout the classical world. For a discussion of Artaud's reference to Kabbalah in this passage, see Lepetit, *Esoteric Secrets of Surrealism*, 38–9.

[27] Quoted in Lepetit, *Esoteric Secrets of Surrealism*, 39.

[28] 'offre un exemple parfait des civilisations primitives d'esprit magique', Antonin Artaud, 'Au Ministre des Affaires étrangères' [August 1935], *Oeuvres complètes*, vol. 8, 342–4, 343.

[29] 'le secret de la haute magie mexicaine', Antonin Artaud, 'Au Ministre de l'Éducation nationale?' [August 1935], *Oeuvres complètes*, vol. 8, 344–7, 345.

[30] 'l'âme magique des anciens peuples mexicains', Antonin Artaud, 'Les Forces occultes du Mexique' [1936], *Oeuvres complètes*, vol. 8, 282–6, 283.

Artaud had received continued support from some Surrealists after his break with the group and his relationship with Breton had been resumed in late 1936 after an unplanned encounter. That contact took place by letter and postcard, through which he also corresponded with Breton's wife Jacqueline Lamba. In 1937, Artaud was instructed in the use of the tarot by the Catalan artist Manuel Cano de Castro. This information was used in the last text he published before his internment, *The New Revelations of Being* (1937), where apocalyptic events were prophesied at a moment in European history when they were expected anyway.[31] Artaud sent Breton a copy – it was perhaps motivated by Artaud's reading of the episodes of divination recorded in *Mad Love*, which had appeared at the beginning of that year – and continued his correspondence with Lamba up to and beyond the moment he was incarcerated in September.[32] This disastrous episode followed his confused post-Mexico journey in August to the Aran Islands off the west coast of Ireland in possession of what he believed was a magic cane once belonging to Saint Patrick, which had been taken with the idea, as Susan Sontag put it, of 'exploring or confirming his magic powers'.[33]

This esoteric, self-confessedly occultist Artaud is quite dissimilar to the one sponsored from the 1950s by American writers and artists, or the one formulated in the texts of French theory from that decade.[34] It is the post-Surrealist writings of *The Theatre and its Double* (1938, written 1931–6) that are given pre-eminence there. This is in spite rather than because of such comparison in that book between the development of 'theatre's *virtual reality*' and the 'purely assumed dreamlike level on which alchemist signs are evolved', applied in the text 'Alchemist Theatre'.[35]

[31] Antonin Artaud, *Oeuvres complètes*, vol. 7, Paris: Gallimard, 1967, 449; Julia F. Costich, *Antonin Artaud*, Boston: Twayne, 1978, 58; Stephen Barber, *Antonin Artaud: Blows and Bombs*, London and Boston: Faber and Faber, 1993, 89–90; Antonin Artaud, 'The New Revelations of Being' [1937], trans. David Rattray, *Artaud Anthology*, ed. Jack Hirschman, San Francisco: City Lights, 1965, 84–99.

[32] See the testimony of Artaud's contact with Breton and Lamba in Barber, *Antonin Artaud*, 89, 94. Two letters to Breton of 30 July and 14 September 1937 (the religious mania of the second, in particular, showing Artaud's mental disarray) can be found in Antonin Artaud, *Selected Writings*, ed. Susan Sontag, trans. Helen Weaver, New York: Farrar, Straus and Giroux, 1976, 400–3, 405–10. The letters from Artaud to both from May to late September 1937 are reproduced in Artaud, *Oeuvres complètes*, vol. 7, 221–2, 228–9, 231–2, 235–7, 238–9, 240–3, 253, 254, 258–9, 260–2, 265–9, 272–3, 286–93, 296–7, 299.

[33] Susan Sontag, 'Artaud' [1973/1976] in Artaud, *Selected Writings*, xvii–lix, xlv.

[34] My concern here is with the latter but for discussion of the former, see Douglas Kahn, 'Artaud in America', Edward Scheer (ed.), *100 Years of Cruelty: Essays on Artaud*, Sydney: Power Publications and Artspace, 2000, 237–62; Lucy Bradnock, 'Lost in Translation? Nancy Spero/Antonin Artaud/ Jacques Derrida', *Papers of Surrealism*, no. 3, spring 2005, n.p.; Lucy Bradnock, 'Life in the Shadows: Towards a Queer Artaud', *Papers of Surrealism*, no. 8, 2010, n.p.; Joanna Pawlick, 'Artaud in Performance: Dissident Surrealism and the Postwar American Literary Avant-Garde', *Papers of Surrealism*, no. 8, 2010, n.p.; and Lucy Bradnock, *After Artaud: Art in America, 1949–1965*, unpublished Ph.D. thesis, University of Essex, 2009. Artaud's continuing relevance to writers and artists is attested to in the exhibition and catalogue held in Madrid: Museo Nacional Centro de Arte Reina Sofía, *Espectros de Artaud: Lenguaje y arte en los años cincuenta*, 2012.

[35] Antonin Artaud, 'Alchemist Theatre' [1932] in 'The Theatre and its Double' [1938, written 1931–6], *Collected Works*, vol. 4, trans. Victor Corti, London: Calder and Boyars, 1974, 34–7, 35.

In 1956, in the wake of the zero degree writing or literature of 'erasure' of Samuel Beckett and the Nouveau Roman, Maurice Blanchot had already borne witness in *La Nouvelle revue française* to the 'infinite proliferation of emptiness' of Artaud's texts.[36] A special issue of the poetry review *La Tour de feu* was dedicated to Artaud in December 1959, with contributions from Breton (the interview I referred to in my introduction to this chapter) and André Masson, but it was only with Michel Foucault's *History of Madness* (1961), where Artaud's writings are compared with the last ones of Friedrich Nietzsche and van Gogh's 'last visions' – a comparison with the painter that Foucault took from Artaud himself – that the process of his restoration in France began in earnest.[37] Artaud soon became extensively reintroduced to French intellectuals and their audience through the theory and culture review *Tel Quel* (1960–82). Artaud's 'Shit to the Spirit' (1947), the attack on all intellectual, philosophical, religious and political schools, systems and tendencies including Surrealism, Marxism, Platonism and, by then, Kabbalah and hermeticism, had already appeared in the third number of autumn 1960, charging mind or consciousness with being 'propped up by the most filthy kind of magic'.[38] As I am going to demonstrate, that text was spurred by the forthcoming international exhibition *Le Surréalisme en 1947*. The primacy given in *Tel Quel* to such later attacks by Artaud on esotericism generally and magic specifically shows an entirely different emphasis in the periodical to that of Surrealism, which had continued to prioritize and explore indefatigably those areas of knowledge right up to that day in its next big manifestation in Paris, the *Exposition InteRnatiOnale du Surréalisme* of 1959–60 titled *EROS*.

Foucault was the first to state an opinion publicly on the importance to *Tel Quel* of Artaud alongside Bataille and the poet Francis Ponge at the colloquium 'Une nouvelle littérature?' organized by the review and held at Cerisy in September 1963, but it had little to do with the Surrealist pasts of all three.[39] The colloquium was followed by the special number of *Tel Quel* devoted to Artaud in winter 1965. It including letters by him and an article by Philippe Sollers where Artaud is seen 'to live his thought integrally and write himself in it', aspiring to pass beyond the practice of signification of individual

[36] See Maurice Blanchot, 'Artaud' [1956], *The Book to Come* [1959], trans. Charlotte Mandell, Stanford CA: Stanford University Press, 2003, 34–40, 38.
[37] Michel Foucault, *History of Madness* [1961], ed. Jean Khalfa, trans. Jonathan Murphy and Jean Khalfa, London and New York: Routledge, 2006, 28 (in fact, every time he is mentioned in this book by Foucault, van Gogh is triangulated with Artaud and Nietzsche, who together are said to create a problem for those seeking to demarcate madness and reason). It has been declared by his biographer that Foucault's book in its entirety was a response to the questions raised by Artaud's state of mind and writings, and particularly to the distressing 1947 performance *Histoire vécue d'Artaud-Mômo* that I come to shortly: James Miller, *The Passion of Michel Foucault*, London: Flamingo, 1993, 94–6.
[38] Antonin Artaud, 'Shit to the Spirit' [1947], trans. Jack Hirschman, *Artaud Anthology*, 106–12, 111. Following this first appearance in *Tel Quel*, seven more essays by Artaud were published in the review from 1963–71.
[39] Danielle Marx-Scouras, *The Cultural Politics of Tel Quel: Literature and the Left in the Wake of Engagement*, University Park PA: The Pennsylvania State University Press, 1996, 79.

thoughts in his work.[40] It also comprised the much better known essay by Jacques Derrida, 'La parole soufflée', in which Artaud's struggle against the metaphysics of representation from a position beyond it in *The Theatre and its Double* and in the other later texts from Rodez (recording his belief that God took away his body at birth) was seen to have inevitably failed.[41] In 1972, finally, another *Tel Quel* colloquium at Cerisy, 'Artaud-Bataille, vers une révolution culturelle', led to further important consideration of Artaud in the winter 1972 and spring 1973 issues of the review, by Sollers, Marcelin Pleynet and, importantly, by Julia Kristeva.

It was Kristeva who figured Artaud most powerfully as a case study in an examination of the 'subject in process' where he is seen to represent the denial of metaphor, which had been central to Surrealism as I showed in my Introduction, in the sense of his struggle to capture the pre-Symbolic (pre-metaphorical) drives in his art and life.[42] Metaphor was understood by Kristeva to be complicit in the identification with the Law of the Father, the very authoritarian, social and Symbolic logic the Surrealists purported to be in revolt against, which therefore remained unaltered by their efforts. As Kristeva knew and saw in Artaud, however, the denial of the Symbolic is the experience of schizophrenia. That same denial is not played out in her own writing where consistency and even essentialism are returned by way of a unified reading of Artaud's *oeuvre* (as in Derrida, perhaps due to the fallacy of a 'complete works' lamented by Sollers), which is consolidated and let us say formulated on the bedrock of the very

[40] See Philippe Sollers, 'Thought Expresses Signs' [1965], *Writing and the Experience of Limits* [1968], ed. David Hayman, trans. Philip Barnard with David Hayman, New York: Columbia University Press, 1983, 87–102, 96.

[41] Jacques Derrida, 'La parole soufflée' [1965], *Writing and Difference* [1967], trans. Alan Bass, Chicago: University of Chicago Press, 1978, 169–95. For his other reflections on Artaud, mimesis, the body and language, see the essay that first appeared in *Critique*, in which a Nietzschean Artaud emerges (probably with its source in Foucault's *History of Madness* and soon to be furthered in Gilles Deleuze's writings) who conceived a non-representational, 'non-theological space' in the Theatre of Cruelty: Jacques Derrida, 'The Theatre of Cruelty and the Closure of Representation' [1966], *Writing and Difference*, 232–50, 235; and also Jacques Derrida and Paule Thévenin, *The Secret Art of Antonin Artaud* [1986], trans. Mary Ann Caws, Cambridge, Mass. and London: MIT, 1998.

[42] Julia Kristeva, 'Le sujet en procès', *Tel Quel*, no. 52, winter 1972, 12–30; Julia Kristeva, 'Le sujet en procès, (suite)', *Tel Quel*, no. 53, spring 1973, 17–38. See Julia Kristeva, 'The Subject in Process' [1973], trans. Patrick ffrench, Patrick ffrench and Roland François-Lack (eds), *The Tel Quel Reader*, London: Routledge, 1998, 133–78. Kristeva's article and another by Sollers titled 'L'État Artaud' were collected alongside other papers from the 1972 Cerisy colloquium with the discussion they prompted: Philippe Sollers (ed.), *Artaud*, Paris: 10/18, 1973, 43–133; 13–42. A partner publication on Bataille also emerged from the event: Philippe Sollers (ed.), *Bataille*, Paris: 10/18, 1973. Although they now seem joined in perpetuity at the limits of experience due to this reception begun in the 1960s, there is no evidence that Bataille saw much correspondence between his own writing and Artaud's. When Bataille averred resignedly that the letter he received from Artaud in 1943 was 'obviously the letter of a madman', he even gainsays in advance Sollers who attempted later to use a passage from Bataille's *Literature and Evil* (1957) to demonstrate 'how the accusation of "madness" brought against Artaud is quite simply displaced', Georges Bataille, 'Surrealism from Day to Day' [1951], *The Absence of Myth: Writings on Surrealism*, ed. and trans. Michael Richardson, London and New York: Verso, 1994, 34–47, 44; Sollers, *Writing and the Experience of Limits*, 95.

psychoanalytic theory that Artaud rejected.[43] Artaud's 1947 letters to Breton, which I come to shortly, are quoted from by Kristeva as evidence of Artaud's rejection of static, identificatory, Symbolic and therefore non-revolutionary systems (such as Surrealism).[44] However, Kristeva gave no serious space to magic, except, naturally, where she translated it as a malignant manifestation of the 'whole series of unities – linguistic, perceptive, conceptual and institutional (the ideological, political and economic apparatuses)'.[45] The appearance in *Tel Quel* of a late poem by Artaud, extending the vilification of magic carried out in 'Shit to the Spirit' and titled 'Il y a dans la magie . . .', had preceded the publication of Kristeva's 'The Subject in Process' in the review.[46] Yet when Kristeva looked back on *Tel Quel* and her own discovery of Artaud while attempting to account for his continuing importance in 1996, she made no mention of magic and certainly not of Surrealism.[47]

In Kristeva's writings, those of Foucault and the others in *Tel Quel* and *Critique*, as in the slightly later ones they inspired by Gilles Deleuze and Félix Guattari, emphasis is placed on the ways in which Artaud's behaviour, thought and inscription, in which the very possibility of representation is always at issue, impact our understanding of the subject by its examination of its limits and unity: the constraints of its language, writing, body and reason.[48] Although Derrida alluded briefly at one remove to the Gnostic

43 Sollers, *Writing and the Experience of Limits*, 102 n. 2. '[F]rom the depth of my soul I am determined to avoid psychoanalysis, I will always avoid it as I will always avoid all attempts to hem my consciousness in with concepts or formulae, with any verbal systematisation', Antonin Artaud, 'To Dr. Allendy [letter of 30 November 1927]', *Collected Works*, vol. 1, 201–4, 202.
44 Kristeva in ffrench and François-Lack (eds), *Tel Quel Reader*, 168–9.
45 Kristeva in ffrench and François-Lack (eds), *Tel Quel Reader*, 167.
46 Antonin Artaud, 'Il y a dans la magie . . .' [1948], *Tel Quel*, no. 35, autumn 1968, 90–5.
47 Julia Kristeva and Edward Scheer, 'Artaud: Madness and Revolution – Interview with Julia Kristeva' [1996], Scheer (ed.), *100 Years of Cruelty*, 263–78.
48 See the inarticulate, schizophrenic and mythic 'body without organs' (derived from Artaud's 1947 radio play *To Have Done with the Judgement of God*) first imagined in Gilles Deleuze, 'Thirteenth Series of the Schizophrenic and the Little Girl', *Logic and Sense* [1969], ed. Constantin V. Boundas, trans. Mark Lester with Charles Stivale, New York: Columbia University Press, 1990, 82–93 (this was translated earlier in an expanded and revised version as Gilles Deleuze, 'The Schizophrenic and Language: Surface and Depth in Lewis Carroll and Antonin Artaud', Josué V. Harari (ed), *Textual Strategies: Perspectives in Post-Structuralist Criticism*, trans. Josué V. Harari, Ithaca NY and London: Methuen & Co. Ltd., 1979, 277–95). The body without organs and Artaud himself – the first 'present[ing] its smooth, slippery, opaque, taut surface as a barrier . . . utter[ing] only gasps and cries that are sheer unarticulated blocks of sound', the second '[breaking] down the wall of the signifier' and 'decoding the flows of desire' in *Van Gogh, the Man Suicided by Society* – have a pivotal role in Gilles Deleuze and Félix Guattari, *Anti-Oedipus: Capitalism and Schizophrenia* [1972], trans. Robert Hurley, Mark Seem and Helen R. Lane, London: The Athlone Press, 1985, 9, 135; and the 'BwO' is explored under various guises in the sixth part of Gilles Deleuze and Félix Guattari. *A Thousand Plateaus: Capitalism & Schizophrenia* [1980], London: The Athlone Press, 1996, 149–66. Artaud's body without organs is characterized as 'opposed less to organs than to that organization of organs we call an organism' and becomes, along with Artaud's larger writing on the body, a means of reading the figure in the paintings of Francis Bacon in Gilles Deleuze, *Francis Bacon: The Logic of Sensation* [1981], trans. Daniel W. Smith, London and New York: Continuum, 2003, 32. Also see the survey of those who, like Artaud, entered into a critique of judgement (they are Franz Kafka, D. H. Lawrence and the inevitable Nietzsche) in which 'Artaud-van Gogh' is even introduced as a single entity judged by 'psychiatric expertise', and Artaud's target is seen to be the judgement of God: Gilles

content of Artaud's writings in 'La parole soufflée' in his reference to the demiurge, that theme is diverted from consideration of its broader occultist context (and so from a Surrealist one) in Artaud's epistemological field by Derrida's consideration of it as a metaphor, once again, for the self, and his conclusion that 'the metaphor of myself is my dispossession within language'.[49] However, in *The Theatre and its Double*, Artaud demanded:

> We ought to consider staging from the angle of magic and enchantment, not as reflecting a script, the mere projection of actual doubles arising from writing, but as the fiery projection of all the objective results of gestures, words, sounds, music or their combinations ... a playwright who uses nothing but words is not needed and must give way to specialists in objective, animated enchantment.[50]

Indeed, Artaud had become interested in magic in the first place because of 'a central collapse of the mind' that he attempted to represent in his early poetry.[51] He identified it with 'something that is destroying my thinking', which was subsequently less articulated than disarticulating in his writing.[52]

In that period of writing on Artaud, only Sontag posed his Gnosticism in relation with Surrealism. She saw it as evidence of a 'specific type of religious sensibility' and in direct contradiction with the positive and optimistic Bretonian version of Surrealism in which the quest for improvement for and of the human race through Marxism or anarchism insisted, in its emphasis on social harmony and justice, on limits that Artaud could never have tolerated.[53] This goes as much for the post-war Artaud of the 1940s as the one that discovered magic in the early 1930s. However, Sontag ignored how much

Deleuze, 'To Have Done with Judgement' [1993], *Essays Critical and Clinical* [1993], trans. Daniel W. Smith and Michael A. Greco, London and New York: Verso, 1998, 126–35, 135. More recently, 'French theory' has given us the essay on Artaud's self-portraiture by Jean-Luc Nancy, 'Le visage plaqué sur la face d'Artaud', Paris: Bibliothèque nationale de France, *Antonin Artaud*, 2006, 12–15. Some of these French writings are included in the main anthology of texts on Artaud in English, only one of which, however, refers to 'the shadow of the alchemical code' in Artaud's writing (specifically in *Van Gogh, the Man Suicided by Society*), and to his 'gnostic conception of existence', even though, as with Derrida's brief remarks on the demiurge in 'La parole soufflé', Surrealism is not introduced as a potential context for Artaud's thought nor Artaud's for Surrealism's: Umberto Artioli, 'From "Production of Reality or Hunger for the Impossible?"' [1984], Edward Scheer (ed.), *Antonin Artaud: A Critical Reader*, London and New York: Routledge, 2004, 137–47, 137, 144 (this first appeared in a special issue of a journal on Artaud that was introduced by Philippe Sollers: *Europe*, year 62, no. 667/668 ('Antonin Artaud'), November–December 1984). For evidence that the 'post-structuralist' Artaud is alive and well, see C. F. B. Miller, 'Artaud's Heliogabalus', *Papers of Surrealism*, no. 10, summer 2013, n.p.

49 Derrida, *Writing and Difference*, 182. Also see the notice given Artaud's 'spells', which are then instantly diverted towards a discussion of grammar: Sollers, *Writing and the Experience of Limits*, 99–100.
50 Artaud, 'The Theatre and its Double', *Collected Works*, vol. 4, 1–110, 55.
51 Antonin Artaud, 'Antonin Artaud to Jacques Rivière [letter of 29 January 1924]', trans. Bernard Frechtman, *Artaud Anthology*, 10–12, 10.
52 Artaud, *Artaud Anthology*, 11.
53 See the discussion by Sontag in Artaud, *Selected Writings*, xlv–liii.

his attitude towards magic had soured by the time he emerged from Rodez in 1946. Ironically, as we will see, this created a new breach between himself and an increasingly esoteric Surrealism. This is important to comprehend because the most recent scholarly work on *Van Gogh, the Man Suicided by Society* gives no evaluation of Surrealism's role in the formation of that text.[54] Yet it was from the other side of this rupture, disenchanted by both Surrealism and magic, but unable or unwilling to disengage himself fully from either, that he wrote on van Gogh in 1947.

Challenges and provocations: Van Gogh, Artaud and Breton

At the end of 1946, Artaud was organizing his *Oeuvres complètes* for Gallimard, while writing new poems and texts and preparing the 'comeback' performance to be called *Histoire vécue d'Artaud-Mômo. Tête à tête par Antonin Artaud, avec 3 poèmes déclamés par l'auteur* and held on 13 January 1947 at the Théâtre du Vieux-Colombier. At this moment, he received an invitation to write on van Gogh from his friend the gallery owner and dealer Pierre Loeb, who had longstanding links with Surrealists, Pablo Picasso and other artists. Artaud was too distracted by his current projects to comply but decided to do so when Loeb made the same request again by letter after the Vieux-Colombier event. Using as a pretext the exhibition *Vincent van Gogh* at the Musée de l'Orangerie, which I mentioned in my fifth chapter on Gauguin, to take place from 24 January till 15 March, Loeb also enclosed a cutting from *Arts* of an extract (figure 8.2) from the recent, major book mainly authored by the psychiatrist François-Joachim Beer, *Du demon de Van Gogh* (1945).[55] Artaud was sent into a fit of rage at the 'official' diagnosis recorded there of the 'madness' of van Gogh's paintings as understood through his symptoms, and of the artist himself as a schizophrenic also suffering from a 'degenerative' condition as read out of his physiognomy.[56] He immediately made notes towards a rebuttal (his text would open by confronting head on the alleged madness of van Gogh marked by Beer as supposedly revealed in the artist's behaviour) and agreed to Loeb's commission with little knowledge of the artist's *oeuvre*, even though he had alluded to van Gogh in recent writings.[57]

[54] I am referring to the Musée d'Orsay exhibition that is current as I write this in 2014: *Van Gogh/ Artaud: Le suicidé de la société*.

[55] The brief article was embedded in a group of responses to the exhibition: François-Joachim Beer, 'Sa folie?' *Arts*, no. 104, 31 January 1947, 8. News of the event itself had dominated the cover of the publication the previous week: Anonymous, 'Le Film de la vie de Van Gogh', *Arts*, no. 103, 24 January 1947, 1.

[56] Cahn in *Van Gogh/Artaud*, 16. The article in *Arts* was extracted from François-Joachim Beer, *Du démon de Van Gogh*, Nice and Lyon: A. D. I. A and Cartier, 1945, 53–5.

[57] See, for instance, Artaud's text on the Comte de Lautréamont that takes a similar line to the one on van Gogh, listing the artists and writers (Nietzsche and Gérard de Nerval are also mentioned) whom he thought were locked up or silenced to avoid the destabilization of a reality imposed by the bourgeoisie: Antonin Artaud, 'Letter About Lautréamont' [1946], Artaud, *Selected Writings*, 469–73, 471.

Figure 8.2 François-Joachim Beer, 'Sa folie?' *Arts*, no. 104, 31 January 1947, 8.

Artaud was able to gain some familiarity with van Gogh's painting through a visit on 2 February to the Orangerie exhibition with his friend Paule Thévenin. This was the largest display of the artist's work since the massive one of June–October 1937, listing 226 individual items (missed by Artaud because it coincided with his absence from Paris and subsequent incarceration), that took place within the confines of the Exposition Internationale, which had been the first solo show of van Gogh's painting in a French museum and has been established as a key source for Joan Miró's important *Self-Portrait 1* (1937–8).[58] Future Gauguin specialist René Huyghe had supplied the perfunctory introduction for the catalogue of that exhibition. He also provided the much shorter and more melodramatic micro-biography for the thin booklet that accompanied the 1947 show, where 172 works in all media are listed compared to 101 in the Gauguin programme two years later. Although Huyghe's 1937 essay was written

58 Cahn in *Van Gogh/Artaud*, 23; David Lomas, *The Haunted Self: Surrealism, Psychoanalysis, Subjectivity*, New Haven and London: Yale University Press, 2000, 192.

at the time Surrealist art was undergoing its peak visibility in Paris, and the 1947 one when it had become thoroughly canonical, neither speaks from a contemporary or retrospective position that revises van Gogh's art with the aid of Surrealist art and writing, or the other way around.

Indeed, with the minor exception of Miró, van Gogh had received scant attention from the movement's major artists and writers and even when given it was done so freighted heavily with reservation.[59] This relative coolness towards the artist had held since the beginnings of Surrealism, even though it was during the 1920s and 1930s that his reputation had soared in France, Britain and Germany. As shown in great detail by Nathalie Heinich, van Gogh's legend had been secured by the time of his first solo exhibition at Bernheim-Jeune in 1901 by means of a rhetoric of tragedy, mysticism, madness, excessive ambition and passion.[60] However, his critical reputation in France in the first fifteen years of the twentieth century 'rapidly expanded, and almost as rapidly, waned', according to another key source, so that by the end of the First World War: 'he had been given a distinctive, but limited place in the history of French modernism.'[61] By the beginning of the 1920s, van Gogh was established irreversibly as a bankable artist on the international art market, from which point a remarkable escalation of publications on him took place, reaching a figure of 220 in that decade compared to seventy-nine in 1910–19 (itself up from thirty-five in 1900–9).[62] Such attention on several fronts – monographs, catalogues, biographies, correspondence, memoirs – had made van Gogh's standing unassailable by the time he was included with Cézanne, Gauguin and Seurat at *The Museum of Modern Art First Loan Exhibition* in New York in 1929. Yet apart from Georges Bataille's reading, given from the fringe of Surrealism, of van Gogh's self-mutilation as a solar auto-sacrifice – an interpretation that only magnified the spectacle of the artist's alleged madness – barely a murmur was forthcoming from the Surrealists on van Gogh in that decade or the one after.[63] This reticence continued up to and including the massive 1937 exhibition, which prompted

[59] See, for instance, the game that I refer to several times in this book where the affirmative responses in the otherwise mixed welcome afforded van Gogh are heavily mediated by reserve: The Surrealist Group, 'Ouvrez-vous?' *Médium: Communication surréaliste*, no. 1, November 1953, 1 and 11–13, 13. André Masson's art and writings demonstrate surprisingly little interest in van Gogh, yet he stated later in that decade that the artists who had most impressed him around 1910 were van Gogh, Cézanne and Odilon Redon: Georges Charbonnier, *Entretiens avec André Masson* [1957], Paris: Ryôan-ji, 1983, 30. When he raised the question 'Cézanne or van Gogh?' with Miró near the beginning of their friendship in the 1920s, he recalled that 'sa réponse fut rapide: "Van Gogh oui, quant à Cézanne c'est de la" Ce fut la première et seule fois que je l'entendis prononcer un "gros mot"', André Masson, 'À Joan Miró pour son anniversaire' [1972], *Le rebelle du surréalisme: écrits*, ed. Françoise Will-Levaillant, Paris: Hermann, 1976, 86–8, 87.
[60] Nathalie Heinich, *The Glory of Van Gogh: An Anthropology of Admiration*, trans. Paul Leduc Browne, Princeton NJ: Princeton University Press, 1996, 27–8.
[61] Carol M. Zemel, *The Formation of a Legend: Van Gogh Criticism, 1890–1920*, Ann Arbor MI: UMI Research Press, 1980, 79.
[62] Heinich, *Glory of Van Gogh*, 36.
[63] Georges Bataille, 'Sacrificial Mutilation and the Severed Ear of Vincent van Gogh' [1930], *Visions of Excess: Selected Writings, 1927–1939*, ed. Allan Stoekl, trans. Allan Stoekl with Carl R. Lovitt and Donald M. Leslie, Jr., Minneapolis MN: University of Minnesota Press, 1985, 61–72.

Bataille to a brief sequel anticipating his theory of general economy, equally mesmerized by van Gogh's 'tragic canvases' and the 'powerful magic' of his 'madness'.[64]

At the Orangerie event a decade later, Artaud saw paintings from every period of van Gogh's life, even though his extremely sensitive condition did not allow their extensive perusal. He left in an excited state, however, and immediately set about writing the text that would become *Van Gogh, the Man Suicided by Society*. Jogging his memory with two illustrated books, the large-scale, mainly black and white volume *Vincent van Gogh* (1937, prefaced by an essay by Wilhelm Uhde) and the compact, almost entirely black and white survey *Van Gogh* of 1941 (with an introductory essay by Anne-Marie Rosset), Artaud worked over the initial fragments in a partly improvised way from 8 February till 3 March 1947, while Thévenin read aloud to him from a volume of the letters to Theo.[65] Work on the forthcoming book was known to writers in Paris judging from Charles Estienne's article on van Gogh in *Fontaine* in April, in which the artist was portrayed as a *peintre maudit* and compared with the Comte de Lautréamont, Nietzsche, Arthur Rimbaud, the self-taught painter Séraphine Louise and Artaud himself, with detailed reference to the latter's recently published writings on his visit while in Mexico to the Tarahumara people.[66] Excerpts from *Van Gogh* appeared in *Combat* in May, where Estienne had reviewed the Orangerie exhibition in January and had compared the writer and the artist, not long after Loeb's first approach to Artaud to write on van Gogh.[67] Estienne had also written a brief, partly critical account of Breton's address on Artaud at the Théâtre Sarah-Bernhardt the previous year.[68] He now compared Artaud's language in *Van Gogh* to Charles Baudelaire's and Stéphane Mallarmé's, soon after the book was published on or around 15 December 1947.[69]

64 Georges Bataille, 'Van Gogh as Prometheus' [1937], trans. Annette Michelson, *October*, no. 36 ('Georges Bataille: Writings on Laughter, Sacrifice, Nietzsche, Un-Knowing'), spring 1986, 58–60, 58. For more on the reception of van Gogh in France and elsewhere, see John Rewald, *Studies in Post-Impressionism*, eds Irene Gordon and Frances Weitzenhoffer, London: Thames and Hudson, 1986, 244–54.

65 Antonin Artaud, *Oeuvres complètes*, vol. 13, Paris: Gallimard, 1974, 305.

66 Charles Estienne, 'La Réponse de Van Gogh', *Fontaine*, year 8, no. 59, April 1947, 139–47. It is worth noting that as he entered the Surrealist circle, Estienne would write a dull book on van Gogh for Skira's 'The Taste of Our Time', where his volume on Gauguin appeared the same year: Charles Estienne, *Van Gogh*, trans. S. J. C. Harrison, Geneva, Paris, New York: Skira, 1953.

67 Antonin Artaud, 'On peut vivre pour l'infini: Van Gogh vu par Antonin Artaud', *Combat*, no. 876, 2 May 1947, 2; Charles Estienne, 'Van Gogh à l'Orangerie', *Combat*, no. 823, 29 January 1947, 2.

68 Charles Estienne, 'Hommage à Antonin Artaud au Théatre Sarah Bernhardt', *Combat*, no. 624, 8 June 1946, 2.

69 Charles Estienne, 'Van Gogh vu par Antonin Artaud', *Combat*, no. 1073, 19 December 1947, 2. The genesis, publication and reception of Artaud's book are set out in Artaud, *Oeuvres complètes*, vol. 13, 299–307. Excerpts were translated into English immediately after the first French edition: Antonin Artaud, 'Van Gogh, The Suicide Provoked by Society' [1947], trans. Peter Watson, *Horizon*, vol. 17, no. 97, January 1948, 46–50; credited to 'the Surrealist poet Antonin Artaud', the text was again translated into English in America just over a year after its first French publication: Antonin Artaud, 'Van Gogh, The Man Suicided by Society' [1947], trans. Bernard Frechtman, *The Tiger's Eye*, vol. 1, no. 7, 15 March 1949, 93–115 (see editorial remarks, 60).

Through the first part of the period of the writing of *Van Gogh*, Artaud had entered into an acrimonious exchange with Breton. This began immediately after performing *Histoire vécue d'Artaud-Mômo* (there is a letter to Breton dated the day after the event), and it was fanned by the ongoing plans for Surrealism's own comeback performance that year.[70] That was to be *Le Surréalisme en 1947*, held at the Galerie Maeght from 7 July till 30 September 1947, which advertised the centrality of esotericism to the movement in the post-war period through what Breton fatefully called its '"initiatory" setting'.[71] The visitor climbed twenty-one stairs decorated with painted spines of books important to the Surrealists, corresponding to the major arcana of the tarot (minus one), leading to a sequence of heavily designed and ambiently lit rooms. First there was an upper space of works by established Surrealist artists, then a Hall of Superstitions, conceived by Duchamp and realized by Frederick Kiesler including tribal artefacts and work by Max Ernst, Kiesler, Miró, Yves Tanguy and others, which was followed by a 'purification' room of falling water containing a billiard table, leading on finally to what is now the best remembered space of the exhibition in which the Surrealist aspiration to supplant Christianity with a new myth was conveyed by means of twelve pagan altars (figure 8.3) by various Surrealists corresponding to the signs of the zodiac and inspired by characters in modern art and literature (taken from Breton's 'Great Invisibles', Lautréamont's *Chants de Maldoror* (1869), Duchamp's *Bride Stripped Bare by Her Bachelors, Even* or *Large Glass* (1915–23), Ernst's personal mythology and so on).[72] Calling the altars a 'few *haloed beings or objects*' in 'Surrealist Comet' shortly after, Breton linked them clearly enough to his earliest proposal of there being 'certain subjects having a *halo*' in his tentative and unlikely reflection ten years before on Cézanne the seer in *Mad Love*.[73]

Naturally, Artaud had received from Breton the standard letter of invitation to participate in the exhibition.[74] One can imagine how his writing since the classic Surrealist texts of 1925, *Umbilical Limbo* and *Nerve Scales*, could have been represented in the conception of the Hall of Superstitions and the room of altars.[75] More so, since,

[70] Antonin Artaud, 'À André Breton [letter of 14 January 1947]', *Oeuvres complètes*, vol. 14(i), 152–6.
[71] André Breton, 'Before the Curtain' [1947], *Free Rein*, 80–7, 85.
[72] For a lengthier explanation of the relationship of myth to the altars, see André Breton, 'Surrealist Comet' [1947], *Free Rein*, 88–97, 95–6. For a description by a sympathetic contemporary, see Pierre Guerre, 'L'Exposition internationale de surréalisme', *Cahiers du sud*, year 34, no. 284, 1947, 677–81; and for another by Surrealism's historian, see Marcel Jean with Arpad Mezei, *The History of Surrealist Painting* [1959], trans. Simon Watson Taylor, New York: Grove Press, 1960, 341–4. More recently, interpretive accounts have been given of the genesis of the show by José Pierre, 'Le Surréalisme en 1947', Marseille: Centre de la Vieille Charité, *La Planète affolée: Surréalisme, Dispersion et Influences, 1938–1947*, 1986, 283–8; and of the event itself by Durozoi, *History of the Surrealist Movement*, 466–72; and Alyce Mahon, *Surrealism and the Politics of Eros, 1938–1968*, London: Thames & Hudson, 2005, 116–32.
[73] Breton, *Free Rein*, 95; André Breton, *Mad Love* [1937], trans. Mary Ann Caws, Lincoln and London: University of Nebraska Press, 1987, 106 (translation slightly modified).
[74] An extract from this letter can be found at the back of the exhibition catalogue: André Breton, 'Projet initial', *Le Surréalisme en 1947*, Paris: Pierre à Feu, 1947, 135–8.
[75] For these important Surrealist texts, see Antonin Artaud, 'Umbilical Limbo' and 'Nerve Scales', *Collected Works*, vol. 1, 49–65; 69–86.

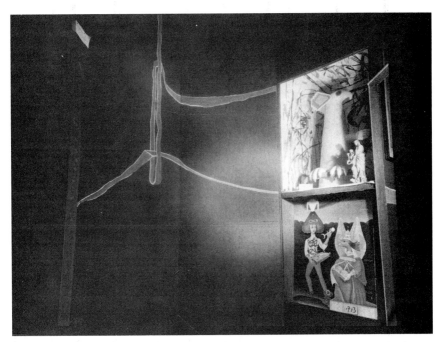

Figure 8.3 Photograph of Victor Brauner's altar from the *International Exhibition of Surrealism*, Paris, 1947. © Photo Galerie Maeght, Paris © ADAGP, Paris and DACS, London 2018 © Association Willy Maywald/ADAGP, Paris and DACS, London 2018.

as I showed, his interest in occultism can be traced back to the 1920s and, more broadly, in esotericism to the early 1930s. However, that invitation coincided with Breton's tactless statement made to Artaud that he was 'hostile' towards the Théâtre du Vieux-Colombier performance and his verdict that it showed Artaud had 'remain[ed] a man of the theatre'.[76] This remark showed Breton's continued resistance since the days of Dada to what he felt was the trivialization through theatricalization of ideas and discourse. In fact, during his tribute-lecture on Artaud at the Théâtre Sarah-Bernhardt the previous year, he had spoken of being 'somewhat troubled by this new tendency, which I am discovering, to track with a circus spotlight – or to tolerate as much – some of those intellectual investigations that we used to believe were best conducted in the shadows'.[77] Breton's lament had its source in the *Second Manifesto* and it constitutes a direct line to Surrealism's current preoccupations with occultism, since Breton had requested there that Surrealists and their contemporaries:

[76] For his fixation on the terms used by Breton, see the correspondence of about 28 February 1947: Antonin Artaud, 'Letter to André Breton by Antonin Artaud' [1947], trans. Clayton Eshleman, *Sparrow*, no. 23, August 1974, n.p.

[77] Breton, *Free Rein*, 77 (translation slightly modified).

stop showing off smugly in public and appearing behind the footlights. The approval of the public is to be avoided like the plague. It is absolutely essential to keep the public from *entering* if one wishes to avoid confusion. I will add that the public must be kept panting in expectation at the gate by a system of challenges and provocations.

I ASK FOR THE PROFOUND, THE VERITABLE OCCULTATION OF SURREALISM.[78]

This was a task, which, presumably, Breton now believed would be sustained by the offer of 'initiation' at the 1947 exhibition – a public event entirely concerned with displaying the limits of its audience's inclusion. The issue of the level of public involvement in intellectual discourse was perhaps brought up again at the 1946 tribute because of (or at least meant to include) Jean-Paul Sartre's use of the stage and the novel as media for expounding his ideas, since his *No Exit* had debuted in 1944 at the same Théâtre du Vieux-Colombier of Artaud's performance (Breton had glancingly questioned the limits of Sartre's idea of 'engagement' at the Théâtre Sarah-Bernhardt).[79] Perhaps Maurice Nadeau's book promotion event of December 1945 for his recent *History of Surrealism*, also held at that theatre, aggravated Breton further.[80] It probably did not help either that the supposedly intransigent Artaud was beginning the orchestration of his own reception through the arrangement of his manuscripts for the canonical *Oeuvres complètes*, to be published by Gallimard.[81]

Partly as a result of his lack of tact, no doubt, Breton's ethical ambivalence became the object of exposure and attack in the volley of letters meant for him written by Artaud. These coincided precisely with the period of writing *Van Gogh, the Man Suicided by Society* in 1947, and the initial publication in May of extracts from that text.[82] Refusing participation in the Galerie Maeght exhibition, they bear witness to what was now a professed loathing by Artaud of magic and his protestations against Surrealism's

[78] Breton, *Manifestoes of Surrealism*, 177–8 (translation slightly modified).
[79] Marie-Françoise Christout, Noelle Guibert and Daniele Pauly, *Théâtre du Vieux-Colombier 1913–1993*, Paris: Institut Française d'Architecture, 1993, 126–7; Breton, *Free Rein*, 78.
[80] Surrealism comes across with some meticulousness in the account of Nadeau's talk written by the emerging Charles Estienne, 'Au Vieux Colombier: Maurice Nadeau parle du surréalisme', *Terre des Hommes*, no. 10, 1 December 1945, 3.
[81] The official stamp that the *Oeuvres complètes* give Artaud as a professional writer remains an embarrassment for his admirers, especially the academic ones. I alluded earlier to Sollers' mockery of the 'absurd expression' of the term 'complete works' from an Artaudian perspective, while he complimented, nevertheless, the editor, and even helped with the translations: Sollers, *Writing and the Experience of Limits*, 102 n. 2. Elsewhere along the same lines we read: '[m]aybe it's not very Artaudian, this collection of academic essays', Edward Scheer, 'Introduction: On Antonin Artaud', Scheer (ed.), *Antonin Artaud*, 1–8, 8.
[82] One writer on *Van Gogh, the Man Suicided by Society* quotes from Artaud's letters to Breton in his footnotes, but does not affirm a clear connection between the two as I am doing here, nor to my knowledge has any previous text on Artaud's book: Jacques Sojcher, 'Le Jugement et la répétition (Autour de *Van Gogh le suicidé de la société*)', *Obliques* no. 10/11 ('Antonin Artaud'), 1976, 161–5, 165 n. 7 and n. 9. Also see in the same volume G. A. Goldschmidt, 'Un Cauchemar génésique (Artaud et Van Gogh)', 161–6.

new direction, showing a remarkable re-radicalization of his thought since the 1930s, beyond the constraints of even the forgotten, arcane, humiliated or discarded areas of knowledge associated with Gnosticism, occultism and magic. Defending his Vieux-Colombier performance as an attack on its own parameters that only just stopped short of assault on the bourgeois patrons of the theatre, the first of Artaud's letters of about 28 February turned to Breton's invitation with the same aim of attacking the regulatory coordinates of the proposed Surrealist manifestation:

> But how after that, André Breton, and after having reproached me for appearing in a theatre, can you invite me to participate in an exhibition, in an art gallery, hyper-chic, ultra-flourishing, loud, capitalistic (even if it had its funds in a communist bank) and where all demonstration can only have now the stylised, limited, closed, fixed character of a tentative art
>
> the objects on display are put in a box (in a coffin) or in show-windows, in incubators, that's no longer life;
>
> all the snobs meet there like, alas! at the Orangerie they met before van Gogh who deserved a much different night.
>
> For there is nothing that brings down to earth the cosmography, the hydrography, the demography, the science of eclipses, of the equinoxes and the seasons as does a painting by van Gogh.
>
> No, I can absolutely not participate in an exhibition, and especially in a gallery,
>
> all the more so because there is one last thing in your project that lifted me from my seat in horror.
>
> This parallelism of the Surrealist activity with occultism and magic. – I no longer believe in any notion, science or knowledge and especially not in a hidden science.[83]

Artaud went on to display a seemingly limitless obduracy in the face of the classificatory procedure that constituted the organizational principle of the Surrealist exhibition, borrowing from orthodox science like astronomy as well as 'accursed sciences' such as astrology, which were all one to Artaud:

> I have my own idea of birth, of life, of death, of reality, and even of destiny, and I do not allow any others imposed on me or even suggested to me,
>
> for I do not participate in any of the general ideas through which I could have with any other man than myself the opportunity to meet myself.
>
> You have therefore separated this exhibition into 15 rooms, with an altar in each one, modelled, you say, on those of Voodoo or Indian cults.
>
> and representing the 15 degrees or stages of an integral initiation.

[83] Artaud, 'Letter to André Breton', n.p. It seems that this letter never actually reached Breton, but was diverted somehow and published in *Samedi-soir* to Artaud's great indignation; Breton refused to sign the 'lettre d'invectives' prepared for that publication by Artaud: Prevel, *En compagnie d'Antonin Artaud*, 135–6.

It is here that my entire physiology rebels for I do not see that there is anything in the world to which one can be *initiated*.

... there is no universal reality, no absolute to be known, and to which one must be led, that is to say, initiated.[84]

Artaud sustained his repudiation of esotericism and specifically 'initiation' in correspondence that ran parallel to the one with Breton.[85] In these terms of absolute refusal, he showed himself a Gnostic of the most extreme kind, suffering 'metaphysical anxiety and acute psychological distress', as Sontag sketches the experience of the Gnostic, 'the sense of being abandoned, of being an alien, of being possessed by demonic powers which prey on the human spirit in a cosmos vacated by the divine.'[86]

This feeling was not a new one for Artaud. But after Rodez, his once-held optimism about cinema revealing an occult life or about Surrealism or any other esoteric 'system' looking 'beyond forms for the occult and magical presence of a fascinating reality', as we saw him put it in one of the texts he wrote in Mexico, was forgone. This is what he told Breton:

No, there is no occultism and no magic, no obscure science, no hidden secret, no unrevealed truth, but there is the bewildering psychological dissimilation of all the tartuffes of the bourgeois infamy, of all those who ultimately had Villon, Edgar Poe, Baudelaire, and above all Gérard de Nerval, van Gogh, Nietzsche, Lautréamont

but there are *spells*, obscene ritual spellbinding manoeuvres periodically set up against consciousnesses in which all of society participates ...[87]

The final part of his letter to Breton, as I have quoted it here, was in keeping with the opinion given in the text 'Insanity and Black Magic', which was read out at the performance at the Théâtre du Vieux-Colombier.[88] Artaud referred there to the

[84] Artaud, 'Letter to André Breton', n.p.
[85] For the vilification of the 'books of hermetic scholarship used by the forever insatiable ignorance of the so-called "Initiates"', and the remark about the 'kennel of initiates' in the post-Rodez text mauling 'the cock-and-bull stew known as the Kabbalah' that is closely related to the earlier mentioned 'Shit to the Spirit', see Antonin Artaud, 'Letter Against the Kabbalah' [1947], trans. David Rattray, *Artaud Anthology*, 113–23, 115, 117, 113 (translation slightly modified).
[86] Sontag in Artaud, *Selected Writings*, xlv.
[87] Artaud, 'Letter to André Breton', n.p.
[88] The text is dated 12 January 1948 in Artaud, *Selected Writings*, 532; however, see the eyewitness testimony of its recital at the event by Artaud's friend Jacques Prevel in Barber, *Antonin Artaud*, 137. For another first-hand account of Artaud's disturbing performance, which is as depthless as the earlier one he gave of Gauguin and friends in Le Pouldu, see André Gide, 'Antonin Artaud' [1948], *Feuillets d'Automne*, Paris: Mercure de France, 1949, 132–4; and for a lengthier and carefully contextualised consideration, making the convincing suggestion that the letters to Breton and the critic Maurice Saillet attempted to compensate for precisely the failure of the performance that Breton had indicated (either to subvert the form of the theatre or provoke its bourgeois patrons), see Odette and Alain Virmaux, 'La Séance du Vieux-Colombier (ou le Discours abandonné)', *Obliques* no. 10/11, 79–88, 85.

promotion of 'the most sinister and debauched magic' by doctors in their administration of electro-shock treatment, dispatching patients into the state of 'non-self' that Artaud called 'Bardo' after the *Tibetan Book of the Dead* (now referred to by him as an 'idiotic book'): 'Bardo is death', he wrote, 'and **death is only a state of black magic which has not existed long**.'[89] This new attitude towards magic, in which the individual becomes subject to its power, was partly formed through Artaud's incarceration. It was apparently confirmed by his disenchantment with Surrealism at the time of the 1947 exhibition. This is the notion of magic that fed into the contemporarily written *Van Gogh, the Man Suicided by Society*.

Disenchanting Van Gogh

In that book, Artaud did indeed place the alleged madness and actual suicide of van Gogh in a context that leads to such a perception, treatment and outcome as denoted by the title of the piece. However, unlike Sollers and the 1960s milieu of French writers (and as Sontag reminds us), his estimation at the outset that 'it is not man but the world which has become abnormal' is less social critique than a judgement on a cosmic malevolence.[90] Although he regarded van Gogh as a visionary in the same way he did those of his usual litany, consisting of Baudelaire, de Nerval, Hölderlin and so on – and primarily, of course, himself – Artaud's idea of them falling foul of 'bourgeois inertia' has nothing to do with ideology or false consciousness, but rather bewitchment of and by the bourgeoisie, which is therefore beyond the analysis let alone the cure of Marxism.[91] His paranoid reading of van Gogh's fate as an artist and person moves between two levels in *Van Gogh, the Man Suicided by Society*, then, portraying a prophetic victim of a bourgeoisie that practised 'civic magic' upon those it 'wanted to prevent from uttering certain unbearable truths', and a bourgeoisie that was itself in the grip of a universal tormentor[92]:

The authors of the last of these record the disapproval of the event by some who went and others who stayed away. Surrealism's critics frequently accuse it of venerating mental illness; this is an opportunity to dispute that charge by pointing out that Surrealists like Breton, former Surrealists and those close to the group were far less susceptible to the tendency to make an icon of the Vieux-Colombier Artaud, perhaps because some of them had been in a position to see the terrible personal price he had paid for his passage from Surrealist poet to *Tel Quel* idol. See, for instance, the opinion given of the 'lamentable, haggard, and rather disgusting wreck who was the joy of a number of epigoni during the last few years of his life', André Thirion, *Revolutionaries Without Revolution* [1972], trans. Joachim Neugroschel, New York: Macmillan Publishing Co., Inc, 1975, 163.

[89] Antonin Artaud, 'Insanity and Black Magic' [1947], *Selected Writings*, 529–33, 530, 531, 533 (Artaud's bold lettering).

[90] Antonin Artaud, 'Van Gogh, the Man Suicided by Society' [1947], *Selected Writings*, 483–512, 483.

[91] Artaud, *Selected Writings*, 483.

[92] Artaud, *Selected Writings*, 486, 485.

Besides the minor spells of country sorcerers, there are the great sessions of world-wide spell-casting in which all alerted consciousness participates periodically.

Thus on the occasion of a war, a revolution, or a social upheaval still in the bud, the collective consciousness is questioned and questions itself, and makes its judgement.

This consciousness may also be aroused and called forth spontaneously in connection with certain particularly striking individual cases.

Thus there were collective magic spells in connection with Baudelaire, Poe, Gérard de Nerval, Nietzsche, Kierkegaard, Hölderlin, Coleridge,

and also in connection with van Gogh.[93]

and he did not commit suicide in a fit of madness, in dread of not succeeding.

on the contrary, he had just succeeded, and discovered what he was and who he was, when the collective consciousness of society, to punish him for escaping from its clutches,

suicided him.

And this happened to van Gogh the way this always generally happens, during an orgy, a mass, an absolution, or some other rite of consecration, possession, succubation or incubation.

Thus is wormed its way into his body,

this society

absolved,

consecrated,

sanctified

and possessed,

erased in him the supernatural consciousness he had just achieved, and, like an inundation of black crows in the fibres of his internal tree,

overwhelmed him with one final surge . . .[94]

Artaud partook of the common misunderstanding that *Wheatfield with Crows* (figure 8.4, 1890), which closed the 1947 van Gogh exhibition and its catalogue, was the artist's last painting. For that reason it took a central place in his thinking and book as in the movement of the second passage I quote here. The animism suggested by the image of van Gogh's 'internal tree' was carried by Artaud from that painting across the *oeuvre*, which, he thought, depicted 'things of inert nature as if in the throes of convulsions'.[95] His language is close enough to Breton's theory of convulsive beauty – especially as that was applied to the animism Breton perceived in Seurat's notebook

[93] Artaud, *Selected Writings*, 486.
[94] Artaud, *Selected Writings*, 487.
[95] Artaud, *Selected Writings*, 488.

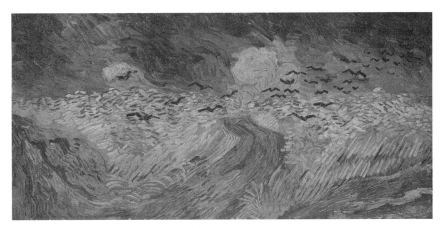

Figure 8.4 Vincent van Gogh, *Wheatfield with Crows* (1890). Oil on canvas, 50.5 × 103 cm. Van Gogh Museum, Amsterdam. Image courtesy Van Gogh Museum, Amsterdam. © Vincent van Gogh Foundation.

entry, which he quoted from and linked to magic in his Haiti lecture the year before Artaud's text (as examined in my third chapter and noted at the beginning of this epilogue) – for us to begin to comprehend Breton's high opinion of Artaud's *Van Gogh*.

In fact, while the internal contradictions in Artaud's book are obviously the outcome of a refusal of mere consistency, which has led his followers to compare him to Nietzsche, they show clearly enough how much Surrealism and magic kept their hold on its author. This is only confirmed by the vehemence of Artaud's attack on both in the letters he sent to Breton in the period, which repeat much of the content of the first one as I sketched it in above as well as whole sections of *Van Gogh*.[96] In his writings after Rodez and his letters of protest to Breton against Surrealism's current orientation and ongoing exhibition plans, Artaud claimed repeatedly to have acquired 'a terrible horror for all that concerns magic, occultism, hermeticism, esotericism, astrology, etc., etc.',[97] and to 'not believe that there is an occult world or something hidden in the world', because he believed those things are really the unfaceable things of this world.[98] However, that did not prevent Artaud from assessing van Gogh in the same way as he had Surrealism while he was in Mexico in 1936: as though he were writing on Ernst, he invested van Gogh with both occultist and alchemical powers, as Jarry had done and as Albert Aurier did when he viewed his art metaphorically in the earliest article

[96] Five letters of February–May 1947 are collected as Antonin Artaud, 'Lettres à André Breton', *L'Éphémère*, no. 8, winter 1968, 3–53.

[97] 'une épouvantable horreur pour tout ce qui touche à la magie, à l'occultisme, à l'herrmétisme, à l'ésotérisme, à l'astrologie, etc., etc.', letter of 28 February (this is a follow-up letter to the one I quoted from above, written the same day), Artaud, 'Lettres à André Breton', 20–5, 23.

[98] Artaud, 'Letter to André Breton', n.p.

on the artist,[99] by describing his transformation of the 'sordid simplicity' of everyday life into:

> these kinds of organ peals, these fireworks, these atmospheric epiphanies, in short, this 'Great Work' of a sempiternal and untimely transmutation.
> These crows painted two days before his death did not, any more than his other paintings, open the door for him to a certain posthumous glory, but they do open to painterly painting, or rather to unpainted nature, the secret door to a possible beyond, to a possible permanent reality, through the door opened by van Gogh to an enigmatic and sinister beyond.[100]

Although the language sounds familiar, his difference with the Surrealists and with his own earlier, metaphorical understanding of the occult is shown where Artaud understood its forces to be not 'hidden' or displaced in some way, but manifest to whoever was prepared to stare them down through art or writing. That is why he now praised van Gogh's occult realism over the *metamorphic* transmutational Surrealism of artist seers such as Ernst, Victor Brauner and Masson with whom Breton had implicitly compared Cézanne ten years earlier in *Mad Love*.[101]

When understood in this way, Artaud's occultist reading of van Gogh's art reaches theoretical consonance with the one that would be arrived at by Breton a few years later in *L'Art magique* in the sense of its transformative intent. However, the two diverge insofar as Breton came to view van Gogh as a 'failed magician', due to the sorrow he thought his work imparted. This was van Gogh's 'depreciation of reality in place of its exaltation', as Breton would have put it under the rubric of 'miserabilism', the latter rapture being achievable through a prophetic and elevated mythic vision.[102] Naturally, then, when Artaud was stirred to compare van Gogh with Gauguin following his viewing

99 For a discussion of Aurier's alchemical reading of van Gogh in the *Mercure* early in 1890, see Patricia Mathews, 'Aurier and Van Gogh: Criticism and Response', *The Art Bulletin*, vol. 68, no. 1, March 1986, 94–104, 97–9. Given the frenzied, Symbolist version of the artist who emerges in Aurier's article, it is surprising that the Surrealists were not more sympathetic towards van Gogh. They must have known about it and the remark by Breton/Legrand that I quoted earlier about 'the splendour of [van Gogh's] wheat fields and skies baked from the same enamel' might even have been drawn from Aurier's about van Gogh's 'pierres, des terrains, des broussailles, des gazons, des jardins, des rivières, qu'on dirait sculptés en d'inconnus minéraux, polis, miroitants, irisés, féeriques; ce sont de flamboyants paysages qui paraissent l'ébullition de multicolores émaux dans quelque diabolique creuset d'alchimiste', G. Albert Aurier, 'Les Isolés: Vincent van Gogh', *Mercure de France*, tome 1, no. 1, January 1890, 24–9, 25.

100 Artaud, *Selected Writings*, 489 (translation modified). Also see the remarks in this text about the 'sensation of occult strangeness' given off by van Gogh's painting, especially the one of his sleeping quarters: '[o]ccult, too, his bedroom, so charmingly rural', Artaud, *Selected Writings*, 500, 501.

101 In 'La parole soufflée', Derrida quotes from as far back as Artaud's Surrealist-period book *Nerve Scales* to show that '[i]t is metaphor that Artaud wants to destroy', Derrida, *Writing and Difference*, 184. That may well have been the rhetoric of that text, but its content is steeped in metaphor all the same: '[t]here is a luminous point where all reality is rediscovered, only changed, transformed, by – what? – a nucleus of the magic use of things. And I believe in mental meteorites, in personal cosmologies', Artaud, *Collected Works*, vol. 1, 72.

102 André Breton, 'Away with Miserabilism!' [1956], *Surrealism and Painting* [1965], trans. Simon Watson Taylor, New York: Harper & Row, 1972, 347–8, 348.

at the Orangerie of *Gauguin's Chair*, which Breton would advance in *L'Art magique* as one of the artist's few successes (and Bataille had read as van Gogh's representation of Gauguin as his ego ideal),[103] Gauguin came out second best for exactly the same reasons that would ensure he found favour in Surrealism over the next few years:

> I believe that Gauguin thought that the artist must look for symbol, for myth, must enlarge the things of life to the magnitude of myth,
> whereas van Gogh thought that one must know how to deduce myth from the most ordinary things of life.
> In which I think he was bloody well right.
> For reality is frighteningly superior to all fiction, all fable, all divinity, all surreality.
> All you need is the genius to know how to interpret it.
> Which no painter before poor van Gogh had done,
> which no painter will ever do again,
> for I believe that this time,
> today, in fact,
> right now,
> in this month of February 1947,
> reality itself,
> the myth of reality itself, mythic reality itself, is in the process of becoming flesh.[104]

In my last three chapters and at the beginning of this epilogue, I showed how Breton's greater appreciation of Gauguin commenced in the year or two after he read this. Breton's estimation of Gauguin's replacement of Greek and Roman myth with a personal mythology took place in the wake of his own call for the imposition of a 'new myth', and he was already led to call Gauguin's art 'magic' in his earliest remarks on the artist in the 1950 interview I referred to in my fifth chapter.[105] This was confirmed in *L'Art magique*, as though that book was spurred by the arrival of the Surrealist Gauguin

[103] Bataille, *Visions of Excess*, 65–6.
[104] Artaud, *Selected Writings*, 491.
[105] '... you'll note that magic [in Gauguin's painting *Where Do We Come From? What Are We? Where Are We Going?* of 1897–8] – for that's what it's about – here asserts its supreme potency, that it stands as the great overseer', André Breton, 'Interview with J.-L. Bédouin and P. Demarne (for the Radio Programme *Where Do We Come From? What Are We? Where Are We Going?* July 1950)', *Conversations: The Autobiography of Surrealism* [1952], trans. Mark Polizzotti, New York: Paragon House, 1993, 231–7, 236. Breton's remarks in this interview (which were Huyghe's really) were quoted at length and given unusual recognition concerning Surrealism's contribution to the study of modern painting as 'establish[ing] Gauguin's credentials in the history of art as a philosophical thinker' in the lengthiest discussion of *Where Do We Come From?* as a painting inspired by occultism: Albert Boime, *Revelation of Modernism: Responses to Cultural Crises in Fin de Siècle Painting*, Columbia MO and London: University of Missouri Press, 2008, 135–220, 141. The post-Greenberg readings from the late 1960s of Gauguin-as-magician, 'an initiate at the inn in Le Pouldu' and reader of Flora Tristan's friend Éliphas Lévi, which enrich without acknowledging Surrealism's earlier, more intuitive interpretation of the artist, are recorded by Vojtech Jirat-Wasiutyski, 'Paul Gauguin's *Self-Portrait with Halo and Snake*: The Artist as Initiate and Magus', *Art Journal*, vol. 46, no. 1 ('Mysticism and Occultism in Modern Art'), spring 1987, 22–8, 25.

at the beginning of the decade. It was this purpose for art that Artaud refuted with what he saw as van Gogh's encounter with the occult as reality itself and not fathomed 'behind' it and reproduced metaphorically in the garb of 'reality'.

That other reality – the one of Gauguin's paintings *Vision of the Sermon (Jacob Wrestling with the Angel)* (1888) and *The Loss of Virginity* (1890) – was reached through what van Gogh called 'abstraction' or not working from a model. It was what Surrealism assiduously advocated from the 1920s in the primacy it gave the imagination, but had been shunned by van Gogh in the late 1880s as 'enchanted ground' in spite of his admiration for Gauguin's achievements.[106] And it was, indeed, a work of disenchantment that Artaud attempted on various fronts in 1947, in *Van Gogh, the Man Suicided by Society* and in the enmity he voiced on the subject of Surrealism's attraction to magic and its testimony in *Le Surréalisme en 1947*.

Artaud's endeavour was furthered through the drawings he showed at the Galerie Pierre to reinforce his antagonism. These appeared under the title *Portraits et dessins par Antonin Artaud* on 4–20 July 1947 to coincide with the launch of the Surrealists' event. The brief presentation titled 'The Human Face' that Artaud gave to open his exhibit demonstrates van Gogh was still at the front of his thoughts.[107] He was the master portraitist, here, whom Artaud opposed to contemporary abstract art and, we can infer, 'bourgeois' Surrealism. This small display showcased Artaud's use of image and text in his coloured drawings, which he had been working on since January 1945 while he was still in Rodez.[108] The sketchbook, study-like appearance of the earlier drawings had given way to the portraits and more finished ones that were executed at Ivry-sur-Seine and these were shown together at the Galerie Pierre (figure 8.5).[109] They were borne on calculatedly poor quality paper, often punctured, sometimes burnt and resembling more the *art brut* admired by Surrealism than anything by the movement's artists (Jean Dubuffet was quick to request Artaud show him examples of the new works[110]), and still less the meticulous, dense, calligraphic landscapes accomplished by van Gogh, never mind the economical, polished studies of

[106] I referred to the quotation in my Introduction and sixth chapter: 'When Gauguin was in Arles, I once or twice allowed myself to be led into abstraction, as you know . . . and at that time abstraction seemed an attractive route to me. But that's enchanted ground, – my good fellow – and one soon finds oneself up against a wall', letter to Émile Bernard of about 26 November 1889 in Vincent van Gogh, *The Letters: The Complete Illustrated and Annotated Edition, Vol. 5: Saint-Rémy-Auvers 1889–1890*, eds Leo Jansen, Hans Luijten and Nienke Bakker, London and New York: Thames & Hudson, 2009, letter 822, 146–53, 148.

[107] Antonin Artaud, 'The Human Face' [1947], trans. Jack Hirschman, *Artaud Anthology*, 229–34.

[108] Natacha Allet, 'Les dessins cruels d'Antonin Artaud: rythmes et traces', *Van Gogh/Artaud*, 63–76, 64. Drawings by Artaud exist from as early as 1915 but as Thévenin records, he 'almost completely stops drawing toward 1924', which was not coincidentally the time he began frequenting the Rue Blomet, met Masson and joined the Surrealists; he would start again in 1937 off and on, around the time of his trip to Ireland from where he sent 'those first missives, conjuratory and protective or offensive and vindictive, that he calls "spells"', then consistently from the beginning of 1945: Derrida and Thévenin, *Secret Art of Antonin Artaud*, 9–10, 14, 19.

[109] For precise dating of the late drawings, see New York: Museum of Modern Art, *Antonin Artaud: Works on Paper*, 1996.

[110] Derrida and Thévenin, *Secret Art of Antonin Artaud*, 19.

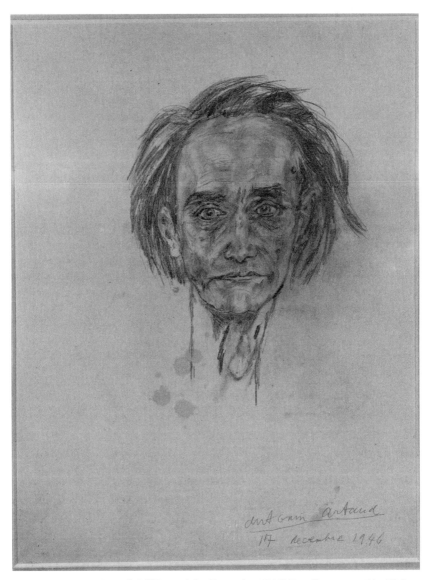

Figure 8.5 Antonin Artaud, *Self-Portrait* (17 December 1946). Pencil on paper, 64 × 52.5 cm. Private collection. © BNF. © ADAGP, Paris and DACS, London 2018.

Seurat.[111] Their purpose was one of spell-casting, which was the last thread connecting Artaud to magic in the way I have presented it here; as a means, that is, of defence against 'civic magic'.[112] This was manifested in the wordplay surrounding the portrait of Thévenin titled *Paule aux ferrets* (figure 8.6, 1947) – 'Je mets ma/fille en sentinelle/elle est fidèle/car Ophélie s'est levée tard' – drawn soon after the first excerpts from *Van Gogh* appeared in print and interpreted recently by Natacha Allet as 'magic, strictly speaking, establish[ing] a pact of fidelity and love: bewitching.'[113]

As was seen in my Introduction to this book and also in my first chapter on Breton's interpretation of Cézanne, this belief in the powers of an object, representation and/or an incantation to effect action-at-a-distance has been one of the best-known ways by which magic has been traditionally understood.[114] However, it was manifested in Artaud's post-Rodez thinking as a kind of last resort when his larger confidence in magic as an alternative means of understanding the world had disappeared. It is impossible to view the raw, nervy, under-skilled stabs and loops of pencil, crayon and chalk of these late drawings without recalling the unfortunate Artaud's terrible illness and experiences during the Second World War. Knowledge of that gives them the air of a hard won achievement, which must have resonated with those who had survived the German occupation. In this and in their zigzag between the enchanted ground of Surrealism and the disenchanted terrain of realism, they bond with the equally hard won yet disjointed attempts in *Van Gogh* to give what we might call a materialist theory of the occult.[115]

In its rhetorical tilt towards scepticism, in spite of the residue of Surrealism and magic, as well as a paranoid occultist Gnosticism I have traced in *Van Gogh*, Artaud's late-period writing was more in tune with the times than that of Surrealists past and present. For it was also in 1947 that (without mention of Artaud) Henri Lefebvre, Sartre and Tristan Tzara launched attacks on the movement from positions informed by

[111] Van Gogh enters Artaud's drawings on at least one occasion, as testified by Artaud himself in the letter to Thévenin of 18 June 1947 telling of a portrait he had completed of her: 'I have done the one of your sister too as in the wheat fields of a van Gogh', Derrida and Thévenin, *Secret Art of Antonin Artaud*, 35.

[112] Artaud's little drawings on burnt scraps of schoolbook paper called 'grisgris' date back to 1938, the year after the advent of the *sorts* or 'spells', drawn and coloured figures meant to resist ordinary compositional and spatial constraints: Antonin Artaud, *50 Spells to Murder Magic* [2004], ed. Évelyne Grossman, trans. Donald Nicholson-Smith, London, New York, Calcutta: Seagull Books, 2008, vii.

[113] 'proprement magique, établit un pacte de fidélité et d'amour, ensorcelant', Allet in *Van Gogh/Artaud*, 74.

[114] Marcel Mauss, *A General Theory of Magic* [1902], trans. Robert Brain, London and New York: Routledge, 1972, 15; and Sigmund Freud, 'Totem and Taboo' [1913], *The Origins of Religion*, ed. Albert Dickson, trans. James Strachey, Harmondsworth: Penguin, 1985, 43–224, 138.

[115] For a similar if under-explained claim made about Surrealism itself as 'a kind of occultomaterialism' (in the sense, seemingly, that 'matter is the basis of the Great Work'), see Michel Carrouges, *André Breton and the Basic Concepts of Surrealism* [1950], trans. Maura Prendergast, Alabama TN: University of Alabama Press, 1974, 49.

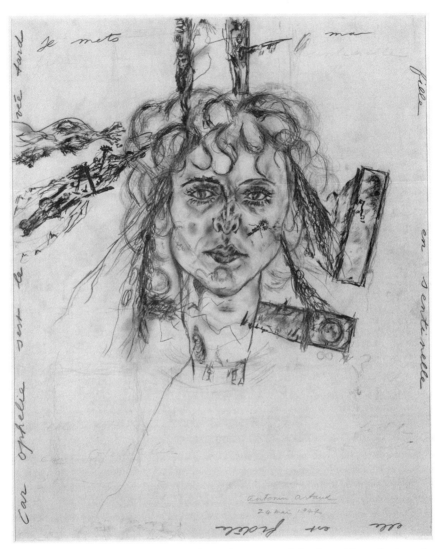

Figure 8.6 Antonin Artaud, *Paule aux ferrets* (24 May 1947). Lead graphite and coloured chalk on paper, 64 × 52.5 cm. Centre de création industrielle, Musée national d'art moderne, Centre Georges Pompidou, Paris. Photo © Centre Pompidou, MNAM-CCI, Dist. RMN-Grand Palais/Philippe Migeat. © ADAGP, Paris and DACS, London 2018.

Marxism (Lefebvre and Tzara were members of the PCF at the time).[116] Along with the remarkable success of *Van Gogh, the Man Suicided by Society*, which was awarded the Prix Sainte-Beuve in 1948, and Artaud's death that year, an increasing disenchantment *of* his work began then that culminated in the 1960s writings I alluded to earlier in this epilogue, alongside the disenchantment *with* Surrealism. The latter now willingly entered a critical and theoretical wilderness with its advocacy of magic and occultism in its art, poetry and theory, and its insistence on the 'indispensable condition of enchantment' – the impenetrable nucleus of resistance to human inquiry that exists within any system of knowledge – as Breton put it not long after Artaud's passing.[117]

[116] For the accusation that Surrealism intended to 'belittle the real in favour of the magical and the marvellous' in a 'concerted attack directed against everyday life and human reality', see Henri Lefebvre, *Critique of Everyday Life, Volume 1* [1947], trans. John Moore, London and New York: Verso, 1991, 110. Sartre's broadside, accusing Surrealism of ineffectual political posing and carrying the notorious statement '[t]hey were the proclaimers of catastrophe in the time of the fat cows: in the time of the lean cows they have nothing more to say', viewed the 'pretty lollipop of the 1947 exhibition' as irrelevant to 'a new ideology' after the war, 'which permits man to live', Jean-Paul Sartre, 'Situation of the Writer in 1947' [1947–8], *What is Literature?* trans. Bernard Frechtman, London: Methuen & Co., 1967, 123–231, 146, 223. Tzara's lecture at the Sorbonne on 17 March 1947 (attended by Artaud) was famously interrupted by Breton, and published the following year: Tristan Tzara, *Le Surréalisme et l'Après-Guerre*, Paris: Les Éditions Nagel, 1948; see Prevel, *En compagnie d'Antonin Artaud*, 113–14.

[117] André Breton, 'Caught in the Act' [1949], *Free Rein*, 125–69, 129.

Coda: On André Breton

Surrealism's journey into obscurity after *Le Surréalisme en 1947* was confirmed and accelerated by the increasing dominance then triumph of modernist, formalist criticism and art history in America and Europe in the 1950s. In attempting to collate, revive, revisit and revise Surrealist readings of the painting that followed Impressionism, the purpose of this book has been to reveal not only alternative interpretations by Surrealism to the formalist ones of the canonical artists of the fin de siècle, but also the means by which its focus on the allusive, metaphorical, mythic, poetic or magic resonance of art can intervene and provide a critical perspective within that canon.

Most books on Surrealism give a special place to André Breton's writings (not to mention his personality) and that is the case for mine, too. That will be criticized, no doubt, by those who currently see the texts of Georges Bataille as a more credible guide to Surrealism and to twentieth-century art as a whole, even as the positivist *détournement* Bataille's writings undergo to make them amenable to rationalist art history converts them into something far tamer than Breton's theory of art-as-divination. However, Breton's writings over a period of half a century have been encountered here in many different ways and put to many different purposes. They have been in no way presented as the sole means by which modernism is tested against Surrealism, even if a 'future continent' or enchanted ground was what he demanded Surrealism seek in the visual arts as opposed to 'logical structure', 'formal design' or whatever.

As I said in my first chapter, Breton was the one who temporarily bucked the general trend in Surrealism to discard Cézanne by discerning a mediumistic tendency in his practice. Here and in my second chapter, the young Breton was oddly indulgent of Impressionism and Renoir in his earliest writing on art until Surrealism settled on a set of theoretical positions that complicated its relationship with modernism and entailed their revocation. Elsewhere, here, Breton was more of an interlocutor, attempting and failing to comprehend the turn taken by Magritte's style in the 1940s towards Impressionism. It was important to lay some necessary contextual groundwork in the Second World War and occupation of Belgium for Magritte's adoption of a free version of Renoir's style, on which I offered my own interpretation in the absence of any specialized scholarship on those paintings. I demonstrated how far Magritte strayed from Surrealism and how true Breton stayed to the implications of his 1930s writings in the frequently disparaged later phase in which Surrealism engaged fully with magic and the occult. I also wanted to place Breton's hopeful vision of a political art in the earlier period in contrast with postmodernism's pessimistic departure from the modernist project and show how Magritte's Renoir style fits into neither, hence its lack of commentary till now.

It was in my third chapter on the reception of Seurat in France that Breton comes across most markedly as an important figure. This is observable not just in his, at once, unfashionable and counter-intuitive commitment to that artist from the 1920s, but also in his remarkable dialectical re-reading of Seurat in the 1940s, which opens out onto a rethinking of the entire 'project' of modern art itself. Breton broke a path onto the appreciation of Seurat within Surrealism that allowed the inclusion of the artist's drawings in *Minotaure* in the late 1930s. In my fourth chapter, those become the means by which I looked at what I understand to be the overriding tonal theme of that magazine, quite beyond any essential identity that can be ascribed to Seurat's drawings (as nocturnes, for instance). This was carried out more with reference to the text of Pierre Mabille and through comparison with the photography of Brassaï, which gave *Minotaure* its house style, but can be read as a kind of 'Bretonism' in the absence of Breton himself.

The emphasis in my fifth chapter on Gauguin was shared between Breton and other writers, too. I showed that René Huyghe and Charles Estienne both had contact with Surrealism from the 1930s to the 1950s and played significant roles in attuning Gauguin's aims and paintings to Surrealism at the midpoint of the twentieth century by taking up questions of epistemology and pedagogy respectively. My sixth chapter, also on Gauguin, returned to episodes that took place in Brittany and were recorded by Breton in *Mad Love*, and were alluded to in my first chapter on Cézanne. Like that chapter, this final one took the liberty of proposing a Surrealist reading of Gauguin that the Surrealists never got around to articulating fully themselves. However, it was hinted at by Breton, and my interpretation took the Celtic Brittany as that has been understood inside and outside the movement as its point of departure. Breton had plenty to say about Gauguin from about 1950. But, at the most, those chapters were shaped by his wider 'influence' as a curator, example, mediator, interlocutor, enemy and so on, set against the imposing and even intimidating shadow of historical Surrealism.

His hard-to-define presence extends well outside of Breton's own writings specifically and I only began to comprehend its expanse in the writing of this book, without grasping it, obviously. I am trying unsuccessfully to name the scarcity of what we can understand historically of an artist or writer merely through their 'complete works' or biography, the elusiveness of the channels through which their stereotypes, metaphors, theories, thoughts or opinions circulate in their own time and after. For that reason, I felt able to close my book with an epilogue that examined the interpretation of van Gogh by former Surrealist Antonin Artaud, made at a time Surrealism was exhibiting its new occultist paradigm in Paris in 1947 and Artaud was rejecting it in (sometimes imagined) dialogue with Breton.

Without having it as my main aim, I also set out in this last part of my book the origins of how Surrealism as an avant-garde (which is how it has been understood by many), as well as Breton's writing as the conduit by which we might understand it, came to be challenged in academic writing by those proposing Artaud and Bataille as the most relevant of his contemporaries in France and even as more valuable in the interpretation of twentieth-century art. Given the way such readings have 'gone viral',

as they say, in university courses in cultural studies, literary theory and particularly in my own discipline, art history, much of this book can be seen as a kind of proposed corrective attempting to re-establish 'Breton' as an array of means for evaluating art and criticism (inseparable, admittedly, from 'Surrealism'), and also to restore André Breton as a considerable writer on modern art and a critic of modernism.

Select Bibliography

Ades, Dawn and Michael Richardson with Krzysztof Fijalkowski (eds and trans.). *The Surrealism Reader: An Anthology of Ideas*, London: Tate, 2015.

Alexandre, Arsène. *Paul Gauguin: sa vie et le sens de son oeuvre*, Paris: Bernheim Jeune & Cie, 1930.

Allmer, Patricia. *René Magritte: Beyond Painting*, Manchester and New York: Manchester University Press, 2009.

Allmer, Patricia and Hilde Van Gelder (eds). *Collective Inventions: Surrealism in Belgium*, Manchester Metropolitan University and Leuven University Press, 2007.

Andersen, Wayne with Barbara Klein. *Gauguin's Paradise Lost*, London: Secker & Warburg, 1972.

Apollinaire, Guillaume. *Apollinaire on Art: Essays and Reviews 1902–1918* [1960], ed. Leroy C. Breunig, trans. Susan Suleiman, Boston, Mass.: MFA, 2001.

Aron, Paul and José Gotovitch (eds). *Dictionnaire de la Seconde Guerre mondiale en Belgique*, Brussels: André Versaille, 2008.

Artaud, Antonin. *Oeuvres complètes*, twenty-four vols, Paris: Gallimard, 1956–88.

Artaud, Antonin. *Artaud Anthology*, ed. Jack Hirschman, San Francisco: City Lights, 1965.

Artaud, Antonin. *Collected Works*, four vols, trans Victor Corti and Alastair Hamilton, London: Calder and Boyars, 1968–74.

Artaud, Antonin. *Selected Writings*, ed. Susan Sontag, trans. Helen Weaver, New York: Farrar, Straus and Giroux, 1976.

Aubenas, Sylvie and Quentin Bajac. *Brassaï: Paris Nocturne* [2012], trans. Ruth Sharman, London: Thames and Hudson, 2013.

Barcelona: Fundació Antoni Tàpies. *Brassaï*, 1993.

Barr, Jr, Alfred H. *The Museum of Modern Art First Loan Exhibition, New York, November 1929: Cézanne, Gauguin, Seurat, van Gogh*, New York: Museum of Modern Art, 1929.

Barr, Jr, Alfred H. *Cubism and Abstract Art*, New York: The Museum of Modern Art, 1936.

Bataille, Georges. *Visions of Excess: Selected Writings, 1927–1939*, ed. Allan Stoekl, trans Allan Stoekl with Carl R. Lovitt and Donald M. Leslie, Jr, Minneapolis MN: University of Minnesota Press, 1985.

Bauduin, Tessel M. *Surrealism and the Occult: Occultism and Western Esotericism in the Work and Movement of André Breton*, Amsterdam: Amsterdam University Press, 2014.

Bédouin, Jean-Louis. *Vingt ans de surréalisme, 1939–1959*, Paris: Denoël, 1961.

Beer, François-Joachim. *Du démon de Van Gogh*, Nice and Lyon: A. D. I. A and Cartier, 1945.

Bernard, Émile. *Souvenirs sur Paul Cézanne*, Paris: Société des Trente, 1912.

Berson, Ruth. *The New Painting: Impressionism 1874–1886: Documentation*, vol. 1, San Francisco: Fine Arts Museums of San Francisco, 1996.

Boime, Albert. *Revelation of Modernism: Responses to Cultural Crises in Fin de Siècle Painting*, Columbia and London: University of Missouri Press, 2008.

Boston, Mass.: Museum of Fine Arts. *Gauguin Tahiti*, 2004.

Boyle-Turner, Caroline. *Paul Sérusier*, Ann Arbor, MI: UMI Research Press, 1983.

Brassaï. *Conversations with Picasso* [1964], trans. Jane Marie Todd, Chicago and London: The University of Chicago Press, 1999.

Brassaï. *Paris by Night*, Boston, New York, London: Bulfinch, 2001.

Brassaï and Paul Morand. *Paris by Night*, Paris: Arts et Métiers Graphiques, 1932.

Brest: Musée des Beaux-Arts. *Charles Estienne, une idée de nature*, 1984.

Breton, André. *Manifestoes of Surrealism*, trans Richard Seaver and Helen R. Lane, Ann Arbor: University of Michigan Press, 1972.

Breton, André. *Surrealism and Painting* [1965], trans. Simon Watson Taylor, New York: Harper & Row, 1972.

Breton, André. *What is Surrealism? Selected Writings*, ed. Franklin Rosemont, London: Pluto Press, 1978.

Breton, André. *Mad Love* [1937], trans. Mary Ann Caws, Lincoln and London: University of Nebraska Press, 1987.

Breton, André. *Oeuvres complètes*, four vols, Paris: Gallimard, 1988–2008.

Breton, André. *Communicating Vessels* [1932], trans Mary Ann Caws and Geoffrey T. Harris, Lincoln and London: University of Nebraska Press, 1990.

Breton, André. *L'Art magique* [1957], Paris: Éditions Phébus, 1991.

Breton, André. *Conversations: The Autobiography of Surrealism* [1952], trans. Mark Polizzotti, New York: Paragon House, 1993.

Breton, André. *Arcanum 17* [1944], trans. Zack Rogow, Toronto: Coach House Press, 1994.

Breton, André. *Free Rein* [1953], trans Michel Parmentier and Jacqueline d'Amboise, Lincoln and London: University of Nebraska Press, 1995.

Breton, André. *The Lost Steps* [1924], trans. Mark Polizzotti, Lincoln and London: University of Nebraska Press, 1996.

Breton, André. *Anthology of Black Humour* [1945/1966], trans. Mark Polizzotti, San Francisco: City Lights, 1997.

Breton, André. *Break of Day* [1934], trans Mark Polizzotti and Mary Ann Caws, Lincoln and London: University of Nebraska Press, 1999.

Breton, André. *Martinique: Snake Charmer* [1948], trans. David W. Seaman, Austin TX: University of Texas Press, 2008.

Brettell, Richard R. and Anne-Birgitte Fonsmark, *Gauguin and Impressionism*, New Haven and London: Yale University Press, 2005.

Broude, Norma (ed.). *Seurat in Perspective*, Englewood Hills NJ: Prentice Hall, Inc., 1978.

Broude, Norma. *Impressionism, A Feminist Reading: The Gendering of Art, Science, and Nature in the Nineteenth Century*, New York: Rizzoli, 1991.

Cabanne, Pierre. *Dialogues with Marcel Duchamp* [1967], trans. Ron Padgett, London: Thames and Hudson, 1971.

Cachin, Françoise. *Seurat: Le rêve de l'art-science*, Paris: Gallimard, 1991.

Callen, Anthea. *The Work of Art: Plein-Air Painting and Artistic Identity in Nineteenth-Century France*, London: Reaktion, 2015.

Canberra: National Gallery of Australia. *Masterpieces from Paris: Van Gogh, Gauguin, Cézanne & Beyond, Post-Impressionism from the Musée d'Orsay*, 2012.

Canonne, Xavier. *Surrealism in Belgium: 1924–2000*, Brussels: Mercatorfonds, 2007.

Cariou, André (ed.). *Charles Filiger-André Breton: À la recherche de l'art magique*, Quimper: Musée des beaux-arts, 2006.

Carr, Gillian, and Simon Stoddart (eds). *Celts from Antiquity*, Cambridge: Antiquity Publications Ltd, 2002.

Carrouges, Michel. *André Breton and the Basic Concepts of Surrealism* [1950], trans. Maura Prendergast, Alabama TN: University of Alabama Press, 1974.

Caute, David. *Communism & the French Intellectuals, 1914–1960*, London: Andre Deutsch Limited, 1964.

Chassé, Charles. *Gauguin et le groupe de Pont-Aven: documents inédits*, Paris: H. Floury, 1921.

Chassé, Charles. *Le Mouvement symboliste dans l'art du XIXe siècle*, Paris: Librairie Floury, 1947.

Chassé, Charles. *Gauguin et son temps*, Paris: La Bibliothèque des Arts, 1955.

Chassé, Charles. *The Nabis & Their Period* [1960], trans. Michael Bullock, London: Lund Humphries, 1969.

Chicago: The Art Institute of Chicago. *Seurat: Paintings and Drawings*, 1958.

Clark, T. J. *The Painting of Modern Life: Paris in the Art of Manet and His Followers*, Princeton NJ: Princeton University Press, 1984.

Clark, T. J. *Farewell to an Idea: Episodes from a History of Modernism*, New Haven and London: Yale University Press, 1999.

Cohen, Margaret. *Profane Illumination: Walter Benjamin and the Paris of the Surrealist Revolution*, Berkeley, Los Angeles, London: University of California Press, 1993.

Conway, Martin. *Collaboration in Belgium: Léon Degrelle and the Rexist Movement 1940–1944*, New Haven and London: Yale University Press, 1993.

Conway, Martin. *The Sorrows of Belgium: Liberation and Political Reconstruction, 1944–1947*, Oxford: Oxford University Press, 2012.

Cooke, Peter and Nina Lübbren (eds). *Painting and Narrative in France*, London and New York: Routledge, 2016.

Cooper, Douglas (ed.). *Paul Gauguin: 45 lettres à Vincent, Théo et Jo van Gogh*, The Hague and Lausanne: Staatsuitgeverij/La bibliothèque des arts, 1983.

Coquiot, Gustave. *Georges Seurat*, Paris: Albin Michel, 1924.

Coquiot, Gustave. *Renoir*, Paris: Albin Michel, 1925.

Cousturier, Lucie. *Seurat* [1921], Paris: Les Éditions Georges Crès & Co., 1926.

Dalí, Salvador. *La Conquête de l'irrationnel*, Paris: Éditions Surréalistes, 1935.

Dalí, Salvador. *Le Mythe tragique de l'Angelus de Millet*, Paris: Jean-Jacques Pauvert, 1963.

Dalí, Salvador. *The Collected Writings of Salvador Dalí*, ed. and trans. Haim Finkelstein, Cambridge: Cambridge University Press, 1998.

De Hauke, César M. *Seurat et son oeuvre*, two vols, Paris: Gründ, 1961.

De Rotonchamp, Jean. *Paul Gauguin, 1848–1903*, Paris: Édouard Druet et Cie, 1906.

Denis, Maurice. *Théories, 1890–1910: Du symbolisme et de Gauguin vers un nouvel ordre classique* [1912], Paris: L. Rouart et J. Watelin, 1920.

Derrida, Jacques and Paule Thévenin. *The Secret Art of Antonin Artaud* [1986], trans. Mary Ann Caws, Cambridge, Mass. and London: MIT, 1998.

Dorra, Henri and John Rewald. *Seurat: L'Oeuvre peint, biographie et catalogue critique*, Paris: Les Beaux-Arts, 1959.

Duchamp, Marcel. *Affectt Marcel._ The Selected Correspondence of Marcel Duchamp*, eds Francis M. Naumann and Hector Obalk, trans. Jill Taylor, London: Thames and Hudson, 2000.

Dumoulin, Michel, Vincent Dujardin, Emmanuel Gerard and Mark Van den Wijngaert. *Nouvelle Histoire de Belgique: vol. 2, 1905–1950, La Belgique sans Roi, 1940–1950*, trans. Anne-Laure Vignaux, Brussels: Éditions Complexe, 2006.

Durozoi, Gérard. *History of the Surrealist Movement* [1997], trans. Alison Anderson, Chicago: The University of Chicago Press, 2004.

Eisenman, Stephen F. *Gauguin's Skirt*, London: Thames and Hudson, 1997.

Estienne, Charles. *L'Art abstrait: est-il un académisme?*, Paris: Éditions de Beaune, 1950.

Estienne, Charles. *Gauguin*, trans. James Emmons, New York: Skira, 1953.

Estienne, Charles. *Van Gogh*, trans. S. J. C. Harrison, Geneva, Paris, New York: Skira, 1953.

Estienne, Charles. *Le Surréalisme*, Paris: Éditions Aimery Somogy, 1956.

Fabre, Daniel and Jean-Pierre Piniès (eds). *René Nelli et les Cahiers du sud*, Carcassonne: Garae/Hésiode, 1987.

Farley, Julia, and Fraser Hunter (eds), *Celts: Art and Identity*, London: The British Museum, 2015.

Fénéon, Félix. *Oeuvres plus que complètes*, vol. 1, ed. Joan U. Halperin, Geneva and Paris: Librairie Droz, 1970.

Foa, Michelle. *Georges Seurat: The Art of Vision*, New Haven and London: Yale University Press, 2015.

Foster, Hal, Rosalind Krauss, Yve-Alain Bois, Benjamin H. D. Buchloh and David Joselit. *Art Since 1900: Modernism, Antimodernism, Postmodernism* [2004], London: Thames and Hudson, 2016.

Frankfurt: Kunsthalle. *René Magritte 1948: La Période Vache*, 2008.

Franz, Erich and Bernd Growe. *Georges Seurat: Drawings* [1983], Boston, Mass.: Little, Brown and Company, 1984.

Fry, Roger. *Vision and Design* [1920], Harmondsworth: Penguin, 1961.

Gamboni, Dario. *Paul Gauguin: The Mysterious Centre of Thought* [2013], trans. Chris Miller, London: Reaktion, 2014.

Garb, Tamar. *Bodies of Modernity: Figure and Flesh in Fin-de-Siècle France*, London: Thames and Hudson, 1998.

Garnett, David. *La Femme changée en renard* [1922], trans Jane-Simone Bussy and André Maurois, Paris: Bernard Grasset, 1924.

Garnett, David. *La Femme changée en renard* [1922], trans Jane-Simone Bussy and André Maurois, Paris: Arthème Fayard & Cie, 1932.

Garnett, David. *The Golden Echo*, London: Chatto & Windus, 1953.

Garnett, David. *The Flowers of the Forest*, London: Chatto & Windus, 1955.

Garnett, David. *The Familiar Faces*, London: Chatto & Windus, 1962.

Garnett, David. *Lady into Fox* [1922], London: Hesperus Press, 2008.

Gauguin, Paul. *Avant et après*, Leipzig: K. Wolff, 1918.

Gauguin, Paul. *Lettres de Gauguin à Daniel de Monfreid*, Paris and Zurich: Éditions Georges Crès et Cie, 1918.

Gauguin, Paul. *The Intimate Journals of Paul Gauguin* [1903, pub. 1918] trans. Van Wyck Brooks, London: William Heinemann, 1923.

Gauguin, Paul. *Lettres de Gauguin à sa femme et à ses amis*, ed. Maurice Malingue, Paris: Éditions Bernard Grasset, 1946.

Gauguin, Paul. *Lettres de Gauguin à Daniel de Monfreid* [1918], ed. Annie Joly-Segalen, Paris: Georges Falaize, 1950.

Gauguin, Paul. *Ancien culte mahorie*, Paris: La Palme, 1951.

Gauguin, Paul. *The Writings of a Savage* [1974], ed. Daniel Guérin, trans. Eleanor Levieux, New York: The Viking Press, 1978.

Gauguin, Paul. *Letters to his Wife and Friends* [1946], ed. Maurice Malingue, trans. Henry J. Stenning, Boston: Museum of Fine Arts, 2003.

George, Waldemar. *Seurat*, Paris: Librairie de France, 1928.

Gibson, Marion, Shelley Trower and Garry Tregidga (eds). *Mysticism, Myth and Celtic Identity*, London and New York: Routledge, 2013.

Gide, André. *Feuillets d'Automne*, Paris: Mercure de France, 1949.

Gide, André. *If it Die . . .* [1920], trans. Dorothy Bussy, London: Secker & Warburg, 1950.

Goldwater, Robert. *Gauguin*, New York: Harry N. Abrams, Inc., 1957.

Goris, Jan-Albert (ed.). *Belgium Under Occupation*, trans. Jan-Albert Goris, New York: The Moretus Press, 1947.

Gracq, Julien. *Au Château d'Argol* [1938], Paris: Librairie José Corti, 1945.

Gracq, Julien. *Le Roi pêcheur*, Paris: José Corti, 1948.

Gracq, Julien. *A Dark Stranger* [1945], trans. W. J. Strachan, London: Peter Owen Limited, 1951.

Gracq, Julien. *Château d'Argol* [1938], trans. Louise Varèse, London: Pushkin Press, 1999.

Greenberg, Clement. *The Collected Essays and Criticism*, four vols, ed. John O'Brian, Chicago and London: The University of Chicago Press, 1986–93.

Gréhan, Amédée (ed.). *La France maritime*, four vols, Paris: Chez Postel, 1837–53.

Halperin, Joan Ungersma. *Félix Fénéon: Aesthete & Anarchist in Fin-de-Siècle Paris*, New Haven and London: Yale University Press, 1988.

Hauptman, Jodi (ed.). *Georges Seurat: The Drawings*, New York: Museum of Modern Art, 2007.

Heilbrun, Carolyn G. *The Garnett Family*, London: George Allen & Unwin Ltd, 1961.

Heinich, Nathalie. *The Glory of Van Gogh: An Anthropology of Admiration*, trans. Paul Leduc Browne, Princeton NJ: Princeton University Press, 1996.

Hendrix, Lee (ed.). *Noir: The Romance of Black in 19th-Century French Drawings and Prints*, Los Angeles: The J. Paul Getty Museum, 2016.

Herbert, Robert L. *Seurat's Drawings* [1962], London: Studio Vista, 1965.

Herbert, Robert L. *Seurat: Drawings and Paintings*, New Haven and London: Yale University Press, 2001.

Homer, William Innes. *Seurat and the Science of Painting*, Cambridge, Mass.: MIT, 1964.

Hulten, Pontus (ed.). *The Surrealists Look at Art*, trans Michael Palmer and Norma Cole, Venice CA: The Lapis Press, 1990.

Hutton, John G. *Neo-Impressionism and the Search for Solid Ground: Art, Science, and Anarchism in Fin-de-Siècle France*, Baton Rouge and London: Louisiana State University Press, 1994.

Huyghe, René. *Dialogue avec le visible*, Paris: Flammarion, 1955.

Huyghe, René. *Gauguin* [1954], trans. Helen C. Slonim, New York: Crown Publishers Inc., 1959.

Huyghe, René. *Ideas and Images in World Art: Dialogue with the Visible* [1955], New York: Harry N. Abrams, Inc., 1959.

Huysmans, Joris-Karl. *Certains* [1889], Paris: Tresse & Stock, 1894.

Jacob, Mira. *Filiger L'Inconnu*, Strasbourg: Éditions des Musées de Strasbourg, 1989.

Jaguer, Édouard. *Les Mystères de la chambre noire: le surréalisme et la photographie*, Paris: Flammarion, 1982.

Jaworska, Wladyslawa. *Gauguin and the Pont-Aven School* [1971], London: Thames and Hudson, 1972.

Jean, Marcel with Arpad Mezei. *The History of Surrealist Painting* [1959], trans. Simon Watson Taylor, New York: Grove Press, 1960.

Jones, Caroline A. *Eyesight Alone: Clement Greenberg's Modernism and the Bureaucratization of the Senses*, Chicago and London: The University of Chicago Press, 2005.

Kandinsky, Wassily. *Du Spirituel dans l'art* [1911], trans. 'M. et Mme. de Man', Paris: Éditions de Beaune, 1954.

Kandinsky, Wassily. *Concerning the Spiritual in Art* [1911], trans. M. T. H. Sadler, New York: Dover, 1977.

Kantor, Sybil Gordon. *Alfred H. Barr, Jr. and the Intellectual Origins of the Museum of Modern Art*, Cambridge, Mass. and London: MIT, 2002.

Krauss, Rosalind and Jane Livingstone (eds). *L'Amour fou: Photography and Surrealism*, New York and London: Abbeville Press, 1985.

Kunstler, Charles. *Renoir: peintre fou de couleur*, Paris: Librairie Floury, 1941.

Lawrence, D. H. *The Fox* [1921], London: Hesperus Press, 2002.

Le Gros, Marc. *Andre Breton et la Bretagne*, Quimper: Blanc Silex, 2000.

Legrand, Gérard. *Gauguin*, Paris: Club d'Art Bordas, 1966.

Legrand, Gérard. *Breton* [1960], Paris: Pierre Belfond, 1977.

Leighton, John and Richard Thomson. *Seurat and the Bathers*, London: National Gallery, 1997.

Lengyel, Lancelot. *L'Art gaulois dans les médailles*, Montrouge-Seine: Éditions Corvina, 1954.

Lepetit, Patrick. *The Esoteric Secrets of Surrealism: Origins, Magic, and Secret Societies* [2012], trans. Jon E. Graham, Rochester VT and Toronto: Inner Traditions, 2014.

Lewis, Mary Tompkins (ed.). *Critical Readings in Impressionism and Post-Impressionism: An Anthology*, Berkeley, Los Angeles, London: University of California Press, 2007.

Lippard, Lucy R. (ed.). *Dadas on Art: Tzara, Arp, Duchamp and Others* [1971], Mineola NY: Dover, 2007.

Lomas, David. *The Haunted Self: Surrealism, Psychoanalysis, Subjectivity*, New Haven and London: Yale University Press, 2000.

London: Courtauld Institute of Art. *Cézanne's Card Players*, 2010.

London: Grafton Galleries. *Manet and the Post-Impressionists*, 1910.

London: Grafton Galleries. *Second Post-Impressionist Exhibition*, 1912.

London: Hayward Gallery. *Brassaï: 'No Ordinary Eyes'*, 2001.

London: Royal Academy of Arts. *Post-Impressionism: Cross-Currents in European Painting*, 1979.

London: Royal Academy of Arts. *Monet in the 20th Century*, 1998.

London: Tate Gallery. *Cézanne*, 1996.

London: Tate Modern. *Gauguin: Maker of Myth*, 2010.

London: Wildenstein & Co. Ltd. *Seurat and his Contemporaries*, 1937.

Los Angeles: Los Angeles County Museum of Art. *Magritte and Contemporary Art: The Treachery of Images*, 2006.

Los Angeles: Los Angeles County Museum of Art. *Renoir in the 20th Century*, 2010.

Lövgren, Sven. *The Genesis of Modernism: Seurat, Gauguin, van Gogh and French Symbolism in the 1880s*, trans. Albert Read, Stockholm: Almqvist & Wiksell, 1959.

Löwy, Michel. *Morning Star: Surrealism, Marxism, Anarchism, Situationism, Utopia* [2000], trans Jen Besemer and Marie Stuart, Austin TX: University of Texas Press, 2009.

Lübbren, Nina. *Rural Artists' Colonies in Europe 1870–1910*, New Brunswick NJ: Rutgers University Press, 2001.

Magritte, René. *Écrits complets*, ed. André Blavier, Paris: Flammarion, 1979.

Magritte, René. *Selected Writings*, eds Kathleen Rooney and Eric Plattner, trans. Jo Levy, Minneapolis MN: University of Minnesota Press, 2016.

Mahon, Alyce. *Surrealism and the Politics of Eros, 1938–1968*, London: Thames and Hudson, 2005.

Malraux, André. *The Voices of Silence* [1951], trans. Stuart Gilbert, New York: Doubleday & Company, 1953.

Mariën, Marcel. *Les Corrections naturelles*, Brussels: Librairie Sélection, 1947.

Mariën, Marcel. *Activité surréaliste en Belgique (1924–1950)*, Brussels: Éditions Lebeer Hossman, 1979.

Markale, Jean. *Les Celtes et la civilisation celtique: Mythe et histoire*, Paris: Payot, 1969.

Marseille: Centre de la Vieille Charité. *La Planète affolée: Surréalisme, Dispersion et Influences, 1938–1947*, 1986.

Marseille: Musée de Marseille. *Le Jeu de Marseille: Autour d'André Breton et des Surréalistes à Marseille en 1940–1941*, 2003.

Masson, André. *Le rebelle du surréalisme: écrits*, ed. Françoise Will-Levaillant, Paris: Hermann, 1976.

Mathews, Nancy Mowll (ed.). *Cassatt and Her Circle: Selected Letters*, New York: Abbeville Press Publishers, 1984.

Mathews, Nancy Mowll. *Paul Gauguin: An Erotic Life*, New Haven and London: Yale University Press, 2001.

Maurer, Naomi Margolis. *The Pursuit of Spiritual Wisdom: The Thought and Art of Vincent van Gogh and Paul Gauguin*, Madison and Teaneck NJ: Fairleigh Dickinson and London: Associated University Presses, 1998.

Mauss, Marcel. *A General Theory of Magic* [1902], trans. Robert Brain, London and New York: Routledge, 1972.

Meier-Graefe, Julius. *Cézanne und sein Kreis*, Munich: R. Piper and Co., 1918.

Meier-Graefe, Julius. *Cézanne*, trans. J. Holroyd-Reece, London: Ernest Benn Limited, 1927.

Merlhès, Victor. *Correspondance de Paul Gauguin: Documents, témoignages*, Paris: Fondation Singer-Polignac, 1984.

Morgane-Tanguy, Geneviève. *Yves Tanguy: Druide surréaliste*, Paris: Éditions Fernand Lanore, 1995.

Morice, Charles. *Paul Gauguin*, Paris: H. Floury, 1919.

Motherwell, Robert. *The Dada Painters and Poets: An Anthology* [1951], Cambridge, Mass. and London: The Belknap Press of Harvard University Press, 1981.

New York: Metropolitan Museum of Art. *Georges Seurat: 1859–1891*, 1991.

New York: Museum of Modern Art. *Antonin Artaud: Works on Paper*, 1996.

New York: Museum of Modern Art. *Gauguin: Metamorphoses*, 2014.

Noël, Bernard. *Marseille – New York: 1940–1945. Une Liaison surréaliste*, Marseille: André Dimanche, 1985.

Orton, Fred and Griselda Pollock. *Avant-Gardes and Partisans Reviewed*, Manchester and New York: Manchester University Press, 1996.

Ozenfant, Amédée and Charles-Edouard Jeanneret. *La Peinture modern*, Paris: Les Éditions G. Crès & Co., 1925.

Pach, Walter. *Georges Seurat*, New York: Duffield and Company, 1923.

Paris: Bibliothèque nationale de France. *Antonin Artaud*, 2006.

Paris: Centre National des Arts Plastiques. *Charles Estienne & l'art à Paris 1945–1966*, 1984.

Paris: Galerie René Drouin. *Kandinsky: époque parisienne 1934–1944*, 1949.

Paris: Institut Neerlandais. *Oeuvres écrites de Gauguin et van Gogh*, 1975.

Paris: Le Bateau-Lavoir. *Dessins Symbolistes*, 1958.

Paris: Musée de l'Orangerie. *Cézanne*, 1936.

Paris: Musée national d'art moderne, Centre Georges Pompidou. *André Breton: La beauté convulsive*, 1991.

Paris: Musée d'Orsay. *Van Gogh/Artaud: Le suicidé de la société*, 2014.

Paris: Musée pédagogique. *Pérennité de l'art gaulois*, 1955.

Paris: Orangerie des Tuileries. *Gauguin: Exposition du centenaire*, 1949.

Parkinson, Gavin. *Surrealism, Art and Modern Science: Relativity, Quantum Mechanics, Epistemology*, New Haven and London: Yale University Press, 2008.

Parkinson, Gavin. *Futures of Surrealism: Myth, Science Fiction and Fantastic Art in France 1936–1969*, New Haven and London: Yale University Press, 2015.

Péret, Benjamin. *La Parole est à Péret*, New York: Éditions Surréalistes, 1943.

Perruchot, Henri. *La vie de Seurat*, Paris: Hachette, 1966.

Pierre, José. *Gauguin aux marquises: roman*, Paris: Flammarion, 1982.

Pierre, José (ed.). *Tracts surréalistes et déclarations collectives, 1922–1969*, two vols, Paris: Le Terrain Vague, 1982.

Pierre, José. *L'Univers surréaliste*, Paris: Somogy, 1983.

Pierre, José. *André Breton et la peinture*, Lausanne: L'Age d'Homme, 1987.

Pissarro, Camille. *Letters to his Son Lucien* [1946], ed. John Rewald, trans. Lionel Abel, London and Henley: Routledge & Kegan Paul, 1980.

Polizzotti, Mark. *Revolution of the Mind: The Life of André Breton*, revised and updated, Boston: Black Widow Press, 2009.

Pont-Aven: Musée de Pont-Aven. *Seguin, 1869–1903*, 1989.

Prather, Marla and Charles F. Stuckey (eds). *Gauguin: A Retrospective*, New York: Hugh Lauter Levin Associates, Inc., 1987.

Quimper: Musée des beaux-arts. *Gauguin et le groupe de Pont-Aven*, 1950.

Quimper: Musée des beaux-arts. *Yves Tanguy: L'univers surréaliste*, 2007.

Quimper: Musée des beaux-arts. *Yves Elléouët*, 2009.

Redon, Odilon. *Lettres d'Odilon Redon, 1878–1916*, Paris and Brussels: G. van Oest & Cie, 1923.

Redon, Odilon. *To Myself: Notes on Life, Art and Artists* [1979], trans Mira Jacob and Jeanne L. Wasserman, New York: George Braziller, Inc., 1986.

Renoir, Jean. *Renoir: My Father*, trans Randolph and Dorothy Weaver, London: Collins, 1962.

Renoir, Jean. *Pierre-Auguste Renoir, mon père* [1962], Paris: Gallimard, 1981.

Rewald, John. *Cézanne et Zola*, Paris: Éditions A. Sedrowski, 1936.

Rewald, John. *Georges Seurat*, trans. Lionel Abel, New York: Wittenborn and Company, 1943.

Rewald, John. *Georges Seurat*, Paris: Éditions Albin Michel, 1948.

Rewald, John. *Post-Impressionism: From Van Gogh to Gauguin*, New York: The Museum of Modern Art, 1956.

Rewald, John. *The History of Impressionism* [1946], New York: The Museum of Modern Art, 1973.

Rewald, John. *Studies in Post-Impressionism*, eds Irene Gordon and Frances Weitzenhoffer, London: Thames and Hudson, 1986.

Rewald, John. *Seurat: A Biography*, London: Thames and Hudson, 1990.

Rey, Robert. *La Renaissance du sentiment classique: Degas, Renoir, Gauguin, Cézanne, Seurat*, Paris: Beaux-Arts, 1931.

Reynaud Paligot, Carole. *Parcours politique des surréalistes 1919–1969* [2001], Paris: CNRS Éditions, 2010.

Rich, Daniel Catton. *Seurat and the Evolution of La Grande Jatte*, Chicago: The University of Chicago Press, 1935.

Richardson, Michael and Krzysztof Fijalkowski (eds and trans). *Surrealism Against the Current: Tracts and Declarations*, London and Sterling, VA: Pluto Press, 2001.

Rivière, Georges. *Le Maitre Paul Cézanne*, Paris: Henri Floury, 1923.

Roger-Marx, Claude. *Seurat*, Paris: Les Éditions G. Crès & Co., 1931.

Roger-Marx, Claude. *Renoir*, Paris: Librairie Floury, 1937.

Rookmaaker, H. R. *Synthetist Art Theories: Genesis and Nature of the Ideas on Art of Gauguin and his Circle*, Amsterdam: Swets & Zeitlinger, 1959.

Rosemont, Franklin. *André Breton and the First Principles of Surrealism*, London: Pluto Press, 1978.

Rosemont, Franklin. *Revolution in the Service of the Marvelous: Surrealist Contributions to the Critique of Miserabilism*, Chicago: Charles H. Kerr, 2004.

Rosemont, Penelope. *Surrealist Experiences: 1001 Dawns, 221 Midnights*, Chicago: Black Swan Press, 2000.

Rosemont, Penelope. *Dreams & Everyday Life: André Breton, Surrealism, Rebel Worker, SDS & the Seven Cities of Cibola in Chicago, Paris & London. A 1960s Notebook*, Chicago: Charles H. Kerr, 2008.

Roslak, Robyn. *Neo-Impressionism and Anarchism in Fin-de-Siècle France*, Aldershot and Burlington, VT: Ashgate, 2007.

Rubin, James H. *Impressionism*, London: Phaidon, 1999.

Rubin, William S. *Dada & Surrealist Art*, London: Thames and Hudson, 1968.

Sanouillet, Michel. *Dada in Paris* [1965], trans. Sharmila Ganguly, Cambridge, Mass. and London: MIT, 2009.

Schapiro, Meyer. *Cézanne*, London: Thames and Hudson, 1952.

Schapiro, Meyer. *Modern Art, 19th and 20th Centuries: Selected Papers*, vol. 2, London: Chatto & Windus, 1978.

Schapiro, Meyer. *Theory and Philosophy of Art: Style, Artist, and Society. Selected Papers*, New York: George Braziller, 1994.

Scheer, Edward (ed.). *100 Years of Cruelty: Essays on Artaud*, Sydney: Power Publications and Artspace, 2000.

Scheer, Edward (ed.). *Antonin Artaud: A Critical Reader*, London and New York: Routledge, 2004.

Schivelbusch, Wolfgang. *Disenchanted Night: The Industrialization of Light in the Nineteenth Century* [1983], trans. Angela Davies, Berkeley, Los Angeles, London: University of California Press, 1995.

Schwarz, Arturo (ed.). *The Complete Works of Marcel Duchamp*, two vols, revised and expanded, London: Thames and Hudson, 1997.

Scutenaire, Louis. *René Magritte* [1948], Brussels: Ministère de l'Éducation Nationale et de la Culture, 1964.

Seligman, Germain. *The Drawings of Georges Seurat*, New York: Curt Valentin, 1947.

Seligmann, Kurt. *The Mirror of Magic: A History of Magic in the Western World*, New York: Pantheon, 1948.

Sérusier, Paul. *A B C de la peinture* [1921], Paris: Librairie Floury, 1942.

Sérusier, Paul. *A B C de la peinture, Correspondance* [1921], Paris: Librairie Floury, 1950.

Shiff, Richard. *Cézanne and the End of Impressionism: A Study of the Theory, Technique, and Critical Evaluation of Modern Art*, Chicago and London: The University of Chicago Press, 1984.

Smith, Paul. *Seurat and the Avant-Garde*, New Haven and London: Yale University Press, 1997.

Smith, Paul (ed.). *Seurat Re-Viewed*, University Park PA: The Pennsylvania State University Press, 2009.

Sollers, Philippe (ed.). *Artaud*, Paris: 10/18, 1973.

Sollers, Philippe (ed.). *Bataille*, Paris: 10/18, 1973.

Sollers, Philippe. *Writing and the Experience of Limits* [1968], ed. David Hayman, trans Philip Barnard with David Hayman, New York: Columbia University Press, 1983.

Spiteri, Raymond and Donald LaCoss. *Surrealism, Politics and Culture*, Aldershot and Burlington VT: Ashgate, 2003.

Sylvester, David. *Magritte*, London: Thames and Hudson/Menil Foundation, 1992.

Sylvester, David (ed.). *René Magritte: Catalogue Raisonné*, six vols, London: The Menil Foundation/Philip Wilson Publishers, 1993.

Taylor, Joshua C. (ed.). *Nineteenth-Century Theories of Art*, Berkeley, Los Angeles, London: University of California Press, 1987.

Terrasse, Charles. *Cinquante portraits de Renoir*, Paris: Librairie Floury, 1941.

Thévenin, Paule (ed.). *Bureau de recherches surréalistes: cahier de la permanence, octobre 1924-avril 1925*, Paris: Gallimard, 1988.

Thomson, Belinda. *Gauguin* [1987], London: Thames and Hudson, 1990.

Thomson, Belinda. *Post-Impressionism*, London, Tate Gallery Publishing, 1998.

Thomson, Richard. *Seurat*, Oxford and New York: Phaidon, 1985.

Thomson, Richard (ed.). *Framing France: The Representation of Landscape in France, 1870–1914*, Manchester and New York: Manchester University Press, 1998.

Tomkins, Calvin. *Duchamp: A Biography*, New York: Henry Holt and Company, 1996.

Van Gogh, Vincent. *The Letters: The Complete Illustrated and Annotated Edition*, six vols, eds Leo Jansen, Hans Luijten and Nienke Bakker, London and New York: Thames and Hudson, 2009.

Varty, Keith (ed.). *Reynard the Fox: Social Engagement and Cultural Metamorphoses in the Beast Epic from the Middle Ages to the Present*, New York and Oxford: Berghahn Books, 2000.

Venturi, Lionello. *Cézanne: son art – son oeuvre*, two vols, Paris: Paul Rosenberg, 1936.

Verhoeyen, Etienne. *La Belgique occupé: de l'an 40 à la liberation* [1993], trans. Serge Govaert, Brussels: De Boeck Université, 1994.

Viallaneix, Paul and Jean Ehrard. *Nos Ancêtres les Gaulois*, Clermont-Ferrand: Association des Publications de la Faculté des Lettres et Sciences Humaines, 1982.

Vienna: Museum Moderner Kunst. *Bad Painting, Good Art*, 2008.

Vollard, Ambroise. *Paul Cézanne*, Paris: Galerie A. Vollard, 1914.

Von Mauer, Karin. *Yves Tanguy and Surrealism*, Ostfildern-Ruit: Hatje Cantz, 2001.

Waldberg, Patrick. *René Magritte*, trans. Austryn Wainhouse, Brussels: André de Rache, 1965.

Wallen, Martin. *Fox*, London: Reaktion, 2006.

Warehime, Marja. *Brassaï: Images of Culture and the Surrealist Observer*, Baton Rouge LA and London: Louisiana State University Press, 1996.

Washington: National Gallery of Art. *The Art of Paul Gauguin*, 1988.

Webb, Mary. *La Renarde* [1917], trans Marie Canavaggia and Jacques de Lacretelle, Paris: Éditions du Siècle, 1933.

Webb, Mary. *Gone to Earth* [1917], London: Virago, 1979.

Wilson, Sarah. *Picasso/Marx and Socialist Realism in France*, Liverpool: Liverpool University Press, 2013.

Young, Edward. *Night Thoughts*, ed. Stephen Cornford, Cambridge: Cambridge University Press, 1989.

Zafran, Eric M. (ed.). *Gauguin's Nirvana: Painters at Le Pouldu 1889–90*, New Haven and London: Yale University Press, 2001.

Zalman, Sandra. *Consuming Surrealism in American Culture: Dissident Modernism*, Farnham and Burlington VT: Ashgate, 2015.

Zemel, Carol M. *The Formation of a Legend: Van Gogh Criticism, 1890–1920*, Ann Arbor MI: UMI Research Press, 1980.

Zimmermann, Michael F. *Seurat and the Art Theory of his Time*, Antwerp: Fonds Mercator, 1991.

Index

In this index illustrations are indicated in italics. For French entries the definite article (le, la, l' and les) is ignored for sorting purposes, e.g. *La Nova Revista* is filed under 'N'.